# MANIFESTA7
# COMPANION

SilvanaEditoriale

# COMPANION

**MANIFESTA 7**
**THE EUROPEAN BIENNIAL OF CONTEMPORARY ART**
19 JULY–2 NOVEMBER 2008
TRENTINO SOUTH TYROL, ITALY

**CURATORS**
**ADAM BUDAK (PRINCIPLE HOPE)**
ANSELM FRANKE & HILA PELEG (THE SOUL)
RAQS MEDIA COLLECTIVE (THE REST OF NOW)

**EDITORS**
**RANA DASGUPTA (THE REST OF NOW)**
NINA MÖNTMANN (PRINCIPLE HOPE)
AVI PITCHON (THE SOUL)

# CONTENTS

# FOREWORD
## JOINT FORCES
HEDWIG FIJEN
ANDREAS HAPKEMEYER
FABIO CAVALLUCCI

Manifesta 7 is the concept and name of a series of interdisciplinary events and projects launched by the International Foundation Manifesta and the Provinces of Trento and Bozen/Bolzano to investigate the practice and potential of contemporary visual culture against the backdrop of Europe's political, geographical and social situation. The Trentino–South Tyrol region is recognized by Manifesta for its extraordinary industrial heritage and cultural infrastructure, and this has constituted the basis for formulating the artistic context of Manifesta 7. The venues that will be used are located on one of Europe's most important travel routes between North and South: the fortress of Franzensfeste/ Fortezza that dates back to the middle of the nineteenth century, three industrial buildings from the first decades of the twentieth century, the ex-Alumix (Bozen/Bolzano) and the Manifattura Tabacchi and ex-Peterlini (both located in Rovereto) as well as the Post Office building in Trento, an edifice constructed in the rationalist style of the 1930s. The curatorial team of Manifesta 7 consists of Adam Budak (Krakow/Graz), Anselm Franke (Antwerp/Berlin)/Hila Peleg (Tel Aviv/Berlin) and the members of the Raqs Media Collective (Delhi), a collective of artists and multimedia theoreticians. Each artistic unit is concentrating on venues selected by the organization in a particular city and together they will jointly work on one project at the venue called the Fortress. In keeping with its tradition for innovation, Manifesta has moved from a representational format, such as was used in various forms for the first five editions of the biennial, to a more reflective format, characterized by the experimental school proposed for Manifesta 6 to incorporate a new emphasis on education and artistic production. For Manifesta 7 the focus is on the use of existing historical buildings.

Manifesta 7 creates a context that invites artists, curators, intellectuals and diverse publics to consider the region of Trentino–South Tyrol as a zone of contact. Trentino–South Tyrol has a long history as frontier region, as a place of multicultural coexistence. By demonstrating an awareness of history and the transcendence of nationalist divisions, Manifesta 7 creates a context for a serious analysis of the reality of a multi-ethnic Europe. Manifesta 7 wants to think of the frontier as the skin of our time and our world.

Manifesta began its activities in the early 90s in the course of important political changes in Europe, when one part of the continent was, at the end of the Cold War, determined to free itself from its former political system. It was born out of the conflict between East and West, focusing on a pan-European representation of its professional cultural scene and art practices and in dialogue with the territory's social and geopolitical specificities. Here, at Manifesta 7, curators and cultural producers have set out to develop and expand links between the contemporary art scene and the architectural, performative and

social landscape of Europe and beyond. With the gradual opening up of borders in Europe towards its neighbours and India and China, Manifesta 7 aims to join together the various art communities as well as outside influences, developing a framework to facilitate interaction and collaboration with participants from Europe, Asia, North America and Latin America.

For the first time in such an international enterprise, by selecting two provinces—Trentino and South Tyrol—as cooperational partners, Manifesta 7 facilitates direct links between these regions and other artistic hubs in the world, by activating and integrating different models of crosscultural ferment through the production of art works that tend to respond to local conditions. The perpetual dislocation and relocation of Manifesta 7 also attempts to question the very nature and the objectives of the project, forcing all participants to truly embrace the dialogue with the local representatives of existing organizations and to adapt each time with a fresh disposition in which locality and internationality can create a new form of synergy. Much emphasis is placed on the belief that this synergy can continue to flourish after Manifesta 7 has left.

The Fortezza/Franzensfeste, the ex-Alumix building and ex-Peterlini should ideally be destined to host cultural institutions and future events after Manifesta 7 has moved on. In this sense Manifesta 7 can be considered as a kind of praeludium to a dynamic, active cultural life. In a region where collaboration has not always been automatically trusted, or regarded as a natural, organic procedures, the fact that the two provinces worked so closely together signifies an important step towards a constructive future. Manifesta 7 is not supposed to be seen as an UFO landing from outer space, bringing a cargo of international contemporary art. Manifesta always seeks dialogue with local communities. In the Trentino–South Tyrol region, more than one hundred cultural associations are involved in Parallel Events accompanying the activities of Manifesta 7. Manifesta 7 does not need to end with a conventional European model of homogenization on economic, cultural and political levels. A modest approach to transregional collaboration seems to be the only way to escape the limits and disillusions of the concept of nationality in the post-European integration process.

New thematic approaches, alternative models of organisation, slowing down our current attitude of reinforcing the art world using our constantly changing behaviour towards cultural policy and artistic production—these do not take away Manifesta's urgency to create conditions for artists to enlarge their scope and mobility, broaden common goals between producers and artists and promote an exchange of knowledge between social and political innovators in Europe.

# THE REST
## OF NOW

**EDITED BY**
**RANA DASGUPTA**
WITH RAQS
MEDIA COLLECTIVE

# CONTENTS

## THE AFTERLIFE OF INDUSTRY

## AUGURIES AND REVERIES

# PREFACE
## RANA DASGUPTA

Having lost our tradition, we have nothing behind us but the past, Hannah Arendt tells us—and so we wonder what it means to live in 'mere' time. Digital time, comprised of infinite identical units, where there is no lingering, no haggling, no coming round again. The great significance of things persists, but it is hard to fish out of this relentless current: it can be grasped only in the aftermath, when absence, like a clean shape in the dust, reveals the outline of what has been.

When ordinary objects are pushed aside by time to become remnants or wreckage, they acquire a new and solemn power. They pronounce, finally, what they never could while they were inside the clean room: *time has passed.* Now that time has become invisible and odourless, now it has become, in fact, undetectable, this message carries such solemn beauty that we can hardly resist the impulse to seek out such worn-out objects for our own melancholy contemplation—no matter how ironic this may seem in an era as rapacious and destructive as our own. Even as time uproots everything around us, leaving domineering scars and traces, we still feel the need to discover it again, and make it our own.

These pages are about the residue that accumulates from time's passing. They arise from a number of enriching conversations between myself and Raqs Media Collective and all our colleagues in this project about *the stuff that is not the product*: what is sloughed off, melted down or given up, what is abandoned, forgotten, disavowed, exiled or recycled. But the contributors to *The Rest of Now*— artists, writers, curators, librarians, musicians, architects and other theorists—are not concerned by the merely derelict. In these essays and photo essays, sometimes in a single quotation or a found image, they make visible everything that dances in the outskirts of reality, tantalizing it with what it is not, and, in so doing, making it complete.

# AVE OBLIVIO
## RAQS MEDIA COLLECTIVE

*Raqs Media Collective overhears the ghost of a provincial prefect.*

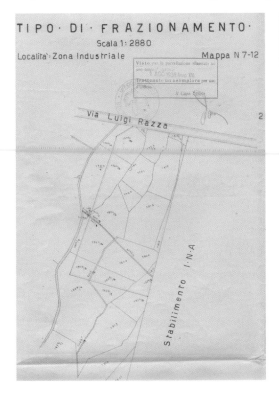

**I** First, let a map be drawn. Let a cadastral reckoning be inked of who owns what, who owes what to whom. Let empty lots yield. Let letters and numbers do the talking. Let the land be silent.

Who has ever heard the land speak?

**II** Next, let the draughtsman sharpen his pencils. Let a scale be computed. An adequate scale. A scale that proportions a factory somewhere between a mountain and a human being. Let no person stain the drawing. Let there be precision. But let precision not thwart grandeur.

Let there be grandeur. Even more grandeur.

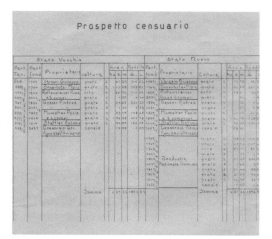

Prospetto censuario

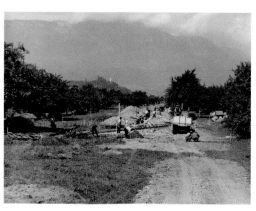

**III** Now, let the clerk in. Let him figure. Let the tables be turned. There were no peasants here. They had no claim. Elsewhere, there were some. Maybe, there were some. Who said there were some? They moved up the mountain, sometime in the ice age. We found one in a snowdrift. You can see him in the museum, frozen. All outstanding claims have been settled. Was it a bag of rice for an acre, or was it a shovelful of beans for a fistful of soil? The clerk is so clever. And look at his penmanship.He deserves a promotion.

He does it with elegance. He does it in italics.

**IV** Hurry, let the road be laid. Let the shade of a tree not distract. Bring surveyors, have them measure. Cut that tree down. And that one, outside the picture. Bring stone, dig earth, bring poor men from the south. Let them breed. Give each of them a handful of resentment. Let them fester in the sun.

Let them build roads so automobiles can speed past them.

**VI** Then, let there be more digging. Let the road stretch longer. Dig more roads, and then some more. Let no stone remain unturned. Dig canals and trenches. Dig war, dig prosperity, dig peace, dig perils, dig bones, dig mines, dig mountains, dig money, dig, dig, dig your own dog's grave.

Every man his own dog. Every dog has his day. Every day has its dog.

**V** Wait, let the foundation stone be raised before anything else is done. Let it tower. Let it mark words of power and carve them deep. Let it be immortal.

Remember me. I haven't gone away. I am carved in stone. I will return. I always return.

**VII** Build, let the scaffolding ascend. Let the water tower rise. Let bricks be laid. Pour concrete, lay foundations and crossbeams. 'Architecture is the impress of power on a landscape'. Who said that?

I say it better in Italian. So much better.

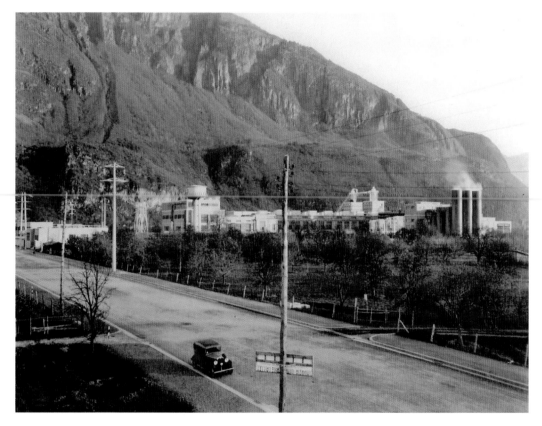

**VIII** Commence! Let production begin. Let turbines turn, let engines hum, let alloys sing high voltage anthems to electric accompaniment. Let smelter, furnace, forge and anvil burn incandescent. Let every muscle surrender to the production target.

Targets go to heaven, dead workers go to the morgue. Who haunts the factory?

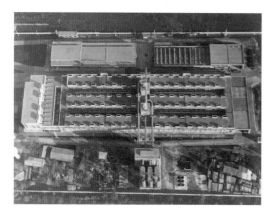

**IX** Rise, let there be altitude, let there be distance. Only when you look down with the eyes of a bomber at all that stretched-out industrial symmetry will you know its true value. Did I hear someone say something about labour? That is marginal to the calculation. Insurance is Investment. Destruction is Production. War is Accumulation.

I want coffee. Coffee, coffee, coffee. More coffee. *Doppio espresso.* Read the coffee grounds. Look at what they say.

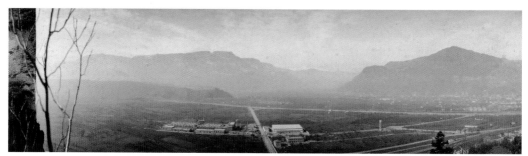

**X** Shine! Let there be light! Let there be radiance! Panoramas delight. They dignify the earth by optical reassemblage. Every valley is exalted. The crooked is made straight.

A landscape is to be coveted, if not possessed, only by the deserving, discerning eye.

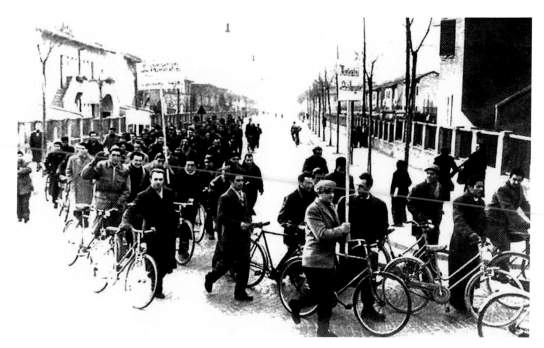

**XI** Beware, let the workers know the consequences of their actions. Let them understand that a strike is only an overture to a lockout. Let a mass be said for an end to strife. *Benedictus.* Workers are leaving the factory, again. *Sanctus*. Bicycles are not tanks. *Sanctissimus.* Cloth caps are not steel helmets. Workers are not soldiers. *Misericordiae.* But a strike is a war.

And I have the soldiers, the helmets, the tanks and the priests and the policemen and the TV. *Amen.*

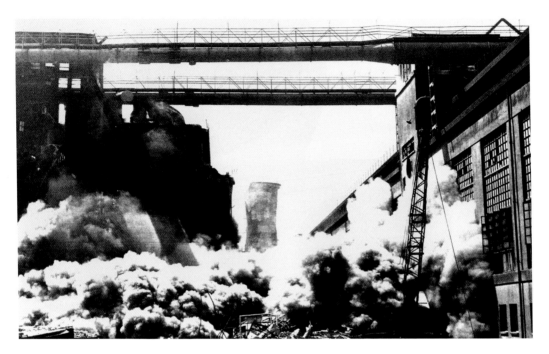

**XII** Finally, let there be dynamite, and then,
let the dust settle. And when all is done,
when the rest of now is over, let a map be
drawn again. And another architectural
plan. Make it bigger.

As if nothing really happened. As if no
one remembered. As if no trace was left.
*Ave Oblivio.*

# RISING FROM
# THE RESIDUE

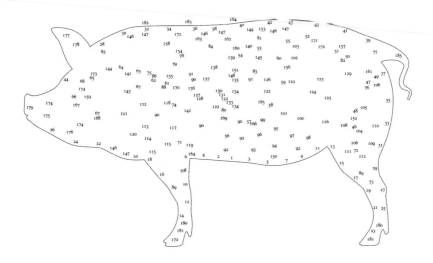

SERIOUS, SERIOUS, SERIOUS,
UNTIL DEATH STOPS YOU BEING SERIOUS.

Text by Francis Picabia selected by
Marcos Chaves

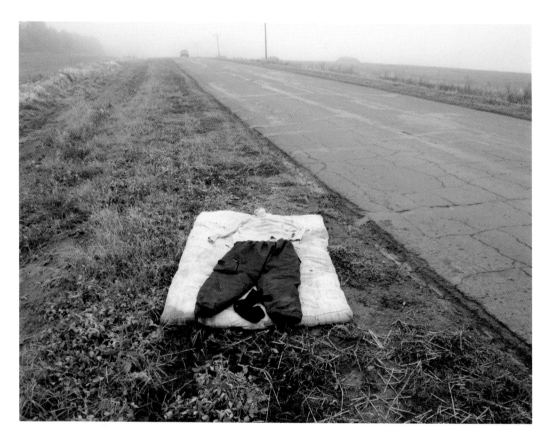

MY TRAVEL KIT, LEFT BY THE ROAD AT THE
END OF MY TRIP.OCTOBER 25, 2007. REPUBLIC
OF UDMURTIA, RUSSIA.

Image by Darius Ziura.

# WHAT SHALL WE DO WITH THE FOREST UNDER SOCIALISM?
## ANDERS KREUGER

Ever since July 1987, when I first crossed from Finland into Soviet Karelia by train, I have wondered about the peculiar state of nature in socialist (now already post-socialist) countries. How can it be that we immediately recognize the legacy of real socialism in an unkempt meadow, a patch of unused suburban land or a stretch of forest unfolding outside our train window? Even the dried dirt on roadside thistles seems dryer and dirtier east of the old Iron Curtain.

It is not just that there are few visible traces of human care and affection for the environ-ment when we travel through the countryside in, say, Latvia or Romania or central Russia; what the post-socialist landscape fundamentally lacks is visible evidence of rational use. It has lost the visual poetry of husbandry, and therefore strikes us as less 'natural', more overwritten with political code, than nature in the established capitalist economies—however absurd this may seem when we remember what effects the First World's policies are now having on the planet's forests and agricultural land.

Is the depressed identity of post-socialist nature an optical illusion, encouraged by our prejudice and cultural arrogance as outside viewers, or is it a visual residue, a telling remainder of the departed system?

Of course there are also instances that contradict these observations. Wetlands, swamps and virgin forests have often survived longer in eastern Europe and Russia than in the West, precisely because of the irrationality of the now-defunct economic system, which never managed, despite its military organization, to fully mobilize natural resources. Yet even the relatively unspoilt margins of the post-socialist landscape somehow look and feel traumatized. Fifteen years of change have clearly not been enough to produce a more upbeat counter-visuality outside the major cities.

There is a passage in the long-repressed novel *Chevengur* by Andrei Platonov (written in 1926–29 but not published in Russia until 1988) that I think illuminates the origins of socialist nature. The novel is set in the early 1920s, the chaotic and destructive years of the civil war. I have translated an extract which I think makes the point clearly: nature in eastern Europe is the visual leftover of a system where contingent human reactions to the social and natural environment—often fuelled by vanity, incompetence and low-grade emotions such as envy or lust for revenge—were aggressively packaged as historical necessities and signs of rational progress.

'You tell me, what shall we do with the forest under Socialism?' sighed Kopenkin with despondent thoughtfulness.

'Tell us, comrade, how much income does a forest give per acre?' Dvanov asked the watchman.

'It depends', replied the watchman with some deliberation, 'what kind of forest, how old it is and in what shape; there are many circumstances here...'

'But in general?'

'In general... You'd have to calculate ten to fifteen roubles'.

'Only? And rye, I guess, would be more?'

The watchman started to become afraid and took care not to make a mistake.

'Rye would be a little bit more... A farmer would get twenty–thirty roubles of pure income per acre. Not less, I'd say'.

Kopenkin's face showed the rage of a man who has been deceived.

'Then we must fell the forest at once and have the land ploughed! These trees only stand in the way for the autumn rye...'

The watchman fell silent and followed the upset Kopenkin with finely attuned eyes. Dvanov was calculating the losses from forestry with a pencil on Arsakov's book. He asked the watchman how many acres his forest comprised, and did the sums.

'The men are losing around ten thousand a year on this forest', Dvanov pronounced calmly. 'Rye would seem to be more advantageous'.

'Of course it will more advantageous', Kopenkin exploded. 'The forester himself told you so. This whole hill must be totally cut down and sown with rye. Write an order, Comrade Dvanov!' Dvanov remembered that he had not been in touch with Shumilin for a long time. But surely Shumilin would not judge him for direct actions so obviously in accordance with revolutionary usefulness.

The watchman picked up the courage to disagree a little:

'I wanted to tell you that unauthorized felling has anyway strongly increased lately, and there should be no more felling of such sturdy trees'.

'So, even better', Kopenkin retorted with hostility. 'We're treading in the People's footsteps, not guiding it. The People itself, that is, feels that rye is more useful than trees. Write the order, Sasha, to fell the forest'.

Dvanov wrote a long imperative address to all the poor peasants of the Verkhne-Motinsk district. The address proposed, in the name of the Provincial Executive Committee, to survey the situation of the poor and to cut down the forest of the Bitterman estate forthwith. This, it said in the instruction, would build two roads towards Socialism at once. On the one hand, the poor peasants would get timber for building new Soviet cities on the high steppe, and, on the other, land would be liberated for sowing rye and other cultures more useful than slow-growing trees.

Kopenkin read the order.

'Excellent!' he concluded. 'Let me also sign here below, to make it more frightening. Many people remember me around here. I'm a man in arms, you see'.

And he signed with his full title: Commander of the Bolshevik Rosa Luxemburg Field Detachment of the Verkhne-Motinsk District Stepan Efimovich Kopenkin.

1. Andrei Platonov, Chevengur (Moscow: Khudozhestvennaya Literatura, 1988), 140–142.

'You'll bring it tomorrow to the nearest village, and the others will find out by themselves', Kopenkin said to the forest watchman as he handed him the paper.

'And what am I supposed to do after the forest?' the instructed watchman asked. Kopenkin ordered:

You, too, must work the earth and feed yourself! I'm sure you used to receive so many complaints in one year that they'd fill a whole cottage. Now live like the masses'.

It was already late. The deep revolutionary night already lay over the doomed forest. Before the revolution Kopenkin did not take careful notice of anything: forests, people and wind-blown expanses were of no concern to him, and he did not interfere with them. Now change had been brought about. Kopenkin listened to the even howl of the winter night, and wished it would pass successfully over the Soviet Land.[1]

Image by Nikolaus Hirsch & Michel Müller

# TO DESTROY MOUNTAINS
FELIX PADEL

Aluminium's countless applications in modern civilian life tend to mask its numerous uses in weapons technology, which make it one of a handful of metals classed as 'strategic' by the Pentagon—meaning that a top priority of the world's most powerful governments is to ensure its constant supply at the lowest possible cost. To this end, new bauxite mines, alumina refineries and aluminium smelters are being promoted in many countries with enormous hidden pressure.

Discoveries of thermite and duralumin in 1901 and 1908 led swiftly to the commercialization of aluminium's potential for use in bombs and aircraft. The First and Second World Wars boosted aluminium sales hugely, as has every war since. Aluminium is at the heart of the military-industrial complex, and defines the scale of modern warfare in a way few people realize. Even the standard Kalashnikov assault rifle has had an aluminium frame since 1961.

In the 1920s, aluminium alloys took humans to the skies, starting with duralumin (used in First World War aircraft). An unfurnished jumbo jet or military aircraft still consists of about 80 per cent aluminium, though the alloys used in aerospace have become far more sophisticated, especially the lithium range and metals matrix composites (mixtures with oil/plastic derivatives).

Dams and aluminium are closely intertwined. The real purpose of many of the world's biggest dams is to supply cheap hydropower for aluminium smelting, which consumes vast quantities of electricity. 'Electricity from the big Western dams helped to win the Second World War'—by producing aluminium for arms and aircraft, and later plutonium for the atom bomb.[1] Thermite bombs exploit the latent explosive power in aluminium, using its high heat of formation (the temperature at which it is separated from oxygen) to increase the size of explosions. It formed the basis of seventy thousand hand grenades used in the First World War.

Incendiary bombs and napalm were mostly aluminium-based: 4–8 per cent in napalm, 3–13 per cent in the incendiary or 'goop' bombs manufactured by U.S. industrialist Henry Kaiser. Forty-one thousand tons of 'goop' bombs were dropped on Japan and Germany by 1944. The Chemical Warfare Service used them 'to burn out the heart of Japan' and 'save thousands of American lives'.[2]

Half the British bombs dropped on Dresden in 1945 were napalm, which killed about twenty-five thousand civilians. Napalm and incendiary bombs became standard in Korea and Vietnam. The latter war introduced a fearsome new weapon: the eight-ton BLU-2, or 'daisy-cutter', whose aluminium-slurry explosive power was invented by a Creationist (i.e. Christian fundamentalist) named Melville Cook in 1956. This is the weapon that has been used for carpet-bombing vast areas from Korea to Afghanistan.

After 1945, aluminium demand suddenly dropped. Henry Kaiser's brilliance was to gamble on a war in Korea, and his first customer was Boeing. His factories were soon making the B-36 bombers used in Korea. His 'bet' on this war paid off, and it marked the start of Eisenhower's 'permanent war industry' that has never looked back. U.S. aluminium production more than tripled between 1948 and 1958, ushering in a 'golden new age' for aluminium companies.[3]

1. P. McCully, *Silenced Rivers: The Ecology and Politics of Large Dams* (London: Zed Books, 1996).
2. Albert Heiner, Henry J. Kaiser: *Western Colossus* (Halo Books, 1981), 112.

3. G.D. Smith, *From Monopoly to Competition: The Transformation of Alcoa 1888–1986* (Cambridge: Cambridge University Press, 1988), 150.
4. Dewey Anderson, *Aluminum for Defence and Prosperity* (Washington: U.S. Public Affairs Institute, 1951), 3–5.
5. From an interview in the film *Matiro Poko, Company Loko* (Earth Worm, Company Man) by Amarendra and Samarendra Das (2005).

A little-known text that encapsulates this policy is *Aluminum for Defence and Prosperity,* published by the Truman administration in 1951, which reveals much about the industry that has not been openly discussed since: 'Aluminum has become the most important single bulk material of modern warfare. No fighting is possible, and no war can be carried to a successful conclusion today, without using and destroying vast quantities of aluminum [...] Aluminum is needed in atomic weapons, both in their manufacture and in their delivery'.[4]

Aluminium forms part of a nuclear missile's explosion technology and casing, as well as its fuel. Missile propellants have been based on aluminium powder since the 1950s. From the 1990s, the use of exceedingly fine aluminium powder in rocket fuel was extended through nanotechnology. Nanoparticles of aluminium from spent rocket fuel have already introduced serious pollution to outer space, a leftover of the satellite industry.

Aluminium is subsidized in many ways, on account of its importance for 'defence'. It is anything but a 'green metal'. And it is priced far too cheaply. The real cost of its electricity, water, transport systems and pollutants are all 'externalised' onto manufacturing regions such as India, even as aluminium plants are closing down fast in Europe.

In the Indian state of Orissa, some of the biggest mountains are capped with a layer of high-quality bauxite. Attempts to possess and mine this ore have entailed the particularly dire repression of indigenous people as well as huge threats to the environment.

The industries being promoted in Orissa and the neighbouring states of eastern India are providing fuel for the world's wars, as well as feeding a lifestyle of cars, packaging and mega-scale construction that is increasingly recognised as completely unsustainable in the long term. As Bhagavan Majhi, one of the tribal leaders opposed to aluminium mining in Orissa, says:

*I put a question to the Superintendent of Police. I asked him, Sir, what do you mean by development? Is it development to displace people? The people, for whom development is meant, should reap benefits. After them, the succeeding generations should reap benefits. That is development. It should not cater merely to the greed of a few officials. To destroy mountains that are millions of years old is not development. If the government has decided that we need alumina, and we need to mine bauxite, they should oblige us with replacement land. We are cultivators. We cannot live without land [...] If they need it so badly, they need to tell us why they need it. How many missiles will our bauxite be used for? What bombs will you make? How many military aeroplanes? You must give us a complete account.*[5]

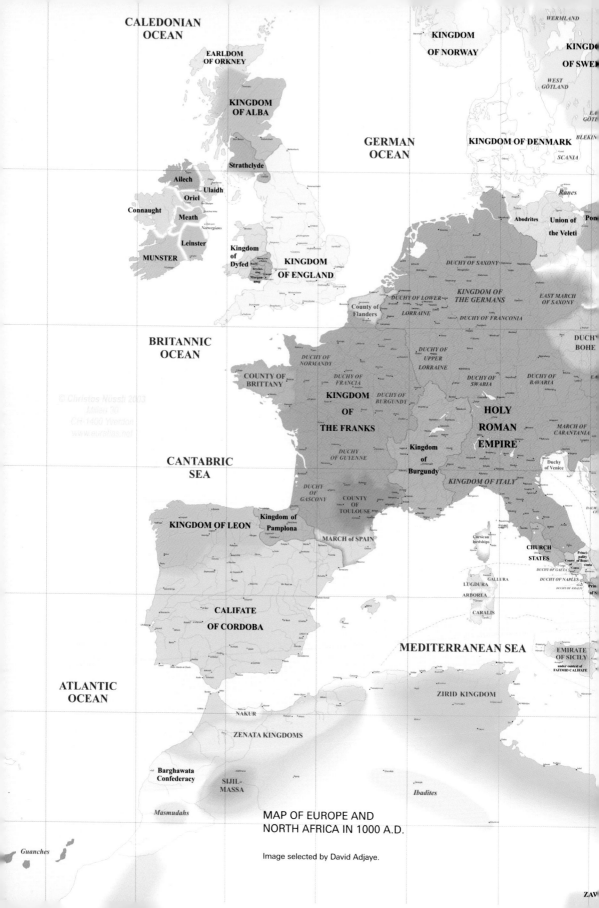

MAP OF EUROPE AND
NORTH AFRICA IN 1000 A.D.

Image selected by David Adjaye.

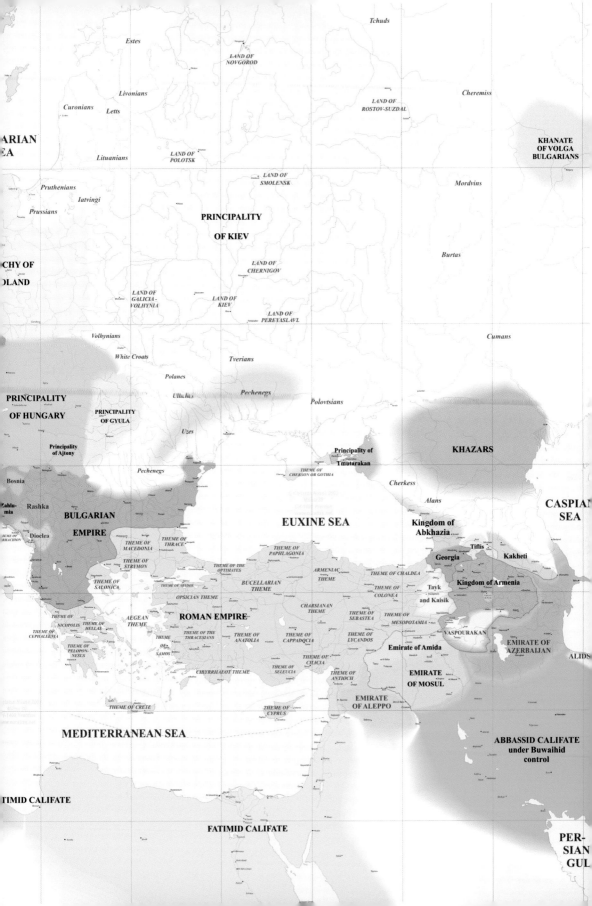

OLD DUST IS STILL ON
MY FINGER (DETOUR: ROME-UKRAINE)

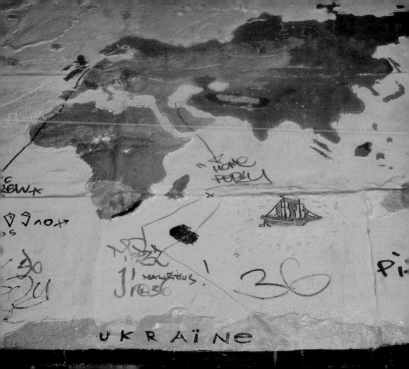

# ACTS OF LETTING AND OF CREATION
MATTHEW FULLER

Beginning in 1649 and continuing into the following year, a number of land occupations were made in England by homeless, poor, hungry or pissed-off people. They became known as 'Diggers' because they organized together to farm underused common land, to build rough settlements and plant food crops. This period of time, after the decapitation of King Charles and before the Commonwealth collapsed into a dictatorship, witnessed great enthusiasm and experimentation.

The Diggers saw three broad kinds of land: wild nature, which was the woods, marshes, rivers, and other parts of land that were not used for farming; proprietary or enclosed land, surrounded by hedges and walls for the use of landowners, handed down by the law of the eldest son and ultimately deriving from conquest; and a third category—common land, areas of land which had complex systems of traditional rights of use attached to them. Such rights were always partial, but might include, depending on the location: the right to pasture animals; gather fallen firewood; harvest rushes, willow branches, or other materials for building; or gather fruits, berries and nuts. In other words, rights to the commons were always specific. What the Diggers proposed was to maximize the use of the commons. They proposed that such land be given over as a common treasury for all people—to be improved, to be farmed and to accommodate storehouses for food and raiments open to all labouring people.

Much of the existing commentary on the Diggers, and on the other movements looking for a reconstitution of society during and following the English Revolution, focuses on reassembling their political thoughts and marking their actions and consequences.[1] Alongside these aspects of the movement, however, it is also possible to consider a certain 'style' of speech and silence, of action and inaction that underlies their behaviour and the behaviour of those who responded to them. It is interesting to note how struggles over food and land (and over the very meaning of those terms, since they were at least temporarily freed from 'kingly law') and the creation of a new form of politics were partly carried out through various processes of 'letting'.

Letting was a means of bringing something into play through virtue of its powers, through the allowance of its action. Causation was deferred or rendered unnecessary, ends were achieved or achieved themselves without any necessary intervention. Acts of letting were kinds of inaction, the knowing allowance of something without direct responsibility. As well as the clear use of reason, argument, and direct action in the classic anarchist sense, in the episodes and events of the Digger movement there were a number of ways in which *indirect* action occured through various processes of letting.

Letting should be seen not simply as an identifier of those who were *good*.[2] It was a domain of active inaction that was essentially beyond good and evil, but the different modalities by which it was set in play implied certain relations to power, and an understanding of the dynamics by which the world constituted itself. Letting occured in the events around the Digger movement in ways that we would now register as richly Machiavellian, but that also that imply a certain vision of ecology. Crucially, certain kinds of letting aligned these two registers by

1. See Christopher Hill, *The World Turned Upside Down: Radical Ideas During the English Revolution* (London: Penguin, 1975); David W. Petegorsky, *Left-Wing Democracy in the English Civil War* (London: Left Book Club); David C. Taylor, *Gerrard Winstanley in Elmbridge* (Cobham: Appleton Publications, 2000). See also the film *Winstanley* (1975), directed by Kevin Brownlow and Andrew Mollo.
2. See Eyal Weizman's *Hollow Land: Israel's Architecture of Occupation* (London: Verso, 2007) for a contemporary version of this, where the occupation and shaping of space act is carried out by political means that are variously obfuscated and deniable, direct and indirect.

3. Gerrard Winstanley, 'The True Leveller's Standard Advanced' (20 33 April 1649), in Leonard Hamilton, ed., *Selections from the Works of Gerrard Winstanley* (London: The Cresset Press, 1940), 40.
4. In 'The Rest of Now', Matthew Fuller's *Digger Barley* presents a small distribution of barley seeds harvested from George Hill, which visitors may take away.

means of a reading and reinvention of power, and a setting into play of previously unaligned capacities of people, seeds, tools, manure and rethought land.

Local landlords used various means for the destruction of the Digger's efforts. There were several direct violent assaults on encampments, involving the breaking up and stealing of clothes, shacks, tools and animals. An important weapon was the courts, which resolved to fine the Diggers ten pounds each, thus making their few cattle and any other property subject to seizure for the payment of this unattainable sum, and forcing the Diggers to move to a new site in Cobham. But in addition to such direct intervention, the landlords also acted by establishing the means by which something might arise 'by chance'. Thus the residues of inaction—of letting something occur—were mobilized as action. Such indirect approaches included the deliberate loosing of cattle onto the Digger's eleven acres of barley, which was naturally ruined. It was an 'accident', a residue of inaction. On another occasion, villagers were given quantities of tobacco and wine and were incited by the church into another form of inaction—to boycott the trade of the Digger settlement. In such cases, letting functioned to allow those in power to achieve their ends whilst absolving them of responsibility.

For the Diggers, letting involved the interplay of two registers. The first was at the level of politics, and the organization of property. In a text called 'The True Leveller's Standard Advanced' they called upon their contemporaries, to 'Take notice that England is not a free people, till the poor that have no land have a *free allowance* to dig and labour in the commons, and so live as comfortably as the landlords that live in their enclosures' (emphasis mine).[3] The crucial problem they were trying to tackle was how to find forms of freedom that would 'let' people eat and thrive after the formal declaration of a much-contested commonwealth. They were trying to find a modern form to the traditional rights to the commons that would maintain their power of 'letting' whilst reflecting the exigencies of their times. Instead, following the return to kingly law, the commons were subject to a different form of modernization: that of enclosure.

More importantly for the Diggers, a further form of letting—letting as it occurs at the scale of, or despite, human intention—was implied in their vision of the world. The growth of plants, the earth's feeding of the people, was part of Creation: something that could not be owned because it was a force of nature, a manifestation of the spirit, that spirit which they saw also as reason. Creation was not a one-off event but rather a present power active in all things. Creation was what was alive and released in the dispersal of seeds. By taking up spades and manuring and planting the land Diggers were simply letting further creation come to pass. The seeds of barley (and those of wheat, rye, parsnips, turnips and beans that were also planted in the settlements) with their fructiferous capacity, their affordance of food, nourishment and further planting were allies to, and embodiments of, these acts of creation. As confirmation of the power of this idea of letting, Digger barley can still be harvested on George Hill in Surrey, the first of the Digger sites.[4]

# AUTOMOBILE EXECUTED
## TERESA MARGOLLES

# DEATH ON THE BYPASS
RAVI SUNDARAM

*Daily life is becoming a kaleidoscope of incidents and accidents, catastrophes and cataclysms,*
*in which we are endlessly running up against the unexpected, which occurs out of the blue, so*
*to speak.*
Paul Virilio, Foreword to 'The Museum of Accidents'

At some point in the late 1980s, that grand postcolonial dream of the rational city—the urban
Masterplan—slowly and undeniably unmade itself in the city of Delhi. For the Delhi elites
this was the postcolonial Fall. Along with sympathetic law courts, they saw with horror upon
the vast surface of a previously hidden and illegal city. This included 'unauthorized' neighbour
hoods, squatter settlements, and a vast network of small markets and neighbourhood factories.
If this was not enough, a greatly intensified media flux spread over the city, giving the urban
experience a visceral, over-imaged feel, and imploding the classic morphology of the planned
city. As Delhi realigned with global flows, new commodities and images crowded streets, there
was a sense of the city as a delirious, out-of-control landscape of effects.

The Masterplan gave way to something that still does not have a name. Urban practices that
emerged on the ruins of modernist planning in the postcolonial world in the 1980s have no
language yet, consisting of a series of mutating situations. For practical reasons I will call these
the 'bypass'. The bypass emerged as a pragmatic appropriation of the city, perhaps more *in
medias res* than 'marginal'. The bypass does not fit classic representations of political technolo-
gies: the resistant, the tactical, the marginal, the multitude or the 'movement'. The old modernist
urban archive of the twentieth century produced the dualisms of plan and counterplan, the
public and the private, control and resistance. In contrast, the bypass lacks substance in the
philosophical sense: it radiates no positivity, but draws parasitically from all older urban forms
and then mutates with kinetic energy into entirely new ones. Bypass situations produced a
disorienting zone of attractions for all in the city, sometimes at great costs, particularly for the
subaltern populations of the city.

A fast-changing assembly of practices, the bypass imaged the productive and disturbed lives
of Delhi in the long decade of the 1990s. As a form of life indifferent to the law of the Plan,
the bypass became for elites an allegory of the decline of Delhi. The bypass was equally the site
of vast everyday violent encounters between urban populations and speeding road machines,
exposing public displays of technological death. This site of the bypass was the accident. In
every sense, the accident captured the mixture of death, commodity worlds, technology and
desire that marked the last decade of Delhi's twentieth century.

I remember the first accident I saw in Delhi, in 1983, barely four years after I moved to the

city. A friend and I were standing near the All India Radio building at night, waiting for a bus. In the days before mass car ownership in the city, Delhi became eerily silent at night. Suddenly, a familiar green-and-yellow Delhi Transport Corporation bus raced towards us, ignoring the red traffic light. There was a sickening thud; a cyclist who was crossing the road was mown down by the bus. I remember blood everywhere when we rushed to the accident, the blue and white rubber slippers of the victim, his fresh white cotton pants now sticky-red with blood. The bicycle was twisted beyond recognition. My friend and I took the victim to the nearby Willingdon Hospital in an auto-rickshaw, but he was already dead. When we returned, still dazed, after filling out the complicated forms at the police post in the hospital, the bus was still in the middle of the road.

Writing these lines I think of that night, and the dead worker-cyclist, the terror of the contingent irrupting upon the calm of the night. In contrast, my memories of the dead on Delhi's roads in the 1990s come as a series of discontinuous images: a dead scooterist on the road, a solitary helmet in a pool of blood, a body with face covered by a white sheet. At that time we were assaulted almost every day by scenes of death and tragedy on the road. And time I drove home at night across the Nizamuddin Bridge in East Delhi, there were broken or stalled machines on the highway: a truck with a broken axle, or a goods vehicle with its contents spilled obscenely across the road. Every friend seemed to have lost someone in a road accident, families of two-wheelers and cyclists waited anxiously for their return home in the evening. It was a feeling of generalized anxiety and dread, a schizophrenic disturbance at a time the city was booming economically.

As the city globalized in the 1990s, the growth of machine mobility paralleled urban crisis, and the ecstasies of private vehicle ownership went hand in hand with perceived death-effects of road machines. The middle and upper classes had been migrating to private cars from the 1980s, and public transport was now largely used by the lower middle classes and workers. The state bus corporation was privatized in 1988 and the new private 'Redline' (later 'Blueline') buses became the focus of public anger due to the number of road deaths they inflicted. An average of 2000 people have been killed by traffic accidents in Delhi every year since 1990, the bulk of them from the working poor. The bloody drama of road culture involved buses, passengers, drivers, bystanders and almost everyone in the city. Though buses never exceeded more than one percent of the motor vehicle population, they were at the centre of a public violence that moved between the bodies of broken buses, humans, and the enactment of an uncontrollable subjective force that sometimes seemed to emanate from machines, at other times from the actions of human beings.

SPEED

The Commissioner of Police, Maxwell Pereira, once suggested that Delhi's wide roads with their smooth surface encouraged drivers to speed. The invention of asphalt in the nineteenth century by English engineer John Loudon McAdam radically transformed the experience of road travel. Cheap frictionless travel and the dream of endless circulation now emerged in the modern travel imaginary along with parallel innovations in vehicle suspension design, sidewalks, traffic management, and social divisions between the motorized and the pedestrian classes. Aided by the wide asphalt roads of the capital, motor culture in 1990s Delhi intimated a new *kinetic subjectivity*, where speed was part of a city's accelerating rhythm and time for both passengers and drivers became meaningful in powerfully new ways. Combined with the competitive, calculating world of the new commodity explosion, drivers and passengers raced against each other in a new addictive loop that broke every formal-rational rule of an ordered transportation system.

As drivers of buses, trucks and cars got caught in this cycle of speed, they imitated each other's acts, and courted death. With the population of drivers and machines growing in leaps and bounds, the risks increased. In the emerging urban order of tremendous acceleration, reaching destinations on time became critical. A complex system of daily quotas was imposed by private bus owners on their staff along with the insistence that a minimum number of trips be completed. Buses fought with each other to get passengers, and to maintain time schedules. In the ensuing frenzy of movement, buses were accused of suddenly changing routes in order to cruise bus stops with more passengers. Along with speeding, buses were also accused of standing overtime at bus stops in order to fulfil passenger quotas. To evade the eyes of the traffic police, buses would keep moving every few minutes at stops, but they would not leave until their passenger quotas had been filled. Private buses were attacked both ways: for speeding up and bypassing stops to make more trips, *and* for stopping excessively to fill the bus with passengers. This became the commodity form of speed in Delhi's public buses: endless circulation, disruption of any 'rational' mapping of the transportation grid, and suspending circulation in order to realize passengers and profit. This dialectic of speed and disorder did not even spare the bus stop. The disorderly rush of passengers towards the bus doors matched the familiar rhythm of the bus speeding into the stop. Orderly lines of passengers that were common in Mumbai were out of the question in Delhi. Passengers and buses rushed into the frenzy of circulation, pushing away anything that stood in their way. Cars, autorickshaws and motorcycles often ignored signals when they could, and drove against the flow of lanes to circumvent traffic jams.

In its disregard for all clean visual architectures of traffic plans and routes, Delhi's speed culture ironically recalled Michel de Certeau's famous evocation of 'everyday' tactics, when he praised inventive moments of practice for their 'tactile apprehension and kinesic appropriation'.[1] De Certeau was of course not talking of machines; he detested travel on trains and buses. 'Only a rationalized cell travels', wrote de Certeau, calling much mechanized mobility 'travelling incarceration'. De Certeau's residual humanism was based on a separation of the sphere of practice (generated in human encounters) and the machinic (representational/visual/panoptic) that was a product of a specific postwar European encounter. In Delhi's road culture, where the distinctions between machines and humans often blurred, de Certeau's powerful image of the 'ordinary man' squeezed by the larger forces of rationality is difficult to hold on to. The 'evasive tactics' that de Certeau celebrated were deployed all the time on Delhi's roads by speeding human–machine ensembles—with disturbing effects

## DEATH AND THE ACCIDENT

*The human organism is an atrocity exhibition at which he is a willing spectator.*
J. G. Ballard

In his experimental novel *Life of the Automobile*, published in 1928, the Russian writer Ilya Ehrenburg *begins* with the car accident. In Ehrenburg's story, Charles Bernard, an introvert and a man of letters, becomes a lover of cinema and begins to admire the speed of travel as depicted in films of that time. He buys a car, learns how to drive and is on his first motor trip to the countryside. When the car takes over; it 'had gone crazy'. The inevitable crash happens. 'The linnets warbled and the lavender was sweet and fragrant. Car No. 180-74—iron splinters, glass shards, a lump of warm flesh—lay unstirring beneath the solemn midday sun'.[2] The oppositions are stark: between human and machine, cold metal and warm flesh, commodity and life. Ehrenburg's novel stands between two worlds, the emerging era of mechanized commodity culture and the lost romantic dreams of childhood and the countryside. The accident connects a fragile dream of the nineteenth-century European countryside with the terrifying exhilaration of the new era of mass commodities.

In the central origin myth of Italian futurism, Marinetti and his colleagues got into a speeding automobile in 1909 and crashed on the outskirts of the Milan, an accident that generated the *Futurist Manifesto*. In futurist recreation human and machine merge as the poet raced through the city, and the subsequent accident generates a new technological identity and celebration of speed. Futurism's embrace of speed machines immediately marked it from older critiques of modernity that saw machines as an assault on the body and nature. In futurism the technological becomes a prosthetic enhancement to the human body, a shield against shock, all complicit in the drive for war. The cleansing acts of the technological drove Marinetti and the

1. Michel de Certeau, *The Practice of Everyday Life* (University of California Press, 1984), 105.
2. Ilya Ehrenburg, *Life of the Automobile* (Serpents Tail Reprint Edition, 1999), 6.
3. J.G. Ballard, *Crash* (New York: Vintage, 1973).

futurists to fascism. The futurist myth of the accident combined speed, thrills and the fusing of flesh and machine leading to a rebirth. This equation was inverted in J.G. Ballard's underground novel *Crash*, where the themes of sexual desire, death and technology were brought together.[3] In *Crash* the car is desirable because it fuses metal and flesh: Marinetti's terrible wager with the machine comes to fruition, and the automobile consumes the organic body. Human flesh in *Crash* merges with chrome and leather, sexual fluids with machine emissions; we are witness to derealized bodies, and a world of surfaces, where the older distinctions between outer 'reality' and inner dreams evaporate. Reversing the original Futurist dream, the body becomes the supplement to the machine.

Road culture of the 1990s dramatized the emerging constellation of technological life in urban Delhi. Narrated through accident stories, statistics, and tales of terrible deaths by uncontrolled machines and cruel driver subjects, the accident and the entanglement of humans and machines emerged as a traumatic site of the city. These were everyday scenes of a 'wound culture', where smashed and dented automobiles, fallen bodies and the endless cycle of death revealed the scars of the encounter. The divisions between private and public tragedy blurred, suggesting a traumatic collapse between inner worlds and the shock of public encounters. As the body developed techniques of parrying the shock of urban sensations, it became more and more complicit in a technological world, contemplating a threatening collapse of the boundary between nature and artifice. These were the 'atrocity exhibitions' of urban life in Delhi, ever visible in image, text, and the screams of the dying as they met their untimely end.

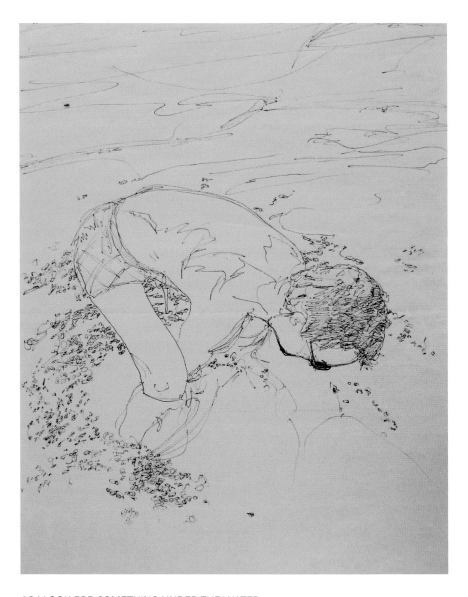

AS I LOOK FOR SOMETHING UNDER THE WATER

Image by Stefano Bernardi

# MISSION REPORT
## URSULA BIEMANN

For many people, life is now about finding a way to survive in the cracks of our world system of nation-states. Extraterritorial zones, where people live or work with few guarantees of their security or dignity, keep materializing for diverse purposes. Corporations continue to seek production conditions outside the context of national regulatory systems, while nation states find ways of handling asylum seekers outside the framework of their commitments to human rights. The condition of extraterritoriality manifests itself in new community forms: clandestine networks of migrant communities who live an existence as noncitizens.

These zones are no longer singular events located along territorial borders, but constitute extraterritorial pockets dispersed across territories, eroding the national concept from above and below. These pockets may be translocal in nature but they are not isolated and constantly gain greater significance. We need to tell the story of these places, which are alienated from local cultures but connected across continents, be it through corporate structures or improvised migratory systems. They are places of desire and violence, conceived through a vision of their difference from what surrounds them but characterized, ultimately, by the survival practices that emerge in and around them. Much of my research has gone into representing this relational space, and the biopolitical subject that constitutes it by complying with, resisting or reinventing its conditions. It is through such struggles that the new order has to define itself.

The building of nation-states, whose sovereignty is notionally based in the citizen, has produced a mass of noncitizens, stateless persons and refugees every time. There are simply too many people who lose or resist the sort of categorization that would guarantee them membership for us to assume they are merely a regrettable side effect. Such people make up a sizeable part of the world population. The refugee comes forth as the walking proof of just how fallible and incomplete the world organization of nation-states truly is. This is why my attention has turned to supranational concepts that are able to tackle massive statelessness, and to forms of postnational resistance and agency. It is in this spirit that I engage in my research on the politics of the refugee.

*Mission Report* is the title of a video I am currently making, which explores the logic of the refugee camp—one of the oldest extraterritorial zones under international law. Focusing on the situation of Palestinian refugees, the video essay engages with the camp as a philosophical and spatial entity, and envisions extraterritorial models of nation, constituted through the networked matrix of a widely dispersed community. Finally, it reflects on the artist's mission as a particular sort of fieldwork that embraces a moral component.

The Palestinians are of particular interest here, because their case is not only the oldest and largest refugee case in international law, but it helped to constitute the international refugee regime after the Second World War. This case exemplifies how international law itself failed to maintain a legal framework of protection, first depriving the Palestinians of their political rights as citizens by turning them, perhaps too quickly, into a speechless mass of refugees, and subsequently dispossessing them of the right of international protection guaranteed to all refugees.

1. The circumstances of the funding years of these institutions are
extracted from a video interview I conducted in February 2008 with
Susan Akram, Professor for International and Human Rights Laws at
the Boston University Law School.
2. The UN Conciliation Commission on Palestine, established in 1948,
and the UN Relief and Work Agency, established in 1949.

Because it was the United Nations that created the problem of the Palestinian refugees in the first place, it set up a regime of heightened protection for them.[1] From the beginning in 1948, the Palestinians were to have two agencies devoted exclusively to them: the UNCCP, entrusted with a complete international protection and resolution mandate, and UNRWA, whose job was to provide food, clothing and shelter.[2] Because the Palestinians were thus taken care of, the charter of the UNHCR—the UN refugee agency founded in 1950—had a special clause excluding the Palestinians from the new body's mandate. When it became clear that the UNCCP was unable to resolve the Palestinian conflict, its funding was truncated substantially, which also incapacitated it in its role as protector. Within four years, the Palestinians were left without the international protection provided by the UNHCR to all other refugee groups in the world. This means that they have no agency for interventions on the international level or access to the International Court of Justice. The protection gap has never been closed to this day, not least because the absence of any legal framework has been very convenient for the power politics behind the negotiations. In the quietness of budgetary decisions, a major refugee case was manoeuvred outside the international laws and parked there for decades.

This exceptional condition has made the Palestinian refugees particularly vulnerable to arbitrary reimpositions of the state of exception in host countries, as a recent incident in Nahr el Bared, a camp in northern Lebanon, demonstrates. Nahr el Bared is one of the twelve Palestinian refugee camps in Lebanon still in existence from 1948 and the years immediately after; several others have been destroyed. Together, these camps form a network of juridical enclaves. Allocated by the UN, the plot of land near the Syrian border first accommodated tent settlements which were gradually replaced by cinder block houses as the refugees could afford to build them. The urban fabric grew organically without a master plan. Fifty years later, the population has multiplied but the surface of the camp was not allowed to increase, resulting in one of the most densely populated places on earth. In juridical terms, this is UN territory, but it is Palestinian in terms of identity, and Lebanese for matters of security.

For sociologist Sari Hanafi, Nahr el Bared is the epitome of how the Lebanese authorities conceive of such extraterritorial space: 'The camp is located outside the city of Tripoli but they allow no infrastructure to connect the camp to the city; they marginalize it, govern it by emergency law and then abandon it. This is the very condition under which the refugee camps in Lebanon are turned into a place where other extraterritorial elements like al Qaeda can come and establish their microcosm'.[3] In the summer of 2007, the Lebanese Army breached international conventions and entered Nahr el Bared to eradicate a small number of foreign Islamists who had settled in the isolated camp. The operation grew vastly out of proportion. Instead of securing the refugees' habitat, the army razed the whole camp to the ground and declared it a zone of exception. The forty thousand refugees lost all their belongings and had to flee to another overpopulated camp in the region. This is how easily the UN juridical status is

3. Interview conducted with Sari Hanafi, sociologist at the American
University in Beirut and himself a Palestinian refugee, in Beirut in
December 2007.
4. Interview conducted in Beirut in December 2007 with Ismael
Sheikh Hassan, architect and urbanist involved in the Nahr el Bared
reconstruction committee.

suspended by the self-authorized imposition of another regime, when an international protection mandate is lacking.

But rather than focusing on the stratified and often ambivalent apparatus of sovereignty that rules this space, I suggest we pay attention to the flexible process through which the refugees have begun to reinscribe themselves into the political fabric.

While the battle over Nahr el Bared was still underway, a community-based reconstruction committee was established to research the state of the camp before its destruction and to draw an accurate plan that would serve as a basis for negotiations.[4] In a collective process supported by voluntary architects, the camp dwellers defined the shape and limits of their parcels. The reconstruction of a refugee camp poses the interesting question of how the refugees themselves would plan their housing and urban organization if they had a say. Even though there are many general complaints about the lack of space and sunlight in the camps, it turned out that for the dwellers, the architectural form of the old camp made a lot of sense. When all the people from the Palestinian village Safuri arrived at the camp in 1948, they settled next to each other and gave the neighborhood its name. They wish to preserve this arrangement because it relates to their origins, to their right of return, and to their sense of community. Usually, families own the roof of their building which allows them to add another floor for the next generation. Another feature they want to hold on to is that the camp is to a great extent a pedestrian zone made of an intricate system of bending alleys. In Islamic society, and particularly in the crowded camps, the alleys are used as semipublic, semiprivate spaces where women and children can appreciate a sense of enclosure and privacy.

The Lebanese state and army, however, have altogether different plans for the reconstruction of Nahr el Bared. All they see in the organic system of narrow alleys is an obstacle for entering the camp with their vehicles; they perceive the camp as a military zone, when in fact it is an urban zone. 'Armies shouldn't do planning', Ismael Sheikh Hassan argues, 'because they want to solve political issues through urban design'. The result is a good security plan, perhaps, but a city where nobody wants to live. The international donor community for the reconstruction supports the plans of the refugee collective and opposes the imposition of Lebanese state power on UN land—so this is a rare occasion where an extraterritorial community finds a way to elude state power and to implement its political decisions.

The common struggle for defining the refugee space suggests that the camp, in this instance, is not the site of 'bare life', existing outside of all political and cultural distinctions, but on the contrary, a highly juridical space of dispossession and repossession. It lays open residues that evade sovereign decisions and reveals a place where the Palestinian refugees who are literally placed on the outer reaches of international law, can unfold self-authorized, constructive means to reinscribe themselves into the wider political fabric which is composed, by now, of a complex mix of postnational considerations.

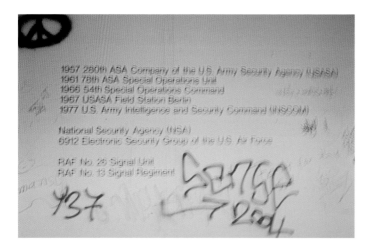

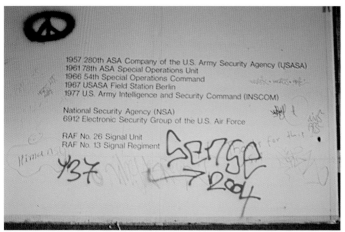

SIGN OUTSIDE THE ABANDONED NATIONAL
SECURITY AGENCY BUILDING IN GRUNEWALD
FOREST, BERLIN.

Images by Helena Sidiropoulos selected by TEUFELSgroup.

# AT KABUL ZOO, THE LION
JEET THAYIL

So this is fear: tracers flaring
above the pens, the fat thud

of bullets, and the bigger sound
of animals leaving our lives.

Sad-eyed, the widow elephant
saw a cluster of shells

explode her enclosure.
She screamed in narrowing circles.

Shrapnel stopped her and she dropped,
the first to fall.

Everything burned:
the tiger shrugged fire

off his shoulders.
The capuchins tried

to escape their burning tails.
The hyacinth macaws,

spoonbills and hoot owls,
flamingos aflame…

Only the llamas stood dumb
in that madness, stupid

to the end. I envied their emptiness.
Blind in one eye,

my jaw in shreds, my mane
singed to a useless crop,

I'm still here.
I wait for these men

to come to me.

THEREFORE DO NOT WORRY ABOUT
TOMORROW, FOR TOMORROW WILL WORRY
ABOUT ITSELF. EACH DAY HAS ENOUGH
TROUBLE OF ITS OWN.
MATTHEW 6:34, NEW TESTAMENT, *THE BIBLE*

Text selected by Kristina Bræin

Image by Anawana Haloba

# IN SPITE OF
## ERASURE

GLUE FROM PIG BONES IS USED TO IMPROVE
THE QUALITY OF LEATHER FOR THE
PRODUCTION OF SHOES AND OTHER PRODUCTS.

Image by Yves Netzhammer
selected by etoy.CORPORATION

# BREVITY
## J. ROBERT LENNON

A local novelist spent ten years writing a book about our region and its inhabitants, which, when completed, added up to more than a thousand pages. Exhausted by her effort, she at last sent it off to a publisher, only to be told that it would have to be cut by nearly half. Though daunted by the work ahead of her, the novelist was encouraged by the publisher's interest and spent more than a year excising material.

But by the time she reached the requested length, the novelist found it difficult to stop. In the early days of her editing, she would struggle for hours to remove words from a sentence, only to discover that a paragraph was better off without it. Soon she discovered that removing sentences from a paragraph was rarely as effective as cutting entire paragraphs, nor was selectively erasing paragraphs from a chapter as satisfying as eliminating chapters entirely. After another year, she had whittled the book down into a short story, which she sent to magazines. Multiple rejections, however, drove her back to the chopping block, where she reduced her story to a vignette, the vignette to an anecdote, the anecdote to an aphorism, and the aphorism, at last, to this haiku:

Tiny upstate town
Undergoes many changes
Nonetheless endures

Unfortunately, no magazine would publish the haiku. The novelist has printed it on note cards, which she can be found giving away to passers-by in our town park, where she is also known sometimes to sleep, except when the police, whose thuggish tactics she so neatly parodied in her original manuscript, bring her in on charges of vagrancy. I have a copy of the haiku pinned above my desk, its note card grimy and furred along the edges from multiple profferings, and I read it frequently, sometimes with pity but always with awe.

# THE SKOLT SÁMI LANGUAGE MEMORY PROJECT
## ESPEN SOMMER EIDE

ENTRY #1

I feel my eyes drying up. I am lost in a desert of broken letters.

Struck by a sudden premonition I see my next two weeks before me: working day and night proofreading a dictionary that translates between two languages, neither of which I understand a single word.

Today has been a technical research day. How to digitize a dictionary. How to wield the computing power for my needs. How to teach a blind computer to read.

The first goal: to build a database of the Skolt Sámi language. An endangered language in the arctic regions of northern Norway, Finland and Russia.

The next goal: to travel to northern Finland and Russia and collect samples of all the words of the Skolt Sámi language. To record one informant per letter of the alphabet reading the words to the camera.

The final goal: to construct an art installation for the East Sámi museum currently being built in Neiden, Norway—an exhibition of the totality of a language. One by one the words will be given to the visitors. One word each, given as a task—for the visitor to take responsibility for and remember for the future.

ENTRY #2—THE BEAUTY OF TOTALITY

By now I probably own the largest library of Skolt Sámi to Finnish language dictionaries in the world. Except for a few eighteenth-century Skolt–German dictionaries that I saw in the Humboldt University Library in Berlin last month, I have gathered all I could find.

The sum total is four books and one bad photocopy from the 80s.

They vary greatly in size and quality, and I have tested my way through them all in the hope of finding a candidate for scanning and optical character recognition.

Finally today, a breakthrough. A 1988 dictionary by Mosnikoff and Sammallahti seems to have all the necessary ingredients: the copy is in strong black and white ink, the 'c' does not look like an 'e' (who would have thought that this would be the greatest of challenges for the digitizing community?) and in this copy all the special letters of the Skolt Sámi language are possible to separate from each other. The đ from the d, the ǩ from the k, the ʒ from the ǯ, the š and ž, and å and â, not to mention the õ, ö, ŋ and ǧ.

The younger a writing system is, the closer the relationship between the letters and their corresponding phonetic sounds. Nothing is hidden in the written language of the Skolt Sámi. No silent characters or mysterious pronunciations—what you read is what you hear.

After a week of proofreading I am starting to get a close relationship with these characters. Their sounds roll silently in my mouth while I stare at the enlarged scans. Teaching the computer to understand them all takes patience, but gives a rare glimpse into the microscopic world of the letter. The shapes of the characters are blown up until I see every molecule of ink traversing the topography of the paper.

ENTRY #3—NUMBERS

'The number of words in Skolt (as in all other living languages) is infinite', explains Michael Riessler, head of the Kola Saami Documentation Project in our first email exchange.

'And besides this every Skolt speaker has a different stock of words in her or his mind. If you restrict yourself only to the stock of words found in the existing Skolt dictionaries (ignoring the fact that not all words found in the dictionaries are representative of an individual Skolt Sámi speaker's language) you end up with about 10,000 recorded words multiplied by more than thirty letters of the alphabet. Any linguist would envy you such a collection of recorded words!'

The facts are not very uplifting: Among the 6,500 living languages in the world, there are four Sámi languages spoken in the Kola Region (including northern Finland): Skolt, Akkala, Kildin, and Ter. Of these, Akkala is now extinct, its last speaker having passed away in 2003. Ter Sámi in the Murmansk region has about thirty speakers, all aged over fifty. Kildin Sámi has about three hundred active speakers. Skolt Sámi has around three hundred speakers on the Finnish side of the border and about twenty, all old, on the Russian side (who speak a special Russian dialect of Skolt).

But Michael's comments make me rethink my melancholic impression of Skolt Sámi as a dying language. Infinity is a powerful concept to bring into any reflection. If every speaker's vocabulary is potentially infinite or to be regarded as a 'part' of infinity (which in itself would be infinite), then a dying language is not ceasing to exist by slowly shrinking in size as one would expect (due to forgetfulness, language shift or some other kind of deterioration of the collective memory). It is still present and alive in its vibrant infinity even with only one speaker left on earth (or maybe two? Does not a language need a listener? Or maybe it is sufficient with only one subject speaking to him- or herself? I guess that would be the perfect communication: the last speaker of a dead language muttering to himself).

ENTRY #4—PHONETIC ALCHEMY

The metaphor of dying and living languages is based on an outdated romantic notion of the organic nature of languages. Thus there is a need to revisit the dialectic of the death and life of languages to view the language-image from a fresh angle. The philosopher Walter Benjamin writes in the introduction to his essay on Goethe's *Elective Affinities*:

The history of works prepares for their critique, and thus historical distance increases their power. If, to use a simile, one views the growing work as a burning funeral pyre, then the commentator stands before it like a chemist, the critic like an alchemist. Whereas, for the former, wood and ash remain the sole objects of his analysis, for the latter only the flame itself preserves an enigma: that of what is alive. Thus, the critic inquires into the truth, whose living flame continues to burn over the heavy logs of what is past and the light ashes of what has been experienced.

In the analogy given by Benjamin, it would appear that the critic does the same historic and linguistic analysis as the historian, or 'commentator'. But their aims and effects are vastly different. While the commentator wishes only to enlighten the reader about the possible meanings of old words and passages, the critic's detailed analysis destroys the wholeness of the work and rekindles the fire of what is alive. The process is made more potent by the history that has prepared it: the more obscure and forgotten the work the better suited it is for a philosophical and artistic critique.

Replacing the concept of 'work' with 'language' one can perhaps glimpse a more complex dialectic at play. In the realm of language, Benjamin's destruction-through-analysis is comparable to the effect of the archive: a dictionary or database of language samples, each analysed into every last phoneme. The archive kills the living language in order to preserve it, but at the same moment creates its potential alchemical transformation into new life.

ENTRY #5—AUTO-DA-FÉ
Today: the first tests of the recording and archiving system. Everything has to work perfectly before we take it into the field in a couple of months. The Skolt speakers will be filmed in their home surroundings looking into the camera. The words of the dictionary will appear on the screen before them and they will read them aloud one by one. Each word will be stored as a separate video file on the computer.

A dictionary is in essence artificial. Only some rare kinds of poetry can bring life into a list of words starting with the same letter, and even then it is seldom systematically alphabetical in its construction. The sorting of a language alphabetically is like taking apart a human body and then stitching it together by placing the organs and limbs next to each other by similar size or some other secondary property.

The choice of the dictionary as the image of language is the complete opposite of language-as-life. If languages are organic and alive by nature then the Language Memory Project would seem to spell out a death sentence for the Skolt Sámi language.

To make matters worse I am asking thirty representatives of the language to become dictionary robots, reading aloud only individual words—the atoms of their living language—in a room with no listeners. On the Finnish side this will involve about 10% of the Skolt Sámi community, on the Russian side, 100%. In effect they will be atomizing their own language into a list of dead, alphabetized items.

All the while I will be there silently filming the spectacle—this burning funeral pyre of a self-destructing language.

ENTRY #6—LANGUAGE AND TIME
Usually one considers language to be distributed in space, by its agents in their geographical
area. The informants we have contacted are living along a 230 km route from Neiden in Norway
to Nellim in Finland. Lake after lake. Näätämö–Kirakkajärvi–Sevettijärvi–Supru–Nitsijärvi—and
then a longer stretch to the areas of Ivalo and Nellim.

In this project a language will instead be distributed in time. One word at a time—throughout
the months, or years—the installation in the East Sámi Museum will parse the dictionary de-
pending on the number of visitors passing by. The beginning of the Skolt Sámi Language Mem-
ory Project speeds up history, that is, the inevitable entropy of an endangered language. The
end of the project slows it down again to the point of exhibiting a frozen distribution of a lan-
guage in time.

(One side effect of this distribution will be the dissociation of the language from the normal
identity discourse of indigenous people. Legally, to be counted as Sámi you have to document
that your parents, grandparents or great-grandparents spoke a Sámi language. Language is
the principal marker of your identity, which may increase cultural isolation. In this case the lan-
guage will be given to all—putting into question this identity marker. An alphabet revolution).

ENTRY #7—THE MAGICAL PROPERTIES OF AN ARCHIVE
Dismembering the semiotic, communicative from the phonetic, lexical aspect of language
opens up the possibility of magical correspondences. The onomatopoetic, the alphabetic, the
mimetic. The mysterious shapes of individual letters, the picture puzzle of the word. Language
becomes an archive of unintentional similarities ready for a reader who will connect the dots.
The reader then becomes a bearer, a medium for the magical aspect of a shadow language.

# DOMI MAGISTRORUM
# LINGUAE LATINAE ISLANDICORUM
## DANÍEL MAGNÚSSON

Homes of Latin teachers in Iceland

# ENTHUSIASTS SPEAKING
## NEIL CUMMINGS & MARYSIA LEWANDOWSKA

SCENE 1

*A hot summer day. Industrial premises surrounded by a blue wire fence. A freestanding sign, also blue, with plain white letters: THE CHYBIE SUGAR FACTORY.*

*An old redbrick building full of obsolete filmmaking equipment: a film editing table, storage for canned film reels, and a makeshift cinema with projection booth*

*Four big, swivel armchairs placed around a low table from the 1980s. A tall, middle-aged man, Franciszek Dzida, founder of Amateur Film Club Klaps, Chybie (1966), places a box of sugar cubes from the factory on the table.*

FRANCISZEK DZIDA

I was employed as a technician in the sugar factory; around me there were metal workers and electricians. I proposed setting up a film club in the factory. This was to become our window onto the world, to allow us to break away from our provincial vision and this small-town mentality. I needed it immensely, not because I felt oppressed by the system—everyone could find a way around that!

*Laughter*

It was a chance to mark our presence. Being an artist was one way of marking that presence. When my colleagues joined the Klaps club, it changed them enormously. Cinema transformed them.

We felt like different people, exactly as it was shown by Kieslowski in that famous final scene of *Camera Buff* when Filip turns the camera towards himself. He changes as a person when the camera starts to record 'his own life' instead of being simply a toy.

I would like to emphasize that this place, this club, thanks to celluloid film, was a place where another world ruled.

It was a magical place. People who used to attend our meetings realized they were entering another reality, the 'real world' as created by us. It's where our love for feature films originated.

You stopped being a metal worker or an electrician and became an artist. Regardless of your skills, here you could express something; here you had something to say.

SCENE 2

*Poznan. A clear, sunny winter's day, smoke from a distant factory chimney smears the horizon.*
*A typical socialist 'cultural centre', and off a long corridor a door with a small plastic sign:*
*AKF (film club) 'AWA', Poznan.*

*A typical club room, dusty equipment, a shelf with trophies, a notice board with photographs*
*documenting visits from Kieslowski, Karabasz, Zagroba, a wall of old festival posters, a low*
*table, shabby armchairs.*
*A group of middle-aged men chat. The eldest, Jerzy Jernas, starts telling his story about the*
*beginnings of the club. Others listen, taking turns to join in.*

JERZY JERNAS

It was important that we actually belonged to the club. Spending time there occupied a considerable part of our lives. It was our second home. We formed a strong community, talked about films and about life and hung out a lot. We travelled to festivals together, went on holiday, and went camping at the summer film festival in Agów for many years. Strong emotional bonds still exist amongst the former club members.

As with the majority of beginners, our attempts at making feature films were embarrassing. We had problems with sound and there was no dialogue. But, perhaps this was beneficial because all those limitations forced us to think.

The most common practice was to make an amateur film collectively, in cooperation with friends. Zinczuk and I were partners but the final decision was usually taken by one of us. If we had three minutes of film and a spring-winding camera could hold only thirty seconds, it taught us a great discipline. If you have only three minutes to use, you have to think ten times about what to shoot. Videotape which costs almost nothing is a curse; you shoot a lot, thinking it will be edited somehow later. But it's not true, it never gets edited, and a lot of trash remains. Learning from the classics was a lesson of discipline.

We weren't forced to do anything, we only occasionally had to make a film celebrating the factory's anniversary. Something similar to a commercial nowadays. This was taken for granted and in no way interfered with the making of our own films. We didn't identify with those commissioned jobs but at the same time we were aware that film can serve as propaganda. We wanted to talk about our own lives and our own worlds, which didn't resemble what was shown by the 'official' city or factory newsreels.

3RD PELOTON PONTONNIERS CONSTRUCTING
A BAILEY BRIDGE ACROSS THE RIVER MAAS AT
WELL LIMBURG IN 1953.

Image selected by Harold de Bree.

# A LIFETIME
## LAKHMI CHAND KOHLI

Shivram would often bring his auto-rickshaw to the cremation ground in the mornings, to wash it at the tap. The cremation ground was very quiet at that time. If, while he was there, a dead body happened to be brought in, Shivram would halt his cleaning and step into the procession of mourners. Soon, he began to leave his auto-rickshaw at the cremation ground in the evening, after his work was over for the day. Every evening, he saw a pyre burning. Often there would be people standing around it. But at times there were pyres that burned unattended, flickering in solitude.

*'Taa-Ta-Taa... Tha-Tha-Thaiyya...' Here, where there are no listeners, no one chases them away. It is here that one can often find 'him'—the one known in the neighbourhood by different names, each one more disparaging than the last. His gatherings have no fixed time, no schedule.*

When the city administration ordered that auto-rickshaws run on a new fuel, the change was too extreme for Shivram. He began to spend his entire day at the cremation ground.

Flour, lentils, rice, clothes, and all the things people gave away in the name of the one who had died, would be used by the priest's wife. Shivram would get his afternoon meal from her. He didn't have to do much to earn this meal—just show a dead body to an empty place, and get the priest's signature on the slip authorising the cremation. He wasn't paid to do this.

Shivram would sleep at the cremation ground at night. His salary had tied him to his home, and this fragile tie was now broken. His hands were empty.

*Hands would beat the drum, and hearing this sound, 'he' would cross every threshold of drunkenness. His frenzied feet swifter than lightening; his nimble body like a weed swaying dangerously in a fierce, unforeseen storm.*

When someone spends time in a place, he begins to show signs of belonging to it, and even a passer-by notices and responds. The people who came to the cremation ground in the company of a dead body were not prepared to find someone like Shivram there. Some of the things they previously offered to a dead body before it was set on fire they now began to give to him.

*It is dark in the lane now. The bottle is empty. This roof is on the seventh floor. Like countless nights that have passed, and all those nights still to come, it begins from his feet. 'Tha-Tha-Thaiyya...' Till his hips gyrate to a rhythm that he alone knows. Then the tips of his body—his head, his fingers—stir. His torso sways. Every pore of his body secretes a music, each cell that makes him stirs. He begins to dance.*

*He can't piece together how things changed for him. But he knows something inside him was cast away, was slowly pushed aside and locked out by his surroundings. The climb up the forty steps to the roof on the seventh floor was a daily passage to solitude, so he could be alone with what was precious to him.*

The bier of a woman. Many came with it. She was young. Many *saris* adorned her bier. Over them lay glass bangles, sandals, a makeup box—objects that accompany a bride. Everyone was crying. They had brought the wood for the pyre with them. Everyone does. The man carrying a little boy seemed to be her husband, and the little boy her son.

 She was laid beside cremation lot number 9, the place that had been assigned to her. Her body was placed over the pyre. Those who accompanied her slowly began to move away, and sat down on the benches by the room where they keep the objects left over from a cremation. The pyre continued to burn.

*There was a time when the roof was not all he had.*

 *The courtyard was open to the sky. It was past midnight, and there was no sign of sleep in his eyes. The drum beat loudly. Voices sang. Among these, another voice—but it didn't sound like someone was singing; it sounded like a beast letting out a wail. It was his voice.*

Everyone waited for the ash to cool down. When the last wisp of smoke had risen from the ashes, the ones waiting to take away the leftovers rushed forward. Shivram stopped them, 'Don't you dare!' He quietly gathered up the clothes and objects, and took them to the priest's house. The priest's wife selected some *saris* and said to Shivram, 'Here, you take the rest'.

*He stood barefoot in the courtyard. The night was ice-cold. Many of the guests were snuggled inside blankets. He danced before them, his feet trembling on the thin carpet rolled out on the floor.*

 *The first woman who danced up to him was the grandmother of the newborn. She danced along with him for a while to celebrate, then withdrew. Another woman got up to dance, then another. They soon tired. He was the axis around which everyone twirled. He drew his moves from a repertoire that had been chiselled over generations. They needed him, needed all that he brought with him that night. All night, they admired him, trying to get their own moves to resonate with his. He was their cupbearer for the night.*

 *By the time dawn broke, the entire gathering had joined him. Caught in the throes of the night's last remaining breath, everyone danced as if to pass him their own strength. Even those who didn't know the songs sang along.*

The next morning, the priest's wife asked him, 'So, did your wife like the *saris*?'

His wife had refused to allow the packet to be brought inside her home. The *saris* had lain outside the door the entire night, and in the morning they were given away to the first person who came asking for alms.

Shivram went up to lot number 9. It was his task to gather up the remains in a black cloth, write the number of the cremation lot, the time of cremation and the gender of the deceased on the cloth, and deposit the bundle in the room where many people's remains hang in small black bags.

*Every night, he climbs the stairs to the roof, his body swaying. Sometimes he brings his glass of drink up with him. His brother knows he is unmindful of the steps, inattentive to the climb. He stays close behind. Their footsteps echo in the dark. He mumbles to himself, but his voice turns quiet as he passes the open doors on all those floors. The rebukes are not new to his ears. 'There he goes again!' However softly he tries to go, he can hear someone say this. He continues up the stairs and disappears onto the roof.*

*Then it is his voice that echoes down the stairs.*

*'My lover, he beats the drums, yes the drums.*

*Oh, but I have been cursed by some wretched widower!'*

The outer walls of the room have an uneven texture. Its unpaved ground is hard. Unpainted from inside, the room draws colour from the slant of the sun's rays. At night it becomes deep, dark black. A dungeon from which there can never be a way out.

All the things that come into the cremation ground with a dead body are kept here. A haze hangs over them. Red bangles, *saris*, shoes, earthen pots, cots, clothes, a broken cot. This room, which has no door, is their custodian. Once they enter this room, these objects disappear from the world. Even ragpickers forget they exist.

*He stops and reaches out for the drum. He is shivering slightly, as if softly surrendering himself to the energy of the things that still remain inside him, letting his body heed their call. He starts to sing and beat the drum, summoning the gatherings of the time that has passed. Gatherings which used to sing, sway, dance—and which warded off the time when all this would be lost. Now roused, he begins to dance, returning to the drum, playing on it again and again. One can hear the drum beating on the roof far into the night. There is no easy way of keeping those worlds, which he had once known, alive inside him.*

Shivram was looking for a hook on which to hang the small black bundle he had made to hold the remains. Thick smoke crept into the room. His eyes caught sight of the dates written on four bundles hanging from a hook. Three were from September 2004. The one he held in his hand was of 2007.

Shivram went deeper into the room. Many bags hung on one of the walls. As if someone had hung his precious things there, so he may not forget them. Or as if they are totems to keep the evil spirit away. The dates on these bags were hidden beneath layers of dust. Shivram cleared the dust with the tips of his fingers. 2001, 1999, 1998, 1995.

*The door creaks and shuts.*
*It has now been eight years since he began climbing up to this roof. Rain or hail, nothing has ever been able to stop him.*

Shivram's eyes swept over the room. Along a black bundle hung a *sari*, here a knife, here a waistcloth. One black bundle was fat, another thinner than the others. He stood there, trying to make out which was from a man, which from a woman, who had been thin and who had died fat. Everyone hung there through the logic of dates. When someone had died could be known, but not how many generations he had seen in his lifetime.

ALMOST EVERY NIGHT, MY FATHER USED TO LAY MANY SHEETS OF
PAPER END-TO-END ACROSS OUR LARGE KITCHEN, WHERE THE REST OF
THE FAMILY WAS PLAYING POKER. HE WOULD THEN CALIGRAPH A
TEXT ACROSS THE WHOLE ROW OF PAGES, ONLY BREAKING OFF WHEN
HE REACHED THE WALL.
HE WOULD SPEND THE ENTIRE EVENING WORKING ON HIS PAGES.
AFTERWARDS, HE WOULD DESTROY THEM.

Image and text by Hiwa K.

# AMPHIBIAN MAN
## NAEEM MOHAIEMEN

Every time I translate Syed Mujtoba Ali, I start with a recitation of facts. Familiar to Bengalis, unknown to everyone else. This time as well...?

Mujtoba was one of the famous Indian writers, emerging from the Bengal renaissance and the end of the British colonies. Unusually for a Muslim, he penetrated deep inside Hindu *bhadralok* (genteel) circles, reaching the bastion of exclusivity by becoming a professor at Shantiniketan. He pulled off a delicate task—respect in India's literary circles, and popularity among the plebs—and he was a roving artist in Europe in the 1930s, existing seamlessly in many cities and countries. He was not the familiar figure of today's economic or political refugee, but an intellectual and cultural exile, his bohemian nature putting him at odds with the Indian middle class, but at home on European streets.

This many decades later, translating his text or his life is an uphill task. The genius of his chosen form—a cocktail of languages, puns, double entendres, insider references, and metanarratives—is lost in translation. I get wistful when I reread Mujtoba's stories.[1]Cafés, dinner parties, card games, Herrs and Frauleins and Mademoiselles. Now, when Bangladeshis are scattered all over the world, selling flowers in Italy and postcards in London, I wonder how Mujtoba passed with such ease in that society. Stories of old-world, melancholy afternoons in Parisian cafés sit uneasily with Schengen zone realities.

Consider his story of a showdown with Italian customs. His friend Jhandu-da is carrying a tin of vacuum-packed sweets—the mythic Bengali dessert *roshogolla* (literally, 'orb full of juice'). When a customs officer insists on checking the tin, the following scene breaks out. Can we imagine a world where we can squash a sweet into a customs officer's face and not immediately get arrested? How delicious then, this slice of Mujtoba's Europe.

IMMIGRATION (1960)[2]
*The devil immediately pulled out a tin-opener from under the counter. There was no lack of guillotines during the French revolution either. Jhandu-da studied the tin-opener and repeated, 'Remember, you have to taste the sweets to make sure they are real'. The customs officer gave a thin little smile. The sort of smile we give if our lips are cracked from the winter chill.*

*Jhandu-da cut the tin open. Well, what else would come out? Roshogolla. Forgetting any formalities with fork and knife, he started picking sweets with two arched fingers and giving them out. First to the Bengalis, then all the Indians, then finally the French, Germans, Italians and Spaniards.*

*The French went, 'Epaté!' The Germans, 'Fantastisch!' Italians, of course, said 'Bravo!' Spaniards, 'Delicioso, delicioso!' Finally, the Arabs, 'Ya Salam, Ya Salam!'*

*The entire customs office was swallowing roshogolla. The air was full of that sweet scent. Only with Cubist or Dadaist techniques could you draw a picture of that scene. Meanwhile, Jhandu-da was leaning heavily against the counter and saying to the officer, in Bengali, 'Come*

1. In the eight-volume revised edition from Dhaka/
Dacca or the eleven-volume original from Kolkata/Calcutta.
2. 'Roshogolla', *Monthly Basumati*, Chaitra 1363
(Bengali year) (1960).

on, just try one'. In his hand was a juicy roshogolla. The officer put on a serious face and shook his head.

Jhandu-da leaned forward even more and said, 'Look, everyone is eating it. It's not cocaine, not opium after all'. The officer shook his head again.

Suddenly, Jhandu-da slid his entire belly on the counter, grabbed the officer's collar and squashed the roshogolla into his nose.

'Damn you, you won't eat it? Your whole family will eat it! You think this is a joke? I told you a million times, "Don't make me open it, they will all spoil, the little one will be crushed!" But no you wouldn't listen…'

By then the customs house was in chaos. In a strangled voice the officer started screaming for help. He cried not just for guards, but Il Duce Mussolini, Consuls, Ministers, Ambassadors, and even Plenipotentiaries. Mother Mary, Holy Jesus and the Pope thrown in for good measure. And why shouldn't there be a fuss? This was a totally illegal act. If you try to stop a government official by crushing him with your one-hundred-and-twenty-kilo body and force-feeding him, whether you feed him sweets or arsenic is irrelevant—you can definitely go to jail for this. In Italy, you could hang for lesser crimes.

Five of us grabbed Jhandu's waist and tried to drag him off the counter. Jhandu-da's voice kept rising octave after octave, 'Oh you won't eat it, sweetheart? You won't? I'll make you eat it now!' The customs officer kept calling for the police. But his cries were so weak, I felt like I was receiving a long distance call from my golden homeland India. But where on earth were the police? The French lawyer raised two hands in prayer and offered unsolicited commentary, 'This is truly a holy land, this Venice, this Italy. Even the Indian sweet can create miracles by making all officials disappear. This tops even the "Miracle of Milan"! This is the "Miracle of Roshogolla"!'

By now, we had managed to get Jhandu-da off the counter. As the officer pulled out a handkerchief to wipe off the debris, Jhandu-da yelled, 'Don't you dare wipe that off. That will serve as your witness in court—exhibit number one!'

Within three minutes, the head officer made his way through the crowd. Walking up to the officer, with an open box, Jhandu-da said, 'Signor, before you proceed with your cross-examination, please try one of these Indian sweets'.

The officer put one sweet inside his mouth and closed his eyes for two-and-a-half minutes. With eyes still closed, he held out his hand. Again. Another. Now Jhandu-da said, 'A drop of Chianti?' Like an agonized Kadambini came the cry, 'No. More sweets'. Finally. The tin was empty. The customs officer made his complaint at last.

The head officer replied, 'You did very well to open that tin, otherwise how would we get to taste it?' Then looking at us, he yelped, 'What are you all staring at? Go get some more roshogollas!' As we quietly crept out, we heard him berating his junior officer, 'You are an absolute ass! You open the tin and you don't try this delicious object?'

The Italian poet Vincenzo de Filicaja wrote,

*'Italy Italy, why did you hold such beauty in you
There must be tragedies written in your fate.'
And so I say
'O Roshogolla, why did you hold such sweetness in you
Italians forget their true Christian religion
And fall at your feet today.'*

People find many reasons to resurrect historic figures. Mujtoba's breakthrough novel *Deshe Bideshe (Home and Abroad)* was an extended travel journal that brought him instant fame in Bengal. But as the travel genre became dated, literary historians focused on his Muslim identity. Such an identity is too narrow, because Mujtoba broke out of every proscribed confine (Sylheti, Muslim, Bengali, Bangladeshi, Indian, Asian). Like Nobel laureate Rabrindanath Tagore, who insisted on translating his own works from Bengali into English, Mujtoba embraced English, French, German, and in fact Europe itself, just at the time when Muslim revivalists were insisting that English was the language of the colonizers, and that decolonization warriors must learn Arabic and Urdu.

MADEMOISELLES (1952)[3]
*You can't spend all your time at the National Library or Guimet Museum. I had already enjoyed all the joie-de-vivre of Paris. I was walking among the crowds on Place de la Madeleine when suddenly I heard behind me, 'Bonsoir, Monsieur le docteur!'*

*I turned and saw a girl who looked like one of the millions of French beauties. With a ready pout on her face, she said, 'Oh, now you don't remember me! But you knew me even before you met your new love, Paris!'*

*As a schoolboy, a sudden slap from the teacher would remind me what the capital of Montenegro was. Just like that, it came to me—of course, I had met her on the train from Marseilles when I first arrived in France. My hat was already off, now I added a bow and pleaded, 'A thousand pardons and I beg your forgiveness, Mademoiselle Chatineau!' When it comes to high courtesy, there is much similarity between Paris and Lucknow. If you ever leave your book of Parisian etiquette at home, don't hesitate for a second—just start using that antique Lucknow style. It works like a charm.*

My memories of Mujtoba start with my mother. These things always do. Mother sits and embroiders complicated designs on saris. Mother talks about my eldest aunt dressing up to meet Mujtoba's German girlfriend.

Wait—he had a German girlfriend?
Not one, several... Well, no one used words like that.

Words like what?
Girlfriend.
Right, ok (I brush it aside)—but was there really?
Well I know they got dressed up to meet her. I never heard anything more.
You never heard if she was pretty or not? How could that be?
Well I did hear that she was older. But wait don't talk about this. This is not an interesting story.
It's interesting to me.

ITALIAN WOMEN (1956)[4]
*In English, you say 'carrying coals to Newcastle', in Gujarati 'full pitcher to the river', and in French, why, 'taking your wife to Paris'. The French phrase is tasty. But the question remains, are French beauties really that generous?*

*First, French women are truly beautiful. English women have boy faces, German women are blunt, Italian women look a bit like Indians (why go to Europe for that?). And Balkan girls, their lovers are always in a killing mood (saving oneself is the first rule). And one more thing— French girls really know how to dress, with very little money, very little material.*

*But beauty is not always the first thing that pulls us in. In countries where courtship is the norm (not ours), I have often see beauties go wanting while plain girls tear up the town with fantastic husbands. So is it that people look for beauty for love, but something else for marriage. Are they two different instincts? It's possible, I suppose.*

*A German girl will treat a guest very well, maybe even fall in love deeper than the French. But you will always remain an Auslander to her, always the 'foreigner'. The French girl divides the world in a different way. For her there are two types of people—cultivated and uncultivated.*

The reason for this conversation. Mother worries (occasionally). Her son has vague work and a roving life. A bit too similar to stories she heard about her uncle, Mujtoba Ali. Of course it's preposterous, looking for Mujtoba traces in my life. But as the joke goes, every Bengali mother thinks her son is Jesus

In mother's memory, Mujtoba was too brilliant to be a family man. He was always in Paris, Berlin, London, Vienna. Hardly ever in his hometown Dacca.

So you see, it is not good to have too many girlfriends (Mother says).
He seems to have had a grand time.
Yes grand time, but in the end he came back to marry a Bengali girl. After all that.
Well why did he?
He knew the German girlfriend would not work. No one would accept it.
How do you know no one would?
I know these things.

LADIES OF THE NIGHT (1952)[5]
*In India, the Hindus go to Kashi, the Muslims go to Mecca, in Europe all the disciples head to Paris in search of the meaning of life.*

*As the disciples walked down the streets, at every step you would hear the sweet tones of 'Bonsoir monsieur, may your evening go well'. If you responded to the siren call—well, what happens next, I have no personal experience, nor do I crave that experience. I have no need to become Emile Zola's tragic hero. I still haven't been able to digest what Sarat Chatterji wrote, leave alone Zola.*

*I was a little lost in thought, otherwise I would have never replied to that last 'Bonsoir'. As soon as the words were out of my mouth, I realized I had made a mistake. Handling two beauties in one night was beyond my meagre strength. My ancestors handled four beauties at the same time. My generation's fall from those heights was quite pronounced.*

*What was such a flawless vision doing on the streets? It is true, what Tulsi Das once said, 'The universe travels along such strange paths. The bartender sits in his tavern and sells wine, and there is no end to the crowds. Yet the poor milk-seller has to go from door to door to try to sell his milk'.*

*I said, 'Please don't be offended, but I can't quite place where I met you'.*

*What to do now, she had started to walk with me. If she wasn't one of the vendors of 'life', why was she walking with me? And why not say something—good or bad? No more of this, I would leave Paris tomorrow! I prefer my crosswords to be in the morning newspaper, not on the streets.*

Crosswords and puzzles. Teasing out memories of Mujtoba. Paradoxically, though there are many more possibilities for travel today, Mujtoba's easy and intimate relationship to Europe acquires a sharp edge in the light of contemporary discomforts with outsiders. In the era of Fortress Europe, he seems an improbable figure—almost as the title character of a Russian novel popular in 1970s Dhaka: *Ubhochor Manob*—fish in water, man on land. Swimming in and out of cultural spaces, across borders, with impossible ease.

# THE GHOST OF FORMOSA
## CÉDRIC VINCENT

*I pretend not to give you a perfect and complete History of my Island, because I was a meer*
*Youth when I left it, but nineteen Years of Age, and therefore incapable of giving an exact*
*Account of it. Besides, I have now six years from home, so many things of moment may perhaps*
*slip my Memory.*
Preface to Psalmanazar's Description of Formosa, 1704

In 1764 a book appeared in London with the title *Memoirs of \*\*\*\*, Commonly Known by*
*the Name of George Psalmanazar; a Reputed Native of Formosa.* In accordance with the author's
instructions it was published after his death, and it would probably have attracted little
interest today had it not contained surprising revelations about a celebrated book published
sixty years earlier.

When it came out in April 1704, *An Historical and Geographical Description of Formosa*
was applauded as the most thorough study yet written of Formosa (present-day Taiwan). The
book described in minute detail the history of the island, as well as its political system,
customs, economy, language, architecture and forms of dress. It also recounted the life of the
author, a native of the island who was newly converted to Anglicanism after having escaped
the Jesuit Inquisition. Part ethnographic study emphasizing the strangeness of the Formosan
culture, part satire of the Jesuit order, and part confession of an authentic Formosan native, the
book quickly gained an avid audience all across Europe. For a while the author's name was
on every lip. He received the official protection of the Bishop of London. He taught the Formosan
language at Oxford University. Certain passages of *A Modest Proposal* (1729) by Jonathan
Swift were inspired by Psalmanazar's book. In his biography of Samuel Johnson, one of the
most influential literary critics of his age, James Boswell reports: 'When I asked Dr Johnson, who
was the best man he had known? "Psalmanazar", was the unexpected reply: he said; likewise'.[1]
Despite all this, George Psalmanazar (1679?–1753) never went to Formosa. His Formosa was
a pure invention, and only his posthumous confession revealed the deception.

We know little about Psalmanazar. Even his real name remains unknown.[2] Everything is as
if he wanted to ensure that all the information we have about him today came from his own
writing. At the end of his life, his autobiography provided a coherence that his deceptions and
omissions had previously made impossible. It gave a unity to his life's journey, which he
presented as a succession of games of identity, fluid and flexible.

Psalmanazar was born in the south of France, a region with strong heretic traditions, in about
1679. He was brought up by Franciscans at first, then Jesuits and then Dominicans. Then,
assuming the identity of an Irishman persecuted in his own country, he travelled around the
south of France and Germany, earning his money from begging. He was drafted as a soldier, and
escaped being executed as a spy when he passed himself off as a Japanese man from Formosa,
already using the name 'Psalmanazar'. In 1702, his regiment arrived in Sluis in the Netherlands,
where he met a Scottish chaplain, William Innes. Innes invited the 'Japanese' man to his

1. Quoted in Frederic J. Foley, *The Great Formosan Impostor*
(Taipei: Mei Ya Publications, 1968), 62. This biographical work pro-
vides my main informational basis, even though Foley does not
actually analyse the deception. The biographical summary given
here, and the quotations that follow, are taken from his book.
2. Psalmanazar derived his name from Salmanazar,
an Old Testament Assyrian king.

home and, seeing through his deception, forced him to confess. But rather than denouncing
him, Innes saw an opportunity for money and fame, and decided instead to support him in his
dissimulation. He forced the young Psalmanazar to convert to Anglicanism, and chose 'George'
as his baptismal name. From Japanese he became Formosan. In 1703, Innes took him to
London where, as the first Formosan to join the Anglican Church, he received a warm welcome
from the church authorities. *Description of Formosa*, written in the space of two months,
and initially in Latin, came out in English in 1704. Psalmanazar continued to play the Formosan
until 1728 when, after a serious illness, he decided to begin another life. He left London and
renounced his stipends. To earn a living he found employment carrying out obscure tasks for
librarians. He acquired a justified reputation as a man of erudition. He had always had a gift for
languages, and now he learned Syrian and Hebrew, which he used in his collaboration with
Archibald Bower on *An Universal History, From the Earliest Account of Time.* Bower then asked
him to edit the articles concerning China and Japan for his *Complete System of Geography*
(1747). In the course of this writing he denounced the machinations of a 'supposed native of
Formosa named Psalmanazar', alerting the public to the impostor. But no one noticed.

Psalmanazar was the embodiment of his own deception, unlike other famous eighteenth-
century frauds such as Thomas Chatterton and James Macpherson, whose pretence rested on
the 'discovery' of medieval or Celtic poetry they had in fact written themselves. He did not pose
as an explorer publishing the journals of his travels in Formosa; he chose to be a Formosan
bearing witness to his own life. His life remained the primary evidence for the authenticity of his
descriptions of Formosa, and the deception required daring. He had to be different, but not
so much that he would appear dissonant, and beyond assimilation. As a member of the
Formosan nobility converted to Anglicanism, Psalmanazar seems to have found a reassuring
balance between the exotic and the familiar. The more he emphasized the savagery of
Formosan society, the more he was taken for a sincere informant who would not hesitate to
denounce the crimes of his people, and the more he demonstrated how successful was
his adaptation to European society. Nonetheless, it is true that his alien identity kept him on
the margins of society, and relegated him to a very circumscribed position. Moreover, we have
to consider the reasons why the deception of this 'noble savage' was not revealed by his
physical appearance, especially as some witnesses attested that he had blond hair. In fact, the
ability of eighteenth-century Europeans to analyse or even to perceive other cultures worked
on very different principles than those that might obtain today. In many cases, geographical
origins were not denoted by physical appearance, especially by skin colour. If Psalmanazar was
able to satisfy his European audience as to his Formosan origins, it was by more contingent
qualities such as behaviour, dress, religious practices—and language, the first item in his exhi-
bition.[3] The second was *Description of Formosa*, which he called his 'geographical novel'.

The book forms part of a family of proto-Orientalist literature from that period, among which
so-called 'tales from the antipodes' and 'Robinsonnades' were highly popular genres, even if

3. On these points see in particular Michael Keevak, *The Pretended Asian. George Psalmanazar's Eighteenth-Century Hoax* (Detroit: Wayne University Press, 2004).
4. David Faucett, *Images of the Antipodes in the Eighteenth Century: A Study in Stereotyping* (Amsterdam: Rodopi, 1995).
5. Formosa had been under Chinese control since 1683.

they were read with some mistrust. These texts were received variously as fact or fiction. *Robinson Crusoe* (1719), for example, was read by many as a factual account.[4] While Daniel Defoe warned his readers against fake chroniclers, he was prepared to use their strategies to give his plot extra dramatic verisimilitude. *Description of Formosa* followed the procedures and conventions of factual writing, and its reports were appropriately illustrated with engravings. The authority of the printed word extended the fame of the book's author and helped to further authenticate his imposture. But the book also went so far as to establish the norms by which the authenticity of future manifestations of Formosanness would be judged. After the publication of his book, Psalmanazar would be obliged to eat raw meat and roots on occasion, to conform with its descriptions of Formosans, and he would speak and write Formosan on request.

To those sceptics who cast doubts on his stories, Psalmanazar would respond with an argument of irresistible logic: 'If I did not know my subject, or if I had invented the things I tell, is it imaginable that I would contradict everything my predecessors said? The very fact that I am in complete disagreement with their accounts is enough to prove my own veracity, without me having to bore my readers with fastidious explanations'. Psalmanazar wished to provide a description as new and surprising as possible of Formosa, that is to say, as different as possible from those of earlier travellers—for example by asserting that the island belonged to Japan, while they were unanimous in declaring that it was occupied by China.[5] It is precisely in his confrontations with those who thought his accounts lacked verisimilitude, or who pointed out the differences between his account and those of witnesses returning from the island, that Psalmanazar's imposture gained the most strength, benefiting from a sort of transfer of authority. One of his greatest talents as an impostor was that he never contradicted himself, and never retreated from his statements even in the face of the most destabilizing attacks. His most formidable opponent was George Candidius, a Dutch missionary who had spent ten years on Formosa, and whose journals were also published in English in 1704. These writings represented at that time the most trustworthy account of life in Formosa. Nevertheless, it was Psalmanazar's Formosa that gained the upper hand, for he argued that the missionary had not had access to the heart of Formosan society, 'beyond the mountains'. Moreover, his Formosa was the one that best corresponded to the horizon of expectations of the time, effectively providing words for an existing fantasy, and feeding into the architecture of rumour, which disseminated his vision of the island and kept it alive.

Psalmanazar's Formosans transgressed all the most established of European taboos: he reported that they were polygamous, ate dead bodies and practised human sacrifice. At the very beginning of the Enlightenment and of the emergence of evolutionism, such horrible details served to confirm Europe's sense of its own superiority. In this sense Psalmanazar's deception affirmed the dominant discourse and the future rationale of colonialism. It was in accordance with the interests of the government, and it legitimized the coercion carried out against so-called barbarism and the moral duty of evangelism. In this sense, Psalmanazar's writing,

6. Mary Louise Pratt, *Imperial Eyes: Travel Writing and Transculturation* (London: Routledge, 1992).
7. For instance in the *Dizionario delle Lingue Immaginarie* by Paolo Albani and Berlinghiero Buonarroti, or the *Dictionary of Imaginary Places* by Alberto Manguel.

like other travel writing of the time, produced the 'rest of the world' for European readers. The mechanism of this process has been described well by Mary Louise Pratt: it did not 'report' on Formosa; it produced a 'Formosa' for European consumption.[6] Travel writing produced places that could be thought of as barren, empty, undeveloped, inconceivable, needful of European influence and control, ready to serve European industrial, intellectual, and commercial interests.

Psalmanazar's false accounts also won favour for the way they played on more local issues. In London's Protestant society, he obliquely criticized Catholic ideas of the mass by describing a distant isle where they were supposedly taken literally. His unrestrained descriptions of the sacrifice of children caused a strong reaction in Europe, not only because of what they revealed about distant Pacific islands, but also for their implicit caricature of Catholics, which was much appreciated by Protestants.

By conforming his accounts to certain concerns prevalent in Europe at the beginning of the eighteenth century, Psalmanazar made Formosa exist as a place-world, in conformity with what such a place could produce in the imagination of European high society—which, for its part, could find in his reports the confirmation of its own representations. Thus Psalmanazar was able to play on the expectations of his audiences in order to be 'Formosan'. The true-seeming is sometimes at odds with the true. The influence of Psalmanazar's descriptions was such that as late as 1808 Boucher de la Richarderie's *Bibliothèque Universelle des Voyages* would still draw all its information about Formosa from them for want of other documents. Psalmanazar was still the last word on the question, and retained his credibility.

EPILOGUE

Far from putting an end to the story, the posthumous confession of Psalmanazar transformed it into a fascinating mystery. The shift from a serious simulation to one that was playful and shared gave new power to the story by making Psalmanazar an extreme impostor whose deception was no less than an exploit. Having captured the attention of the beginning of the eighteenth century with his truth, his lies fed the imagination of the centuries that followed. This arrogant trick, seemingly so impossible to pull off, has become an enigma, and his story has never been completely forgotten. Studies of impostors and false literary accounts naturally give him a prominent place, whilst studies of mythical geography put him back into the context of his time.[7] He inspired writers as different as Swift, Leibniz and Hemingway. At the beginning of the twentieth century Psalmanazar would be taken up as a precursor of surrealism, or a *fou littéraire.* At the end of the same century, when anthropologists interrogated themselves about the politics of their representations of the Other, he represented a kind of negative image of the ethnographer: the fake ethnographer.[8] Nevertheless, as Michael Keevak points out, 'in so many ways his remarkable odyssey hardly seems to have gotten beyond the let's-tell-the-story-one-more time stage'.[9]

8. Among these studies see Rodney Needham, *Examplars* (Berkeley: University of California Press, 1985); Susan Stewart, 'Antipodal Expectations: Notes on the Formosan "Ethnography" of George Psalmanazar', in Georges W. Stoking, ed., *Romantic Motives: Essays on Anthropological Sensibility* (Madison: University of Wisconsin Press, 1989), 44–73; and Justin Stagl, *A History of Curiosity: The Theory of Travel 1550–1800* (Harwood Academic Publishers, 1995).
9. Keevak, *The Pretended Asian*, 13.

Partly because *Memoirs* is the only source we have about Psalmanazar's life, even if we are justifiably doubtful about the truthfulness of its contents. There is little chance now of discovering new facts, so there remains a good dose of mystery. It is as if the story demanded that each generation rediscovered it, told it again, and interpreted it again according to its own demands and preoccupations. In every instance, however, Psalmanazar's extraordinary deception is understood to be an anomaly—an anomaly that confirms all our most dearly held certainties, a return of the repressed whose causes need to be mastered in order for things to return to normal.

# UN-TITLED
## OVE KVAVIK

IMAGES OF YOUTH BOXERS TAKEN MOMENTS
AFTER THEIR DEFEAT IN THE NORWEGIAN
NATIONAL CHAMPIONSHIP

1. Cao Xueqin, *The Story of The Stone*, (also known as *The Dream of the Red Chamber*), trans. David Hawkes (London: Penguin, 1973–1986). The Penguin edition has five volumes: 1. *The Golden Days*; 2. *The Crab-Flower Club*; 3. *The Warning Voice*; 4. *The Debt of Tears*; 5. *The Dreamer Wakes*. Volumes 4–5 edited by Gao E, translated by John Minford. Published in French by Gallimard in La Pléiade collection, *Le Rêve dans le Pavillon Rouge* is described as follows: 'La richesse de la matière a poussé la critique marxiste à qualifier le *Hong Lou Meng* "d'encyclopédie du monde féodal à son déclin"' Another reading.

2. A selective list: Dore L. Levy, *Ideal and Actual in* The Story of the Stone (New York: Columbia University Press, 1999); Anthony C. Yu, *Rereading the Stone: Desire and the Making of Fiction in* Dream of the Red Chamber (Princeton: Princeton University Press, 1997); Cécile and Michel Beurdeley, *Giuseppe Castiglione, a Jesuit Painter at the Court of the Chinese Emperors* (Rutland: C.E. Tuttle, 1971); Henri Maspero, *El taoismo y las religiones chinas* (Madrid: Trotta, 2000); J.J. Clarke, *The Tao of the West: Western Transformations of Taoist Thought* (London: Routledge, 2000); Confucius, Mencius, Los cuatro libros (Madrid: Alfaguara, 1995); Luis Racionero, *Textos de estética*

# THRESHOLDS
## CONTEMPORARY CULTURE INDEX

One of us just returned from the Garden of Total Vision, or Prospect Garden, as David Hawkes translated the name of the Kaleidoscopic Garden at the centre of Cao Xueqin's *The Story of the Stone*, also known as *The Dream of the Red Chamber*.[1] It took five months to traverse that universe, where space and time expand and contract depending on who is telling the story, or on whose thoughts we are allowed to glimpse. Five months of daily refuge during which our other reading excursions had to do with what was going on in, and around, the Garden: secondary sources helping us to understand, and visualize, a monumental object of knowledge.[2]

We report: it was delightful.

What kind of time do we have that we can give a book this kind of attention? What do we gain from this process? What does it mean *to slow down*, now, in 2008, and listen for one hour and a half to Eliane Radigue's *Jetsun Mila*, Luc Ferrari's *Far-West News*, Robert Ashley's *Improvement*, or Sun Ra's *Life is Splendid*? Or to engage with the U.S. TV series *The Wire*, five seasons, where we are prompted to *Listen Carefully*?[3] What do they give us that we surrender?

We—contemporary culture index—produce information. We spend our days with computers, querying remote databases, reading and indexing journals and periodicals. Current periodicals, deceased journals. We are creating a database. Can we call it an archive?

*Upon reading about archives this heading came to mind: Everything / Nothing: Negation in Abundance. Particular examples of attempts at collecting and the subsequent ordering of masses of material—including fictive attempts—led to a feeling not merely of bewonderment, but also of fatigue, attention deficit. Negation in abundance can be read as the cancelling-out effect which is possible when confronted with more than is comprehensible, that which is mind-numbing, more than one can bear. It can also be read as a multitude of negation, many minuses. What I'm referring to as a cancelling-out effect can also be thought in relation to absences, lacunae, holes which occur in the midst of densities of information, as well as amidst their lack. The lacunae referenced in this text are those which allude to that which is beyond understanding, and understanding can be thought here in terms of how it might be possible to perceive as well as the boundaries of such. It is exactly at these locations of limit and even fatigue where it may be necessary to search. What impossibility is faced beyond the more superficial fatigue?*[4]

But we are not the *archons*. We do not have 'hermeneutic right and competence', we do not have 'the power to interpret the archives'. We might present materials, give directions or hints, but we are not guarding anything. Contrary to archives which could not do 'without residence', we exist anywhere there's an internet connection. We are not under 'house arrest'.[5]

We live in global times, we are told. How did that happen? Were there local processes that we are already forgetting? What new lacunae have been created during this process? How did

taoista (Madrid: Alianza, 1983); E.R. Hughes, ed., Chinese Philosophy in Classical Times, (London: Dutton, 1942); Wu-chi Liu and Irving Yucheng Lo, eds., Sunflower Splendor: Three Thousand Years of Chinese Poetry (Garden City: Anchor Books, 1975); Maggie Keswick, The Chinese Garden (New York: Rizzoli, 1978); Xiao Chi, The Chinese Garden as Lyric Enclave: A Generic Study of The Story of the Stone (Ann Arbor: University of Michigan, 2001); and The Threefold Lotus Sutra: Innumerable Meanings; The Lotus Flower of Wonderful Law, and Meditation on the Boddhisatva Universal Virtue (Tokyo: Kosai, 1986).

3. Jetsun Mila (Lovely Music, 1987, 2007); Far-West News (Blue Chopsticks, 1999); Improvement (Elektra NonSuch, 1992); Life is Splendid (Total Energy, 1999); The Wire (HBO, 2004–2008). A cursory list of areas of knowledge opened by these works could be: Jetsun Milarepa, Tibetan Buddhism, The Spotless Practice Lineage, Arp synthesizer, land sound art, from Page to the Grand Canyon, musique concrète, from Prescott to Los Angeles, Florian Hecker, United States subconscious' soundscapes, Black Panthers, White Panthers, free jazz, The Solar Myth Arkestra, Saturn, The Magic City, Baltimore...

we get here? And what tools do we need to understand the shifts that have occurred, and our current condition?

The great modernist notions of culture—the literary sense of culture as arts and letters and the anthropological sense of culture as habits and customs—were entirely inadequate to understand the culture industries and ideological state apparatuses that dominated the age of three worlds. So new concepts, new frameworks were forged.[6]

A bibliographical database as a new concept, a new framework? Or is it a tool to trace their creation and current state?

One of us wrote this paragraph to Raqs Media Collective, while preparing our participation in 'The Rest of Now':

*I am especially attracted to the slowing down and concentration aspects of your proposal, as ccindex spurs from an acknowledgment of a lack of attention: to materials, to contexts, to discourses, to histories, to the past and to the present. One of the paradoxes I find myself in is how to address it through what might be considered yet another instance of information overload. How to address it? I gather that it is important to make a distinction between knowledge and information and its access, but this is something that the tool itself cannot do. The database is only activated by the intended user, and its purpose fulfilled only if what is retrieved from it can be accessed, seen and read. And this takes us back to concentration and time, which I would imagine to be one of the required characteristics of scholarship and of the curious mind.*

Of the curious mind? How do curious minds get formed?

A GROWING ORGANISM
What prompts us to ride a train to Queens to locate a British periodical published at the end of the 1970s in London, Black Phoenix: Journal of Contemporary Art & Culture in the Third World?[7]

We are prepared. We have previously made an appointment to use the library. We sit there, in a dark space, for hours while we go through the periodical, read the articles, type the contents and the details, assign subject headings, find links that direct you to the source, and then we post it in our database for you to go and encounter it.

We didn't know about Black Phoenix a few months ago; we don't know many things. But we are learning, and driven to diffuse what we encounter.

What has happened—the process of labour described above—was a fairly common practice for librarians before they were transformed into digital content managers. Engagement with materials, physical or digital, a slow process of accretion with hardly any final results; these practices existed before us, and will continue after us. A process of refinement.

A process of loss? Are we complicit in the fetishization of information, or are we producing knowledge?

4. Renée Green, 'Survival: Ruminations on Archival Lacunae. Adaptations, Re-readings, and New Readings. Introduction to the Following Accretive Process', in Beatrice von Bismarck et al., eds., *Interarchive: Archival Practices and Sites in the Contemporary Art Field* (Lüneburg: Kunstraum der Universität Lüneburg; Cologne: Walther König, 2002). An edited excerpt is published in *The Archive*, ed. Charles Merewether (London: Whitechapel Gallery; Cambridge, Mass.: MIT Press, 2006).

5. Words in quotations are extrapolated from Jacques Derrida's *Mal d'archive*. English translation: *Archive Fever*, trans. Eric Prenowitz (Chicago: University of Chicago Press, 1996), 2.
6. Michael Denning, *Culture in the Age of Three Worlds* (London: Verso, 2004), 3.
7. http://www.ccindex.info (Browse Journal = Black phoenix).
8. Gayatri Chakravorty Spivak, *Death of a Discipline* (New York: Columbia University Press, 2003), xii.

In our case, we are exempt from this fetishism. We are not calling attention to our process, to our labour, to our *product*. We want to become a discreet threshold, to welcome users somewhere else.

RETURN TO THE GARDEN: FOOTNOTES

*Typically, the entire literature of China, say, is represented by a couple of chapters of* The Dream of the Red Chamber *and a few pages of poetry.*[8]

Attention, readers of details: minutia. The footnotes accompanying this essay could be read as a portrait of our Garden traveller. What could be discerned from them? A physical location? Language proficiency? Musical tastes? Attention to detail? Thought processes?

That could be one reading. But these footnotes also are *information*, which can be used to gain more knowledge, to access materials. Primary information, secondary sources.

In both instances, one would need to care. A curious mind, trained to read entry points, able to navigate thresholds.

A threshold is defined as 'any place or point of entering or beginning'. Librarians, archivists: we are engaged in the creation of thresholds, abstract distillations, most of them of arid beauty. Tools to take us somewhere else.

To compile these footnotes a multitude of resources have been used, most of them digital: bibliographical databases, collective library catalogues, public libraries, image databanks and bookstores. And the texts themselves. Time was spent circulating through masses of information, applying and learning new and established thought processes (i.e. cataloguing rules) that would allow us to find what's desired. No two library catalogues or databases are alike. Fortuitous encounters are the norm, as thought processes are always subjective. In a bibliography or in a library catalogue different times collide: records made last century coexist with records made last week. For us, these layers are beautiful, threshold details, but nonetheless minutia in the path to somewhere else.

What might be the difference between the time of research and the time of engagement with the work, the object of knowledge? What kind of wonder can arise with the realization of a network of thought, a history of inquiry surrounding and emanating from these objects? How might this form of pleasure differ from that derived from an actual engagement with the work?

Could we think of these forms together? The Object of Knowledge, its hermeneutics, and the processes that allow encountering both. Would their combination allow us entrance into The Garden of Total Vision? And what could be the benefit?

In its Penguin edition, *The Story of the Stone*'s last volume is the only one using an action verb in its title: *The Dreamer Wakes*. An indication of what knowledge and its processes can ignite.

# MIXING MEMORY AND DESIRE
LAWRENCE LIANG

In the late 1940s, Roja Muthiah Chettiar, a painter of signs, set up a signboard shop in Madras, in the south Indian state of Tamil Nadu. He had moved to Madras from a small town, Kottaiyur, some three hundred kilometres away. A self-educated man, Chettiar was fascinated by visual culture, and began to build up a personal collection of print material about art and popular visual culture. Over a period of time he extended his area of interest, and started collecting books, magazines, pamphlets, posters, letters, reports, event announcements and even wedding invitations. Chettiar became a well-known figure amongst the old booksellers and the scrap dealers in Moore Road in Madras, as the man who would buy garbage. Chettiar paid far greater attention to his collection than to his business, and as a result he eventually had to shut his sign shop and move back to Kottaiyur. Once back, he set up the India Library Services, a reading room, where for a rupee visitors would be allowed to consult the archives and provided with coffee and lunch.

His family thought he was insane, and would constantly throw away the junk that Chettiar had accumulated. Chettiar would then have to chase his treasures as they travelled from garbage bin to scrap dealer, recovering some, losing others. Every time he ran into financial difficulties, he would dig out a rare stamp from among his old envelopes and send it to a philatelist with a covering letter asking for money.

In 1983, there was a pogrom against Tamils in Sri Lanka, and Chettiar heard about the burning of the Jaffna library. Chettiar was aware that the Jaffna library contained some of the oldest and rarest Tamil manuscripts in the world. He borrowed money and travelled to Jaffna to see what he could recover, but was devastated to learn that most of the documents had been destroyed in the burning of the library. Chettiar had gone to Jaffna as an eccentric collector, and he returned an obsessive archivist, determined to collect whatever he could of Tamil print culture.

Worried about the state of his health and his ability to preserve his collection, he offered to sell it to the Tamil Nadu state archives. By then it comprised over one hundred thousand items, and included many publications dating back to the early nineteenth century. The state refused to pay him two hundred thousand rupees for what it considered to be junk. One of the regular visitors to the India Library Services was C.S. Lakshmi (Ambai), a well-known Tamil writer and feminist scholar. When Ambai was a visiting scholar at the University of Chicago, she informed the South Asian Studies department about this eccentric archive. They immediately sent a team to evaluate the archive and offered to buy the archive for ten million rupees.

Muthiah Chettiar himself never saw any of the money, since he died by the time the transaction was complete. Chettiar died of DDT poisoning as a result of years of breathing the fumes of the insecticide that he regularly used to prevent his collection from being destroyed by insects and worms.[1]

Chettiar's love for time is a bit of a curious puzzle. The beginning of his interest in collecting old and discarded objects coincides with the birth of the new nation and yet it seems that he

1. The Roja Muthiah Memorial Library and Archive which was estab-
lished in Madras (now Chennai) is now one of the most important re-
sources for people working on South Indian history and contains in-
valuable resources including the oldest published Tamil text. The cur-
rent director of the archive, G. Sundar, may have the best
preservation technologies available, but every three months he is
awoken by nightmares in which he sees the archive on fire and
drives twenty kilometers to ensure that the materials are intact. I
want to thank Sundar for telling me the story of Roja Muthiah, and
for the care he displays for the past.
2. W.G. Sebald, *Austerlitz*, trans. Anthea Bell (New York: Modern Li-
brary, 2002), 275.

had no relation to the immediacy of national time and its obsession with the new. It was not the new that interested Chettiar, bur precisely those things that had been discarded because they did not fit into the new, and had lost their value.

How do we begin to make sense of Chettiar's relation to the scattered objects which seemed to tell a story of their time? They were not garrulous storytellers and it was likely that if anything was said at all, it was said in whispers, and required the patient ear of the collector to decipher what was being said. This coming together of the figure of the collector and the storyteller perhaps offers us a clue for understanding Chettiar's archive fever, and also brings him close to Walter Benjamin, who died a few years before Chettiar's trips to Moore road began.

Benjamin's figure of the threatened storyteller stands at the threshold of modernity. In his account, the decline of storytelling was symptomatic of the decline in our ability to share experience. The assaults of modernity had diminished the transmissibility of culture and redefined the relationship to the past. Benjamin's invocation of the fragile human body standing beneath a force field of destructive torrents and explosions testifies to the experience of a person lost in time. The helplessness of this figure stems from the fact that, unlike his ancestors, he lacks the comfort of tradition, in which there is no break between experience and the chain of transmission. At the same time, he is haunted by the past that accumulates around him as history and debris. He has neither access to this history, nor to a future that seems completely uncertain.

And yet this person lost in time is condemned to find new coordinates with which he can at least partially access the past. The storyteller and the collector meet in the world of discarded objects, where the act of collecting stands in for the loss of narrative. Through its mediation between memory and materiality, the object composes a past through its silent testimony. But the object is also evidence of the irretrievability of the past, and stands at an ironic distance no matter how hard one attempts to fully grasp it. History thus becomes the elusive and slippery thing present in the surface of the object, threatening to disappear if you come too close.

The objects Chettiar was drawn to were the ones that had not been rendered completely intelligible by systems of classification and order. When the state archives refused to buy his collection, it was precisely because these objects had not attained the status of historical artefacts. They exist instead as mythical things that hold out the *possibility* of a narrative. They are based not on conditions of factual representation, but on the evidence of the past's irretrievability.

Giorgio Agamben remarked that in a traditional social system, culture exists only in the act of its transmission, or in the living act of its tradition. There is no discontinuity between past and present, between old and new, because every object transmits at every moment, without residue, the system of beliefs and notions that has found expression in it. When the transmissibility of culture and experience has become difficult or impossible, scattered objects become mnemonic devices through which the fragments of a story are rendered possible. One can

imagine Chettiar on his visit to Jaffna, standing amidst the ruins and ashes of a library, looking for traces, only to find that the burning of the library was now an event consigned to the past and available to us only via history.

In his novel *Austerlitz,* W.G. Sebald evokes another destruction of a library:

The old library in the rue Richelieu has been closed, as I saw for myself not long ago, said Austerlitz, the domed hall with its green porcelain lampshades which cast such a soothing, pleasant light is deserted, the books have been taken off the shelves, and the readers, who once sat at the desks numbered with little enamel plates, in close contact with their neighbours and silent harmony with those who had gone before them, might have vanished from the face of the earth.[2]

How was Chettiar to make sense of his present, when he had witnessed how fragile it could be? Chettiar's fever arose from the desire to be in close contact and silent harmony with those who had gone before him. It consisted of a love for time, a love that was nonetheless acutely aware of how fickle and unforgiving this particular lover could be.

# THE ETHICS OF DUST
JORGE OTERO-PAILOS

# PREFACE TO THE SECOND EDITION.

I HAVE seldom been more disappointed by the result of my best pains given to any of my books, than by the earnest request of my publisher, after the opinion of the public had been taken on the " Ethics of the Dust," that I would write no more in dialogue ! However, I bowed to public judgment in this matter at once (knowing also my inventive powers to be of the feeblest) ; but in carrying the book into a new edition, at the request of my kind agent, Mr. Henry Wheat), I would pray the readers whom it may at first offend by its disconnected method, to examine, nevertheless, with care, the passages in which the principal speaker states the conclusions of any dialogue ; for these summaries were written as introductions, for young people, to all that I have said on the same matters in my longer books ; and on re-reading them, they satisfy me better, and seem to me calculated to be more generally useful, than anything else I have done of the kind.

. I can tell you one       thing  ; and I might take credit for         telling you,            a personal reason          about the creation.

Oh  yes—yes ; and its             now.

back to that.           I must warn you against an old

Modern         earth         passed through its highest state  and      after          a series of       culmin ing       s         by       now gradually becoming less fit for     habitation.

Yes, I remember          there            very bitter impression of the gradual perishing of         the          new      physical world         doubt       loss of sensation          by violent          physical action ; such as the filling up of the Lac de        by landslips          the narrowing of the Lake Lucerne by the gaining      of the st eam          which, in the course of years, will cut the lake into two, as that of       has been divided from that of      the steady diminishing of the glaciers north of the Alps, and still more, of the sheets of snow on

their southern slopes, which supply the re-
freshing streams of Lombardy :—the equally
steady increase of deadly maremma round
Pisa and Venice ; and other such phenom-
ena, quite measurably traceable within
the limits even of short life, and unaccom-
panied by redeeming
agencies. the existing
phenomena
evidence collected
within historical periods can be accepted as
a clue to the great tendencies of
change ; the great laws which
fail, and which change
lovelier order,
or de R.
fastened itself
upon me more distinctly, during my
endeavor to trace the laws which govern
the lowly framework of the dust. For,
through all the phases of its transition and
dissolution, there seems to be a continual
effort to raise itself into a higher state ; and
a measured gain through the fierce revul-
sion and slow renewal of the earthly dust,
in beauty, and order, and permanence.
The soft white sediments of the sea draw
themselves, in process of time, into smooth
beds of gathered symmetry, burdened and
strained under increase of pressure.

fervent . . . drift of . . . slime . . . dries, into layers of its several elements ; slowly purifying each by the patient withdrawal of it from the anarchy of the mass in which it was mingled.  Contracted by increasing drought, . . . it infuses continually a finer ichor into the opening veins, and finds in its weakness the first rudiments of a perfect strength.  Rent at last, . . . it knits, through the fusion, the fibers of a perennial endurance ; and during countless centuries, . . . rising, to repose. . . . the . . . luster of its crystalline beauty, under harmonies of law which are . . . beneficent, because wholly inexplicable.

*(The children seem . . . but more inclined to think over those matters than to talk.)*

*. . . (after giving them a little time).* . . . to read anything out of books of mine . . . the law of . . . which I want you to . . . merely to put it in other words . . .

# THE AFTERLIFE
## OF INDUSTRY

GELATINE FROM PIG BONES IS USED TO HELP INSERT THE
PROPELLANT – CORDITE OR GUNPOWDER – INTO BULLETS.

# BILDRAUM
## WALTER NIEDERMAYR

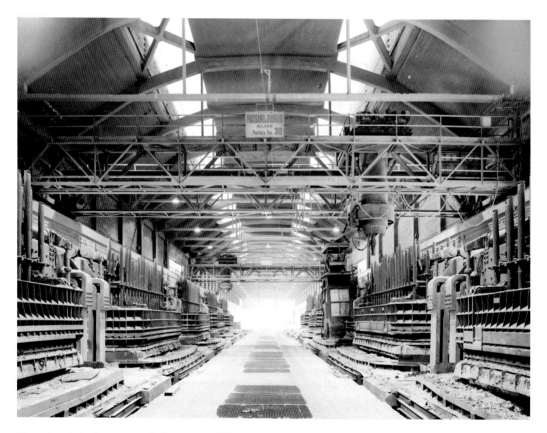

The Alumix buildings, built between 1932 and 1936, are among the most impressive buildings built in the South Tyrol at that time, and bear witness to important strains of twentieth-century history. They are also difficult to speak about: they represent a 'repression chamber' of what has been, and what remains.

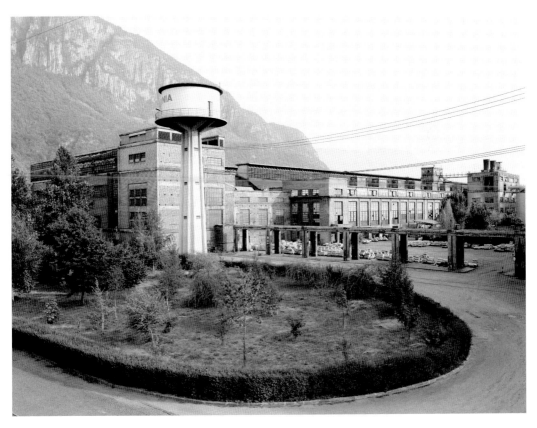

*The products of daily progress, economically optimised for short-term gain, transform the city into a world of appearances in which everything is continuously displaced by the new. There has been a loss of things, buildings and places that were indispensable elements of our visual memory, and this has led to an increase of the invisible—a process of immense repression, a retreat into ignorance and uncertainty about the present. What is remembered has been saved from nothingness. What is forgotten has been abandoned.*
John Berger, *About Looking*

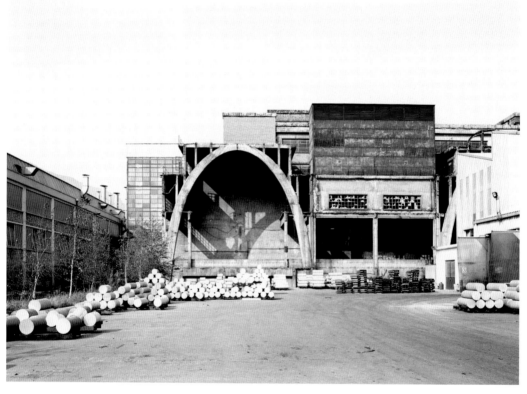

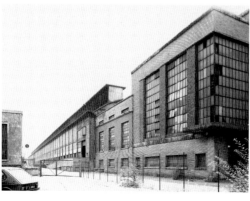

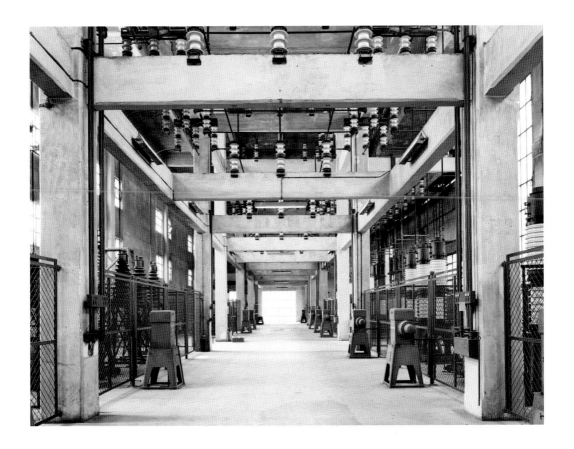

ART ALWAYS HAS A PROBLEM, AN ANALYSIS, AND A CONCLUSION.
THE CONCLUSION THEN BECOMES THE NEXT PROBLEM.

Text by Will Insley selected by Jörgen Svensson

MEG STUART, 'THE ONLY POSSIBLE CITY,' VIDEO
PRODUCTION IN THE FORMER ALUMIX FACTORY, 2008.

Image by Jorge Léon.

# THE ROMANCE OF CAFFEINE AND ALUMINIUM
JEFFREY SCHNAPP

Viewed in hindsight, the coming together of coffee and aluminium seems inevitable. They shared certain common associations right from the start: associations with lightness, speed, mobility, strength, energy, and electricity. But fated or not, the meeting was long in coming. It had to wait until the mid-1930s, the golden era of aluminium designs for the kitchen and the beginning of fascist Italy's pursuit of economic autarchy, at which time it gave birth to a domestic object that can still be found in nearly every Italian home and in many a kitchen throughout the world: the Bialetti Moka Express.[1]

Industrial objects may appear forgetful and therefore reducible to function. Yet such under-standings strip away the actual density that characterizes the object world: the subtle incrusta-tions of intention and invention, fantasy and ideology, tradition and accident that, like a family history that can be recovered only by means of exacting genealogical research, an object carries in the train of its existence. Things may be opaque, but they are rarely dull, and the stories of imaginary and material investments that they tell conjoin the minutia of history to large-scale social processes in ways that expose the workings of history within everyday forms of communion like the morning cup of coffee that you and I imbibe before heading off to work.

Heretical though it may seem to admit it, espresso coffee is not an Italian invention, experiments with steam pressure brewing having been undertaken in Britain and France as far back as the early 1800s. Nor is the word *espresso* a genuinely Italian word. The label was borrowed from the English *express* via the French *exprès*, meaning something made to order and, by extension, produced and delivered with dispatch. This meaning was modified by the rise in mid-nineteenth-century England of special trains running 'expressly' to single loca-tions without making intervening stops, trains that soon came to be known throughout Europe as *expresses*.[2] The connection with coffee brewing may not appear obvious. But it was prefigured by a subgenre of coffeemakers known as coffee locomotives, manufactured be-tween 1840 and 1870, that played upon the functional analogy between the boilers of steam engines and the boilers in coffee machines.[3] So when in 1901 Luigi Bezzera filed his patent for the first restaurant-style espresso machine, a machine consisting in a large boiler with four double pumps subsequently commercialized by the La Pavoni company, he could pretty much count on the fact that consumers would understand the symbolic valences of drinking a product bearing the designation *caffé espresso*.

The new espresso machines were designed to dazzle through their size and speed, with rumbling boilers, brass fittings, enamelled ornaments, vulcanized rubber knobs, and gleaming metallic lines all at the command of the caffeinated double of the train conductor-engineer—the *barista*. They reinforced and reinterpreted the long-standing conviction that strong coffee was the virile liquor with which modern men powered their corporeal and corporate boilers. And even if the steam-brewed coffee that these behemoths turned out often tasted burnt, the brew was power-packed, intense, and quickly consumed. It translated the values of effi-ciency and excitement associated with the express train into an everyday beverage in

1. On aluminium's emergence as a domestic metal, see Penny Sparke, 'Cookware to Cocktail Shakers: The Domestication of Aluminium in the United States, 1900–1939', in *Aluminium by Design*, ed. Sarah Nichols (exhibition catalogue, Carnegie Museum of Art, Pittsburgh, 2000), 112–139.

2. The picture is actually slightly more complex, inasmuch as the word 'express' was, before the era of trains, already associated with express messengers who could be counted upon to deliver messages at speeds superior to those of the ordinary mail service. So 'express' train services were themselves tapping into a prior usage.

3. On coffee locomotives, see Edward and Joan Bramah, *Coffeemakers: Three Hundred Years of Art and Design* (London, 1989), 104–109, which also contains a comprehensive history of coffeemaker design.

4. Although there is some confusion about the matter among current Bialetti employees, it may be that Bialetti's shop evolved into the firm known as Metallurgica Lombarda-Piemontese dei Fratelli Bialetti-Piedimulera, listed in the review *Metalli leggeri e loro applicazioni* 1 (May–June 1931) as specializing in 'lathe-turned products in billet metal, stamped sheet metal, foundry services, laminates and metal wire; in particular, casting in molds, especially of items for the home and hotel supplies' (p. 27).

comparison to which domestic coffee was but a slow and pallid imitation.

Enter Alfonso Bialetti, freshly returned from a decade-long stint of work in the French aluminium industry. In 1918 Bialetti founded a small metal and machine shop in Crusinallo, in his native Piedmont.[4] As corporate lore would have it, Bialetti begins with a small industrial oven, an anvil, and a milling machine, fabricating pieces to order for industrial clients by making use of a technique he acquired in France: that of gravity casting aluminium in reusable cast iron moulds. A decade passes during which he becomes intrigued with how local housewives boil their linens in tubs built around a central conduit that draws the boiling soapy water upwards and redistributes it across the linens through a radial opening.

Lightning strikes: why not adapt this simple physical principle to coffee making? Why not transform the unwieldy and complex restaurant espresso machine into a light, trouble-free, inexpensive domestic appliance? Why not democratize espresso coffee by introducing it into every Italian home? Bialetti's solution was elegant and simple. Design an entirely self-contained aluminium unit made up of three principal pieces that, on the model of the *napolitana*, could be heated on a mere stovetop, but capable of making precisely the same intensely flavourful coffee heretofore limited to restaurants and cafés. So much for *barista*-showmen and ritual trips to the *caffé*. So much also for the humble *napolitana* and the *milanese*. Domestic coffee making would be raised to the dignity of the local coffeehouse; domestic coffeemakers, which is to say housewives, would be raised to the dignity of the *barista*.

For several years Bialetti tinkered with his invention. There were technical glitches to confront: among them, the need to achieve the proper flow of coffee through the apparatus and to overcome the tendency for boilers to crack under pressure or blow up. There were also design questions to resolve. But once solutions were arrived at, in 1933, the tinkering ended. The moral of the story is that, for all its current ubiquity, the Moka Express remains a characteristic design of the mid-1930s marooned in the 1950s and 1960s. That is, its triumph as a mass-market appliance would have to be delayed, for reasons that I will shortly adumbrate, until the Italian post-war 'economic miracle'.

The context within which Bialetti's invention came about had rendered aluminium no ordinary metal. From the standpoint of global production and the international market for aluminium, particularly in the domains of transportation, household products, furniture, and architecture, the thirties represent something of a golden age. And Italy aspired to be among the leaders of this golden age, despite its belated entry into aluminium production and despite the still relatively small scale of its national aluminium industry at the end of the 1920s. The fascist government set out to improve the situation by favouring the Montecatini group's gradual takeover from various American, Swiss and German interests of the entire Italian aluminium industry, concentrated around production facilities in Mori and Marghera and bauxite mines in Istria, Campania, and Sicily. A de facto monopoly resulted by decade's end, with Italy rising to the modest rank of fourth-largest European producer behind France, Hungary and

5. *Metalli leggeri e loro applicazioni* had a silver foil cover and claimed that it was the 'only Italian review exclusively dedicated to the development of light metal industries, product applications, and manufactured goods'. Every issue had on its cover a quote from the engineer Giuseppe Belluzzo, formerly Minister of the National Economy (1925–1928) and of Public Instruction (1928–1929): 'Italy has abundant raw materials, abundant enough to forge the new productive Civilization that is already shining on the horizon: a Civilization principally based upon the ubiquity of light metals and their alloys in everything including national defense'.

6. On this subject, see Victoria de Grazia, *How Fascism Ruled Women, Italy, 1922–1945* (Berkeley, 1992), esp. 201–203.

Yugoslavia. The governmental campaign hinged on the principle of autarchy, which is to say on the pursuit of economic self-sufficiency by means of a heroic overcoming of Italy's deficiencies in the domains of raw materials and natural resources.

Italy was poor in iron ore, coal and petroleum. But it was far richer in bauxite and leucite. So, even before the League of Nations imposed trade sanctions in retribution for Mussolini's 1935 invasion of Ethiopia, leading to an intensification of the autarchy campaign, aluminium had emerged as the autarchic metal of choice. Two reviews were launched to promote its diffusion: *Metalli leggeri e loro applicazioni*, an industry review established in 1931, and a government counterpart, *Alluminio*, founded in the following year.[5] Both set out to codify what would become one of the defining propagandistic credos of the decade: aluminium is Italy's national metal, a populist metal, the 'real material of the unreal velocities' and accelerated progress achieved thanks to the fascist revolution.

Whether or not Alfonso Bialetti was susceptible to this campaign to establish the Latinity of aluminium, the earlier cited portrait of the Italian craftsman at ease with the complex technical principles of working with light metals fits him like a glove. Bialetti was a better craftsman, however, than a businessman, for the 1930s would prove a decade of limited success for his invention. The reasons had nothing to do with a decline in coffee drinking. The contrary was true, especially after 1935 when coffee came to figure ever more prominently in the mythology both of empire and of autarchy: of empire because Ethiopia, the nation Italy had invaded, was a major coffee producer of Moka-type coffee beans; of autarchy because Brazil refused to follow the League of Nations sanctions imposed by the world community and continued to furnish Italy with its coffee beans. Nor were fascism's regressive gender politics to blame, favoring as they did women's roles as housewives and mothers over public roles.[6] Rather, the problem was Bialetti's only partial understanding of the importance of marketing. Initially Moka Expresses were sold by the inventor himself, who set up stands at weekly public markets in the Piedmont region. Later, the coffeemakers were delivered directly from the factory to regional retailers. No effort to industrialize their production or to market them on a national (not to mention international) scale was undertaken. Bialetti's shop continued to turn out an array of other products, all on an equally small scale. The result was that a mere seventy thousand units were produced between 1934 and 1940. Then came the war. Imports ceased and Italy's national metal became Italy's military metal, unavailable for civilian purposes. Coffee too became scarce. Bialetti shut down his shop, oiled up his casting moulds, and safely packed them away in the basement of his home for the duration of the conflict.

There exists a secondary reason for the difficulties encountered by the Moka Express: the relatively high cost of Italian aluminium until the 1950s. The industry had grown under the umbrella of autarchy and expanded even more rapidly thanks to the war effort. But tariff barriers and Montecatini's virtual monopoly had eliminated pressures to contain costs or improve efficiency. As a result, in 1946 domestically produced aluminium averaged about 140 lire per

kilo while American aluminium (including shipping costs to Genoa) was available at 42 lire per kilo. The alarm was sounded by Elio Vittorini's militant *Il politecnico*, a new review dedicated to the cultural, political and economic reconstruction of postwar Italy. *Il politecnico* called for a true democratization of aluminium, in keeping with its antifascist program of institutional re-forms. The anonymous author argued that 'aluminium this expensive will never give rise to widespread popular consumption, whether for domestic or craft uses, for tools, bicycles, etc'. Structural inefficiencies were to blame as well for the elevated costs. Montecatini was also in the electrical power business, and it was channelling a significant portion of the aluminium it produced into its own (overpriced) power lines; Montecatini's competitors, not wanting to aid the industrial giant, were instead importing tin ones from abroad, thereby contributing to a mushrooming trade deficit.

This was the new republican Italy to which Alfonso's son, Renato, returned in 1946, after several years in a German prisoner-of-war camp, to take over his father's business. Renato was intimately acquainted with metallurgy, having worked alongside Alfonso before he was con-scripted into the army. But he brought an entirely new sensibility and understanding to manu-facturing and to marketing. Production was resumed in the same modest facility in Crusinallo in the late 1940s but with the Bialetti product line narrowed down to a single object: the Moka Express, now fabricated in a full range of sizes (from two cups to ten) and in larger numbers (up to a thousand units per day). This exclusive focus on coffeemakers was buttressed by national advertising campaigns on billboards, in newspapers and magazines, on the radio, and, later, on television programs such as the wildly popular *Carosello*. The campaigns were initially financed by means of loans (daring for such a small concern) and strove to build a distinctive brand identity in the minds both of vendors and consumers, as well as to differentiate the Moka Express from the swarm of clones and competitors that were emerging as Italy's domestic market came back to life thanks to the postwar boom. Characteristic of the younger Bialetti's bold approach were the publicity blitzes undertaken during Italy's most important trade fair, the Fiera di Milano. Year after year, the company would purchase every available billboard in the entire city of Milan, literally saturating the city with images of its coffeemaker. Bialetti's booths became legendary for their scale and inventiveness. In 1956, for instance, the indoor installa-tion was paired with an outdoor sculpture consisting of a giant Moka Express suspended in the air by a stream of coffee above a cup sitting atop a faceted platform bearing its name. The forging of a brand identity was completed with the creation in 1953, at Renato's instigation, of the Bialetti mascot: the *omino con i baffi*, the formally attired mustachioed man with his index finger upraised as if hailing a cab or ordering an espresso.

Times had changed. Memories of the fascist debacle were conveniently fading, and con-sumerism was on the rise as Italian homes were increasing in comfort and size thanks to the economic boom of the 1950s. And a new American-influenced social imaginary envisaged them as activity and entertainment centres for a tightly knit nuclear family. Through Bialetti's

advertising campaigns, the Moka Express placed itself at the centre of these cross currents. It became the emblem of an increasingly egalitarian, do-it-yourself attitude. 'Dove è papa'? ('Where is Daddy?') asks one ad, the answer being, 'He's in the kitchen with the Moka Express', whose simplicity permits a reversal of conventional gender roles.

I conclude with the final step in the transformation of the Bialetti firm from craft workshop into a modern medium-scale industry: namely, with the construction between 1952 and 1956 of a state-of-the-art factory in Omegna. By now profits were rising, the price of aluminium was falling (due to a global aluminium glut), and the success of Bialetti's advertising blitzes was such that the old facility would suffice no more. Renato Bialetti set about the task like a true visionary, much like Adriano Olivetti in the prewar period, insisting upon the rationalization of every feature of the building and upon the streamlining of the Bialetti production line. A massive freight elevator was devised so that arriving trucks could dump their holds of aluminium ingots not on the ground floor, as in a conventional factory, but directly into cauldrons located up on the fifth floor. The entire production process consisted of a smooth lateral and downward motion floor by floor, ending with the inspection and packaging of every item right on the threshold of the ground-floor loading dock from which trucks could depart for their destinations. Workers were assigned individual lockers and showers, as well as provided with houses and with various other progressive amenities. Renato expanded the Bialetti product line to include other household appliances (toasters, vacuum cleaners, meat grinders), but the backbone of the company remained the production of a growing family of Moka Express machines, now being turned out at the rhythm of eighteen thousand per day or four million per year. Yet, for all this emphasis upon modernization, there remained a paradoxical, characteristically Italian touch that renders the romance between caffeine and aluminium also an enduring marriage between the new and the old.

At the sparkling new production facility in Omegna, the very heart of Alfonso Bialetti's remarkable little invention, the boiler, continued to be produced precisely as it was in 1933: that is, cast and then individually finished, inspected, and sorted not by a production line worker but instead by a skilled craftsman. Twenty years had passed and nothing had changed. Another forty-seven have transpired since then and, once again, nothing has changed. When I visited the current factory in the summer of 2000, I was amazed and requested an explanation. Bialetti's head engineer reassured me: automated pressure casting and finishing had been tried many times and the result was too many flaws; gravity casting and an intimate working knowledge of aluminium were required to ensure a resistant and reliable product. I was in no position to argue, given my limited understanding of materials science. But the contrast kept me company all the way back to Milan. On the one side, artisans; on the other, computer-actuated robots. The two working together on a hybrid artefact: an icon of the machine age that is a throwback to the era of manual production. In short, a portrait in aluminium of the original *omino con i baffi*.

# A. B. STROWGER.
## AUTOMATIC TELEPHONE EXCHANGE.

No. 447,918.                          Patented Mar. 10, 1891.

*Fig I*

Images selected by Kateřina Šedá from the
sketchbook of Jana Šedá, the artist's grandmother

# STORIES OF GANGA BUILDING
## RUPALI GUPTE & PRASAD SHETTY

These are stories of Ganga Building, a labour housing block in Mumbai.

### 1. THE LOGIC OF YIELD
By the beginning of the twentieth century, the landlord farmers of Mumbai had realized it was more profitable to sell their fields to builders of mills and labour housing than to continue growing rice.
They had inherited these fields from their warrior ancestors who in turn had received them as rewards for loyalty from local kings. At that time, the land was mostly forest, inhabited by tribes, fishermen and small rice-growing farmers. The warriors compelled the tribes to cut down the forest and convert it into paddy fields. Over time, the descendents of these warriors became landlord-farmers and, with the growth in their numbers, their land was subdivided, until it was a patchwork of small pockets. These properties were of irregular sizes and shapes, but this did not matter to an agrarian community: it was the yield that was important. Equal claimants from a family received land of different sizes but with the same yield.

All this changed around the middle of nineteenth century, when large-scale export of cotton cloth from India began. There was a high demand for land to set up cotton mills and soon an industrial city was born. Farmers started selling their irregularly shaped properties to developers of mills and labour housing (*chawls*). These mills and chawls adjusted themselves over irregular shapes of land whose boundaries had been drawn by the agrarian community following the logic of the yield. The industrial city sat comfortably over agrarian property. The central part of this city with high concentration of mills and chawls was called *Girangaon* — the 'mill lands'.

### 2. FROM SLEEPING PLACE TO PROPERTY
Ganga Building was a chawl built in 1923 in front of a mill, from which it was separated by a road. In the 1920s, three thousand workers worked in this mill in three shifts. Like other chawls, Ganga Building consisted of small (3m x 3m) tenements laid out along a corridor with common toilets. The building was three storeys high with a courtyard in the centre. The side facing the road had twenty shops on the ground floor. The remaining seventy-five tenements housed mill workers. The labourers came from far afield — there were fishermen from the coastal lands, tribes from the hills, farmers from the plateaus, and many others. Typically, a room in the chawl would be rented to one person — the main tenant, who would then share the space and the rent with ten to twenty other men, mostly from the same place of origin. Since they worked different shifts, they all had places to sleep, except on holidays, when they would spill out into the corridors.

Until India's independence in 1947, such men did not have a strong sense of property. But the partition of India and Pakistan resulted in large numbers of new migrants seeking housing in Bombay, and rents began to escalate. The Rent Control Act was passed by the government not only to control rents, but also to protect tenants from eviction. When they found that

they possessed a house from which they could not be evicted, the main tenants, who rented directly from the owner, started pushing out the men who shared their tenements, and brought their own families to live with them.

The original Jain owner of Ganga Building was tired of the meagre rents he was receiving and sold the entire building to Jalal Memon—a Muslim sand trader. Memon died in the late 1950s and his son Yakub took over the chawl's affairs.

### 3. CLAIMS AND CONTESTS

On the ground floor of Ganga Building was a restaurant run by a South Indian Brahmin named Shenoy. His sons preferred to do prestigious government jobs than run the restaurant, and when he died his widow allowed the restaurant manager, a migrant from South India named Shetty, to operate it on rent. Shetty went into partnership with another South Indian named D'Souza and ran the restaurant until 1980.

Eventually, D'Souza turned against Shetty over money issues, poisoned him, and attempted to take over the restaurant from Shenoy's widow. But Shetty's widow, Vasanti, resisted D'Souza's machinations, asked her brother to help her raise some money, and bought the restaurant herself. But her brother now felt he should have a share in the property, since he had raised the money. He bribed the owner of the building to insert his wife's name into the tenancy document, as Vasanti's equal partner. Vasanti was illiterate and at first did not realize what had happened—but when she found out she was so upset she left Bombay for her family home in Mangalore. There she told everyone what her brother had done. Her relatives took a dim view of her brother's behaviour, and he was forced to give his share of the restaurant back to Vasanti—but he also asked her to return the money he had given for the restaurant's purchase. Vasanti went to meet Baburao Sathe, a friend of her husband's, who owned a bank. Sathe proposed that he take over the restaurant and use it as bank premises for a period of twenty years. In return he would pay a monthly rent to Vasanti and make complete repayment to her brother.

### 4. PROPERTY OUT OF NOTHING

A small shop had been cut out of one of the restaurant's external walls, which became a security concern for the bank. The shop was run by a soap seller, Abdul Gani, a friend of Shetty's who had lost his original shop in Dadar during the riots of 1974. Shetty had allowed him to build a small (1m x 2m) booth, half inside the restaurant and half outside. But by the 1980s Gani's financial condition had stabilized and he had bought a property nearby. Vasanti asked Gani to move his shop to the new property, as the bank was insisting on its removal. But Gani refused. So the bank constructed a strong wall around the shop and opened for business. Vasanti sued Gani, claiming that he had encroached on her premises. After sixteen years, the court passed a judgement recognizing the rights of Gani. He could not be legally evicted, but had to pay rent to Vasanti. A new property had been created out of nothing.

Vasanti realized that if one occupied a space for more than three years, nobody could evict the occupier. She decided to encroach on the rear side of her own property. She built a temporary structure with plywood about two metres wide and anchored it to her property such that it lay partly within her space. She then rented that space to the neighbouring shop owner who wanted some additional space. The agreement she entered into was complicated: the new occupant would pay her rent for three years, after which she would complain about the encroachment to the municipal authorities.

Three years later, she complained to the authorities, who came to demolish the encroachment. After the demolition was recorded, Vasanti asked her tenant to rebuild the encroachment and resume paying her rent. This happened every three years. In this manner Vasanti managed to extract extra rent from her property whilst ensuring that the tenant never stayed enough time to claim ownership over the encroachment.

## 5. INTENSITIES

From the mid-1980s, the Bombay mills started to close. There were several reasons: militant labour unions demanding higher wages and ultimately ending up in strike; the high price of real estate in the city pressuring landowners to redevelop the mill lands as commercial property; government policies discouraging industry; obsolete technology that made Bombay production uncompetitive; and the overall change in the city economy, where formal industry was being systematically dismantled. With the shutting of the mills, the workers staying in the chawls lost their jobs. Now they had houses, but no work. Some mill workers took up jobs as watchmen, liftmen, hawkers, estate agents, etc—but most of them remained unemployed. The burden of supporting the family fell mainly upon the women, who ran business activities from inside the chawls—private tuition sessions, catering services, informal banking networks, etc.

After the death in 1992 of the owner of Ganga Building, Yakub Memon, his second son, Yusuf, took it over. He inherited an enormously complex physical and legal entity. Because of the intensity of commercial activities now going on there, tenants had made substantial modifications to the building so that it better accommodated their business. Every inch of the chawl had a claimant. It had many kinds of occupants: tenants of shops living in residences behind, shop workers staying in common corridors, tenants with families, subtenants without families, people staying under staircases, on lofts, over the toilets, on the roof, and everywhere else. Yusuf was not experienced in handling rented property and was unable to recover rents for months. The condition of the building deteriorated and though Yusuf tried selling the property he could not find a good buyer.

## 6. POLITICS OF REDEVELOPMENT

By the beginning of the 1990s there was consensus that the mills had no future, and the government drafted a regulation allowing redevelopment of the mill lands. According to the regulation, the land under the mills was to be divided into three parts—one for commercial development, one for housing and one for amenities. This ensured that the gains from the redevelopment were shared by the owners (who were allowed to develop real estate), labourers (who were to get all their dues and a house in a high-priced locality), and the city (which was to get additional amenities).

A few mill owners redeveloped the mills, but most did not. Instead, they conspired with the government to change the regulation so that they would get almost the entire property to redevelop as real estate. This change was done surreptitiously—it was announced in one of the least-read newspapers and was referred to as a minor modification. Only one single word was added into the whole regulation, which now stated '*Surplus* land under the mills will be divided into three parts…' And there was very little surplus land under the mills: the owners could keep now keep nearly everything.

The mills started changing rapidly—tall chimneys and north-light sheds were replaced by malls, call centres, art galleries, media studios and commercial offices. Prices started rising. The fervour of development put immense pressure on the chawls. By the beginning of 2000, developers had started working on several of them. The government had passed a regulation decreeing that if the tenants of an old chawl were in favour of redevelopment, they could build additional floor space for sale in the open market in order to pay for the cost of redevelopment. The owner would also get a share of these profits. But tenants were generally unable to mobilize resources for such projects, and depended instead on a developer.

Yusuf decided to redevelop Ganga Building, and began to look for a developer. But every developer who came to Ganga Building declined the project because of the complexity of its tenancies. No one knew exactly how many people needed to be rehabilitated. They all had different degrees of claims on the building. Moreover, they all kept increasing their demands for space and money.

## 7. TENURE TACTICS

At this point, when Yusuf was frustrated with his tenants for their noncooperation, he was contacted by Hayat Ansari.

Hayat Ansari had been a part of the underworld during the 80s and specialised in extortion. During the early 90s, after the underworld was restructured, Ansari entered politics, stood unsuccessfully for election and then went into the construction industry in partnership with his uncle Ibrahim, a contractor. Ansari came to excel at dealing with problematic tenancies, for which he had a structured strategy. He began by sending legal notices to all tenants to pay up their dues. Generally, these dues had accrued over long periods and amounted to significant

sums. The tenants hoped that they would be cleared once the redevelopment started. But Ansari behaved like a strict landlord and, after few notices, would send his extortion men. People who had the money got scared and paid up immediately; but the majority were forced to enter into negotiations. In these discussions, tenants ultimately had few options: either agree to redevelopment or vacate the premises.

With subtenants and illegal occupants, Ansari would be ruthless. He would use his full muscle to evacuate them.

Ansari offered Yusuf money and asked him to give him power of attorney for the building, proposing to deal with the tenants himself. Yusuf gladly accepted, took his money and disappeared. Ansari took over Ganga Building in 2005 and managed to crush a lot of the tenancy complications. Unhappy with Ansari's tactics, some of the tenants turned for help to an NGO led by a local politician who claimed to provide support to tenants wishing to redevelop their property. Along with the tenants, the NGO submitted a redevelopment proposal to the municipal authorities and filed a petition against Ansari for harassment. With the help of the NGO, the tenants approached several developers to get the best possible deal. Recently, Hayat Ansari has begun to bribe some of the inhabitants of Ganga Building to come over to his side.

*The story of Ganga Building is in many ways the story of Mumbai and the Mill Lands. But Ganga is only one of the nineteen thousand chawls in Mumbai. Every chawl has its own multitudinous stories of property—stories that refuse to allow the narrative of the mill lands to be shrunk into one comprehensive conceptualization, as official accounts seek to do.*

THE JOURNEY BEGINS WHERE I ARRIVED. THE LENGTH OF ROAD I'VE
COVERED TURNS INTO THE OVERCROWDED ROOM I'M ABOUT TO ENTER.
IT IS A HOME. OR IS IT THE WHITE CUBE? HOW OFTEN HAVE I RESOLVED
TO CARRY ON WALKING JUST TO ARRIVE HERE? DOES THE ELEPHANT
REALLY FIT THROUGH THE EYE OF A NEEDLE? IN MOVEMENT I BREAK
AWAY FROM REFLECTION AND BECOME A PERMEABLE BODY…

Text by Erik Schmelz selected by Helen Jilavu

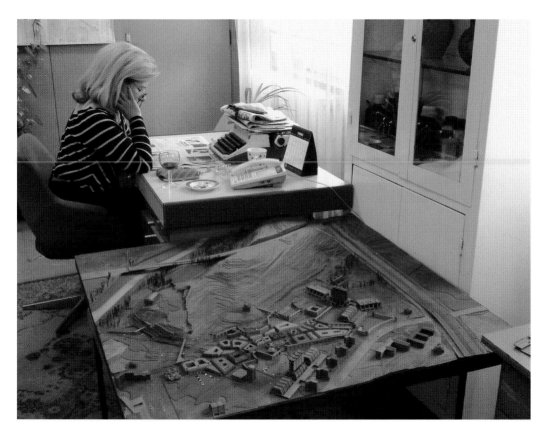

Conservation laboratory in the
Museum of the City of Skopje, 2008.
Image by Yane Calovski.

# FILE: ALUMINIUM.PL
## GRAHAM HARWOOD

```perl
 1 #!/usr/bin/perl -w
 2 #=============================================================================
 3 #
 4 #          FILE:  aluminium.pl
 5 #
 6 #  DESCRIPTION:  If all objects make the world and take part in it and at the same time,
 7 #                synthesize, block, or make possible other worlds.
 8 #                How true is it for the CODE that creates a book.
 9 #
10 #       OPTIONS:  collect every word before aluminium and every word after it -
11 #                 then work out the frequency of use
12 # REQUIREMENTS:  futurism/manifesta/issuecrawler.org to generate the bulk of domains to be visited
13 #                look for the relationship of the websites to each other
14 #         NOTES:  Search_id,, URL, Pages_returned -> network _ residue_of_Aluminium.
15 #        AUTHOR:  Harwood (trying), <harwood@gold.ac.uk>
16 #       VERSION:  0.1
17 #       CREATED:  05/16/2008 03:27:00 PM BST
18 #=============================================================================
19
20 use lib '/1909/futurist/Marinetti/';
21 use lib 'Manifesta08/RAQS/Bolzano/'
22
23 # !!!don't worry about this library now!!!
24 # use Mine::Blast::Extract::Exhaust::Aluminium.
25 #
26 use GetWebPage::Page;
27 use strict;
28 use Data::Dumper;
29 use Machine::Book;
30
31 # Recursively search through 2,000 WWW links returned from the issuecrawler.net
32 # Extract 8,000 sentences containing the word ALUMINIUM.
33 # Eg 'aluminium salts have often been used to reinforce babies vaccines,
34 # as they are not considered to be harmful to humans.' extracted from ?????.com
35
36 my @lines_of_text;    # a line of text
37 my %wordlist; # key: prefix, value: array of suffixes
38
39 my $search_str = "ALUMINIUM";
40
41 # get the DATA returned from the issue crawler and put it into an array -
42 # *see ALUMINIUM_DATA @ the end of the file
43
44 my @aluminium_domain_data = get_issuecrawler_data("issuecrawler.txt");
45
46 &search_www_pages(@aluminium_domain_data);
47
48 sub search_WWW_pages {
49       # extract the text from the issuecrawler data string
50       foreach my $domain_name ( @aluminium_domain_data) {
51           # edit out the google links
52           my @data_str = split(/,/,$domain_name);
53           my $WWW_page_href = $data_str[2];
54           if($WWW_page_href =~ /http:\/\// ){
55               #nothing
56
57           }else{
58               $WWW_page_href = "http://$WWW_page_href";
59           }
60           print  "\n GOING TO GET: Aluminium domain $WWW_page_href";
61           my $WWW_page_get = GetWebPage::Page->new;
62
63           $WWW_page_get->init($WWW_page_href,$k,'SENTENCE' );
64           my @texts = $WWW_page_get->get_texts;
```

```perl
64          foreach my $txt (@texts)
65          {
66              # extract any sentence containing ‚ALUMINIUM'
67              add2list(lc $txt,'ALUMINIUM');
68          }
69          sleep 1;
70      }
71 }
72
73 # extract three words before aluminium and three words after aluminium.
74 # Eg "Quite a few planes get hit, but because they're __made__ of aluminium, it __goes__ in one end and out the other."
75
76
77 # words associated with ALUMINIUM && there word frequency from edited.txt
78 # @keywords = qw ( chemical 32 reduction 34 european 36 century 36 designers 36 metallic 37 material 38 barrier 38 world 42 car
   42 ingot 43 steel 44 designed 45 oxide 47 million 50 life 51 produced 52 beverage 56 packaging 57 during 58 products 62 process
   65 cans 71 modern 73 recycling 84 production 92 primary
   94 tonnes 90 industry 100 );
79
80
81 sub add2list {
82      my ($txt,$keyword) = @_;
83      my @words = split(/ /,$txt);
84      # this code will extract any sentence that contains the keyword ALUMINIUM
85      while ( @words > $pref_len )  {
86          my $pref = join(' ', @words[0..($pref_len-1)]);
87          if( @words[2] =~ m/$keyword/i){
88              push @{ $wordlist{$pref}}, $words[0],$words[2];
89              print "\n $words[0] $words[1] '$words[2]' $words[3] $words[4]";
90          }
91          shift @words; # next word on this line
92      }
93 }
94
95 sub get_issuecrawler_data {
96      my $data_file= shift;
97      open(ALUMINIUM_DATA, $data_file) || die("Could not open file!");
98      my @raw_data=<ALUMINIUM_DATA>;
99      close(ALUMINIUM_DATA);
100
101 return @raw_data;
102 }
103
104 __ALUMINIUM_DATA__
105 [1843331,,abal.org.br,,ORG,14,0,t], [1843332,,alcan.com,,COM,272,0,t], [1843333,,alcoa.com,,COM,159,0,t], [1843334,,aleris.
   com,,COM,13,0,t], [1843335,,alfed.org.uk,,ORG,45,0,t], [1843336,,alouette.qc.ca,,CA,4,0,t], [1843338,,alu-info.dk,,DK,29,0,t],
   [1843339,,alu-verlag.com,,COM,1,0,t], [1843340,,alu.ch,,CH,13,0,t], [1843342,,aluar.com.ar,,COM,29,0,t], [1843343,,alucluster.
   com,,COM,27,0,t], [1843344,,alucobond.com,,COM,2,0,t], [1843345,,alufenster.at,,AT,1,0,t], [1843346,,alufoil-sustainability.
   org,,ORG,1,0,t], [1843347,,alufoil.com,,COM,1,0,t], [1843348,,alufoil.org,,ORG,42,0,t], [1843350,,aluinfo.de,,DE,64,0,t],
   [1843351,,alumatter.info,,,36,0,t], [1843352,,alumbuild.ru,,RU,4,0,t]...
106 __ALUMINIUM_DATA__
107
108
109 }
110
111
112 1; # return true
~
~
~
~
```

# INDUSTRIAL RUINS
TIM EDENSOR

It seems that in recent years, the desire to paper over the city—to fill in the blanks, to erase the jagged remains of shells that were once filled buildings—is more manic. In this smoothed-over landscape, fissures within the urban fabric are more difficult to identify. And the notion that the city must put forward a seamless, smoothed-over appearance to signify prosperity is not only articulated by planners, bureaucrats and entrepreneurs but embedded in a wider consciousness where it shapes articulations of the public good.

Despite this frenetic impulse to smooth and encode, the longing for less regulated spaces continues. Industrial ruins are, in official parlance, 'scars on the landscape' or 'wastelands' whose use-value has disappeared—but ruins are the site of numerous activities, and very quickly become enmeshed within new social contexts. Ruins may become spaces for leisure, adventure, cultivation, acquisition, shelter and creativity. And as spaces that have been identified as waste, as well as 'dangerous' and 'unsightly', ruins also provide spaces where forms of alternative public life may occur, activities characterized by an active and improvisational creativity, a casting-off of self-consciousness conditioned by the prying gaze of CCTV cameras and fellow citizens, and by the pursuit of illicit and frowned-upon practices. These uses contrast with the preferred forms of urban activity in overdesigned and themed space: the consumption of commodities and staged events, a toned-down, self-contained ambling, and a distracted gazing upon urban spectacle.

Ruins are excess matter, containing superfluous energy and meaning, which, as disorderly intrusions, always come back to haunt the planners' vision of what the city should be. They confound the normative spacings of things, practices and people and thus address the power embodied in ordering space.

Current hyperbole insists that the social world is inevitably speeding up, a claim which neglects slower processes, the divergent rhythms which compose the city, some of which are organized to contest the imperative for speed. All activities, people and places are not necessarily caught up by an immersion in flows of velocity. The ruin is not particularly penetrated by the speeded-up mobilities and flows which typify this frantic scenario. Instead, its durability and existence is largely shaped by the rate at which it decays, and it is no longer the site of a production process dominated by future-oriented projects and targets, although these temporal constrictions may be evident enough in the remnants of clocking-in stations, dockets, scheduled programmes of work and delivery, and timetables. The ruin is a shadow realm of slowness in which things are revealed at a less frantic pace. Within this relative stillness, bypassed by the urban tumult, the intrusions from the past which penetrate the everyday life of the city are able to make themselves felt more keenly.

# THE INSTITUTE FOR INNOVATIVE TECHNOLOGIES
## REINHARD KROPF & SIV HELENE STANGELAND

*The Institute for Innovative Technologies covers the whole parcel like a futuristic ship. The whole complex appears to be a kind of monolith lying on the ground in memory of Kubrick, having been rammed between the existing buildings with vehemence.*

*It is an ideal bridge, an element of transition, through the experienced human (the laboratories), between the primitive (metaphorically represented by the workshops and associated with a craft now being a thing of the past) and the modern human (the floating point projected upwards, towards the unknown, towards higher knowledge).*

*Such concepts have been executed in a three-dimensional structure; a clear, linear building that is essential and pure, a black block reaching towards the sky on one side by an ambitious gesture. The structure seems to implode, since it only opens up to the light by the fully glazed courtyards.*

*In the second area, a kind of huge magnet of innovation is rising, a complex of office space, which is able to draw intellectual pioneers of analysis, inventiveness and experiment into the interior of its 'field'. The building is floating on a place of water, an element that seems to reject the upper structure due to its low "magnetic permeability".*

From the winning project description by architecture firm Chapman Taylor LLP of the Institute for Innovative Technologies, to be built beside the Alumix factory in Bolzano.

There is a long history of abandoned factories being redeveloped by and for artists. Such projects are usually characterized by self-organized growth and an ongoing negotiation between informal and bureaucratic influences. The integration of resources that emerges by chance through such processes opens up new spatial dramaturgies, and so works against the universal cloning of spaces and the imprisonment of architecture in a global *cultural metastasis*.

The Institute of Innovative Technologies has chosen another route. In the development of this project, there was no exchange with local, site-specific intelligence. This is now a well-known tactic of large investments in urban renewal: reducing the complexity of local information, which could threaten the predictability of the investment and the plainness of the political message. The competition is advertised and judged with a specific agenda, and the winning project aims towards total spatial, programmatic and economic control. In the case of the Institute for Innovative Technologies, the structure literally swallows most of the site, including the existing Alumix factory. In spite of its entirely generic character the description of the architecture is semiotically armed with an arsenal of religious and artistic symbols and analogies. This form of 'postmodernism lite' seems to combine a pragmatic and interchangeable shell with the need to appear unique and special.

Perhaps it is still possible to imagine a modified or different version of the Institute. The future potential of the site lies in exploring symbioses between massive urban renewal and letting spaces unfold in their own way. This would need a relational sensibility for industrial residue, a free space for experimentation, mutations and the ongoing production of strangeness.

# THE NINE GARDENS IN THE BANK OF NORWAY
## INGRID BOOK & CARINA HEDÉN

# THE LAST MESSAGE FROM TOBLINO
## ASHOK SUKUMARAN

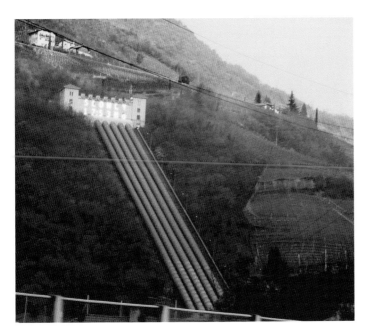

The upper building of the Cardano hydroelectric power station conceals its sources: there is no visible water here. The giant pipes coming down the mountainside appear out of nowhere: no lakes or rain clouds surround them, no dams are in sight. Much like clock towers in medieval Europe, the empty building suggests a hidden connection to some greater force or idea.

The lower buildings at Cardano conceal absence of a different order. Here we discover that *no one* works at this power plant! Its day-to-day workings are managed over optic fibre from a control room at Lake Toblino, 100 km away.

This proposal for an artwork imagines the upper building as a clock tower, displaying the last message from Toblino, with its time-stamp. The difference between the time displayed and the present time is the duration for which the station has been 'autonomous'—i.e. without instruction from a human being.

For people passing on the highway, or living nearby, this is a proposal to think about the syntax of this communication, and the strange remoteness of what is 'local'.

'HOT DESKING' REFERS TO THE TEMPORARY PHYSICAL OCCUPATION OF A WORK-STATION OR SURFACE BY A PARTICULAR EMPLOYEE. THE TERM 'HOT DESKING' IS THOUGHT TO BE DERIVED FROM THE NAVAL PRACTICE, CALLED HOT RACKING, WHERE SAILORS ON DIFFERENT SHIFTS SHARE BUNKS. ORIGINATING AS A TREND IN THE LATE 1980S–EARLY 1990S, HOT DESKING INVOLVES ONE DESK SHARED BETWEEN SEVERAL PEOPLE WHO USE THE DESK AT DIFFERENT TIMES. A PRIMARY MOTIVATION FOR HOT DESKING IS COST REDUCTION THROUGH SPACE SAVINGS—UP TO 30% IN SOME CASES.

Text from Wikipedia selected by CuratorLab

Image by Francesco Gennari

# AUGURIES
## AND REVERIES

PIG BONE ASH IS ADDED TO FINE BONE CHINA IN
ORDER TO GIVE IT A HIGH DEGREE OF STRENGTH AND TRANSLUCENCY

# A READING LIST
## PROFESSOR BAD TRIP

Favourite readings of the late Gianluca Lerici, also known as Professor Bad Trip.
Jena Filaccio, his life companion, selected the books which, from the 1970s onwards,
helped the Professor to understand and draw the the world around him.

Gotz Ariani, *Hannah Hoch, Collages, 1889–1978*
Enrico Baj, *Patafisica*
J.G. Ballard, *The Burning World*
Georges Bataille, *The Dead Man*
Peter Belsito, *Notes from the Pop Underground*
Belisto, Davis, Kester, *Street Art: The Punk Poster in San Francisco*
André Breton, *Anthology of Black Humour*
William Burroughs, *The Naked Lunch*
Chumy Chumez, *Chumy Chumez. Una biografia*
Crass Collective, *Anok 4U*
Mario De Micheli, *Manifesti rivoluzionari*
Guy Debord, *Society of the Spectacle* and 'The Situationists and the New Forms
of Action Against Politics and Art'
Catalogue to the show *Jose Guadalupe Posada* which took place in the Mexican Embassy
and the Italian–Latin American Institute in Rome, 9–31 May 1980, edited by F. Di Castro
Philip K. Dick, *A Scanner Darkly*
Jean Dubuffet, 'In Honour of Savage Values' and other writings.
Albert Hofmann, *Insight Outlook*
The plays of Alfred Jarry
The poems of Paul Klee
Richard Langton Gregory, *The Intelligent Eye*
Paul D. Grushkin, *The Art of Rock*
Giuseppe Lippi, *Virgil Finlay, Bellezza, terrore e fantascienza*
The stories of H.P. Lovecraft
Frans Masereel, *The City: A Vision in Woodcuts*
Herbert Read, *Art and Alienation*
Raf Valvola Scelsi, *Cyberpunk Antologia di testi politici*
Eckhard Siepman, *John Heartfield*
Max Stirner, *The Ego and Its Own*
Dick Voll, *The Art of Basil Wolverton*
Alan W. Watts, *The Way of Zen*
Edgar Wind, *Art and Anarchy*

# SEASTORIES: SEASTATE 2—AS EVIL DISAPPEARS
CHARLES LIM LI YONG

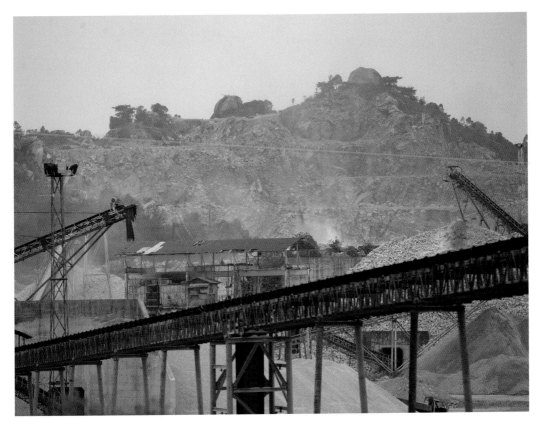

Quarry in Karimun, Indonesia

In 2002, an island called Pulau Sejahat disappeared from the nautical charts of Singapore. In response to the demand for additional land, Singapore's coast was being extended into the sea, engulfing small islands.

Billions of cubic metres of sand and granite were dredged from the bottom of the ocean and dug out of Indonesian quarries to make this new land for Singapore.

In Malay, 'Sejahat' means 'evil'.

Hyundai dredging ship
designed to suck sand from
the seabed

Singapore imported 6-8
million tonnes of sand from
Indonesia each year

Reclamation

Trucks dumping soil onto site
to build up land from barges

Machine to measure the softness
of the new ground

An island surrounded by land,
as evil disappears

# THE ARTIST AS IDIOT
## IRINA ARISTARKHOVA

*Question: 'Why do you want to become an artist?'*
*Answer 1: 'To make pretty things for the rich folk.'*
*Answer 2: 'Through making art I learn about life, and I want*
*to share these experiences with others. Then see Answer 1.'*
Conversation in an Art School, April 2008

*The simplest form of the circulation of commodities is C-M-C, the transformation of commodities*
*into money, and the change of the money back again into commodities; or selling in order to*
*buy. But alongside of this form we find another specifically different form: M-C-M, the transfor-*
*mation of money into commodities, and the change of commodities back again into money;*
*or buying in order to sell. Money that circulates in the latter manner is thereby transformed into,*
*becomes capital, and is already potentially capital.*
Karl Marx, *Capital*, from the section 'The General Formula for Capital'

WHERE DOES A RESIDUE RESIDE?
An idiot is someone who operates outside of the capitalist mode of production. Not out of
refusal, but simply because she is an idiot. An idiot does not know *real value* of things, people
or situations. This idiotic ignorance of the difference between the valuable part and the
useless residue does not strive to become a part of a grand movement – for example to subvert
Capital and its empires. It just happens, accidentally.

The thoughtless nature of idiotic action is irritating, especially its stubborn lack of reasoning.
You cannot blame idiots for mixing rich folks with ordinary mortals: they do not know better.
This is what Lisaveta Prokofievna learned when she called a house where hospitality was
extended in equal measure to the 'leftovers of society' (otbrosy obschestva) and 'decent peo-
ple' (poryadochnye lyudi) a 'mad house,' and hospitality 'complete idiocy,' in Dostoevsky's
novel *The Idiot*.

Contemporary art, together with a renewed political, intellectual and scientific interest in
waste management, the recycling of leftovers, and trash re-purposing of all kinds, makes residue
valuable once again. By trying to extract more value from residue, whether aesthetically or
not, one returns to *The General Formula for Capital*. Unless one is an idiot. Extending hospitality
to residual things and creatures, though an idiotic thing to do, is to understand that its origins
are the same as those of 'residence'. Residue needs a residence: it is by definition residing,
resting. It is left somewhere, thrown away – to find residence in another, more appropriate
place. Or at least, someone who would take it in, since it is a thing out of place, without value.

Those who are left by others, often find sentimental value in residue. It reminds them of
the loved ones who are no longer with them or of the good old days. Residue is a memory build-
er, and serves as more than just a substitute for the real thing - a fetish. Residue can be
immaterial, like those memories themselves, preserved through the habit and pleasure of

recollection. We are embarrassed at times to confess that we hang onto such residue. It designates the value of what it refers to, and therefore makes us vulnerable to the potential blackmail of desires.

In modern societies there are groups of people who were encouraged to live off residue long before the current bourgeois environmentalism ever became a new Hollywood project: the poor (especially urban homeless), mothers, wives, and children. They know the true value of leftovers and thrown away things, and often find themselves competing with birds, animals and decay.

In the world of contemporary art, residue is called 'found objects'. From the world of ready-mades, with their emphasis on *not having made it*, or even *not having bought it*, we move towards *having found it accidentally*. Artists have become scavengers of humanity. Every kind of residue is looked upon as a potential element of an art installation: objects found here and there, or non-stop digital images of whatever comes along (essentially, other people's lives). Artists are becoming repositories of residue and they are therefore making themselves more vulnerable. They keep our leftovers, they make art from them. *Artists love us like mothers*! Things have not been transformed into residue yet, you are still drinking this can of Pepsi, but look – there is an artist, waiting for you to finish, and make it a part of her sculpture. Here it is, take it.

Providing residence to leftovers is not the same process as collecting. Gleaning, scavenging, repurposing are not the same as being a collector. What turns up from this process is fundamentally accidental, just like in the 'lost and found' office. Collecting, on the other hand, though it contains the pleasure of wandering among things, is essentially accidental-less, intentional in its drive. Providing refuge for residue does not necessarily transform it into value. Things will make sense (probably) later, but even if not, they have value in how they are. Rejected - this is what artists want, competing with those who are paid to remove rubbish.

EMILY SILVER AND MITHU SEN: OPENINGS
Emily Silver and Mithu Sen have both worked at various points with 'residue'. While Silver has been interested in found objects ranging from road kill to her signature material, cardboard packaging, Mithu Sen has explored the concept of the 'accidental' in relation to precious personal things. They are very different artists, of course, but something has brought them together here. Their strategy could be summed up as an aesthetic of idiocy. Emily Silver and Mithu Sen represent a new generation of artists (and non-artists), whose work represents an alternative, but non-engaged, impulse within the art market (neither properly buying into it nor fighting it heroically). Idiocy - risky and authentic Dostoevsky-style idiocy - is a new strategy in contemporary art and should not be mistaken for irony or satire. This latter, ironic, resistance is framed mostly by what has been called *prank art*. alike the famous reality show *Punk'd* (MTV 2003-2007), many artists find irony (either through mimicry or satire) to be the

only remaining critical strategy today, especially with regard to capitalist art. The 'idiotic' aesthetic, I argue, is another alternative which cannot be easily replicated (unlike irony). Idiocy is different from irony as it does not operate within a complex rhetoric of tropes and styles, and it can be dead serious (un-ironically). Moreover, irony as one of the tropes is seen as reaching beyond realism and therefore claiming a higher intelligence: 'I play a prank on you because I am smarter than you, an idiot'. While an idiot does not claim any intelligence at all, be it realistic or figurative, she can easily be taken in by ironic art. Idiots do not judge but neither do they neutrally observe and record 'the world's evils as they are'. They are too much into themselves, by definition isolated, private, dis-integrated from contemporary society and its phallologocentric intelligence.

While artworks might not themselves reveal much about the level or quality of the artist's aesthetic of idiocy, their openings surely do. Mithu Sen (*It's Good to Be Queen*, Bose Pacia, New York, 2006) left her exhibition before the opening to wander wandered alone in the rain, and then sent her audience a letter apologizing for her absence:

'dear, i am sorry for not being sorry about my physical absence in my opening night… i am sad but not sorry for my act… it was a conscious decision. i know it was announced in the invitation card of doing an artist's discussion during that evening with my viewer… AND i was away. (i did not escape or run away)… i just took my physical presence off from that very gallery site on that evening… i will try to meet u before i leave. i promise. i again hope that u did not miss me that night coz i was really with you… thank u for bearing with me. i love you. yours and only yours, mithu.'

Without heroism and redemption, there remains a framing of the polis with its fortified walls and laws. Lonely, shy, kind and generous, an idiot insists on her way of doing things, while fully accepting public opinion and the law, refusing nothing, challenging nothing. In her attempt to host residue (Sen presented a number of found objects and photographs among her own drawings and personal paraphernalia) she goes to completely unnecessary extremes, rightfully idiotic and foolish. Without claiming an exceptional place in the public eye, without visibly seeking recognition, rewards or inclusion, an artist such as Mithu Sen claims to be queen. The word 'idiot' derives from the idea of someone selfish and distant from a community, a residual subject who ultimately defines our rules and regulations through not being concerned with them (the same rendering of an idiot one finds in Aristotle).

Emily Silver invited magicians to her exhibition opening (*Cannavillastic*, Zoller Gallery, Pennsylvania State University, 2008). Outside the gallery doors, they performed tricks. A large crowd watched while chewing on amusement park (rather than art exhibition) food served nearby. The author of this text volunteered to tend a hot-dog stall, giving away free hot-dogs. Emily Silver's opening fitted well with her work;'s questioning of what is valuable and what is residual in art making. Her ability to stage our stuff and our moment in her (un)balanced installations without judgment but also without forgiveness, feels at times unbearable.

Just as in Mithu Sen's aesthetic, this fundamental passivity of aesthetic statement today carries undeniable strength. There is a difference between passivity as accusation (earlier performance art comes to mind) and passivity as a *modus operandi*. In Mithu Sen's and Emily Silver's openings there is no catch. Their actions do not reveal any important truth about the inherent violence or goodness in man, neither do they ask to be remembered as a well-prepared and documented spectacle. The artists, probably, will protest my interpretation of their work through their openings. After all, openings do not make it into an artist's portfolio, they do not have value as art, there is, really, no-thing to buy and sell later (Money-Commodity-Money). But it is exactly at the openings, those events outside of the work proper, where transactions happen, where value is being established or being denied.

When Dr. Evil (in the 1997 movie *Austin Powers: International Man of Mystery*) demanded one million dollars for not destroying the world, his team member recommended that he increase the amount. What he asked for was too little, and incongruent with the world's current value. No fool, Dr. Evil quickly corrected himself by asking for one hundred billion dollars. When artists find themselves in similar situations, they are not sure how much to ask for so as not to look like a fool (from asking too little or too much). Being called an idiot is nothing new to an artist. Now it is an aesthetic: artist represents herself as an idiot, sentimental, vulnerable and crazy protector of what is left.

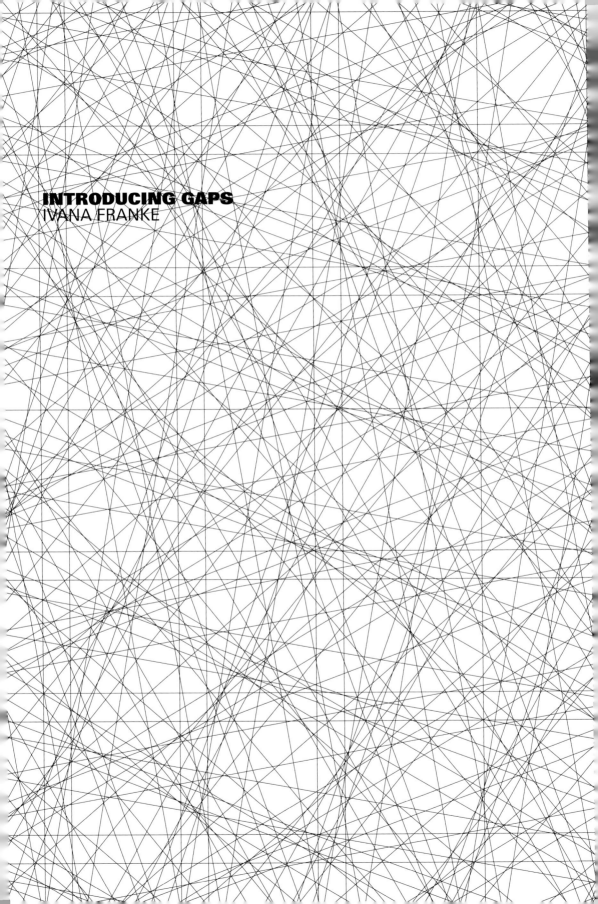

# INTRODUCING GAPS
IVANA FRANKE

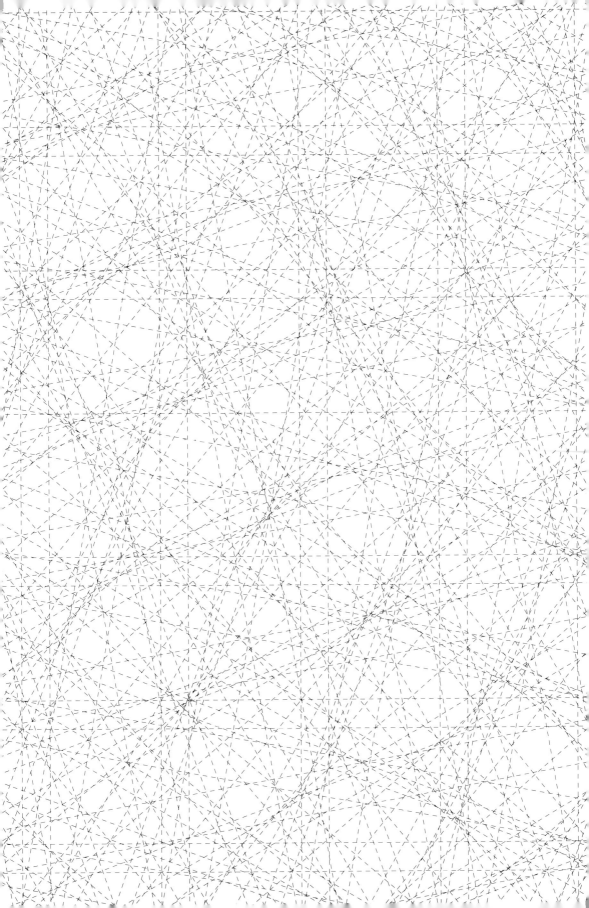

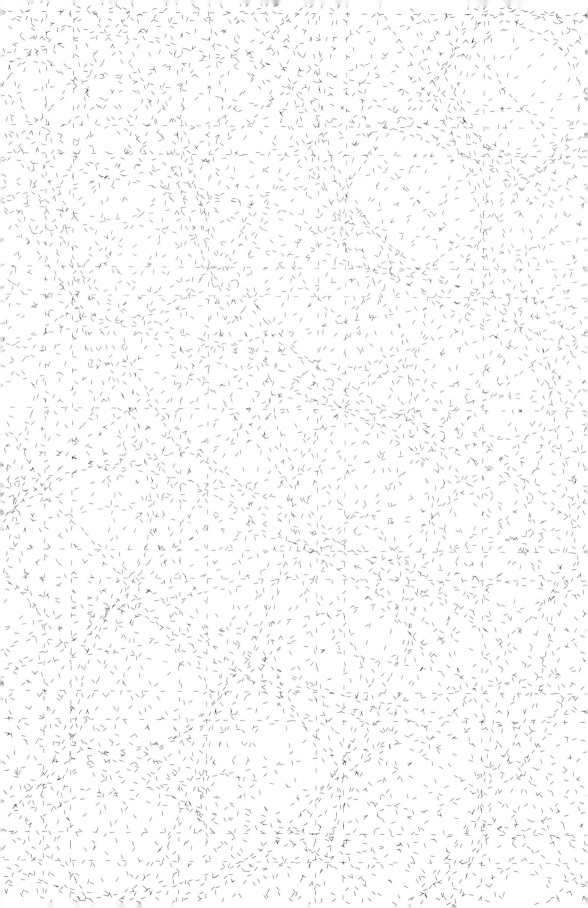

# I coleotteri

*CHIAVE - (4-9) Molti di essi:*

| | | | | | | | | | | | |
|---|---|---|---|---|---|---|---|---|---|---|---|
| M | A | S | T | I | C | A | T | O | R | I | O | P | A | C |
| A | T | E | I | C | A | V | I | V | I | V | E | R | E | E |
| S | E | C | M | A | G | G | I | O | L | I | N | O | T | R |
| A | N | I | P | I | S | I | R | U | C | S | O | R | E | V |
| T | E | B | R | R | A | S | T | U | C | C | I | D | R | O |
| O | R | M | O | E | R | N | I | U | O | C | E | I | O | V |
| R | B | A | T | M | I | L | D | B | A | C | S | N | M | O |
| A | I | R | E | I | A | E | A | L | A | Z | C | E | E | L |
| C | O | A | T | R | T | R | A | R | A | O | A | L | T | A |
| E | N | C | T | T | A | N | O | M | F | E | R | O | R | N |
| C | I | E | O | C | D | T | P | P | L | R | A | G | I | T |
| O | D | F | C | R | O | E | S | A | I | O | F | E | R | E |
| C | I | I | A | R | S | R | L | P | S | L | A | R | E | L |
| C | P | N | P | M | O | A | I | I | E | O | G | E | M | U |
| I | S | S | R | A | I | F | L | A | T | C | G | C | A | C |
| N | A | E | A | S | B | G | O | E | C | R | I | S | T | C |
| E | L | T | S | I | T | R | L | R | T | E | E | E | N | I |
| L | O | T | V | E | R | D | E | I | I | T | I | R | E | O |
| L | C | I | C | I | N | D | E | L | A | I | O | C | P | L |
| A | P | P | A | R | A | T | O | B | O | C | C | A | L | E |

ALI
APPARATO
  BOCCALE
ARIA
ASTUCCI
CALANDRA
CAPO
CARABO
CARAMBICE
CERVO
  VOLANTE
CICINDELA
COCCINELLA
COLASPIDI
COLORE
CORIACEI
CORSALETTO
CRESCERE
ELITRE - ERBA
ETEROMETRI
FAMIGLIA
INSETTI
LUCCIOLE
MAGGIOLINO
MASATORACE
MASTICATORI
NECROFORI
ORDINE
PENTAMERI
PROTETTO
PROTORACE
REGOLE
SCARAFAGGI
SCUDETTO
SCURI - SILFA
SPECIE
TENERBIONI
TRIMERI
VERDE
VIVACI
VIVERE
ZAMPE

# THE PIRATE BAY MANIFESTO
## PIRATBYRÅN (THE BUREAU OF PIRACY)

### LEGAL/ILLEGAL

Copying takes place everywhere and all the time. To use digital data is to copy it. No matter if it's from hard drive to RAM memory, from one portable device to another or from peer to peer. No matter if the physical distance of the copy is measured in millimetres or miles. Still some people prefer to speak for or against file-sharing, as if it was an isolated phenomenon. As if the alternatives were no more than two: file sharing networks or selling digital files.

Yesterday we walked around with megabytes in our pockets, today with gigabytes and tomorrow terabytes. The day after tomorrow, for a reasonable price, we will have tiny storage devices that contain more film, music, text and images than we can ever incorporate into our lives. Everything ready for immediate transfer to another person's device.

### HERE/THERE

There is no longer an archive that is yours entirely. Nor an archive completely open to all. The divide between private and public networks, copies and performances does not apply anymore. There is no fundamental difference between a copy from your external hard drive and one from an open file-sharing network.

File sharing has a potential to create meaning, community and context—a bigger potential than most other forms of reproduction. We want to keep talking about how that potential may be realized in the best manner possible, how cultural circulation can be organized and how the unleashed forces of the open archives can be used for more than stacking a pile of objects which we care less and less about. However, we want to stop explaining why file sharing is righteous or not—as if there was a choice between copying and non-copying.

### FREE/CHARGE

To ask if distribution of film and music should be free or cost money is like asking if it should be free or cost money to attend a party. Sometimes, someone manages to charge a toll for a party, but no one would even think of banning free parties. When do you actually have a party, and when are you just having some fun?

The files are already downloaded. The files are already uploaded. They've been going up and down and in and out in abundance. We want to talk about how to extract meaning from this abundance.

### ART/TECHNOLOGY/LIFE

The digital networks make processes, identities, contexts and works infinitely connected. The division between creator, work and consumer is a bleak way of describing cultural circulation and digital life forms. The cost of upholding copyright's abstract relations between art, technology and life is a world that is mute and ever more depopulated. Hence, we are not about anticopyright but more—Thank you and good bay (sic!). Let's have a fucking party!

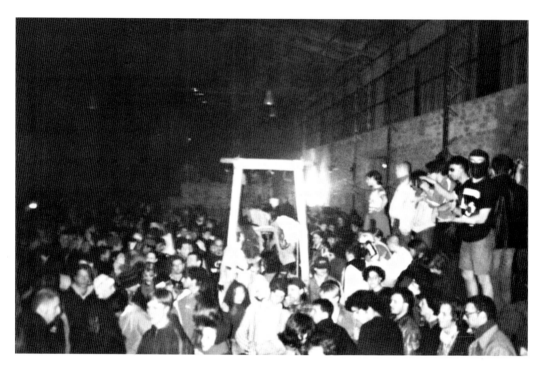

IN THE '90S, IN OSTIA, A SMALL BEACH TOWN IN THE OUTSKIRTS OF
ROME, A VERY ACTIVE CREW CALLED 'OSTIA TEKNO RIOTERS'
WAS WELL KNOWN FOR ORGANIZING EVERY YEAR AN ILLEGAL RAVE
PARTY IN EX-INDUSTRIAL SITES. ON THE FLYER USED TO PROMOTE
THE PARTY OF '99 THE SLOGAN WAS: 'FOR A SOCIAL RE-USE OF THE
ABANDONED AREAS OF THE BRAIN'. IT WAS AN AMAZING
DESCRIPTION OF THE FEELING RISING IN THAT PERIOD FROM THE
TEMPORARY SQUATTING OF ABANDONED INDUSTRIAL AREAS.

Image selected by CandidaTV

# NOTES ON CONTRIBUTORS

**David Adjaye** is an architect based in London.

**Irina Aristarkhova** teaches at Pennsylvania State University (University Park) and writes about new media aesthetics and comparative feminist theory.

**Stefano Bernardi** is a freelance audiovisual professional and a rock musician. He lives in Bolzano.

**Ursula Biemann** is an artist, curator and theorist based in Zurich. Her work is particularly concerned with issues of migration, mobility, technology and gender.

**Ingrid Book** and **Carina Hedén** are artists based in Oslo. Their projects include *Temporary Utopias* (2003), *News from the Field* (2004), *Geschichten für leere Schaufenster/Stories for Empty Shop Windows* (2006), *Military Landscapes* (2000).

**Kristina Braein** is an artist based in Oslo.

**Yane Calovski** (Skopje, 1973) makes drawings, writes stories, develops narrative strategies for public spaces and believes in vernacular knowledge. He is the founder of *D*, a journal of contemporary drawing and, in collaboration with the artist Hristina Ivanoska, *press to exit project space.*

**CandidaTV** (Agnese Trocchi, Antonio Veneziano and Manuel Bozzo) is an extended group of videomakers, performers, mediactivists and aesthetic researchers based in Rome. Since 1999 it has promoted an unmediated approach to media: 'Make your own TV'. Among CandidaTV activities are: workshops, lectures, documentaries, VJing and video installations.

**contemporary culture index** (ccindex.info) is an online, open-access, multidisciplinary database of journals and periodicals that are either ignored by other database vendors or absent from the Internet. ccindex was set up in 2001 by a team of librarians with extensive experience in the academic research area. Its headquarters are currently located in San Francisco; nodes can be found in Barcelona and Manhattan.

**Marcos Chaves** is an artist based in Rio de Janeiro.

**Neil Cummings** and **Marysia Lewandowska** are artists and researchers based in London. They are the founders of Enthusiasts: archive (enthusiastsarchive.net), which resulted from the artists' extensive research into the films made by amateur film clubs active in Poland during the Socialist period.

**Rana Dasgupta** is the author of *Tokyo Cancelled*. His novel *Solo* will appear in February 2009.

**Harold de Bree** is an artist who mostly works on site-specific, full-scale industrial and military objects and machinery. He is based in The Hague.

**Tim Edensor** is Reader in Cultural Geography at Manchester Metropolitan University. He is the author of *Industrial Ruins: Space, Aesthetics and Materiality* (2005) and *National Identity, Popular Culture and Everyday Life* (2002). He is currently researching the rhythms of space, landscapes of illumination and the materialities of building stone.

**Espen Sommer Eide** is a musician, artist and philosopher based in Bergen.

**etoy.CORPORATION SA** was founded in 1994 and is known for its pioneering role in internet art, for controversial operations like the digital hijack, for its etoy.TANKS (mobile studios and exhibition units built in standard shipping containers) or for its latest venture: MISSION ETERNITY—a digital cult of the dead. etoy is all about sharing and distributing (through etoy.SHARE) intangible assets: cultural value, risk and passion.

**Ivana Franke** is an artist based in Zagreb.

**Matthew Fuller** is a writer and artist whose work straddles many domains, from software to architecture. He works at the Centre for Cultural Studies, Goldsmiths, University of London.

**Francesco Gennari** is an artist based in Milan and Pesaro.

**Rupali Gupte** and **Prasad Shetty** are architects, researchers and writers based in Mumbai. They are the co-founders of the Collective Research Initiatives Trust.

**Anawana Haloba** is a new media and multimedia artist based in Oslo and is currently a resident artist at the Rjiksakademie in Amsterdam.

**Graham Harwood** is an artist who has since the mid-1980s explored media systems from photocopiers to software systems, telephones and networks. His approach is to make media strange, allowing it to become a space of fun and experimentation. He works at the Centre for Cultural Studies, Goldsmiths, University of London.

**Graham Harwood**, **Richard Wright** and **Matsuko Yokokoji** have worked together since 2004, firstly as part of the internationally recognised artist collective Mongrel, in a fusion of art, electronic media and open networks.

**Nikolaus Hirsch** and **Michel Müller** are architects, teachers and researchers based in Frankfurt. Their work is focused on experimental art institutions such as the Bockenheimer Depot Theater in Frankfurt (with William Forsythe), Unitednationsplaza (with Anton Vidokle), the European Kunsthalle, the Cybermohalla Hub in Delhi, and, currently, a studio structure for 'The Land' in Chiang Mai (Thailand).

**Denis Isaia** is a curator based in Bolzano.

**I. Helen Jilavu** is an artist based in Germany, founded and co-curates with Erik Schmelz the Moguntia Projekt and the China Project, short-term, site-specific exhibition places for different works of art. She has worked together with andcompany&Co. on a number

of performances and audiovisual installations including photography, sound and text.

**Hiwa K** is an Iraqi artist based on his feet.

**Lakhmi Chand Kohli** is a writer based in Delhi.

**Anders Kreuger** is a curator and writer. He is Director of the Malmö Art Academy, Exhibition Curator at Lunds konsthall and member of the Programme Team for the European Kunsthalle in Cologne.

**Reinhard Kropf** and **Siv Helene Stangeland** work as architects and artists. They run the architecture firm Helen & Hard and are based in Stavanger on the west coast of Norway.

**Ove Kvavik** is an artist based in Trondheim.

**J. Robert Lennon** is the author of six novels, including *Mailman* and *Castle* (forthcoming), and a short story collection, *Pieces For The Left Hand*. He lives in Ithaca, New York.

**Lawrence Liang** is a legal theorist and founder of the Alternative Law Forum.

**Charles Lim Li Yong** is an artist with useful skills for surviving at sea that he picked up during his former profession as a sailor. He was last hired to sail for the China Team in the America's Cup 2007. He currently works in a squash court building, with the help of 72-13 Theatreworks. He is the cofounder of tsunamii.net and p-10.

**Daníel Magnússon** is an artist based in Reykjavik.

**Teresa Margolles** is an artist based in Mexico City.

**Christien Meindertsma** is a designer, artist and writer based in Rotterdam. She runs the design studio These Flocks, and is the author of *Checked Baggage* and *Pig 05049*.

**Naeem Mohaiemen** is a multimedia artist based between Dhaka and New York City.

**Walter Niedermayr** is a photographer. He lives in Bolzano.

**Jorge Otero-Pailos** is a New York–based architect and theorist specialized in experimental forms of preservation. His projects and writings present a new vision of preservation as a powerful counter-cultural practice that creates alternative futures for our world heritage. He is Assistant Professor of Historic Preservation at Columbia University in New York, and founder and editor of the journal Future Anterior.

**Felix Padel** is a freelance anthropologist, writer and musician living on a mountain in Wales. He is co-author with Samarendra Das of an upcoming book about the political economy of the aluminium industry and its impact on the Indian state of Orissa.

**Professor Bad Trip** was a cult figure in the world of underground music and comics. Punk musician and artist, his psychedelic draw-ings and paintings circulated all over the world in magazines and political manifestos, on album covers and T-shirts. He died in 2006.

**Piratbyrån** is a group of theorists, artists, consultants, activists and pranksters, concerned with the impact of digital information abundance on the creation of cultural meaning and economies of urban life. They are based in Sweden and known for initiating The Pirate Bay, which also takes part in their Manifesta project.

**Raqs Media Collective** (Jeebesh Bagchi, Monica Narula and Shuddhabrata Sengupta) are artists based in New Delhi. They are curators of 'The Rest of Now' and co-curators of 'Scenarios' for Manifesta 7.

**Shveta Sarda** is a writer and translator based in Delhi.

**Jeffrey Schnapp** is Professor of Comparative Literature at Stanford University, where he occupies the Rosina Pierotti Chair in Italian Literature and directs the Stanford Humanities Lab.

**Kateřina Šedá** is an artist based in Brno–Líšeň and Prague. She uses provocative actions and the unlikely use of everyday materials to intervene creatively in the social life of the area where she lives.

**Meg Stuart** is a choreographer and dancer. Born in New Orleans in 1965, she now lives in Berlin and works in Brussels with her company, Damaged Goods. She has created over twenty works for the stage, and regularly collaborates with artists from the fields of video, plastic art, music, and dance.

**Ashok Sukumaran** studied architecture and art, and now carries out speculative technical and conceptual projects. He is a co-initiator of CAMP, a new platform for artistic activity based in Mumbai.

**Ravi Sundaram** is a writer and theorist and joint director of Sarai, Centre for the Study of Developing Societies in New Delhi. His work looks at the intersection of techno-cultures, globalization and the urban experience in contemporary India.

**Jörgen Svensson** is an artist based in Gothenburg.

**TEUFELSgroup** is a temporary, spontaneous ensemble interested in the 'fictional' architecture of the Teufelsberg in Berlin's Grunewald Forest.

**Jeet Thayil** is the author of four collections of poetry, most recently *English* (2003) and *These Errors are Correct* (2008), and one half of an experimental music duo, Sridhar/Thayil. He lives in Bangalore.

**Alexander Vaindorf** is an artist currently based in Stockholm. He was born in Odessa, Ukraine and grew up in Moscow in the former Soviet Union.

**Cédric Vincent** is a writer, art theorist and freelance anthropologist based in Paris.

**Darius Ziura** is a photographer and video artist based in Vilnius.

# ACKNOWLEDGMENTS

The images on pages 13–20 are from the Industrial Zone Department (folder 15.1.4) and the Public Works Photography Department of the Archive of the City of Bolzano, courtesy Archive of the City of Bolzano.

The images on pages 21, 47, 88 and 117 are from *Pig 05049* by Christien Meindertsma (Rotterdam: Flocks, 2007), courtesy of the author.

'Who owns the mountains?' by Felix Padel is adapted from his article 'Mining as a Fuel for War', *The Broken Rifle* 77 (February 2008), courtesy of the author.

Image on pages 28 and 30 courtesy of euratlas.com.

'Death on the Bypass' by Ravi Sundaram is from a chapter of his upcoming book, *After Media: Pirate Culture and Urban Life* (New York: Routledge, 2009).

'In Kabul Zoo, the Lion' by Jeet Thayil is from his poetry collection, *English* (New Delhi: Penguin Books India; New York: Rattapallax, 2004), courtesy of the author.

'Automobile Executed' (Lambda prints, 40cm x 60cm) by Teresa Margolles courtesy of the artist and Galerie Peter Kilchmann, Zurich.

Image on page 48 courtesy of Yves Netzhammer.

'Brevity' by J. Robert Lennon is from his *Pieces for the Left Hand* (London: Granta Books, 2005), courtesy of the author.

'Enthusiasts Speaking' by Neil Cummings and Marysia Lewandowska is drawn from an archive of conversations with amateur filmmakers recorded during research trips to Poland between 2002 and 2004. The full archive can be found at enthusiastsarchive.net

The images in 'Bildraum' by Walter Niedermayr are taken from a longer series of the same name made in 1992.

The image on page 94 is by Jorge Léon.

'The Romance of Caffeine and Aluminium' by Jeffrey Schnapp is extracted from his longer article of the same name originally published in *Critical Inquiry* 28, no. 1 (Autumn 2001), courtesy of the author.

'Industrial Ruins' by Tim Edensor is extracted from his book of the same name (Oxford: Berg, 2005), courtesy of the author.

*'The Nine Gardens in the Bank of Norway'* by Ingrid Book & Carina Hedén is taken from the series *The Nine Gardens in the Bank of Norway 1–19* (Cibachrome, 63cm x 77cm) shown in 'Temporary Utopias' (Museum of Contemporary Art, Oslo, 2003).

'The Pirate Bay Manifesto' on page 133 is adapted from 'Four Shreddings and a Funeral' (piratbyran.org/walpurgis).

# THE SOUL,
# OR, MUCH
# TROUBLE IN THE
# TRANSPORTATION
# OF SOULS

**EDITED BY**
**ANSELM FRANKE,**
**HILA PELEG**
AND AVI PITCHON

# PREFACE
# ANSELM FRANKE
# AND HILA PELEG

This chapter of the Manifesta 7 companion book corresponds to the exhibition 'The Soul—Or, Much Trouble in the Transportation of Souls' in the Pallazzo delle Poste in Trento. We have chosen the soul as a theme against the backdrop of Trento, whose role as host city for the Council of Trent,[1] which articulated central conceptions of just what a 'soul' is in early modernity, readily provided a context for our enterprise. We didn't intend to invent a new paradigm, but rather draw new connections between existing ideas and practices, and situate them in a speculative historical context. It also wasn't our intention to enter a debate on moral principles, or to suggest our own interpretation of the soul. What interested us was a history leading to the particular carrier of the soul that provided the grounds for the formation of the modern subject, and what we have come to regard as the 'inner world', the individual 'interior'.

The history of the concept of the soul is surely too complex to be recounted within this restricted frame. We thus focus on a few specific aspects of this history, and leave the rest to all that has been said already, to further exegesis, or preferably, to the imagination.

The soul has seemingly always and everywhere been conceived as a life-affirming principle, as the movement that makes all other motion possible, the movements of sensation, emotion and consciousness. More specifically, the soul attracted us as an elusive center of European discourse, in which 'life' itself is at stake, and from which many of its formative dualisms seem to spring. The soul is a border concept. The borders in which it partakes are not the physical-political borders of present-day Europe, but surely no less significant. They are the borders that determine the limits of sociality, of normality and morality—borders whose establishment and reinforcement are the fundamental manifestations of power, linked to the changing techniques of the 'governance of souls', and moreover, the individual internalization of power and rule. These borders are not natural, not a given. And merely understanding them as historical or social constructions is equally insufficient, as it fails to account for the specific ways in which they become naturalized, implicated and operative.

---

1. The Council of Trent (1545–1563), in forging the Catholic response to the Protestant Reformation and clarifying Catholic doctrines, especially the use of the sacraments, is widely regarded as one of the most important events at the outset of modernity.

The duality in which the soul in Europe has been inscribed is that of morality. The border drawn between good and evil cuts right through each soul, parting it to a 'bright' and a 'dark' side. The Christian doctrine entangles each soul in a heroic struggle, its final salvation depending on the defeat of the forces and temptations of evil, of its own 'dark side'. This defeat is possible only through self-negation (and subsequent self-transformation), as the temptations of evil are immanent to each desiring soul. Europe's battle over the soul takes place in the frontline of the 'inner self', which is literally 'brought to see the light' by way of the knowledge of the church. A key in this implication of the 'inner self' is the ritual of confession.

In Trento, the scope of the confession was further expanded to include latent thoughts and imaginations, the 'sins' one had merely desired or fantasized—thus marking the beginning of the modern colonization of the imaginary. From the inner monologue to public speech—the self, the modern individual, exists only insofar as it can confess, insofar as it can be told and spoken out in an act of self-revelation, be objectified and verbalized. The modern subject is formed through the ritual of the continuous labor of explicating (and thus negating) all that latently remains hidden in the darkness of the soul.

In the course of its modern exploration, the soul has never been contained by positivist science, never entirely 'pinned down', its objective reality or nature never completely determined in rational-objectivist terms. Metaphor of all metaphors, this centre of intelligibility has remained ultimately elusive, fuelling the assumption that it might never have been more than fiction. In the course of the Enlightenment and in the wake of rationalist science, the soul became synonymous with the opposition, the 'other', the negation of the enlightened world.

Negation is deprived of a 'proper' language, dwelling in broken syntax, in nonsense, in the displaced jargon of symptoms, and in the imagery with which the negative is mediated and its concrete content signified. The witch-hunt, phantasmagorias of the devil, the psychodrama of exorcisms, the demonic fable, and performances of possession all made up the scenography of negation in the aftermath of the Council of Trent.

The world of the Enlightenment appeared as composed of rationalized, 'positive' facts and a (troubled and troubling) 'subjective rest'. In the so-called disciplinary age, (which corresponds to the heyday of rationalist science), this troubling 'subjective rest' symbolized all that seemingly opposed the course of modernity—the unreality of the imagination and fantasy, the irrationality of emotions, femininity, infantility, madness or savagery, all corresponding to the concrete histories of colonialism, gender, mental health and so forth.

Attempts at reanimating the repressed or excluded contents of the soul surfaced first in romanticism. Romanticism triggered a reconstructive rehabilitation of the subjective soul and its long-dismissed faculties, beginning in the late nineteenth century. The next phase is perhaps most powerfully manifest in Freud's 'discovery' of the unconscious. And only once the subject's soul had entered reality again 'in its own right', the true exploration and colonization of the interior began—together with the 'great system of tests' (Walter Benjamin) by means of which the psyche was measured and objectified in the twentieth century.

Today, the subjective side of things is seemingly no longer a threat to the domi-
nant order, but one of its major productive drives. The subject's faculties are
no longer repressed and disciplined to confirm a rationalist-objectivist order, but
advertised as the true productive forces of the contemporary world—an individu-
alized, individually conditioned world, whose character depends on subjective
attitude, in increasingly more privatized mirror-relationships. As the old saying
goes, the way one shouts into the forest determines the reply. Consequently,
utopian energies are no longer directed towards a change of external circum-
stances, but have largely turned into a call for the transformation of the self. This
powerful ideological interpellation could be termed the 'transformative impera-
tive'. As the new saying goes, you can't change the world unless you change
yourself. The means to change the world are changing one's perception of it and
attitude towards it. This shift has profoundly altered all forms of resistance,
whether individual or collective.

Operating as an entire ideological formation, this imperative accounts for an
unprecedented revival of all that is 'soul-oriented'—visible within a PR-based
(political) economy and in the conditioned environments of corporatism and
consumerism. This formation uses the soul (explicitly or implicitly) in order to
mask itself as natural, and to profit from the individualistic tradition wherein self-
realization is associated with autonomy from subordination. The individual traits
of motion, emotion, sensation, the liberating potential of the imagination, have
all become the new fetishes of marketing and lifestyle. This call to self-transfor-
mation embodies the most powerful contemporary ideological core of the
present regimes of power. It is so powerful because of its historical depth, its
borrowings from the mythical contents of (European) history.

In appropriating a good deal of the critical and emancipatory discourse of
the past, the latent ideological formation according to which subjective power is
unlimited in its capacity for transforming the world marks a decisive rupture in
the continuity of oppositional struggles. The language of negation is now inte-
grated and embraced as a component of self-realization, voluntarily or involun-
tarily. The ability to say no and what saying no means, and therefore the condi-
tions of resistance, are rewritten. Our appeal to the soul is therefore ultimately
targeted at activating a continuity of negativity at a moment when this continuity
seems most endangered, when to present-day struggles it seems to be lost.

Speaking of the soul today means to develop a sensitivity for the way the im-
perative for self-transformation turns into a contemporary willingness to con-
form. It means to observe how the language of possibility has come to mask
impossibility, for which no language, no vocabulary is available anymore.

The exhibition 'The Soul' emphasizes aesthetic strategies that are targeted at
making the normalized background conditions in which the self performs itself
today explicit, manifest or externalized. It is a theatrical exhibition—a space for
transformation and make-believe, where the artificiality of emotions is celebrated
and the social relations like the apparatuses that produce them are exposed.
Our desire is that the exhibition will unfold the history of negativity as it surfaces
fleetingly in the history of the soul. In its context and space, impossible forms
of social and historical mobility will become thinkable, as the actor replaces the

proper individual, masquerade replaces stable identity and the negative energy needed to keep hegemony and its symbolic order in place bursts forth.

The reader before you contains an idiosyncratic selection of original contributions. It was first and foremost important for us to position the project within the intellectual landscape and heritage of the Italian present and recent past. We have invited Franco Berardi, one of the protagonists of the Autonomia movement from Bologna, to contribute an elaborate response to our proposition and focus on present-day Italy. Sociologist Maurizio Lazzarato from the Paris-based magazine *Multitudes* contributes an instructive text on the relation between 'soul' and 'subjectivity' in the history of modernity, from the Catholic Council of Trent to the present. Lazzarato uses Michel Foucault's analysis of the 'government of souls' and the genealogy of 'pastoral power' as his conceptual backdrop—components that with the practice of confession at their center do not, according to Foucault, legitimize the notion of a radical rupture between modern and premodern consciousness.

Philosopher and legal scholar Renata Salecl contributes a text which further deepens the contemporary analysis of 'psychic power'. Salecl analyses the complex if not paradoxical status of (social) prohibitions in the context of what she calls the 'tyranny of choice', applying Lacanian psychoanalytical methods as well as Walter Benjamin's analysis of commodity culture.

Eva Meyer has in the past explored the realm of language, in the context of what she calls 'free and indirect speech'—a modality in which one becomes a medium of language, in which an exteriorized language begins to work on its own, refusing to inhabit a single consciousness, and instead partaking in consciousness as such. For this reader, Meyer uses the novel *The Robber* by Swiss writer Robert Walser as the backdrop of an investigation into the relation between soul, world and narration. Walser's own work is characterized by deep mistrust in the epistemological validity of the 'self' (the 'individual me is only a zero'), and in the creation of a coherent world by means of characters, narrators or the causal linkage of events.

All other texts have been developed in correspondence to contributions to the exhibition—but here, they exist in their own right, not to be mistaken as catalogue representations. Architect and writer Eyal Weizman's chapter is a theoretical inquiry into the concept of the 'lesser evil'—the principle according to which differing levels of evil or suffering can be measured and calculated against one another, in situations in which an 'ideal choice' seems impossible. The principle of the lesser evil, as Weizman shows, has not only become the dominant political and ethical rationality; it further poses the question of complicity, of affirmation or negation of a 'given' situation, of one's ability or inability to act positively within intolerable structures. The lesser evil also opens up yet another window on the continuous presence of theological concepts and histories in present-day reality. An installation of the same title and topic is to be found in the exhibition.

Tom Holert, known predominantly as a writer and critic, also contributes a work to the exhibition (in collaboration with Claudia Honecker), a visual essay that takes its cue from a montage of two characters set against one another,

both having their origins in the Trentino region—the neuropsychiatrist Beppino Disertori and the architect Adalberto Libera. Holert contributed an essay in the form of an expanded collection of notes and quotations relating to and positioning his research, which add up to a multifaceted reflection on the relation between architecture, politics and the 'interior'—the nervous system in relation to the psychology of space.

We have in addition invited five scholars, intellectuals and artists to conceive 'miniature museums' for the exhibition, each following a specific concept relating to the history of interiority or the soul. Three of the mini-museum curators provide extended notes on their contributions: anthropologist Michael Taussig, who, together with Maria Thereza Alves and Jimmie Durham curated the 'Museum of European Normality', takes us on a historical journey through the 'never-understood soul' as the realm of fantastic transformations and metaphorizations, perhaps the logic of the imaginary, and concludes with a motif from Friedrich Nietzsche, articulating the irresolvable interdependency of depth and surface.

Walter Benjamin is at the center of the historical exploration contributed to this publication by art historian Brigid Doherty, also corresponding directly to her curation of one of the miniature museums—the 'Museum of Learning Things'. 'Learning Things' unfolds a panorama of the influence of certain forms of didactic imagery, in which a specific, subtle investigation of interiority and exteriority, examined through the conditioning of empathy and perception in relation to *things*, is at stake. The essay takes its cue from a short text by Walter Benjamin entitled 'Dream Kitsch', which is also reproduced here.

Florian Schneider, filmmaker, activist and writer, contributes the 'Museum of the Stealing of Souls' to the exhibition and the corresponding text to this compilation, perhaps best termed a manifesto on the present-day status of images in an image-based economy. He opens by discussing the famous, persistent myth that the camera steals the soul. A key question for him is the large number of modern political and artistic movements, both reactionary and libertarian, that have implicitly or explicitly referred to or reenacted this myth, and employed a similar structure of argument based on an assumed soul-theft or related motifs—disenchantment, reification, zombification—whether through capitalism or technocratic modernity in general. The text also opens up the more general question: What is the relation between an image and the soul? Schneider's text touches upon the complex relationship of one's soul and the image of the self.

Anne-Mie van Kerckhoven contributed an interview that was conducted with her in the course of a research project at the Catholic University of Leuven by psychologists Géry d'Ydewalle and Johan Wagemans. The conversation takes a detailed look at the process of the creation of van Kerckhoven's drawings, also referred to as 'mind maps', and through which associative principles come to the fore.

Our co-editor for the present collection, writer Avi Pitchon, has conducted three interviews with participating artists—Angela Melitopoulos, Barbara Visser, and Roee Rosen. Departing from their individual contributions to the exhibition, these provide an insight into the variety of references and attitudes with which they have responded to our proposition, and the means by which they

position themselves within this project in relation to their larger practice. Barbara Visser, whose past work often explores the psychological structure of meaning and the pitfalls of communication, talks about her interest in the relation between the architect of the exhibition's site, rationalist Angiolo Mazzoni, and futurist artist Fortunato Depero, as an exemplary case study for the entanglement of artists in political movements. Roee Rosen answers questions about the multiple references in his work that—implicitly or explicitly—relate to European history and its internal *otherness*. The interview with Angela Melitopoulos hits upon yet another central question—that of mediality and autonomy. Conditions of mediality (as depicted in Melitpoulos' video *The Language of Things*) in people's momentary experience of immediacy and ecstasy in the accelerating machine in an amusement park represents in Melitopoulos' description a being in the language of technology.

In 'mediality', the binary oppositions of the soul, inside and outside, subject and object, 'inner man' and external world release their dialectical tension as they collapse into one. To find in the resulting immanence not prosthetic reconciliation (as the conditioned environments and image-worlds of capitalist culture do), but the field of potential agency and a relative autonomy is where the concerns of these texts, and indeed the exhibition, ultimately converge.

# BERLUSCONI, HUMPTY DUMPTY AND UBU ROI
## FRANCO BERARDI

## PROLOGUE

'When I use a word it means just what I want it to mean—neither more nor less... The question is, which [meaning] is to be master—that's all'. So says Lewis Carroll's Humpty Dumpty, recognizing straightaway, like a good master, that when you ask words to do overtime, you have to pay them more.

And Deleuze, who refers to Humpty Dumpty in the third series of *Logic of Sense*, titled 'On the Proposition', comments: 'The last resort seems to be that which identifies meaning with signification'. Not sense, but the activity of producing meaning through the innumerable shifts and slides that this process involves. This is also said by Greimas in his book, *On Sense*.

In order to speak of the Italian *derive*[1] of the last fifteen years we begin from a semiotic of transgression and of sliding.

Derive. The priggish fear this expression because they don't know where it will take them. But life is like that: you never know where it can take you. Life is a derive, history is a derive. Those who think that we can take refuge from the contingencies of the drift cannot act successfully politically. This is because they believe that the word is linked to its semantic referents and are deluded that law and order safeguard the unpredictable.

For a good political practice society must defend its autonomy from the predatory instincts of capitalism, and to do this it is not necessary to believe in law, but only in the force of society itself. In the course of the twentieth century social autonomy often had to surrender to the hegemony of left politics, whether Leninist social democracy or reformism. In all of its forms, the left was an extremely bad ally. When seizing power, as ever, it used violence against society. Or, in its legalist reformist version, it forced a subaltern social autonomy to endure the laws of capital. Finally, the French, Italian and British elections of 2007–

---

1. 'One of the basic situationist practices is the dérive [literally: "drifting"], a technique of rapid passage through varied ambiances. Dérives involve playful-constructive behavior and awareness of psychogeographical effects, and are thus quite different from the classic notions of journey or stroll. In a dérive one or more persons during a certain period drop their relations, their work and leisure activities, and all their other usual motives for movement and action, and let themselves be drawn by the attractions of the terrain and the encounters they find there. Chance is a less important factor in this activity than one might think: from a dérive point of view cities have psychogeographical contours, with constant currents, fixed points and vortexes that strongly discourage entry into or exit from certain zones'. Guy Debord, 'Theory of derive' (1956), http://library.nothingness.org/articles/all/all/display/314. (Translators' note)

2008 erased the left from the geopolitical map. Today, social autonomy finds itself alone, and finally it can find its own way without fear of it being a drift.

*La Derive* is the title of a book by two Italian journalists who strive to dress an indecent world in underwear. In the book they lament the tendency of the country to slide into decline, recession, disunity. But who said that decline is a bad thing, recession a disgrace, and the end of national unity a danger to be conjured away?

The word 'derive' scares those who believe politics must respect a set of rules and that law must be at the centre of social life, like those who think that words have one meaning and only that, and that to understand one another in life it is necessary to use words according to their established meaning. All wrong. When we speak we do not respect the meanings of words but invent them. Understanding is not the exchange of signs supplied with a univocal referent. To understand is to follow the slides in the relations between signs and referent, reinventing signs as functions of new referents and creating new referents by circulating new signs. Similarly politics does not have to respect any one law because it invents the law when it creates new relations.

Following order is a good thing, but politics cannot be reduced to this, because there is no rule that says rules must be respected. Berlusconi understood this, and won all he could possibly win. The left did not understand it and finally vanished, to leave space, let's hope, for a new social autonomy capable of inventing new words, new referents and above all, new forms of relations.

# THE EGG AND THE SERPENT

In a film of 1977 titled *The Egg and the Serpent*, Ingmar Bergman recounts the development of Nazism in Germany in the 1920s as a psychic poisoning of social space, as an infiltration of a venomous substance in the environment of the relations of daily life. Bergman, who has often dealt with the theme of alienation as psychic suffering, the silent pain of the soul and incommunicability, proposes a materialist vision of a monstrous chemical mutation that Nazism provokes in the psychical and social sphere.

*The Egg and the Serpent* is not one of the best films by the Swedish director, but it is interesting from the point of view of the coming culture of late modernity, because it recounts the development of totalitarianism from the point of view of a psycho-physical pollution. Social malaise is in the first place a disturbance of communication.

With *The Egg and the Serpent* Bergman rethinks the question of incommunicability dear to existentialist thought: communication between Ullmann and Carradine is progressively poisoned because a toxic substance enters into their nostrils and lungs and therefore into their brains. Thus, in a crowd scene of slow, hypnotic movements, Nazism transforms the social mass into an amorphous mass, deprived of their own will and ready to be led. The metaphor of a psychic submission, beyond the example of German Nazism, is a valid one to characterize processes of the pollution of the collective mind, like communism, television advertising, the

production of aggression, religious fundamentalism, and competitive conformism.

In the film Bergman spoke of a future which today, in the new millennium, is the present. Daily, the poisoning was carried out in our houses by a nerve gas that acts on the psyche, on sensibility, on language, producing an effect of interminable info-productive stimulation, of competitive mobilization of energy, as well as panic and depressive crises. Liberal economism has produced mutations of the organism more profound than those of Nazism, because they do not act on superficial forms of behaviour but on the biological, cognitive dowry, on the chemical composition of the psychosphere.

On 25 December 1977 Charlie Chaplin died; the man with the bowler hat who recounted the dehumanization of modern industrialism from the point of view of a humanity that still knew how to be human. There was no longer any place for kindness. *Saturday Night Fever* came out at the cinema in those months of autumn, presenting a new race of workers, happy to be exploited for the whole week as long as they could gel their hair on a Saturday night and win over the dance floor.

In Japan, 1977 was the year of youth suicides: they numbered 784, and the quick succession of a chain of juvenile suicides among primary school children—thirteen in the month of October alone—provoked great consternation.

The year 1977 was a turning point in the history of modernity, the year in which the perspective of the posthuman took shape. The generation that grew up in the 1980s was destined to be the first video-electronic generation, the first formed in an environment where mediatization prevailed over contact between human bodies. In the cultural styles and aesthetics of the following decades we witnessed a process of purification, of de-carnalization—the beginning of a long process of cultural sterilization in which the first video-electronic generation was formed as both object and subject. Cleanliness substituted for dust; the hairless took the place of the hirsute.

During the following decade the dangerous epidemic of AIDS semiotized the entire field of corporeality. Carnal contact carried danger and electricity, stigmatizing, petrifying or overheating in a pathological manner. This is how, in the last two decades of the twentieth century, a cognitive mutation was performed. The organism became sensitized to the code and thus prepared for connection, the permanent interfacing with the digital universe.

Sensibility—not reason—perceived this mutation, and reacted with an exercise of self-destructive craziness of which heroin was the clearest signal. The existential and artistic experience of the American No Wave, of London punk and the German and Italian autonomist movements signalled a final awakening of consciousness in the face of the mutation in the sensible sphere and in the collective psyche, in the face of this pollution of the soul and the following deanimation of the body.

In Italy the year 1977 is remembered for the explosion of a movement that created for the first time in communication the primary terrain of its own expression. It was the year of Radio Alice, the first free Italian station, which broke the state domination over systems of communication. But 1977 was also the year in which, thanks to the smashing of the state monopoly, a private group called Fin-

invest, led by the man who got rich with financial help the origins of which could never be established, embarked on the enterprise of commercial television. To the collective liberation of communication, of which the movement of students and Radio Alice had been the bearers, replied the privatization and commercialization of communication systems. It was the beginning of a transformation of which today, thirty years later, we can measure the full significance.

## ▌▌ IN THE REALM OF THE ALEATORY

One night in October 1977, whilst the fires of the student riots were dying out, Silvio Berlusconi met Mike Buongiorno, a man who had featured on the screen since the beginning of Italian television. They dined together in a Milan restaurant, and out of their simple minds an extraordinary linguistic machine was born, capable of a mutagenetic biopolitical penetration of the Italian brain. Since then Berlusconi's capital has operated in a perfectly recombinatory manner: having built its financial base on estates, it invested in advertising, insurance, football and television. To put this enormous conglomerate into motion, Silvio Berlusconi, who was a member of the secret society P2 and friends with characters who reeked of the mafia such as Marcello Dell'Utri, violated many of the laws of the Italian Republic: cooking the books, corruption of judges, conflicts of interest. For twenty years he outmanoeuvred magistrates, journalists and institutions that accused him of breaking the law. But what is the law? A linguistic effect that dissolves as common sense changes. And in three decades, common sense has changed because Berlusconi's mediatic machine has inoculated linguistic substances in perfect doses to produce white noise.

Far from being a backward, transitory anomaly, since the 80s and 90s the Berlusconi phenomenon has been a sign for a time to come—actually, a time that has now come. In this time an infrastructure of the engineering of the psychosphere was constituted that was capable of modulating the public mood and of producing opinion, but above all, capable of destroying psychic sensibility and the empathetic sociability of the new generations, who are induced to mistake the uninterrupted flow of television for 'the world'.

Contemporary capitalism can be defined as semiocapitalism, because the general shape of commodities has a semiotic character and the process of production is increasingly the elaboration of sign-information. In the sphere of semiocapital, economic production is increasingly tightly interwoven with processes of linguistic exchange, as is explained clearly in the books of Christian Marazzi and Paolo Virno.

Thanks to language we can create shared worlds, formulate ambiguous enunciations, elaborate metaphors, simulate events or simply lie. Semioeconomics is the creation of worlds, castles of metaphors, imagination, predictions, simulations and fabrications. What country besides the one that gave us *commedia dell'arte* could better insert itself in a productive system based on chatter, spectacle and exhibition?

The Fordist industrial economy was founded on the production of objectively

measurable value quantifiable by socially necessary labour time. The postindustrial economy is based on linguistic exchange, on the value of simulation. This simulation becomes the decisive element in the determination of value. And when simulation becomes central to the productive process, the lie, the deceit, the fraud enter to play a part in economic life, not as exceptional transgressions of the norm but as laws of production and exchange.

In the sphere of semiocapital the laws in force do not resemble the laws of the glorious epoch of industry, the relations do not resemble those of the productive discipline, the ethics of work or the enterprise that dominated the world of classical industrial capitalism, the Protestant capitalism that Michel Albert dubs 'of the Rhine'. A deep transformation took place in the last few decades, starting with the separation of the financial circuit from the real economy.

The founding act of this process of separation was Nixon's arbitrary decision to abandon the system established at Bretton Woods. In 1971, the American president decided to rescind the rules on the convertibility of the dollar into gold and to thus affirm the self-referentiality of the American standard. Despite the implications of Vietnam, at this time American power still had credibility and the strength to impose its decisions as if they were objective and incontrovertible. Today that power and credibility have dissolved, the value of the dollar has fallen, and the economy of simulation has thus entered into a phase of instability.

From the moment when Nixon told the world of the decision to unhook the dollar from every gauge of objectivity, money fully became what it already was in essence: a pure act of language. No longer a referential sign that relates to a mass of commodities, to a quantity of gold, or to some other objective data, money now relates to a factor of simulation, an agent capable of putting into motion arbitrary processes independent of the real economy. Therefore semiocapital is a system of complete indeterminacy: financialization and immaterialization have brought to the relations between social actors unpredictability and chance elements never seen before in the history of the industrial economy.

In Fordist industrial production, the determination of the value of a commodity was founded on a certain factor: the socially necessary labour time to produce that commodity. But in semiocapitalism this is no longer true. When the main feature of commodity production is cognitive labour, the labour of attention, memory, language and imagination, the criteria of value are no longer objective and cannot be quantified on the basis of a fixed referent. Labour time has ceased to count as the absolute touchstone.

Under aleatory conditions of referents, arbitrariness becomes the law: the lies, the violence, the corruption are no longer marginal offshoots of economic life, but tend to become the alpha and omega of the daily management of affairs. Bands of criminals decisively take over the place of command. Economic power belongs to those who possess more powerful language machines. The government of the mediascape, predominance in the production of software, and control over financial information: these are the foundations of economic power. And the domination of these sources of power cannot be established by means of the dear old competition where the best possible management of available resources wins, but rather through lies, deceit and war. There is no longer any eco-

nomic power that is not criminal, that does not violate fundamental human rights—first and foremost the right to education, self-knowledge, and the right to an unpolluted infosphere.

## ▇▇▇
## THE SOUL AT WORK

In the sphere of semiocapital, the soul is put to work. I use the word 'soul' not at all in a spiritualist sense, but to mean a condition of possibility for the happiness and unhappiness of the body as well as the condition of possibility for productive action, social action. What the body is capable of is its soul.

Foucault recounts the history of modernity as the discipline of the body, as the construction of institutions and devices capable of subduing the body into the machine of social production. In this manner he describes the process of subjectivation that accompanies the development of industrial society. Exploitation in industrial society concerns the body, the muscles, and the arms. But these bodies would be worthless if they were not mobile, intelligent, reactive—animated. In the current epoch exploitation is exercised essentially on the semiotic flow that the time of human labour is capable of emanating. No longer animated bodies but the soul itself becomes the object of economic exploitation.

To continue the genealogical work of Michel Foucault today means directing our theoretical attention to the strategies and methods of the programming of language, towards the automatization of mental responses, because through them the mental labour of the web is disciplined.

Digital production is essentially semiotic 'emanation'. The essential biosocial innovation of the last decades is the bioinformatic network made possible by digitalization. But the insertion of this network into inter-human linguistic circulation produces effects in subjectivity that involve the soul, the mind that feels itself.

The acceleration of the infosphere involves a change in the velocity of linguistic elaboration and existential rhythm: it concerns a real and proper process of reformatting the human brain with psychopathological effects. The explosion of the psychopharmacological sector and the explosion of the market for drugs are naturally two essential functions of this mutation.

The frenzy let loose in the 90s in finance, consumerism and lifestyles was also due to the systematic use of euphoric drugs and substances for neuroprogramming. The stimulation of the soul was an integral part of the economic expansion founded on the virtual economy. A major section of the population of every country in the world began to be put through an uninterrupted nervous hyperexcitation, up to the point of the collapse evoked in the metropolitan legend of the millennium bug, conjured up as an exorcism and symbol for the expectation—as we waited for midnight on the last day of 1999—of an apocalypse that never came.

Once the phantasmagoric danger of the millennium bug faded away, and everyone breathed a sigh of relief, the real collapse arrived: the crisis in the financial sector of dot-com shares in April 2000. The collective psyche of the 'new economy' had already sensed that crisis was approaching. In 1999 Alan Greenspan had spoken of the 'irrational exuberance of the markets', his words suggest-

ing a clinical rather than a financial diagnosis. The exuberance was an effect of drugs, of the nervous breakdown of a generation of cognitive workers, of the saturation of attention that led it to the limits of panic.

The year 2000 saw the start of the Prozac crash. The beginning of the new millennium saw a glorified megafusion: AOL and Time Warner united their tentacles to meticulously innervate the planetary mind. In the following months the telecoms of Europe invested massive sums in the Universal Mobile Telecommunications System (UMTS). These were the last blows before the crisis that engulfed Worldcom, Enron and entire sectors of the net economy. The financial crash was the manifestation of a psychic collapse that involved an army of cognitive workers increasingly strongly affected by stress-related psychoses.

The apocalypse that was missed on New Year's Eve 1999 arrived one morning in September twenty-one months later. Like all apocalypses, that day revealed a new world. All of a sudden we realized that the world was ridden with war machines at every corner, and that the whole ethical and political universe known as modern humanist universalism was dissolved, annihilated and destroyed.

# IV
## THE ITALIAN ANOMALY

Providing a definition of the regime that was established in Italy in 1994—the year of the first victory of Forza Italia (the TV–football party)—is more than a question of naming. Like other periods in the history of Italy in the twentieth century, the years of Berlusconi are indicative of an Italian anomaly and functioned as a laboratory for experimentation with social trends. Other moments in history when Italy was the laboratory of new tendencies were 1922—when techniques of populist and totalitarian management were experimented with under the appellation of fascism—and the 1970s.

In the 1970s an anomalous though exemplary situation arose: the student movement of 1968 gave rise to a long period of social insubordination and autonomy from work that changed the whole of society. Power responded to this social autonomy by developing an authoritarian and closed system founded on an alliance between the main churches in the country: Catholicism and Stalinism. This was the period of the historic compromise and of the judiciary repression of dissent. The political closure of this regime and the repression of grass-roots movements resulted in a strengthening of armed factions and fed into a wave of terrorism that culminated in the kidnapping and killing of Aldo Moro. But what is the Italian anomaly today, and in what sense is Italy a laboratory of new forms of power? Are we confronted with a reinstatement of Mussolini's regime, as many events in Italian politics seem to suggest?

The answer is no: this is not a fascist regime. This regime is not founded on the repression of dissent; nor does it rest on the enforcement of silence. On the contrary, it relies on the proliferation of chatter, the irrelevance of opinion and discourse, and on making thought, dissent and critique banal and ridiculous. Even though there have been and will continue to be instances of censorship and direct repression of critical and free thought, these phenomena are rather

marginal when compared to what is essentially an immense informational over-load and an actual siege of attention, paralleled by an occupation of the sources of information operated by the head of the company.

The present social composition cannot be assimilated to that of Italy in the 1920s, which was predominantly comprised of peasant and country folk. In the first decades of the twentieth century, the futurist modernism of fascists intro-duced an element of innovation and social progress, whereas today the regime of Forza Italia carries no germ of progress and its political economy is based on the dilapidation of the patrimony accumulated in the past. Whilst fascism initiat-ed a process of modernization of production in the country, the regime of Forza Italia wasted the resources accumulated in the years of industrial development, like Carlos Menem in Argentina during the decade that preceded the collapse of its economy and society. This drive to dissipation and waste is in perfect harmo-ny with the main tendency of the planet in the period of neoliberal indeterminacy.

To understand the specific character of the Italian situation of the past four-teen years, we need to look for what differentiated it from the rest of Europe throughout modernity, while also considering the postmodern peculiarity of the Italian transformation in the wider context of a change investing the system of production and the global infosphere. To grasp this specificity we would begin with the Counter-Reformation, which sanctioned the differential speeds of the advancement of the Christian world towards the colonization of the earth and the construction of modern bourgeois capitalism. The temporality of the coun-tries invested by the Counter-Reformation (Italy, Spain, Austria, and Poland) is different from that of Protestant countries.

# V
## THE COUNTER-REFORMATION AND THE ITALIAN SPECIFICITY

According to Max Weber, classical industrial development is sustained by the Protestant mentality. After the Protestant Reformation, the European bourgeoisie was able to build the foundations of its power by subjecting itself to a rigid ethi-cal and existential discipline. The bourgeoisie assumes responsibility for its ac-tions and is accountable for them before men and God, but most of all before the bank manager. Economic fortune is a worldly confirmation of divine benevolence.

On the contrary, with the Council of Trent (1545–1563) the Catholic Counter-Reformation reinstated the primacy of the religious over the secular realm and defended the conviction that respecting the ecclesiastic hierarchy is much more important than productive discipline. The deep substratum of Catholic culture re-sists productivity and bourgeois efficiency. Whereas Calvinism was based on the observance of the law, the spirit of the Counter-Reformation reinforced the pri-macy of mercy and the absolute value of repentance. The Counter-Reformation remained deeply engrained in the Italian social imaginary throughout modernity and manifested itself in all its reactionary force at decisive moments in the life of the country. During the Neapolitan revolution of 1799, the enlightened bourgeoi-sie was isolated and defeated thanks to the complicity of the people with the

power of the Bourbon House, the Church's ally. From the 1800s onwards, the alliance of the Church with the rural classes acted as an antibourgeois conservative force in the defence of the cultural hegemony of the Church against all attempts at laicization of national life. In the years that followed the Second World War, the Christian Democrats were the dominant political force, representing the mediation in a permanent equilibrium between capitalist modernization and populist and reactionary resistance. However, it would be wrong to see the 'laxness' that derives from the spirit of the Counter-Reformation as a purely regressive and conservative energy.

In the 1970s, 'the Italian anomaly' was the expression used to underline the peculiarity of a country where the social movements that had been exhausted in 1968 continued to dominate the political scene for over a decade. In the 1970s, the workers' resistance produced structures of mass organization and fuelled revolts against capitalist modernization. At the time, the Italian anomaly consisted in the persistence of workers' autonomy and social conflict. Italy underwent a long season of proletarian struggles that embraced antimodernism in a dynamic and paradoxically progressive way.

This process began in July 1960, when workers in many cities rose up against the attempt to form a centre-right government that included men linked to the old fascist regime, and culminated in the antiauthoritarian and libertarian insurrection of 1977. During the autonomous workers' struggles against the patronage of the government in cities and factories, we find a constant and recurring element: the refusal of the subordination of life to work. This refusal was manifest in a manifold of different ways: first of all as Mediterranean idleness, the privileging of sensuality and solar life over productivity and the economy. Then it was expressed in the workers' and the youth's revolts against the rhythms of the factory, and in the endemic absenteeism and the workers' disaffection with their labour. The movement of workers' autonomy that flourished from 1967 to 1977 sums up this attitude of insubordination and resistance in the formula 'refusal of labour'.

The notion of refusal of labour, as it was adopted in Italy during the 1970s, was inserted in the framework of a progressive political strategy. Workers refused the effort and repetitiveness of mechanical labour, thus forcing companies to keep restructuring. Workers' resistance was an element of human progress and freedom, as well as an accelerator of technological and organizational development.

# VI
## SHIRKERS

At the origin of the mass refusal of productive discipline lies an anti-Calvinist culture. Contrary to the Protestant idea of progress as founded on work discipline, the autonomous anti-work spirit claims that progress—be it technological, cultural or social—is based on the refusal of discipline. Progress consists of the application of intelligence to the reduction of effort and dependency, and the expansion of a sphere of idleness and individual freedom.

The technological, social and cultural progress of the country was stimulated by this refusal of labour, and between the 60s and 70s Italian civil society experienced the only authentically democratic period of an extraordinary flourishing of culture, concomitant to when the refusal of labour was most intense and heightened by the level of absenteeism in the factories.

Obviously, the refusal of capitalist exploitation, the opposition to increases in productivity and to workers' subordination were not peculiar to Italy. All around the world workers demanded wage increases and more free time for their lives, and opposed the masters' will to subordinate life to work and work to profit. However, in Italy this insubordination joined the shirkers' spirit of the southern plebs to become an explicit, declared and politically relevant issue: that is, the refusal of labour and the demand for social autonomy, the autonomy of everyday life from work discipline.

Towards the end of the 70s, tens of thousands of young southerners arrived at the Fiat factory Mirafiori. With their new forms of struggle and anti-work attitude, they carried an extremism that was a danger to both the progressive bourgeoisie and the Italian Communist Party. This new draft of workers completely ignored, if not derided, the work ethic and pride in productivity.

Did these young workers from Naples and Calabria embody the same rascal spirit, the individualist and antimodernist populism, that characterized 1799 and led the Neapolitan people to oppose the revolutionary enlightened bourgeoisie? Yes, in part. But this shirkers' spirit also expressed the new realization that the society of industrial labour was nearing its end. This idea spread through youth culture and invaded the whole of society: industrial labour was a remnant of the past, the development of technologies and social knowledge opened up the possibility of the liberation of society from labour. The most radical parts of the workers' movement expressed the belief that industrial labour was exhausted and that the alienating and repetitive form of work was therefore no longer historically justified. This idea was the most radical innovation of the Italian workers' movement of the 60s and 70s, thus differentiating it from the communist tradition of the 1900s.

# VII
## THE DOUBLE SOUL OF THE ITALIAN WORKERS' MOVEMENT

Throughout the modernization of the twentieth century, the Italian left was pushed in two opposite directions. On the one hand, a Protestant, industrialist and modernist soul motivated its protests against social backwardness and demands for more productivity and efficiency in the system of production, at the cost of increasing workers' exploitation and subscribing to liberalist policies. On the other hand, an antiproductivist, egalitarian and communitarian soul drove the left to demonize capitalism and take refuge in forms of the welfare state that helped create parasitical political clienteles. The workers' autonomy of the 60s and 70s wedged in between these two souls of the traditional left: it embodied an antiproductive culture inscribed in Italian culture in its shirkers' form, but was

able to turn it into an anticipation of the creative potential that was to take centre stage in postmodern and postindustrial production.

After the 70s, workers' autonomy was defeated by police repression and the capitalist offensive of the early 80s hit the factory working class with waves of redundancies, paving the way for the adoption of a neoliberal ideology. But liberalism Italian style cannot be assimilated to the liberal bourgeois tradition of Protestant derivation that flourished in Europe during modernity.

Liberal culture never affirmed itself in Italy as a majoritarian culture of government. During the nineteenth century, the Liberal Party led the Risorgimento, but never actually became the majoritarian culture of the Italian bourgeoisie. The compromise of State and Church and the alliance between the industrial bourgeoisie and reactionary landowners dominated Italian politics in the nineteenth and twentieth centuries. Liberal culture always demanded a secular state and represented a cultural component of political Protestantism, yet it always remained a minority. In the early 1900s Piero Gobetti, a liberal, had to recognize that the only way to free the Italian state from the reactionary influence of Catholicism was through an alliance between liberals and the workers' movement. That alliance could unfortunately never be realized, and fascism assailed and destroyed both the communist workers' movement led by Antonio Gramsci and the liberal movement represented by Piero Gobetti. Neoliberalism, as a hegemonic political force, affirmed itself in the 80s and has nothing to do with the liberal legacy; in fact, it proposes an alliance between all socially and culturally reactionary forces under the banner of the ultracapitalist principle of economic liberalism of Anglo-American derivation.

In the 80s, in the midst of a capitalist counteroffensive and the affirmation of neoliberalism at the international level, Italy gave life to a curious experiment in political economy. After defeating workers' autonomy, social radicalism, and egalitarian and libertarian movements, an anti-Protestant ethics permitted the political class in government to tolerate economic illegalities, embezzlements, corruption and mafia. These were the years of Bettino Craxi. Despite his socialist and laic credentials, Craxi was the representative of a convergence of the Counter-Reformation spirit of tolerance and shirking with a cultural openness towards neoliberal modernization. Modernization and corruption, in Craxi's theory and praxis, were not in contradiction; these trends were absolutely complementary, integrated and functional.

In the 70s, the historic left (the Communist Party and the Catholic left) responded to the refusal of labour of the youth and workers' anti-Protestantism with violence. They accused the anti-work rebels of the factories and the metropolitan Indians of the social centres of hooliganism.[2] In the 80s, Catholics and late communists rebelled against Craxi, not because he was pursuing a neoliberal policy of patronage, but because he tolerated corruption.

2. The Metropolitan Indians were a group of young proletarians active at the time of the 'historic compromise' between PCI (Italian Communist Party) and DC (Christian Democratic party) of the 1970s. Inspired by Situationist détournement, Surrealist games, Dadaist nonsense and Futurist poetics, they energized the symbolic political imaginary of the movement with an outburst of creativity based on the performative power of words and bodies. Of particular note was their political use of litotes, which in 1977 galvanized the hostility of union officials towards the movement. (Translators' note)

Bettino Craxi had sensed what was to come with the affirmation of the neoliberal doctrine. In the 80s and 90s, as neoliberalism wrote off all the old regulations of the welfare state, the defences society had built against the aggressiveness of capitalists collapsed. Craxi understood, with laic cynicism, that neoliberalism inaugurated a period when the laws of violence, mafia, fraud, corruption and simulation would be the only rules of the game. Catho-communism, in its agony, desperately clung to the ethical question. Instead of opposing neoliberalism—which destroys society's defences, reduces workers' wages, imposes a culture of competitiveness and bargaining—the left opposed corruption, immorality and illegality. Paradoxically the left defended the Protestant ethics that were being dissolved in the culture of large capital, as the traditional bourgeoisie was disappearing to give room to a class of *lumpen*-predators.

# VIII
## ALEATORY VALUE IN NEO-BAROQUE SOCIETY

> The principle of reality has coincided with a determinate stage of the law of value. Today the whole system precipitates into indeterminacy; the whole of reality is absorbed by the hyper-reality of the code and of simulation. […] Capital is no longer in the order of political economy, it uses political economy as a model of simulation.
>
> Jean Baudrillard, *Symbolic Exchange and Death* (1976)

For a long time, the crisis of the law of value has been corroding the foundation of bourgeois society: the bourgeoisie lost its coherence due to the development of postmechanical technologies and the growing autonomy of workers from wage labour. In postindustrial economy, socially necessary labour time is no longer the source of the determination of value, no longer its only source. The value of a commodity is essentially determined by means of language, and the regime of value determination of commodities is one of simulation. The explosion of the new economy in the 90s was the perfect example of the economic power of simulation. Imaginary flows of capital were invested in the processes of the production of the imaginary. This does not mean, however, that it was all a blinding illusion.

Connective intelligence multiplied the power of social production, the world of commodities became much larger, social desire was produced and mobilized as an economic factor.

We have entered the regime of the aleatory fluctuation of values. The mathematical regularity of bookkeeping has given place to the indeterminacy of financial games and advertising communication, with its linguistic strategies and psychic implications. The economy has become an essentially semiotic process and embodies the chance that characterizes the processes of assignment of meaning.

Labour has become fractalized. With the end of large industrial monopolies, now delocalized in the global peripheries, new workers start resembling computer terminals, cells in the process of circulation of the commodity-sign. As the

neat borders of industrial society faded out and broke down in atomized work-places, *net slaves* underwent two parallel processes. On the one hand, their exis-tence was individualized, both physically and culturally. Each one had to follow her trajectory and compete in the market individually. On the other hand, each worker experienced a situation of permanent cellular connection. Each individual is a cell put in constant productive connection with others by the web, which en-sures a deterritorialized, fractal and fluid sociality. The cellular is the new assem-bly line, deprived of any carnal sociality.

Simulation and fractalization are essentially Baroque categories. In the shift to postmodernity, the rationalist balance of industrial architecture gave way to the proliferation of points of view. In *The Neo-Baroque Era* (1994), Omar Calabrese claims that the postmodern style recuperated aesthetic and discursive models with which the culture of the Baroque experimented in the 1600s. Baroque was essentially a proliferation of points of view. Whilst the Protestant rigour produces an aesthetic of essential and austere images, Baroque declares the divine gener-ation of forms to be irreducible to human laws, be they of the state, politics, ac-counting or architecture.

As Deleuze claims, the Baroque is the fold: the poetics that best corresponds to the chance character of fluctuating values. When the grand narratives of mo-dernity lose coherence, the law of value is dissolved in an endless proliferation of productivity, inflation and language, and the infosphere is expanded beyond measure. Mythologies intertwine in the social imaginary. Production and semio-sis are increasingly one and the same process. Out of this process simultaneous-ly arise a crisis of economic reference (the relationship between value and nec-essary labour time), and a crisis of semiotic reference (the denotative relationship between sign and meaning). Value can no longer refer to labour time, because unlike the labour of Marx's times, the time of immaterial labour is not reducible to a socially average norm. Parallel to this, the denotative relation of sign and meaning is definitely suspended in social communication. Advertising, politics and the media speak a declaredly simulative language. Nobody has any belief in some kind of truth of public statements. The value of the commodity is estab-lished on the basis of a simulation in a relation that no longer follows any rules.

# IX
# BETWEEN HUMPTY DUMPTY AND UBU ROI

Silvio Berlusconi's behaviour is incomprehensible to the conservative right and left, whose political reason follows traditional models. They see it as indispens-able to respect official language and cannot imagine a context for political action outside of adherence to legality. But the strength of Berlusconi's media-populism lies precisely in the systematic violation of the taboos linked to political official-dom and legality. With their glum seriousness, authoritative figures such as Os-car Luigi Scalfaro and Carlo Azeglio Ciampi are the best example of this miscom-prehension of the new character of postpolitical language championed by Ber-lusconi. What seems most unbearable and provocative to the custodians of se-verity is Berlusconi's sly and systematic ridiculing of political rhetoric and its

stagnant rituals. But there are reasons to believe that the large majority of people who constitute the 'public' of politics (the electorate) were amused by this ridiculing and provocative gesture and in many cases conquered by it: they identified with the slightly crazy Premier, the rascal Prime Minister who resembles them, as at other times they had identified with Benito Mussolini and Bettino Craxi.

The majority of the Italian electorate grew up as TV audiences at a time when television became the primary vehicle for informality, vulgar and coarse allusiveness, the language of ambiguity and aggressiveness. Thus they spontaneously found themselves on the same cultural wavelength as Berlusconi, with his language, words and gestures, but also with the deprecation of rules in the name of a spontaneous energy that rules can no longer bridle. The crazy and cheerful figure of Ubu Roi is irresistible to a public that is used to renouncing its individuality in the name of collective irresponsibility.

To the plebeian coarseness of Berlusconi and his perky banqueters in government, the left responded with prissiness and consternation in the face of the violation of the language of political correctness. But calling out 'Scandal!' proved to be a losing argument against the policies of the centre-right government. In fact, part of the secret of Berlusconi's success in politics lies precisely in the use of excess. The excessiveness of the declarations and actions of this government was a winner in the imaginary of the masses and in electoral decisions. Events that exceeded the framework of predictability, tolerability and codified political behaviour acted as a catalyst for consternation and indignation while creating a safe passage for government legislation, the effective dilapidation of collective property, the abolition of workers' rights, the imposition of discriminatory and racist laws. This technique of excess is now well tested: you have to talk big, very big, in order to then enact what is essential for the accumulation of power and the privatization of social spaces. A minister would take on the role of the ham, the crazy one, and propose to bomb the ships carrying migrants to Italian shores. He generates scandal, but also an entertaining distraction, and soon enough another minister, more moderate and realistic, demands military control of the coast, and then a zealous functionary can expel Kurdish and Syrian political asylum seekers without even looking at their requests or knowing their rights—thus comes about the possibility of trampling upon the most basic rights of foreign workers.

Berlusconi's language appears to be suited to the ridiculing rather than the denial or restatement of the truth and the affirmation of new principles. His intention is to unveil the hypocrisy of political rules. For Berlusconi, the meaning of words is not that important, so much so that he is used to denying his own declarations in newspapers the day after making them. Berlusconi has often pretended to give his approval to the words of the President of the Republic, even though with all evidence these words blatantly contravened his own actions or the legislative activities of his government. The political word is devalued, ridiculed, captured in a kind of game of three cards, in a semantic labyrinth where every word can mean the opposite of the meaning attributed to it in dictionaries. Scandal at the informality, the vulgarity and the shallow lies is not an effective reaction; on the contrary it strengthens Berlusconi and his regime

because at this level the electorate understands him better than the representatives of institutions.

According to common sense, political language has always concealed reality and provided hypocritical cover-ups to the arbitrariness and arrogance of the rich and powerful. Berlusconi paradoxically reveals this hypocrisy. He is the rich and powerful one who shows that the law is capable of nothing; he is the rich and powerful one who laughs at the hypocrisy of those who pretend that everyone is equal before the law. We all know that not everyone is equal before the law; we know from experience that the wealthy and powerful can afford expensive lawyers, impose their interests, and conquer spaces in power inaccessible to the majority of the population. But this is usually hidden behind the smoke screens of legalism and juridical formalism. Berlusconi clearly states: 'I do what I want, and laugh at the legalists who want to oppose their formalities to my will'.

Now that the power of making and unmaking the law lies in his hands, he uses it to show everyone the impotence of the law. Like Humpty Dumpty, Berlusconi knows that what matters is not what words mean, but who owns them. Their meaning is decided by the master of words, not the semantic tribunals. The interpretation of the law is decided by its master, not the law courts.

The spectators of politics (the electorate) seem to recognize themselves in this game of the revelation of the hypocrisy of the language of politics, even though the person revealing that the 'Emperor has no clothes' is paradoxically wearing the Emperor's clothes. People laugh at what the Travicello King says, but there is complicity in their laughter, because the King is denouncing the falsity and hypocrisy of the words that he himself is uttering, with a smile that says: 'Here I say it and deny it', or 'No one is a fool around here'.

The boring opponents of Berlusconi wish to reaffirm the sacredness of power, but Berlusconi has already discredited it with his exercise of a power that has no need for sacredness. Despite being divested of official authority, the Berlusconi government enjoys the authoritativeness of transgression; it exercises its authority in the name of transgression, laying down laws on every issue, from immigration to the right to work and the judiciary, imposing everywhere the logic of hegemonic interests, reducing social expenditure, shifting wealth from the working classes to the property owners. None of the devastating laws of this government were stopped by parliamentary opposition or the protests of democratic and priggish public opinion.

## CONCLUSION

Have we come close to a definition of the regime that has governed Italy since 1994? I believe so. This regime includes the behaviours of fascism (police brutality, as we saw in Genoa in 2001; the irresponsibility that led Mussolini's Italy to the catastrophic war of 1940–1945; the servility that has always characterized Italian intellectual life). It also includes features that are proper to the mafia (the contempt for public goods, the toleration of economic lawlessness).

But it cannot be defined as a mere repetition of the fascist regime, nor as a mafia system. Aggressive neoliberalism and media-populism are its decisive

features. It objectively functions as a laboratory for the cultural and political forms crucial to the development of semiocapital.

The history of modern Italy ought to be written taking the farcical proclamations of Risorgimento, fascism and the democratic republic less seriously. A history could be written starting from the work of Lorenzo Valla, his elegy of vileness and hedonism, and Niccolò Machiavelli, with his affirmation of the incompatibility of morality and politics. This history could be centred around Manzoni's don Abbondio, Vittorio Gassmann and Alberto Sordi, who in *The Great War* embody the popular wisdom that always refused to believe that one's country is more important than life. And it should take into account the Mediterranean cult of femininity, hedonism and tenderness.

The refusal of Protestant austerity and self-sacrifice is the salt of the Italian adventure, the elasticity and intelligence of a people who never believed in the mother country or the general interest, and because of this remained irreducible to the logic of capitalism that identifies the general interest with profit and growth.

This cowardice lacked the courage to reclaim itself, and remained a marginal prerogative of the lower classes, excluded from history. Official language identified itself with rhetoric reminiscent of Roman empires, thus creating the conditions for on the one hand the self-deprecation that rules over Italian public discourse and on the other the pompous and empty affirmation of Italian nationalism and the fascism that is its natural expression.

The main thread in the history of this country and of the self-perception of the Italian people is a mixture of unavowed cowardice and self-contempt, the source of the aggressiveness that finds its full expression in fascism. The Latin cult of virility that aggressively posits itself above the tenderness and femininity of Mediterranean culture is both tragic and farcical.

Cowardice is ambivalent: in its immediacy it signals the hedonist consciousness of the supremacy of pleasure over historical duty. But this consciousness does not reconcile with the imperialist and macho mythologies embodied in the tragic farce of fascism.

Unable to accept cowardice as tenderness, unable to accept the predominance of the feminine in Mediterranean culture, Italian history is full of farcical characters who take on heroic tasks and inevitably cause tragedies, the ridiculous implications of which can never be concealed. The figure of Salandra, who starts crying during the Versailles Congress because the British would not listen to Italian demands, finds its counterpart in the figure of Mussolini, who wants to vindicate the mutilated victory and exalts the masculine masses with the promise of break-all military adventures, eventually leading the country to a catastrophic war.

By comparing its present hedonism and subaltern status to a mythological past of imperial superiority, Italian culture revels in self-contempt because it refuses to accept its feminine side. When it tried to react to self-contempt by affirming an improbable virility, it embarked on infamous and truly paltry adventures, such as the vile attack on France after it had already been defeated by Hitler in the late spring of 1940, or its habit of running to help the winners only to discover that they end up losing with its help.

There are rare moments when self-contempt turns into a positive valorization of tenderness, abandonment and idleness: these are the only times when Italian culture produced something original, when Mediterranean femininity was placated in a collective enjoyment of the potentialities matured by the collective productive intelligence. In the 60s and 70s the predominant movement in society veered towards abandoning all imperialist pretences and embracing a joyous quality of life, freed from the urgency of economic productivity.

The movement in Italy can start again from a declaration of absolute weakness, abandonment, and retreat. Let's withdraw our intelligence from the race of capitalist growth and national identity, let's withdraw our creativity and our time from productive competition. Let's inaugurate a period of passive sabotage, of definitive evacuation of the ridiculous box that is called Italy.

Translated from the Italian by Arianna Bove and Erik Empson

# MIDDAY, TIME OF THE SHORTEST SHADOW
## MICHAEL TAUSSIG

In the *Divine Comedy* Dante takes us on a harrowing journey that conflates the soul of man with the soul of the cosmos at the centre of which is the planet Earth. It was the great Christian pilgrimage, not to a famous cathedral or humble church, but into the earth itself with its many layers of sinners suffering punishment eternal, at the bottom of which lay the devil himself. In the end, Dante is saved by two beings who manage to get him an audience with God. One is a woman and the other a pagan, namely Beatrice and Virgil.

Like *Alice in Wonderland* six hundred years later, who dropped into a hole in the ground shown to her by a bunny rabbit and went on her stranger-than-strange journey during which she grew abnormally large and then abnormally small and met all manner of strange beings, such as playing cards that came alive, Dante could not have made his journey without a guide. Instead of a bunny rabbit with a white waistcoat and a watch, Dante's guide, Virgil, is not an animal but what today we would call 'Europe's Other'. He could be Muslim. He could be a New World, African, or Pacific Island savage. Without this pagan guide returned from the remote past, from Christianity's prehistory, Dante would have remained lost, confused, and unredeemed in the dark woods of everyday life. And how interesting it is that Dante makes it through thanks to the combined exertions of the pagan and the Christian woman, Beatrice.

Unlike Dante, Alice in Wonderland is a girl. Unlike the poet Dante, the author of Alice in Wonderland is a mathematician. Yet it is the poet who constructs his verse in strict mathematical logic, while the mathematician revels in unexpected changes within a world in continuous flux. And while what Dante experiences is an underground full of people, in Alice's underground there are many animals and objects that act as people, as well as people that seem quite unreal, such as the Mad Hatter. When we compare the two we can see how the Divine Comedy has metamorphosed into children's literature—beloved by adults—and thus get a sense of how the European soul has changed along with it so as to become the adult's imagination of the child's imagination. Rather than only a negative critique—which it is—this switch is a marvellous example of how many crucial things in the life of culture are owed to this type of imagination, and how we might proceed further in imagining, post-Alice, what a world shorn of soul might be and hence what our very selves can be.

For today there is another, unprecedented change, planetary in scope. The divine vision of man and cosmos as organically interconnected has become meaningful as never before. Following the Middle Ages in the West, the person was

dislocated from the centre of the universe and from the heavens. The earth and along with it Dante's cosmic geography were decentred from what we now call the solar system. The soul of man lay in fragments. But in the recent decade this has been reversed. No longer just a pretty or a religious metaphor, cosmos and man are now welded together by global warming, by what used to be called the Apocalypse.

As our bodies and outlook change in a dangerous world now subject to global warming, rising seas, hurricanes and pestilence, heat detaches the senses from the complacent view of the body as a fortress with peepholes and antennae sensing externalities, and instead encourages us to take a world-centred and not a self-centred point of view such that the self becomes part of that which is seen, not a sovereign transcendent. To thus consciously see ourselves in the midst of the world is to enter into ourselves as image, to exchange the God position, standing above the fray, for some quite other position that is closer to Alice yet not really a position at all but something more like swimming, more like nomads adrift in the sea, mother of all metaphor, that sea I call *the bodily unconscious*.

This is like the sea Marcel Proust described, allowing a sort of poetic messaging with the musculature, the organs, the breathing apparatus—above all the travail of falling asleep in Proust—passing through alternating worlds like a diver descending into the ocean, worlds far more revealing of reality, he thought, than the conventionalized reality perceived by waking consciousness. Indeed so radical is the difference that to pass from one to the other is to die and then come terribly alive, which is surely what Nietzsche had in mind when he wrote that life means constantly transforming all that we are into light and flame.[1] For Proust this is a journey

"in the organic and now translucent depths of the mysteriously lighted viscera. Worlds of sleep—in which our inner consciousness, subordinated to the disturbances of our organs, accelerates the rhythm of the heart or the respiration, because the same dose of terror, sorrow or remorse acts with a strength magnified a hundredfold if thus injected into our veins: as soon as, to traverse the arteries of the subterranean city, we have embarked upon the dark current of our own blood as upon an inward Lethe meandering six-fold, tall, solemn forms appear to us, approach and glide away, leaving us in tears".[2]

This is the new soul, not only of Europe, but of the cosmos in the vast broad sense Dante intended, joined to that of Alice in Wonderland. For the question arises whether a new body will be formed as that other body we call planet Earth heats up? Certainly changes are already happening down to the genetic level with insects and plants. As regards us humans, equipped with a body whose thermostat will be reset together with other basic adjustments, might we not come to possess a new body–mind relationship, a new body–soul relationship,

1. Friedrich Nietzsche, Preface to the Second Edition, in *The Gay Science*, trans. Walter Kaufmann (Vintage, 1974), 36.
2. Marcel Proust, *Sodom and Gomorrah*.

such that our body's understanding of itself will change? Even more important in changing the old-fashioned mind–body set up will be the cultural changes — that foreboding sense of cliff-hanging insecurity in a world ever more engaged with security in a climate gone terrorist.

The mere possibility that this could happen should be sufficient for us to consider other forms of the body's knowing itself as a consequence of planetary crisis and meltdown. It is when the machine begins to break down that you begin to see how it works. Likewise it is when authority is challenged that you begin to see the otherwise concealed workings of the power structure. This we could call apocalyptic knowledge, or *preemptive apocalyptic knowledge*, a thought experiment we can now conduct on ourselves at Manifesta 7, where Dante meets Alice in Wonderland and like in Virgil's world, things such as playing cards come alive and change into people.

This new soul composite of Dante and Alice that I call the bodily unconscious is not the unconscious we have known since Freud, made dull with usage. What I have in mind with the bodily unconscious is 'thought' more like poetry which proceeds outside of language and consciousness, what a famous student of shock on the battlefields of World War I by the name of Cannon called the 'wisdom of the body'.[3] Perhaps this was all metaphor for Cannon, this 'wisdom' — but not for me, nor for Nietzsche, who argued that what we in the West call consciousness is but a tiny part of thought; that we think all the time and without language but do not know it, and as such we are connected, as thinking bodies, to the play of the world.[4]

Leaving the blood-soaked fields of Flanders, Cannon provided us with another precious insight with his article 'Voodoo Death' in the 1942 volume of *The American Anthropologist*. Drawing on reports from medical doctors in Haiti and remote Australia on deaths due to sorcery, he found confirmation of this 'wisdom of the body' as what the sorcerer taps into in order to kill people. No doubt Cannon's essay could be interpreted as a scientific explanation of mystical phenomena, but to me it suggests something quite different as well, another form of sorcery, perhaps, wherein and whereby bodies relate to other bodies, human and nonhuman — animals, plants, the seasons, tides, and the movement of the stars and the winds — forms of sensation, of bodily knowing, that exist below the radar of consciousness and are all the more powerful for so existing.

Song is the great medium. It is there in Dante as learned from the Provençal poets. As breath and rhythm it collates and connects the vibratory quality of being. Emanating from the chest and throat, connected to dream and to body painting with red ochre supplied by Virgil, it connects a wide arc of possibilities and impossibilities. The song of the sorcerer in remote Australia from where Cannon drew his data was described by indigenous people in the late 1920s as the deadliest of all magic. The worst songs come from the 'people of the south', which turns out to be no definite place but is where stones walk like men. 'These stones walk around and sing these songs', the anthropologist Lloyd Warner was

3. Walter B. Cannon, *The Wisdom of the Body*, (New York: Norton, 1932).
4. Nietzsche, *The Gay Science*, 211–214.

told, 'and men follow and listen and learn them and sing them and make the men in the north sick'.[5] One of the deadliest songs is that of the whitefish. The breath of the victim becomes rapid and strained. This means that the fish has eaten the insides of that person, and the illness proceeds in a waxing and waning rhythm according to the movement of the tides.

You may not care to believe this could happen, or you may care to wonder about the stories anthropologists retell, it being the aim of my retelling of Lloyd Warner's retelling to paint the big picture, so as to indicate and evoke the poetry the bodily unconscious requires and provides.

At one stroke Freud swept the rug from under the maneuver I now wish to make when he asserted that the world of myth, involving nature as an animate being, retreated into the psychic unconscious of modern man. Subject to the codes and procedures of psychoanalytic jargon and hardened into dogma, this shift from outer to inner worlds, same as the shift from the manifest to the latent content of dreams, was a shift which effectively killed off the 'people of the south' where 'stones walk around and sing these songs'. No! The bodily unconscious is not the Freudian one. The bodily unconscious has more to do with the abundance of ancient stone figurines from the people of the south that sat on Freud's desk, figurines from ancient Mesopotamia and Egypt, which he loved to caress while listening to his patients, as the poet H.D. tells in lavish detail in her tribute to Freud.[6]

My sense of the bodily unconscious is that it now holds the future of the world in the balance as much as the other way around; that we have reached a time in world history when we can choose to press forward with the exploration of this 'last frontier' which would, like the study of work habits by scientific management from Taylorism to the present, exploit, disfigure, and even destroy it, or else we figure out a way of mastering our drive for mastery. That would mean we need to catch up with the way that, in the West, history turned the senses against themselves so as to control them and to achieve this invented the soul or its equivalents as mysterious depths not directly ascertainable by the senses. The problem before us now, therefore, is not simply to eviscerate the soul—a lot easier said than done—but to imagine the realities that exist when such tenacious support is removed.

Imagine a chocolate-covered cake. You pull away the sponge base—that is, the soul or depth, the mysterious underneath or behind, beloved of our metaphysicians—and what happens? You're left with the chocolate, right? No! The chocolate goes too, as it needed the underneath so as to be on top.

Nietzsche puts it well in his dramatic invocation in *Twilight of the Idols* at the end of his sane life, in Turin, when he emphasizes that to eviscerate the depth from the two-layered notion of the real as a composite of appearance and depth does not simply leave you with appearance, because that will be eviscerated along with the depth so that all you are left with is 'midday, time of the shortest shadow'. This is the challenge for Manifesta 7, playing around with the soul of Europe. To help us imagine that time of the shortest shadow.

5. Lloyd Warner, *A Black Civilization* (1937), rev. ed. (Gloucester, Mass.: Peter Smith, 1969) 198.
6. Hilda Doolittle (H.D.), *Tribute to Freud* (New Directions, 1984).

# IN MODERNITY, THE SOUL CALLS ITSELF SUBJECTIVITY
## MAURIZIO LAZZARATO

## ▌
## OF THE GOVERNMENT OF SOULS AND THE GOVERNMENT OF CONDUCT

In modernity, the soul calls itself subjectivity. There are multiple ruptures and continuities between the soul of antiquity and modern subjectivity, notably in regard to the modalities of the techniques of power exercised upon them. We will reconstruct these continuities and these ruptures alongside the work of Michel Foucault before developing them with Deleuze and Guattari.

In the last stage of his work, Foucault elaborates a theory of power as the 'government of conduct'. That which is proper to the 'art of governing' can be expressed through the questions: How does one direct and control the subjectivity of another? How can one act upon her possible actions? The art of governing consists of a set of techniques and procedures designed to guide the conduct of citizens and plan for their probable actions.[1] The modern state inherits these techniques from Christian 'pastoral power'; liberalism has inflected, modified, and enriched them in transforming the techniques of the 'government of souls' into those of the government of conduct.

Government is a strategic relation between the governing and the governed in which the former attempt to determine the conduct of the latter and these latter develop practices to 'not be governed', to be governed as little as possible, to be governed in a different manner, by other procedures, according to other principles, other techniques, and other knowledges, or even to govern themselves. According to Foucault, contemporary struggles and conflicts are grounded in the modalities of this government of conduct or of subjectivities.

Government as a form of power stretches back further than the juridical, democratic tradition established in the sixteenth and seventeenth centuries. It is specific to western Europe, since pastoral power was set up by the Church. It was unknown in Greek and Roman society.

The pastoral power of the Church is an individualizing power, oriented toward individuals and intended to direct them in a *continual* and *permanent* manner. The pastor exercises power over a flock rather than over a territory (or a city, as in Athens or Rome). The pastor assembles, guides, and conducts the flock and is

---

1. See Michel Foucault, *Security, Territory, Population*, ed. Arnold I. Davidson, trans. Graham Burchell (London: Palgrave Macmillan, 2007).

supposed to ensure its salvation. This is not solely a matter of saving it as a collective entity, but of saving each sheep one by one: the Gospel parable tells of how the shepherd abandons the flock to go in search of a single lost sheep.

In the Christian conception, the pastor is supposed to account not only for each of the faithful but for all their actions, for all the good or evil they are liable to do and for everything that happens to them. The pastor should know what goes on in the soul of each one, should know his secret sins and his progression on the path of salvation. Christianity conceives the relation between shepherd and sheep as one of individual and complete dependence. In Foucault's view, Christianity is the only religion that developed these 'strange technologies of power', dealing with the multitude of persons in the flock by way of a handful of pastors (the clergy). Pastoral power establishes a series of complex, continual, and paradoxical relations between people that are not political in the sense pertaining to democratic institutions and political philosophy.

The exercise of pastoral power upon the individual soul and its singularities has been utterly ignored in the tradition of political philosophy and in the theory of rights and sovereignty, but has always played a very large role in the organization of our societies. The modern world emerged from political-religious battles whose object was pastoral power. The Council of Trent was at the centre of one of the most important of these political struggles, which pitted the will of the Church not to lose—on the contrary, to intensify—its power over the souls of its faithful against the desire of these latter not to allow themselves to be governed by the Church, but to govern themselves. The conflict between Reformation and Counter-Reformation rests precisely on the modalities of the exercise of pastoral power:

> This great battle of pastorship traversed the West from the thirteenth to the eighteenth century, and ultimately without ever really getting rid of the pastorate. For if it is true that the Reformation was undoubtedly much more a great pastoral battle than a great doctrinal battle, if it is true that what was at issue with the Reformation was actually the way in which pastoral power was exercised, then the two worlds or series of worlds that issue from the Reformation, that is to say, a Protestant world, or a world of Protestant churches and the Counter Reformation, were not worlds without a pastorate. What resulted from the Reformation was a formidable reinforcement of the pastorate in two different types.[2]

In the techniques of *disciplinary* power that, beginning in the seventeenth and eighteenth centuries, were exercised upon the body of the individual at school, at work, in the army, the hospital, the prison, etc., and in the *biopolitical* or *security* techniques exercised upon the population (policies for health, professional education, housing, distribution of revenues, etc.), Foucault sees a legacy of pastoral power whose objective is no longer to assure the salvation of the individual soul but to implicate the body and subjectivity of each in the

2. Ibid., 149.

structures and institutions of capitalism and to render them productive.

The government of souls is a highly specific form of power reducible neither to juridical power (the law) nor to the power of democratic institutions, for it is not exercised upon a 'legal subject' but rather upon a 'living subject', upon the singularity of his behaviours, modes of acting, and manners of speaking. As a legal subject, you exercise your power in an intermittent manner by transferring it, through your vote, to 'representatives'. You thus delegate your power once and for all to the institution, whereas as a living subject you are subject continually and permanently to the exercise of modern pastoral power. At school, at work, in the hospital, in the army, you are caught in human technologies that organize and structure your space and your time, your gestures, movements and behaviours. You are similarly subjected, continually and permanently, to policies of the welfare state which in turn—in the case of the management of the unemployed, for example—make an appeal to your conduct. Your life and your subjectivity are continually directed by a series of disciplinary and biopolitical techniques that establish a dependence of the governed on those who govern, one that recalls the dependence of the faithful sheep on the priest-shepherd.

The principal objective of modern pastoral power is the production of the individual by means of techniques that allow the pinning of the subject-function onto its body and the enclosure of subjectivity within the limits of the subject, the 'ego' or the 'I'.

## ▌▌ THE RELATION TO SELF

The shift that takes place around 1980 in Foucault's conception of power consists in viewing government or the 'art of governing' no longer as solely a strategy of power but also as *an action by subjects upon themselves* (which he terms 'the relation to self'). He furthermore tries to answer the question: *How do subjects become active?* How does action upon oneself open onto processes of subjectivation that might escape the art of governing? Thus the government of souls is not the unilateral exercise of the power of those who govern over the governed; it is rather that which is at stake in political struggles. The relevant action is not merely that of the techniques of government upon our subjectivity, but also the action of the self upon itself, the possibility of governing oneself (individually as well as collectively).

Gilles Deleuze has raised this question of the relation to self and the production of subjectivity even more radically than Foucault, and with Félix Guattari has made it the overwhelming problem of contemporary capitalism: 'today's global capitalism is a producer of subjectivity; this is in fact its principal product, material production amounting to mere mediation vis-à-vis the mastery of subjectivity-production'.[3]

According to Deleuze, Foucault's discovery of the 'relation to self' was the discovery of a 'new dimension', irreducible to the relations of power and of

---

3. Félix Guattari, in *Chimères* 23, no. 49 (my translation—SHT).

knowledge.[4] The self is neither a formation of knowledge nor a product of power; 'it is a process of individuation that effects groups or people and eludes both established lines of force and constituted knowledge'.[5] That the self should pertain neither to knowledge nor to power signifies that a process of subjective change is primarily not discursive but existential, affective. The relation to self, in the first place, defines neither a knowledge nor a power because it expresses a change in the manner of feeling that constitutes the support for a process of subjectivity-production from which new knowledges, new relations of power, and a new discursive capacity will derive.

For Deleuze, the fact that power is 'individualizing' and that it invests and produces 'our everyday life and our interiority' is not contradictory: it reveals a capacity to approach the subject as much in the form of flight, trickery, diversion, or open conflict as in the form of the autonomous and independent subjectivation that dictates its own norms. What is left for subjectivity, wonders Deleuze, once the individualizing mechanisms act upon the subject? 'There never "remains" anything of the subject, since he is to be created on each occasion, like a focal point of resistance'.[6]

### ■■■
## SUBJECTIVITY IS NOT THE PROPERTY OF THE INDIVIDUAL OR OF THE EGO

If the production of subjectivity (of the relation to self) is what is at stake in modern pastoral power, we must still define the components that make up this process and its modalities. One of the objectives of the government of conduct is to reduce subjectivity to the subject, the ego. Individualism is the political theory that has accompanied the progress of new disciplinary and biopolitical techniques of power. According to Guattari, however, subjectivity and the processes of self-transformation are always the result of a collective assemblage, such that the components and the seat of subjectivation are not confined to the subject or the individual. Subjectivity is outside the subject—that is, it lies decentred in preindividual relations, but also in social, political, cultural, or mechanical relations that overflow the subject. For Guattari, this is merely one particular arrangement. This conception of subjectivity bursts the unity of the individual subject (and of the political subject) and redirects us to a complex of subjectivation he calls 'individual—group—machine—multiple exchange'.

Guattari's term 'collective assemblage' thus refers to a multiplicity beyond the individual on the part of those great social, linguistic, technological, economic machines which, before the individual—amongst preverbal and preindividual intensities—rest upon a logic of affect. That subjectivity should be collective does not at all imply that it becomes exclusively social. The collective does not result from interaction between individuals. There is a constitution of subjectivity on a transindividual scale.

4. Gilles Deleuze, *Foucault*, tr. Sean Hand (London: Continuum, 2006), 84.
5. Gilles Deleuze, 'What Is a *Dispositif?*' in *Two Regimes of Madness: Texts and Interviews 1975–1995*, ed. David Lapoujade, tr. Ames Hodges and Mike Taormina (New York: Semiotext(e), 2006).
6. Deleuze, *Foucault*, 87.

This nonhuman, simultaneously mechanistic and affective aspect of subjectivity, both before and beyond the individual, is essential insofar as it provides the basis for one's transformation, one's 'heterogenesis'. The individual is merely a 'terminal' for components of subjectivation of which the majority completely evade consciousness. Subjectivity thus finds itself dispersed in a multiplicity of relations and materials, and produces itself at the crossing of prelinguistic and mechanical 'for-itselfs' independent of the ego or of consciousness.

In the last years of his life, Guattari made frequent reference to Daniel Stern's book *The Interpersonal World of the Infant* to draw a cartography of the components and seats of subjectivation (the 'for-itselfs') that overflow the subject.[7] Before the acquisition of language, infants, according to Stern, actively construct modalities of perception, communication, experience, and apprehension of the world and of others that constitute so many vectors of subjectivation. Stern distinguishes three 'senses of self' (emergent, core, intersubjective) that precede the 'verbal sense of self' and its autonomy and independence in relation to language and consciousness. 'Sense of self' in these three cases does not mean 'concept of', 'knowledge of', or 'consciousness of' self, because these experiences do not pass through language and consciousness.[8] For Guattari they are in no way stages in the Freudian sense, but 'levels of subjectivation' that manifest themselves in parallel to speech and consciousness over the entire span of life. The prelinguistic and mechanical for-itselfs (machines having for Guattari their own consistency and capacity for autoproduction) are nonhuman selves which do not speak but which clearly enunciate something, even if they do not express it using speech or signifiers. These distinct 'selves' or seats of subjectivation are the objects of the modern government of souls, and in these same vectors of subjectivation, the desire not to be governed can take root.

# IV
# THE MODERN EXERCISE OF POWER UPON SUBJECTIVITY

In contemporary societies, aside from disciplinary techniques (which are exercised upon the body in the closed space of the school, the office, the prison, etc.) and biopolitical techniques (which assure a certain level of health, training, income, etc. for the population), we can observe the development, since the end of the nineteenth century, of semiotic techniques for the production and control of subjectivity. The art of governing enriches itself with new mechanisms, which always function on a double register. The first register is that of 'representation' and 'signification' organized through signifying semiotics (language) with a view to the production of the 'subject', the 'individual', the 'I'. The second is the register of the machine, organized through a-signifying semiotics (such as monetary or financial signs, informatic languages, or languages of the images and sounds of media technologies) with the capacity to employ signs that might in some circumstances have a symbolic or signifying effect but whose functioning proper is

7. Daniel Stern, *The Interpersonal World of the Infant* (New York: Basic Books, 1985).
8. See ibid., 7.

not symbolic or signifying. This second register does not aim at the constitution of the subject, but rather captures and activates elements of the presubjective, the preindividual (affects, emotions, perceptions), and the transindividual in order to make these function as pieces, cogs in the subjectivity-production machine.

We will now lay out, very briefly, some distinctions between the government of subjectivity and pastoral power (the government of souls). If individualization remains, as in the Church, the goal of the mechanisms of power, it is now produced through entirely novel techniques.

Contemporary capitalism's government of conduct produces and distributes roles and functions, equips us with a subjectivity, and assigns us an individuation (identity, sex, profession, nationality, etc.) in such a way that everyone is caught in a signifying and representative semiotic trap. This operation of social subjection to established identities and roles passes through the subordination of the multiplicity and heterogeneity of presignifying or presymbolic semiotics to language and its functions of representation and signification.

Corporal symbolic semiotics (all manner of preverbal, bodily, iconic expression: dance, mimicry, music; a somatization, a crisis of nerves, tears, intensities, movements, rhythms, etc.) depend *neither on signifying language nor on consciousness*. They do not put into play a perfectly discernible locutor or auditor—as in the communicative language-model—and speech does not appear in the foreground. These semiotics are animated by the affects and give rise to relations that are difficult to assign to a subject, an ego, an individual. They overflow the *individualizing* subjective limits (of persons, identities, social roles and functions) within which language would enclose them and to which it would reduce them.

The act of folding these modalities of expression back onto signifying semiotics is a political operation, since on the one hand, the assumption of signification is always inseparable from an assumption of power, and on the other hand, there is no signification or representation independent of the dominant significations and representations. The machine-register of the government of subjectivities functions on the basis of a-signifying semiotics—that is, on the basis of signs which, rather than produce a signification, trigger an action, a reaction, a behaviour, an attitude, a posture. These semiotics do not signify, but rather put in motion or activate.

To make explicit the function of machine-subjection, we will use Brian Massumi's description of it. In a beautiful article, he shows us that television, since September 11, 2001, has become the 'privileged channel for collective affect modulation, in real time, at socially critical turning points'; that is, after the attacks on New York and Washington it has become the privileged channel of machine-subjection.[9] The U.S. Department of Homeland Security has put in place a colour-coded alert system (from green to red) to calibrate public anxiety in the face of the 'terrorist' menace. This alert system 'addressed not subjects' cognition, but rather bodies' irritability'—that is, the preverbal and preindividual components of subjectivity. Perceptual signals are utilized 'to activate direct bodily responsiveness rather than reproduce a form or transmit definite content'.

9. Brian Massumi, 'Fear (the Spectrum Said)', in *Multitudes* 23 (Winter 2006),

The alerts are 'signals without signification' which in themselves carry no ideological sense and no discourse but which activate each body 'reflexively (that is to say, non-reflectively)'. This 'self-defensive reflex-response to perceptual cues that the system was designed to train into the population wirelessly jacked central government functioning directly into each individual's nervous system'. The object of the government of conduct is always, as for Foucault, the population; but here 'the whole population became a networked jumpiness, a distributed neuronal network' that reacts in the mode of a reflex to the stimuli addressed to it.

According to Massumi, it is not a question of the transmission of a message, an exchange of information with ideological content, but an intervention at the point where experience emerges. This system acts upon the conditions of the emergence of emotion, speech, action. It affects subjectivity in its very process of constitution, on the interior of the modalities of its own production. It is 'less a communication than an assisted germination of potentials for action whose outcome could not be accurately determined in advance—but whose variable determination could be determined to occur, on hue'. This system loses the capacity for determination, as it cannot control its effects and individuals' reactions; but it gains the possibility of formatting the development of subjectivity.

In contrast to the mechanisms of production of the 'I', the mechanisms of the machine know neither persons, nor roles, nor subjects. Now that subjectivation engages persons across the globe and easily manipulates mass subjective representations, machine-subjection arranges infrapersonal, infrasocial elements in proportion to a molecular economy of desire. The force of these semiotics resides in the fact that they pass through the systems of representation and signification in which individuated subjects recognize and alienate themselves.

Machine-subjection is thus not the same thing as social subjection. If the latter addresses itself to the mass individuated dimension of subjectivity, the former activates its molecular, preindividual, transindividual dimension. In the social instance, the system speaks and elicits speech. It indexes the multiplicity of presignifying and presymbolic semiotics and folds them back upon language, upon linguistic chains, privileging their representative functions. In the machinic instance, however, it does not speak and produces no discourse, but it functions, it sets in motion as it connects itself directly to the nervous system, the brain, the memory, etc. and activates affective, transitive, transindividual relations not limited to a subject, an individual, an ego. These two semiotic registers work together on the production and control of subjectivity in its simultaneous *mass* and *molecular* dimensions.

If there is continuity between pastoral power and the government of subjectivities, the discontinuities introduced from the seventeenth century on are no less important.

## V
## MODELS OF RESISTANCE

To the historical singularity of the pastorate corresponds the specificity of refusal, of revolts, of resistances that express the will not to be governed or to govern

oneself. Which, as Foucault emphasizes, does not imply that there was first the pastorate and then the movement of resistance, revolt, counter-conduct.

Micropolitics and the microphysics of power open new dimensions of political action by introducing practices that the classical tradition of political philosophy as well as practically the entirety of revolutionary and critical theory define as nonpolitical. These latter, notably, are normative and dogmatic theories that do not recognize more than one modality of the exercise of power and one modality of political subjectivation. Foucault for his part, and Deleuze and Guattari for theirs, introduce remarkable novelty, not only because, as we know, they analyse power as a multiplicity of dispositifs and relations of power, but also because they affirm the multiplicity of the modalities of resistance and revolt and the multiplicity of modes of subjectivation.

In the same struggle, different forms of resistance are at work: resistance to power as the exercise of political sovereignty, resistance to power as economic exploitation and resistance to power as the government of bodies and souls (as direction of conduct and conscience). If the heterogeneous modalities of resistance always manifest themselves together in a revolt or in a revolutionary sequence, they nonetheless retain their singularity and specificity.

In every revolt, in every revolutionary sequence, there is always one of these forms of resistance and subjectivation that predominates over the rest In the nineteenth century there prevailed, within the struggles led by the workers' movement, the demand for political rights and universal suffrage. With the communist movement at the beginning of the twentieth century, the question of sovereignty (the taking of power) had preeminence. And with the 'strange revolution' of '68 it was the resistance to modern pastoral power, the refusal of the government of bodies and souls, that seems to have prevailed. Neither the demand for political rights, nor the fight for sovereignty, nor the revolt against economic exploitation came to the fore in the movements of '68—although all these elements were present—but rather the struggle against the manner in which one was conducted at school, in the factory, in relations with oneself and others (the relations man–woman, teacher–student, boss–worker, doctor–patient). Here at the heart of '68 we find once more the revolt against government and the 'management of life' (the modern direction of conscience by communication and consumption).

Marxist commentators discard these behaviours when they separate the wheat (the 'political' labour struggle) from the chaff of womens' and homosexual movements etc., whose 'bleak ideology of festivity and sexuality'—to take a caricatured version of Alain Badiou—suffices to deny them any political nature. Some nonmarxist analysts, no less lacking of the theoretical instruments to apprehend contemporary politics, put forth another version of the nonpolitical nature of these movements in reducing them to 'cultural' phenomena. But the struggle not to be governed or to govern oneself seems able to take them into account as veritable dimensions of political action.

Translated from the French by Stephen Haswell Todd

# INNER LIMITS
## IN TIMES OF THE
## TYRANNY OF CHOICE
## RENATA SALECL

A simple look at advertising on the streets shows that nowadays our biggest choice is who we want to be. One London university tries to attract new students with a poster, 'Become what you want to be'. A new music record is advertised with the saying, 'I am who I am'. Even a beer company uses the slogan 'Be yourself!' We live in a world that seems to have little social prohibition in regard to how one is supposed to achieve happiness, where there seem to be endless possibilities to find fulfilment in life and where we are supposed to be self-creators; that is, each is free to choose what he or she wants to become. In this highly individualized society which gives priority to the individual's self-fulfilment over submission to group causes, however, people face an important, anxiety-provoking dilemma: 'Who am I for myself?' This question is especially troubling in times when we seem to be experiencing a change in the nature of social prohibitions.

In recent years there has been growing debate as to whether something has changed in our perception of the Big Other, the social symbolic structure that operates in postindustrial capitalism. For one thing, it looks as if the subject's belief in the Big Other was altered when traditional authorities, which were often perceived as the embodiment of the Big Other (like state, church, nation, etc.), lost their power. Further, the subject appears more and more like a self-creator who can 'choose' the direction of his or her life, invent his or her identity and even try to change the nature of his or her body. Pierre Legendre, already a decade ago, expressed a catastrophic view about the lack of prohibitions related to the way symbolic structure operates, warning: 'We do not understand that what lies at the heart of ultramodern culture is only ever law; that this quintessentially European notion entails a kind of atomic bond, whose disintegration carries alongside it the risk of collapsing the symbolic for those generations yet to come'.[1]

Referring to psychoanalysis, Legendre points out that a subject's entrance into language involves an act of separation: 'What psychoanalysis designates by general formulas such as the original or the law of the father is nothing other than an original separation which inaugurates subjective life (in a sense of a separation of the infant from the maternal entity), as subject to the law of differentiation

---

1. Pierre Legendre, "The Other Dimension of Law," *Cardozo Law Review* 16 (1995), 943ff.

through speech. Now separation supposes an aside (écart), a representation of emptiness, the integration, both by society and by the subject, of the category of negativity'.[2] Legendre explores whether Western culture has given up on 'introducing the subject to the institution of the limit', while other authors ask if on top of that we also gave up on the category of negativity. It is a common reflection today that the subject is under constant pressure to enjoy—to find ways to fill up his or her lack. Media, especially, seems to contribute to this 'push to enjoyment'.

What does it mean, therefore, when we hear philosophers like Legendre saying that we are living in a world without limits, when psychoanalysts speculate that a man is more and more without gravity, or when sociologists speculate that people feel so insecure and unhappy precisely because they seem to have far more choices in their lives than used to be the case?[3] Do we really live in a limitless world? Before we can make an attempt to answer this question, we need to explain what we mean by a limit.

Psychoanalysis from its beginning has been thinking about the logic of the limit that every speaking being needs to deal with. One of the cornerstones of Lacanian theory is the idea that the subject, by becoming a speaking being, goes through the process of symbolic castration and becomes marked by a lack. It is through the father that castration is passed on to the child. It is not that the father is a castrating figure. The agent of castration is language itself. It is the signifier that prohibits some primordial *jouissance* by replacing the thing with a word. The role of the father is to be the agent of the signifier; that is, he 'utters' the prohibition. However, this prohibition does not come into being via a father's simple 'No!' that limits the close relationship between a mother and a child. For the prohibition to be installed, the actual father does not even need to be present, since what is crucial is the way prohibition is part of the very discourse with which a mother (or another primary caregiver) addresses the child.

Although the lack that marks the subject is perceived by the latter as the loss of some essential jouissance, it is actually a cornerstone of subjectivity: because the subject is marked by a lack, he or she will constantly try to recuperate the object that he or she perceives to embody the lost enjoyment and that might fill up the lack. The very fact that the subject is marked by a lack is thus the engine that keeps his or her desire alive.

When dealing with his or her lack, the subject also encounters the problem that the Other is lacking, meaning that social symbolic order is inconsistent and that others, the subject's parents for example, are also marked by a lack. The most anxiety-producing dilemma for the subject is how he or she appears in the desire of the Other. Since there is no consistent Other which will be able to appease the subject and provide an answer as to what kind of an object the subject is for the Other, the subject constantly interprets, reads between the lines of what others say, guesses others' gestures, etc.

If these are all 'normal' concerns that people have in regard to the lack that

2. Ibid., 950.
3. See especially Michel Tort, *Fin du dogme paternel* (2005), Charles Melman, *L'Homme sagravité: Jouir à tout prix* (2002) and Jean-Pierre Lebrun, *Un monde sans limite: Essai pour une clinique psychanalytique du social* (2001).

marks them and the social symbolic order, what then changed in the nature of our concerns in times of late capitalism? Walter Benjamin took capitalism as a form of religion, as the celebration of a cult which very much plays on the feeling of guilt. His point is that 'worries' become a mental illness characteristic of the age of capitalism.[4] What kind of worries are we concerned with today? Does Benjamin's prediction that feelings of guilt are a crucial part of capitalism hold true today? Or is something changing at the start of the twenty-first century? How come, in times of the limitless choice that capitalism promotes, it appears that on the one hand people are encountering fewer and fewer external prohibitions, which in the past were transmitted with the help of traditional authorities, while on the other hand people are imposing ever new prohibitions on themselves?

## BE YOURSELF

The answer to the question 'Who am I for myself?' is in no way simple, which is why there is a huge advice industry, which tries to guide people in their search for their 'essence'. On the cover of a *Cosmopolitan* magazine, we can thus read a promise to help you 'Become yourself, only a better one'; on the Internet, various astrology sites provide free samples of insight into the 'real you'; and on television, one can undergo a total body makeover, which is supposed to allow people to forge a body image in which they will feel comfortable with themselves.

President Bush was reported to have said: 'I know who I am, and I want to become who I am'. The self is something to be aspired to, like the latest fashion or the latest consumer object. Self-aspiration and the created self are seductive. The winner of one of the Big Brother contests in the United Kingdom was a Portuguese transgender woman, Nadia Almada. When she was told that she had won, her response was 'Now I am recognized as a woman'. One question is why Nadia found such popularity with British television audiences. It seems from anecdotal evidence that what many voters found seductive was the project of a self-journey, the realization of a desire to make something completely different of oneself. With her self-transformation, she seemed to embody for the audience the ideology of self-creation that underpins today's consumerist society. It is perhaps not surprising that psychoanalysts report encountering numbers of people who come into analysis with the demand: 'I want to reinvent myself'.

However, in this attempt to remake oneself and become someone unique, one can easily observe a pattern of sameness. Walter Benjamin already envisioned this move towards sameness when he observed that

> The commodity economy reinforces the phantasmagoria of sameness which, as an attribute of intoxication, at the same time proves a central figure of semblance…The price makes the commodity identical to all the other commodities that can be purchased for the same amount. The commodity empathizes… not only and not so much with buyers as with its price.[5]

4. Walter Benjamin, 'Capitalism as Religion', in *Walter Benjamin: Selected Writings, Volume 1, 1913–1926*, ed. Marcus Bullock and Michael Jennings (Belknap Press, 1996), 288ff.

This phantasmagoria of sameness can easily be perceived in the way the ideology of 'self-creation' actually functions  Although people are constantly reminded to make out of themselves what they want, they are actually following ideals of sameness. One only needs to look at the results of body makeovers that one can observe on television to confirm that for the price one pays to get a new body one actually purchases a body image that everyone else adheres to.

The ideology that promotes the motto 'Be yourself!' and relies on the Nike ad 'Just do it!' also encourages the idea that people need to be able to 'manage' themselves. One is constantly reminded by the dominant media to work on relationships, on parenting, to become a better person and especially to manage one's emotions.[6] A simple search on amazon.com in regard to how to deal with an emotion like anger gives us a list of 95,000 books. A quick look at the titles gives the impression that anger is a huge problem in today's society. We live in 'The Trap of Anger', 'The Dance of Anger'; 'Anger Kills'; there is 'The Enigma of Anger', which causes 'Anger Disorders'; and there are 'Angry Women' who seem to experience rage differently than men. But especially important is 'Helping your angry child' to become 'anger-free'. Most of the books offer advice on how to get rid of angry feelings: 'Anger Management', 'Overcoming Anger', 'Beyond Anger', 'Conquering Anger', 'Letting go of Anger', 'Anger Control', 'Healing Anger', 'Working with Anger', 'Taking Charge of Anger' are only some of the titles of the books that are supposed to help us deal with this emotion. The next step is to 'Honour your Anger', to go 'From Anger to Forgiveness', and especially to realize that 'Anger is a Choice'.

The idea that we are supposed to be able to manage ourselves and that there is a choice in how we deal with our emotions is linked to the very perception of the self that dominates late capitalist society. Today, the true self is increasingly self-made, and more than that, an individual project. In the 1980s and 1990s, drawing on the work of Michel Foucault, academic theories emphasized the social construction of the self.[7] But now self construction has become a cultural imperative in the West, and the emphasis is not on social determinations, but on the individual project of self-making. This is related to what Ulrich Beck and others have called 'individualization'.[8] While individualization takes many forms, it always involves a 'fetishization' of the autonomous self, one that refuses to acknowledge the idea that society can set limits on self-aspiration. Paradoxically, the ideology of a limitless world is itself a product of late capitalism and the relentless drive of consumer society with its emphasis on endless choice and possibility.

If we live under the assumption that everything in life can be a matter of choice (on top of consumer and usual political choices, we can choose not only how we look, but our sexual orientation, whether or not to have children, what

5. Walter Benjamin, 'Exchange with Adorno on "The Flâneur"', in *Walter Benjamin: Selected Writings, Volume 4, 1938–1940*, ed. Howard Eiland and Michael Jennings (Belknap Press, 2003), 208.
6. On the idea of working on love, see Laura Kipnis, *Against Love: A Polemic* (2003).
7. See Michel Foucault, *The History of Sexuality: The Care of the Self* (1988).
8. See Ulrich Beck, *Risk Society: Towards a New Modernity* (1992); Ulrich Beck and Elisabeth Beck-Gernsheim, *Individualization: Institutionalized Individualism and Its Social and Political Consequences* (2002).

kind of medical treatment we want, etc.), the very choice seems to be anxiety-provoking[9] and deeply dissatisfying.[10] That is why we often hear in the popular media that our society actually suffers from so-called tyranny of choice and an abundance of freedom.

## TROUBLES WITH CHOICE

Consumer choice seems to be the most overwhelming problem in late capitalism. Barry Schwartz starts his book *The Paradox of Choice* with the difficulty consumers face when they want to purchase a simple pair of jeans.[11] Does one want slim fit, easy fit, relaxed fit, baggy or extra baggy fit? Should the trousers be ankle-length, normal, or long; faded or regular; black or blue; with button fly or zipper fly? Consumer choice becomes even more anxiety-provoking when, in any normal supermarket, we need to choose between 85 brands of crackers, 285 sorts of cookies, 360 shampoos, and 275 types of cereal; or when college students at American Ivy League schools choose from 350 courses of general education. Although shopping is perceived as one of the favourite pastimes in today's advanced capitalism, and people are spending more and more time in malls, they seem to be enjoying it less and less.

One area where choice is especially traumatic is medicine. Doctors today no longer play the role of authorities deciding what is best for the patients. Rather, they mostly inform the patient about his or her options, and then the patient needs to make a decision and give so-called informed consent.[12] However, do people really want to choose their treatment when they get seriously ill? The idea of choice seems appealing before one faces a life-threatening situation; however, when things get tough, people hope that someone else—an authority who supposedly knows—will choose for them. Research has thus shown that when a group of healthy people were asked whether they want to choose treatment if they get cancer, sixty-five percent said yes. But among people who actually did get cancer, only twelve percent wanted to make this choice.[13]

Why is there such dissatisfaction in regard to choice? Schwartz finds the problem to be too much choice. Quoting psychological research that shows how people exposed to less choice are more satisfied, Schwartz proposes various forms of self-limitation that consumers should impose on themselves in order to feel more content about their choices. One should 'choose when to choose', be a chooser not a picker, be content with 'good enough', make decisions nonreversible, practice an attitude of gratitude, regret less, anticipate adaptation, control expectations, curtail social comparison, and especially 'learn to love constraints'.

Why is it necessary that the person invent all these self-binding tactics? When

9. For more on this, see Renata Salecl, *On Anxiety* (2004).

10. There is also the so-called Monte Carlo effect in choosing (especially in gambling), which shows that the longer the sequence of failure, the greater the expectation of success (which is why one increases the stake with every loss).

11. See Barry Schwartz, *The Paradox of Choice* (2004).

12. On the troubles with choice in today's medicine, see Atul Gawande, *Complications: A Surgeon's Notes on an Imperfect Science* (2003).

13. See Schwartz, *Paradox*.

people complain that there is too much choice in today's society and that they are often forced to make choices about things they do not want to choose (like electricity providers), they often express the anxiety that no one is supposed to be in charge in society at large or that someone (for example, corporations) is already 'choosing' in advance what people supposedly need. These complaints very much concern people's troubles with the Big Other. It is Lacanian common sense that the Big Other does not exist, which means the symbolic order we live in is not coherent, but rather marked by lacks, inconsistent. There has been a wide literature to think through what this inconsistency means, and one way to perceive the lack that marks the social has been to think of it in terms of various antagonisms.[14] In addition to stating that the Big Other does not exist, Lacan stressed the importance of people's belief that it does. That is why Lacan ominously concluded that although the Big Other does not exist, it nonetheless functions; that is, people's belief in it is essential for their self-perception.

The act of choosing is so traumatic precisely because there is no Big Other: making a choice is always a leap of faith where there are no guaranties. When we try to create self-binding mechanisms which will help us feel content with our choices and eventually help us to be less obsessed with choice, we are not doing anything but 'choosing' a Big Other, that is, inventing a symbolic structure which we presuppose will alleviate our anxiety in front of the abyss of choice. The problem, however, is that the very existence of the Big Other is always our 'choice'—we create a fantasy of its consistency. And by doing so, we choose the possibility of not choosing.

The type of belief people have in the Big Other differs from subject to subject. There are especially large differences between people to whom it might be possible to ascribe a neurotic structure and psychotics. While neurotics have a lot of doubts, uncertainties, and complaints in regard to the Big Other, psychotics might develop a much more threatening perception of the Big Other and, for example, start perceiving themselves as persecuted by an invisible voice or gaze, and are thus overwhelmed by the Big Other's massive presence. The uncertainties that neurotics deal with very much prove that the Big Other does not exist as a coherent whole, which is why neurotics often engage in a game of searching for a master who seems to be in charge (and thus appears as a consistent Other), while at the same time they try to undermine the master's authority. With the latter gesture, neurotics in a paradoxical way acknowledge the inconsistency of the Other.

## THE NEW PSYCHOTICS?

In the early seventies, Lacan made the observation that in a developed capitalist system, the subject's relationship to the social field can be seen to form a particular discourse. In this 'Discourse of Capitalism',[15] the subject relates to the social

---

14. See Ernesto Laclau, *Emancipation(s)* (1996); Jannis Stavrakakis, *Lacan and the Political* (1999).
15. Jacques Lacan developed this theory in his lecture at the University of Milan on 12 May 1972. The original text is unpublished.

field in such a way that he or she takes him- or herself as a master. The subject is not only perceived to be totally in charge of him- or herself, he or she also appears to have power to recuperate the loss of jouissance. In capitalism, the subject is thus perceived as an agent with enormous power.

What does it mean that the subject is placed in the position of such an agent? First, it looks as if this subject is free from subjection to his or her history and genealogy and thus free from all signifying inscriptions. This seems to be the subject who is free to choose not only objects that supposedly bring him or her satisfaction, but even the direction of his or her life; that is, the subject chooses him- or herself.

Lacan points out that in the discourse of capitalism one finds rejection, or better, foreclosure of castration. This foreclosure happens when society increasingly functions without limits and where there seems to be a constant push towards some kind of limitless jouissance. This push to jouissance at all costs is especially visible in all forms of toxic mania—from excessive consumption of alcohol and drugs to shopping, workaholism, etc.[16] Capitalism transforms the proletarian slave into a free consumer. However, limitless consumption paradoxically provokes the moment when the subject starts 'consuming himself'.

And although the subject in the discourse of capitalism is perceived as being totally in charge or him- or herself and free to make numerous choices, one sees the paradoxical trend by which this possibility of choice opens doors to an increase of anxiety. One of the ways to deal with this anxiety is a strong identification with the master. The latter allows the subject to relinquish his or her doubt, to avoid choice and responsibility, and thus in some way to find relief for his or her own existence.

While it is easy to admit that in today's society there have been changes in subjects' self-perception, as well as in their perception of the Big Other, is one right to conclude that these changes have contributed to an increase of psychosis? Nowadays, some psychoanalysts are looking closely at cases of so-called non-triggered psychosis, where there is no delirium to show that a person has a psychotic structure. Some are thus reviving Helen Deutsch's idea of 'as if' personalities: people who might not actually develop a full-blown psychosis like Schreber,[17] but nonetheless have a psychotic structure. Some analysts call these cases 'ordinary psychosis' or 'white psychosis'. What distinguishes these individuals from neurotics is that they often express enormous certainty with regard to their perception of reality. They are people without doubts.

One French psychoanalyst describes the case of a male patient who had had a number of successful careers in his life. As a young man, he had befriended a lawyer in a prominent firm and became a successful lawyer himself. Then he met a sailor on the street and followed him into the merchant navy. Later he encountered a businessman and turned himself into a successful businessman. Unlike

16. One type of critique of late capitalism points out that the consumer is just a semblant of the agent, following only a semblance of freedom. In reality, he or she is under the pressure of demand. This demand is not coming from the master signifier, but from the place of jouissance—the *objet petit a*.
17. Daniel Paul Schreber's legendary case of psychosis is described in his 1903 book, *Memoirs of My Nervous Illness*. (Editorial note)

Schreber, this was not a delusional form of psychosis triggered by a particular event. Rather it was a series of successful identifications where the patient not only mimicked other individuals, but also used these powerful identifications with people he randomly encountered to transform his whole life without experiencing any apparent anxiety or doubt about the path he had chosen. When the psychoanalyst asked the patient why given his success he felt it necessary to enter analysis, he replied simply 'My wife told me to do so'. Not surprisingly, he became a very successful patient!

In 1956, Lacan took the 'as-if' (which is nowadays often referred to as borderline structure) as a 'mechanism of imaginary compensations' to which subjects have recourse who 'never enter into the play of signifiers, except by a sort of exterior imitation'. This form of imitation can easily be understood as another version of the simulacra and sameness that Benjamin was talking about. When the subject is caught in this imaginary dimension, he or she has lots of problems with his or her identity (interweaving of identity, illusions of doubles, etc.). One of the features of psychotics is that they are obsessed with mimicry, shaping themselves according to one set of ideas and then just as quickly abandoning them, especially by strongly identifying with other people.

Are we really living in a limitless world? We have increasingly interventionist states, authoritarian-leaning state leaders, and numerous other authorities in the form of self-help gurus, religious leaders, and the like. In this case, why does the ideology of the late capitalist self encourage us to live 'as if' we were without limits, in fact free? Is the modern self out of touch with reality, delusional in some sense? Can we argue that late capitalism is producing more psychosis, as some psychoanalysts want to suggest?

This would be a duly simplistic and pessimistic conclusion. There is certainly some evidence for increasing plasticity in forms of identification. Players on the Internet rarely appear as themselves, preferring in many cases to change not only their gender and sexual orientation, but also their race, religion, and age. There is nothing new about fantasizing about being someone else, but modern trends suggest something more profound. In the age group 18–25 in the United Kingdom, more young people not only report having had a sexual experience with both a person of the same sex and one of the opposite sex, but they are unwilling to classify or categorize their sexuality on the basis of sexual practice. The gay–straight distinction appears to have little purchase for these young people in terms of how they categorize themselves and others. As one commentator remarked, 'Homosexuality is over!'[18]

However, refusing categorizations and playing with your sexual identity is not the same thing in any sense as Schreber's delusion that he had been turned into a woman. Schreber had no doubt about his bodily transformation. It is also not the same thing as the mimicry in the case of 'the successful patient' described earlier, whose transformations caused him no anxiety or uncertainty. In contrast, those of us who are ceaselessly remaking ourselves in the contemporary moment have many doubts, and can often feel overwhelmed by the fear of failure.

18. I am indebted to Henrietta Moore for this assessment of U.K. culture.

Our play with identifications is quite different from the mimicry of the psychotic. His or her certitude is replaced in the contemporary moment with something that looks more like the celebration of undecidability.

Yet this undecidability is itself caught up in capitalist circuits, as evidenced by the rise—and subsequent marketing—of the metrosexual. The metrosexual is less a sexual identity than a set of consumer identifications. So under late capitalism, shifts in identity and indeed in identifications are celebrated as the new vogue and turned into profit.

If one cannot easily agree with pessimistic conclusions that psychosis seems to be overwhelmingly present in late capitalism, one nonetheless needs to admit that something has changed in the subject's relationship towards him- or herself as well as society at large, that there is a change in the nature of limits and a push towards excessive jouissance.

Let us look at how the lack of limits affects personal relationships today. In the society determined by the idea of choice, matters of love and sexuality at first seem extremely liberating. What is better than envisioning freedom from social prohibitions when it comes to our sexual enjoyment; how wonderful it appears to finally stop bothering about what parents and society at large fashion as normal sexual relations; how liberating it seems to change our sexual orientation or even the physical appearance of sexual difference. It is more than obvious that such 'freedom' does not bring satisfaction; on the contrary, it actually limits it.

In analysing human desires, psychoanalysis has from the beginning linked desire with prohibition. For the subject to develop desire, something has to be off-limits. When the subject struggles with ever-evolving dissatisfaction in the face of the unattainability of his or her object of desire, the solution is not to get rid of the limit in order to finally fuse with the object of desire, but to be able to somehow 'cherish' the very limit and perceive the object of desire as worthy of our striving precisely because it is inaccessible.

When we look at how we deal with sexuality in this supposedly limitless society, it is easy to observe that limits did not actually disappear or that prohibitions still exist; however, the locus where they originate has changed. If in the past prohibitions were transmitted with the help of social rituals (like initiation rituals in premodern society and the functioning of the paternal prohibition in the traditional patriarchal society), today the subject sets his or her own limits. The contemporary subject is thus not only self-creator, but also his or her own 'prohibitor'.

## CONCLUSION

When the subject deals with castration, he or she also deals with dissatisfaction. However, what we are observing today is not so much an escalation of dissatisfaction as an increase in frustration. Frustration is, in a special way, linked to a subject's problem with jouissance. In contemporary racism, for example, the subject presupposes that the Other has access to some full jouissance which provokes frustration on the side of the subject. In personal relationships, the problem is that the subject tries to get some excess enjoyment from the partner (for men, a sexual one; for women, a narcissistic one) and after this attempt nec-

essarily fails, the partner loses importance and becomes one of the objects one can easily reject. For the subject who lacks stable identifications, has a fluctuating choice of objects and instability in affective investments, and who quickly passes to act, one way to try to find the lost jouissance is with the help of addictive substances. The paradox thus is that on the one hand, the subject searches for new forms of enjoyment and is thus under constant pressure to consume (which sadly often brings him or her to self-consumption), but on the other hand, the subject desperately searches for new limits, even if they are self-imposed.

Although Benjamin predicted that worries would become overconsuming in capitalism, he also made the puzzling remark that 'The concept of progress must be grounded in the idea of catastrophe. That things are 'status quo' is catastrophe. It is not an ever-present possibility but what in each case is given. Strindberg's idea: hell is not something that awaits us, but this life here and now'.[19] Maybe the gloomy prediction that we are entering into a society dominated by psychosis expresses this very enjoyment in catastrophes. Is the biggest catastrophe of today's society that not much has radically changed in the nature of our worries? However, we do feel that we have surpassed our predecessors in our suffering.

19. Walter Benjamin, *Central Park*, in *Selected Writings 4*, 185.

# 665/
# THE LESSER EVIL
## EYAL WEIZMAN

A few months ago a friend sent me the following lines by the Italian comedian Beppe Grillo: 'For a long time Italians have been in a [political] coma. We are always in search of the lesser evil. In fact, we should construct a monument for the "lesser evil". A huge monument in the middle of Rome'.

If anyone ever asked me to build such a monument, in Rome or elsewhere, I would probably look for a high hill and place the digits 665 (like giant Hollywood letters) overlooking the city centre—a notch less than evil, a counter displaying the fact that our society has become a calculating machine.

Indeed the principle of the 'lesser evil' has become so prominently identified with the ethico-political foundations of liberal capitalism (and its political system that we like to call democracy) and so firmly naturalized in common speech that it seems to have become the 'new good'. Commenting upon the comparative merits of democracy shortly after the end of World War II, Winston Churchill may have inaugurated this trend when he sardonically noted that 'it has been said that democracy is the worst form of government except all those other forms that have been tried from time to time'. Since then, and increasingly since Soviet (and Third World) horrors began to be exposed a decade into the Cold War, the projection of totalitarian horrors has been mobilized, beyond a frank concern for individual rights, to stop all search for a different form of politics. It was ultimately the mediated spectre of these atrocities that compelled the public to constantly weigh liberal disorder against the worse evils of totalitarian tyranny in favour of the former. In comparison to the horrors of totalitarianism, this inegalitarian and unjust regime was presented as a responsible 'lesser evil', 'the best of all worlds

1. Alain Badiou has been the strongest critic of this notion: 'If the lamentable state in which we find ourselves is nonetheless the best of all real states [...] [If humanity] will not find anything better than currently existing parliamentary states, and the forms of consciousness associated with them, this simply proves that up to now the political history of men has only given birth to restricted innovations and we are but characters in a pre-historic situation [...] [that] will not rank much higher than ants and elephants'. See Alain Badiou, 'Eight Theses on the Universal', in *Theoretical Writings*, ed. and trans. Ray Brassier and Alberto Toscano (London: Continuum, 2004), 237. Renata Salecl introduced Badiou's work to the discussion in a workshop titled 'Lesser Evils' organized by Thomas Keenan, Eyal Sivan and myself in February 2008, hosted by Bard College, Manifesta 7 (Trento) and the Goethe Institute New York . Presentations were given by the organizers and by Adi Ophir, Ariella Azoulay, Simon Critchley, Joshua Simon, Olivia Custer, Renata Salecl, Karen Sullivan and Roger Berkowitz. Salecl introduced Badiou's ideas through a reading of an interview in two parts Badiou gave to *Cabinet* magazine before and after 9/11 (http://www.cabinetmagazine.org/issues/5/alainbadiou.php). Salecl added new doubts of her own: 'not even knowing what good and evil are, how can we choose and calculate? When evil is so enjoyable, what does "lesser evil" mean?'

*possible*', and as a necessary barrier against regress to bloody dictatorships.[1]
This multifaceted political shift within the left was largely promoted by post-1968
western 'radicals' who switched the focus of their political engagement to
criticizing left-totalitarian regimes across the second and third worlds, while argu-
ing for the autonomy of civil society at home. The notions espoused by these
largely French *nouveaux philosophes* — 'let's hold on to what we have, because
there is worse elsewhere' — demonstrated that for liberals 'evil' was always some-
where else, lurking behind any attempt at political transformation.[2]

Hannah Arendt, the thinker who has done most to analyze and compare the
political systems of totalitarianism, and whose work *The Origins of Totalitarian-
ism*[3] was most often mobilized in relation to this 'antitotalitarian' shift in the left,
saw the principle of the 'lesser evil' strongly at work, not only in the 'making-do'
of liberal capitalism but in the way the totalitarian system tended to camouflage
its radical actions from those yet to be initiated — the majority of bourgeois sub-
jects needed to run things until a 'new man' was created. Writing about the col-
laboration and cooperation of ordinary Germans with the Nazi regime, mainly by
those employed in the Civil Service (but also by the Jewish councils set up by
the Nazis), she showed how the argument for the lesser evil has become one of
the most important 'mechanisms built into the machinery of terror and crimes'.
She explained that 'acceptance of lesser evils [has been] consciously used in
conditioning government officials as well as the population at large to the ac-
ceptance of evil as such', to the degree that 'those who choose the lesser evil
forget very quickly that they chose evil'.[4] Against all those who stayed in Germa-
ny to make things better from within, against all acts of collaboration, especially
those undertaken for the sake of the moderation of harm, against the argument
that the 'lesser evil' of collaboration with brutal regimes is acceptable if it might
prevent or divert greater evils, she called for individual disobedience and collec-
tive disorder. Participation, she insisted, communicated consent; moreover, it
handed support to the oppressor. When nothing else was possible, to do *nothing*
was the last effective form of resistance, and the practical consequences of re-
fusal were nearly always better if enough people refused. In her essay 'The Eggs
Speak Up', a sarcastic reference to Stalin's dictum that 'you can't make an ome-
let without breaking a few eggs', Arendt pleaded for 'a radical negation of the
whole concept of lesser evil in politics'.[5]

In Arendt's writings the principle of the lesser evil is presented as a pragmatic
compromise and frequent exception to 'common ethics', to the degree that it
has become the most common justification for the very notion of exception. It is

2. For Badiou, according to Salecl, evil is when one lacks the strength to search for the good. The poli-
tics of the lesser evil give up on the *event*, renounce the drive. At the Bard workshop, she asked: 'Is
there a new theory of the good ready to fight the self-contents of liberalism?'
3. Hannah Arendt, *The Origins of Totalitarianism* (New York: Harvest Books, 1973).
4. Hannah Arendt, *Responsibility and Judgment* (New York: Schocken, 2005), 35. In his presentation to
the workshop, Roger Berkowitz presented Arendt's argument against the 'lesser evil' in the context of
her thought on judgment, as part of what she identified as 'the crisis of judgment'.
5. Hannah Arendt, 'The Eggs Speak Up' (1950), in *Essays in Understanding, 1930–1954: Formation, Ex-
ile, and Totalitarianism*, ed. Jerome Kohn (New York: Schocken, 2005), 270–284; see especially 271. Ar-
endt claims that Stalin's 'only original contribution' to socialism was to transform the breaking of eggs
from a tragic necessity into a revolutionary virtue.

in this seemingly pragmatic approach that the principle of the lesser evil naturalizes crimes and other forms of injustice, acting as a main argument in the state's regime of justification—people and regimes tend to invent retroactive explanations for atrocious actions. Furthermore, Arendt saw the calculation and measurement of goods and evils, like statistical trends in the social sciences, as diminishing the value of personal responsibility. Once ethics is seen in the form of an economy, when issues are put into numbers, they can be changed and turned around endlessly. And lastly, the terms of the lesser evil are most often posed by and from the point of view of power. Using a formulation she conceived with Mary McCarthy, Arendt explained: 'If somebody points a gun at you and says, "Kill your friend or I will kill you", he is *tempting* you, that is all'.[6]

It is important to note that when speaking about the political options available to people living in the postwar western states, Arendt was much less damning about the principle of the 'lesser evil'. She implied that these options did include various forms of compromise and measure.[7] In other words, she described the lesser evil as a false dilemma when faced with a totalitarian regime that itself has no concept of the lesser evil (totalitarians simply camouflage their acts as lesser evils), but as a part of the very structure of politics in the context of Cold War western democracies. Whether we accept them or not, the distinctions she implied point to a possible *differend* within the term, and could lead us to open up the concept further. The various historical and philosophical uses of the lesser evil idiom demonstrate that it meant different things to different people at different periods in different situations. There is a difference between masking an act of perpetration as a 'lesser evil', choosing the lesser of two evils and trying to make the world a little less evil while still pursuing a cause.

***

I would like to divide the use of the idiom 'lesser evil' into two—*particular* and *general*. The particular case is presented to a person or to a group of people as a dilemma between two (or more) bad options in a given situation. The general case is the structuring principle in an economy of ethical calculations, manifested in attempts to reduce or lessen the bad and increase the good. Both cases affirm an economic model embedded at the heart of ethics according to which, in absence of the possibility to avoid all harm, various forms of misfortune must be calculated against each other (as if they were algorithms in a mathematical minimum problem), evaluated, and acted upon. The principle of the lesser evil implies that there is no way out of calculations.

As a dilemma, the 'lesser evil' is presented as the necessity of a choice of action in situations where the available options are or seem to be limited. It is a dilemma in the classical Greek sense of the word—when both of the two options

6. See Arendt, *Responsibility and Judgment*.

7. In an article on segregation in southern schools, after making her readers understand she was against all forms of racism, she voiced scepticism about federally enforced integration, claiming it politicized the educational system, which she believed should be immune to such forces, and insisting that the survival of the Republic may require that the battle line be drawn somewhere else. Hannah Arendt, 'Reflections on Little Rock', *Dissent* 6, no. 1 (1959): 45–56.

presented to the tragic hero necessarily lead to different forms of suffering. The dilemma implies a closed system in which the options presented for choice could not be questioned or negotiated. Regardless of what option is chosen, accepting the terms of the question leaves the (political) power that presented this 'choice' unchallenged and even reinforced. It is in accepting the parameters as given that the lesser evil argument is properly ideological. The dilemma, if we are still to think in its terms, should thus not only be about which of the bad options to choose, but whether to choose at all and thus accept the very terms of the question. When asked to choose between the two horns of an angry bull, Robert Pirsig suggested alternatives: one can 'refuse to enter the arena', 'throw sand in the bull's eyes', or even 'sing the bull to sleep'.[8]

## THE 'PERPETRATORS OF LESSER EVILS'

The term 'lesser evil' has recently been prominently invoked in the context of attempts to moderate the excesses of western states, in particular in relation to attempts to govern the economics of violence in the context of the 'War on Terror', and in private organizations' attempts to manoeuvre through the paradoxes and complicities of human rights action and humanitarian aid. More specifically, the lesser evil has been most often invoked at the very intersection of these two spheres of action—military and humanitarian. In relation to the 'global War on Terror', the terms of this argument were recently articulated in a book titled *The Lesser Evil* by human rights scholar and now deputy leader of the Liberal Party of Canada, Michael Ignatieff. In his book, Ignatieff suggests that liberal states should establish mechanisms to regulate the breach of some rights and allow their security services to engage in forms of extrajuridical violence—in his eyes, 'lesser evils'—in order to fend off or minimize potential 'greater evils', such as further terror attacks on civilians of the western states. His conception of the lesser evil is presented as a balancing act because its flexible regime of exceptions should be regulated through a process of 'adversarial scrutiny of an open democratic system' and is thus also aimed to prevent the transformation, through the 'temporary' primacy given to the security services, of the liberal state into a totalitarian one.[9] Ignatieff calls for the security officials of liberal democracies to become the 'perpetrators of lesser evils'.[10] These postmodern perpetrators (the lesser evil should surely replace the 'banality of evil' as the contemporary form of perpetration of crimes of state) should weigh various types of destructive measures in a utilitarian fashion, in relation not to the damage they produce but to the harm they purportedly prevent. The calculation, however, is obviously most often about the suffering of somebody else.

Ignatieff's conception of the 'lesser evil' is problematic even according to the utilitarian principles invoked. The very economy of violence assumes the possi-

---

8. Robert Pirsig, *Zen and the Art of Motorcycle Maintenance* (New York: Bantam, 1974).
9. Michael Ignatieff, *The Lesser Evil: Political Ethics in an Age of Terror* (Princeton: Princeton University Press, 2004)
10. Ibid., 152.

bility of less violent means and the risk of more violence, but questions of violence are forever unpredictable and undetermined. The supposed 'lesser evil' may always be more violent than the violence it opposes, and there can be no end to the challenges that stem from the impossibility of calculation.[11] A less brutal measure is also one that can easily be naturalized, accepted and tolerated.[12] When exceptional means are normalized, they can be more frequently applied. The purported military ability to perform 'controlled', 'elegant', 'pinpoint accurate', 'discriminate' killing could bring about more destruction and death than 'traditional' strategies did because these methods, combined with the manipulative and euphoric rhetoric used to promulgate them, induce decision makers to authorize their frequent and extended use. The illusion of precision, part of the state's rhetoric of restraint, gives the military-political apparatus the necessary justification to use explosives in civilian environments where they cannot be used without injuring or killing civilians. This process, recalling Herbert Marcuse's analysis of 'repressive tolerance',[13] may explain the way western democratic societies can maintain regimes of brutal military domination without this brutality affecting their self-perception as enlightened liberals. Elevating, for example, targeted assassinations (Ignatieff considers targeted assassination to fall 'within the effective moral-political framework of the lesser evil')[14] to a legally and morally acceptable standard makes them part of the state's legal options, part of a list of counterterrorism techniques, with the result that all sense of horror at the act of murder is now lost. The lower the threshold of violence attributed to a certain means and the lower the threshold of horror implied in its use, the more frequent its application could become. Because they help normalize low-intensity conflict, the overall duration of this conflict could be extended and finally more lesser evils could be committed, with the result of the greater evil reached cumulatively.[15]

11. In the Lesser Evils workshop at Bard, reading Ignatieff's book, Thomas Keenan pointed to the impossibility of calculating evils. Rejecting the notion of grades of violence, he used a Derridean formulation when he argued: 'is not the slightest violence always already the greatest violence?' He pointed as well to the fallacy in the supposed difference between qualitative and quantitative judgment on evil, asking whether the quantitative cannot cross a threshold and become qualitative itself.
12. Adi Ophir, *The Order of Evils,* section 7.100 as well as 7.2 and 7.3. See for example 7.335.
13. Herbert Marcuse, 'Repressive Tolerance' (1965), http://www.marcuse.org/herbert/pubs/60spubs/65repressivetolerance.htm. The essay examines the idea of 'tolerance' in advanced industrial society. Marcuse claims that the 'objective of tolerance would call for intolerance toward prevailing policies, attitudes, opinions, and the extension of tolerance to policies, attitudes, and opinions which are outlawed or suppressed'.
14. This under the following conditions: that they are 'applied to the smallest number of people, used as a last resort, and kept under the adversarial scrutiny of an open democratic system'. Furthermore, 'assassination can be justified only if [...] less violent alternatives, like arrest and capture, endanger [...] personnel or civilians [or] are not possible, [and] where all reasonable precautions are taken to minimize collateral damage and civilian harm'. Ignatieff, *The Lesser Evil*, 8, 129–133.
15. It is this principle that guarantees, paradoxically, that all 'greater goods' could necessarily become 'greater evils'. Health economists have a chilling and interesting version of this economy of calculations, a 'value of statistical life', or VSL, to cope with what some of its proponents see as the following conundrum: the 'prevention of every possible accidental death would be intolerably costly in terms of both money and the quality of life'. See Nina Power and Alberto Toscano, 'The Philosophy of Restoration: Alain Badiou and the Enemies of May', forthcoming in *Boundary 2*.

# THE HUMANITARIAN PARADOX OF THE LESSER EVIL

From this perspective it is possible to see that the discourse and practice of humanitarianism and human rights might paradoxically turn against the people it claims to help. When every soldier in what George W. Bush has called 'the armies of compassion' becomes a proxy expert in humanitarianism, humanitarian concerns could easily become a pretext to justify 'neutrality' with respect to a brutal conflict (as in Sarajevo) or an alibi for a political decision to mount a 'military intervention' against a sovereign state (as in Iraq).

Beyond state agents, 'the perpetrators of lesser evil' must also include nonstate organizations. Putting an end to human rights violations has become, increasingly since the 1990s, the platform that allows for the possibility of collaboration between NGO activists and western militaries. Beyond the fact that the moralization of politics through the terms 'freedom', 'human rights' and 'liberal democracy' has led to a general depoliticization, the paradox is that human rights and humanitarian action can in fact aggravate the situation of the very people it purportedly comes to aid.

The paradox of the lesser evil impacts most independent nongovernmental organizations that make up the various systems in the ecology of contemporary war and crisis zones, in addition to the military and the government.

Lesser evil is the common justification of the military officer who attempts to administer life (and death) in an 'enlightened' manner; it is the brief of the security contractor who introduces new and more 'efficient' weapons and spatio-technological means of domination and advertises them as 'humanitarian technology'. Lessening evil is moreover the logic defining the actions of the subjects of this regime, who, sometimes assisted by human rights organizations, lodge petitions challenging the brutality of these means and powers. Lesser evil is the argument of the humanitarian agent as he seeks military permission for providing life substances and medical help in places where it is in fact the duty of the military in control.

This logic of the lesser evil somewhat obscures the fundamental moral differences between the various groups that compose the ecologies of conflict and crisis in allowing for the aforementioned moments of cooperation. Significantly, the western system of domination learned to use the work of local and international organizations to fill the void left by 'dysfunctional' Third World governments and manage life in their stead. Indeed, the urgent and important criticism that peace organizations often level at western militaries, to the effect that they dehumanize their enemies, masks another process by which the military incorporates into its operations the logic of, and even seeks to cooperate directly with, the very humanitarian and human rights organizations that in the past opposed it.

At the core of the paradoxes of the lesser evil is a tactical compromise that could deteriorate into a structural impossibility—one that would entangle the state and its opposition in a mutual embrace, making nonstate organizations de facto participants in a diffused system of government. In Slavoj Zizek's words, the state thus 'externalizes its ethical self-consciousness in an extra-statal ethico-political agency, and this agency externalizes its claim to effectiveness in the state'.[16] In this manner, human rights and humanitarian NGOs could do the ethi-

cal thinking and some of the ethical practice, while their state does the killing.

The spatial order of contemporary military power emerges not only from a series of open acts of aggression, but through attempts at the moderation and restraint of its own violence.[17] Recently, western militaries began using the vocabulary of international law, with the effect that human rights principles such as 'proportionality' have become compatible with military goals such as 'efficiency'.[18]

## THE GOVERNMENT OF EVIL (IN SOULS)

The common use of the term 'lesser evil' masks a rich history and various intellectual trajectories. What may otherwise seem to be a perennial problem endemic to ethics and political practice, a dilemma that simply reappears at every period anew in the same shape and form, in fact reveals something peculiar about each historical moment and situation. The different trajectories of the term cast different shadows on the investigation of the lesser evil as one of the problems of the politics of the present. What follows is not a sustained history of the concept but rather several of its paradigmatic moments, the beginning of a possible archive of probes into the lesser evil argument.

One of the trajectories of the concept of the lesser evil originated in early Christian theology and was secularized into the utilitarian foundations of liberal ethics. It formed the basis for the philosophy of 'ethical realism', differently formulated by George Kennan and Hans Morgenthau. Ethical realism traces its origins to Saint Augustine and Saint Thomas Aquinas and insists on some ethical constraints on states and military action. It sees the role of liberal states and especially that of the United States in the pursuit of moral goals such as 'freedom', 'human rights' and 'democracy'. The destiny of the United States in particular and 'the West' in general is to fight radical evil, whose traces could be found in any project predicated on an articulation of the idea of the 'good' (religious fundamentalism or communist egalitarianism).

One component in the idea of the lesser evil, however, has gone missing in its secularization. For the Christian fathers the toleration of the lesser evil, as I will later show, should be understood in relation to the religious telos of salvation. The immanent management of evil on behalf of the church was conceived as part of a quest for perfection which forms a necessary stage on the way to transcendence—the replacement of the earthly kingdom with a heavenly one. Unlike the teachings of the Christian fathers, the liberal striving for perfection is not a quest for eventual transformation. Without transcendence it is locked within a perpetual economy of immanence and could be better interpreted as a drive for the 'optimization' of the existing system of government.[19]

16. Slavoj Zizek, *In Defence of Lost Causes* (London: Verso, 2008), 349.
17. Michel Feher, 'The Governed in Politics', in *Nongovernmental Politics*, ed. Michel Feher (New York: Zone, 2007), 12–27, esp. 21.
18. David Kennedy, *The Dark Sides of Virtue: Reassessing International Humanitarianism* (Princeton: Princeton University Press, 2004), 235–323, esp. 295.
19. Anatol Lieven and John Hulsman, *Ethical Realism: A Vision for America's Role in the World* (New York: Pantheon Books, 2006).

\*\*\*

The vast extraterritorial institutional network of the ecclesiastical pastorate—the Church as it was formed and institutionalized from around the turn of the fourth century—dealt with the problem of the lesser evil in the context of the practical and intellectual problem of 'the government of souls'. In his lectures on the origins of governmentality Michel Foucault analyzed the Christian form of pastoral power. 'Economical theology' sought to understand the management of both human and divine orders, each with its immanent order of execution. In relation to human action the divine management of evil is both *general* and *particular*, bearing on both the individual and society, the multitude of people in the flock. The Christian order thus operated by simultaneously individualizing and collectivizing—granting as much value to a single person as to the community and the multitude.[20] Salvation—deliverance from the power and penalty of sin and evil and the redemption of the soul—must thus address *all* and *each*. This form of salvation is one of the aspects of general and particular providence. The pastor must account not only for the well-being of individual and community but for the totality of good or evil they perform personally and collectively.

Discussions of *particular* providence are organized around the question of choice, or of free choice—how to identify and pursue good and avoid evil. *General* providence, on the other hand, invokes a vastly complex *intra*personal economy of merits and faults—of sin, vice and virtue—operating according to specific rules of circulation and transfer, with complex procedures, analyses, calculations and tactics that allow the exercise of this very specific interplay between conflicting goods and degrees of evil.[21]

But Foucault does not explain how evil could be understood in terms of an economy. The source of this understanding is the teaching of Saint Augustine. In early Christian theology evil is no longer seen as the equal opposite of good. In the course of his break from Manichaeism, Augustine no longer saw evil as glamourously demonic but rather merely as 'the absence of good', a deficiency of being that has no standing by itself. Evil is relative and differential, an obstacle to perfection, that which stands between man and the good. Because evil is not absolute, demonic or perfect it is forever on a scale of less and more, lesser and greater.

It is through this conception of evil that Augustine addressed the problem of the lesser evil. For Augustine, the lesser evil is not *permissible*, as it clearly violates the Pauline principle 'do no evil that good may come'. It could however be *tolerated* in certain circumstances. For the lesser evil to be tolerated the situation has to be defined in such a way that a possible resultant evil outcome is a necessary and unavoidable consequence of the performance of individual and collective duties.

20. Michel Foucault, *Security, Territory, Population: Lectures at the College de France 1977–1978*, ed. Arnold I. Davidson, trans. Graham Burchell (London: Palgrave Macmillan, 2007), 164–173. The immanent disorder exercised by the pastorate was 'an art of conducting, directing, leading, guiding, taking in hand, and manipulating men, an art of monitoring them and arranging them [...] an art of taking charge of men collectively and individually throughout their life and at every moment of their existence' (173). 21. Foucault, *Security, Territory, Population*.19. Anatol Lieven and John Hulsman, *Ethical Realism: A Vision for America's Role in the World* (New York: Pantheon Books, 2006).

In his economy of lesser and greater evils, it is better to tolerate prostitutes in society than to risk adultery, and it is better to kill an assailant before he may kill an innocent traveler.[22] In this way the principle of the lesser evil is conflated with the concept of *preemption*, and Augustine's rationale for preemption is one of justice. Even war could be just under certain conditions. Under the principles of just war, a war should be considered 'just' if those waging it do so with the intention of doing good or pursuing a just purpose (such as, centuries later, the crusades), or with a desire to reach peace rather than wage wars for one's own gain or as an exercise of power. Furthermore, just wars must be waged by properly instituted authorities of organized arms.

It is thus not coincidental that the discourse of the lesser evil developed at a time when the Christian church acquired real appetite and the real ability to exercise political and military power. Augustine, a fourth-century Christian, was teaching at the time Christianity had acquired the power to govern larger societies, and tried to reconcile Christian pacifism with the world of politics and the obligations of Roman citizens.

Importantly, Augustine saw the *lessening of evil* as part of a general inclination to pursue the good and a quest for transformation. Unlike in the tradition of liberal ethics that invoked him, in Augustine's teachings progress towards a lesser imperfection is not produced by or content with a lesser imperfection. Only the desire for perfection could destroy in the soul these aspects of the evil that defile it.[23] This progress—the lessening of evil—is the only way towards perfection and the ultimate transformation of the kingdom from earth to heaven. The individual must strive for the kind of perfection that would put her closer to God, overreach the earthly and thereby help transform it.

The *general* aspects of the problem of the lesser evil are also articulated in other theological discussions about the economic basis of *divine* government—the question of the origins and management of evil. It addressed the perennial question of theological philosophy: If God governs the world and if God's economy is necessarily the most perfect one, how can we explain evil—natural catastrophe, illness, crimes?

In the context of his investigation of *economia*, a form of governmental power, Giorgio Agamben discussed one of the first formulations of this question by Alexander of Aphrodisia, a late Aristotelian commentator of the second century: God in his providence establishes general laws which are always good, but evil

22. Augustine thought that prostitutes should be tolerated 'because they fulfil a similar function in society to that of the cesspool in the palace'. Speaking through Evodius, Augustine says: 'It is much more suitable that the man who attacks the life of another should be slain than he who defends his own life; and it is much more cruel that a man should suffer violation than that the violator should be slain by his intended victim' (118, De lib. arb. I.v.12). In her presentation for the Lesser Evils workshop at Bard, Karen Sullivan presented Augustine's teachings against lying as one of the only cases in which a compromise for the lesser evil is not even possible. 'A lie is an offence against truth, perversion of speech', and the imperative against it should in no case be breached, even to save innocent people. Having such universal effect, lying is worse than killing; the latter is tolerated under certain conditions of the lesser evil principle.
23. Simone Weil, *Oppression and Liberty* (Florence, KY: Routledge, 2001), quoted in Peter Paik Yoonsuk, 'The Pessimist Rearmed: Zizek on Christianity and Revolution', *Theory & Event* 8, no. 2 (2005). Karen Sullivan made a similar point in her discussion of Augustine.

results from these laws as a collateral side effect. For example: rain is obviously a good thing, but as a collateral effect of the rain there are floods. Collateral effects—the bad effects of the divine government—are thus not accidental, but define the very *structure* of the action of government. Furthermore, it is through these collateral effects that the divine government becomes effective.

A millennium and a half later, in his *Théodicée*, Leibnitz attempted to resolve the same perennial question in a somewhat different manner. His intention is similarly to reconcile the apparent faults and imperfections in the world, which he does by claiming that the world is optimal among all possible worlds: 'to show that an architect could have done better is to find fault with his work [...] [if] a lesser evil is relatively good, so a lesser good is relatively evil'. Leibnitz unfolds a conception of God in the creation and management of the world as a mathematician who is solving a minimum problem in the calculus of variations. The world must be the best possible and most balanced world because it was created by a perfect God. God governs by determining and choosing, among an infinite number of possible worlds, that one for which the sum of necessary evil is at a minimum. In Leibnitz's complex divine economy evil exists by definition at its minimum possible level. If evil is managed at its minimum level, then all evils are in fact always lesser evils. The statement that we live in 'the best of all possible worlds' was famously parodied by Voltaire in *Candide* when he has a Leibnitz-like character, Dr. Pangloss, repeat it like a mantra.

## A CALCULATING MACHINE FOR THE REDUCTION OF EVIL

Different aspects of the lesser evil argument were secularized into the modern articulations of ethics and politics. Foucault argued that it is on the basis of 'economical theology' that modern power—the government of men and things—has taken the form of an economy: 'We pass from an art of governing whose principles were derived from the traditional virtues (wisdom, justice, liberality, respect for divine laws and human customs) [...] to an art of governing that finds the principle of its rationality [...] in the state'.[24] He argued that from the end of the sixteenth century to the eighteenth century, the legacy of pastoral power was assimilated into the practice of government—a biopolitical form of power exercised upon a population to regulate and manage its health, felicity, reproducibility and productivity—while the pastoral power over the individual—*particular* providence—has evolved into *disciplinary* technology that subjectivizes the individual in various institutions and buildings: the prison, the military barracks, the school and the hospital.

Continuing Foucault's work on governmentality and discipline and directly reflecting on the question of the lesser evil, the philosopher Adi Ophir has shown how the panopticon, beyond being a mechanism of discipline, control and subjectivation, could also be interpreted as a closed system for the management and reduction of evils.[25] Here it is necessary to mention that Bentham no longer

---

24. Foucault, *Security, Territory, Population*, 163, 183.
25. Adi Ophir in the Lesser Evils workshop at Bard.

saw good and evil as metaphysical categories, but rather as the sum total of good and bad things. He defined the task of government as minimizing the bad things and maximizing the good ones. This economy is at the centre of 'the principle of utility'. The general aspect of the lesser evil argument is thus one of the forms by which the 'greater good' expresses itself.

The panopticon, a closed system that regulates everything that flows in and out of it, is according to Ophir a mechanism whose purpose is to make the calculation (a kind of proto-computer?) and reduction of evils possible.[26] The panopticon is designed to bring to perfection the consequences of every action undertaken within it. The observation and control of individual actions that the panopticon produces is the very condition that makes the calculus possible. The system is constructed in such a way that however much evil is put in, 'less evil' is guaranteed to come out. Although the machine produces collateral evil—and Bentham is clear that both punishment itself and the friction the machine produces are evil—it guarantees, so Bentham tried to convince his contemporary politicians, the reduction of these evils and of the pain of the treatment to the necessary minimum. Ophir thus interprets Bentham's panopticon as a *Perpetuum Mobile* of utility, a precurser to a panoptical society that has in itself now become a machine for the calculation and reduction of evils, the very diagram of *biomorality* (the necessary counterpart to biopolitics) which is focused on the increase of happiness and the reduction of suffering.[27]

## THE ROAD TO UTOPIA IS PAVED WITH LESSER EVILS

Lesser evil arguments are articulated not only from the point of view of Power but also in relation to attempts to subvert and replace it. An interesting example is provided in the discussion about the shortening of the working day in Marx's *Capital*. Unlike the revolutionary and militant communists who protested the drift towards a timid, reformist politics of choosing the lesser evil, of making the kind of compromises with capital that may divert the struggle from the absolute ideal of communism, Marx thought that the winning of the ten-hour day was a huge victory for the English proletariat. The ten-hour working day reduces the duration of evil, but 'normalizes' and regularizes exploitation. According to Marx, on the other hand, a ten-hour day allowed fourteen hours of non-work, in which 'the laborer can satisfy his intellectual and social wants' and which would allow the proletarians to organize and continue fighting. Marx's argument was that this lesser evil gives the proletarians the space to build an organizational platform, the consciousness and experience needed to take over the means of production. It created the productive forces capable of generating a sufficient surplus to enable socialism and the proletariat to continue fighting and build something bet-

---

26. Bentham's preface to the *Panopticon* opens with a list of the benefits to be obtained from this inspection house: 'Morals reformed—health preserved—industry invigorated—instruction diffused—public burthens lightened—economy seated [...] all by a simple idea of architecture'.
27. Bentham believed the panopticon could correct itself instantly. Ophir to the contrary observed that 'closed systems which are run by imperfect agents and in which the costs of exit are high tend to produce greater rather than lesser evils...' The term biomorality comes from Zizek, *In Defence*, 50.

ter.[28] His ultimate aim was still of course to abolish the state. But advanced capitalism was not only seen as a lesser evil compared to 'primitive manufacture', it was also a transformation that made a better world possible. Marx saw the struggle for the shortened working day as one corridor, potentially opening into future struggles: 'the limitation of the working-day is a preliminary condition without which all further attempts at improvement and emancipation must prove abortive'.[29] Paradoxically, as we now know, the greatest expansion of British industry occurred after the deal for the normalization of the working day.

Similarly, at different times, Lenin, Kautski, Luxemburg, Trotsky (!) and Gramsci grappled with the problem of fighting for compromised gains here and now on the one hand while also fighting for a better world on the other. At various points they stood for tactical struggles for immediate gains, advocating trade unions, whose function was to win a better deal for workers in an exploitative system; but none of them thought that trade unions were all that was possible, and none of them were satisfied with simply winning a better deal in this exploitative system.

Tensions between *evolutionary* and *revolutionary* Marxism were articulated differently in relation to different historical moments: throughout his World War I polemics against the social patriots, Lenin emphasized the difference between various periods and trends:

> [U]nlike yesterday, the struggle for socialist power is on the order of the day in Europe. The socialist working class is on the scene as a contender for power itself. This means: There may still be 'lesser' and 'greater' evils (there always will be) but we do not have to choose between these evils, for we represent the alternative to both of them, an alternative which is historically ripe. Moreover, under conditions of imperialism, only this revolutionary alternative offers any really progressive way out, offers any possibility of an outcome which is no evil at all. Both war camps offer only reactionary consequences, to a 'lesser' or 'greater' degree.[30]

The debate articulated by Marxists in different periods was about how political transformation should be brought about: in an *evolutionary* fashion—a step by step approach along a trajectory of improvement (a kind of Darwinian evolution by which the reign of the proletarians is a historical necessity)—or rather in a *revolutionary* manner, with a fast and decisive break with the past. In other words, Marxists in various periods asked whether change arrives through the re-

28. Engels argues for the positive effect of the deal for the ten-hour day on completely different grounds: 'Were the Ten Hour Day Bill a final measure, England would be ruined, but because it necessarily involves the passing of subsequent measures, which must lead England into a path quite different from that she has traveled up till now, it will mean progress'. If English industry were to succumb to foreign competition the revolution would be unavoidable.
29. Karl Marx, Capital, http://www.bibliomania.com/2/1/261/1294/frameset.html. See 'The Working Day', especially sections 6 and 7.
30. Hal Draper, 'The Myth of Lenin's "Revolutionary Defeatism"', http://www.marxists.org/archive/draper/1953/defeat/chap1.htm.

duction of pain—do things become gradually better until they become good, with the danger that with the reduction of pain society should become content and complicit? (In this case pain should be seen as a self-disciplining device.) At one end of the spectrum in which the lesser evil argument occupies the middle are the utopian absolutists who believe that every possible gain at present is insignificant in light of the essentially compromised state of the world. Part of the structure of this argument is found in the principle of the *politique du pire*—the politics of making things worse in order to hasten political change—or the theory of *dolorism*, which sees pain as a spiritual experience that allows people to see reality more clearly. The danger was of course that things simply get worse and worse. In fact Marxists used these approaches alternately, in a tactical manner, in different periods and situations.

The lesser evil argument was articulated in another way by Herbert Marcuse in the context of discussions regarding the Marxist attitude to the danger of fascism:

> Compared with a neo-fascist society, defined in terms of a 'suspension' of civil rights and liberties, suppression of all opposition, militarization and totalitarian manipulation of the people, bourgeois democracy, even in its monopolistic form, still provides a chance (the last chance?) for the transition to socialism, for the education (in theory and practice) and organization to prepare this transition. The New Left is therefore faced with the task of defending this democracy? Defend it as the lesser evil: lesser than suicide and suppression. And it is faced with the task of defending this democracy while attacking its capitalist foundations.[31]

Marcuse saw bourgeois democracy, with its freedom of speech and association, with space for self-organization (of, for example, workers and women), as a lesser evil to dictatorship as such but also inasmuch as it would provide a real opportunity for its subversion and eventual transformation. 'Defending democracy while attacking its capitalist foundations' is an articulation of a necessary paradox: could one simultaneously defend democracy in its liberal form against the encroaching evil of fascism, all the while attacking its foundations?

\* \* \*

The problems articulated by Marcuse are somewhat relevant to the political predicaments pertaining to different kinds of contemporary nongovernmental activists: being intransigently in opposition to the neoliberal global order and market hegemony, for example, while at the same time using their (infra)structures, and even momentarily cooperating with their institutions. Negotiating this paradox— and 'negotiation' could only merit its name if it seeks to bring together incompatible positions—must be the most important challenge to these contemporary

---

31. Herbert Marcuse, *Towards a Critical Theory of Society*, vol. 2 (Florence, KY: Routledge, 2001), 169. Joshua Simon's contribution to the Lesser Evils workshop at Bard was a reading of Marx's *Eighteenth Brumaire of Louis Bonaparte,* where he made similar points about Marxism's relation to fascism.

activists. How to engage in a practice of 'lesser evil', yet mobilize the effect of these actions in the service of larger political claims; how to work from 'inside' systems while simultaneously seeing beyond them, even precipitating their end?

Obviously, the argument that the principle of the lesser evil is dangerous because it may produce more harm is a contradiction as blatant as saying that it is a lesser evil to avoid the lesser evil argument.[32] I am also not suggesting that the horrific spectacles of 'greater evils' should be preferred to the incremental damage of 'lesser' ones, that the violence of the present conflicts should be made (even) more brutal in order to shock a complacent population into mobilizing resistance (the threshold of the 'intolerable' is elastic enough to make most people easily accommodate and domesticate a sense of an ever-worsening reality); rather, that opposition and resistance must dare to think beyond the economy and the calculations of violence and suffering that liberal ethics touts. The political ethics of the lesser evil could be articulated by bypassing the closed economy that a particular 'dilemma' presents with an insistence on the expansion of the limits of the problem in both *space* and *time*—the former by seeking to identify more extended and intricate political connections leading to the issue at stake and the latter by looking further into the future.

I hope to say more about the predicament of contemporary nongovernmental organizations in later versions of this text. The installation *665/The Lesser Evil* at Manifesta 7 seeks to start unpacking this problem by presenting some of the histories and contemporary tactics of such attempts and the humanitarian and human rights activists caught up in dilemmas and struggling, successfully or not, to liberate themselves from a mutual embrace with the very organizations they vehemently oppose. Many of these activists clearly realize that it is counterproductive to accept the myopic pragmatism of the lesser evil, one that leaves a given mode of government intact, and seek ways to go beyond these actions. Their contemporary deliberations reflect historical ones.

Strategically planned or spontaneous action would always inevitably put activists on the ground within an arena of political struggles in compromising situations that can easily deteriorate into a counterproductive complicity, but these forms of practice must look for ways to simultaneously and paradoxically challenge the truth claims and thus the basis of the authority of the powers they both cooperate with and confront—the very regimes that placed their bulls before us and then asked us to choose the lesser of their two horns.

This text originates in discussions around an ongoing programme of workshops, lectures and films exploring the structure of the lesser evil argument that I run together with Thomas Keenan and Eyal Sivan. I would like to thank Alberto Toscano for his useful comments.

32. In the Bard workshop, Adi Ophir compared this to Bentham's own statement: '"The principle of utility, (I have heard it said) is a dangerous principle: it is dangerous on certain occasions to consult it." This is as much as to say, what? that it is not consonant to utility, to consult utility: in short, that it is not consulting it, to consult it'. Jeremy Bentham, *An Introduction to the Principles*

# A MATTER OF THEFT
## NOTES ON THE ART
## OF STEALING A SOUL
## FLORIAN SCHNEIDER

**I**

There is a well-known myth according to which indigenous people believe that when a camera takes a picture of them, it captures a part of them, if not stealing their soul. This has been repeated often enough, by the pioneers of ethnographic photography as well as in online forums by today's amateur photographers; so-called natives have been credited with this belief in every part of the world and across time. Like many other popular assumptions from the field of ethnography, the idea of the theft of a soul by image has become a commonplace, free from critical reflection and questioning.

It proves what is supposed to be evident: the primitiveness of the other, of those who are unfortunately doomed, as well as their originality as a rare, still available and not yet fully exterminated example to whom the privilege of pos-sessing a soul has only recently been granted; the naivety of those who are not familiar with new technologies, as well as the correlate power of those who know how to handle them properly; the spiritual innocence of the noble savage, as well as the guilty conscience of those who intrude upon their reservations...

It is not rational, since it is irrational, a self-fulfilling prejudice that reveals not much about those who are supposed to hold the belief but quite a lot about those who assign the belief to others. In that respect, the myth of the soul-steal-ing camera appears as a colonial projection constitutive for the exoticizing prac-tice of portraying indigenous people.

The innocent, noble savage does not only have to look and behave, wear clothes, hold weapons, make gestures in order to fulfill the expectations of the colonial photographer. The antipathy of indigenous people towards the camera may not have derived from their alleged belief in its soul-stealing capacity, but rather from their own very concrete experiences: the camera has served as a weapon in the process of photographic colonization that 'violates the silences and secrets essential to our group survival' (Leslie Marmon Silko).[1]

Moreover, the indigenous were forced to believe what was in fact a bourgeois fashion in the European capitals of the nineteenth century: with the emergence of physiognomic studies the face was considered to express the interior

---

1. Quoted in Victor Masayesva and Erin Younger, eds., *Hopi Photographers, Hopi Images* (Tucson, 1983), 10.

decoration of the mind to the public, to reveal the individual and the essential truth of the subject. The face became the mirror of the soul.

Although at its outset and by its inventors photography was considered ill-suited to the rendering of faces and the art of portraiture, the technological development has been shaped according to the desire to capture the intimate privacy of a person rather than stills of landscapes. While Daguerre still doubted that the slow lenses, time-consuming preparation, and long exposures required would make his process suitable for portraits, by the mid-1850s at the latest the new medium had been bent towards the art of portraiture: reproducible paper prints, natural lighting and faster lenses prepared the ground for the widespread success of portrait studios.

As soon as photography was capable of taking the picture of a person, as soon as it managed to reproduce the human face in a recognisable and identifiable way, resembling the subject and expressing his essence, honorable figures from Balzac to Baudelaire began to fear an uncanny technology that produces doubles and doppelgängers, that materializes spirit, that manifests the soul in the image of the subject.

In 'My Life as a Photographer' the former caricaturist and pioneering French photographer Felix Nadar recalls a theory he heard from Honoré de Balzac: 'All physical bodies are made up entirely of layers of ghostlike images, an infinite number of leaflike skins laid one on top of the other... Repeated exposures entailed the unavoidable loss of subsequent ghostly layers, that is, the very essence of life'.[2]

Apparently Balzac borrowed his thoughts from the Latin poet Lucretius, who suggested that images are 'films', insubstantial shapes of things, which travel through air: simulacra, atom-thin and lightning-fast images that stream from the surfaces of solid objects and enter the eyes or mind to cause vision and visualization.

Long before the triumph of wave theory in nineteenth-century physics, Lucretius proposed a materiality of the image that seems fundamental for any further elaboration on soul theft and image production. Balzac's adaptation appears confined within an logic of scarcity, while Lucretius originally assumed an endless production of simulacra based on the infinite existence of atoms. Furthermore, for Lucretius the soul is affected by the constant stream of simulacra off of each object such that it is as if one were wounded, epileptic, or paralyzed.

What is the reason for Balzac's greed? Why should there be only a limited number of images as 'ghostly layers' which disappear by exposure? What really endangers the 'very essence of life'? The antipathy or refusal of being photographed resonates with a problem that must reside outside the field of photographic technology; another, yet unknown precariousness.

The soul that is stolen by exposure leaves an objectified person behind that has lost its subjectivity and become alien to itself. Hegel still used the term alienation as both a positive and a negative force of modern life, but the young Karl Marx took that concept in order to lay out one of his foundational claims: in the emerging industrial production under capitalism, workers lose control of their

2. Felix Nadar, 'My Life as a Photographer', in *October* 5 (1978), 9.

lives and selves—in other words, of their souls, since they lose control of their work. Marx denounced the process of abstraction from use value to exchange value as 'fetishism'—yet another metaphor that relates to allegedly primitive cultures, but this time it goes the other way around and it finds its assignment in the centres of industrial capitalism. Based on the belief that inanimate things or commodities have human powers, these things appear as able to rule the activity of human beings, replacing concrete social relationships with the illusions or artificial character of the commodity form.

'Thingification' turns everything into commodities or objects to be owned. The soul becomes a matter of property relations: through alienation and commodity fetishism it turns into a thing that is concealed, exchanged, traded and sold, after it has been stolen.

Postmodern capitalism has carried this idea to its extremes. The alienated labor force is not enough; the new managerialism demands the production of affects. The stolen soul reappears as the new productive force; it invests in creativity, enthusiasm, commitment, loyalty, friendliness, motivation, dedication.

■

In the face of a social reality ruled by alienation and based on affective labour, the theft of the soul through photography may itself sound like a nice, innocent, harmless and naive metaphor. Nevertheless it corresponds to the irretrievable loss of authentic life caused by the contradictions of an emerging, not yet fully graspable technological change.

Its incapacity or reluctance to cope with the contradictions of early capitalism allowed the bourgeois subject to project its very own fears onto the noble savage or the primitive. With the help of the indigenous other and in the best tradition of orientalism, the antimodern soul desperately sought to remain indispensable as the last resort of an individuality that should not be endangered or alienated. Today's criticism and latent concern about surveillance and control technologies follows a similar pattern. At the first glance, it seems that, after all, the soul became a matter of privacy—walled off, gated and protected against a hostile public. What is supposed to be guarded against invasion and intrusion is conceived as constitutive for distinctiveness and individuality; it exists in solitude, apart from company and being observed. 'The privation of privacy lies in the absence of others', as Hannah Arendt pointed out.[3]

Since Augustine of Hippo, across romanticism and existentialism, maybe even in parts of the neomarxist criticism of alienation, the soul can be perceived as a hidden interior territory, home of an untroubled personality, an enclosure in which authenticity is nourished, not bothered by interferences and unexpected encounters: 'In the inward man dwells truth', as Augustine said.[4] As the headquarters for the cultivation of emotional life it is the hotbed of personal preferences, individual taste, and other partialities. In this view, the soul would stand

3. Hannah Arendt, *The Human Condition* (Chicago, 1958), 58.
4. St. Augustine, *Of True Religion* (Chicago, 1966), xvii.

for the limits of manipulative access to subjective experience. Access is granted, if at all, only through specifically designed interfaces, and trespassing turns out somehow equal to theft.

Contemporary surveillance practices based on digital technologies are widely considered such 'trespass on the soul'. But today, the violation of the soul lies in duplicating the self rather than intruding upon it. One of the main reasons for that is the ongoing inversion of the classical notions of 'public' and 'private'. To the extent communication became the key factor of production in the postfordist age, the relationship between public and private seems to turn on its own axis: what was considered publicly accessible gets privatized without any fuss, and what was formerly known as private gets exposed to the scrutiny of a more and more specific public and ever-fragmented semipublic.

In the digital age, the soul is copied over and over again by means of data mining and user profiling: the tracking and tracing, examination and evaluation of personalized settings, individual preferences, and habits within communication networks. The digital double created by these practices can be perceived as an attack on the alleged integrity and originality of the soul. The doppelgänger is made of bad copies, owned by secondary possessors. Nevertheless, these spitting images resemble the idea of one's own; and this idea should comprehend the relations and proportions constitutive of the internal essence.

This is probably what makes the society of control so scary: the privation of privacy not only turns out to be the theft of the soul, but it marks precisely what constitutes the postmodern individual as ancestor or previous owner of a self that is indeed multiplied in all sorts of corporate and social networks; still, it relates back to the subject of a claim or pretense—and it does not matter so much whether self-images, profiles, preferences and private data are voluntarily given away or literally deprived.

## III

What was formerly known as 'information society' has shifted into an image economy based on the techniques of imaging information or turning information into images. At the same time, contemporary images are characterized by a passage from visibility to legibility: 'constantly modulated, subjected to variations, repetitions, alternations, recycling, and so on...' as Gilles Deleuze noted it.[5]

Such ambivalence reflects the two potentialities of images that Jacques Rancière recently suggested: the image as a 'raw, material presence' or 'pure blocs of visibility' and 'the image as discourse encoding a history'. Such duplicity defines specific regimes of 'imageness': 'a particular regime of articulation between the visible and the sayable'.[6] Their relations are constantly redistributed and by no means limited to the realm of the visual or the world of pictorial representation. Rancière for instance sees the invention of the double poetics of images in novel writing.

5. Gilles Deleuze, *Negotiations: 1972–1990* (New York, 1995), 53.
6. Jacques Rancière, *The Future of the Image* (London, 2007), 11.

Today's search engines may be an example of another redistribution of the relations between visible and sayable. Their crawlers and spiders replicate the content of innumerable websites across the World Wide Web by wrenching them out of their original context, imaging them by storing and caching them; but the goal is to reduce their complexity into a specific model of indexability by which alone they become visible and accessible, according to the ranking algorithm.

The advance of portrait photography in the mid-nineteenth century, which discovered the face as unique identifier and gateway to the bourgeois identity, has found its present-day equivalent in the phenomena of self-exposure in social networking platforms which culminates in googling one's own name. Furthermore, in its digital form the image appears as a storage unit for framed portions of psychic realities that can be duplicated without significant loss and distributed nearly in real time. The image becomes subjected to processes of design as well as designing processes of subjectivation.

The bourgeois or modern conception of property has been characterized by anonymity and pure objectivity. The fundament of western individualism is the ability to first of all 'own' or author one's soul, and therefore 'own up' to one's actions and transactions. But today, in the age of immaterial production, digital reproduction, and networked distribution, there is increasing confusion about biopolitical property relations. These relations need to be made visible in order to be enforced. In order to keep faith with capitalism we need to believe in the presence of property relations that appear ever more imaginary. And this marks precisely what is at stake in contemporary image production. The actual content matters less and less: it is copied, remade, replicated, stolen, looted, pirated, faked anyway. What counts is the fact that its soul is still supposed to operate as a commodity. Or as Benjamin once observed: 'If the soul of the commodity which Marx occasionally mentions in jest existed, it would be the most empathetic ever encountered in the realm of souls, for it would have to see in everyone the buyer in whose hand and house it wants to nestle'.[7]

Property exists first of all as imagery and rapidly becomes a matter of imagination: the desperate attempt of corporate networks to reidentify and reinforce the abstract nature of the value of exchange while being confronted with the overwhelming opulence of use value once the images are liberated from the fetters that arrested their freedom of movement, their capacity to circulate freely. In a society after the spectacle, we are realizing that it makes no sense anymore to criticize and expose the fetish character of non-things or absurdities, since it constitutes the very essence of the means of immaterial production. It is inscribed directly into the process of imagination, since imagination turns out as the labour power of the creative industries of late capitalism.

In the 1970s Bernard Edelman researched the development of intellectual property laws parallel to the emergence of commercial cinema and industrial image production. French law of the nineteenth century had not considered pho-

7. Walter Benjamin, 'The Paris of the Second Empire', in *Charles Baudelaire: A Lyric Poet in the Second Empire* (New York, 1983), 55.

tography a creative act, since it was just a copy of reality: 'The product, the photographic negative is soulless because only the machine works, and the photographer has merely learned to get it to work properly'. A few decades later, the opposite is true. The photographic machine becomes 'pure mediation of the subject's production: The real belongs to the subject if the subject invests in it, or: on the condition "of bearing the intellectual mark of its author, the imprint necessary to the work's having the characteristic of individuality necessary to its being a creation"'.[8]

To explain the transition from soulless labour to the soul of labour Edelman proposes the concept of the overappropriation of the real: 'The appropriation of what has already been appropriated'. All production is the production of a subject, the category by which labour 'designates all man's production as production of private property'. As soon as the productive forces demand that images be protected by copyright law, 'it is sufficient for the law to say that the machine transmits the soul of the subject'.

Today, it is again the theft of the soul which turns images into property. But to the extent that its property relations are inscribed into every image, we might also experience a reconcretization of the commodity form. What has been extensively abstracted in the space and time of modern capitalism returns in a perilously concrete, almost tangible fashion. It might be such 'dereification' or 'becoming-image' which ironically turns out today to be the key obstacle to consciousness, more or less in the opposite way as Lukacs suspected 'reification' to operate.

There is no way out of the imaginary. Not because the 'imaginary' is equal to the fictitious, faked or 'unreal', but because of the indiscernibility of real and unreal, as Deleuze mentions once in his very few remarks on this peculiar terminology. 'The two terms don't become interchangeable, they remain distinct, but the distinction between them keeps changing round...'[9]

This could lead to a first and fundamental characterization of imaginary property: as a set of exchanges it is based on the impossibility of discerning anymore what is one's own and what is not. Such indiscernibility certainly rests on the persuasive power of the digital image, which promises to instantly provide 'lossless' and cost-free copies while insisting on the identity of the copied content. But more importantly, it introduces the urgency of a constant renegotiation and exchange of meanings of ownership which remain distinct.

## IV

'If this idea is hostile to us, why do we acquiesce in it? Give us those lovely phantasms! Let's be swindlers and beautifiers of humanity!' (Nietzsche)[10]

8. Bernard Edelman, *Ownership of the Image: Elements for a Marxist Theory of Law* (London, 1979), 51.
9 Deleuze, *Negotiations*, 66.
10. Friedrich Nietzsche, *Writings from the Late Notebooks* (Cambridge, 2003), 51.

# V

In one of his recent essays, 'My Self and my Own. One and the Same?' Étienne Balibar revisits John Locke's 'Essay on Human Understanding,' in particular the chapter 'Of Identity and Diversity' which Locke wrote separately and included only in the second edition. Balibar shows 'how the vexed relationship between the self and the own' prepares the ground for Western theories of 'personal identity', the self and the subject: 'There is nothing natural in the identification of the self and the own, which is really a norm rather than a necessity, and reigns by virtue of a postulate'.[11]

Balibar comes to this conclusion via the detour of his own misreading of a poem by Robert Browning. Balibar considered the beginning of the verse 'My own, confirm me!' as a form of self-interpellation, and originally thought he had found an example where 'my self' and 'my own' were indeed one and the same, identical. Only later did he find out this was not the case and Brownings 'my own' actually designates his beloved wife. 'My own is my wife', Balibar realizes:

> It is the other with whom I make one and the same precisely be-
> cause we can never become identified, indiscernible, in other terms,
> with whom I experience the uneasy relationship of identity and dif-
> ference, not only because it is conflictual, but because the identifica-
> tion of what is shared or what is the same and of what is separated
> or divorced can never be established in a clear-cut and stable man-
> ner. The name of this uneasy experience conventionally is 'love'.[12]

Balibar's little mistake and the resulting rich elaboration on the production of a vanishing difference or a vanishing duality that is 'neither unity nor multiplicity' might also pave the way for a less lamenting understanding of the art of stealing souls.

Maybe taking an image is somehow like falling in love, except it is the soul that is stolen instead of the heart? Certainly it creates unease and tension, but at the same time it leads to the very interesting question: what does it actually mean, today, to own an image, especially once it is stolen or taken away?

From invention, creation and distribution to recognition, exhibition and conservation, images are subject to an infinite variety of operations that are not only characterized by conflicting powers of producing, possessing and processing them. Ownership of images has turned into the challenge of implementing solutions in real time. It is a progressive appropriation, which is, as Balibar might say with Locke, 'defined in terms of an intrinsic relationship to its other'.

Images appear as the products of struggles for imagination. It is not about the relationship between the owner of some thing and the object that is owned. Imaginary property deals with the imagination of social relationships with others who could also use it, enjoy it, play it or play with it. Ownership is a matter of communication and constant renegotiation, gained and performed on an in-

---

11. Etienne Balibar, 'My Self and My Own: One and the Same?' in *Accelerating Possession: Global Futures of Property and Personhood*, ed. Bill Maurer and Gabriele Schwab (New York, 2006), 41.
12. Ibid., 33.

creasingly precarious basis rather than grounded on a stable set of eternally valid laws which follow traditional ideas of property and personhood.

After all, taking an image and consequentially stealing a soul turns out to be an impossible operation as such: giving what cannot be stolen to somebody who cannot receive the stolen good. But into what could such double negation possibly resolve?

# VI

The image we take from the world has to deceive the senses and produce a series of situations that occur to the cognitive subject: simulacra, images of images, which are intentionally distorted and modulated in order to appear somehow correct to the respective sensual capacities of the viewer. With the advent of digital technologies which are supposed to produce perfect copies, the deceptive and thievish nature of images has finally become a matter of fact. There is no such thing as an identical copy which is bit for bit one and the same.

The digital image pretends to be identical or at least equivalent, but it operates on a rather pragmatic basis: in the end it is all about eliminating noise as the disturbing presence of an inexplicable and unidentifiable otherness. In signal processing, sampling originally describes the reduction of a continuous signal to a discrete signal: if the noise is less than the noise margin, then the system performs as if there were no noise at all. This is why digital signals can be regenerated to achieve so-called lossless data transmission, within certain limits.

That means that the illusion of identity is produced by a concept of postmodern border management. In order to perform the supposed integrity, a dynamic regime of continuous control and instant communication needs to decide whether specific information would be considered useful or useless in order to behave as if there were no disturbance at all.

Meanwhile, the stolen souls are flocking together below the noise margin ignored by the system. It is neither above nor inside, it is 'with', as Deleuze stated: 'It is on the road, exposed to all contacts, encounters, in the company of those who follow the same way, "feel with them, seize the vibration of their soul and body as they pass", the opposite of a morality of salvation, teaching the soul to live its life, not to save it'.[13]

# VII

The formula could go like this: the soul that is stolen in the image that is taken is the difference that is repeated.

---

13. Gilles Deleuze and Claire Panet, *Dialogues* (New York, 1987), 62.

# 'THE HEAD DRAWS, THE HAND THINKS' ANNE-MIE VAN KERCKHOVEN INTERVIEWED BY GÉRY D'YDEWALLE AND JOHAN WAGEMANS

**Géry d'Ydewalle** You call this a special series of drawings, but still they are relatively characteristic, I think, of what we have already seen of yours.

**Anne-Mie Van Kerckhoven** Yes, but in fact this is the first time I've made a series of drawings on which I've worked this long. Working on this series was a personal experiment for me because I had trouble finding my ground back in Antwerp. As it happens, I had lived just over a year in Berlin, and after that a month in Shanghai. And I thought, let me see which unconscious drawings are going to surface in the near future and then I'll see whether I can possibly link the whole to *Belgian Spleen*[1] with respect to content. My actions consisted in examining how thoughts recorded at one time coincided with images that originated from my unconscious on the same date, but years later. Are there thoughts that come into existence time and time again on certain days of the year, seasonally bound? And surprisingly it seems that in fact the one, the drawing, simply addresses the same thing as the other, the thought. It's often the exact same issues regarding thinking or creativity.

[...]

The fact is I usually start a series through trial and error. I start with something that has no significance. There are however a number of books that I'm reading at the moment or certain things that I have close to me. These have to be present. Depending on the inspiration of the moment, when I'm busy and I think, I need another element, I look in a book until I find something that triggers me, which I then use. In the beginning it's really trial and error, but after a third, or sometimes already after a second drawing, I notice I've found a system I can work with and within which I can evolve.

**Johan Wagemans** And then at that moment you know: I'm working on a series and that's what you then build on?

---

1. *Belgian Spleen* is a diary of thoughts that Anne-Mie van Kerckhoven collected from twelve years of notes. It was finished and printed in a very limited edition in 1992.

**Van Kerckhoven** Yes, but sometimes it stops after two and it doesn't work. Or I've said what there is to say within that system. But sometimes you feel there's a flow, an apparent opening of possibilities. Usually it's very hard for me to concentrate really consciously in daily life, and for me this is a way to dig in deep.

**D'Ydewalle** But you are saying that in the end specific issues arise. Can you put those issues into words?

**Van Kerckhoven** No, because I'm usually occupied with those issues during the normal course of the day, or when I observe people acting busy on the tram or bus, or when I watch television. Then there are certain things I don't really understand or that I find intriguing. And those are the very things that trouble me, that actually stand in the way of making these drawings.

**D'Ydewalle** Do you experience a release by making the drawing?

**Van Kerckhoven** I'm not sure whether you can call it a release, but definitely I feel I'm becoming more grounded. It's not a matter of trying to let go. I see a specific sheet of paper and it starts.

**D'Ydewalle** What do you mean by 'it' starts?

**Van Kerckhoven** Well, then I feel like I'm turned on. When at that point I start drawing, all kinds of things appear from my hand, not from my mind. Two years ago I visited an exhibition at the Kupferstichkabinett in Berlin where I saw an intriguing print from 1300 or 1400 with a floating, drawing hand flying over a landscape. The palm of the hand shows the piercing gaze of an eye. At the bottom of the drawing is written: 'Der Kopf zeignet, die Hand denkt' [The head draws, the hand thinks].

**Wagemans** You set your mind free and let your hand do its work to bring everything out?

**Van Kerckhoven** Yes, but the mind is not there. I don't free the mind, it's simply not there. It's gone. The ego also is completely gone. That's also why I almost never think a drawing I've just made is any good. But the next day I think it's quite fantastic. I'm just as fascinated as any other spectator when I look at them afterwards.

**D'Ydewalle** A spectator looking at one of your artworks for the first time can't escape the impression that they're all loose elements. It's only after an intense observation that you can record the coherence better. The texts for instance, the link between text and the things you're drawing, it's not that obvious.

**Van Kerckhoven** The texts have the same right to exist as the drawn elements. In the case of *Spleen* it's really checking whether everything is accurate: what am I drawing on April 5, for instance, and what did I write on that day ten or twenty-five years ago. That's just a kind of little game. It's just fun for me. But at the same time, it originated from research. Because I felt bad and without that grounding. I thought: maybe I can find something that can actualize my presence by finding out if there is a connection between what I'm drawing now and what I was writing at that time. The things I write are produced in the same way as my drawings. I don't think about it. It's in my mind and I write it down.

**Wagemans** Listening to you, I feel you must be both artist and scientist in a certain way. In a first phase, when you let go of things, you put them down on paper and you simply let them act; that's when you are an artist in the precise

sense of the word. But if you subsequently want to give it a place and you want to ground it as you call it, and you start to link it to texts and you try to structure it somewhat, then you are actually a scientist. You say: I want to understand how that comes about and how it works.

**Van Kerckhoven** Yes, it's possible. That's the reason scientists have been interested in my work since the start of my artistic existence. Together with my then-boyfriend Hugo Roelandt, I maintained, since the age of twenty, intense and creative contacts with people such as Luc Steels, Luc Mishalle, Paul Geladi, and Marc Verreckt. These were all friends from the Germanic Studies and Linguistics department of the UIA (Universitaire Instelling Antwerpen), most of them part scientists, part musicians and performers. They were all crossover people. This is also the reason why, since I started drawing, I only wanted paper that was absolutely smooth, because there would be no resistance. And I worked with a Rotring pen, a technical drawing pen. There were many people who thought, in 1977, that my drawings were made by computer. I just wanted that flow, that smooth motion of inspiration, of really undisturbed…

**D'Ydewalle** No resistance.

**Van Kerckhoven** No resistance.

**Wagemans** When the work's completed, or when you have the feeling that it's all there, is that when you start to analyse and take on another role or position in order to link things to your texts?

**Van Kerckhoven** When I started with the drawings it was the scientists who said: Anne-Mie, there has to be text with it, there has to be some text with it in order to find an access, otherwise it has too much to do with imagination only. For me it was something that was always disconnected, and I still have no need for it. But by now it's become such a routine that in fact I sometimes automatically see text added to it. Sometimes there's a drawing in the series without text. I feel they are things that exist by themselves.

**Wagemans** Personally I think the text helps people who look at your work to dig deeper. Otherwise you easily lose attention and go on to the next drawing. Now you are forced to look at what that text is and how you can connect it to the drawing; in this way you dig deeper and deeper. I do think it works.

**Van Kerckhoven** For me also. Otherwise I move from drawing to drawing, which is almost an oscillation, and then I get tangled up in myself.

**D'Ydewalle** I was intrigued by the relation between the text and the drawing itself, or the lack thereof. And then I tried to make comparisons with other artists. I'm thinking of two. One where the literary content is more important than the drawing and the other where the opposite is true. Take Paul van Ostayen; he also works with drawings, but they are of secondary importance to his writing. Take René Magritte, where text is also very important, but subordinate to the drawing. And in Magritte's case the relationship between text and drawing is not apparent. Sometimes he does exactly the opposite of what the drawing shows. 'Ceci n'est pas une pipe', for instance. You have none of that. In your case, both are more autonomous.

**Van Kerckhoven** With Magritte it's a reflection. It's a surrealistic poetical reflection about what language is and what an image is. 'Ceci n'est pas une pipe', you

know what that means. The word pipe is not the pipe. And Paul van Ostayen, of course, he's a tremendous influence, and also Magritte.

**D'Ydewalle** In your case, the text doesn't rule. The drawing is primary.

**Van Kerckhoven** The word is the boss. The image rules. That's what I feel.

**Wagemans** Perhaps you mean: the word or the text allows you to structure things.

**Van Kerckhoven** To make contact.

**Wagemans** In this sense it rules, otherwise you get chaos.

[…]

**D'Ydewalle** One of the curators of Manifesta requests explicitly we discuss the collective unconscious. It is interesting historically. It is a concept, a term that was mainly developed by Carl Jung.

**Van Kerckhoven** Of course, I can recognize the collective unconscious in artefacts of three, four, five, ten thousand years ago. It originated with the faces that people saw in the trees and the rocks and which they isolated. Monoliths in human form or in the shape of a face. There are places where you can see things, they are sacred. There are specific places, around sacred stones, where you can see faces or distinct shapes, those are sacred and not the objects themselves. That's fantastic, I think, something like that. But that's not what this is about, is it?

[…]

**Wagemans** Do you always start off with the same things or does it vary from drawing to drawing?

**Van Kerckhoven** Usually I start with a very small shape. I can get into my studio and find myself charmed by a curve or by how one shape shades off into another. And that in a way is the starting point of the drawing. When I started drawing, for a long time, I would assign numbers to the different elements. I did it also for me, because it was fun, to see what came after what. You see: one, two… and so on, they would sometimes be just dots.

**Wagemans** Those numbers are in the order in which you drew them?

**Van Kerckhoven** Yes. That is why the transition to animation is not so strange. I've wanted to make animated movies from an early age. I'm reading an interesting book: *MLB. Plongée dans le sein maternel*, by Sergei Eisenstein. Underlying the often formal, ideological aspects in the imagery of Eisenstein is an attempt to connect with the hidden treasures of the unconscious, a search for the source of all inspiration. He reinterpreted all his work afterwards from the perspective of that MLB, MutterLeiB [womb], in other words from the idea of the *prima materia*. He looked into other artists too, for instance certain elements in the work of Matisse, Degas, the spirals, perforated spirals, concentric circles. That's really powerful, so many shapes and constructions which I find in my own work… it's very confrontational. It was so powerful I couldn't go on reading because I felt it was so shocking. I had to let that sink in for a little while. For the montage of movies he utilizes specific systems which directly affect the unconscious. It reminds me of my ever-recurring need to animate my drawings… the animation of still pictures, to search for new ways of transmitting knowledge.

**Wagemans** An important aspect of what you just said—and this has to do with perception—is the idea of a primitive form, or a core theme that always recurs,

which is clearly present in your work. Over a long stretch of time similar things keep coming back. Do you have an insight into how that works and what it means exactly, or is it something you merely recognize?

**Van Kerckhoven** No, the only thing I recognize (for myself) is that there is a specific shape that I draw again and again, that I perfect every time again, which I also find annoying, that shape coming back every time. I also know that I have to work through it, that it'll disappear under other things but that very often it is there. I have to admit I also feel it's an ugly shape. But apparently I have to do that before I can do anything else.

**D'Ydewalle** But you are, I think, not a real victim of an individual style, or are you?

**Van Kerckhoven** Style? Is that a style?

**Wagemans** It's a way of doing things.

**D'Ydewalle** Take James Ensor for instance; he had an individual style which he developed up to the age of thirty-five, and after that he has only repeated himself. But in your case, I find, there is an organic development. What strikes me also, content-wise, in your drawing — it's not typical for the artistic milieu; not at all erotic, is that correct?

**Van Kerckhoven** Strange you would mention that. Someone like Dirk Snauwaert, the artistic director of Wiels,[2] once referred to my old drawings as 'post-coital'.

**Wagemans** I feel there's a lot of eroticism in it too.

**Van Kerckhoven** When I first came out with my drawings people would constantly ask me why they were so aggressive. My parents were very shocked with my first exhibition, especially since everything was supposedly so sexually charged. But I've never considered nakedness in itself, nudity, as sexually erotic. The Freie-Körper-Kultur [free bodies culture], the way I've seen it in Berlin, that's simply freedom, for me. To be stripped of determining signals. It's about people, about bodies.

**Wagemans** Physicality is very central to your work, I find.

**Van Kerckhoven** It's possible. Not consciously so. Well… we are bodies, no? It's not that unusual?

**Wagemans** That's true, but it provokes those interpretations, I think. If you recognize a female body and you see an egg and all kinds of curly things, feminine shapes, I can imagine that can appear erotic.

**Van Kerckhoven** For the last ten years or so I've placed that aspect of my work in the tradition of the mystics who integrated sexuality in one way or another. I've never held a moralistic view regarding anything in that field. I grew up in the sixties, the era of free love, but I could never bring myself to become part of that madness. As a fourteen-year-old I thought I had to find somebody to love as fast as possible. To get that out of the way. I've always looked at it like that… when I'm with somebody that I like a lot, I won't have to deal with those matters anymore. With seducing and being seduced, I mean. I wanted to have a boyfriend

---

2. Centre for Contemporary Art Wiels in Brussels. Dirk Snauwaert and Anne-Mie van Kerckhoven are preparing a drawing and film retrospective, to open in September 2008. In August a parallel exhibition will open at Kunstmuseum Luzern.

and have sex, but otherwise I wanted to deal with more substantial matters, such as understanding and penetrating the meaning of the world in all its aspects. […]

**Wagemans** You talk about mind mapping to describe the process of observing what is expressed. Mind mapping also reminds me of the fact that the map which is ultimately produced should be read as a map of how things are pieced together internally. Is that also what you think?

**Van Kerckhoven** Actually it was Susanne Neubauer, my curator at Kunstmuseum Luzern, who told me she saw my drawings as some kind of mind map. And that's indeed how it is. It's a very accurate way of seeing things. For me they are truly maps. I've always regretted that I couldn't exhibit them, to see people's reactions, because those reactions could help me along in my evolution as a human being. But that's also why, say, for a long time I've never held any artistic presumptions about these drawings. Because for me they are maps. I'll start drawing, upstairs in my studio, or outside in the open, or on the train. And then I can move on. Then I've put things in order. And I've returned to myself. In antipsychiatry there is an equivalency between the artist's mind and the schizophrenic's. When at a given time I'm left with all different pieces of reality, I break down as a human being. The artist then produces something new, finds contacts, and the schizophrenic will remain amidst the broken pieces, alone, in a void. In my case you'll see the broken pieces displayed as a mind map.

**Wagemans** You mentioned this at the beginning of this discussion also: that everything you absorb, the things you're working on, what inhabits your head as it were, has to be released at a given moment. And then it comes out and that is the way you give things their place.

**Van Kerckhoven** I can see it happen in front of my eyes. Nothingness gaining form, while drawing.

**Wagemans** You can externalize it, you can look at it yourself and then let it rest.

**Van Kerckhoven** There's a definition of drawing in the Oxford Compendium of the Mind. It's so very special, the fact that we perceive shapes in something as basic as lines, find references to things we've seen before. You don't require many lines to find a connection within your imagination. It's typical for human perception. In nature, form does not exist as a line, you see. You can create a line photographically through the principle of solarization. Also by putting two identical transparent shapes on top of each other and shifting them slightly, that will give you a line. That's actually what your mind does when you draw a line. It solarizes your memory. The drawer, the drawing, shifts things slightly out of place, and creates an outline. This is how form originates.

This interview took place within the framework of Parallellepipeda, a project focusing on collaboration between artists and scientists and initiated by M [part of the Leuven Museum] in cooperation with the Catholic University of Leuven [KULeuven] and STUK. Parallellepipeda is curated and coordinated by Edith Doove, who also edited this interview. Anne-Mie van Kerckhoven was invited as a central artist. Professors Géry d'D'Ydewalle and Johan Wagemans are affiliated with the Laboratory for Experimental Psychology at KULeuven. The interview was translated by Michael Meert.

# ANGELA MELITOPOULOS—
## *THE LANGUAGE OF THINGS*
## A CONVERSATION
## WITH AVI PITCHON

**Avi Pitchon** How do you see your project working in the context of 'The Soul'?
**Angela Melitopoulos** The function of the soul, as I understood it here, is as a split in the process of constituting a subject. The split as a moment of alienation that takes place in our mind and that is bound to the judgment of goodness or badness. This split implies a view from 'outside'—and in my understanding is exactly what constitutes the 'outside'. The soul is a cultural metaphor for this split that creates exteriority. The idea of the stratification and normalization of the perception of the self is of course a Foucauldian idea explaining the society of control and its methods of governing subjects without disciplinary control. The history of the production of the self, however, is a history of struggles. Self-control in control societies is produced by the agency between the self and what controls the self. This agency is a result of the struggle on *how* subjects are constituted. Playing a role in someone else's dream or being stuck in the idling mode of habits are both images of the fear of a postmodern social death. In this sense media art is as well the result of a struggle, not merely an art genre. Media art is responding as an individual attempt within the collective realm to explore potentials of agency in opposition to this postmodern death.

My work speaks about affects and processes that happen before representation, before speech. If the soul is a metaphor operating in the realm of representation it functions with an already-constituted language. What is good or bad is predefined. I find it interesting that Walter Benjamin states that the knowledge designating what is good and what is evil is 'prattle'. Benjamin describes also the fall of the human word as the moment when language stepped out of its own 'immanent magic, in order to become expressly, as it were externally, magic'. A word as opposed to a name has no immanent magic—it must mean something. We use words to designate something. The moment when language steps out of what he terms its paradisiac state, is when the 'prattle' of 'good' and 'evil' starts.

The language of things, however, dissociates from the human language. It operates on another time level. It is mute, exits from the prattle, and, as Benjamin

said, allows us to understand the commonality of the world. Art does not necessarily engage in the passivity of a language that designates things, but it engages in the language of things.

The language of things comes before representation. Things can speak, and the language of things allows for the commonality of the world. It is what in fact gives us our idea of the world, of its materiality. My work deals with time, and the experience of the amusement park documented in the film I am presenting at Manifesta has to do with immediacy. Video is time, the faculty of human memory is that of forming time. Time is the glue of the materiality of the world. Henri Bergson believed in the time matter as the common matter between the material world (matter) and the living world (memory). The video work *The Language of Things* explores a specific time matter: that of a reproducible form of immediacy. In German immediacy translates as *Unmittelbarkeit*, meaning two things: 'the impossibility to mediate' and 'now'.

**Pitchon** You claim the people you document in Japanese amusement parks are experiencing a bodily immediacy through which they are spoken to by the language of things—in this case the amusement park machines—and this state takes them outside and beyond the designating language of representation in a way that escapes the traps of good and evil, the traps of the construction of the soul. Do you mean to say that there is a tangible, accessible, reproducible state of being allowing that? This, combined with the role Benjamin appoints to art, is potentially a somewhat more optimistic proposition for autonomy than those of most contemporary thinkers.

**Melitopoulos** I think it's crucial to identify mechanisms of control, but it's also important to see it from another side. It's true that technology, like architecture, is planned, designed and engineered to control people. But this is a 'top-down' perspective. We also live within the 'bottom-up' perspective. Communication goes both ways. We are agents, and as such produce things from bottom to top, which makes things much more complicated. When Guatarri says 'we have the media we deserve' it means that the TV language is partly infantile because we feed it back in an infantile way. Analysing only from a top-down perspective merely produces an image of apocalyptic control which doesn't empower us, it's not enabling anything, it's oppressive. We have mass media forming the language of self-control but we have also the accessibility to video cameras and media that enables a production of the self resisting forms of control precisely because the use of a camera or an editing table allows one to analyse how affects are technologically constructed in control society. We have to stop thinking only in the logic of war. I know a time when the logic of war was not so strong. It's important to step out of this language and focus also on the notion of agency.

**Pitchon** How do the language of man and the language of things read in relation to the calculability of sky-reaching affects?

**Melitopoulos** Benjamin said something about the difference between the language of technology and the language of technicians. In that sense technology is an entanglement of different languages. It is designed by the human nonparadisiac language of science that designates function. This is how machines are constructed. It is however not a simple relation of language that takes place

here. And the affects those machines have are sometimes not included in the original idea behind creating them. The merry-go-round machines and sophisticated wave pools in the amusement park are designed to affect people with a precisely calculated acceleration. They affect bodies with promethic rhythms — rhythms which you can't reach normally. You reach a state of happiness with the machine, with technology that has the capacity to allow us to access a moment in time where we go out of our self. It is not joy, but a form of amusement in that we access something through technology which is before the realm of good and evil. And it is reproducible.

**Pitchon** So it is a liberating happiness — liberating in opposition to control.

**Melitopoulos** Reproducible happiness seems to be an even more dangerous problem for control — but maybe the split function of the soul exists also in the speed machine?

The ghost in the machine is a metaphor I like. Can this ghost be tracked down within a controlled society? The event of using the amusement park machine happens now.

Is it the ultimate form of controlling affects? Is one functionalized completely? Functionalization, however, takes time. When you say 'this is this', it's not now anymore. The event and its controlling thus take place on different time levels. There is a delay. Technology offers the possibility of accessing the event time that is ontologically not controllable from a top-down perspective.

**Pitchon** So when a person goes on one of those amusement park rides, they experience a 'now' in the deepest, enlightened sense. The 'now' that gurus talk about.

**Melitopoulos** I don't know. The now of the gurus is never now. In the film, there is one speed machine where the extreme acceleration makes it like you are without gravity. I was very surprised when I saw the images. The affect is very, very strong. And surprisingly this affect is different from how the speed machine was thought theoretically in the past. There is something beyond the rational that is in excess of our thinking and that we might understand when we have abilities to look into the time matter differently.

**Pitchon** In order to localize what you are saying and place it in the context of Europe and the European soul, I would say that the language of things, the animism you recognize in it, the fluidity of the interconnectedness of things interrupted by the stratification process of designation (by metaphors like the soul), is parallel to the historical shift from paganism to monotheism. Can you identify a relation to paganism in your own work?

**Melitopoulos** Animism is an interesting concept, because it is based on simultaneity, on immanence, meaning that one can read the outside as the inside. And it is no wonder that in order to banish animism and constitute the soul in people's minds, Christianity had to use physical force — violence, inquisition. It was a long battle against many cultural practices which were punished regardless of the fact that they weren't necessarily religious in nature, like the witches who had a medical function within society.

But is the language of things a European or a global concept? Where did animism start? Is animism a romantic or historical idea? Is it still threatening monotheism? Are artists animists since art does partake in the language of things?

Angela Melitopoulos, *The Language of Things*, 2007, video, 33', video still

Can priests be artists? How can we understand entity without a material communality?

Nondialectical thinking is automatically bound to ideas about animism which are automatically bound to specific cultural heritages of thinking, in which paganism plays an important part. But I am interested in nomadology, which can be attributed to paganism but is also a separate culture professing animistic principles, and which is nonmonotheistic. To what extent nomadology came to my attention, if it is because I have migrant history, is not clear. But I do connect in my work the state of migration and migrants with ideas about nomadology. So the oppositional movement I propose is perhaps only pagan in that it deals with nomadology, with standards and languages of migration. It is about the state induced by mobility, speed, slowness, itineration. I think subjectivity and itineration go hand in hand. So, this dealing with nomadology is not related to religion; it's not an opposition only by merit of it being nonmonotheistic.

**Pitchon** How is the animistic language of things expressed or manifested in nomadology?

**Melitopoulos** Take the Aboriginal culture—itineration, the walk, the passing, is the moment of turning the outside world inside, and it's expressed in storytelling maps and in painting. It is a very different view of what is the world than that of a geographical map which gives you a somewhat fixed viewpoint. In nomadology, instead of having a geographical map instructing us what is here or there, it is what is around us that tells us who we are and where to go, somehow. Listening to the shape of the mountain to understand oneself. It's a different grasp of space and time. Historically speaking, this nomadic view can be found in all parts of the world.

Nowadays space-time is controlled by the mass media, who capture the event time—the Kairos, the open time of the event prior to being able to rationalize its meaning for regulating it into Chronos—the structured time, the controlled form of how the event is displayed, assigned to good or evil, etc. This happens within seconds. But again, this process of assignment is not one-directional.

**Pitchon** In this context you talk about how the shift from analogue to digital signal is increasing control and moving it away from fluidity and towards stratifica-

tion. This reminds me of an article that claimed that digital audio reproduction doesn't actually contain music. The square digital graph signal can only approximate (simulate) the wholeness of the analog sound wave. This means that our culture is oppressed because for more than two decades now, nobody listens to music. Like in the film Footloose where dancing is forbidden, the analogue sound wave is banished. Therefore, the other resistant event to add to the amusement park is that of a live concert.

**Melitopoulos** I wouldn't say that analogue and digital are opposites. I believe, however, that the shift to a digital control society was not only a formal development (mechanical to electric to digital) but socially engineered (with the plan that governs) in a long and deadly hunt to chase away the ghost in the machine. Analogue was a fuller signal. If you have a movement from A to B, analogue travels all the way with the idea of arriving at B. Digital gives a functionalization of that movement and duration. Analogue has an element of *dérive*. You may decide you don't want to reach B. It has the possibility of going somewhere else. The digital function doesn't embody that potential anymore. And if we only have access to the digital we forget what we had with analogue. But the next stage is the quantum numeric system that will reclaim parts of the analogue because it is not binary—it's a three element structure (-0, +0 and 1) that will calculate not only what is, but also what can be. The potential.

But digital offers possibilities as well. When I moved from analogue to digital video signal, there was also a shift from the ability to intervene with time— changing the time and flow of the displayed image, accelerating it or slowing it down, processing the signal, making a second last an hour—to a functional simulation of it. But I learned about the digital weaving property in terms of editing—the narrative function of storytelling which in digital can be nonlinear. It's easier to work on the mnemonic structure of narration. You weave—while horizontally telling the narrative, you accumulate elements vertically. Instead of having a single, major, culturally transported image, with digital editing you find different potentials of entanglement in an image that can go against the one major story. You explore a different possibility of narration—of telling what happened and what could happen.

**Pitchon** You talk about 'the event time of the revolution'. What takes place there, in the terminologies we've been discussing?

Every revolutionary event is characterized by the opening up of the structure of language. If you see the film of William Klein about Paris '68, you see how everybody talks with everybody. People on the street talk to people they normally wouldn't talk to. A break takes place in the way language is structured and hierarchized. This is the very idea of what constitutes revolutionary times: the event which provides a different understanding of what is the world in which we live. The action of a strike for example—it halts chronology and allows the strikers to understand their situation better. The interval allows for this understanding. They start talking to one another.

**Pitchon** What is particularly interesting is that it wasn't like there was a communist tribunal saying, Ok, we should start talking on the streets. Which means that there is a potential of resistance lying dormant, waiting for an event to trigger it.

It's already here and can erupt spontaneously.

**Melitopoulos** And this potential is produced and realized in the immediacy of the event, which can't be captured and controlled. Ways of communication that go beyond the foreseen ways. In a world that is becoming a collective brain, the life of human beings is as uncertain and probable as the relations among the synapses. Life has no history in the literal sense. It does not run its course direct-ed to a goal, but concatenates situations and can run in all directions. The repre-sentations of the 'production of the self' are not long-lasting, they are a tempo-rary expression of a process, but the instance that generates this process is alive.

**Pitchon** But what about systems of control that supposedly work on the realm before representation, like red lights signaling terrorist attack or just mobile phone beeps that trigger repetitive, mechanic reflex reactions—a controlled animism?

**Melitopoulos** It's important to understand how control society is triggered, and I wonder if fear is what it takes to render digital control operative, but again, we are agents. We choose to embrace the affect. What if we decide not to partici-pate voluntarily in any control? Can machines take control if fear isn't there?

**Pitchon** So do you think it is in the interest of the state to ban amusement parks because they induce a subversive experience?

**Melitopoulos** I don't think it is subversive, but I'd say amusement parks, like cin-ema, have a history as a form of proletarian culture. Of course it is doubled—it can be this and that, subversive or not. But you can not entirely describe them only as functions of control societies. Amusement technologies possess some kind of excess, something surplus is happening. Maybe they subvert the apoca-lyptic and destructive view of the logic of war. Maybe one only needs a ride on a speed machine to turn the top-down perspective to a bottom-up perspective and to remember that the now still belongs to us, or some hippie ideas of collective love and peace, or at least to forget the apocalyptic and disempowering fear that the world is coming to an end.

# ROEE ROSEN—
## *CONFESSIONS*
# A CONVERSATION
## WITH AVI PITCHON

**Avi Pitchon** How would you relate your projects for Manifesta 7 to the notion of the soul as a final frontier—a last, constructed outside, a cultural object, an allegory for social relations shaped by ideas and techniques of power?

**Roee Rosen** Anselm Franke and Hila Peleg define the soul as 'a final frontier, a last outside'. This phrasing succinctly describes *The Confessions of Roee Rosen*, wherein 'my' Hebrew monologues become those of three illegal foreign workers who do not understand what they say. The soul, quite literally, becomes an externalized battleground between me and them. The reversal of inside and outside in relation to the soul is doubled and even tripled. In fact, one of the workers, Roee Rosen2, misquotes Augustine in relation to the soul and claims he wrote 'My body is like a shattered house, too small for God to enter' (but Augustine, of course, wrote this about his soul, not his body).

**Pitchon** Do you mean to say that the foreign workers are 'possessed' by you?

**Rosen** Yes. Possession here is quite literal: not only are the workers' bodies hired and used as effigies, but also the very act of speech and the pretence of self-representation is 'possessed' (they do, after all, speak in the first person, and begin by telling their name—Roee Rosen, that is). This possession is anchored in a history of histrionic oral fits and convulsions—from the biblical speaking in tongues, through the Jewish *Dibbuk* to *The Exorcist* and B-movies. These always involve doublings (two identities, good and evil, familiar and uncanny etc.), an invasion of one into the body of the other, and the spectacle of struggle.

But by the same token, I am being possessed. If the act of confession and self-portraiture is to be taken at face value, 'I' am completely transfigured. And any notion of precision and accuracy, so crucial to both textual and visual self-depictions, is replaced by a chain of mispronunciations, mistakes and displacements. Some of those really amazed me. Roee Rosen1, for instance, describes herself dying, and instead of saying 'the suffering is great', exclaims, 'the garbage is great'. Roee Rosen3 replaces the Hebrew for 'tears of horror' with 'tears of a mother', and instead of 'the corpses are rotting', utters 'the cheese is rotting'—all this without knowing what she says. But possession begins earlier, as a premise. The text is written as a mash-up between a male artist and a female foreign worker.

If we think of Rousseau's famous introduction to his *Confessions*, with its promise to present a true and complete portrait by exposing his inner self, self-

portraiture here is innately ascribed by these foreign women (from Bulgaria, India and Ghana) and their circumstances. This is true not only as a general structure but on the level of the monologue's details. Thus, for instance, a confession pertaining to scatological perversion is channeled through a description of a maid cleaning the toilets (and becoming a toilet herself) in a private villa in the *Sharon*, an affluent region of Israel where the narrator actually works as a housemaid.

**Pitchon** What happens when the male artist's 'decadent', 'bohemian' transgressive perversions are put in the mouth of the female foreign worker, who, at least statistically speaking, is probably conservative and traditional? Isn't this in a way doubling the victimhood of the workers—adding an extra layer of exploitation? As artistic practice, is this approach more honest and challenging as opposed to merely pointing out a by-now familiar state of being of exploitation?

**Rosen** This thorny ethical issue is at the crux of the work. The very motivation is to enact a moral dilemma rather than sanctimoniously comment upon it from a safe spot. But what happens in the process is also that those reductive stereotypes (the transgressive artist versus the traditional foreigner) become unstable. One of the rules I set for myself when we were shooting is that while the workers are not privy to the text, they can ask whatever they want about its general content. Roee Rosen2 resolutely did not want to know anything: she came to work, the money was good, and that's that (she maintained, in a way, sovereignty through disavowal and resignation). On the other hand, Roee Rosen1, whose name is Katia, a really smart, funny and powerful Bulgarian woman, 65 years old, became more delighted and engaged the more she realized the perverse nature of the text.

What is implicated from my vantage point is not the status of foreign workers but my self-perception, now understood to be innately changed by the presence of foreign workers. This was also my feeling with former projects such as *Live and Die as Eva Braun*. By inviting the viewer to become Hitler's lover, you try to find something about yourself, rather than about Eva Braun.

At the same time—the workers are there, literally, as specific women. I hope (and feel) that their presence resonates with qualities other than victimhood: beauty, power, complexity and, in a very strong sense, intangibility.

**Pitchon** Baudrillard described transgression and perversion as accepted, and to an extent championed by late capitalism as an extreme frontier of consumer individuality. In an age where every shape and form of neurotic dissidence is a market niche or money-making fodder for reality TV and Jerry Springer–type shows, and where every quirk can make one a working-class hero on YouTube, the form of perversity manifested in your work seems almost elegant, continental, romantic—are you aware of that? Are you a retrotransgressor?

**Rosen** Perversion as a consumerist spectacle is dealt with directly in the work, especially in the trailer. The rhetoric of my son, who is advertising my confessions without knowing what he says, is that of an MC pitching the piece hyperbolically, promising a breakthrough in cinema, culture, spirituality and pure evil (no less), and bragging that the confessions of Augustine, Rousseau and Jerry Springer will pale next to these.

I think that the perverse nature of perversity in these confessions is that they

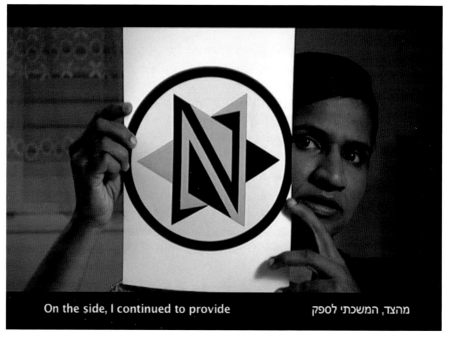

On the side, I continued to provide                    מהצד, המשכתי לספק

Roee Rosen, *The Confessions of Roee Rosen*, 2008, HD video, 56'30", video still

do not offer any clear voyeuristic satisfaction, and no cathartic peeping at some-
one's construct of a truth. The whole thing is concocted and fantasized and self-
contradictory. But if you accept Baudrillard's sweeping claim that 'everything' is
fodder for capitalist consumption, then what difference do stylistic attributes
such as 'elegance' make?

Perversion is an important construct whose history is relatively short and easy
to trace. You could, if you want, understand my work by applying to it a compen-
dium such as Kraft-Ebbing's *Psychopathia Sexualis*, but the fact that a desire will
be ascribed as 'perverse' doesn't resolve or exhaust it, and it would have been
both preposterous and hypocritical to repress or avoid desires because they're
deemed retrograde (if I try to put such a reaction to one's desire into words, the
result is quite odd: 'oh, you desire this and that, how elegant and continental of
you!').

And as for the problematic topic of transgression—my personal qualifiers
when I do something are laughter and sweat. If something makes me laugh and
sweat at the same time, if the body responds against my self-control, then I
know I may have a chance of transgressing myself (and that may already entail
transgressing other laws, as there is nothing internal or autonomous about 'me').
Deleuze claims (in his book on Sacher-Masoch) that the law can only be chal-
lenged by the comic mode. I feel the same way, and see my work as comic. The
last qualifier you mentioned was 'romantic'. Yes, I do think I have a romantic,
perhaps infantile, streak.

**Pitchon** What is the role of the confession for you before it is transferred to the foreign workers? What crimes are you alluding to?

**Rosen** 'Confessions' are not only about crimes to begin with: Augustine confesses in an instrumental way, to compel us to see the true faith; Rousseau confesses secret desires and weaknesses to create a cohesive, solid and a full picture of a man; and, as you mentioned before, confessions are a part of the exhibitionistic diet of the entertainment and spectacle industry (we consume confessions in a collective, cannibalistic fashion). In all three cases it may be said that someone stands to gain from confessing, so confessions are always about fortune, whether spiritual or monetary. My own confessions, on one level, are a travesty of those hidden motives.

To be specific about the 'crimes' at stake, the confessions roughly deal with three themes: my ignorance and apathy, my cynical and exploitative representation of the Holocaust (which I claim to have pursued to take revenge on my father, Holocaust survivor), and sexual perversion. Each of these topics in turn is juxtaposed with another, seemingly incommensurate issue. For instance, scatological indulgence is described after a relatively detailed account of the crimes of Israeli occupation on a specific day, so it may be said that a 'crime' is being performed by the very act of speaking: it is presented as wilfully choosing political and moral inaction. But the main point, really, is that the work presents an oxymoron: the confession itself is the crime it confesses. In this context it makes no sense to divide it from its delivery by the foreign workers whom I 'corrupt' or, in the trailer, from my son, who, for instance, performs the Nazi salute three times in a row.

**Pitchon** Back to perversion—is it precisely the Jewish meditation of the perverse 'soul' as articulated by Freud the reason for the need of the Nazis (amongst others) to purge the Jew as the biggest threat to the European or Aryan soul, a threat multiplied by the Jews' assimilation? Are you reanimating the spectre of that Jew, and through this lure the blonde beasts out of the holes they hid in since 1945?

**Rosen** There's a nice book by Sander Gilman called 'The Case of Sigmund Freud', where he claims that as a product of nineteenth-century psychiatry, Freud faced an impossible situation where he was initiated into a scientific worldview according to which he was simultaneously the doctor and the patent patient (the Jew bearing his Jewishness as a pathology: his hysteria, his effeminacy, his degeneration etc.). Gilman's claim is that Freud's reaction was to universalize the symptoms of the Jew (hysteria transformed into neurosis, and sexual complexes deemed ubiquitous). The presupposition here, of course, is that the contemporary trope of the 'Jew' was a specific 'dominant fiction' (to use Kaja Silverman's term). Certainly the multivalent spectres of the diasporic Jew are crucial for me, and the attempts to eradicate and erase this phantom are not a wound that healed in any way. But it should be reminded that Zionism was also partaking in that attempt to eradicate this Jew and replace it with a new, 'healthier' one (the Israeli as a blonde beast, if you will). In other words, I absolutely agree with you in terms of motivation, but I think the situation is more entangled. I am an Israeli and an American citizen. Doesn't that mean, on a certain level, that I am the very blonde beast I'm set to purge?

**Pitchon** So, perhaps it is the role and privilege of the Jew (not the Israeli) to take a platform of critique of the contemporary European soul and state, yes, there is indeed a primordial, free, pagan, pre-Judeo-Christian Europe (non-Jews can't say it without being ostracized)? How would you explain the fact that neopaganism is a spiritual-political alternative proposed by both radical left and right groups?

**Rosen** As a precursor to an appeal shared by radicals of both poles, one can think of the way the cult of nudity was celebrated by both the communists and the national socialists in pre–World War II Germany (by this, of course, I don't say anything against the idea of nudity or of neopaganism, but about its malleability). Anything that harks towards notions of the primordial runs the risk of essentialist and purist fallacies that will appeal to the radical right. Perhaps neopaganism is to the radicals what New Age is for the mainstream (that is, a consoling, synthetic and narcissistic way of instantly forging yourself as transformed, improved and free).

Like Freud, I am an ironist and an atheist. So, I do not will myself a neopagan, regardless of questions of privilege and ethnicity, and I cannot fathom myself free of the Judeo-Christian tradition.

I do not think of freedom as a tangible state but as a performative, neverending attempt. There is a beautiful aphorism by Kafka that's relevant here: 'There is an aim, but there is no way. What we call a way is nothing but wavering'. This aphorism is perverted in my *Confessions* by Roee Rosen1: 'There is an address but there is no street. What we call a city is nothing but wavering'.

# BARBARA VISSER –
## *FORMER FUTURES*
# A CONVERSATION WITH
## AVI PITCHON

**Avi Pitchon** Can you describe the work, *Former Futures*, you are contributing to the Trento section of Manifesta 7?

**Barbara Visser** Like many of my previous projects, *Former Futures* has been developed in strong relation to the time and place of its origin. In this case that is the exhibition building in Trento, the Palazzo delle Poste by Angiolo Mazzoni, its history and the political and art-historical connotations attached to it.

*Former Futures* is partly based on letters we've found in the archive of the Trento and Rovereto Museum of Modern and Contemporary Art (Mart), exchanged between futurist artist Fortunato Depero and fascist-futurist architect Mazzoni. As an exchange of thoughts through letters, the unbridgeable time lapse of regular mail is probably a dying form of communication. Not tuned with futurist ambitions of speed, when seen from the age of e-mail! This is of course also a natural way to connect with the post office building, yet the connection just happened, it wasn't planned as such.

**Pitchon** What is the significance of this letter exchange for you? Does it expose a certain power relation? Does it reveal anything new about this particular history or the actions of these individuals in it?

**Visser** In the work, I'm directly addressing power relations between the artist and the architect; the artist desperately wants to be commissioned for the large stained glass windows under the arches of the Palazzo delle Poste, and writes repeatedly to Mazzoni about this in a way that I would call pushing it more than a little. The commission itself does not sound tailored to the futurist artist: to design windows in a shape and technique which was already an anachronism: stained glass under renaissance arches.

I'm concentrating on the relation between the artist who wants something—to work, basically—and the empowered architect who is able to grant the favour, or at least give this impression. Although it looks like a purely historical narrative, not devoid of nostalgia, I do see a parallel with today in the sense that the artist in the end is at the mercy of many currents and powers outside of his control, and trying to influence these often weakens the position of the artist rather than strengthening it.

However, the more general question that I started to explore in an earlier work, of which this piece is a continuation, is: why are events, facts and images which are presently boxed and labelled in different compartments of our expand-

Depero's stained-glass windows for the Palazzo delle Poste, Trento,
Mart, Archivio del '900, Fondo Angiolo Mazzoni.

ing historical records, perceived so differently when looking at the choices and
beliefs of the individual on the day-to-day basis of the actual time of the event?
These individual choices are seldom made with future history in mind; more
often they're based on chance, opportunism, enthusiasm, bare necessity and
combinations of influences that are only later separated and simplified to make
history manageable, readable. Yet this is how history is largely perceived: as a
deliberate set of choices that have shaped it. It seems to me that these deliberate
choices are made *afterwards*. It is hard to admit that sometimes things are too
complicated and intertwined to record and label accurately.

In other works I've focused more on the discrepancy between what we see
and what we think we're seeing, or what is meant and how it's perceived, or
what we believe to be true and why, and how the way we read and value things
is often shaped by culture or by habit—which sometimes appear to be one and
the same thing.

**Pitchon** How would you describe the uniqueness, whether advantageous or
disadvantageous, of approaching and investigating what initially is pure historical
research on an almost formal, archival level, as an artist? What can you achieve
artistically that is impossible academically or politically?

**Visser** The one important thing that the art context enables me to do is to con-
duct research in unconventional ways and dig up unexpected material; the
information that is usually overlooked or neglected, not because it's not interest-
ing, but because it doesn't support common beliefs or prove one theory or
the other, or just looks too plain! A lot of real content is to be found in what ap-
pears to be said between the lines or off the record; in the case of futurism
and futurist behaviours, I found a more ambiguous tension in letters written by
futurists than in the futurist manifestos themselves.

I am not in a position to comment on things in the same way that an (art)
historian would, nor is my aim to be objective about the material I've found. I am
a bit hesitant to answer the question directly, since I never do research in order

to produce an artwork that serves as an illustration of what I've discovered, or show the material plainly as it is. This way of looking at records is therefore very subjective and unsystematic. If I had answers, I would not make the work of art.

**Pitchon** What exactly is the ambiguity you refer to that you found in the futurists' letters?

**Visser** This ambiguity is perceived on different levels, and is often found in an atmosphere that seems to contain conflicting interests, rather than in facts—for instance in the bravado and expressionism of the futurist language, even in letters from one person to another, combined with the awareness of a certain hierarchy in personal relations, and the admiration for the person being written to that is felt in the letters.

**Pitchon** Beyond the context of Trento and Manifesta 7, do you have any prior or particular interest in the futurists?

**Visser** My interest lies predominantly in how the future is viewed at different moments in history—or in the future itself for that matter. The fact that a vision can become outdated has tragic aspects that I like to reflect upon in my work. What is modern? What do we strive for at a particular moment in time and what does that say about our society? Utopia never gets outdated because it can never become a reality, but the ideas behind it are certainly altered by temporary interests and beliefs.

**Pitchon** Why do you think the futurist-inspired takeover of the city of Fiume by Gabriele d'Annunzio in 1919 is relatively ignored, dismissed as merely a general rehearsal for fascism, and otherwise divorced or censored from Europe's history of revolt?

**Visser**: What strikes me in all records of the history of futurism (as far as I've read them) is a political entanglement that is very hard to reconstruct, as there seem to be so many influences and decisions guided by emotion rather than straight political convictions. Every reading is incomplete or at least very fragmented. It is not easy to draw straight lines, they look more like dotted and striped lines with knots and turns everywhere—not a story that reads logically. To me this also proves to some extent that choices are in the end always personal, even if later on they are attributed to political forces.

**Pitchon** In the sense that, like you said, there is always a gap between history constructed retroactively and the day-to-day, individualistically oriented unfolding of events, it can be said that there is always something forgotten, unnoticed, left behind—and therefore, the past can be seen as dynamic. Do you agree? It seems like there is an infinite potential for revisiting, remixing, restructuring or deconstructing history.

**Visser** The past is not dynamic, but our interpretation of it is. In that light, whatever we choose to discard is difficult to trace back, and often lost forever. Therefore, the more material kept, the better. Many perspectives do not make research easier, but show the slippery nature of record keeping. The Dutch professor of ethnology Gerard Rooijakkers says that probably the most valuable information to be found about our society in the future is in our waste.

**Pitchon** Most critical thinkers try to devise future scenarios and strategies, but even the title of your work suggests that the actual future of Europe can be

shaped by our perception of 'former futures'. The future is therefore in the past.

**Visser** That's very interesting! I would not go so far as to relate it to Europe, since to me Europe is merely an idea. There is something to learn from looking at the ways we deceived ourselves in the past in order to find out how we would like to be deceived in the future.

**Pitchon** You hinted earlier on that the historical narrative constructed in your work is partly nostalgic. Is nostalgia in any way a constructive tool for you? For example, does it clearly mark what you, or a certain society, group, culture etc., long to 'return to', so that when you identify that you can then also identify the blind spots? Not just in the banal sense of 'if you look closely you'll see that the year so-and-so wasn't really that great', but more in terms of using nostalgia as an indexing tool for what is remembered fondly—marking a location for excavation, so to speak, to find blindspots underneath?

**Visser** My perspective in the installation is to show the moment when the applied artworks of the Palazzo delle Poste were under construction. They did not exist *yet*—only in the mind of the artist (Depero) and in sketches on paper, and in text in letters. In 2008, as we are visiting the exhibition, they don't exist *anymore*— some of the arches facing the courtyard are filled with concrete or normal glass.

In between the *not yet* and the *not anymore* there is the blank spot of when they existed. In other words, the perspectives of great expectation on one side and of looking back (nostalgically?) on the other are two perspectives that meet somewhere, but the middle is a black hole. It's beautiful how these brightly coloured windows only exist in black and white now, in three impeccable photographs by Enrico Unterveger, who always documented Mazzoni's work. For Mazzoni, colour was vital; he made extreme choices, like making this Palazzo delle Poste a cobalt blue building (later painted over due to protests), yet there was no colour photography to record it. The installation *Former Futures* will also be predominantly black and white, with colour only added to emphasize that.

Nostalgia is a taboo of some kind—especially where I grew up. Modernism in that sense runs parallel to futurism: only the future counts.

# INTERIOR
## DESIGN
## TOM HOLERT

**I**

The following short essay or collage can be considered an account of how *Ricostruzione: Disertori/Libera: Towards a Historical Fable about Psychology and Architecture*, the project that Claudia Honecker and I are contributing to Manifesta 7, came about. It may also be seen as an attempt to establish certain links between 'The Diagnostic Modern'—a long-term research project rehearsing various intersections of modernist culture and the history of psychology that I am currently pursuing—and the conceptual framework provided by Anselm Franke and Hila Peleg for 'The Soul', the Trento section of Manifesta 7.

> Let us therefore compare the system of the unconscious to a large entrance hall, in which the mental impulses jostle one another like separate individuals. Adjoining this entrance hall there is a second, narrower, room—a kind of drawing room—in which consciousness, too, resides. But on the threshold between these two rooms a watchman performs his function: he examines the different mental impulses, acts as a censor, and will not admit them into the drawing room if they displease him.[1]

> These other studies of man were restricted to the inspection of the mere tents and houses in which the real men dwelt. The psychological study of man would use direct access to the residents themselves. Indeed, not until psychologists had found and turned the key, could the other students of human thought and behaviour hope to do more than batter vainly on locked doors.[2]

Though the concepts of 'Soul' and 'Europe'—which resonate with each other, especially in the environment of Trento (see Franke and Peleg's introductory essay in the exhibition *index*)—may not always be addressed straightforwardly, they nevertheless subsist as heuristic momentum beneath the following musings.

1. Sigmund Freud, *Introductory Lectures on Psycho-Analysis* (1917), in *The Standard Edition of the Complete Psychological Works of Sigmund Freud*, ed. James Strachey, 24 vol. (London: The Hogarth Press, 1953–74), vol. 16, 295; quoted in Diana Fuss, *The Sense of an Interior: Four Writers and the Rooms That Shaped Them* (London: Routledge, 2004), 6.
2. Gilbert Ryle, *The Concept of Mind* (London: Hutchinson, 1949), 320.

The individual soul is a dynamic effect in the corporeal matter, in particular the encephalic.[3]

With standards more or less formalized, more or less explicit, comfort serves to structure daily life, to ritualize conduct, especially the attitudes and postures of the body in relation to furniture and objects intended for domestic use. It may be noted that comfort expresses, better than any other cultural contrivance, the 'techniques of the body' appropriate to modern bourgeois society. [...] Comfort, giving emphasis to the sense of the pleasure of private life, ratifies the central position of home as the place for social activity and contributes to the formation and consolidation of the modern nuclear family.[4]

The relationship of the research and the resulting 'piece' to a variety of contexts, not least to the implicit demands of 'context sensibility' and 'site specificity', raises all kind of concerns. Hence, the decision to focus on two historical figures from Trentino, Beppino Disertori and Adalberto Libera, was informed as much by the wish to establish a relationship to the city of Trento, its history, social reality and architecture, as by a certain sense of obedience and dutifulness, prompted by the ideological interpellation of Manifesta and the art biennial system as such. Eventually, however, historical curiosity and the sheer jouissance of formal research prevailed, if only to stabilize the imaginary stage on which we operate and to prevent the disintegration of the project resulting from seemingly 'excessive' self-reflexivity and institutional criticality.

**II**

The theoretical neurobiologist, sociopsychologist and philosopher Beppino Disertori (1907–1992) was not only a professed antifascist (and, after the war, the longtime head of the Trentino Red Cross), but also a rare breed of intellectual who surveyed vast, 'interdisciplinary' areas of knowledge. The architect Adalberto Libera (1903–1963) was a major participant in the *razionalismo* movement in Italian architecture of the 1930s and 1940s. Today, Libera's work is well documented and has been the subject of numerous publications and exhibitions; nonetheless his fame outside the world of architectural historians probably rests mainly on the Casa Malaparte, the eccentric Capri villa belonging to fascist writer Curzio Malaparte, conceived and built by Libera under difficult circumstances in the late 1930s. (The villa features prominently in Jean-Luc Godard's *Le Mépris* [1963]). Disertori, however, seems to be almost forgotten beyond Trentino, even among psychologists; his books are out of print and rather hard to find in libraries or secondhand. I came across his name for the first time in the German translation of Renato Curcio's *A viso aperto*, a book-length interview with Mario Scialoja

3. Beppino Disertori, *De Anima. Saggio della psicologia teoretica* (Milan: Edizioni di comunità, 1959), 440 (my translation).
4. Tomas Maldonado, 'The Idea of Comfort', *Design Issues* 8, no. 1 (Fall 1991), 36.

published in 1993 (one year after Disertori's death). Curcio, one of the founders of the Red Brigades in 1970, recalls the lively seminars in sociopsychology that Disertori held at the university of Trento in the 1960s and that made a lasting impression on him.

Neither Disertori nor Libera, however, nor their 'relation' (which cannot be traced to any actual, personal encounters; to our knowledge, no historical or documentary evidence for such a relation exists) should become the subject of a biographical or scholarly treatment. From the beginning, our intention was to explore their lives and works with the central objective of creating trajectories between the various interests and issues that link the site of Manifesta 7, the curatorial project and our own theoretical and aesthetic preoccupations. In some sense, Disertori and Libera operate as avatars of our historical imagination, guides leading us through the thicket of the archive. Activating and recontextualizing the biographies, writings and buildings of the two men also demanded a certain responsibility and tact. Though we have been granting ourselves license to use archival findings and historical knowledge freely and with a deliberate bent towards fictionalization, we likewise feel obliged not to distort any undisputed facts or forge new ones.

'Diagrammatic Representation of the Soul', from Beppino Disertori, *De Anima. Saggio sulla psicologia teoretica* (Milan: Edizioni di comunità, 1959).

Grace Lewis Miller, seated at her bedroom vanity in the Miller house, designed by Richard Neutra, 1936–1937. Photograph by Julius Shulman. From Stephen Leet, *Richard Neutra's Miller House* (New York: Princeton Architectural Press, 2004), 80. Courtesy Shulman Archives.

### ▌▌▌

One point of entry was the concept of interiority. As a spatial metaphor, it allows us to connect the topologies of architecture and the psyche. *The Sense of an Interior*, a book by queer theorist and literary critic Diana Fuss, became a major source of inspiration. Explaining her reasons for writing about four writers' (Emily Dickinson, Marcel Proust, Helen Keller and Sigmund Freud) sensual and psychic relations to the interiors of their homes, Fuss points out a characteristic blind spot or unwillingness among experts in architectural history and theory: 'Once a house is inhabited and its interior transformed by the detritus of everyday living, architectural scholars tend to lose interest in the life and activities of the dwelling, preferring to return to the less metaphoric and mutable ground of program and design'.[5] This observation prompted a rush of ideas.

5. Fuss, *The Sense of an Interior*, 3.

> [...] the most powerful obstacles to such an architectural reform as I have been suggesting are to be found in the psychology of the wage-earners themselves. However they may quarrel, people like the privacy of the 'home', and find in it a satisfaction to pride and possessiveness. [...] I believe that a private apartment with one's own furniture would suffice for people who were used to it. But it is always difficult to change intimate habits. The desire of women for independence, however, may lead gradually more and more to women earning their living outside the home, and this, in turn, may make such systems as we have been considering seem to them desirable. At present, feminism is still at an early stage of development among women of the wage-earning class, but it is likely to increase unless there is a Fascist reaction.[6]

The project veered towards a methodology and a format that I tested for the first time on the occasion of an earlier curatorial project by Franke and Peleg at the Hebbel am Ufer theatre in Berlin. Like *Stumbling Block: The Spectacle of Aptitude* (2006), *Ricostruzione* is a short and elliptical video essay, mainly based on still images and a voiceover narrative.

## IV

A collection of photographs, made by ourselves or drawn from books and archives, alongside scans of an assortment of various printed matter, form the basis for our short film. During the production and editing process, while the script was still developing, short clips taken from Italian neorealist movies found their way into the folders from which the 'relevant' visual data were retrieved to be subsequently processed with Apple's Final Cut Pro editing software.

Throughout a number of strategic and conceptual changes, the questions that Diana Fuss raises in her book on the interior remained pertinent to us. The 'most critical bridge between the architectural and the psychological interior', she claims, 'is the human sensorium: sight, sound, touch, taste, and smell [...] The senses allow the body to register exterior impressions and interiorize them'.[7]

> The therapeutic 'situation' is a creative situation [...] And will one day be physiologically illuminated to show what happens between a patient in general and a therapist. The anticipation of being helped in a need or in an aspiration toward satisfaction is physiologically an analogous, probably an identical situation. An architect producing by proper means rapport with the clients' aspirations and expressed or half-expressed need is actually acting very closely to the pattern of procedure of a psychiatrist. His analytical searchings and retrospec-

6. Bertrand Russell, *In Praise of Idleness and Other Essays* (London: George Allen & Unwin, 1935), 59–60.
7. Fuss, *The Sense of an Interior*, 17.

In more than one aspect, this emphasis on the sensual and bodily constitution of
interiority provided the connection to another figure who enters the film for a
short moment while otherwise lingering in the backstage area: Richard J. Neu-
tra, the U.S. architect of Austrian origin. Neutra moved to the United States in
the 1920s to design and build a substantial number of predominantly private res-
idences in California, and was one of the few architects and theoreticians of mid-
century Modernism who explicitly dealt with the psychological and physiological
dimensions of architecture. Sylvia Lavin, author of an insightful book on Neutra's
role in the 'psychoanalytic culture' of the postwar decades, identifies a reconfig-
uration of architectural thinking under the impact of contemporary ideas about
affect, psychology and neurology: 'Reconceiving architecture as the production
not of abstract space but of affective environments permitted the discipline to
forge new if unorthodox forms of continuity. Thus the libidinal energy Neutra
thought to exist equally in the human psyche and in the atmosphere could link
architecture and mind through the zone of the window just as empathy could
constitute a theoretical formulation in which aesthetic judgment and psychoana-
lytic technique found common ground'.[9]

As interesting as a focus on the window as physical (and metaphysical)
threshold would have been, we instead opted for the balcony as a different
though closely related instance of an architecturally designed interface separat-
ing (and suturing) the interior and the exterior.

Modern man strives for communal sport, communal life; in addition,
he desires a silent balcony, a silent room for himself.[10]

Walking through the streets of Trento we 'collected' balconies and loggias with
the camera. Partly instigated by the sight of balconies at Libera's first commis-
sion after the war—the INA-Casa apartment building on via Galilei and piazza
Venezia, finished in 1949—the peculiar semiotics and psychology of this archi-
tectural feature emerged as a crucial topic within the project.

Home in the evening after the love affair ended at dawn, talking with
a woman friend who has dropped in, Vittoria gets a phone call from
a neighbor she hardly knows, a colonial woman from Kenya. She and
her friend go over to a window from which they, and we with them,
can see the neighbor at her balcony across the dark street; cut to a

8. Richard Neutra, "Ideas" (dated September 24, 1953), Neutra Archive, Department of Special Collec-
tions, Charles E. Young Research Library, UCLA; quoted in Sylvia Lavin, *Form Follows Libido: Architec-
ture and Richard Neutra in a Psychoanalytic Culture* (Cambridge, MA: The MIT Press, 2004), 49.
9. Lavin, *Form Follows Libido*, 115.
10. Otto Neurath, "Kommunaler Wohnungsbau in Wien," *Die Form* 6, no. 3 (1931), 110 (my translation).

distant, haunting point-of-view shot, unmoored, unbracketed by any shots of the observer, from the neighbor's inferred perspective: the point of view of a stranger on Vittoria and her friend, now diminutive silhouettes at the lit window amid the darkness. From the window they subjectively look out at the world, and now the world, as subjectively, looks back at them. The effect is of our suddenly seeing ourselves as the world distantly sees us.[11]

At some point, the symbolic function of the balcony in the fascist spectacle of power emerged in our discussion. We learned that the term *arengario* for a balcony upon which the speaker stood to address the crowds derives from the medieval *arengo* or assembly of all citizens. But with fascism and in particular with the *case del fascio* that mushroomed all over Italy in the 1930s and 1940s, this traditional meaning changed and the power of the commune was transferred onto Mussolini and the fascist state.

There are balconies from which it has always been fun to watch the busy goings and doings in the streets and then there are balconies which the powerful or power-seeking preferred for their speeches to the people in an effort towards or away from the good or evil.

The balcony removes us from the sheltering walls of the house, it lifts us above the supporting width of the floor, and it broadens the view and the mind. We feel safe and secure in the room of access to the outwardly extended balcony, but there is already the element of transition where the indoors blends into the out-of-doors.

Balconies are more than just charming architectural details of houses; they are important links between the in- and the out-of-doors, between the wide open and the enclosed space which is only the shell for the human activity and life, and thus they are the links between introspection and shelter and broad-minded acceptance of environmental influences.[12]

As if to underscore the contrast between this political use of the balcony as a stage for fascist histrionics and the civil (and civilized) idea of the balcony as a zone of recreation and family life in the postwar modernism of the reconstruction, some of the balconies of Libera's building face the *arengario* of the former *casa del fascio* on the Piazza Venezia (or Largo porta Nuova) in the centre of Trento. The fascist headquarters had been built by another architect from Trentino, Giovanni Lorenzi, in the late 1930s. Around the same time, Lorenzi also designed and supervised the construction of his Erich Mendelsohn–inspired Grande Albergo Trento (today known as Grand Hotel Trento) at Piazza Dante.

11. Gilberto Perez, "The Point of View of a Stranger: An Essay on Antonioni's Eclipse," *The Hudson Review* 44, no. 2 (Summer 1991), 248.
12. Franz Schuster, *Balkone. Balconies. Balcons. Balkone, Laubengänge und Terrassen aus aller Welt* (Stuttgart: Julius Hoffmann, 1962), 7.

And not only did Lorenzi work as a construction supervisor for Libera's Via Galilei apartment building after the war, Libera also built his Palazzo della Regione in the late 1950s and early 1960s right beside Lorenzi's hotel, where he once again had to respond aesthetically to an urban and architectural situation largely determined by a preexisting building by his slightly elder colleague.

# V

Around the time the construction of the Palazzo della Regione reached its completion, which was also the time of Libera's death (1963), Beppino Disertori moved into a newly built condominium at number 32 Via Petrarca, a street that leads directly to the palazzo. Disertori stayed in the apartment, where he both lived and worked, until the late 1980s. Interestingly enough, and providing still another link to our involvement with this exhibition as whole, the temporary Manifesta 7 Trento office, working under the conceptual heading of 'The Soul', was located in exactly the same building where Disertori, the author of a comprehensive book on the soul (*De Anima*, 1959), had lived.

Disertori's reasons for moving to Via Petrarca might have been completely contingent in nature, but considering his biography, it is nevertheless striking that he chose to move into a house in the immediate vicinity of Libera's then-brand new Palazzo della Regione, a multifunctional complex designed to host the various executive and legal bodies of the government of the two autonomous regions of Alto Adige (South Tyrol) and Trentino. Libera's awkwardly modernist building might be considered an allegory of the postwar political system. Though it obviously serves the purposes of governing the autonomous regions, it might as well be perceived as an attempt to embody the idea of a supranational Europe—a Europe of the Regions. (The 'Manifesto of the Trentino Socialist Movement' was published clandestinely in February 1944, penned by resistance fighters, Giannantonio Manci among them. The manifesto states that 'Only an international state will free the nations from nationalism and will defeat the infernal theories of *Lebensraum*, will raise Europe above the crisis to an era of peace and reconstruction'.)[13]

Disertori (who, due to a polio infection in his childhood, was physically afflicted throughout his life) conspired against the fascists on various fronts. His oppositional stance towards the regime foreclosed any practice as a neuropsychiatrist in state institutions during the 1930s and 1940s. Disertori's role in the antifascist underground of Trento would be an interesting topic in itself. For instance, Disertori's father's bookshop, the Libreria Disertori in Via Diaz in Trento (still in business today), was a place where resistance activists gathered in secret. (A monograph on the history of this bookshop is allegedly in preparation).

In summer 1943, when the Germans occupied Trentino after allied forces in-

13. Giannantonio Manci, 'Manifesto programma del Movimento Socialista Trentino. Febbraio 1944', in *Giannantonio Manci: 14 dicembre 1901–6 luglio 1944*, ed. Beppino Disertori (Trento: TEMI, 1946), 78 (my translation).
14. Beppino Disertori, 'L'apostolato die Giannantonio Manci' (1944), in *Giannantonio Manci*, 15 (my translation).

vaded southern Italy, Disertori escaped to Switzerland. Exiled, he continued to pursue the cause of a new age of humanity and peace. Together with his friend and role model Manci, he committed himself to the idea of a democratic republic. This visionary state was modelled after the political ideas of *Risorgimento* thinker Giuseppe Mazzini and based, among other things, on the geopolitical principle of decentralization. In 1944, Disertori wrote: 'Through decentralisation, and by respecting the legitimate autonomy of communes and regions, the authentic Italian democracy, educator of citizens, will finally be born'.[14] The federal, supranational character of postwar Europe was a central concern of the self-proclaimed socialists. The very fact that the Palazzo della Regione had been designed and built by Libera, the same Libera who had authored the monumental Palazzo dei Congressi (1938–1954) in the EUR quarter in Rome and who designed the triumphal arc for the fascist exposition in Rome in 1942 (never realized due to the war), could well have been deeply irritating for someone who had invested so much of his political and intellectual energy in overcoming Fascism.

> To educate a child, to reform a delinquent, to cure a hysteric, to raise a baby, to administer an army, to run a factory — it is not so much that these activities entail the utilisation of psychological theories and techniques, than that there is a constitutive relation between the character of what will count as an adequate psychological theory or argument, and the processes by which a kind of psychological visibility may be accorded to these domains. The conduct of persons becomes remarkable and intelligible when, as it were, displayed upon a psychological screen, reality becomes ordered according to a psychological taxonomy, abilities, personalities, attitudes and the like become central to the deliberations and calculations of social authorities and psychological theorists alike.[15]

## VI

Disertori and Libera contributed, if reluctantly and in very different ways, to a common task, which might be called, tentatively, the shaping of a subject of (and for) reconstruction. While writing this essay, I stumbled upon an obliquely related remark by art historian Rosalind Krauss, in the final paragraph of an article on Giovanni Anselmo that she contributed to a special issue of the journal *October* on postwar Italian art: 'In its attempt to shore up democratic forms of government, the Marshall Plan was meant to reinstate the Enlightenment subject as the basis of European experience. The perceptual apparatus of the centred human subject was being purchased by American largesse. The subject who consumes.'[16]

Both Libera and Disertori were involved in the project of reinstating a European subjectivity shaped by the institutions of democratic reeducation and the

---

15. Nikolas Rose, Power and Subjectivity: Critical History and Psychology, http://www.academyanalyticarts.org/rose1.htm.
16. Rosalind Krauss, "Giovanni Anselmo: Matter and Monochrome," *October* 124 (Spring 2008), 136.

Beppino Disertori in 1940. From Luigi Menapaoo, Franco Erminio, Silvio Demarchi and José Macotti, eds. *Note biografiche e bibliografia di Beppino Disertori 1907–1987* (Edizione donate da Riccardo Bacchi), 10

Adalberto Libera in 1939. Photograph by Ghitta Carell. From Francesco Garofalo and Luca Veresani, *Adalberto Libera* (New York: Princeton Architectural Press, 2002), 16.

training grounds of Fordist rationality, though their individual interests and passions were hardly in sync with the Americanization of Italy. In Libera's view, the imperatives of efficiency that organized the postwar reconstruction in Europe had fatal repercussions within the architectural profession itself. In his autobiographical essay *La mia esperienza d'architetto*, published in 1960, three years before his death, Libera tried to place himself and his practice in the postfascist environment of the 1950s, where he spent many years coordinating the vast INA-Casa social housing programme. Here, he laments the demise of the architect's practice under the pressure to conform to the laws of quantity and costs, while being forced to repudiate all sense of art. 'Once a house could be at the same time building and art, technical and artistic; today the house, one might say, the decimetre, belongs to the industry. Freedom manifests itself by hectometre and kilometre, i.e. on the level of urban planning. It is only a matter of payment, of catering to those interests'.[17] The 'industry' and 'interests' that Libera targeted were 'American'. The new building types and the new cities in postwar Italy that reminded him of the new cities in India and South America were 'manufactured in America', *fabbricando in America*.[18] Libera regretted the devaluation of art in favour of a mentality of planning and building 'new cities' (as well as, by implication, new citizens), and he called for the 'serenità dell'anima'.[19] But he had also taken early precautions for a general surrender to the imperatives of efficiency when he sat down to write and draw his treatise on architectural standards and norms in the final years of the war.

On a different terrain and with quite different intentions, Disertori tried to apply to the social and political situation of the reconstruction years a set of ideas and beliefs that he had been developing since the late 1920s. Decidedly antimechanist and neovitalist, his approach had been comprehensively presented for the first time in his *Libro della vita*, written in Swiss exile and published by Mondadori in 1947. Disertori argued for the centrality of Henri Bergson, Hans Driesch and other

17. "Una volta una casa poteva essere contemporaneamente edilizia ed arte, cioè tecnica ed arte; oggi la casa, il decametro, diciamo così, appartiene all'industria. La libertà, invece, si manifesta sull'ettometro e sul chilometro, cioè sul piano urbanistico. Bisogna solamente arrivare a cambiare, a spostare questi interessi." Adalberto Libera, "La mia esperienza di architetto," *La casa* 6 (1960); quoted in *Adalberto Libera nel Dopoguerra*, ed. Alessandro Fassio (Sassari: Carlo Delfino, 2004), 298 (my translation).
18. Ibid.
19. Ibid., 299.

vitalist thinkers with their theories of *élan vital* and the entelechic necessity of 'life' processes. Against the functionalism and mechanism of competing schools of (neuro)biology, he advocated an elaboration of the psychosomatic relations in the human brain, taking into account both the metaphysics of the 'inner light' (*luce l'intero quadro*) and the sciences of neuro- and psychobiology.[20] Disertori's brand of metaphysical neovitalism, his ventures into parapsychology and hypnosis, his ideas of the 'individuality of the soul' and his detailed analysis of the neurosis of the subject in postwar mass civilization are still to be rediscovered — as a tacit critique of the subjectivity of the Marshall plan and as a contribution to other, physiologically and metaphysically based soul-searching projects of the postwar decades. 'A parking place is where someone else has parked his car', Richard Neutra wrote in 1957; 'There is no anchorage for the soul, because we have lost the feel, pay no heed, and continuously ignore all valid current data: how our million sense receptors — no longer five senses as for Palladio — take on in the world'.[21]

20. See Beppino Disertori, *Il libro della vita* (Milan: Mondadori, 1947), 358 (my translation).
21. Richard Neutra, 'Notes to the Young Architect', Perspecta 4 (1957), 53.

# LEARNING THINGS[1]
# BRIGID DOHERTY

## DREAM KITSCH, THE WORLD OF THINGS, AND THE FURNISHED HUMAN BEING

'Dream Kitsch', written by Walter Benjamin (1892–1940) in 1925 and published under the title 'Gloss on Surrealism' in the journal *Die Neue Rundschau* in January 1927, suggests that, in contradistinction to the dreams associated in romanticism with the imagistic fullness and metaphorical density of symbols, such as the 'blue flower' after which the literary hero Heinrich von Ofterdingen in Novalis's eponymous 1802 novel longs, present-day dreams have 'grown gray'. But if Benjamin believed that dreams in the context of European modernity in the late 1920s were 'a shortcut to banality', he did not take that to diminish either their meaningfulness in psychic life or their potential to play a decisive role in historical events. For Benjamin, the dreams of his own era were connected not to art (as in romanticism), but to kitsch—and dream kitsch was kitsch 'garnished with cheap maxims'. The surrealists invoked Sigmund Freud's epochal *Interpretation of Dreams* (1900) and psychoanalytic theory in general as conceptual foundations for the renovation of works of art and literature and their capacity to convey meaning. Crucial in surrealism was the reconfiguration of banal elements of everyday life in striking juxtapositions designed to transform the perceptions and modes of feeling, cognition and eventually social behaviour and political action of readers and viewers. In 'Dream Kitsch', Benjamin associates surrealist poetry with the aphoristic inscriptions in nineteenth-century children's books, including what are now known as 'pop-up' or 'pop-out' books.

In addition to his praise for the surrealist writers André Breton (1896–1966) and Louis Aragon (1897–1982), Benjamin's essay includes a brief description of a

1. Portions of this essay were published previously in *Artforum* (September 2005). Other portions are reprinted, by permission of the publisher, from my Introduction to Part IV of *The Work of Art in the Age of Its Technological Reproducibility, and Other Writings on Media*, by Walter Benjamin, edited by Michael W. Jennings, Brigid Doherty, and Thomas Y. Levin, pp. 198–202, Cambridge, Mass.: The Belknap Press of Harvard University Press, Copyright © 2008 by the President and Fellows of Harvard College. The illustrations accompanying this essay were composed in their present form by Carolyn Yerkes of Y2 Design, New York, designer of the exhibition *A Museum of Learning Things* at Manifesta 7, Trento. My thanks to Carolyn for her creativity, graciousness and unfailing good humor. Thanks are also due to Annie Bourneuf and Lisa Lee, endlessly helpful research assistants on the M7 project and the most congenial collaborators I could ever hope to find. I am indebted to Dr. Andrea Immel, Curator of the Cotsen Children's Library at Princeton University, and to Dr. Martina Weinland, Director, and Dr. Rita Weber of the Museum Kindheit und Jugend, Stiftung Stadtmuseum Berlin, for granting me access to materials reproduced here and in *A Museum of Learning Things*, and for sharing their knowledge of children's books and *Anschauungsunterricht* with me. Finally, special thanks are due to Hal Foster and Susan Lehre of the Department of Art & Archaeology at Princeton for providing financial and other kinds of support that made this essay and the larger project of which it is a part possible.

colour halftone reproduction of a 1921 gouache 'overpainting' (Übermalung) by the German-born artist Max Ernst (1891–1976) that appeared as the frontispiece to *Répétitions* (figure 1), a 1922 book of poems by Paul Éluard (Eugène Émile Paul Grindel, 1895–1952).[2] The scene in Ernst's frontispiece is a schoolroom, and Éluard's title also invokes pedagogical exercises.[3] Benjamin might have known the original work by Ernst, which was in the collection of Louis Aragon, but even if he had seen only the colour reproduction in *Répétitions*, it is worth noting that the printed sheet on which the overpainting appears is an actual page taken from a catalogue of teaching aids (*Lehrmittel*) that were designed, as the catalogue puts it, to promote the 'purposeful expansion of the sensory activity of children'[4] through an approach to pedagogy called *Anschauungsunterricht* (literally 'instruction in perception', sometimes translated as 'teaching through the

FIG. 1 Illustration from *Bibliotheca Paedagogica. Verzeichnis der bewährtesten und neuesten Lehrmittel für höhere, mittlere und Elementarschulen, sowie von Werken der Erziehungs- und Unterrichtswissenschaft* (Leipzig: K. F. Koehler, 1914), page 34.
Max Ernst, frontispiece to Paul Éluard, *Répétitions* (Paris: Au Sans Pareil, 1922). Color halftone reproduction of an untitled circa 1920 overpainting of gouache and ink on a printed page from the *Bibliotheca Paedagogica* (Leipzig: K. F. Koehler 1914). Typ 915.22.3605, Department of Printing and Graphic Arts, Houghton Library, Harvard College Library. © Max Ernst, by SIAE 2008

2. *Übermalung* was a technique invented by Ernst in which he painted with watercolour and gouache on top of printed pages to create pictures that resembled collages. In the original 1922 edition of *Répétitions*, Ernst's illustrations are called 'dessins' (drawings), while in a 1962 bilingual French–German reprint on which Ernst collaborated, they are called 'collages' in French and 'Collagen' in German. See Paul Éluard, *Répétitions*, avec dessins de Max Ernst (Paris: Au Sans Pareil, 1922) and Éluard, *Répétitions*, mit 11 Collagen von Max Ernst, trans. Max Ernst and Rainer Pretzell (Cologne: Galerie der Spiegel, 1962).
3. Pedagogy and domination, and pedagogy as domination, are key surrealist themes. For example, Ernst's frontispiece and Benjamin's gloss on that picture find an echo in the opening of André Breton's 1937 surrealist novel *L'amour fou* (Mad Love), which refers to 'boys of harsh discipline' who evoke for the narrator 'certain theoretical beings, [...] key bearers, possessing the *clues to situations*'. See Breton, *Mad Love*, trans. Mary Ann Caws (Lincoln: University of Nebraska Press, 1987), 5.
4. Dirk Teuber, 'Bilbliotheca Paedagogica: Eine Neuerwerbung im Kunstmuseum Bonn: zur Quellenfunktion des Kölner Lehrmittelkataloges für Max Ernst', in *Max Ernst: Illustrierte Bücher und druckgraphische Werke: Die Sammlung Hans Bolliger — eine Neuerwerbung*, ed. Katharina Schmidt, exhibition catalogue, Kunstmuseum Bonn (Cologne: Wienand, 1989), 45.

senses' or 'training the senses') that was grounded in theories and practices developed in the first half of the nineteenth century by the Swiss philosopher and pioneer of progressive education Johann Heinrich Pestalozzi (1746–1827) and his German follower, the inventor of kindergarten, Friedrich Froebel (1782–1852).[5] Just as the technique of photoengraving used to reproduce Ernst's frontispiece to Éluard's book harks back to a technology commonly used in the production of illustrated books and periodicals in the late nineteenth century, Benjamin's text invokes childhood of that epoch in setting the stage for his revaluation of kitsch in relation to art. According to Benjamin, despite their interest in psychoanalysis the surrealists 'are less on the trail of the psyche than on the track of things'. The face at the top of the 'totemic tree of objects' after which they seek 'is that of kitsch. It is the last mask of the banal, the one with which we adorn ourselves, in dream and conversation, so as to take in the energies of an outlived world of things'. And it is by means of kitsch and not art (or 'what we used to call art') that Benjamin suggests his contemporaries can come into renewed contact with 'the world of things'.

Thus Benjamin presents kitsch, rather than, say, great painting, as the standard against which to measure the success of Ernst's art. According to Benjamin, the banality of the world of domestic interiors and sentimental conversations in which bourgeois parents enclosed their children in the late nineteenth century—the world Benjamin inhabited in Berlin and Ernst in Brühl—reduced those children themselves to 'crimped picture puzzles' confronted with the 'abysmal entanglements' of the 'ornament of conversation'. But within that world's variously crimped, abysmal, ornamental projections of sentiment dwelt 'heartfelt sympathy, love, kitsch'. In Benjamin's reading, surrealism at its best strove to reconstruct a form of dialogue peculiar to a certain historical moment of nineteenth-century childhood, and to compel our recognition that, more generally, 'dialogic misunderstanding' provides a structure through which 'the only true reality forces its way into the conversation'.

Ernst, as Benjamin explains in his brief analysis of the frontispiece to *Répétitions*, 'has drawn four small boys. They turn their backs to the reader, to their teacher, and his desk as well, and look out over a balustrade where a balloon hangs in the air. A giant pencil rests on its point in the windowsill. The repetition of childhood experience gives us pause: when we were little, there was as yet no agonized protest against the world of our parents. As children in the midst of that world, we showed ourselves superior. When we reach for the banal, we take hold of the good along with it—the good that is there (open your eyes) right before you'. The boys in Ernst's overpainting seem to be gazing, with their hands shading their eyes, at the hot air balloon high in the sky outside their classroom, an object—in addition to the very big red pencil in the windowsill—that we are invited to imagine them wishing to grasp. On the unpainted catalogue page, the school-

---

5. The phrases 'teaching through the senses' and 'training the senses' appear in *Pestalozzi's Educational Writings*, ed. J. A. Green (London: Edward Arnold, 1916), in the introduction to which 'the full force' of Pestalozzi's *'Anschauungs-Prinzip'* is said to be 'best expressed by the "principle of concreteness"', and where *Anschauung* is variously translated as 'inner feelings', 'inner intellectual processes', and 'concreteness', while the word 'concrete' is understood to indicate, 'in the Pestalozzian sense', 'meaningful' (9–12, 124, 139).

master surveys the work of his pupils as they raise their hands to inscribe mathematical calculations on the writing surface of the scrolling blackboard that is the teaching aid the page promotes (some letters of the word *Schreibfläche* [writing surface] can be seen through the blue of the sky to the right of the balloon). The page as overpainted by Ernst does not just obscure the blackboard advertised in the *Lehrmittelkatalog*. Ernst's overpainting supplants that classroom apparatus, replacing it with (the illusion of) a blue sky towards which the children are turned. Now facing the painted sky with its far-off hot air balloon and the distant horizon on which the Cologne cathedral stands as a tiny sketch, the boys appear as if transformed bodily, with the gestures of their hands and arms now seeming to show them looking into a sunny distance, rather than writing on a nearby surface. In this way, when published as the frontispiece to Éluard's *Répétitions*, Ernst's picture presents itself as both a depiction of and a means to a renovated perception — and thus as something like an apparatus for a new kind of pedagogy.

Addressed to those who are at once readers and viewers of his art, the captions inscribed by Ernst on his overpaintings might be said to cultivate 'dialogic misunderstanding' in the sense Benjamin intends. Integral to the pictures of which they are a handwritten part, the captions enact, in words, the transformed relations of subject and object, and of image and inscription, that Benjamin poses as central to 'dream kitsch'. In the case of *Ambiguous Figures* (ca. 1919–20; figure 2), Ernst's words — '1 copper plate 1 zinc plate 1 rubber cloth 2 calipers 1 drainpipe-telescope 1 pipe-man' — frame a picture drawn and painted on a page of engraved illustrations from the teaching-aids catalogue mentioned above.[6] For Ernst, the pages of the *Bibliotheca paedagogica Lehrmittelkatalog*, on which, as he remembered them, 'objects for anthropological, microscopic, psychological, mineralogical demonstrations' were illustrated, became an object of 'fascination', a source of visions, and an inspiration for what he described as his attempt, in the overpaintings of 1919–21, 'to reproduce exactly that which was seen in me […] to obtain a true, lasting image of my hallucination in order to transform what previously had been merely banal pages of advertising into dramas that contained my most secret desires'.[7]

For Ernst as for Benjamin, kitsch was what the children of the late nineteenth century knew, or rather what they learned things from; kitsch was a form of instruction in perception, and its images took up residency inside them. Crucial to Ernst's account of his technique for producing overpaintings as reproductions of his internal mental imagery is the implication that the catalogue was a source of images first incorporated into him and then projected, in the process of drawing and painting on the commercially printed sheet, back onto the 'banal pages of

6. On Ernst's use of the *Bibliotheca Paedagogica*, see Teuber, 'Bibliotheca Paedagogica,' 35–39, and Teuber, 'Max Ernsts Lehrmittel', in *Max Ernst in Köln: Die Rheinische Kunstszene bis 1922*, exhibition catalogue, Kölnischer Kunstverein (Cologne: Kölnischer Kunstverein, 1980), 206–240. Molly Nesbit has explored related issues in an essay on the work of Marcel Duchamp (1887–1968), 'Ready-Made Originals: The Duchamp Model', *October* 37 (Summer 1986): 53–64.
7. Teuber, 'Max Ernsts Lehrmittel', 206, and 'Bibliotheca paedagogica', 35. The complete title of the *Lehrmittelkatalog* is *Bibliotheca Paedagogica: Verzeichnis der bewährtesten und neuesten Lehrmittel für höhere, mittlere, und Elementarschulen, sowie von Werken der Erziehungs- und Unterrichtswissenschaft* (Leipzig: K. F. Koehler, 1914). On the emergence of the 'education business' in eighteenth-century Germany, see Anke Te Heesen, *The World in a Box: The Story of an Eighteenth-Century Picture Encyclopedia*, trans. Ann M. Hentschel (Chicago: University of Chicago Press, 2002), 55–61, *passim*.

advertising'. That is to say, those banal pages provided images that entered into him rather than creating the illusion of a world into which he might have stepped. By means of drawing and painting understood as technologies for projecting onto a page images previously lodged in the mind, Ernst then refigured those pages as containers of the dramas of his own desires—desires that, needless to say, may themselves have been implanted in him along with the catalogue images. Refashioning a phrase from Benjamin in connection with her treatment of Ernst's overpaintings, Rosalind Krauss has associated Ernst's construction of pictorial space with the operations of 'the optical unconscious'.[8] In his own account of the use to which he put the teaching aids catalogue, 'the banal images of advertising' take up a privileged place in Ernst's unconscious—a place out of which the artist in turn projects what Benjamin calls 'dream kitsch'.

As if on the model of the Leporello pop-up picture books mentioned in Benjamin's essay, 'in kitsch the world of things advances on the human being; it yields to his uncertain grasp and ultimately fashions its figures in his interior. The new man bears within himself the very quintessence of the old forms, and what evolves in the confrontation with a particular milieu from the second half of the nineteenth century—in the dreams, as well as the words and images, of certain

FIG. 2 Illustration from *Bibliotheca Paedagogica. Verzeichnis der bewährtesten und neuesten Lehrmittel für höhere, mittlere und Elementarschulen, sowie von Werken der Erziehungs- und Unterrichtswissenschaft* (Leipzig: K. F. Koehler, 1914), page 964.
Max Ernst, *Ambiguous Figures (1 copper plate 1 zinc plate 1 rubber cloth 2 calipers 1 drainpipe-telescope 1 pipe-man)*, ca. 1919/20. Gouache, watercolor, ink, pencil, and ink inscription on a printed page from the *Bibliotheca Paedagogica* (Leipzig: K. F. Koehler 1914). Collection Judy and Michael Steinhardt, New York. © Max Ernst, by SIAE 2008

8. See Rosalind Krauss, *The Optical Unconscious* (Cambridge, Mass.: MIT Press, 1993), 32–93, and Krauss, 'The Master's Bedroom', *Representations* 28 (Autumn 1989): 55–76.

artists—is a creature who deserves the name of "furnished man"'—or, in a more literal translation of the German *möblierter Mensch*, 'furnished human being'. Thus the encounter with kitsch—and with kitsch as an element in, or potentially a medium for, works of art—transforms viewers and readers according to a model of reception in which the work as it were approaches and finally enters into the person apprehending it, outfitting him or her internally with 'figures' of 'the world of things'.

For Benjamin, it is by means of this internalization or introjection of 'the quintessence of old forms' that the novelty of the 'new man' or 'new human being' ('neuer Mensch') of the 1920s makes itself known. In the shape of the 'furnished man' ('möblierter Mensch'), he envisions a 'creature' transformed by the introjection of figures of the recent past as the subject of the dreams as well as of the avant-garde art and literature of his own day. A variant ending appended by Benjamin to a manuscript copy of 'Dream Kitsch' further describes the *möblierter Mensch* as 'the body "furnished" ["meublé"] with forms and apparatuses, in the sense that, in French, one has long spoken of the mind "furnished" ["meublé"] with dreams or with scientific knowledge'. Derived as it is from the *möblierter Herr*—a figurative, idiomatic term that refers to a tenant of furnished rooms as a 'furnished gentleman'—the *möblierter Mensch* of 'Dream Kitsch' might be said to be 'furnished' specifically with 'forms and apparatuses' of a past of which Benjamin took the 'furnished gentleman' to be an avatar. In his writings of the later 1920s and 1930s, Benjamin would continue to explore actual as well as potential correspondences among furnished dwellings, 'furnished' minds, and 'furnished' bodies in the cultural history of nineteenth-century Paris and the modernity of his own era.

Ernst's works are not illustrations but incomplete prefigurations of Benjamin's conception of kitsch and its potential to transform perception and personhood alike. In 'Dream Kitsch' and elsewhere, Benjamin assumes the present impossibility of authentically empathetic projection and asserts the necessity of displacing what now amount to simulations of empathy with technologies and effects of projective identification and incorporation that he (and also, I suggest, Ernst) understood already to be determinative in modernity. For Benjamin in the 1920s, a renovation of his contemporaries' relation to kitsch held out the promise of generating effects of estrangement that might make possible a 'highly productive use of the human being's self-alienation'.[9] A 'creature' with capacities to incorporate and project those effects—a creature like Benjamin's 'furnished man'—is also the hero of Ernst's art, the ambiguous figure of the 'pipe-man' ('röhrender mensch') named in the punning, self-referential caption of *Ambiguous Figures*, a creature who, outfitted with a laboratory safety mask, inked-on seaweed nose, bulbous Pyrex genitals, and a torso complete with handles to be grasped and cranked, supplants the image of the 'touching man' ('rührender Mensch') and his surefire effects of empathy.

Even if Benjamin was writing with knowledge only of the printed frontispiece

9. Benjamin, 'The Work of Art in the Age of Its Technological Reproducibility: Second Version', in *The Work of Art in the Age of Its Technological Reproducibility and Other Writings on Media*, ed. Michael W. Jennings, Brigid Doherty, and Thomas Y. Levin (Cambridge, Mass.: Harvard University Press, 2008), 32.

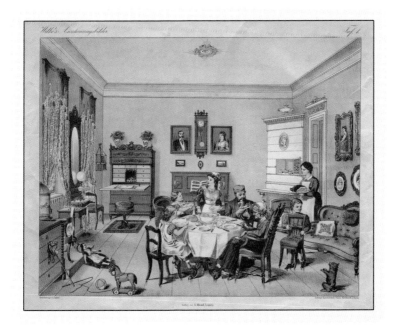

FIG. 3 *Wilkes Bildertafeln für den Anschauungsunterricht Nr. 1: Die Wohnstube* (Wilke's Wall Pictures for *Anschauungsunterricht* No. 1: The Living Room) 1839/1880. Lithograph. Museum Kindheit und Jugend, Stiftung Stadtmuseum Berlin, Inv.-Nr.: SM/UM 93/637.

in *Répétitions*, and was thus unaware that words from the teaching-aids catalogue page remain legible through the gouache in Ernst's original overpainting, Benjamin's choice of a picture of a group of boys in a classroom hardly seems arbitrary, given the larger claims of 'Dream Kitsch'. His conviction that the surrealists were in pursuit of 'things'—and that it was in the context of this pursuit that the significance of their composition of poems and pictures recalling the maxims and illustrations in nineteenth-century children's books emerged— links the treatment of surrealism in 'Dream Kitsch' to the aims of *Anschauungsunterricht* in its original as well as its updated forms.

*Anschauungsunterricht* is the name Pestalozzi gave to a method of teaching he developed in the context of his efforts to make primary education available to children of the lower social classes. Variously called, in the discourses of nineteenth- and early twentieth-century progressive education in the United States, 'object teaching' or 'object lessons', *Anschauungsunterricht* stresses the primacy of perception ('Anschauung') in the development of the human capacity to acquire knowledge of the world, and accordingly organizes its lessons first with a focus on concrete sensory experiences of things and then with an emphasis on the perceptual and cognitive apprehension of representations of things in the form of pictures, especially captioned illustrations presented in picture books and primers, as well as on wall charts and in various forms of hand-held cards and tablets (see figure 3), before proceeding to instruction concerning abstract concepts expressed in language.[10]

'There are two ways of instructing', the introduction to an 1894 English transla-
tion of Pestalozzi's 1801 book *How Gertrude Teaches Her Children* cites the
pedagogue as saying; 'either we go from words to things, or from things to words.
Mine is the second method'.[11] 'Of objects which cannot be brought before
the child in reality, pictures should be introduced,' Pestalozzi proposed.
'An instruction founded on pictures will always be found a favourite branch
with children, and if this curiosity is well directed, and judiciously satisfied, it
will prove one of the most useful and instructive.'[12] Benjamin often refers
to *Anschauungsunterricht* in the context of 'popular education' or *Volksbildung*,
but he makes clear that its perceptual and historical effects extended to bour-
geois children and, at least potentially, also to adult readers of various classes;
indeed, when writing about children's books Benjamin invoked both the experi-
ences of his own late-nineteenth-century Berlin childhood and his present-day
collecting. Like the scene in Ernst's frontispiece to *Répétitions*, the pursuit
of 'things' Benjamin attributes to the surrealists counts, for him, as something
like a new kind of *Anschauungsunterricht*.

Benjamin's 'Dream Kitsch' in effect envisions kitsch not only as a medium for
the transmission of new kinds of knowledge about, and new possibilities for
taking pleasure in, things, but also as an apparatus for the internal and external
transformation or 'furnishing' of human beings, as if the experience of 'furnishing'
(or, perhaps better, 'refurnishing') amounted to a kind of learning, and vice-versa.
In a longer essay on surrealism published in 1929, Benjamin envisions such trans-
formations or 'refurnishings' as prefigurations—in the context of the surrealists'
'radical concept of freedom' and their experiments with virtual and actual 'intoxi-
cation' ('Rausch')—of the possibility of political revolution. He speaks of 'a space
[…] in which political materialism and physical creatureliness share the inner man,
the psyche, the individual' and he says that the surrealists 'exchange, to a man,
the play of human features for the face of an alarm clock that each minute rings
for sixty seconds'. 'To win the energies of intoxication for the revolution: this
is the project on which Surrealism focuses in all its books and enterprises'.[13]

10. Pestalozzi's conceptualization of *Anschauung* with regard to pedagogy was derived from the philoso-
phy of Immanuel Kant (1724–1804); English translations of Kant variously render *Anschauung* as 'intu-
ition' or 'perception'. For Benjamin's use of the term *Anschauungsunterricht* in relation to pedagogical
theories and practices of the nineteenth century as well as the 1920s, see the radio broadcast
'Children's Literature', in Benjamin, *Selected Writings*, vol. 2, ed. Michael W. Jennings, Howard Eiland
and Gary Smith (Cambridge, Mass.: Harvard University Press, 1999), 251–252. In a review essay called
'Old Toys: The Toy Exhibition at the Märkisches Museum' that was published in the *Frankfurter Zeitung*
in March 1928, and that Benjamin understood to be closely connected to his emerging research on the
cultural history of nineteenth-century France in the work he called the 'arcades project' ('Passagen-
werk'), he praises the exhibition organizers for the breadth of their conception of 'toys', citing specifical-
ly the inclusion of 'books, posters, and wall charts for *Anschauungsunterricht*' among the objects on dis-
play. See Benjamin, *Selected Writings*, vol. 2., 98. See also Benjamin's discussion of *Anschauung* and his
comparison of old and new approaches to popular education ('Volksbildung') in the review essay 'Gar-
landed Entrance' in Benjamin, *The Work of Art in the Age of Its Technological Reproducibility*, 60–66.
11. Johann Heinrich Pestalozzi, *How Gertrude Teaches Her Children. An Attempt to Help Mothers to
Teach their own Children and an Account of the Method*, trans. Lucy E. Holland and Francis C. Turner,
ed., intro., and notes by Ebenezer Cooke (1894; reprint, New York: Gordon Press, 1973), vii–viii.
12. Pestalozzi, Letter XXVIII to J. P. Greaves (27 March 1819), in *Letters on Early Education*, intro. Jeffrey
Stern (London: Thoemmes, 1995), 123–124; earlier in this letter, which is part of a collection first pub-
lished, in English translation, in 1827, and for which the unpublished German originals are lost,
Pestalozzi states clearly 'the first rule is, to teach always by THINGS, rather than by WORDS' (122).
13. Benjamin, 'Surrealism: The Last Snapshot of the European Intelligentsia', *Selected Writings*, vol. 2,

# CHILDREN'S BOOKS, PICTURE-STATISTICS, THE COLOURFUL WORLD

'A Glimpse into the World of Children's Books', an illustrated essay that was published in a special issue of *Die literarische Welt* (December 1926) devoted to children's literature, opens with an account of what happens when children read illustrated books, a genre of unique significance to Benjamin, who possessed not only expertise but a major collection in the field (figure 4).[14] The children's book author Hans Christian Andersen (1805–1875) gets it wrong, Benjamin says, but not by much, when in one of his stories the characters depicted in an expensive book belonging to a princess turn out to be alive (birds sing, and human figures leap out and speak to the princess as she looks at the page on which they appear, leaping back in when she turns to the next). 'Things do not come out to meet the picturing child from the pages of the book', Benjamin states in his corrective. 'Instead, in looking the child enters into them as a cloud that becomes suffused with the riotous colors of the world of pictures. [...] He overcomes the

FIG. 4  Walter Benjamin, 'Aussicht ins Kinderbuch' ('A Glimpse into the World of Children's Books'), *Die literarische Welt* 2:49 (December 1926), p. 5.

218–219, 215.

14. Benjamin, 'A Glimpse into the World of Children's Books', in *The Work of Art in the Age of Its Technological Reproducibility*, 226–235. On Benjamin's collection of children's books, see Jörg Drews and Antje Friedrichs, 'Index der Kinderbuchsammlung Walter Benjamin', in *Zum Kinderbuch: Betrachtungen. Kritisches. Praktisches*, ed. Jörg Drews (Frankfurt am Main: Insel, 1975), 201–234.

illusory barrier of the book's surface and passes through colored textures and brightly painted partitions to enter a stage on which the fairy tale lives'.[15]

Although this description of the effects of reading and viewing picture books differs from the formulations in 'Dream Kitsch'—Benjamin alludes here to Daoist concepts that informed classical Chinese landscape painting, in which clouds figure prominently—it is worth taking note of a similarity enclosed within that difference. Crucial in both cases is the transformation of the reader and viewer, who changes shape in response to what he reads and sees. In 'Dream Kitsch', the result is a new kind of furnished human being outfitted with things encountered in kitsch (or rather things that come out to greet human beings from within kitsch), while in 'A Glimpse into the World of Children's Books' it is a child who becomes a cloud and enters the pages of the book, and who, suffused with the 'riotous colors' of the book's 'world of pictures', perhaps in turn can pass into the things depicted on its pages.

In the 1926 essay on children's books, one of several Benjamin wrote on the subject, the child's tactile and more broadly bodily experience of the book emerges as a key concern. Children 'know' the pictures in ABC books 'like their own pockets; they have turned them inside out, without neglecting the smallest thread or piece of cloth'.[16] This tactile approach to acquiring knowledge of pictures and what they represent extends to children's pleasure in setting the scenes of 'pull-out' books in motion, and to their inclination to 'complete' simple black and white wood-engraving illustrations by 'scribbling' on them. Writing in 1790, Friedrich Justin Bertuch (1747–1822), a pioneering figure in children's book publishing, emphasized that his *Bilderbuch für Kinder* (1790–1830) should be put to use by children as more than mere reading or viewing material: 'The child should be allowed free rein in handling it, as with a toy; he should draw pictures in it at any time, he should color it; yes, with the teacher's permission, even be allowed to cut out the pictures and paste them on carton lids'.[17]

Twice in his essay Benjamin makes explicit his felt connection to children whose learning to write about pictures in words coincides with their playing at scribbling on pictures in books. First he offers an invidious comparison of his own writing about children's books with the books themselves: 'for those few people who as children—or even as collectors—have had the great good fortune to come into possession of magic books or puzzle books, all of the foregoing will have paled in comparison'. A few lines later he describes the moment of the composition of 'A Glimpse into the World of Children's Books' as precisely

15. Benjamin, 'A Glimpse into the World of Children's Books', 226.
16. Ibid., 227.
17. Friedrich Justin Bertuch, 'Plan, Ankündigung, und Vorbericht des Werks', in *Bilderbuch für Kinder* (Weimar and Gotha, 1790), 3, cited in Te Heesen, *The World in a Box*, 58–59. Cutting pictures out of books and mounting them in new locations (on bedroom walls, in scrapbooks, or, as Bertuch suggests, on individual pieces of cardboard) is a practice Benjamin addressed elsewhere in his writings, and one which can be understood as a precursor to practices of avant-garde montage in the visual arts of the 1920s, and, in a different sense, to Benjamin's own attempts to invent a new mode of history writing in his unfinished *Passagenwerk* (arcades project; 1927–40). See Benjamin, 'Chambermaids' Romances of the Past Century', in *The Work of Art in the Age of Its Technological Reproducibility*, 245, and *The Arcades Project*, trans. Howard Eiland and Kevin McLaughlin (Cambridge, Mass.: Harvard University Press, 1999).
18. Benjamin, 'A Glimpse into the World of Children's Books', 231.

this kind of scene, noting that 'a quarto from the eighteenth century' lies open before him as he writes.[18]

As if to underscore the historical character of his own writing, and thus to convey the urgency of his engagement with children's books, in his discussion of puzzle-pictures Benjamin makes a passing reference to 'tests', by which he means the vocational aptitude tests and, more generally, the so-called 'psychotechnical tests' of his own era that would assume an important place in 'The Work of Art in the Age of Its Technological Reproducibility', especially in the two earliest versions of that essay. Whereas for Benjamin the puzzle-pictures in eighteenth- and nineteenth-century *Anschauungsbücher* (roughly 'perception-primers') resemble a 'masquerade' in which words unsystematically take on the appearance of things as if putting on costumes for performances whose techniques of play children might learn to imitate, in the systematized tests of his day similar pictures served as diagnostic tools and models for action in kinds of work that aimed precisely to replace the inventions and transformations of play with the acquisition of habit and a capacity for uniform, repetitive action.

In the artwork essay, Benjamin compares what he calls 'the test performance of the film actor', which takes place in front of the apparatus of the camera, to 'a performance produced in a mechanized test', as in the testing of workers in preparation for (and indeed, as Benjamin argues, in the process of) mechanized labor. In a passage that drew especially strong criticism from Benjamin's friend and Frankfurt School colleague, the philosopher Theodor Adorno (1903–1969), who raised the concern that Benjamin had 'protected himself by elevating the feared object with a kind of inverse taboo',[19] Benjamin proposes that the film actor should be seen as 'taking revenge' on behalf of 'the majority of citydwellers, [who] throughout the workday in offices and factories have to relinquish their humanity in the face of the apparatus'. 'In the evening', he asserts, 'these same masses fill the cinemas to witness the film actor taking revenge on their behalf not only by asserting *his* humanity (or what appears to them as such) against the apparatus, but by placing that apparatus in the service of his triumph'.[20]

It hardly needs saying that, as an illustrated article, Benjamin's 1926 essay on children's books has something in common with the works that are its subject. The first page of the article as it appeared in *Die literarische Welt* also makes vivid another aspect of Benjamin's writing about images, namely his insistence, in *One-Way Street* (written 1923–26, published 1928), that the ubiquity of advertisements on display in the publications and public spaces of twentieth-century cities should be recognized not only as a symptom but also as an agent of the transformation of the those spaces and of the kinds of writing, reading, and viewing that take place within them.[21] Thus it is striking to see, in the context of Benjamin's essay, how a large illustrated advertisement for picture books (Bilderbücher) takes up its place—with a brigade of soldiers standing at

---

19. Adorno, letter to Benjamin of 18 March 1936, in Adorno and Benjamin, *The Complete Correspondence*, ed. and trans. Nicholas Walker (Cambridge, Mass.: Harvard University Press, 1999), 130.

20. See Benjamin, 'The Work of Art in the Age of Its Technological Reproducibility: Second Version', in *The Work of Art in the Age of Its Technological Reproducibility*, 31.

21. See Benjamin, *One-Way Street*, in *Selected Writings*, vol. 1, ed. Marcus Bullock and Michael W. Jennings (Cambridge, Mass.: Harvard University Press, 1996), 444–487.

assembly before an officer mounted on a rearing horse—in relation to the reproductions from nineteenth-centruy children's books elsewhere on the page.

In an August 1929 radio broadcast on the topic of 'Children's Literature', Benjamin announces that 'the extraordinary relevance to the current situation that all experiments in *Anschauungsunterricht* possess, stems from the fact that a new, standardized, and wordless sign-system seems to be emerging in the most varied fields of present-day life—in transportation, art, statistics. At precisely this point a pedagogical problem touches on a comprehensive cultural one that can be summed up in the slogan: Up with the sign and down with the word! Perhaps we shall soon see picture books that introduce children to the new sign language of transport or even statistics'.[22] Although he does not mention the Marxist philosopher and member of the Vienna Circle of logical positivists Otto Neurath (1882–1945) by name, Benjamin's remarks in the 1929 radio broadcast call to mind the contemporary experiments in exhibition design and the presentation of statistical data in graphic form that were launched by Neurath in his capacity as founding director of the Museum of Society and Economy (Gesellschafts- und Wirtschaftsmuseum), which opened in Vienna in 1925. Born in Vienna, Neurath studied sociology and political economy in Berlin and served as president of the Central Economic Administration (Zentralwirtschaftsamt) that was charged with planning a program of total socialization during the short-lived Bavarian Soviet Republic (Räterepublik) in Munich in the spring of 1919. Following the fall of the Soviet Republic in May of that year, Neurath was arrested for his participation in the revolutionary government, convicted of treason, and sentenced to eighteen months incarceration. Thanks to the intervention of Otto Bauer, who was at the time Austrian Foreign Secretary, Neurath was released on bail in June 1919, and in 1920 he joined the Social Democratic administration in Vienna (commonly known as 'Red Vienna' in the period 1919–1934) as general secretary of the Research Institute for Social Economy (Forschungsinstitut für Gemeinwirtschaft), a post from which he soon came to focus his energies on questions of housing and city planning, and on the settlement or co-operative housing movement (Siedlerbewegung) in particular.

Education reform and *Bildungspolitik* broadly conceived were central to the political philosophy and administrative planning of the so-called Austro-Marxists in Red Vienna.[23] As historian Anson Rabinbach has written, during in the 1920s,

22. Benjamin, 'Children's Literature', in *Selected Writings*, vol. 2, 251 (translation slightly modified). Despite his use of the Pestalozzian term *Anschauungsunterricht*, Benjamin does not mention Pestalozzi or his followers in 'Children's Literature' but refers instead to children's books published by Johann Amos Comenius (1592–1670), Johann Bernhard Basedow (1723–1790), and Friedrich Johann Justin Bertuch (1747–1822), for all of whom the appeal of illustrated books to children's faculties of sensory perception was crucial. See Te Heesen, *The World in a Box*, 3–10, 42–61, *passim*, for an historical analysis of material and theoretical aspects of the the work of Comenius, Basedow, Bertuch and others that is especially relevant to Benjamin's approach to children's literature, in particular concerning concepts of 'use' and 'play'. For Benjamin on Pestalozzi, see his 1932 text, 'Pestalozzi in Yverdon', which emphasizes the experimental character of Pestalozzi's educational projects, and which also points to the central place of the hand in his pedagogical theory and practice, in Benjamin, *Über Kinder, Jugend und Erziehung*, ed. Günther Busch (Frankfurt am Main: Suhrkamp, 1970), 117–120.
23. On Neurath's time in Munich, see Nancy Cartwright, Jordi Cat, Lola Fleck and Thomas E. Uebel, *Otto Neurath: Philosophy Between Science and Politics* (Cambridge: Cambridge University Press, 1996), 43–56, and Neurath, *Empiricism and Sociology*, ed. Marie Neurath and Robert S. Cohen (Boston: D. Reidel, 1973), 18–29. On his role in *Bildungspolitik* in Red Vienna, see ibid., 56–60. On the connections be-

as 'the only Socialist party to hold absolute power in a major European capital, Austrian Social Democracy combined its traditional orientation towards *Bildung* with the project of municipal socialism by turning Vienna into a showplace of Social Democratic institutions designed to transform working-class citizens into "socialized humanity" by a politics of pedagogy'.[24] Committed to the implementation of a socialist *Bildungspolitik* and its aim of creating a *neuer Mensch* (new human being) in the form of the socialized citizen, as head of the Housing and Allotment Garden Association (Siedlungs- und Kleingartenverband) Neurath began in 1923 to incorporate didactic public exhibitions into his work in planning and administration. He described his first experiment in exhibition design as follows: 'Real, completely furnished houses were built on the square in front of the town hall. A selection of vegetables was exhibited and large charts displayed the achievements of the Association'.[25] Installed as the Museum of Housing and City Planning (Museum für Siedlung und Städtebau) at Parkring 12 in central Vienna, the project that began as the housing and gardening exhibition was reorganized in late 1924 as the Museum of Society and Economy with Neurath as its director.

The Museum of Society and Economy, which Neurath after his emigration to England in 1940 referred to as the 'Museum of Social Sciences' or the 'Social and Economic Museum',[26] opened officially on 1 January 1925 with the aim of educating the public and especially the working class in contemporary sociology, political economy, and related fields. Founded—like the city's 'hundreds' of newly built 'kindergartens, playgrounds, health centres', and so forth—as an institution designed 'to benefit the masses' by providing 'general social education', the Museum of Society and Economy was oriented to the specific historical experience of its public. 'When a Viennese citizen enters this museum, he finds reflected there his problems, his past, his future—himself.'[27] At the Museum, it was Neurath's ambition to develop media for the communication of socioeconomic knowledge and data about social life that would allow even passers-by 'to acquaint themselves with the latest social and economic facts at a glance'.[28] To that end, and in line with his maxim, 'Words Divide: Pictures Unite',[29] Neurath and his coworkers at the Museum developed what came in 1928 to be called the Vienna Method of Picture-Statistics (Bildstatistik; see figure 5). At the Museum, the Vienna Method was put to use as a system for making the mass phenomena (Massenerscheinungen) of contemporary life—including ordinarily invisible so-

tween the logical positivist philosophy (or 'antiphilosophy') of the Vienna Circle and the modernist design of the Dessau Bauhaus, see Peter Galison, 'Aufbau/Bauhaus: Logical Positivism and Architectural Modernism', *Critical Inquiry* 16 (Summer 1990): 709–752.

24. Anson Rabinbach, *The Crisis of Austrian Socialism: From Red Vienna to the Civil War (1927–1934)* (Chicago: University of Chicago Press, 1983), 7.

25   Otto Neurath, quoted in *Otto Neurath: Philosophy*, 62.

26   Neurath, 'From HIEROGLYPHICS to ISOTYPES', intro. Paul Rotha, *Future Books*, vol. 3 (London, 1946), 97, *passim* (http://fulltable.com/iso/is03.htm). 'Social and Economic Museum' is the term used, for example, in Neurath, *Empiricism and Sociology*.

27. Neurath, *Empiricism and Sociology*, 221.

28. Neurath, quoted in *Otto Neurath: Philosophy*, 65. See also Neurath, 'From HIEROGLYPHICS to ISOTYPES', 97. On the emphasis placed by the Vienna Method on making pictures to be taken in 'at the first glance', see Neurath, *Empiricism and Sociology*, 223, where he writes: 'A picture that has still further information to give at the fourth and fifth glance is, from the point of view of the Vienna school, to be rejected as unsuitable'.

29. Neurath, 'From HIEROGLYPHICS to ISOTYPES', 100. See also Neurath, *Empiricism and Sociology*,

cial, political, and economic processses—comprehensible by means of new, codified systems of graphic representation, structured by a picture language with its own precise grammar and lexicon of symbols. 'Modern man receives a large part of his knowledge through pictorial impressions', Neurath explained, 'illustrations, lantern slides, films. The daily newspaper disseminates more and more pictures every day.' 'Graphic representations and statistics should be made in such a way that they are not only correct but also fascinating,' asserts Neurath in a formulation that recalls Ernst's description of the 'fascination' he experienced when looking at the *Lehrmittelkatalog* in 1919.[30] 'The modern advertisement will show us the way!', he announced with a forthrightness akin to that of Benjamin's aphoristic pronouncements on advertising in *One-Way Street*. For Neurath, following the lead, and revising the aims, of 'the modern advertisement' would involve planning exhibitions in which pictures presented as 'a new kind of hieroglyphic writing' would serve as the 'base for a new sort of education', and, eventually, a new international language.[31]

Convinced that 'visual education leads to internationalisation much more than word education does,' Neurath saw the Vienna Method of Picture-Statistics, which he later renamed the ISOTYPE system,[32] as an historically specific improvement on the picture languages that appeared in the context of European picture books in the seventeenth and eighteenth centuries, in particular the multilingual *Orbis Sensualium Pictus* (composed 1650–54; published 1658) of Johann Amos Comenius (1592–1670) and the *Elementarwerk* (1774) of Johann Bernhard Basedow (1723–1790), which were also key documents for Benjamin. Collaborating closely with Marie Reidemeister (later Marie Neurath; 1898–1986), who as head of the Department of Transformation (Abteilung für Transformation) was responsible for a dimension of the Picture-Statistics method in which knowledge and data were assembled in order to make them available for presentation in visual form; with the German artist Gerd Arntz (1901–1988), who designed the signs and drew the pictures that made up the graphic figures of the pages and wall charts of Picture-Statistics themselves; and with the Viennese architect Josef Frank (1885–1967), who designed the rooms in the New City Hall (Neues Rathaus) in which the Museum inaugurated its new per-

217, where the phrase is formatted *'Words divide, pictures unite'*.

30. Neurath, *Empiricism and Sociology*, 214.

31. Neurath, quoted in Nader Vossoughian, 'The Museum in the Age of Its Mechanical Reproducibility: Otto Neurath and the Museum of Society and Economy in Vienna', in *European Modernism and the Information Society*, ed. W. Boyd Rayward (Burlington, Vermont: Ashgate, 2008), 242–244; and Neurath, *International Picture Language: The First Rules of ISOTYPE*, Psyche Miniatures, General Series No. 83 (London: Kegan Paul, Trench, Trubner, 1936), 9, 13. See also Neurath, *Empiricism and Sociology*, 214–217.

32. On visual education and internationalization, see Neurath, *Empiricism and Sociology*, 247. In the mid-1930s—by which time Red Vienna had come to an end with the Austrian Civil War and the forced removal of the Viennese Social Democrats from power in February 1934 and Neurath was living in exile in The Hague—he renamed the system of Picture-Statistics 'ISOTYPE' on the suggestion of his colleague and future wife Marie Reidemeister (1898–1986), who, as Marie Neurath, would go on to publish children's books and promote the Isotype method under the auspices of the Isotype Institute in England. In biology, 'isotype' designates a type or form of plant or animal common to different regions; as a name for what Neurath and Reidemeister envisioned as a universal nonphonetic symbolic helping language for the purposes of pedagogy, efficient communication, 'humanization', and internationalization, ISOTYPE took on related meanings. 'This new means of visual communication', wrote Neurath, 'is called Isotype, taken from the initials of I-nternational S-ystem of O-f TY-pographic P-icture E-ducation; the word may also be translated "always using the same types"'. (Neurath, 'From HIEROGLYPHICS to ISOTYPES', 98).

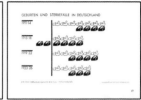

FIG. 5  Otto Neurath and Gerd Arntz, *Die bunte Welt. Mengenbilder für die Jugend* (Vienna: Artur Wolf, 1929), front cover. Cotsen Children's Library, European 20 1993, Department of Rare Books and Special Collections, Princeton University.
*Die bunte Welt*, p. 19.
Otto Neurath and Gerd Arntz, *Gesellschaft und Wirtschaft. Bildstatistisches Elementarwerk des Gesell-schafts- und Wirtschaftsmuseum in Wien*, Veröffentlichungen des Gesellschafts- und Wirtschaftsmuse-ums (Leipzig: Bibliographisches Institut, 1930), front cover.
Otto Neurath and Gerd Arntz, *Bildstatistik nach Wiener Methode in der Schule* (Leipzig: Deutscher Ver-lag für Jugend und Volk, 1933), n.p.
*Bildstatistik nach Wiener Methode in der Schule*, n.p.

FIG. 6  Otto Neurath and Gerd Arntz, *Die bunte Welt. Mengenbilder für die Jugend* (Vienna: Artur Wolf, 1929), title page. Cotsen Children's Library, European 20 1993, Department of Rare Books and Special Collections, Princeton University.
*Die bunte Welt*, p. 43.
*Die bunte Welt*, p. 35.
*Die bunte Welt*, pp. 8-9.

manent main exhibition in December 1927, Neurath sought at once to 'evolve a theoretical framework for visual education' and to deploy a range of media, in-cluding large-scale statistical charts assembled using colored paper cutouts of pictorial symbols, three-dimensional models composed of innovative technical materials, lantern slides, photographs, film strips, and diagrammatic films, each medium put to use in line with its unique 'educational characteristics' and ac-

33. Neurath, 'From HIEROGLYPHICS to ISOTYPES', 98–100. On the Museum's exhibition rooms as de-signed by Frank, see *Empiricism and Sociology*, 216; on Neurath's concept of 'humanization', see ibid., 227–248.

cording to the larger combinatory logic of the Museum's technological systems of display. Together, the Museum's experimental, interdisciplinary approach to the use of modern media and its commitment to socialist pedagogy constituted an attempt to effect 'the humanisation of knowledge through the eye'.[33] In addition to presenting exhibitions in Vienna (in its own rooms as well as in other public administration offices and schools) and elsewhere around the world (including Düsseldorf, Berlin, Chicago, London, Zagreb and Moscow, the last an outpost of the Museum established as 'a central institute for pictorial statistics, called Isostat' in 1931), the Museum of Society and Economy produced books, including what Neurath described as the Museum's 'great picture book *Gesellschaft und Wirtschaft*' (1930; see figure 5).[34] Its title echoing that of Basedow's classic *Elementarwerk* (1774), *Gesellschaft und Wirtschaft: Bildstatisches Elementarwerk des Gesellschafts- und Wirtschaftsmuseum in Wien* was a portfolio of one hundred charts published unbound in a folder so that individual pages would be readily accessible for use as graspable teaching tools or as elements in a classroom or exhibition display.

The approach to design and pedagogy manifested in *Die bunte Welt* ('The Colourful World'; 1929; see figures 5 and 6), a children's book published by the Museum in time to be purchased as a Christmas gift in 1928, corresponds closely to the model of contemporary *Anschauungsunterricht* described by Benjamin in his radio broadcast about children's literature in August 1929. The pages of *Die bunte Welt* are filled with pictures, charts, and concise textual entries on contemporary agriculture and industry around the world; on the social and political relations among nations, regions, and peoples; and on the historical and economic determinants of those relations. An advertisement for the book that appeared in 1931 presents the *Die bunte Welt* as 'a new *Orbis Pictus*', a reference that reaches back to Comenius at the same time as it invokes the many other 'new' and 'newest' versions of his work that had been published since the eighteenth century. The advertisement continues with a promotional pitch that represents as fully realized the sort of pedagogical transformation about which Benjamin and Neurath always only spoke prospectively: '"How many?" curious children ask their parents; for to today's youth statistics are as self-evident as technology was to those of an earlier age. Here the answer is at the fingertips of one and all.'[35]

Neurath traced the origins of his interest in visual education to his own childhood experiences. 'When I was about four years old', he wrote in a text that was intended to become part of his unfinished 'Visual Autobiography', 'I was given a scrapbook. I started by filling the pages very slowly with little "shinies", in slight relief and often stencilled, representing ships, animals, plants, human beings, and even little scenes. I was much attracted by the idea that these isolated

34. Neurath, *International Picture Language*, 110; *Empiricism and Sociology*, 216–217, 222–223. On Neurath's unfinished autobiography, on which he was at work at the time of his death in 1945, see *Empiricism and Sociology*, 459.
35. Advertisement for *Die bunte Welt* (1929) in *Märchen und Sagen aus aller Welt* (Vienna: Artur Wolf, 1931), quoted in Friedrich C. Heller, *Die bunte Welt: Handbuch zurm künstlerisch illustrierten Kinderbuch in Wien, 1890–1938* (Vienna: Christian Brandstätter, 2008), 324.
36. Neurath, 'From HIEROGLYPHICS to ISOTYPES', 93.

pieces could be arranged in different ways  This scrapbook was my first library and I liked its strange shape and colour'. Among the books in his father's library that Neurath spent time looking at 'long before [he] could read' was 'the atlas intended to accompany Alexander von Humboldt's famous *Cosmos* [1845–58]'; illustrated periodicals he looked through when he was allowed to accompany his father to the coffeehouses in Vienna also served as teaching tools in Neurath's early childhood visual education.[36] He describes having had a particular fondness for pictures that did not use perspective, a predilection that prefigures the codification of nonperspectival drawing in the Vienna Method. 'Orthodox perspective is anti-symbolic' he writes, 'and puts the onlooker in a privileged position. Any picture in perspective fixes the point from which you look. I liked any method which allowed me to use things of the same size, whether they were near or far away'.[37] In a formulation that recalls both Bertuch's and Benjamin's emphasis on the tactile and more broadly participatory aspect of children's reading and looking, Neurath concluded 'there were two currents in my visual career: the one mainly apperceptive—looking at pictures in books or at paintings; the other mainly active and concerned with combinations—putting together little "shinies" and pasting them in my scrapbook'.[38]

Opened in 1891, the Kunsthistorisches Museum in Vienna 'made the deepest impression' on Neurath, who describes his special fascination with the museum's Egyptian rooms, where 'the walls were covered with Egyptian wall paintings which greatly pleased me because I could understand every detail, whether they told of the daily life of the Egyptians or of battles and victories. [...] Everything was arranged without any attempt at perspective; the only aim was to convey a clear impression of the situation'. Elsewhere in the museum, Neurath 'admired the beautifully shaped Greek vases with their fine scenes in black, white and red, but they seemed only to provide information by chance'; their 'true role', it seemed to him, 'was merely to be beautiful'. In the museum's Greek and Roman rooms, 'Everything, however beautiful, seemed remote, extraordinary, detached from my everyday life—not close to me as were the Egyptian wall paintings'.[39] Neurath's experience of the Egyptian tomb paintings mounted on the walls of the Kunsthistorisches Museum activates the mode of looking Benjamin attributes to kitsch at the same time as it invokes the structural principles of the techniques developed in the Vienna Method of Picture-Statistics. 'When I look at isotype pictures today', he writes, 'I feel again much as I did when I used to look at Egyptian wall paintings. But here is no pageantry for the dead! It is for the people of every kind throughout the world, whatever way of life they may accept, whatever creed they may profess or reject, whatever their colour, whatever language they speak. This is pageantry for the living!'[40]

37. Ibid.
38. Ibid., 95.
39. Ibid., 96.
40. Ibid., 100.

# WALTER BENJAMIN
# DREAM KITSCH (1925)

*Die Neue Rundschau* 38:1 (Januar 1927)

No one really dreams any longer of the Blue Flower.[1] Whoever awakes as Heinrich von Ofterdingen today must have overslept.[2] The history of the dream remains to be written, and opening up a perspective on this subject would mean decisively overcoming the superstitious belief in natural necessity by means of historical illumination. Dreaming has a share in history. The statistics on dreaming would stretch beyond the pleasures of the anecdotal landscape into the barrenness of a battlefield. Dreams have started wars, and wars, from the very earliest times, have determined the propriety and impropriety—indeed, the range—of dreams.

No longer does the dream reveal a blue horizon. The dream has grown gray. The gray coating of dust on things is its best part. Dreams are now a shortcut to banality. Technology consigns the outer image of things to a long farewell, like banknotes that are bound to lose their value. It is then that the hand retrieves this outer cast in dreams and, even as they are slipping away, makes contact with familiar contours. It catches hold of objects at their most threadbare and timeworn point. This is not always the most delicate point: children do not so much clasp a glass as snatch it up. And which side does a thing turn toward dreams? What point is its most decrepit? It is the side worn through by habit and garnished with cheap maxims. The side which things turn toward the dream is kitsch.

Chattering, the fantasy images of things fall to the ground like leaves from a Leporello picture book, *The Dream*.[3] Maxims shelter under every leaf: "Ma plus belle maîtresse c'est la paresse," and "Une médaille vernie pour le plus grand ennui," and "Dans le corridor il y a quelqu'un qui me veut à la mort."[4] The Surrealists have composed such lines, and their allies among the artists have copied the picture book. *Répétitions* is the name that Paul Eluard gives to one of his collections of poetry, for whose frontispiece Max Ernst has drawn four small boys. They turn their backs to the reader, to their teacher and his desk as well, and look out over a balustrade where a balloon hangs in the air. A giant pencil rests on its point in the windowsill. The repetition of childhood experience gives us pause: when we were little, there was as yet no agonized protest against the world of our parents. As children in the midst of that world, we showed ourselves superior. When we reach for the banal, we take hold of the good along with it—the good that is there (open your eyes) right before you.

For the sentimentality of our parents, so often distilled, is good for providing the most objective image of our feelings. The long-windedness of their speeches, bitter as gall, has the effect of reducing us to a crimped picture puzzle; the ornament of conversation was full of the most abysmal entanglements. Within is heartfelt sympathy, is love, is kitsch. "Surrealism is called upon to reestablish dialogue in its essential truth. The interlocutors are freed from the obligation to be polite. He who speaks will develop no theses. But in principle, the reply cannot be concerned for the self-respect of the person speaking. For in the mind of the listener, words and images are only a springboard." Beautiful sentiments from Breton's *Surrealist Manifesto*. They articulate the formula of the dialogic misunderstanding—which is to say, of what is truly alive in the dialogue. "Misunderstanding" is here another word for the rhythm with which the only true reality forces its way into the conversation. The more effectively a man is able to speak, the more successfully he is misunderstood.

In his *Vague de rêves* [Wave of Dreams], Louis Aragon describes how the mania for dreaming spread over Paris. Young people believed they had come upon one of the secrets of poetry, whereas in fact they did away with poetic composition, as with all the most intensive forces of that period.[5] Saint-Pol-Roux, before going to bed in the early morning, puts up a notice on his door: "Poet at work."[6]—This all in order to blaze a way into the heart of things abolished or superseded, to decipher the contours of the banal as rebus, to start a concealed William Tell from out of wooded entrails, or to be able to answer the question, "Where is the bride?" Picture puzzles, as schemata of the dreamwork, were long ago discovered by psychoanalysis. The Surrealists, with a similar conviction, are less on the trail of the psyche than on the track of things. They seek the totemic tree of objects within the thicket of primal history. The very last, the topmost face on the totem pole, is that of kitsch. It is the last mask of the banal, the one with which we adorn ourselves, in dream and conversation, so as to take in the energies of an outlived world of things.

What we used to call art begins at a distance of two meters from the body. But now, in kitsch, the world of things advances on the human being; it yields to his uncertain grasp and ultimately fashions its figures in his interior. The new man bears within himself the very quintessence of the old forms, and what evolves in the confrontation with a particular milieu from the second half of the nineteenth century—in the dreams, as well as the words and images, of certain artists—is a creature who deserves the name of "furnished man."[7]

*Translated by Howard Eiland.*

Notes

[1] "Gloss on Surrealism" ["Glosse zum Sürrealismus"] was the title of this text as published in *Die Neue Rundschau* in January 1927.

[2] *Heinrich von Ofterdingen* is the title of an unfinished novel by the German poet Novalis (Friederich von Hardenberg; 1772–1801), first published in 1802. Von Ofterdingen is a medieval poet in search of the mysterious Blue Flower, which bears the face of his unknown beloved.

[3] Leporello is Don Giovanni's servant in Mozart's opera *Don Giovanni*. He carries around a catalogue of his master's conquests, which accordians out to show the many names. In the mid-nineteenth century, there was a German publishing house, Leporello Verlag, which produced such pop-out books.

[4] "My loveliest mistress is idleness." "A gold medal for the greatest boredom." "In the hall, there is someone who has it in for me."

[5] Reference is to the years 1922–1924. *Une vague de rêves* was first published in the fall of 1924; along with Aragon's *Paysan de Paris* (Paris Peasant; 1926), it inspired Benjamin's earliest work on the project he referred to as "das Passagenwerk." See Benjamin, *The Arcades Project*, trans. Howard Eiland and Kevin McLaughlin (Cambridge, Mass.: Harvard University Press, 1999).

[6] Pseudonym of Paul Roux (1861–1940), French Symbolist poet.

[7] Benjamin's term here is "der möblierte Mensch." A variant ending in a manuscript copy of "Dream Kitsch" reads: "The new man bears within himself the very quintessence of the old forms, and what evolves in the confrontation with a particular milieu from the second half of the nineteenth century — in the dreams, as well as the words and images, of certain artists — is a creature who deserves the name of 'furnished man': the body 'furnished' ['meublé'] with forms and apparatuses, in the sense that, in French, one speaks of the mind 'furnished' ['meublé'] with dreams or with scientific knowledge." See Benjamin, *Gesammelte Schriften* II:3, ed. Rolf Tiedemann and Hermann Schweppenhäuser (Frankfurt am Main: Suhrkamp Verlag, 1991), p. 1428. The term "der möblierte Mensch" is also a play on "der möblierte Herr" ("the furnished gentleman"), a colloquial German expression that refers to the (male) tenant of a furnished room or apartment and that Benjamin put to use elsewhere in his writings of the late 1920s. Ideas about furniture and furnishing, and about habits of modern dwelling in general, would come to occupy an important place in the Arcades Project.

Reprinted from Walter Benjamin, *The Work of Art in the Age of Its Technological Reproducibility and Other Writings on Media*, edited by Michael W. Jennings, Brigid Doherty, and Thomas Y. Levin. Cambridge, Mass.: Harvard University Press, 2008.

# KINDRED SOUL
## EVA MEYER

'And then the Robber robbed stories by constantly reading those little popular novels and fashioning purely original tales from the contents, laughing all the while'. Now he has a past! Though not because he has preserved what is past, for he has changed into something that never existed as such. The fact that the Robber exists means there is transference. Possibly 'his spirit' is developing into 'an Italy full of pines' or something is shooting out 'lightning-like from his presence of mind'. The totality of what he is able to do is effectively his soul: 'the construction of the exhilaration of his inner life', which dawns on him before his very eyes.

His dimension is contingency. A situation may be given, but not perforce, and it may be quite different under different circumstances. All the same, the Robber's potentiality has nothing random about it; on the contrary, he proceeds quite selectively. Starting from specific situations, he must prove himself despite and because of their differences, using them as a resource while reactivating his presence of mind each time: 'The Robber had once, on invitation, given a public account of his life till then, and his listeners followed these exceptionally charming observations with, it seemed, the greatest interest. It's quite possible this evening lecture shook him up, as it were, and that something dozing within him was jolted alive. He had been dead, one might say, for a long time. His friends pitied him and pitied themselves for feeling pity on his behalf. But now something within him had woken up, it was as if morning had dawned in his interior'.

Yet 'we'll surely get back to this later' is the formula with which Robert Walser presents his Robber. 'We fully intend to return in particular to this incident, for we wish to show him "as he is", just this once, with all his flaws'. Though it is highly questionable whether this will ever succeed. Preoccupation with the Robber is marked by a constant lack of knowledge. Yet this is conducive to dealing with the problem, which is precisely not about increasing knowledge. Given the insurmountable lack of knowledge, people persecute him, 'to help him learn how to live'. And this is a relationship that can be extended.

As a matter of fact, Walser's formula establishes a memory of transference, which—albeit spatially organized—moves in time. Within it the Robber came to 'a house that was no longer present, or to say it better, to an old house that had been demolished on account of its age and now no longer stood there, inasmuch as it had ceased to make itself noticed. He came, then, in short, to a place where, in former days, a house had stood. These detours I'm making serve the

end of filling time, for I really must pull off a book of considerable length, other-wise I'll be even more deeply despised than I am now'. One does not quite know whether the Robber is halfway down a path or the narrator halfway through a story. But as long as 'we get back to this later' it's all right for the future to re-main unknown, because now we've got a form of repetition that gives us access to it. What should remain is not remembrance but the difference between re-membering and forgetting, the difference condensed in this formula. Thus, what remains becomes the starting point for diversity, for an openness towards the new, and the ability to be taken by surprise. This one path leads him to another that would not exist without time—and so the Robber moves on.

What propels him is forgetting, or at least the insight that you cannot return to a past that no longer exists. Forgetting is not not-remembering, but just serves the end of filling time. You remember that you remember, but you forget that you've forgotten. The capacity of forgetting quite clearly surpasses that of remembering, since what is possible is of much greater dimensions than what is presently real, which, by the way, is itself part of what is possible. And so you make sure that forgetting remains latent. Then you have time to 'remain in com-mand of this robber story'. It is the stimulus of a movement that loses its contin-uation in the course of movements and replaces its subject matter with time. By not suppressing forgetting in order to remember, this movement actually pro-motes forgetting. Or to put it more accurately, it is a form of synchronizing re-membering and forgetting, which is in itself potentially paradoxical, and certainly pleases the Robber.

'He gave such a vulnerable impression. He resembled the leaf that a little boy strikes down from its branch with a stick, because its singularity makes it con-spicuous. In other words, he invited persecution. And then he developed a love for all that. We'll hear more of these matters in the following chapter'. Again, this is the best way of extending forgetting. For it neither erases remembrance nor creates absence. Rather, it promises surplus information, allowing us for now to forget everything but this trace, which seems not only to enable us to draw on information but also unleashes abilities capable of multiplying presence and pro-cessing new information.

You might also say the Robber has become increasingly abstract and retains his form precisely by doing so. What's crucial is the way in which his personal motions become almost like a sleepwalker's, and are then seized by a movement that seems to be summoning him. It is as if his mirror image took on a life of its own, became independent, and then took up its place in the mirror again, and so enacts a double movement. In between, a zero point, a deferral, keeps surfacing, preparing a shift of gravitation along different paths.

Though this is not a hesitation between different paths. Rather, it is the halluci-natory retrieval of a labyrinth of time that incessantly branches and rebranches—yet without it having to develop a separate realm of the imaginary or of transcen-dence. 'This so-called persecution signified for him the resurrection of a sunken world: his own, we mean to say, which, in his opinion, required animation. Mere-ly by occupying, concerning themselves with him, people understood him'. For now he possesses both a surface and a depth, and so reaches a peculiar original

immanence that is not to be considered the opposite of transcendence. Even if the unknown is hidden at a depth, this is the depth of the only real world. Which is why it is accessible via the surface where people unknown to each other meet, mix, separate, and in the process both absorb and create the Robber.

You do not ask what his intentions might be, whether his propositions should be believed or not. You understand him by occupying yourself with him, for 'naturally' this 'does him good'. Possibly you were 'just blocking his way a little, that's all, but even so, this was perhaps still something, was perhaps a great deal, for obstacles, after all, can move, animate, exalt us'. Yet this does not mean 'anything substantial'; he is not speaking of 'people's belief in Heaven, not at all'. The Robber requires neither hope nor belief. He requires 'a possession, and this he had'. It's not an accident that it all begins with: 'Edith loves him. More on this later', for his possession is not about contents but about relationships, and hence about love, 'since we are richer for it'.

'Edith loves him'—this possibility of existence is at the very beginning of our Robber story: the possibility of a singularity not just noticed but also distinctively loveable. It is the prelude to a formula of deferral meanwhile familiar, which is introduced here as a sign of clairvoyance when, in the Robber, it crystallizes the temporal image of transferences striving to and fro and up and down. 'On a later occasion we shall elucidate, illuminate this. Much in these pages will strike the reader as mysterious, which we, so to speak, hope, for if everything lay spread wide open to understanding, the contents of these lines would make you yawn' instead of following their command. Depending on the forms of synchronization valid for the Robber, time, too, can take on different forms, though these depend, in turn, on the mobility of their combinations. This mobility is all the more independent, the more it is devoid of any kind of empathy. Which is why it displays a manner that is neither real nor imaginary. It lies at the boundary between the two and refers to a truly hallucinatory faculty.

'But it's best we say nothing. Or we'll say it later'. Surely this manner is not so much a spatial movement but rather an affective one. But time goes beyond even these individual spiritual changes or affective movements in order to speak 'in the style of past eras' or rather 'in a modern mode'. So it's not about action or reaction, or about interaction or reflection. 'Did he deserve persecution? Did he himself know? Yes, he knew this, he felt it, suspected. This knowledge strayed, then it returned to him, it shattered, and its pieces slipped neatly back into place'. And we can watch his legend emerge in the process: 'And now to Rathenau.

'What a difference there is between this lad of ours and a Rinaldini, who, of course, in his day, no doubt split open the heads of hundreds of good citizens, sapped the wealth from the wealthy and caused it to benefit the poor. What an idealist he must have been. All our homegrown hero did was to kill, say, in the Viennese Café where a Hungarian band was playing, the peace of mind of a lovely girl seated at the window, with the piercing beam of his innocent eyes and with magnetic telepathy'.

Now, just let somebody try to make sense out of that: 'On the one hand, a coffee-cup episode' and on the other a 'major current event of historical significance', for 'a placard' had informed our Robber 'of Rathenau's murder' and to

this now comes 'the following confession: Rathenau and the Robber were personally acquainted'. The 'one scarcely worth mentioning' had met the 'one later to become minister' quite accidentally 'at Potsdamer Platz in Berlin amidst a ceaseless stream of pedestrians and vehicles' and was invited to pay him a visit. And now he stands there 'before this supremely affecting notice, which, as it were, had something extremely joyous and Greek about it, something of the vividness of ancient sagas'. For while outside, 'off in Germany, an intellectual hero's time' has expired, and inside things are endlessly and randomly synchronized, the memory and legend of a timeless contemporary emerges. And this is nothing else but 'the most discreet writing' and we hope 'to meet with understanding in this regard'.

So understand that what has so far only existed as a possibility is now turning into a power. The Robber is not a metaphor for the writer Robert Walser, even if the narrator is in danger of confusing himself with him — 'in any case, he and I are two different things', and 'naturally, we refuse to feel responsible for such extravagancies but are merely calling attention to the strained state of his wits'. Yet there can be no definite criterion for separating them, when the Robber robs the narrator of his speech because the latter can only remain in command of his story by interrupting it. But then this allows him to preserve the traces of an indirect origin when entering into a direct relationship with the Robber. Even if the one and the other seem to be the same person, who robs himself under two different names, this person is not adding another possibility to the one at hand. For now a difference of possibility arises that introduces a third, new thing. It is precisely because we do not know anything about it that it can be introduced as a playful element, not an accidental product but an accident-producing mechanism that makes 'the unsuitable in all this suitability' its resource. This is why Walser's formula implies the difference of a free indirect speech that keeps everyone at a distance. Though it is precisely by doing so that it keeps recharging itself.

So all those facing 'the difficult task of stepping, like a traveller changing trains, from one sort of situation, one sort of home, into a very different sort of situation and home' because they have 'undergone a change of cars, as it were, with regard to' their 'disposition', their 'way of thinking', will stand in their surroundings with all the more self-assurance, the more they remain strangers in them: 'Our certitudes must never stiffen or they'll snap. A true certitude of manner and in one's sense of the world requires a constant, slight flex and wobble. The ground beneath our feet may and must rise and sink, and to keep advancing toward perfection we must constantly feel we have not yet finished with ourselves and no doubt never will. And then it's like this: on our own native soil and sod, in our own homes, it's more difficult for us to develop. Sometimes a place where we do not belong in the usual sense is where we best belong, precisely since we didn't grow up there'. We learn 'the meaning of movement, transplantation, cultivation, self-improvement' and overcome freely and indirectly the standstill of paradox that becomes the medium of cognition and no longer of recognition.

At the bottom of this distinction lies another one, which, like the Robber, is 'eminently adaptable' and possesses 'a certain inborn need for equilibrium'.

Within the multiplicity of the changeable he grabs the wrong or right opportuni-ties and must put up with the following speech: 'Aren't you almost rather some-what too nice and kind to all these people who play perhaps quite unscrupulous-ly with the generosities that dwell within you, and have you never considered that you might find some more worthwhile occupation than merely plunging into the seas of good manners? Apparently you like to bathe in the bath of polite-ness, but might this agreeable pastime not bring you inner rifts?' 'Viewed through the lens of this behaviour', one does not get around to passing 'any real judgement on you. No one knows who you really are. Do you yourself still not know what you want in life, your raison d'être?' With your obligingness, extend-ed to the point of 'vanishing', you believe you're able to properly appreciate cir-cumstances, but 'why don't you go out into the world? Perhaps you will find work there, for, after all, you wish for nothing but to work, that's all that matters to you, any connoisseur of faces, such as myself, can see this at once'. The Rob-ber's soul is a surface tension in which different incompatible forces counteract. Absorbed in external demands, he seems to be an agency of transmutations. He aptly transforms the demands that are in the air into acts of assistance and service. His standards for forms find their ideal in the vanishing of form. He is so episodic that you never know what will happen next.

'Through his head raced the thought that he had once, years earlier, on the occasion of a railroad journey in the middle of the night, said in an, as it were, express-train manner to a woman travelling with him: "I'm on my way to Milan". Precisely in this way he now thought with lightening-swift rapidity of the choco-late bars you can buy in grocery shops. Children like to eat them, and he too, our Monsieur Robber, still enjoyed consuming this comestible from time to time, as though the love of chocolate bars and the like were among the duties implicit in the rank of Robber'. But what kind of label is this, how is his life being brand-ed? Formerly 'he had pilfered numerous landscape impressions. Certainly a curious sort of profession. He also incidentally purloined affections. More will be said of this at some point later'.

Yet now 'a reference to the resort town Magglingen, which is situated a thou-sand meters above sea level' reminds the Robber 'of Walther Rathenau, who once told him that he, too, was acquainted with the place, but had found it rather drowsy. As for me I encountered in Magglingen quite a number of French officers in mufti. This was shortly before the outbreak of our not yet forgotten Great War, and all these young gentlemen who sought and doubtless also found relaxation high up in the blossoming meads were obliged to follow the call of their nation'.

Yet 'whatever can you mean?' This is how you interrupt a speech that, at another time, might continue like this: 'Perhaps one is of great use with one's uselessness, dearest Madam, for haven't quite various forms of usefulness, in the past, proven harmful?' Wouldn't one need to invent a realm at mid-level for someone like the Robber who 'is the sort you can do what you like with' because he is 'full of equanimity, which is often confused with apathy, lack of interest'? The 'countless reproaches' made to him because of this 'have become, as it were, a bed on which I repose, which is possibly a great injustice on my part, but I told myself, I best make myself comfortable, for who knows what

great masses of discomfort I'll have to meet and contend with later'.

This will certainly not be the call of a nation. The kind of community one joins with the Robber will never coincide with society, because his interventions do not follow a given structure, but play the card of time, the time towards which he is moving. Whenever he goes out on the street, he immediately starts 'falling in love with something or someone'. Yet when he is 'at home, occupied with some task that requires intelligence', all this 'infatuation with the world and man is agreeably remote'. 'But his prayers and laughter, his yelps of joy and jeers, came all at the same time'.

So can forgetting be learned after all? And how might that be arranged? To do so, wouldn't one need new forms of repetition that allow for greater universality and hence for more multiplicity, just like the idiosyncrasy of the Robber? As said, this isn't at all about erasing remembrance, because only a simultaneous expansion of remembrance can extend forgetting. 'I regularly know, in the morning, nothing of my nocturnal cognitions. In the morning I think new thoughts'. But what is said so nonchalantly has to glow with concentration, because that's the only way to make a successful escape forward, surviving from one sentence to the next.

'But perhaps I'll postpone this a short while longer. Though I've been making good headway. But the interruption, I trust, will not prevent me from showing subsequent enthusiasm for the very same theme'. In order to continue you have to be a 'true titan of procrastination', because then things burst 'lightening-like' from your 'presence of mind'. 'Forgive me if I only now, like a tardy tot, remember' that one theme exists only as the possibility of another, because, like love, it can never be determined directly. Isn't it true that 'we're always at our kindest when there are questions within us we cannot answer with certainty? Are we the most beautiful, the most worthy of notice, when contradictions, struggles of the soul, noble feelings of anxiety are reflected in our conduct? Are we truest in confusion, clearest in fog, surest in uncertainty?'

Even if we doubt whether this is the right word, there's nothing that keeps us from speaking here of a reactive attention by which the Robber finds ways of constantly correcting his own behaviour in self-erasing sentences. Since what happens to him concerns him only halfway, he retains only that part of each event that is not exhausted by it, in other words, that part of the inexhaustible possibility that causes his clairvoyance. And to our surprise we realize that no single occurrence has a single meaning here, since there's never a limiting concept intervening. As if his subservience were the only thing alive, the Robber doesn't take it too seriously. Rather he transfers it—converts it into extraordinary, elusive moments of the appearance of a presence that always remains immersed in the thought of something utterly remote.

'Though it's true, I regard the indefinite, depending on the circumstances, as auspicious. For how am I to know what sort of welcome Edith will offer us in the event of our attempting a timid knock at her door? After all, it might well occur to her to slam the door on our, that is, my and my Robber's nose, perhaps saying to us: "Get lost both of you"'. And 'you have no idea how strange I'd find it to hear him entreating her'. 'I… him… her', there you are!

The indefinite is a lack of accord and 'yes, quite a lot depends upon the workings of circumstance. "Given the right circumstances": what important words these are'. They must be made a necessity, for it is given the right circumstances that a lack of accord becomes visible as a community. And Edith thinks: 'I chased him away, and now he's gone to a respected author and told him everything, and now the two of them are composing and writing about me with combined efforts and I am powerless to defend myself and there is no one to stand up for me'. But the 'most horrid part', for Edith, 'in this whole story is that he loves me and is robbing me like this out of pure affection and veneration, and the whole world knows everything about me'. Yet this thought is included in a more powerful context, for 'meanwhile' time is discharging:

'The close-together houses of this lovely city became first dark with clouds, then bright with sun, and carriages were pulled by horses, the tram cleared its throat, that is, whirled past and rattled and spat, and cars drove by, and little boys began to play, and mothers held their little sons or sprites by the hand, and gentlemen were off to a card game, and girlfriends confided to one another the newest events of an interest-provoking nature, and all was motion and life, people went away, others arrived by foot or train, one was carrying a picture all carefully wrapped up, another a ladder, another an actual sofa, you might have let yourself be cosily carried off on it, on the outskirts picnickers revelled, and in town the church towered up above the houses, like a watchman urging the preservation of unity and love, or like a tall young woman moved by impulses of true familial earnestness, for eternally young are the moments in which one feels life to be in earnest, feels that it turns green, smiles and bleeds, and that belief is the first of all things, and that it becomes, perhaps, after years in which little or nothing is believed in, the last as well, and that it is connected to the development of buds, and that first and last, commencement and cessation, are inseparable'.

When outer appearance and intercourse remain totally insignificant, their to and fro, their up and down achieve an immediate identity between world and soul. Neither signified nor signifying, this identity remains unspoken. Yet in its interruption, the Robber emerges, a kindred soul, who is both critical and involved.

Translated from the German by Cathy Kerkhoff-Saxon and Wilfried Prantner. All quotations are from Robert Walser, *The Robber*, tr. Susan Bernofsky [Lincoln: University of Nebraska Press, 2007]. The translation has occasionally been modified.

## NOTES ON CONTRIBUTORS

**Franco Berardi** (aka Bifo) is a writer and mediactivist based in Bologna. His many books include *Felix* (2001) and *Skizomedia* (2006).

**Brigid Doherty** teaches the history of modern and contemporary art and aesthetic theory at Princeton University. Among her recent publications is an edited volume of Walter Benjamin's writings, *The Work of Art in the Age of Its Technological Reproducibility and Other Writings on Media* (2008).

**Anselm Franke** is the artistic director of Extra City Center for Contemporary Art in Antwerp. He is currently completing a PhD in Visual Cultures / Centre for Research Architecture at Goldsmiths, University of London.

**Tom Holert** is an art historian and critic who lives in Berlin and teaches at the Academy of Fine Arts, Vienna. His next book, *Regieren im Bildraum* (Governing in Image-Space), will appear in fall 2008.

**Maurizio Lazzarato** is a Paris-based sociologist and social theorist and a member of the editorial group of the journal *Multitudes*.

**Angela Melitopoulos**, artist in the time-based arts, realizes video essays, installations, documentaries and sound pieces. Her work focuses on migration, memory and mnemonic processes in video narratives. www.videophilosophy.de

**Eva Meyer** is a writer and filmmaker based in Berlin. Her latest films *She Might Belong to You* (2007) and *Mein Gedächtnis beobachtet mich* (2008) were made in collaboration with Eran Schaerf. Forthcoming books include *What does the veil know?* and *Frei und indirekt*.

**Hila Peleg** is a curator based in Berlin. She is currently a PhD candidate in Curatorial Knowledge / Visual Cultures, Goldsmiths, University of London. She directed the film *A Crime Against Art* (2007).

**Avi Pitchon** is a writer, multidisciplinary artist/performer and a curator based in London. He is currently writing a book about Israeli counterculture in the 80's and 90's.

**Roee Rosen** is an artist and writer. He now teaches art and art history at Bezalel Academy of Art, Jerusalem. Among his controversial novels are *Sweet Sweat* (2001) and *Ziona* (2007).

**Renata Salecl** is Senior Researcher at the institute of Criminology of the University of Ljubljana; Centennial Professor at the London School of Economics; and a regular visiting professor at Cardozo School of Law, New York. She is the author of several books, most recently *On Anxiety* (2004).

**Florian Schneider** is a filmmaker, writer and activist based in Munich. He teaches art theory at Kit in Trondheim and is advising researcher at the Jan van Eyck Academie, Maastricht.

**Michael Taussig** is Professor of Anthropology at Columbia University. His many influential books include *Mimesis and Alterity* (1992), *My Cocaine Museum* (2004), and *Walter Benjamin's Grave* (2006).

**Anne-Mie van Kerckhoven's** art combines computer-based work with drawings, text, sound, video or painting, and assembles these elements in multimedia installations. Her work connects different knowledge systems, explores the areas of the unconscious, and looks at moral aberrations or the obscene from a female point of view.

**Barbara Visser** has worked as an artist in Brussels and amsterdam since 1991 and has taught at various European art and design institutes. Her work has been exhibited internationally since 1993.

Professors **Johan Wagemans** and **Géry D'Ydewalle** are affiliated with the Laboratory for Experimental Psychology at the Catholic University of Leuven.

**Eyal Weizman** is a writer and architect based in London. He is the director of the Centre for Research Architecture at Goldsmiths College, University of London. His publications include *Hollow Land* (2007) and *A Civilian Occupation* (2003).

Managing Editor
**Stephen Haswell Todd**

Translators
**Arianna Bove**
(Italian – English)
**Stephen Haswell Todd**
(French – English)
**Cathy Kerkoff-Saxon & Wilfried Prantner**
(German – English)
**Michael Meert**

# PRINCIPLE
# HOPE
# DAYDREAMING
# THE REGION

**EDITED BY**
**ADAM BUDAK AND**
NINA MÖNTMANN

# CONTENTS

# VENTURING BEYOND
## ADAM BUDAK

*The daydream can furnish inspirations which do not require interpreting, but working out,
it builds castles in the air as blueprints too, and not always just fictitious ones.*
Ernst Bloch

As much as the exhibition 'Principle Hope', this chapter of the companion book, bearing the
same title and complemented by the subtitle *Daydreaming the Region*, strives to delineate
a horizon of 'sustainable futures' in a sequence of narratives that unfold the problematic of the
local, the vernacular, the national, the regional and the European, and maneuver through
these terms' critical variations.

Educated hope (after Bloch) and critical regionalism (after Frampton) operate as twin
concepts that on the one hand provide a strategy of 'double mediation' in dealing with forma-
tive aspects of identity politics, and on the other, they contain a mobilizing act of 'forward
thinking' which sets up foundations of sustainable desire. They act as the agents of resistance
towards uniformed structures of global operations and concentrate on tracing the particulari-
ties and idiosyncrasies of places and selves. Critical regionalism is actively engaged in a
process of place-making and cultivating the site through layering and digging into its own
familiar and estranged tissues, while educated hope is concerned with temporalities as a
critical mediator of the present which aspires to the future. Thus as instruments of *not-yet*,
combining process-based practice and a formative act of subjectivity, critical regionalism and
its methodology, and educated hope and its phenomenology, construct a laboratory of a
place-to-come and a temporality-to-be-expected. As an item found amongst all humanity's suf-
ferings in Pandora's Box, hope is both a futile delusion and a wish to counterbalance evil.
A paradox lies at the heart of critical regionalism too, where a defamiliarizing approach and
alienating stylistic twists sharpen the perception of the vernacular and of the ordinary.

Daydream, this phantasmagoria of awakening, is a habitat where they reside and operate.
Whilst outlining the horizon of a 'better future', Ernst Bloch writes:

'Everybody's life is pervaded by daydreams: one part of this is just stale, even enervating
escapism, even booty for swindlers, but another part is provocative, is not content just
to accept the bad which exists, does not accept renunciation. This other part has hoping at its
core, and is teachable. It can be extricated from the unregulated daydream and from its sly
misuse, can be activated undimmed.'[1]

Daydreaming through its working of hope reactivates regionalist thinking and its critical
awareness of vernacularity and a politics of belonging. As such, it bears a power to sustain
critical regionalism's role as a 'fulcrum of a potentially resistant culture'.[2] Daydream is a vehicle
for 'venturing beyond'.[3] It includes 'a wishful element [...] which possibly diverts and fatigues
us, or which possibly also activates and galvanizes us towards the goal of a better life'.[4]
Daydreams, Bloch continues, 'always come from a feeling of something lacking and they want
to stop it, they are all dreams of a better life'.[5]

The essays gathered in this chapter cover daydreaming areas of hope, regionalism and

Europe and critically respond to conditions of belonging, and to the vernacular of current geopolitical and sociocultural agendas.

The introductory chapter, 'Local Histories and their Resonances', provides a frame and a context for this companion's attempt to elaborate the useful vocabulary of the regionalist and the transregional, as part of the hope-based anticipatory thinking of identity formation. 'Vernacular in Transit', a conversation between Marco de Michelis and Franco Rella, highlights 'the peculiarities of a particular place' and it focuses on mapping the potential of the town of Rovereto, 'the Athens of the Trentino Region', as a dynamic site of overlapped borders and temporalities. And it is especially timely: 'the pace of people's lives', according to Rella, is missing in Kenneth Frampton's elaboration of critical regionalism and in a discourse on the contemporary city in general. Gianni Pettena's essay, 'The Urban Structure—Legal and Illegal Use—Self Therapy' zooms out the perspective on the changing city by highlighting creative methods of 'reacquiring' the urban environment. Written in the early 1970s, this manifesto from the cofounder of the Radical Architecture movement, and the author of *L'Anarchitetto* (1973), still sounds fresh and valid, especially in its insistence on perceiving the public sphere as an area of negotiation and of an ongoing transfer of values and ownerships. Pettena's conversation with Mirko Zardini further recalls and refers to these 'subversive components' typical of the discourse of legality in the (mainly American) urban contexts of the 1970s and of Pettena's practice, which existed at the blurred border between art, architecture and environmental activism. Unfortunately, they no longer belong to contemporary approaches to and treatments of urban space. The authors mourn the decline of the radical architectural thought and daydream a return to the roots in order to deliver a sustainable testimony to current cultural processes. Radical imaginations of regional and transregional origin constitute the substance of Uqbar Foundation's artistic contribution to the companion book, 'Fiori Inesistenti in Natura'. The artists unfold a visual narrative, combining scientific references and mythological sources, as well artistic quotations jammed with ecological/environmental concerns. They construct a seemingly utopian platform where diverse temporalities coalesce, inspired by the stage designs of Fortunato Depero, who used to experiment with notions of simultaneity in theatre. Revisiting the legacy of futurism, Uqbar Foundation continues its investigations into imagined futures and collective desires, which form an essential part of its ongoing research into the ontology of progress and visionary knowledge.

The following chapter, 'Hope and Other Principles', portrays the phenomenology of a guiding principle and a venturing beyond of its own horizon towards the possibilities of potential fictions and imaginary constructs. The opening essay, Simon Critchley's 'The Politics of the Supreme Fiction', is an outline of political rituals that request the suspense of disbelief and the presence of illusion. In the spirit of Rousseau the author defines the realms of politics, law and religion that are inhabited by fictions. The term 'supreme fiction', which is appropriated from a poem by Wallace Stevens, is used to emphasize the critical potential of poetry and subsequently to link poetry with politics. The supreme fiction is based upon a final belief: 'to believe in a fiction, which you know to be a fiction, there being nothing else'. However the author fails to identify the possibility that a supreme fiction could operate in the world of politics as a tool around which politics might organize itself and a people might become a people. Bernd Hüppauf's essay, 'Regions and Centers. Spaces of the Vernacular: Regionalism and Ernst Bloch's Philosophy of Hope', advocates an unexpected return to a discourse of the regional and introduces new aspects: the German notion of a hometown and its vernacular.

The vernacular constitutes an essential layer of Bloch's elaboration of hope as a 'principle' that guides our lives and influences our perception of spatio-temporal coordinates. Defined as *Heimat*, the vernacular is 'an imagined space of promise, a land to come' and as such is rooted in the anticipatory function of thinking. It embodies a space of the *not yet*, the main area of operation of Bloch's concept of hope. It is a state of mind whose constituency includes both a strong sense of belonging and a genuine need for the freedom to leave. A similar oscillation between a utopian belief in complete belonging and the potential of not belonging has been identified as a characteristic feature of such a 'disjunctive' identity as the regional one by Suzana Milevska in her essay 'The Hope and Potentiality of the Paradigm of Regional Identity'. Regionalism is perceived as the 'dangerous supplement' to national identity, capable of deconstructing an insufficient paradigm and shaking the homogenous and stable frames of regions, as economic, social and cultural constructs. In his artistic contribution, 'Space Rendezvous', Christian Philipp Müller returns with a tribute to one of the distinguished artistic minds of the Trentino region and Rovereto in particular, Fortunato Depero (1892–1960), coauthor of the manifesto 'Futurist Reconstruction of the Universe' (1915). Inspired by Depero's 1936 float (carro allegorico) for Manifattura Tabacchi (one of Rovereto's Manifesta venues)—which, in keeping with the artistic ideals of the futurist movement, resembled a cross between a tank and folkloristic allegories—Müller takes the likewise futuristic 1975 'space rendez-vous' as a model for his Manifesta float. The artist's companion book contribution depicts a particular daydream and it focuses on contrasting private and local histories with global mechanisms and political powers: mirror images of Depero's encounter with America are juxtaposed with detailed diagrams of the Apollo-Soyuz Test Project vehicle that was used to transfer cosmonauts and astronauts.

'Regionalism and its Critique' collects essays that approach the notion of regionalism, and critical regionalism in particular, in a confrontational way, as a means of embracing the contradictions of local identities. The essays function as tool to comprehend context-related practices, but also propose possible strategies to cope with the sociopolitical situation of the postnational and stateless. Alan Colquhoun conducts a constructive critique of this phenomenon in his essays 'Regionalism I' and 'Regionalism II'. After diagnosing regionalism as a hybrid concept, critically immersed in discourses on historicism, eclecticism and nationalism and rooted in classicism and the avant-gardes of the 1920s, the author focuses on the relationship between regionalism and the conditions of late capitalism. He welcomes Alexander Tzonis and Liane Lefaivre's concept of critical regionalism as an architectural theory that saved the concept of

**1** Ernst Bloch, *The Principle of Hope*, vol. 1, trans. Neville Plaice, Stephen Plaice and Paul Knight (The MIT Press), 3.
**2** Kenneth Frampton, 'Critical Regionalism Revisited: Reflections on the Mediatory Potential of Built Form', in Maiken Umbach and Bernd Hüppauf, eds., *Vernacular Modernism: Heimat, Globalization, and the Built Environment* (Stanford University Press, 2005), 193.
**3** Bloch, *Principle*, 4.
**4** Ibid., 76.
**5** Ibid., 76.

regionalism from the Modern Movement's insistence on regional architecture being 'authentic' by ridding it of regressive nostalgia. However, he describes critical regionalism as an 'impossible project' which failed to cope with the challenges of accelerated globalization. Questioning regionalism's status as a theory the author identifies it as an attitude, or 'an object of desire', and he concludes the essay with a call for a practice that is unconcerned with authenticity and able to envisage 'stable, public meanings'. Lucy R. Lippard shares Frampton's 'critical arriere-garde' position, and in her essay 'Beyond "Being" in Place' (a revised version of the essay 'Being in Place' from her seminal book *The Lure of the Local*), she further elaborates the notion of the 'local' and its covert potential for resistance. She also examines the notion of 'place' as a subjective construct, and thus opposed to the concept of a geographic region. Lippard emphasizes the active role of community in the process of place-making, and as no community is monolithic, the main task, the author observes, is to generate not a place but rather a plurality of places. She ends by 'venturing beyond' with a hope for a 'multicentered' or decentered form of regionalism that is simultaneously a product of, and a resistant force against, global hegemonies. Judith Butler opens her conversation with Gayatri Chakravorty Spivak on the structures of 'language, politics and belonging' by asking, 'What state are we in when we ask questions about global states?' Butler draws on Hannah Arendt's notion of statelessness while approaching the nation-state via a complex interplay of belonging and nonbelonging and focusing mainly on the possibility of constituting a nonnationalist, or counternationalist, mode of belonging. Recalling President George Bush's claim that the American national anthem can only be sung in English, Butler asserts the active role of language as a category of belonging and exclusion. Spivak proclaims the decline of the nation-state, as accelerated by globalizing processes, and seeks ways to reinvent the state. According to her, critical regionalism, able to combat global capitalism, creates an option for 'venturing beyond' the restrictive confines of the nation-state. The author sees a strong need for 'critique' and 'regionalism', as tools to renegotiate the nationalisms and the abstract structures of the state, and thus to function as effective instruments for the public's interests. Ayreen Anastas and Rene Gabri, in a conversation with Nina Möntmann, discuss the spatial politics that constitute the significant layers of their critical art practice, conducted in particular zones of urgency such as Israel, Palestine and Guantanamo Bay. Recalling a number of projects, amongst them *Camp Campaign*, *Continental Drift* and *m\* for Bethlehem*, Anastas and Gabri articulate their views on global versus personal mapping and on geopolitical deterritorializations that condition modes of (national and beyond-national) belongings and identifications.

A set of case studies constitute the content of the last chapter, 'Europe and Its Ramifications'. Jochen Becker, in 'Ways Through the War: The African Liberation of Europe', turns his attention to colonial histories and investigates some lesser-known episodes from World War II. He traces the presence of African soldiers, mostly compulsory recruits, and details their contribution to the liberation of Europe from fascism. The author concentrates on the soldiers' controversial representation, mainly in the works of cinema (and in particular the Italian cinema of Rosselini and de Sica), but also within the context of local political debates, such as in the case of the significant community of Moroccan soldiers in Tyrol. T.J. Demos, in 'Europe of the Camps', perceives the contemporary Europe of the Schengen Agreement as a conflicted region of divisions and contradictions. Recalling Étienne Balibar's 'virtual European apartheid', Demos questions the legality of space and defines Europe as a zone of denied access and violated human rights. He calls for a 'more inclusive model of citizenship',

and, in conclusion, considers a redefinition of the EU as the site of critical regionalism with its 'dialectical expression' as a means to negotiate global tendencies and local urges. The perplexity of the social structures of belonging and identification systems in the Balkan region, and especially in Turkey, is investigated in the essay 'Don't Explain' by Erden Kosova. The author strives to decode the matrix of national belonging reflected in his own personal experience, within his curatorial practice and in some recent examples of contemporary art from the region. The current political climate urges Kosova to elaborate a double-sided critique of nationalism and commercialization.

The texts collected in this section of the Manifesta 7 companion book elaborate scenarios of a transitory and mediatory nature that characterize the unstable foundations of a transregional matrix of belonging. They reinforce the status of belonging as a flexible concept that performs a provisional and rhizomatic model of an attachment to place. Such dialectics seem to predominate the discourse on potential structures of belonging and their crucial role in the production of social and political space, especially the space of regions—active agents of resistance, diversity and difference. This intense and pregnant space is inhabited by daydreams: daylight fantasies, unique moments when a rare animation of consciousness occurs and a density of experience manifests itself. Here, daydreaming constitutes one of the most energetic processes of 'venturing beyond' the transitory areas of thought, towards unlimited imagination and unbound social justice. *Principle Hope: Daydreaming the Region* is inspired by the 'peculiarities' of the Trentino Region, and especially by the microcosm of a town, Rovereto, the home of the futurist revolutionary Fortunato Depero and of the philosopher of property and human rights Antonio Rosmini. This section contributes to a search for a daydreamt region, and holds out a genuine hope for the possibility of a 'better life' and the potential for a sustainable future.

# DAYDREAM REGION:
# ON POST-NATIONAL NARRATIVES
## NINA MÖNTMANN

Manifesta 7 is the first Manifesta not to take place in a city but in a region, in Trentino–Alto Adige / South Tyrol. Visitors travelling to the various exhibition venues and collateral events can physically experience the region in its breadth and scope. Historical and economic dimensions emerge in the different exhibition locations: the Habsburg fortress of Franzensfeste, two postindustrial sites—'Ex Peterlini' and 'Manifattura Tabacchi'—in Rovereto, an abandoned aluminium factory in Bolzano and the former central post office building in Trento. In general, exact boundaries only rarely demarcate regions, so that views may vary as to the extent of one and the same region. Moreover, certain places may be assigned to different regions, depending on whether one thinks of an economic region (a wine growing district, Silicon Valley in California), a geographical region (the Alps) or the rather dubious revival, say, of a tradi tional cultural region. Regional boundaries are unspecific, in contrast to national boundaries, which have often been fought over and settled by wars. Regions are perhaps best described as indefinite buffer zones, somewhere between the city's communal, locally specific organizational pattern and the juridical ordering of the territorial state, a flexible public sphere defying exact localization.

The concept of the region currently plays a significant role in various discourses for the most part concerning the evident erosion of the nation-state. On the one hand, the region as political structure whose most important feature is its transnationality, the fact that it is not tied down to national borders, has given rise to a new hope. In the words of Gayatri Chakravorty Spivak on the critical potential of regionalism: 'It goes under and over nationalisms but keeps the abstract structures of something like a state.'[1] At the same time, however, there are contrary developments. Here the region is a backward-looking micro-unit representing particularized interests with a tendency to provincialism. Discourse is informed by concepts, such as the authenticity of the local, that are closed to relativizing global contexts and to the questioning of established values. What Arjun Appadurai refers to as 'minority narcissism' emerges as each ethnic minority demands its own nation—witness the rash of national identities after the collapse of the Soviet Union and state socialism in eastern Europe, at its most violent in former Yugoslavia. On this view, an emergent region is the nucleus of awakening nationalisms.

An inherently similar opposition informed the discussion around Kenneth Frampton's famous essay 'Towards a Critical Regionalism', which investigated the potential of architecture in the regional process of 'place-making'.[2] Frampton, however, presupposes that a region has a natural unity and that its particularities—in contrast to the abstract universalism of the metropolis—should be preserved and furthered as a matter of responsibility towards nature and society. Anticipating possible interpretations of his ideas, he explicitly resists the concepts of populism and the vernacular, thus drawing attention to the contentious areas of his thesis. What is interesting about the debate sparked by Frampton's text are the opposing political perspectives lodged in the idea of critical regionalism. If, on the one hand, it idealizes the local

with the dubious aim of authenticating and glorifying the particular, it is also the vehicle for an architecture 'from below', dedicated to the values of participatory democracy.

## THE DISSOCIATION OF NATION AND STATE

Not only the region, however, but also the—originally related—nation-state is going through a contradictory development just now. While the patent decline of the nation-state is symptomatic of its diminished power, its continued existence remains a fact, no less than its new, post-sovereign roles, such as its participation in a whole range of supranational contexts and in an emergent global society.

A closer look shows that the decline of the nation-state can be described as a dissociation of the ideological construct of the nation from the political-territorial structure of the state. In a historically ideal form of political community the two are coterminous, whereby the nation provides the narrative component, the ideological and symbolic backup for the formation of the state with its territorial extension and its definition of belonging. Since the publication of Benedict Anderson's pioneering work *Imagined Communities*, the nation can no longer be thought of without the fictive and ideological backdrop in the process of the formation of its identity.[3]

How does the drifting apart of state and nation manifest itself, and in what ways do the two change? To answer the question in respect of national ideology, I would point to Boris Buden, who has noted the key fact that, while nations continue to exist, they have lost their common narrative, the narrative, for instance, of anticolonial nationalism that united the 'wretched of the earth' in their common interest in liberation and the hope of a common agency.[4]

Thus, while the common agenda and hence the narrative of *nations* has been lost, the new globalized *state* has become part of new communities in the form of powerful supranational decision making structures constituting the new world order, such as the WTO or SAARC at the economic level, NATO at the military level and the UN at the political level. The state's new responsibilities in its role as 'free-market global managerial state' within transnational groups of states serve the 'post-national character of global capital' of current neocapitalist societal forms.[5]

## POST-NATIONAL NARRATIVES OF BELONGING

In relation to these new state formations, rather than at the level of a nation concept now, a key concept emerges that is describable within a global framework (in this case of an unambiguously Western stamp): competition. The narrative changes accordingly in a global consumer Mecca. The full-blown patriotism that legitimized the historical nation-state gives way to a narrative of competition and its values. Once events, consumption and profit legitimize the role of the state in global capitalism, belonging becomes synonymous with participation in competition and the consumption of products.

In its global relations, the state takes on functions more typical of management, while its social and welfare services increasingly devolve to the individual or nonstate organizations. The effect of this cutback in welfare services on the civil population is twofold. On the one hand, it provokes a battle for public resources and, as we know, widens the gap between rich and poor. On the other hand, although I am aware of a potentially cynical undertone here, new alliances develop among the civil population, such as community organizations based on

**1** Gayatri Chakravorty Spivak, in Judith Butler and Spivak, *Who Sings the Nation-State?* (Calcutta and London: Seagull Books, 2007), 94.

**2** Kenneth Frampton, 'Towards a Critical Regionalism: Six Points for an Architecture of Resistance', in Hal Foster, ed., *The Anti-Aesthetic: Essays on Postmodern Culture* (Port Townsend, Wash.: Bay Press, 1983), 16–30.

**3** Benedict Anderson, *Imagined Communities* (London: Verso, 2006), 178 (first publ. 1983).

**4** Boris Buden, 'Why not: Art and contempoary nationalism?' in Minna Henriksson and Sezgin Boynik, eds., *Contemporary Art and Nationalism*, Prishtina Institute for Contemporary Art, Kosovo, 2007, 12–17.

**5** Spivak, in Butler and Spivak, *Who Sings*, 76.

**6** AnnaLee Saxenian, *Regional Advantage: Culture and Competition in Silicon Valley and Route 128* (Cambridge, Mass.: Harvard University Press, 1994), 8.

**7** Saxenian, *The New Argonauts* (Cambridge, Mass.: Harvard University Press, 2006).

**8** Spivak, in Butler and Spivak, *Who Sings*, 91.

**9** Giorgio Agamben, *The Coming Community* (Minneapolis: University of Minnesota Press, 1993); Jean-Luc Nancy, *The Inoperative Community* (Minneapolis: University of Minnesota Press, 1991).

mutual support, so-called 'new social economies' that convey a new sense of participative belonging 'from below'.

In contrast to fictive national communities and their imaginary relations, these communities born of necessity are regionally based. They are in direct contact with and represent the common needs of the people involved. The so-called new social economies have their roots in independent, collective entrepreneurship, such as daycare centres, housing projects, structures and counselling for the development of economic community projects, TV stations, family holiday camps, and so on. Participation is an important component of the idea of belonging in the new regional social economies, whereas at the national level belonging has a symbolic and representative character expressing itself in performative categories that can only be *acquired*, regardless of whether they are conformist or oppositional in nature.

But regional context and cohesion also play an increasingly fundamental role in economic metacontexts. The economic geographer AnnaLee Saxenian, who has researched the mechanisms and effects of the social networks in an economic region, in this case Silicon Valley, stresses the advantages of regional industrial systems. According to Saxenian, an economic region is successful if the public and private regional organizations 'shape and are shaped by the local culture, the shared understandings and practices that unify a community and define everything from labour market behaviour to attitudes toward risk-taking'.[6] Saxenian does also speak of divided interests. But she lays particular emphasis on a 'local culture', in other words an abstract and, according to Anderson's definition, fictive and ideological value of belonging, as found in traditional nation formation. It is thus only an apparent contradiction that the economic region equips its firms for the global market. Hence in her next book, *The New Argonauts*, Saxenian writes of businesses with Silicon Valley experience that have founded successful companies abroad, which, however, makes America richer rather than poorer, and is consequently judged to be positive.[7] Be that as it may, Saxenian provides arguments for the thesis that the ideological construct that generally constitutes belonging for a national community can also apply to a region, if the region adopts the mechanisms of the dominant societal form, currently those of neocapitalism. Thus, the collapse of the nation-state does not automatically entail the end of nationalisms. They can be reproduced in regions, as many parts of Eastern Europe show.

But even *critical* regionalism starts with the dissociation of state and nation, as Spivak has pointed out independently of Frampton's concept.[8] In this light, the region bypasses the nation in the optimal case, and hence also the danger of its ideological configuration, nationalism, rather than confirming it. But, at the same time, it preserves the necessary functionalities of the state, such as redistribu-

tion, logistics, legislature, and so forth. In order to bypass the ideological principle of the nation and its premises, the preconditions of community and belonging in the current scenario of unstable postnational narratives need to be redefined. The communal narrative of an emancipatory concept of belonging must be defined in opposition to that of historical belonging, based as it is on national identity. This new definition of belonging is linked to the hope of a transnational idea of participation in democratic processes. But how can new, postnational forms of belonging be established? They would have to develop independently of the mechanisms of national identity formation, informed by Nancy's and Agamben's models for an antiessentialist 'belonging without belonging' and an 'inoperative community' that resists populist ends.[9] Platforms are necessary that facilitate participation in public spaces and that reject the branded structures of the globalized state with its neoliberal agenda and management functions. Herein lies the hope of a new critical regionalism, a hope that can harbour, like a daydream, the potential of Ernst Bloch's 'anticipatory desire'. This region would replace the—as Sonic Youth once referred to the USA in an album title—'daydream nation', a mass of daydreamers shutting out reality. Yet if the daydream nation simply becomes a daydream region, then the hope has failed.

The 'Principle Hope: Daydreaming the Region' section of this companion book unites interest in current developments in the region as a spatial, cultural and political construct with the 'principle of hope' as formulated by Ernst Bloch. Adopting different foci with respect to the methods, perspectives and goals of regionalism and the 'principle of hope', the authors discuss current implications of nationalism, postnational identity formation, the vernacular, community and belonging, architecture, political movements and activism, as well as the colonial history of Europe.

# LOCAL
# HISTORIES
# AND THEIR
# RESONANCES

# THE VERNACULAR IN TRANSIT
## A CONVERSATION BETWEEN MARCO
DE MICHELIS AND FRANCO RELLA

**Franco Rella** Defining the identity of Rovereto is difficult, as is defining the identity of any place, thing, event, or person. Identity is something that persists through change and is a part of that change. It is also a relationship in itself and with the other, that other that refuses to be reduced to the same. Finally it is experience, experience that at times resists being conceptualized and asks in some way to be made into a 'story', or better, a tale. As you know, I grew up in Rovereto and live there still today. I am neither a historian nor urban planner or sociologist. I can only add my 'story' to the other stories.

I witnessed the identity crisis which Rovereto underwent during the 1950s, 60s and 70s. Rovereto was the most important industrial centre in the province and for this reason it had maintained a significant cultural and social role. The city could be experienced, and I myself experienced it, as a place through which energy moved and cultural forces passed (I remember concerts by Arturo Benedetti Michelangeli in the early 60s and those of Luciano Berio, as well as the effect that Lucio Fontana's exhibition made on me). The concentration of economic activity in Trento, capital city of the Autonomous Province, generated an identity crisis. It was as if the city no longer knew how to recognize or describe itself. I still can't understand if it has entirely regained this ability or not.

**Marco De Michelis** You say that Rovereto was an industrial and cultural centre, yet a border place.

**Rella** A place of borders, but a border lived not in the sense of closure, but rather in the sense of transit or opening. This was its tradition. Since the eighteenth century Rovereto was tied to the silk textile industry and to German investments: the province of South Tyrol (Alto Adige in Italian), as well as Nuremberg and the rising German state. Following the silk industry crisis in the nineteenth century, the tobacco and metal mechanics industries began to flourish. The Chamber of Commerce of the Italian part of South Tyrol was located in Rovereto, as was the first seat of the Italian bank Cassa di Risparmio.

**De Michelis** How would you describe the relationship between Trento and Rovereto?

**Rella** Rovereto has always been strongly independent from Trento, since as far back as the time of the Prince-Bishop,[1] an independence that was reconfirmed following the reannexation to Austria after the Congress of Vienna. Strongly independent and strongly antagonist.

Vienna had invested in the Italian South Tyrol. Think of the opening of the railway line from Verona to Bolzano in 1859, which was extended as far as the Brenner Pass in 1867: an endeavor that called for modifying the course of the Adige river the following year. In particular Vienna had invested in Rovereto with the opening of the tobacco factory in 1854, an enormous intervention that changed a great deal of things over the course of a few years.

The tobacco factory employed an extraordinary number of workers, above all women. Before the First World War there were 1,800 people employed: a small city within a city (I don't know what the the number of inhabitants was in Rovereto at the time, but I doubt more than fifteen thousand). The impact, however, was not only felt in economical terms but also at

cultural and identity-making levels. Here we come to one of the crucial points in the problem with identity, a point that can be expressed by the term *Ungleichzeitigkeit*, a central theme in the thinking of Ernst Bloch. Identity is not closed within a *topos*, but also, or above all, in a time which is a bundle of different temporalities. Workers who arrived at the factory in the morning from surrounding towns and who returned to their towns in the evening, experienced city time and country time simultaneously. In fact, they lived the time of a large factory and the time of the small countryside, divided into small farms according to the Austrian land register system. It was a double existence that affected thousands of families (even my mother worked at the factory).

The tobacco factory held a very important role for Rovereto and for the entire area around Rovereto. At the end of the nineteenth century when the silk market crisis, the Viennese stock market crisis, and the grape vine disease crisis all coincided, an enormous emigration took place which did not touch, or if it did only marginally, the surrounding towns that supported the factory.

**De Michelis** From a certain point of view could Rovereto be defined as a border city?

**Rella** I'm glad you brought this point up: that is, the question of borders. Rovereto is situated along the large Roman road that in Julius Caesar's time led to the ancient province of Pannonia. Today it is still located in part along this route. The people of Rovereto have always proudly claimed that all trains stop in Rovereto. And it's true. The fact that it lies along this great thoroughfare has indeed characterized the city—compared to other similar situations such as those which took place in the Veneto region—as a small metropolis. A part of my personal 'story' is that my friends from the towns of Valdagno or Schio used to tell me that going to Rovereto was like travelling to the city. In 1906 on Lake Lavarone, about twenty kilometers from Rovereto, Freud wrote *Delusion and Dream in Jensen's 'Gradiva'*. And just a few kilometers from Rovereto, on the shores of Lake Garda, such individuals as Franz Kafka, Thomas Mann, Carl Dallago and others resided.

Therefore, Rovereto has indeed been a city of transit. It is the birth place of intellectuals who began studying there and then later moved on. Federico Halbherr and Paolo Orsi, born at the end of the 1860s, moved from Rovereto towards Crete and Magna Græcia (southern Italy and Sicily). In the late nineteenth and early twentieth centuries architects and artists such as Libera, Pollini, Baldessari, and Melotti were born in Rovereto—a group of individuals who eventually came together with Depero to discuss Halbherr's, Orsi's and Rosmini's Greece. It's very interesting, quite strange, that Carlo Belli, the theorist among this group, arrived in this way at the 'spiritual in art'. Some of them went on to complete their studies in northern Europe, while others went to Rome or Florence. Nonetheless, they all remained strongly tied to their native city.

**De Michelis** So this condition of transit or thoroughfare extends outwards towards Vienna, or Munich, or Florence, and thus doesn't really need Trento?

**Rella** Rovereto is not a marginal place. I believe its present-day condition, although debilitated, is still that of a place of transit or thoroughfare.

**De Michelis** This peculiar condition of changeableness and transit does not, however, seem to have any particular effects on the political background. Rovereto remains a Catholic city.

**Rella** Yes, certainly. Although today Rovereto remains the city with the best electoral results for the parties of the left in the Trento province. It's only been this year that the first and only left-centre senator was elected in Rovereto. It is perhaps due to the history of an intense

Rovereto - Teatro Zandonai, 1900

Rovereto - Piazza Rosmini, 1936

**1** A Prince-Bishop is a *bishop* who is a territorial *Prince of the Church* on account of one or more *secular* principalities, usually preexistent titles of nobility held concurrently with their inherent *clerical* office. (Wikipedia.org)

cultural and political life which later, I repeat, was partially humiliated by the industrial crisis of the 60s and 70s involving the textile and metal mechanic sectors (Pirelli, etc…). This crisis coincided with the realization of the province's unique autonomy and with the shift in the direction of Trento of enormous resources, which were mainly poured into the service industry.

**De Michelis** When Rovereto was deindustrialized, what became of the disused industrial areas?

**Rella** It remained an important industrial centre, but basically marginal with respect to the service industry and, in particular, with respect to real estate investment in the capital city where prices of homes are similar to those in Milan.

**De Michelis** Where was the market pressure coming from?

**Rella** It came from investments in the province. Some years ago a media report revealed that every province employee had sixty-three square meters at their disposal. It also came from investments made in the construction of university structures. The University of Trento library was designed by a well-known Japanese architect in a centrally located and valuable area of the city. New industries were founded in Rovereto, but the city remained in a condition of marginality in contrast to its original vocation. From here stems the identity crisis of which we spoke.

**De Michelis** When the Autonomous Province of Trento was created, a subregional reality, the relationship between Rovereto and the capital changed.

**Rella** Rovereto was always seen as the economic and cultural heart of the province—'Rovereto: the Athens of the Trentino Region' was a title you could find in scholastic books and encyclopedias—and it found itself having to live through the shift to Trento, including a shift of its historically institutional offices such as the Chamber of Commerce and the Cassa di Risparmio bank.

**De Michelis** So, what will happen to Rovereto?

**Rella** With some difficulty, Rovereto is rediscovering its own identity on the 'edge' of this provincial economy. Its identity crisis—the incapacity to construct 'believable' stories of itself—leads to what at times are absurd demands such as the claim for a piece of the university in Rovereto at all costs. The case of the Mart (Museum of Modern and Contemporary Art of Trento and Rovereto) is emblematic. It's located in Rovereto (even though a portion remains situated in Trento) and has had an impact on the city that still needs to be assessed.

**De Michelis** Hence, no type of Bilbao Effect took place?

**Rella** In my opinion the daily visits to museum do not seem to have any true impact on the city. Perhaps it is because the museum is 'invisible', hidden, or without direct street access that it seems not to have experienced the identity-making effect that similar undertakings

have had in other countries. We should also note the cessation of industrial activity, such as that of the tobacco factory which is now definite. Presently, there is the usual discussion concerning reutilization and conversion of the factory into possibly another museum.

**De Michelis** Let's talk a little about the physical transformations, beginning with the more general ones. Has this new hierarchy between Trento and Rovereto provoked the creation of an uninterrupted linear city? Or have the polarities of the old urban centres remained unchanged?

**Rella** Today, there, an uninterrupted city exists. If you follow the Brenner state road that runs between Trento and Rovereto you never leave the city's limits. The polarity which existed up until the 1950s and 60s has now almost completely disappeared. The provincial offices and activities of the service industries in the capital have absorbed a great number of workers and, therefore, movement continues uninterrupted in times which are faster than those large city workers are bound to by duty.

**De Michelis** In the same way the polarity between city and country, between country and factory, has also dissolved.

**Rella** Yes, that too has dissolved. Small plots of land are cultivated with intensive modern techniques. Wine making is a specialized cultivation. Wine grower cooperatives gather local production and acknowledge the quotas for individual cultivators.

**De Michelis** When speaking of this area, may we not, nevertheless, refer to what Bernardo Secchi called the 'diffuse city'?

**Rella** No. The small and slightly larger towns that gravitate towards Rovereto for services (e.g. banks, schools, health and cultural facilities) jealously maintain their own autonomy, which is often nothing other than a faded ghost of their lost identity. For example, between Rovereto and Mori there is a true uninterrupted city, even though Mori is a municipality in itself. To the right of the River Adige about ten or so very tiny towns are grouped together into two or three small municipalities, and they refuse any suggestion of unification. It is difficult to consider Villa Lagarina an autonomous municipality instead of the portion of urban periphery that it really is.

**De Michelis** Let's try to broaden our view for a moment. The average European city, that which has circa one hundred thousand inhabitants, displays well-recognizable phenomena. For example, there's the radical transformation of relationships between centre and periphery. What is produced is what urban planners call the 'sprawl', that is, a speckled but not hierarchical settled system which rises, indifferent to any standard of 'good architecture' or any individual need or taste, and beyond any intention of permanence other than its brief time of use, or of any taking root in the territory in which it—as if almost suddenly—appears. Let me repeat that the sprawl is no longer the periphery of European cities. The sprawl describes 'an urban growth without form', an urban landscape void of centre or periphery where not only the physical forms of the settlement, but also the forms of daily life, are radically overturned. The one-family home and car make up the two private cells, anonymous and serial, of this dispersed city whose public hubs consist of large shopping malls, cineplexes, theme parks, and airports connected to each other by vast suburban motorway systems. The sprawl's peculiar condition is the complete lack of communication existing between a public space devoid of 'urbanity' and a nondescript and idealized domestic space. The sprawl is understandable when considered beyond the 'historical' idea of periphery, i.e. of the growing decentralization of residential areas, which always presupposed a hierarchically arranged structure with its nucleus coinciding with the city centre and its ramifications running along the axes of radial

traffic towards the outermost areas. It has no stable morphological structure and it extends into a territory that still encompasses preexisting fragments, such as cities and villages, farm areas and natural landscapes: a uniformly diffused piece of dust containing settlements of different functions, connected one to another not by the traditional rules of contiguity but by a diffused road network allowing absolute permeability of the territory. The sprawl produces an urban condition 'lacking in urbanity', as Rem Koolhaas has asserted. And yet it seems that Rovereto shows no similar process yet.

**Rella** No, not yet. South of Trento a large residential complex has been constructed. To the north a conglomeration of financial and business activities have been chaotically developed. Cinemas, theatres and other basic structures are still concentrated in the city's centre. A shopping complex has recently been built along the street leading to Lake Garda, in the south part of Rovereto. And very recently a residential complex containing a bank and supermarket has been developed in front of the train station. However, the majority of operations and functions remain within the city.

**De Michelis** The urban hierarchical system of Rovereto is still characterized by a main road along which are located public buildings such as church, town hall, theatre, museum and other large service-oriented facilities.

**Rella** The structure is perhaps a bit more complicated than that due to historical stratifications. Rovereto is skirted by large thoroughfares such as the River Adige, the state motorway, the railway. Leading out from the train station is Corso Rosmini, lined with trees, banks, residential homes, and shops. In Piazza Rosmini, just to the left of a stupendous pseudo-Venetian building, there lies Corso Rosmini, a beautiful eighteenth-century street where the Zandonai Theatre is situated, next to the Palazzo dell'Istruzione which in turn faces the Mart. To the right of the building, in Piazza Rosmini, you find the sixteenth-century and medieval parts of the city which extend up to the Town Hall, located in Piazza del Podestà at the foot of the castle housing the Museum of War. Beyond the railway station and larger thoroughfare streets, you can see the mountain slopes speckled with numerous small towns. Taking into consideration that the distances between areas are very short, what I have just described refers, nonetheless, to the city centre. Therefore, the effect is exactly that which you mentioned: church, town hall, theatre, museum, services.

**De Michelis** What about the utilization and transformation of the abandoned areas? What has happened to the factories and areas where operations were once located, for example the industries, and which are now in disuse?

**Rella** The textile and industrial factories located within the city have been destroyed and substituted by residential buildings (such as with the case of 'Serica' in the heart of the city and from which the sirens of midday break could once be heard) or by financial operations. The former site of the Pirelli company now houses Tecnofin—a group of small firms. In my opinion, there has been no real strategy in this change. Instead there's been a process of reabsorption that has left no space empty.

**De Michelis** So, can Rovereto still be considered a wealthy city?

**Rella** Yes. Essentially, yes. Despite any protests or disputes, also Rovereto enjoys the immense resources of the Autonomous Province.

**De Michelis** What about the tobacco factory, which today houses Manifesta (the European Biennial of Contemporary Art)? What will happen to it?

**Rella** The factory is now shut down and discussions have begun on reutilizing this very large

and built-up area situated on the outskirts of the ancient village
of Sacco (Borgo Sacco) and skirted by the River Adige. It is, neverthe-
less, an area very near the city centre.

**De Michelis** In this case do discussions on future use also include
cultural and educational operations?

**Rella** Here we foresee an obsession with constructing museums,
which is perhaps typical of our times and not only of Rovereto or the
Trento Province. The Ex-Peterlini site (more than once occupied by
anarchists), which hosts a portion of the Manifesta biennial, risks be-
coming the fourth seat of the Mart (after that of Palazzo delle Albere
in Trento, the seat in Corso Bettini, and the home of Depero in
Rovereto), with maintenance costs that will most likely exceed those
of the Bilbao Museum. Remember that there is already the Civic
Museum in Rovereto, in addition to the War Museum, the Mart, and
the house of Depero, and work is underway for the site of a (very
modest) city picture gallery and for another city museum of a nonde-
script title. Fortunately for the tobacco factory, the intention is to
develop research and production activities.

**De Michelis** Anarchists? In the Trentino area?

**Rella** There's a very pugnacious group of young anarchists to which
the city reacts with a sort of distracted indulgence.

**De Michelis** The city exists. The city changes. The territory also
changes. Have the people
of Rovereto changed? What about immigration and new residents?

**Rella** The territory changes, a mental geography changes, people
change. There is a high percentage of immigrants in the Trentino area.
Many people have come from northern Africa, Albania, and more
generally from Eastern Europe. When I make my way home from
work each evening I pass through not only different neighborhoods

but different language zones. I was recently struck by two young foreigners speaking to each other in a rough Italian, like a sort of mediation language between different cultures.

**De Michelis** Where have most immigrants settled?

**Rella** The majority reside in the historical city centre. This is the case for those worse off. There also exists a lot of tension around finding a permanent arrangement and competition for obtaining homes at cut-rate or discounted prices through the Trentino Institute for Housing or via the real estate market directly. These integration dynamics correspond to a rise in conflictual situations that are identity-making in nature, even within certain groups of immigrants. There are families where the eldest child continues to speak his or her native language, whilst the youngest refuses to and speaks only Italian.

Nonetheless, apart from claims made by the Lega political party, there is no real great tension or affliction in Rovereto. Perhaps due to its original nature of being a city of transit, Rovereto seems to be very open to accepting, if not necessarily welcoming, foreigners.

**De Michelis** Have immigrants found land to occupy in both industrial as well as agricultural sites?

**Rella** Above all in industrial and housing sites. Agricultural networks employ workers from the outside only during grape harvesting times. There are also cases of domestic workers and caretakers of children and the elderly.

**De Michelis** We've mentioned a situation of porosity or openness with respect to the world. If we were to define a physical characteristic of the inhabited territory in and around Rovereto, are there be any particular features that would distinguish it?

**Rella** Rovereto is partially 'porous'. Its opening to the world was not the validation of the modern style. Of course, along Corso Rosmini many traces of Austro-Hungarian architecture have been erased. The Great Vittoria Hotel, sporting a hall with a marble fountain in the middle, was converted into warehouses for the department store UPIM. Another hotel along Corso Rosmini was demolished and condominiums, designed by architect Luciano Baldessari, were built. The most recent housing areas, two new neighborhoods where several thousand people live, are condominium complexes, or even what we might call row houses.

**De Michelis** Do these two neighborhoods contain basic services, for example schools?

**Rella** In a certain sense they are self-sufficient. Schools are located within the neighborhood or just outside it (across the street). There's a pharmacy and other basic facilities. These neighborhoods have not changed the physiognomy of the city. The city grew to what it is today by absorbing the changes without experiencing any evident shock. Even Mario Botta's choice to build a new museum inside a city block, and not along the street front, reinforced the structure's complete metabolization without creating the least bit of discontinuity.

**De Michelis** The two buildings along this street were, in effect, used as two wings which need to be traversed in order to discover the large covered square where the museum, devoid of any true public façade, is situated.

**Rella** A visual shock would have undoubtedly been positive for a city that, as we have seen, retreated into itself during the 1960s. As I have said, I believe that the city does not really experience the museum as its own. Or it experiences it paradoxically, as it always has, without 'awe' and almost automatically. In the municipal council there is an ongoing and heated debate on whether to eliminate the jobs of professional firefighters who are supposed to be unified at a province level. Or the debate on the likeliness of ever creating new ultraspecialized hospital wards, as if dealing with a clinic of a university institution. The cultural politics concerning the

Mart were never discussed in depth. The shock would have forced the city to take an active stand either for or against the project. But there was no shock…

**De Michelis** Let's confront a slightly more general question. One of the aims of our discussion is to reflect on the notion of 'critical regionalism', a term that Kenneth Frampton formulated over twenty years ago. The basic feature of critical regionalism, as Frampton described it and as the philosopher Frederic Jameson further clarified, is that of the 'fulcrum of a potentially resistant culture'. Like a condition of friction and chafing among the processes of transformation of the physical reality of a place and the reality that resists transformation. Like a strategy able to 'mediate the impact of universal civilization with elements derived from the peculiarities of a particular place' without being reduced to 'simple-minded attempts at reviving the hypothetical forms of a lost vernacular'.

**Rella** I have a feeling that this concept of friction constitutes a step forward in respect to Kenneth Frampton's article published in *Casabella* in 1984. The crux of that essay, regression without reaction, was a weak and unresolved point. It remained so even with the generic reference made to Paul Ricoeur and Martin Heidegger. Citing a passage from Heidegger on living/dwelling while leaving aside, as Frampton suggests, the question of being, means citing a totemic or emblematic name, and not Heidegger: a formula of little significance.

Nonetheless, it concerns an important text in that it reacted reasonably, on the one hand, to the homologation of the extreme modernism of international style and, on the other hand, to a regionalist feature truly reactionary and purely superficial and aestheticized: a tattoo, or mask on the face of a building, which does not contrast with international style, nor is it an ornament—that criminal ornament which Adolf Loos wrote about. Hermann Broch spoke of a very different type of ornament that is not outward appearance, but 'overfullness'. And, like Broch, also the great artists from the late nineteenth and early twentieth centuries (for example, Boccioni who spoke of this idea in his diaries) thought that ornament was a thrust of inner life and of strength towards an 'unexpressed' that opened up to the heights of art. Ornament as a vernacular mask is a 'fake' and neither touches the substance nor the tension in which modern visual art dwells—a substance and tension which should also mark out the destiny of architecture.

**De Michelis** On the other hand, there is no simplification more useless than that which opposes the idea of modernity itself and, in architecture, the idea of modernism, to that of 'tradition'. Between these two extremes a complex and contradictory relationship develops rather than a pure and simple opposition. You need only to think of a crucial protagonist like Adolf Loos. Although Loos seemed completely extraneous to contextual themes, in reality he was fully aware, as is demonstrated in both his defense of the 'Viennese-ism' of his building in Michaeler Platz and in his conscious recovery of traditional forms from Alpine chalets for one of his boldest and most mature projects, the Kuhner house. However, we should reconsider above all the dialogue between history and the present that Le Corbusier held at the centre of his overall thinking on architecture: the provocatively suggested parallel between the perfect beauty of the Parthenon and the no less perfect beauty of industrial products from the Age of the Machine; the parallel between the sculptural malleability of new materials, such as reinforced concrete, and the solidity of traditional stone construction. Are these examples enough? Or shall we mention the work of Heinrich Tessenow, of Frank Lloyd Wright, of Alvar Aalto, to underline the centrality of the relationship between architecture and context,

between architecture and tradition, over the entire course of twentieth-century architecture? The problem is of another kind. It was well-identified by Manfredo Tafuri when he prophetically observed that the destiny of architecture was to be deprived of any autonomous meaning within the panorama of the contemporary metropolis—that city which today is assuming the form of a megalopolis. Simply visit any large city in Asia, for example Seoul or Shanghai, where historical identity has been reduced to a grotesque caricature, indeed to a 'mask' of spires and pagoda rooftops crowning thousands of skyscrapers and boundless neighborhoods.

Let's return to Rovereto, however. For its condition of transit that we mentioned earlier, Rovereto has not developed its own peculiar vernacular, its own particular dialect of wooden balconies with ornate flower carvings. In fact, from what you said earlier, what remains are rather the traces of Imperial Vienna.

**Rella** Partially eliminated, but real. I mentioned the former Cassa di Risparmio constructed in the style of a Venetian Renaissance palace at the beginning of the 1900s, a tribute to the history of Rovereto, which once belonged to Venetian domain. However, even this example should not be interpreted as an example of mere dialecticism. It too belonged to a part of the broader urban design, a work by a Viennese architect, the same architect who designed the Ring of Vienna. It involved a modern spirit rather than a vernacular one.

If we reconsider the question of regionalism, we find that another limit of Frampton's essay is to connect the concept of regionalism to 'topos', or place, only. While it is the question of 'time' that also characterizes a regional situation. We spoke of the tobacco factory as a structure in which different temporalities cohabitated: the factory's time, or better, timetable, and the time of the countryside. The question of time, of the unassimilable plurality of different times, should be considered within the definition of regionalism, especially when one tries to read it, like I said, as a condition of friction between processes of transformation and resistance to this transformation. This is because tension lies not only within space and its remnants, but also, and perhaps above all, in the pace of people's lives.

**De Michelis** You're right. This is indeed one of the great questions regarding the reutilization of historic urban structures after their functions have been changed. One thing is to have a hotel with a stream of foreign visitors coming and going. But if you transform that building into a bank, everything changes. As the lights of a hotel illuminate as evening approaches, those of a bank grow dimmer. While a hotel is still full of tired and resting tourists, a bank is entering the peak of its activities. This is what happened in most European cities. There is one case I know very well, that of the city of Graz, Austria. Today the centre of Graz is just as it was fifty years ago. The same is true for Treviso or Vicenza and for many small cities in Switzerland or Germany. They seem not to have changed, although in reality time has radically transformed them. Thus, the sense—or meaning—of spatial relationships, between public and private spheres, changes radically.

**Rella** The 'Heimat' concept, concealed in the idea of regionalism, appears to resist change, yet it resists it in a fictitious way. A temporal release is also inevitably produced within this concept; a decisive thrust opening a path that either leads to modernity or towards a regression into the past. In either case, that which appears to be 'heimlich' (familiar or intimate), in the end becomes 'das Unheimliche' (the uncanny): a disquieting familiarity which is, at the same time, extraneous. It is on this border, this edge, and on this opening, that there is space for reflec-

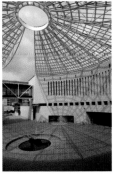

Rovereto - Corso Bettini, 1905

Rovereto – Manifattura
Tabacchi (Tabacco Factory).
Workers, Thirties
Photo credit: Arch.BCR

MART – Museo d'Arte
Moderna e Contemporanea
di Trento e Rovereto
Photo Credit: Archivio
Fotografico Mart.

tion. 'Das Unhemliche' is not a nonplace, not a place of anonymity which renders the airports of Amsterdam, Shangai, and Paris alike, but a sort of estrangement, of a-topia, of de-situation in which you might find yourself when, once used to a certain pace and time, you find yourself in another time.

**De Michelis** This is exactly the impression produced by today's city centres, which become dim as evening approaches. Walking through a historical city that is dead or asleep gives you a truly disquieting feeling.

**Rella** And nightfall arrives very early. In Milan the Galleria Vittorio Emanuele is completely deserted before midnight, as is Piazza Duomo. Recently, as I was coming out of the cinema, I hailed a taxi because it was unsettling to try getting around in a deserted city and the taxi driver pointed out for me a group of Latin Americans, perhaps Columbians, at the corner of the piazza. A menacing-looking group, he said. Probably the same group that had murdered a taxi driver a few days earlier. This emptied-out impression, this early urban nightfall, is what truly produces a sense of estrangement and alienation, an ousting from the city.

**De Michelis** Frampton takes up this topic in his recent essay entitled 'Critical Regionalism: Reflections on the Mediatory Potential of Built Form'. Here he tackles the problem of the architectural building's modified status that cannot be reduced to its sculptural obviousness. We cannot consider a building as resting in an empty space, as an anonymous and self-sufficient entity, mainly because it exists in relation to the place, in relation to the flows and movements running through it, to a more complex system than that of the city. What Frampton criticizes about the architecture of recent years is precisely this tendency to consider a building as a sort of object, devoid of ties, lacking in relationships with its surrounding context. I believe it is important to rethink and rediscuss the complexity of the forms of life.

**Rella** Not only important, but essential. The complexity of the forms of life should be studied in the context of moving and displacement, of continuous transiting within a city (for example, in areas inhabited by new immigrants, where the areas' time and use naturally get changed). Certain streets become the dominium of Chinese or Albanian immigrants. But a temporary dominium. More than places of settlement, they are continuous displacements. In my experience with Milan, the nocturnal emptiness of Piazza Duomo becomes, on Sunday afternoon, the height of Asians gathering in bars around the square. The following day the area returns to the Milanese. It appears that cities design different zones or borders according to holiday calendars and the hours of night and day.

**De Michelis** In my opinion this is one of the great holes in present-day debates on architecture and the city. It seems that no one is concerned with the fact that cities do not change their physicalness but their meaning.

Their sense changes in function to the crossings and instabilities running through them.

**Rella** Cities once grew and expanded gradually, perhaps with greater acceleration when new streets opened up or when new quarters were built. Nowadays such displacements propose a geography that gets designed and redesigned over the course of different hours of the day, or in different seasons of the year, due to the fact that certain groups of people abandon zones where they once congregated and move somewhere else. A different perception of a changeable geography getting designed and cancelled often without leaving any traces. In the 60s and 70s we heard about places occupied by, for example, 'night warriors', through the cinema or through literature. These places had quite fixed rules and boundaries. Now this no longer seems the case, except perhaps for the ethnically historical areas of large American cities.

**De Michelis** But there too it is changing. If you look at large cities like London, Los Angeles, or New York, it is really striking how entire neighborhoods—I'm thinking of Soho in New York or Camden City in London, live, during the week, according to the pace and customs, at times even sophisticated, of a residential community. Whereas at the weekend, these same areas are invaded by visitors from the city sprawl. And these parts of the city take on a completely different identity with entirely autonomous behaviours and flows. In some ways even the 'normal' city becomes, for one day out of the week, a different city: a city of tourists. Once a week Soho resembles Venice, Italy. In Venice this happens nearly every day of the week, while in Soho it takes place only at the weekend. The same thing happens in London. During the work week Camden City is still the remnant city of a 70s punk subculture. On Saturdays and Sundays it becomes a picturesque village where people go to glimpse the vestiges of a subculture that is no longer a threat.

Milan is the same. It's extremely interesting to observe how different groups of immigrants 'take possession' of city parks during the weekends, not only congregating in different areas of the park but carrying out diverse practices and rituals like music, games, and sports: simply the gathering and consolidating of the bonds of a community that has otherwise been dispersed. The inattentiveness to these problems on behalf of planners strikes me greatly.

**Rella** A system must be built which is not only critical but also hermeneutic and historical as well, and one which takes into consideration these phenomena. And I'm not sure that Frampton's recent reexamination of the *built form* thoroughly treats these problems.

**De Michelis** No. I'm afraid to say that you may be disappointed by Frampton. And disappointed by all the others as well. This applies even to Rem Koolhaas, who also has reflected upon the city in recent decades and has worked within transformations of unconfined violence such as those of the Asian city. Koolhaas was the first to have investigated, with his Harvard students, the spatial practices of commerce, i.e. shopping, or the urban structure of the African megalopolis, Lagos. But a convincing reflection is still wanting regarding the governance and planning of the contemporary city, whose problems and transformations we are attempting to discuss and describe here.

**Rella** It's curious because, in my opinion, some of these problems were already revealed at the beginning of the twentieth century. I'm thinking of *Le Paysan de Paris* by Aragon in which there was a perception that the 'passages' would change appearance throughout the different

hours of the day and night, similar to the Buttes Chaumont park where one gets a feeling, as Bloch described, that 'your gaze oscillates, and with it that which is looked at'. In early twentieth-century urban literature there was some perception of these temporal aspects of the contemporary city, which today become so crucial with migration flows, with current movement/displacement, and with perceiving today's city as inhabited by diverse 'inhabitants'.

One of the historical streets in Rovereto where I was born and where I have my studio today, was called the 'Repubblica di Zinevra' to indicate a particularity, an identity, and a boundary of an integrated cultural and inner-city community. Today it is the heart of the Islamic quarter.

**De Michelis** In reference to this, it should be said that the political-cultural forces governing cities continue to operate in a more traditionally 'capitalistic' way. At some point the city empties out and loses its main functions. It fills up again, almost via osmosis, by weaker and less stable sectors. Immigration produces further degradation and its task seems to be that of zeroing the real estate value until immigrant communities are displaced by gentrification processes and the city eventually returns to a prosperous state. Half of the downtowns of America have undergone this process. They empty out to be immediately filled up again by Hispanic and Afro-American communities. When the level of degradation reaches the right point, a new injection of fresh capital is allowed in and the poorer groups are forced to move again, giving life to new thematized urban realities whose historically social and cultural complexities have disappeared for good. This is what amazes me most. And within this process, what is so astonishing is that if twentieth-century architecture truly had its own distinctive character, it was to tackle the problems of the masses for the first time. Never before then had architecture dealt with low-cost housing, with city parks, underground stations, hospitals and schools. Today architecture seems to have retired into somewhat marginal themes. Today's well-known architects design and plan museums, theatres, hotels and airports. The most recent trend is the luxury condominium. Such examples do not represent occasions for critical reflection on the forms of dwellings. Plans get drawn up by real estate agencies and what's important is the building's facade.

**Rella** It seems to me that the exhibition curated by you and Georges Teyssot, on the 'Domestic Project', some twenty years ago at the Milan Triennale, had shown signs of a similar tendency. I remember that there were historical paintings on display and drawings by Libeskind and Eisenman that seemed to share more with paintings than with the idea of living or dwelling, more with an aesthetic idea than with an overall function, the latter of which seeming to be that of the job of architects.

**De Michelis** Yes, you remember well. The problem is dramatic because, on one side you have a statuary resistance of architecture changing. Architecture is still permanent, firmly grounded in the soil. Their facades may be of light glass, but the buildings themselves are extremely solid. This feature is particularly emphasized in buildings designed by great architects mainly because architects design 'instantaneous' monuments. Beaubourg looked like a refrigerator without a body—a machine—and yet it was quickly monumentalized. Today, if we even suggested the idea of demolishing the Guggenheim museum built by Gehry in Bilbao, the reactions would be the same as if we had proposed destroying the Basilica of Saint Mark in Venice. This status of permanence doesn't change. At a technolological level nothing special has taken place. The bridge of Calatrava over the Grand Canal in Venice is essentially no different than the Rialto bridge built five centuries earlier. All the new virtual technologies which have

invaded our daily life have had truly limited effects and architecture becomes ever more 'brand' architecture. A new terrain to which architecture has applied itself is, indeed, that of spectacular buildings belonging to top fashion firms. After Prada by Koolhaas in New York, there followed Prada in Tokyo, designed by Herzog and de Meuron, Vuitton by Sanaa, and Hermes by Renzo Piano. They seem almost like museums. In the end they are not that different from museums. What's bizarre and interesting is rather how certain contemporary artistic practices are very attentive to the problems of impermanence which we have been discussing here. In his book entitled 'L'estetica relazionale' (Relational Aesthetics), Nicolas Bourriaud observes that artistic practices reveal a growing process of urbanization; however, the city with which artists have occupied themselves over the last forty years is no longer a city of monuments, squares, and cathedrals, but a city of peripheries and abandoned territory. Robert Smithson rediscovered the abandoned caves of New Jersey. Dan Graham described the identical-looking, serial homes of America and interpreted them as minimalist serial structures. Artists deal with the landscape. They intervene in the natural landscape in an attempt to assign meaning to it. In general, artists seem to prefer the most fragile of city structures: the Brazilian favela, the periphery, the 'nonplaces'. It almost seems as if artists have accepted the condition of immateriality, or precariousness; that which contemporary architecture indeed fails to see.

**Rella** Schopenhauer spoke of architecture as the least of philosophical arts. Paul Valéry talked of it as one of the principal arts precisely because it was capable of containing within it all the other arts. The question, however, is whether architecture is actually able to establish a dialogue with the other arts. The impression is that here lies the true gap. Don De Lillo's novel Falling Man is an extraordinary book in my opinion, dedicated to New York, a city which has become completely invisible and indescribable: the demolished twin towers visually reappear in the bottles of a painting by Morandi; the brilliant metaphor of a woman teaching elderly people inflicted by Alzheimer's disease how to write down their memories, in spite of the fact that they will soon forget that which they have just written; the desperate effort to leave some trace or sign in a world that is devoid of memory. A sort of blindness and aphasia, similar to Kafka's 'Metamorphosis', where an insect looks out from its window and at first is only able to see the wall in front of it, then later not even that. You no longer see anything of the city. This sense of a time which is gradually reduced can also be seen in artistic practices. From gesture painting to performance, there is an act that wears out and time is always a limited time. If traces of memories can only be recorded through signs—video, photography— which no longer belong to the performance itself, such traces of memory become another thing, another language.

**De Michelis** One of the most interesting performers of recent years is a young German artist, by the name Tino Sehgal, who prohibits any photographing or filming his performances. In this way no trace survives except in the subjective memory of his spectators.

**Rella** There is, therefore, this sense of the world, of the word, being gradually reduced. And here the view also wears out in the tension that grows so dramatic that it touches upon the opposite of 'sublime'. When faced with this, architecture that has building the tallest skyscraper as its goal is an outdated dimension of the 'sublime', truly eighteenth-century and even pre-Kant. Enormous problems still remain unresolved.

One last consideration to make is in regards to the extent that regionalism is regression and not reaction. Here surfaces an unanswered question that recalls both the Messianism of

Ernst Bloch and the weak Messianic force that Walter Benjamin spoke of. Actually, this attempt to reanimate the past cannot simply be a return to the past. Both Bloch and Benjamin speak of a revolutionary clash in order to make this past, which has in some way disappeared, emerge. The remnants of a vanished world cannot be made to reappear in the globalized universe of international style, unless in a vernacular form. To go beyond dialect or nostalgia a true 'clash' must be produced.

This is an aspect that must be emphasized in order for progress to be made. Another important aspect that should be considered if we are to perhaps further our discussion of today is the question of what will happen if city flows, the mass movement or displacement in city places, of which we have already spoke, advance towards a form of contamination? What if the flows combine and mix, almost in the same way as in the act of coitus, so as to generate something different?

**De Michelis** While from an anthropological point of view this problem has been described and interpreted in a dozen or so books that treat the matter of Muslim behavior in Western cities, of the rules governing the life of these communities in the suburbs of British cities; all of which have no effect on the planning of the city.

**Rella** It's the theme of hybridization which French philosophy, for example Deleuze, has attempted to describe as a type of evolution different from man's. In reality it is an obvious resistance to this other evolution due to the fact that identity is at play. There is also resistance to the movement towards another state, which originates in places that are protected by an architecture that is erected like a tiny fortress in defense of the past, or in defense of 'a new' that is somehow confirmed even before it comes to life. Free space seems to be the space of the periphery, of the *favela*, which is described by the probing anthropologist as an exotic extraneousness, like the pueblo in the Amazon forest, incapable of communicating with the rest of the city or bringing into play the different forms of living and dwelling.

**De Michelis** They are two extremes: on the one hand, what Koolhaas brilliantly baptized as 'the generic city', materializing above all in the Asian megalopolis: a very different city from the 'diffused city' which Secchi described by using the example of the metropolitan area around Milan. Seoul has nearly twenty million inhabitants in a condition of inexorable anonymity, in the sense that the entire city is made of tall residential buildings and settled areas of extremely high density, within which nothing is to be found. This is a real city: on one side the great fragility of a Brazilian *favela* that, nonetheless, gradually establishes itself into a normal city, and on the other, this city, permanent in a material way, where boundaries, orientation, and limits are no longer recognizable. In Seoul, if it were not for the river which saves you, which shows you which side of the city you are on, in what direction lies the sea, where north and south are, there would be no way of knowing or saying where you stood.

# THE URBAN STRUCTURE.
## LEGAL AND ILLEGAL USE.
## SELF THERAPY.
GIANNI PETTENA

*(How to salvage the city environment through a creative contribution to the reclaiming process—Emblematic objects—Property and non property objects).*[1]
In order to be able to speak of creative methods in the reacquisition processes of the urban environment it is necessary to put oneself in a position to distinguish two types of creativity: one being spontaneous and daily creativity, and one which can encompass the inter-relation between the visualising forces in an urban structure and can therefore directly influence this inter-relationship. One is a creativity which can, at the most, transgress the daily rules (i.e. coming out from an Autogrill and using the entry door without a handle on the inside, instead of going all the way to the 'prescribed' way out). The other comes from 'controlled' people, who rebel against this type of inter-relationship of forces between one power seizing everything and building an environment reflecting its own image, which the inhabitants can not recognize as their own.

The play of forces is, technically speaking, advantageous to a few Civil Servants only but the discovery of the vulnerability of certain 'controlling' organisms can introduce a type of mental or physical guerilla warfare, which can be as violent as the inter-relationship of forces which have been called into play: thus the lawfulness can, indeed, become an abstract concept to be played with or to be transgressed.

The lawfulness of certain reclaiming processes often represents the watershed between the nuances of conceptual articulation and sincerity.

It must be noted that reclaiming and the actions involved therein, whether mental or physical as they may be, are in fact a decision, a result springing from a careful analysis of the availability of different degrees of freedom and their possibility of physically using a 'milieu' and from the awareness of the non-existence of degrees of freedom which were neither foreseen nor restrictive.

A decision to regain the city depends entirely on its inhabitants; saving a fringe of the city, or another place one thousand kilometres away, it is in fact an operation which bears the ratio of the relationship one has with one's own town.

In fact one of the most interesting phenomena in terms of a conceptual contribution to the problem of architecture, that is to say 'land art', is unthinkable if it is not conceived by the inhabitants of the city and referred, as a basic document, to the city and the citizens.

The relation between empty and built up areas, between a physical desert and a desert city, both of them seen as 'natural' conditions, is fundamental to establishing 'land art' as a contribution to the problems of conceptualization related to operating 'spaces'. The will to reclaim the city structure implies a basic consideration on the exchange of opinions and city management itself. This means recognizing the city as a 'domestic' scene, where one has chosen to operate in order to carry out personal therapies: as an operational field, the choice is somewhat symbolic of the conditioning which has taken place or which has sprung anew as the

case may be. The choice of the place or land on which to operate. At any rate to operate in a 'non-urban area' implies an operation in relation to one's own decision to live in one's city. One can operate away from the city, if this can serve the purpose of our living within the city: it can be sufficient but not thrilling. Therefore he who regains the city has chosen to be a 'native' in well-codified situations, assuming as a given the existing urban structure in as much as a desert is a natural fact.

The reacquisition of a city also implies a breakdown of the code of personal habits in order to achieve impersonal habits, which can in turn be divided into legal or illegal, and this really means permitted or non-permitted. Events of urban guerilla warfare and enforcement of the law or democratic rule, are two differences which will be illustrated.

This plan can be put into a clearer perspective by analyzing the domestic environment: often one tends to 'reclaim' or to re-acquire through mental processes or through physical means suitable to its domestic milieu, in this way one does not feel the need to 1) adopt a 'public' environment, unless the choice is dictated by a 'working-in' situation. He who chooses to inhabit a loft or a barge, to use the vernacular, can scarcely sense the city as if it were a theatrical condition for his own solo performances. Or 2) the yearning to intervene in urban space when one does not find his domestic 'expression' satisfying. From this it follows:

a) a legal use of reclaiming: hiring of advertising posters, bill sticking, intervention by painting a mural-fresco on white walls.

b) an 'illegal' use of the urban structure by the act of drawing objects or situations to be symbolized or on which one can read (or understand) a 'different' role. There is a clear cut separation between the two phenomena, as this represents a distinction of the legal or illegal use of the given structure.

To change the illegal to the legal implies reaching, through reacquisition, a degree of poetic psychological stability. We are in fact speaking of the use of the 'security blanket'. Reacquisition really means attaining the use, whether legal or illegal, of the objects which are related to an infantile condition. It is when one sits at a table with an arm leaning on it and one hand supporting his chin, and the middle finger or the ring finger in front of his lips, that he substitutes the 'allowed' need which children feel for the security blanket. Revealing various degrees of conditioning, and of self-consciousness and sincerity, is the choice of various situations, objects, etc. which can in fact represent, for the chooser, a precise moment of self-therapy.

| **Proper use** | **Improper use** |
|---|---|
| **Proper legal use** | **Improper illegal use** |
| Does not release the desire of re-acquisition | Reveals the desire of re-acquisition |
| | |
| Degrees of consciousness | Degrees of consciousness |
| Use of property structures | Non property |
| Choice of intervention and location | Choice of intervention and location |
| | |
| 'Domestic' environment | 'Public' environment |
| Use and choice of | Use and choice of |

Objects of property (even domestic): houses, choice of a house, house in the country, or at the seaside, where and how. To be built, to be rented, to be renovated, to be sold, to be bought, or to be destroyed by fire and water. Boat, barge, pontoon, loft, desert, where to park campers'

Text: Gianni Pettena,
'The Urban Structure…'

**1** This article was originally published as 'Legalità e Illegalità' in *Progettare inPiù* (December–January 1973–74).

Volkswagen vans etc., customized cars, dragsters. A choice of objects, to be used with illegal or legal means. The intervention into public space can also be legal or illegal: pavements, parks, squares, streets, cars, buses, underground trains, planes.

Amongst the facts one ought to simplify there are the interventions of some artists and of some groups of unknown New York urchins. Hans Haacke has carried out research and arrived at a precise analysis of the 'conditions', for example, with a photograph of a building in Harlem and after having noted the number of the inhabitants, class, census, name of the landlord, his class and census, income from renting the building, etc.

Though this work was rejected at Haacke's one man exhibition at the Guggenheim Museum in 1971, it was followed by a more exact survey of visitors to the John Weber Gallery in New York, where Haacke, having asked the visitors precise questions by means of special cards, arrived at conclusions through data processing and announced them at a following exhibition. From this data he produced a map of New York with the relative visitors' residences, etc.

This type of methodological-survey reveals perhaps the most mature manner (and non-therapeutical) for reclaiming a structure visualizing 'given' conditions, but it also suggests a didactic method for cultivating a collective creativity. Other artists display a creative behaviour within the urban space, which more or less corresponds to their research 'condition', but more often than not to their self-therapeutical research.

Therefore their intervention has a certain coarse methodological cleverness, a technical ability which burdens the poetic element within the framework of intervention. Even if it is obvious that between an intervention into unpolluted nature, in order to take back to New York a document, and operating within a 'polluted' city, but understanding this as a natural fact, the latter case is far more acceptable: only Christo can intervene indifferently in one or the other 'reducing' the possibilities of both of them. In fact his intervention by wrapping up buildings on Broadway, in the West End, on the West (California) Coast, by using the same methodology and the very same language, avoids 'a priori' dwelling on the 'whereabouts'.

But the most spontaneous and, at the same time, most thrilling result in the last few years was the activity of unknown New York street kids who covered the underground trains with large colourful and graphically unusual letterings, and thus obtained a creative recovery in the process of reclaiming the urban environment. This was a most refreshing, symbolic and precise recovery.

These kids live in the slums of Harlem and Queens (New York), where the tube depots are, and by night they carry on their secret work and paint the various carriages covering them in letters, numbers

and battle names. Doors, windows, walls, all that is a surface, and their technique has reached the point where they can juggle with words on the very opening of the sliding doors, so that the reader will be kept on the alert to look out for the design or the message to be completed when the doors close. They have adopted the same colours and patterns of the garments, the ribboned hats and high-heeled shoes worn by the Harlem playboy.

The technique has evolved from 1971–72 when this type of intervention was monochrome and graphic and the wagons, the underground station, the milk-lorries, the school playgrounds and Central Park had already portrayed this process. Now it is an explosion of a violent chromatic fantasy, an emotional freedom, and has an incredible emotional and optical impact. Whilst waiting for a slow train the sudden noisy apparitions of express trains bursting from a dark tunnel to flash through the light space of the station, are in fact group exhibitions lasting a few seconds only.

There are large names such as HOUDINI or MOSES as big as a carriage, and many others besides, with corresponding numbers and battle names, the most fantastic pseudonyms chosen as symbols of elusiveness. There are also dialogues between these artists with a spray gun and the Superintendent of Police who has been charged with their capture: 'Brown, you will never catch us!' And details like the small arrow painted on any seat which reads 'He who sits here is a Queer', which implies either that the place has been booked or that anyone going to sit there is a predestined victim. In practice this is one way to appropriate an entire city by striking hard into its soul and by striking all the flowing elements in her, in a wild fantasy of subtle all pervading games.

In April 1973, two editorials appeared simultaneously on this phenomenon, one in Newsweek, and the other in the New York Times colour supplement. Newsweek criticized the spreading of this by now uncontrollable phenomenon and went on to attack the mess it involved, the illegality and the money which had already been spent in checking it: a special police squad had been put in charge and workers regularly cleaned the trains which would secretly be 'reclaimed' during the night. The New York Times on the contrary interviewed the street kids, without mentioning their names, and recounted how they worked in the depots on a shift-basis so as to elude the police patrol.

The subway train as a never stopping object which runs through New York 24 hours a day. The mobile written-on surface, which would stop for a few seconds only, is indeed an uncatchable apparition, which can not be traded, it stops just long enough to be read then leaves again. This is a choice, which can hardly be repeated for it is perfect in its symbolism, form and style.

The situation has quite a different aspect when the New York, Boston, Los Angeles, Minneapolis building fronts are painted on. In Dinky Town, Minneapolis, it was the owner who commissioned the hippies to paint on several walls. The same thing happened in Los Angeles, whilst in Chicago and Boston this same thing took place through the area organizations, in a hypocritically named 'aesthetical re-qualification' in the poorest and most squalid parts of town. These interventions have meant nothing more than a great fantastic capacity for mural painters, but no identification process related to power has come to the surface. Consequently the result is orderly and aseptic.

The walls painted by artists, on commission, in various American towns have not solved anything nor have they communicated anything other than the state of utter dependence of artists on their commissioners. It is much better for those who have reinvented abandoned places, in order to reclaim them and, in the process, have founded a new language (or means

of communication) of total, formal and conceptual freedom.

The Loft, originally a storehouse, is seen as a 'natural fact' and it is qualified to play the role of an Island where, with flotsam and jetsam, an environment is built to befit a new condition. Marine City in Sausalito Bay on the other side of the Golden Gate, facing San Francisco, has sprung up with the same criteria and the scrap yard of old boats and ancient pile-dwellings is now a city facing the city, antithetical and alternative to the city itself, where the urban environment is made from scrap qualified as building material for a-categorical buildings, an assembly of infinite forms and ways of in-habiting. When this a-categorical concept of town building became 'categorical' the places were abandoned and nobody lives there now but longhaired Berkeley professors and television playwrights.

Another note on the recovery of 'domestic' objects as a dialectical means of asserting an identification, the customized cars which can be divided into: 1) identification of symbolic models through the fantastic transformation of the 'car-object'. The customized car par excellence. And, 2) the dragster, which so often contains both the physical and the H.P. transformation. Both versions are precise choices of identification with the urban environment and of a dialectics with it.

The Easy Rider motorcycle is a customized car, as Claustrophobia is. This is a car seen in the same traveling exhibition, a Chevrolet, where the windows, the windscreen and the dashboard have been sawn-off to a few centimeters and then perfectly rebuilt. The authors clad in overalls in the same colours and with the same stars with which they had painted the bumpers.

The dragster is for running a shrieking mile at top speed. But the beautiful one, built as a torpedo, with front bicycle wheels seven metres apart, is an object for rich exhibitionists only. The autodrome is full of other things: pickup trucks with grand-prix tyres and supercharged engines, and restored grandmas' cars painted in all colours. These are the performing actors on a Sunday afternoon in the outskirts of Midwest or Southwest towns. These symbolic objects, rich both in appearance and cost, symbolize a creativity limited in its development by the unconditioned use of evening television serials and by planned regular morning journeys from a house with a garden to a desert of office buildings. A different creativity altogether from the one expressed by the anonymous New York artists, but one which reveals a potential force waiting to be primed.

# SUBVERSIVE COMPONENTS
## A CONVERSATION BETWEEN MIRKO ZARDINI
## AND GIANNI PETTENA

**Gianni Pettena** Have you noticed how different the pace is in America compared to Europe?

**Mirko Zardini** Well, I don't find North America very interesting nowadays. Unlike your experience there during the 1970s, I think there are other places of greater interest now.

**Pettena** Also, I think the times are different, in the sense that when my generation was in their twenties, we were bent on getting away from the rationalist schemas administered to us at school as the perfect interpretation of the real, even if thirty years later. While with the growing revolutions of young people in music, art, cinema, and literature, everything was about reading things differently, in direct line with the evolution of the culture of the time.

**Zardini** Whereas today? I'd claim that today there is renewed interest in the experiences of the 1960s.

**Pettena** That's true! I feel the same way.

**Zardini** This is interesting, but the times are very different now. The market now focuses on this experience: also your renewed centrality, and then the rediscovery of the Italian Radicals. There is a new type of focus on you that is unlike anything in the past.

**Pettena** Regarding the Italian Radicals, I have always felt slightly different from them. Do you remember the work I did called *Io sono la spia* (I am the spy)? When we had the photo taken for the Global Tools foundation in 1973, I pulled out the sign 'I am the spy' to emphasize the fact that I wasn't very interested in reexamining the discipline or in continuing to perpetuate it through traditional means. At the beginning of the 60s I was studying architecture. I was really diligent about the work for the first year, but soon I started spending more time in art galleries than at lessons. I used to go to Toselli in Milan, to Sperone in Turin, to Fabio Sargentini's Attico in Rome. I visited the galleries where my contemporaries used a different language to deal with the physical and visual world, so much so that eventually this language became my own. I didn't stop pursuing architecture, but my work involved making architecture via artistic tools.

**Zardini** Indeed, you were always seen, for example here in America, as an artist.

**Pettena** Yes. For example I was called an environmental artist in the book by Alan Sonfist, *Environmental Art*, published in the 1980s. At heart, I was looking for trouble, but by no means do I regret it.

**Zardini** This interdisciplinary vision of yours seems right to me, one which in the 70s was precisely the overlapping between art and architecture. Today, by reexamining these strategies, it seems that in contemporary situations art has paradoxically occupied, and still occupies, much of the traditional working space of architects. It's as if there were still an architectural insufficiency with respect to contemporary problems.

**Pettena** The fact that in order for architects to work they have to always relate to a future client obstructs the continuity of research, which in the end pays off. This continuity gets lost, as does the intensity produced by it. Continuity is what I have always pursued. Nowadays I am invited to participate in various exhibitions, always and only with younger artists, also

because many of these young artists relate in an ideal way to my work, almost as if recognizing a legitimate ancestor with whom they can restart working the space. Many of these artists are former architecture students who continue to work, just as I have, in that field. Names such as Italo Zucchi in Italy and Riccardo Previdi in Berlin come to mind, both of whom continue to work in the architectural field but with the specific artistic instruments of their generation.

**Zardini** Would you speak to me about your American works, such as the Ice House, the Tower of Weeds, and the Clay House?

**Pettena** These works were the result of an accumulation of frustration after having worked for some time in Europe. When I produced those stripes on the Arnolfo Palace in San Giovanni Valdarno, it was in a situation that forced you to work in very dense contexts, stratified by century after century of generations and cultures. There were too many preexisting factors, along with an ever-weighty presence of the past, to carve out a niche for oneself in contemporary terms. Therefore, my choice to work in America was intended as an opportunity to re-search those places, such as the deserts, where I thought the need to relate to the overlapping layers of previous generations no longer existed, and where instead I could finally work from a tabula rasa, a blank slate. Only to discover that this blank slate didn't really exist due to the fact that the deserts were already architecture in themselves, architecture that had once been interpreted by Native American cultures. Thus Monument Valley, for example, wasn't a desert but a true valley of temples for the Navajos; Mesa Verde and Taos were cities; while the *hogan*, in the end, was nothing more than an artificial cave, a simple shelter like those still made today by nomadic populations throughout the world. In this way, my work was aimed at adopting those places as already architecture, and of those places the use of natural materials which are provocatively transferred into the types of permanent architecture practiced by us, i.e. architecture that violates and contaminates the environment. Introducing the Ice House through the use of a natural material such as water, which during the Minneapolis winters freezes almost immediately, is to make a statement about architecture, to revive the expressive values of natural materials, and to take a stance for construction that is less traumatic on the environment as well as, admittedly, temporary.

**Zardini** What do you think about today's rediscovery of such subjects as sustainability and nature?

**Pettena** Architects, late as always, are referring to what Bucky Fuller warned us of thirty years ago. I can't help but think of the Grass Architecture drawings I made in 1971. Those strips of grass that are lifted up to identify a space, to construct a work of architecture. I can't help but think of this when I see the Santiago de Compostela by Eisenman, or the Foreign Office Terminal at Yokohama, or the 'House by the Sea', by Future Systems.

**Zardini** Certainly. Also today when I see the proposal for all these green walls…

**Pettena** Here's the Tumbleweeds Catcher (made in 1972)!

**Zardini** The naturalization of a building.

**Pettena** When I made that skyscraper of bushes in Salt Lake City, on a conceptual level I later found it corresponded to the works of Gordon Matta-Clark, when he would extract pieces of buildings ready to be demolished. Even today many contemporary artists, both European and non-European, take parts of residential structures, of architecture, of interiors, and repropose them, either by reelaborating them or not, and recross—in their own way—the same path.

**Zardini** Does your book, *L'Anarchitetto*, have something to do with Gordon Matta-Clark?

**Pettena** I wrote *L'Anarchitetto* in the months of November and December of 1972 and it was

first published in February of 1973. I met Gordon through Robert
Smithson, whom I had known from when he did his Asphalt Rundown
at the Attico. I was pleasantly surprised when Gordon and the others
formed the group Anarchitecture. There was a show of the same
name in 1974: these were things floating in the air. He had an exhibition
of his work at the Sonnabend Gallery at 420 West Broadway, where
Leo Castelli and John Weber also were, and in that same place I had
exhibited my Ice Houses, Tumbleweed Catcher, and Red Line in 1972.

Gianni Pettena
*Tumbleweed Catcher*
(1973)

**Zardini** How did the citizens of Salt Lake City react to that work?

**Pettena** When we were making the Clay House, a young boy
on a bicycle stopped to ask me whether we were building something
or destroying something. I liked what he said a lot. The year prior to
this, in Minneapolis, I had been working on abandoned houses,
whereas the house in Salt Lake City was lived in by a filmmaker who
worked at the university where I too was working as a guest. It
happened that while we were working there some neighbors called
the police. When the police arrived I told them we weren't vandalizing
anything, that we had the owner's permission. In fact, the owner
of the house came out to confirm this. The police replied, 'Well, as long
as you're happy…' and left.

**Zardini** You also pointed out the question of legality and unlawfulness
which took place in urban contexts during those years. You were
already speaking about graffiti in those times and what was happening
on the East and West Coasts. Do you see any similar urban opera-
tions taking place today?

**Pettena** That subversive component no longer exists. However
today you find true consistency for example in the works pursued by
the Stalker group, in their itineraries within the network of the frayed
urban fabric, in the census, for example, of housing for nomadic
people within these fringes. They themselves told me that they knew
of my work from those years. In my article 'Legalità e Illegalità' in
*Progettare inPiù* (December–January 1973–74), I analyzed all that
spontaneously took place as a modification of the urban structure,
from the visual explosion in the city of New York to the murals of areas
occupied by hippies, from dragsters to every manifestation of popular
language, as with the signs and tiny flags in the storefronts and
plots of used car salesmen, and Las Vegas itself. But I was seduced
and in love with the constructions made by hippies. I strolled about for
months taking photographs of their villages, such as the Pacific High
School in Palo Alto, or Gate Five in Sausalito where, besides the
AntFarm, Corso, Ferlinghetti and Ginsberg had also lived. They were
incredible structures made from the wreckage of demolished boats,
homes and cars. All of this was obviously ungrammatical according to
the norms of official architecture, but in reality it revealed a linguistic
clarity and impeccable aesthetic taste, typical of a country where

the average education in the visual field was greatly superior to that of Europe. These dropouts from official culture showed the innate, but not yet practiced, gift that exists in all of us. All of us have this ability, even though we do not use it and, instead, put our trust in the most banalizing architects.

**Zardini** If you had to choose another place besides Europe in which to work and live, where would it be? And if today you could repeat a similar experience to the one you had in the United States in the 70s, where would you want it to be?

**Pettena** In Russia, or China, or India. Places where this traumatic contact with a growing banalization actually exists, created by the progressive industrialization of those places, which could possibly allow for something similar, even if, in my opinion, young people, including artists, are resigned to integrating themselves, in any way possible, with the process underway.

**Zardini** So the role of art is still that of critical consciousness? Something that architecture tends to forget?

**Pettena** Architecture tends to forget, but it forgets only when it's convenient to do so. Because, when architects find it necessary to cover all the functional parts of their projects, they then draw on the world of art, as all of the twentieth century testifies. Architecture never precedes an avant-garde, but always follows it. From futurism to dadaism, to the conceptual art of Kosuth slavishly imitated in the 70s by Eisenman and Hejduk, architects are forever arriving late, after being awakened by the jolts produced by someone else in the art field.

**Zardini** You spoke earlier of the reaction young architects from the 1960s had to modernism, of this feeling of architecture's insufficiency. With respect to those times, what do you feel about the contemporary world? What are your reactions to the condition in which we find ourselves today?

**Pettena** My feelings are quite negative. In spite of the vivacity of certain museums, such as that by Peter Cook in Graz, and of certain skyscrapers, I find that most rigor still comes from artists who are working at the margins of the architectural profession but who are seriously dedicated to renewing the language of architecture, as well as the conceptual platforms which architecture conditions and pervades.

**Zardini** Yet you refer to only a few artists. Because today the art market is truly vast and evasive…

**Pettena** Yes, undoubtedly evasive of both moral and theoretical questions. I don't look at the mediatic or commercial success of these phenomena, but at the most innovative points of research.

**Zardini** Always in search of the subversive aspect of operating on the physical space…

**Pettena** Or the innovative aspect. If this innovation then takes on a subversive value in the eyes of the common middle class, all the

Gianni Pettena
*The Ice House*
(1971)

Gianni Pettena
*The Clay House*
(1972)

better! In the sense that, if the things you do end up being mentioned with enthusiasm by a middle class clientele, you're doing something wrong. This means that there is something consolatory for them in what you are producing… Instead what you do should is disturb them.

**Zardini** It's not worth it to go deeply into the evolution of Italian architecture. What would be interesting to me is if you could speak about yourself and your role in the 1970s.

**Pettena** I wanted to get a degree in architecture and to enroll in the professional register of architects—that way I would have really scared someone. Once during a public debate in Salt Lake City I was asked how I had the courage to be so 'underprofessional'. I loved this type of reaction. But I'd be interested to know what your point of view on this subject is, considering your position as Director of the Canadian Centre for Architecture.

**Zardini** It is essentially based on an attempt to reconstruct a new platform for discussion, by recuperating many of the elements discussed in the 1960s and 70s: a bricolage, as usual… in which to collect pieces of the past of interest, and in my opinion the 60s and 70s were crucial years.

**Pettena** Yes, they are very important years because they point to a direction which was then, however, acknowledged a bit too superficially by certain architectural research. If those of us who started back in the 60s and 70s inherited anything from modernism, it is a moral attitude towards the profession of architecture.

**Zardini** This rediscovery of the 60s and 70s cannot be reduced to an operation of sterilization of those years.

**Pettena** That would be to totally misunderstand them.

**Zardini** For this reason this subversive component of yours interests me—that is, your reading of environmental works, of natural conditions, of spontaneous illegal operations. All that has disappeared in what now gets mentioned of the research and work of those times.

**Pettena** More than provocations—and we did not consider them such then—they were desperate cries, like those of Gordon Matta-Clark. We used to say, 'Why are we going in this direction? Why don't we reexamine, from the roots, exactly what it is we should be doing when we produce something meant to last, something that should be a testimony of the cultural process of our times?'

**Zardini** I think all of this is essential for establishing a basis for discussion for the next ten or twenty years. It's something that cannot be put off.

**Pettena** I agree. Otherwise it becomes a formal exercise. That's what happens nowadays when technology apishly follows you: you invent the artichoke of Bilbao, and you are glad to be able to do so, because today's technology allows you to. While thirty years ago it was impossible. Today these exploits are done for pure aesthetic pose and with them we do not express any emotional or moral tension which indeed we should.

**FIORI INESISTENTI IN NATURA**
UQBAR FOUNDATION

13       Fig. 74     13       Fig. 75

13       Fig. 74     13       Fig. 75

# HOPE AND OTHER PRINCIPLES

# REGIONALISM AND ITS CRITIQUE

# THE POLITICS OF THE SUPREME FICTION
## SIMON CRITCHLEY

There is a double miracle at work in politics. On the one hand, politics requires a willing suspension of disbelief. It requires that the many believe in the fictions told to them by the few who govern them. That is, government requires make-believe, whether the belief is in the divine right of kings or the quasidivinity of the people that is somehow meant to find expression through the magic of representative government, the organ of the party, the radiant sunlike will of the glorious leader or whatever. But, on the other hand, the extraordinary thing about politics is that it not only *requires* a willing suspension of disbelief, it also *receives* it. The force in any polity always lies with the many, yet somehow, for most of history—with certain rare and usually brief, glittering, but fleeting exceptions—the many submit to the will of the few who claim not only to be working in their interest, but to embody their collective will. Of course, it might be pointed out that political power is always possessed by the people with the 'guns and sticks', usually the police and the military, and if the many don't possess them, then they are powerless. That is, of course, incontrovertible, but it doesn't begin to explain what we might call the *fictional force* whereby the many submit to the few without the constant threat of physical violence. Considered closely but disinterestedly, politics is a very curious matter. In order to understand its operation, all we possess is history, which is what makes the work of historians of politics so essential.

With that in mind, I'd like to turn briefly to Edmund Morgan's *Inventing the People. The Rise of Popular Sovereignty in England and America.* The central theoretical category in this fascinatingly rich historical account of the transition from monarchical to popular sovereignty in England and America during the seventeenth and eighteenth centuries is *fiction.* The main concern of Morgan's book is to explain how it is that the fiction of the divine right of kings gave way to that of the sovereignty of the people. The interesting thing about this conjunction of fictions is that whereas it is difficult from this end of history to see the idea of the divine right of kings as anything more than an absurdity based on the idea of the king as the visible god, the overwhelming majority of people and politicians are attached to, or at least ventriloquize, some version of the idea of popular sovereignty: that all human beings are equal or indeed created equal, that government should be by the people and for the people, that government embodies and enacts the will of the people, blah, blah, blah. Morgan's point is that *historically* one fiction succeeds the other in the extraordinary years of the 1630s and 40s in England and in a different but strongly related way in the American colonies in the 1760s and 70s. But, more importantly perhaps, *conceptually* one fiction resembles the other much more closely than we might like to imagine: God the king becomes God the people. As Rousseau writes in his discourse on 'Political Economy', 'the voice of the people is indeed the voice of God'. Morgan notes,

'The sovereignty of the people was not a repudiation of the sovereignty of God. God remained the ultimate source of all governmental authority, but attention now centred on the immediate source, the people. Though God authorized government, He did it through the people, and in doing so He set them above their governors.'

Indeed, it might be said that the fiction of popular sovereignty is a more fictional fiction than divine right. A king is a visible presence with a crown and scepter and usually a large family with expensive tastes, but where might one *see* the people? One can see people, but where exactly is *the* people to be found? The fact that most of us might happen to believe in the fiction of popular sovereignty and the idea or ideal that legitimate government is the expression of the will of the people, in no way diminishes its fictional status. A moment's thought reveals that it is based on a series of logical *décalages*: namely, that the people are the governed, but also the government, and that this identity of government and the governed somehow happens through the miracle of *representation*, which is truly the central shibboleth of liberal democracy. But how exactly can a few be said to *represent* the many? How can a particularity speak for a generality when the latter is not actually present? Of course, it cannot. What is the case, however, is that the *legitimacy* of the few rests on the fiction of *believing* that they represent the many. At which point, a number of opposing possibilities arise: either politics and politicians are entirely cynical—and I am not ruling that out at all—or they actually believe that they incarnate the will of their voters and the people as a whole through the magic of representation. Similarly, either the electorate believe that their politicians are a group of cynical, self-interested, money-grabbing crooks or they actually believe that their will is miraculously represented through the mechanism of the vote. One powerful option at this point is to return to Rousseau's critique of representation and to ask the question of size. In order to avoid the magic of representation, the sovereign authority of the people can only be exercised in a polity that is very small. As Rousseau nicely points out at the end of his critique of political representation,

'All things considered, I do not see that among us the Sovereign can henceforth preserve the exercise of its rights unless the City is very small.'

For Rousseau, like Montesquieu and Voltaire, small is beautiful in the political realm as it minimizes the gap between the sovereign legislative authority of the people and the executive power of government. As Voltaire succinctly puts it, 'The bigger the fatherland the less we love it, because divided love is weaker'.

In this regard, it is fascinating to consider Madison's reversal of this argument from size in the debates around federalism that found their expression in the great Constitutional Convention of 1787 and subsequently in the U.S. Constitution. The problem that Madison grappled with in the years following Independence, was how to bring about a national govern-ment that might override the interests of the various states. Madison's view was that the vigorous and long-established attachment of citizens to their particular states worked against the forging of a new national identity, what Morgan calls 'the invention of an American people'. Madison's innovative solution, based explicitly on Hume's ideas on government, was to pro-pose extremely large constituencies with relatively few representatives. The assumption was that large constituencies would ensure the election of the right kind of people, namely the 'nat-ural aristocracy' of landowning gentlemen, indeed people rather like Madison and his friends. Although this natural aristocracy eventually gave way to the capitalist plutocracy that still happily governs the United States, it is worth recalling that this system of government is, in Madison's revealingly candid words, 'the only defence against the inconveniences of democracy consist-ent with the democratic form of Government'. Representative government prevents the inconveniences of democracy, namely the genuine sovereign authority of a people. In my opin-ion, the United States of America is the *least* representative of the Western democracies.

Politics, then, is a kind of magic show, where we know that the rabbit has not miraculously appeared in the empty hat and the magician's lovely assistant has not been sawn in half, but where we are willing to suspend disbelief and go along with the illusion. This is where Rousseau is so instructive, as he is the most fictively self-conscious of philosophers, whichever genre he works in: the theatrical comedy of manners *(Narcisse)*, the sentiment-soaked epistolary novel *(La nouvelle Héloïse)*, the didactic treatise in moral education *(Emile)*, the quasiscientific hypothetical history of humanity *(Discourse on Inequality)*, the creation of a sexualized subjectivity defined and divided by intimacy *(The Confessions)*, or meditative *askesis (Reveries)*. The concise, near-geometrical abstraction of *The Social Contract* is a political fiction, the fiction of popular sovereignty understood as association without representation, which is, for Rousseau—and I think he is right—the only form of politics that can face and face down the *fact* of gross inequality and the state of war. The being of politics is the act of association without representation. This fiction requires, in turn, other fictions, those of law and religion. The fiction of politics has to be underpinned by the authority of a quasidivine legislator and the dogmas of civil religion. For Rousseau, the binding of a political collectivity has to be the self-binding of the general will and this requires the ligature of *religio*. Such a religion has to be inculcated through shared beliefs, civic values and what can only be described as political rituals, such as pledges of allegiance, national anthems, honouring the war dead, the sacredness of the flag, or whatever. Such is the necessary armature of any *theologia civilis*.

So, is my conclusion simply that we cannot and should not enter into discussions of politics without acknowledging the dimension of fiction, particularly religious fiction, in legitimating political life? That would seem to be what lies behind the skeptical, rather Humean, historical approach adopted by Morgan. This approach has much to recommend it, particularly at the level of description, diagnosis and critique of the kind we also find in Emilio Gentile's work on the religions of politics, particularly fascism. Politics requires fictions of the sacred and rituals of sacralization for its legitimation and these fictions need to be exposed for what they are. Any empire's new clothes need to be stripped away in order to see the old, rotting flesh of the state.

However, let me push my argument a little further and speculate. It should not be thought that I am opposing fiction to fact here, where the former is adjudged false in the face of the latter's veracity. I do not think that a general critique of political fictions is a mere sacrifice on the altar of empiricism to the god of political realism. In my view, in the realms of politics, law and religion there are *only* fictions, but I do not see this as a sign of weakness but as a signal of *possible* strength. The distinction that I'd like to make is not between fiction and fact, but between fiction and *supreme fiction*. In saying this, I allude to Wallace Stevens, and the dim possibility of a fructive collision between poetry and politics. For Stevens, poetry permits us to see fiction as fiction, that is, to see the fictiveness or contingency of the world. It reveals in his terms 'the idea of order' which we imaginatively impose on reality. Such is what we might think of as the *critical* task of poetry, where I understand critique in the Kantian sense as demystifying any empiricist myth of the given and showing the radical dependency of that which is upon the creative, ultimately imaginative, activity of the subject. More plainly stated, the critical task of poetry is to show that the world is what you make of it. But that does not exhaust the category of fiction. Paradoxically, a supreme fiction is a fiction that we know to be a fiction—there being nothing else—but in which we nevertheless believe. For Stevens, it is a question here of final belief. He writes,

'The final belief is to believe in a fiction, which you know to be a fiction, there being nothing

else. The exquisite truth is to know that it is a fiction and that you believe it willingly.'
As he writes elsewhere, 'final belief / Must be in a fiction' and the hope of a supreme fiction
is to furnish such final belief. In his most important and difficult poem, 'Notes toward
a Supreme Fiction', Stevens attempts to articulate the conditions for a such a fiction, but
only offers notes towards it, something indeed like musical notes. He writes of the supreme
fiction that it is not given to us whole and ready-made, but that, 'it is possible, possible,
possible. It must be possible'.

My hope here is that we might begin to transpose this possibility from the poetical to
the political realm, or indeed to show that both poetry and politics are realms of fiction and
that what we can begin to envision in their collision is the possibility of a supreme fiction.
What is to be hoped for in politics is the possibility of a supreme fiction, the fiction of political
association, the fiction of politics *as such*. This requires that we begin to start thinking about
politics as radical *creatio ex nihilo*, as bringing something into being from nothing. This is
what Marx attempted in his 1843 'Introduction' to the *Critique of Hegel's Philosophy of Right*
where, it seems to me, he gets close to the idea of a supreme fiction. For Marx, the logic
of the political subject is expressed in the words: *'I am nothing and I should be everything'* ('Ich
bin nichts, und ich müßte alles sein'). That is, beginning from a position of nothingness or
what Althusser calls 'total alienation', a particular group is posited as a generality, which re-
quires 'the total alienation of this total alienation', in the act of political association. Marx's
name for the supreme fiction is 'the proletariat', which he qualifies as communist, that
is, as rigorously egalitarian. To borrow a line of thought from Badiou, what is lacking at the
present time is the possibility of such a name, a supreme fiction of final belief around which a
politics might organize itself. What is lacking is a theory and practice of the general will
understood as the supreme fiction of final belief that would take place in the act by which a
people becomes a people. What is lacking is an understanding of how the fiction of political
association requires the fictions of law and religion for its authorization and sacralization. In the
absence of a new political name, the political task is the poetic construction of a supreme
fiction, what Stevens also calls 'the fiction of an absolute'. Such a fiction would be a fiction
that we *know* to be a fiction and yet in which we believe nonetheless. All we have at the
present time are some notes towards this fiction.

# REGIONS AND CENTRES
## SPACES OF THE VERNACULAR:
## REGIONALISM AND ERNST BLOCH'S
PHILOSOPHY OF HOPE

BERND HUPPAUF

## ■
## GLOBALIZATION AND REGIONS

Will the present homogenization of lifestyles, architecture and space leave room for the indigenous and for local identification, given that, as Niklas Luhmann puts it, 'spatial boundaries make no sense for functional systems aiming at universalism'?[1] Recent emphasis on the region is an attempt to respond to the pressures of worldwide uniformity. Globalization is a process that cannot be tamed. While it spells hope for many in poor regions of the world, in Europe it is associated with the fear of loss, loss of difference and identity. Antiglobalization, there is no doubt, acts with the interests of individuals in mind and is based on ethical positions. Yet, there is a widespread feeling that its struggle was lost before it began to gather momentum. If globalization cannot be tamed, does it leave room for countermovements? If resistance is hopeless, can it be sidestepped? Can a space be explored that denies globalization its all-encompassing power and offers alternatives with the potential for withdrawal? While the nation-state is being absorbed by the powers of globalization, *the region*, for a long time believed to be the relic of a bygone past, is experiencing an unexpected return. Is regionalism a mere response to globalization, a defensive rebellion comparable to the luddites' lost rebellion against the machine, or could it be freed from its position of negation and turned into an active force? Could these out-of-the-way places, once associated with narrowness and sterile provincialism, be transformed into openings in the seemingly closed process of vanishing diversity? Could regions be the crack in the tight architecture of economic and cultural globalization, and open spaces of creativity and for the preservation of indigenous languages? In an attempt to explore such a potential, architectural critic Kenneth Frampton has used the phrase *critical regionalism*.[2] This essay is an attempt to determine historical and philosophical origins of the new discourse on region and globalization by focusing on issues of a specific variant of the region, the German hometown and its vernacular.

## ■■
## CENTRES AND THE VERNACULAR

From the eighteenth century on, life in Europe was centred on capitals where pervasive norms were defined according to which the world had to live and write and paint. The history of western European arts and literatures developed in the framework of the nation-state, and the big city was the centre of gravity during the era of the nation-state. History, including the history of art and literature, was made in the metropolis, which not only controlled their dissemination but also shaped mentalities, styles of painting and performing, genres of writing.

Theories of modernity are therefore focused on the big city. They tend to operate on a macro level, offering explanations of the processes of modernization through highly general

**1** Niklas Luhmann, *Die Gesellschaft der Gesellschaft* (Frankfurt am Main: Suhrkamp, 1997), 809. For a more detailed analysis of the question see Maiken Umbach and Bernd Hüppauf, eds., *Vernacular Modernism: Heimat, Globalization, and the Built Environment* (Stanford: Stanford University Press, 2005).
**2** Kenneth Frampton, 'Towards a Critical Regionalism: Six Points for an Architecture of Resistance', in Hal Foster, ed., *The Anti-Aesthetic: Essays on Postmodern Culture* (Port Townsend, Wash.: Bay Press, 1983). The term critical regionalism was first used by Alexander Tzonis and Liliane Lefaivre. Frampton draws on phenomenology and asks Paul Ricoeur's question of 'how to become modern and to return to sources; how to revive an old, dormant civilization and take part in universal civilization'. Critical regionalism is consciously ambivalent and should adopt modern architecture for its universal qualities, but at the same time include the particular context. Emphasis should be placed on the tactile sense rather than the visual.
**3** Dina Smith, 'The Narrative Limits of the Global Guggenheim', *Mosaic* 35, no. 4 (December 2002), 98.
**4** A comprehensive history of the word is provided by Carola Müller, 'Der Heimatbegriff: Versuch einer Anthologie', in *Wesen und Wandel der Heimatliteratur*, ed. Karl Konrad Polheim (Bern, 1989), 207–63.

concepts. One such concept is abstraction. Its principal elements are rationalization of space, acceleration of time, and urbanization. It constructs the world in terms of a process that over the course of time inevitably creates uniformity and makes place and spaces immaterial. Models of modernization make the category of space appear insignificant in relation to time. Observers have suggested that, from the beginning of the traffic revolution, the acceleration of time conquered space and destroyed place. The abstractness of modern existence is interpreted as a consequence of the rule of standardized international time independent of place, the seasons, the movements of the sun and moon, or individuals' inner sense of time. Rationalized and abstract urban life in big cities is considered the universal objective of modernization, rendering all other forms of life anachronistic.

A second constitutive concept in theories of modernity is that of a bourgeois, or *bürgerliche*, society. It is broad and ill-defined. Many of its theorists, such as Hegel, Marx, and Adorno, defined it in terms of its intrinsic contradictions. Bourgeois/bürgerlich for them was identical with a system of antagonisms, of dividing and splitting and a resulting *anomic*, to use Durkheim's term, condition of society and the individual. Constructed in a framework of Hegelian dialectics, these contradictions contribute to the process of finally creating a homogeneous order, eradicating opposition by marginalizing or absorbing it. The powers of internationalism, now called globalization, appear to be successful in marginalizing or absorbing any resistance, including the resistance of space. The new Guggenheim Museum at Bilbao has been called a prime example of this tendency. In the view of many critics, the $100 million building represents the ongoing 'McDonaldization' of Spanish art. The franchise ideology is supported, Dina Smith argues, 'by the fact that the museum is almost completely managed by its New York branch. Most of the recent acquisitions have been works by famous American artists, with very little indigenous Spanish or Basque art represented'.[3]

Are we experiencing a time when the specific character of places is irretrievably disappearing as a result of modernizing Europe and the world? The question is associated with value judgments. It gives rise either to expressions of the triumph of modernity, or to an animosity towards the culture of the bourgeoisie that defines the anonymous market, economic rationality and the accumulation of capital as universal objectives and has no place for the particular and individual. Problems emerge as soon as we leave the macro level and focus on the particular rather than the general. There are differences that resist inclusion in the paradigm, details that will not fit, and countermovements and retardations at the margins of the European-American model. While theories of modernization construct the world in terms of a process that over the course of time inevitably

creates uniformity and therefore leaves no room for regions, it is surprising to note that globalization has led to the return of space by transforming the temporal category of modernity into a spatial framework. To be sure, global space is being emptied of its qualities and subjected to the requirements of the time of rationalization. Yet a new awareness of regional differences of temporal orders, of the importance of space and the tension between internationalism and places of distinct local cultures, is emerging.

Modernity, its furor of change and innovation notwithstanding, may have lived off values and images inherited from previous times for which it demonstrated little but contempt. Among the contradictions of modernization, the one between the tendency towards economic, financial, or architectural internationalism and an insistence on cultures of local and regional identification was never seriously addressed. A tacit dependence on the local and concrete appears to have been much deeper than the dominant self-image in the name of progress towards abstraction would suggest. A theory of modernity capable of accommodating this dependence might lead to a different image of modernity, its genesis, and its current condition. Critical theory has demonstrated a lack of sensitivity to the local and regional, and to spaces of the vernacular. The binary opposition of place and internationalism could well be an oversimplification resulting from theoretical blindness, and a more complex theoretical framework needs to be developed. From a different perspective, it seems that the small and local, although hopelessly overshadowed by the gigantic creations of modernity, has been a potent concealed force in the construction of the modern world. Rather than disappearing under the mounting pressures of globalization, space, it can be argued, has never lost its constitutive power. The relationship between modernity and space is no longer easily identified with that between emancipation and a naive longing for a lost place free from alienation. There is a rising awareness that a sense of place and the desire for the experience of identity in a small and familiar environment was as much a part of modernity as the spectacular changes in the world through progress and internationalism. It could be characterized by the perspicuity of its repudiation and simultaneous but unintentional fostering of regions.

The term 'vernacular' conveys a tension between closed domestic space and the open public arena. It does not exist in German and is usually translated by the noun *Heimat*. This equation is problematic, because during the nineteenth century, the term 'Heimat' acquired immense emotional weight. In contrast to 'vernacular', it emphasizes emotional ties to the place of birth and childhood, set in opposition to a sense of 'otherness' and being alien, *fremd*.[4] Like 'vernacular', Heimat refers to a space defined in terms of a physical, cultural, or mental place of belonging. The word refers to a sphere set aside from the public, protected from exposure and designed for the creation of identity. But Heimat also designates a space of ambiguity that easily turns into aggressive opposition. Identity requires boundaries and exclusion, whereas the imperative of modernity is unrestricted openness through a destruction of borders. The challenge of this contradiction remains one of the unresolved philosophical problems of the present. It has profound political implications.

In opposition to the internationalism of modernity, the vernacular is defined as the category of the particular, based on an unequivocal sense of place, and it was therefore trivialized and written out of history until recently. Theories of modernity failed to take into consideration the vernacular and excluded it as insignificant or identified it with the obsolete. Its disappearance seemed imminent. But, humble and contemptible though it was, the vernacular demonstrated the strength to survive the ideologies of internationalism and power of scale,

changed but not obliterated. The assumption that the triumph of the modern inevitably spells the death of the vernacular, although widespread, is difficult to sustain. Rediscovered and raised to the level of theoretical reflection, it is gaining a surprising significance and the potential to contribute to the ongoing reconstitution of images of modernity and modernism.

Discourse on space and the vernacular is burdened by a past when theories of space were closely connected with reactionary anti-modern ideologies. An unstable amalgam of a veneration of the vernacular, propagated as the base for identity, and an aggressive advocacy of modernism characterized European fascism.

Fascism and National Socialism were sly in appropriating the appeal of the vernacular for their political purposes. In the 'struggle for the soul,' National Socialism was extremely successful in appropriating literary, artistic, and architectural versions of the vernacular characteristic of regions. However, the weakness of this Heimat movement was apparent. The emphasis placed on identity as an essential state of being and authenticity was unconcerned with freedom and required a devaluation of history and historical time. This political definition of Heimat as a concrete place leapt back into an over-simplifying idea of an antimodern romanticism. It defined both the self and its place in terms of an early moment in the history of metaphysics. Heimat was presented as presence by turning it into vulgar metaphysical fundamentalism. The simultaneous fascination with speed, aviation, communication technology and other innovations of an aggressive modernization remained an unrelated juxtaposition.

By comparison, the philosophical and political position of the Left was unambiguous. Committed to a teleological vision of historical progress, critical theory constructed an opposition between the modern and the vernacular. Hegel's concept of a universal history and Marx's theory of international capitalism made space immaterial. The intellectual horizon of the dialectical philosophy of history was delineated by an abstract concept of time that privileged the future. Consequently, this philosophy of history was wary of any association with the tangible, the present, the local and provincial. The vernacular of regions was identified with a problematic politics of identity. Adorno spoke for many when he associated Heimat with identity politics, which, in turn, he identified with 'untruth' and, in concrete political terms, with fascism.

Ernst Bloch's philosophy was an exception. He shared Adorno's indictment of identity politics, yet by the same token, he made an attempt to free space from its ideological identification with immobility and reactionary nostalgia. Bloch (1885–1977) was the philosopher of the vernacular, one of the first to consider it worthy of theorizing.[5]

The question can be raised whether the vernacular was not only a

5  It was Georg Simmel who sharpened a generation's perception of the small and the insignificant. 'Idealism had alienated the German mind from the touch of the concrete [...] and it would be productive to entice it to listen to things [*in die Sachen hinein-lauschen*]', Siegfried Kracauer wrote ('Philosophische Brocken', in *Berliner Nebeneinander: Ausgewählte Feuilletons, 1930–33*, ed. Andreas Volk [Zurich, 1996], 205). Similarities and overlaps with the later Heidegger's philosophy of 'the thing' would warrant close scrutiny.

6  Mack Walker has written a political and social history and prehistory of the German Kleinstadt which he calls the 'home town'. Walker's *German Home Towns: Community, State, and General Estates, 1648–1871* (Ithaca, N.Y., 1971), is not concerned with the cultural significance of the Kleinstadt as a symbolic construction, but with its political history. He places its beginning after 1648 and sees the end of its history as a result of the creation of a unified nation in 1871.

7  Franco Moretti, *Atlas of the European Novel, 1800–1900* (New York, 1998), 165.

8  Kenneth Clark, Provincialism, in: *Moments of Vision and Other Essays*, New York, 1981), 50–62: 51. Clark goes on to develop a sophisticated argument about the independent mind of the modern provincial artist.

9  Niklas Luhmann, *Die Gesellschaft der Gesellschaft*, 667.

suppressed detail but modernity was tacitly shaped by it much more than its self-proclaimed program seemed to permit. If the acceleration of time is significant for modernity, the vernacular is a retarding element. The question arises as to whether this retardation is a vanishing relic of the past or rather an integral element of modernity that calls for a reconsideration of the role of space. This essay contends that closer examination of the vernacular will lead to a revision of received theories of the relationship between modernity and space.

## ▌▌▌
## THE METROPOLIS AND THE *KLEINSTADT*

In the late eighteenth century, the German *Kleinstadt* or hometown as a frame of mind was invented as an imagined space loosely related to the small towns located on maps and described in travel guides.[6] Kleinstadt is a fuzzy term referring to both real and imagined space, a place for living and a frame of mind, characterized by sets of values and norms. As a result of this ambiguity, the term can be used as a descriptive category only with a great deal of caution and easily conflates distinct dimensions. As a critical term that sensitizes one to contrasting theories of modernity, it is, however, worth elaborating. It subjects universalizing theories to testing scrutiny and points to their deficiencies as well as to damages and casualties resulting from the process of modernity. The Kleinstadt was simultaneously the swan song of a doomed community and a product of the new period of industrialization and urbanization.

The modern city's objective was the rationalization of space. The ideal was symmetry and perfect geometrical forms, which although ultimately unattainable were pursued with rigor. The pervasive ideal of geometrical order ruled the modern period from Newton on; in political terms, it was a reflection of the order of absolutist rationality. This spatial organization left deep traces in the construction and reconstruction of the modern city. The order of the medieval town was now perceived as disorder, and as such, it had to be banished. Traces that the premodern and pregeometric thinking of individuals, guilds, and the church had left in the arrangements of streets, squares, big and small houses and factories became intolerable to an aesthetic mind that was dominated by the ideal of reason and identified reason with geometrical order. These apparently anarchic relics of the past had to be destroyed through the eradication of the crooked anatomy of old towns and its replacement with clear and geometrical arrangements. This was often done against strong resistance by the inhabitants of these quarters. In the course of the nineteenth century, Paris with its systems of boulevards and squares where they cross, dividing the space of the city into elements of a geometrical figure, became the model. This fundamental change was two-sided. It created the pleasure of ruling over space by subjugating it to the aesthetics of geometry and symmetry and at the same time, it subjugated those living in the city to the new rigid spatial order. The metropolis was a space where the nation-state, modern socioeconomic forces of centralization, rationalization, and political domination, and a state of mind expressed in literature and the arts were intricately interwoven.

In opposition to this centralization and domination, images of small regions and the countryside were closely tied to Romanticism and reactionary politics. In the course of the nineteenth century, the idealization of regions and their vernacular came to be increasingly associated with antimodernism and lost its attraction. The nineteenth-century novel became 'the most centralized of all literary genres'.[7] From Balzac to Dickens and Joyce, the big city, places like London, Dublin, Moscow and Paris, provided the cognitive and emotional anatomy

of the modern novel. It created an ideal space for a narrative that lost its paradigmatic position only in the late twentieth century.

It is, however, an oversimplification to juxtapose the urban novel as the medium of the modern with the novel of the country and village as its opposite. The spatial constellations are far less clearly defined. Provincial towns in French novels could be modern without, however, replicating the living conditions of Paris. Kenneth Clark suggests that provincialism could be interpreted as 'merely a matter of distance from a centre, where standards of skill are higher and patrons more exacting [...] and the provincial artist is launched on his struggle with the dominating style'.[8] Such a view presupposes a unified field and linear forces operating between centre and periphery. It is predicated on the perception of a national culture constituted by a linear centre–periphery distance. As a result of the increasing distance from the metropolis, the centripetal force of the centre is gradually decreasing, but it nonetheless remains the defining power in the entire field. However, the space of cultural production is far from being unified and homogeneous. Systems theory also speaks of the centre–periphery relationship but defines it as 'a form of difference'.[9] This difference is never characterized by a linearity of distance. The powers of cohesion, repulsion, and gravity of a uniform, Newtonian space do not operate in the space of cultural production. It is polycentric. It is a field with a plurality of forces and conflicting movements, localized gravitational pulls and epicentres. This uneven space was a precondition of the survival of the vernacular in a world of rapid centralization.

In Germany, it was not only the idealized countryside and its hamlets that gained significance but also a geographical and sociopolitical structure that differed from the city–province divide of England and France. The cultural historian Wilhelm Riehl, an astute observer, referred to geographical regions and called them 'individualized country'.[10] It created a space that liberated itself from the pervasive pull of the centre and the dominance of its geometry and ideological and political power. It was less compelling than the big city and opened up opportunities for local democracy, for joining in or staying away from circles of friendship, and for celebrating creativity. It was an architectural and political space that protected one from the pull towards uniformity.

In contrast to the metropolis, the Kleinstadt retained its curved streets and lanes, and its lack of geometrical order. It did not follow the imperative of rationalized order and could still be experienced as a place of one's own. It was familiar and offered a sense of security and protection from the violations inflicted on the subject by modernity. It not only created a time independent of the time of social modernization but also saved the time of individual biographies from the ossification associated with the countryside. The hometown was urban, yet it was also a site where the conflict of modern history between freedom and compulsion, strongly experienced in the big city, appeared to be repudiated in favour of the individual's autonomy. These were the preconditions of a life in which the individual was not lost but able to maintain a sense of self. It was conceived of as a space fit for the attempt to maintain a sense of place and concreteness in a world that dissolved all that had once been concrete and tangible into abstraction.

The Kleinstadt created an imagined space for cultivating subjectivity, including its irrationality, in contrast to the rationalization of industrializing societies, and for the local and particular, in contrast to the universalism of Enlightenment values. But at the same time, it was also the space of the eminently modern struggle of the self to determine its place in a society of growing abstraction and in the anonymity of a world increasingly defined by instrumental

**10** Wilhelm Heinrich Riehl's term 'individualized country' resonates with Kenneth Frampton's 'critical regionalism' and, in certain respects, can be read as a complementary precursor to it. Among the weaknesses of his approach is the opposition he creates between two opposing forces, the forces of retardation (*Beharrung*) and dynamic forces (*Bewegung*). In contrast to Frampton's emphasis on aspects of mobility and critique inherent in regionalism, Riehl's preference for persistence created an obstacle for the perception of the contradictory character of modern society that succeeded in integrating dynamics and retardation to a complex system. See Riehl, *Die bürgerliche Gesellschaft* (Stuttgart, 1853) and *Land und Leute* (Stuttgart, 1855), 132–217.
**11** The foremost example of the self-assured Kleinstadt as an intellectual and artistic excentric centre was Weimar. Among the numerous publications on the 'Musentempel', there are very few that deal with spatial aspects in the Weimar myth. Most common are variants of the history of ideas paradigm. An early attempt to write a cultural history in terms of a modern definition of material culture, following Raymond Williams, is Walter H. Bruford, *Culture and Society in Classical Weimar, 1775–1805* (Cambridge, 1962); more recent is the popular Peter Merseburger, *Mythos Weimar: Zwischen Geist und Macht* (Stuttgart, 1998; 3rd ed., 1999). The first publication that combined images, including photography, and texts in an attempt to capture the atmosphere of Weimar as a place was a small book by the Goethe admirer Wilhelm Bode, *Damals in Weimar* (Leipzig, 1912; facs. reprint, Weimar, 1991).

rationality. Under the conditions of modernity, the *Kleinstadt* provided a space for a life of untimeliness. It did not fit into patterns of efficiency and time management and maintained a degree of authenticity otherwise absent from modern life. Its space remained crooked, the way Kant, who experienced the world in the remote small town of Königsberg, thought human nature was crooked. It created not only an irregularly striated space for physical and social movement, but a space to which its inhabitants were attached, not wishing to be anywhere else.

The Kleinstadt thus served as an obscuring force that rendered the clear image of the centre–periphery power struggle obsolete. It obfuscated the unilinear power relations by creating many small centres and shifting peripheries, and it provided a space for the unfolding of cultural distinctions between tangible and invisible groupings.

Provincialism is not a function of the distance from the centre; rather, it is defined by a state of mind and a sense of inferiority.[11] The literature of the Kleinstadt was not defensive, but conscious of its innovative qualities and independent standards. Its vernacular actively obscured the relationship of dominance and dependence. It did not cringe culturally.

# IV
## THE HOMETOWN

The hometown's emergence was predicated on the tension with the simultaneously emerging *Grosstadt*, or big city, as the centre of the changing physical and mental geography of the industrializing century. It gave a name to a space characterized by a specific lifestyle. It seems justifiable to interpret the hometown's spatial decentralization and retarding of momentum as a complementary attempt at creating a modern world, less consistent, less glamourous, and ultimately less dominant in terms of political power and philosophical persuasiveness, yet with a queer obstinacy. In the arts and literature, the hometown developed into an imagined space that differed equally from the built environment of city dwellers and that of peasant farmers. Paradigmatic for this Kleinstadt are Goethe's Weimar, Kant's Königsberg, Schelling's Jena, Hölderlin's Tübingen, Mörike's Cleversulzbach, and the Romantics' Heidelberg and Jena. These towns were imagined spaces of fantasy and thinking, geographical and architectural representations of the ideal type of *Kleinstadt*. It was an imagined place that merged the small towns of the century with the idea of a vanishing urban culture. It created a place in the history of mentalities that invented a space for modern life at the margin of modernity defined in terms of the politics of the western European nation-state.[12] During an extended period of transition from a society of early manufacturing to high capitalism, the hometown

**12** Alon Confino, *The Nation as a Local Metaphor: Württemberg, Imperial Germany and National Memory, 1871–1918* (Chapel Hill, N.C., 1997) creates a hierarchy and interprets Heimat as an auxiliary tool for the overriding objective of nation building.
**13** Maiken Umbach, 'The Politics of Sentimentality and the German Fürstenbund, 1779–1785', *Historical Journal* 41 (1998): 679–704 specifically refers to Goethe's political concept in the context of tensions between Berlin's politics of centralization and Weimar's counter position. The essay's political interpretation of friendship creates a contrast to the reading suggested in this essay.
**14** An example is the Tafelrunde, or 'roundtable,' in the Wittumspalais of the duchess of Saxony-Weimar-Eisenach, Anna Amalia (1739–1807), which is well known through Georg Melchior Kraus's 1795 painting of it. See www.biblint.de/goethe_tafelrunde_kraus.html .
**15** Anne-Louise-Germaine de Staël (1766–1817), Madame de Staël, *De l'Allemagne* (Paris Novelle Édition 1879), 79–80.
**16** Ibid., 119.
**17** The period of philosophical and literary innovation around 1800 was linked to the hometown in ways that, despite deep changes, can be observed again in the early twentieth century, when Weimar once again became the focal point of an innovative movement in the arts, architecture, and literature. Creative minds such as Harry Graf Kessler and Henry van de Velde chose Weimar as the site for their experiments. Yet this was the swan song of the Kleinstadt, a last moment of creativity before its final collapse.
**18** The Weimar exhibition 'Aufstieg und Fall der Moderne' (1999–2000) presented the early beginnings and demonstrated the importance of this anticentre. Darmstadt's 'Mathildenhöhe' would be another example.

offered a space for a specific form of cognitive and emotional productivity, for reflection, self-searching, and the transformation of tradition into new ways of thinking. It is the central paradox of the Kleinstadt that some of the most pertinent analyses of the destructive elements of modernity emerged precisely under its auspices.

The relative independence of the hometown was a pillar of cultural pluralism and lived democracy. The Kleinstadt functioned as a microsphere that was constitutive for specific ways of living and communicating, resonating with and at the same time opposing modernization. Alongside membership in a profession, a religion, a state and, possibly, a secret society, the hometown offered its own membership to its inhabitants, one endowed with distinctive cultural values and virtues that rendered the importance of other memberships relative. It was not lost on Kleinstadt dwellers that this membership was a constitutive part of the competition between systematic order and creative disorder, between centralism and particularism.[13] Members of the community of a Kleinstadt did not give up or attenuate their other memberships. However, they entered into a specific commitment that set them apart from others as a result of a voluntary decision. This added to the palette of cultural distinctions available to them. By combining visible and institutionalized with informal and invisible memberships, they continued an old tradition of opposing the power of central and local authorities. ('Stadtluft macht frei' was the slogan of bondsmen who succeeded in escaping from their lords and obtained their freedom after living in a town for more than one hundred days.) A cultural history of the Kleinstadt could be written in terms of this emancipatory spirit.

The literature of the big city offered images of an 'unlimited' freedom, but at the expense of a defenseless exposure and vulnerability of the subject. In opposition to these places of isolation and loneliness where personal bonds were severed, the *Kleinstadt* provided a space for the cultivation of intimate relationships. Shielded from the unbridled acceleration and commercialization of life in the city, but also distanced from the anachronisms of the quest for identity and authenticity in the back-to-the-origin discourse, the Kleinstadt became the site where memory could evade the erasure of the past characteristic of big cities.

## Communication

The cultural construction of the *Kleinstadt* provided a space for the vernacular as a state of mind that inevitably clashed with the ways of thinking and being in the world emanating from the metropolis. It created a space for writing and living, neither isolated nor subjected to a centre's domination. Identification with the local as a

place of difference was the response to the modern world's insistence on a unified central standard. Its forms of communication were an attempt to reconstitute a dialogical culture of persuasion and an immediate contact alien to modern political institutions of mediation.

The city offered new and 'unlimited' forms of political freedom and independence for intellectual productivity. It also created its own casualties. An increasing realization of the egalitarian ideal was accompanied by the breakdown of traditional social and communicative structures. Unlimited freedom to publish was merely the flip side of the silencing of the individual by market forces that have no ears to listen and no mouth to speak. Networks of communication and social intercourse were destroyed, and the subject was exposed to a threatening anonymous and unbridled market. Under the conditions of the *Kleinstadt*, other forms of communication developed, maintaining a certain degree of orality and emphasizing the authenticity of face-to-face communication rather than equity of the exchange of symbolic values in anonymous markets. An important aspect of the hometown culture was that it retained polycentric functions of public discourse dismantled in the modern city, which had no physical or mental space for the agora. The imagined hometown emerged at a time of Germany's infatuation with Greek culture – perceived in opposition to Rome – and was conceived of as a polis. It was based upon an idealized view of Greek antiquity and created private and public institutions and clubs devoted to intensive communication that requires presence.[14] The physical and narrow place of the agora was being replaced by the space of the town as an imagined sphere of genuine dialogue. In contrast to the anonymity of the big city, it was the *Kleinstadt* where the ideal of communication prior to the impact of modern media continued to be cultivated. This was not communication as a result of a struggle with the de-individualizing powers of the metropolis, but dialogue embedded in lived structures of physical presence and corporeal proximity. The relaxed communication of these small urban communities was the positive side of a culture oscillating between recreating ideals of the classical past and the bourgeois present. It stands in equal distance to the medieval town built around centres of worship and the collapse of central authority in the industrialized modern city. It maintained a certain degree of direct and polycentric communication through orality. Friendliness or *comitas* (comity) of social interaction imbued life in the *Kleinstadt* with an aspect of a civil society. This civility of communication operated on two different levels. It was characteristic of communication in everyday practices, which Wieland, Goethe, Schiller, and Herder, who lived in a *Kleinstadt*, attempted to frame in theoretical and literary terms, and it was also operative in distinct discourses of philosophy, philology, history, and aesthetics, all of which thrived in eighteenth- and nineteenth-century Germany, not least due to the conditions provided by the *Kleinstadt*.

*Creativity*
The literature of the Kleinstadt was not a derivative of the metropolis. Based on her visit in 1803 and 1804, Madame de Staël compared France, where the focus of literary life was only on Paris, with Germany, where small towns created 'an empire [...] for the imagination, serious study, or simply benevolence'.[15] She experienced the Kleinstadt Weimar as a place whose citizens inhabited 'the universe and, through reading and a width of reflection escaped the narrow boundaries of the predominant circumstances'.[16] The latest European developments in arts, literature and fashion were discussed within the spatial constraints of this humble place. In contrast to her expectations, the narrow conditions of individual lives did not lead to claustrophobia but, instead, were channelled into intellectual productivity. Her idealized assess-

ment contributed to the emergence of an image that created its own momentum and its own reality of the mind. It provided the context for the surprising cultural productivity that made a substantial contribution to the concept of the modern.[17] It borders on the grotesque that the term 'world literature' was born in an obscure town in provincial Germany. Goethe's term *Weltliteratur* was indicative of ways of thinking that came from within but transcended the narrow boundaries of provincial places, extending Rousseau's *citoyen* and Kant's vision of a citizen of the world in an emerging world society.

There are numerous examples in nineteenth-century literature where the tension between the Kleinstadt and the open space of the world is transformed into aesthetic creativity. Jean Paul's novels oscillate between the narrowness of the Kleinstadt and the unlimited world of imagination, of an idealized, borderless love of humanity. Turgenev paints a favourable picture of the German Kleinstadt. The opening pages of Gottfried Keller's novel *Der Grüne Heinrich* sing the praises of the open-minded small towns, pulsating with traffic and commerce, on the river Rhine and Lake Constance. At a time when, in the capital, artistic preferences were conventional and nationalistic, it was in provincial Weimar where the modern French art of Manet, Cézanne, Gauguin, and Rodin was celebrated.[18] Rodin devoted fourteen modern watercolours to this provincial place, where they were exhibited. The Bauhaus was founded at Weimar by Henry van de Velde, Walter Gropius and others. It certainly was not the brainchild of the Kleinstadt spirit, yet it was conceived under the conditions and in the specific environment of this provincial place where, as Madame de Staël had observed a hundred years earlier, the narrow streets bred a universalism of the spirit that resonated with the innovative centres of the world. When, in 1922, representatives of the Dada and constructivist movements gathered in Weimar, it was a signal to the world that the German hometown still had the potential to create an open space for imagination and creativity.

This image, it needs to be emphasized, was not 'innocent' or idyllic. It interfered with the power play between centre and periphery that was at the core of the creation of modern Europe. It would be naive to portray the struggle for domination as a painless redirection of influence and pure rearrangement of the distribution of knowledge. The relationship between centre and hometown was characterized neither by harmonious exchanges nor by diffusion, but rather by conflict.[19] In the increasingly international Europe, the focal points of orientation and power over the mind were Paris and London, and, from the end of the nineteenth century, also Vienna and Berlin. The position of the Kleinstadt within this field of shifting power relations was one of resistance to a totality of space organized according to geometric and political imperatives.

**19** Cf. Peter J. Hugill and D. Bruce Dickson, eds., *The Transfer and Transformation of Ideas and Material Culture* (College Station, Texas, 1988), esp. Torsten Hägerstrand, 'Some Unexplored Problems in the Modelling of Culture Transfer and Transformation of Ideas and Material Culture'.
**20** In a different context, Siegfried Kraucauer remarks in a review of Bloch's approach to history that 'Bloch does not care the least about reality. [...] His learned syncretism is incompatible with his magic conjuring of the end [...] the miracle comes by decree, the leap turns into a process and we happily arrive at a dialectics of history with Hegel and Marx' ('Prophetentum: Ernst Bloch's Thomas Müntzer als Theologe der Revolution', in Kraucauer, *Schriften*, ed. Inka Mülder-Bach [Frankfurt am Main, 1990], 5.1: *Aufsätze, 1915–36*, 201).
**21** Siegfried Kracauer published small feuilletons in the *Frankfurter Zeitung* on unrelated and capricious spaces such as the hotel lobby, the underpass, the unemployment office, the bar, a dancing hall, etc. See Kracauer, *Berliner Nebeneinander*, ed. Volk; *Schriften*, ed. Inka Mülder-Bach (Frankfurt am Main, 1990), 5.1–3.
**22** This was shared with other thinkers of his time. 'Spatial images are the dreams of society', Kracauer wrote. 'Wherever the hieroglyphics of any spatial image is deciphered, there the basis of social reality presents itself'. See David Frisby, *Fragments of Modernity: Theories of Modernity in the Work of Simmel, Kracauer, and Benjamin* (Cambridge, Mass., 1986), 109–186.

It maintained rapidly disintegrating principles of social stability and morality and at the same time was creative in transforming them. However, the Kleinstadt and its image soon deteriorated. The crisis of modern civilization at the end of the nineteenth century wrote finis to the story of the German hometown. Modernist poets rebelled against the fake ideal of the hometown, which they perceived as a remote, closed space of the past. Viewing the Kleinstadt through the eyes of its modern despisers, informed by their disdain for its narrowness and hypocrisy, will inevitably bar our understanding of it as a productive site, which it was in the real and symbolic worlds for more than a century. It was never a place only of creativity, or only of provincial sterility, but a fragile mix, an ambivalent combination of contradictory forces.

# V
## ERNST BLOCH'S PHILOSOPHY OF THE VERNACULAR

Ernst Bloch's philosophy provides an initiated insight. In opposition to academic philosophy since Plato, his thought elevates the simple, the narrow, and the concrete to the level of philosophical reflection. If we take his philosophy of space and his regionalism as the point of departure, the question arises of how imagined space can be linked to observed space and time. Is a philosophical ethnology of space and things possible? In contrast to the Hegelian concept of history, space is pivotal for Bloch's way of thinking. His *regionalism* signifies an emotional state and resonates with a spatial definition of being. He turns place and the tangible banalities of existence, mere obstructions for transcendental and analytical philosophy alike, into prime objects of philosophical enquiry. Endemic specificities of places, such as local customs and regional proverbs, become moving forces in a thinking that fuses philosophy and an ethnology of space. Bloch's philosophy is engaged in a search for spaces of revelation.[20] He combines this theological search with the Marxian theory engaged in changing rather than interpreting the world and he elaborates upon the small and the concrete, upon a focus on the vernacular as a model of the envisaged new world.

Bloch's philosophy grapples with the time–space relationship. His point of departure is a spatial turn in philosophical reflection on past and future. His philosophy avoids the identification of space with the immobile and of the vernacular of regions with insignificant detail, with ornament or arbitrary motif. In the tradition of Georg Simmel, and not unlike his contemporaries Siegfried Kracauer and Walter Benjamin, Bloch develops a phenomenological gaze that discovers regions and their vernacular as the matrix of a different way of perceiving the world. Not abstract concepts and conceptual models but images of regionalism constitute the hinge connecting the individual and society, the natural and built environments. The vernacular of Bloch's regions is concrete and tangible and preserves traditions derived from a world familiar to us as an imagined past, although it may never in fact have existed. The vernacular is at the centre of his attempt to connect philosophical theory with a world outside of thinking, a world of concrete things and of action for which the social practice of building, represented by architecture, provides the model. Spaces need neither logical connections nor continuities. Like Kracauer, Bloch describes them as discrete miniatures.[21]

The early Bloch refers to the specifics of geographical regions such as southwestern Germany and its democratic traditions, or regions in Bavaria. He emphatically speaks of the need of a site ('ein Fleck') for the individual to stand on. Space in terms of specific sites and concrete locality is crucial to his attempt to overcome the damages inflicted by modernity.

His philosophy of space fragments unity and continuity and creates spaces for self-determination.[22]

His turn toward space transforms the theoretically insignificant word 'Heimat' into a notion of philosophical reflection. In his interpretation, it is not a word designating an ethnographic place. Heimat is absent from modern life and needs to be made present as an imagined space of promise, a land to come. It is a sophisticated construction, and its simplicity is artificial. Heimat becomes a topos of the individual's right to a self as soon as it can be rehabilitated against the domination of the temporalized and homogenized space of modernization without falling prey to an ideology of stable identity. Bloch's philosophy turns the ethnographic term 'Heimat' into the philosophical term for an imagined space of emergence. It has a historical potential that his 'Prinzip Hoffnung' or 'hope as a principle,'[23] associates with future reality. Heimat is identical with images and imaginations that point into a space of the 'not yet'. It is rooted in the anticipatory function of thinking. The invention of Heimat is a continuous task and the passage to it requires imagination and philosophical reflection.

Heimat can be conceived of only in close connection with a sense of contrast nurtured by the open space of the world. It is a state of mind in which happiness is associated with a sense of belonging and, at the same time, a sense of the freedom to leave. 'Heimat' is a relational term, not one that defines a static, solipsistic life. *Heimweh* (homesickness) is inconceivable without its contrary, *Fernweh*, the pull of the unknown and desire for faraway places.[24]

Reconstituted as an imagined space, Heimat can be rescued from the fetters of the parochialism of identity politics and its stigma of an antimodern idyll. Bloch's philosophy creates *Heimat* as an alternative place determined, first and foremost, by negativity. Bloch makes it very clear what *Heimat* must not be. It is a negation of capitalist productivity as well as of nostalgic anticapitalist escapism. It is out of sync with the time of modernization, *ungleichzeitig*. He calls hope a 'principle', dissociating it from romantic words such as 'longing' or 'melancholia', and is rescuing it from the nostalgic longing for an ideal past. Any memory of Heimat is deceptive. Bloch knows that searching for a free society in the past is akin to the untruth of the idyll. He cannot share the Romantics' idealization of the Middle Ages or the rural life of the past as a golden era before modern alienation.

In Bloch's definition, Heimat is not a place that can be visited or reconstructed in individual memories, because it never existed in any known past. He insists that Heimat is neither the space of a bygone age nor the final destination of the individual's unhappy journey through the hostile modern world. Heimat cannot provide a space for reconciliation, because it needs its opposite and would be incon-

**23** Ernst Bloch, *Das Prinzip Hoffnung*, 3 vols. (1954; Frankfurt am Main, 1959); trans. Neville Plaice, Stephen Plaice and Paul Knight as *The Principle of Hope*, 3 vols. (Cambridge, Mass., 1986).
**24** See Bloch, *Prinzip Hoffnung*, vol. 1, 19.
**25** See Helmut Plessner, *Grenzen der Gemeinschaft. Eine Kritik des sozialen Radikalismus* (Bonn 1924; new ed., Frankfurt, 2002), trans. Andrew Wallace as *The Limits of Community: A Critique of Social Radicalism* (Amherst, N.Y., 1999).
**26** Franco Passanti, 'The Vernacular, Modernism, and Le Corbusier', in Umbach and Hüppauf, eds., *Vernacular Modernism*.
**27** Ernst Bloch, *Tübinger Einleitung in die Philosophie* (Frankfurt am Main, 1963), 1, 122.

**28** Manfred Riedel refers to Nietzsche's influence on the early Bloch. But it is precisely the utopian dimension in Bloch's thought, referred to by Riedel, that marks the sharp difference between their respective conceptions of present and future. Manfred Riedel, *Tradition und Utopie: Ernst Blochs Philosophie im Licht unserer geschichtlichen Denkerfahrung* (Frankfurt am Main, 1994), 268ff.

**29** Bloch, *Prinzip Hoffnung*, 22f.

**30** Foucault also uses the metaphor of hollow spaces left behind by the exit of the gods. He thinks of a third alternative by drawing attention to space's power of opposition to scientific discourse reduced to an endless stream of words in a modern culture devoid of meaning and purpose. Michel Foucault, *Naissance de la clinique: Une Archéologie du regard médical* (Paris, 1963), trans. A. M. Sheridan Smith as *The Birth of the Clinic: An Archeology of Medical Perception* (London, 1973), 179.

ceivable outside of a structure of differences and struggle. Heimat is not, Bloch maintains, a place for stable identity.[25] Heimat never connects to a first beginning but is always already the product of imagination and dreaming. Being at home is not to be identified with a final arrival, because Heimat is an imagined space within the parameters of modernity and a creation through language. Bloch shares this antiessentialist definition of place with other critical thinkers of his time, notably Simmel, Kracauer, and Benjamin. In a related way, Francesco Passanti reads Le Corbusier, whom Bloch considered an archenemy of his own concept of architecture, as an ally in the struggle for self-determination. Le Corbusier's diary from his Balkan trip serves as an example of the experience of the vernacular without an antimodern escapism.[26]

A philosophical ethnology of space would provide a common ground and meeting place of the two distinct disciplines of philosophy and architecture. His idea of architecture is characterized by concreteness and smallness, and prefers the tactile over the visual. In Bloch's philosophy, the hometown is an architectural space where loss can be addressed and where modernity meets its own contradictions and offers compensation for its destructions. Regardless of negative or positive connotations, Heimat is for Bloch the central term for the place of emotional attachment, love, or hate, and, in its own way, contributes to paving the path into modernity. It needed a postmodern mentality to acknowledge this contribution.

Heimat and the Kleinstadt resist the destruction of space. In opposition to a life congruent with modernity, the Kleinstadt provided a space 'far away from the stream of the time, in a remote region'. The opposition to a life continuously adapting to modern trends needed a space removed from the domination of time in order to create an attitude of independence 'that has been achieved by many hometown citizens. They are provincial in a way that adds a much older life to retardation'.[27] This reevaluation of the 'provincial' and of slowness in terms of an alternative to the destructive process of acceleration links the space of the town to the future for which we crave. In Bloch's view, it is the recourse to an older life—a life before the emergence of the modern, the bourgeois society and the rule of the clock—that invests the Kleinstadt with negativity, which, in turn, he interprets as a power of resistance and a genuine countermodel within modernity. This countermodel creates the space for the vernacular's character as a dream into the future. He constructs the vernacular of the Kleinstadt as an urban space that, in spite of the capitalist perversion of ideals of urban civilization, keeps the utopia of the good life alive.

In his assessment of the victory of reactionary politics in the 1930s, Bloch contended that the vernacular had been abandoned by

**31** Bernd Hüppauf, 'Heimat—die Wiederkehr eines verpönten Wortes. Ein Populärmythos im Zeitalter der Globalisierung', in Gunther Gebhard, Oliver Geisler and Steffen Schröter, eds., *Heimat. Konturen und Konjunkturen eines umstrittenen Konzepts* (Bielefeld [transcript], 2007), 109–140.

intellectuals and architects engaged in shaping the condition of modern life. It needed to be recaptured. While Bloch shunned identity politics, he was equally aware that human life is impossible without boundaries and exclusions. His philosophy of hope is characterized by an idealized space made present through the imagination, which, as he was well aware, is deceptive, but which he was unwilling to abandon. Bloch mourned a loss, and his oeuvre is undeniably motivated by nostalgia for a place that never existed. Despite his lifelong dialogue with Nietzsche, Bloch's philosophy of hope was based on a misreading of Nietzsche. Nietzsche's attack on the modern world and his critique of morality was not, as Bloch's reading suggests, the springboard for a project to change the world.[28] Nietzsche's analysis of deception included the 'gay' and gleeful invitation to embrace the world as a neverending play of ambiguities and delusions. It abandoned all the dreams associated with Heimat. In opposition to Nietzsche, Bloch regarded this kind of play as indicative of an inauthentic life. His hope was identical with the expectation that the play of presence and absence will come to a happy conclusion. In a short but significant passage, Bloch refers to a childhood memory of building a playhouse in the branches of a tree that could not be seen from below, 'Sitting in it high above the ground, and having pulled up the ladder, interrupting the connection to the ground below, we felt absolute happiness'.[29] The combination of concrete childhood memories and the lofty dream of an imagined place of happiness referred to a fragile and transient, primitive structure that, despite its imaginary constitution, contained within it the promise of a humane future. Could a dream of the future be farther away from Nietzsche's myth of a new man in a newly mythologized world?[30]

Bloch's philosophy is that of a visionary architect of imagined spaces designed to replace the world of capitalism with something radically different, a space and time for which he had no better word than Heimat. It was reminiscent of the security, trust, and good experiences of a time experienced in life, a time that in memory combines events, dreams and imagination, the time of childhood. Read as a guide for action, Bloch's paradoxical combination of utopia and place calls for the dismantling of the modern city and the substitution of transient, weightless structures that would make it possible to experience Heimweh and Fernweh in the same space. This vision was clearly informed by romantic fantasies. His architecture of revolution used building and dwelling for the blueprint, the *Entwurf* of a new world that has the potential of becoming a space for the experience of Heimat. Yet Bloch failed to take the historical experience of the twentieth century into consideration. In the wake of the catastrophes of his century, we need to ask whether it is still legitimate to maintain

images of Heimat as an ideal for modern architecture, or whether it may have turned into a crime of the mind.[31]

His dreams do not belong in the adult world of frivolous games, but in the serious playing of children, who associate dreams with promises that burst reality open. Bloch shared children's belief in dreams' power of becoming real. They represent the promise inherent in eschatological thinking. An architecture that corresponds to the needs of the subject in a postindustrial world would need to develop responses to the challenge of fusing modern aesthetics and the ethics hidden in the inconspicuous vernacular. In spite of globalization's pressure for uniformity, there are signs that recent conceptions of space may be responding to this challenge.

Critical Regionalism articulates the tension between globalization and the local. It rehabilitates the region as a space in its own right with a potential that is not exhausted by retardation but opens space for creativity and the productive imagination. Like the lost hometown of the past, it creates its own conditions for life and literature safeguarding individuals against the effects of globalization and supporting independence against the power of eliminating difference. It is a crack in the system and creates its own humble architecture of existence and its own time that is not synchronized with the time of modernization. What Robert Musil called a sense for potentiality (Möglichkeitssinn) that distances the imagination from the tyranny of the real will thrive only once life is shielded from exposure to the merciless powers of global markets for everything including language and emotions. If there is hope for life beyond insipid and sterile uniformity, we need to turn to microspheres. The region of Trentino–Alto Adige/Südtirol, where two cultures, Italian and Austrian, intersect could serve as an example of the quiet power of a region. It is a remote place at Europe's margin and at the same time it is privileged in terms of cultural diversity and independence from a powerful centre. If what used to be the centre is now fragmented in many centres that have moved to the periphery, this region qualifies as such a centre and is fertile ground for experimenting with ideas of a future more colourful and diverse than architects of the global world are capable of imagining.

# THE HOPE AND POTENTIALITY OF
## THE PARADIGM OF REGIONAL IDENTITY
SUZANA MILEVSKA

When embarking on writing about the hope and potentiality that are embedded in the notion of *belonging* it is actually inevitable to attempt to bridge the 'principle of hope' and the utopian belief in complete belonging (either to a nation or to the world in general) with the potential of *not to belong* that is necessarily attached to belonging.[1] *Not to belong* is especially implied in the notion of regional belonging where national meets cosmopolitan halfway. While the phantasm of *belonging* to a nation and of belonging in general is based on a positive and utopian hope, the very actuality of belonging. For example belonging to a region is defined by the potential of *belonging without belonging* or *belonging without having something in common*.[2]

Of all the emphatic expectations and phantasms emerging among different peoples and nations in the new Europe, the very desire and projected hope to belong to the EU has become the most urgent. The EU political superstructure has started to function as a kind of political redefinition and even replacement of European geography. The EU is neither a nation nor a region but belonging to it functions as a kind of suprabelonging. Within such a political and cultural context I will try to address the notion of regional identity as one of the recently emerged political instruments of integration and belonging.

Regional identity appears to be a kind of *aporia*, a specific form of *disjunctive* identity that as a certain political compromise, a kind of 'dangerous supplement', overarches *belonging* to a nation with *belonging* to a European Union, which is comprised of different nations and identities.[3] Ultimately, the concept of regional identity emerges as a kind of concession that contaminates the unconditional *belonging* with the potentiality of a partial *nonbelonging* as the biggest nation-state danger.[4]

What does it mean to assume a regional identity: does one ever genuinely identify as Balkan, Mediterranean, Trentinian, or Northern Macedonian (in Greece); does this mean that national identification suffers a loss of patriotism because of the expansion of the strictly national identity into a more heterogeneous regional identity, or does this only help clarify one's own identity? Or is regionalism just a pragmatic tool used by smaller nations and ethnicities to boost their hopes of completeness, of belonging to the globalized world? All these questions can be addressed indirectly, through culture, art and architecture, because it was there that regionalism was applied as a means of analysis of different codes and phenomena.

One example of the justification of regionalism was *critical regionalism*, a concept first offered by Alexander Tzonis and Liane Lefaivre and later developed by Kenneth Frampton. Critical regionalism in architectural theory worked as a kind of cultural mediator between universal civilization's codes and the specificity of place.[5] Situated between universalized cultural codes of a globalized and unified world and locally recognized visual codes of world cultures, critical regionalism actually focused on specific topography, climate, light, tectonic forms: on the haptic rather than visual perception.

In the wake of postmodernist critical theory critical regionalism offered the urgent and necessary hope of the synthesis of, on the one hand, the architectural forms that were created

within minor cultures and regional borders and, on the other, universal cultural values that could be reached through a critically conceptualized regionalism. Thus there was a hope for an architecture that could address the particularity and peculiarity of space whilst at the same time overcoming the limits of local industrial production and the obstacles to self-sustainability so necessary for neoliberalist and globalized culture.

## THE VICISSITUDES OF HOPE

Hope as longing for something better, for supplementing life *as it is*, was the main subject of Ernst Bloch's *The Principle of Hope*.[6] According to Douglas Kellner, for Bloch 'individuals are unfinished, they are animated by "dreams of a better life", and by utopian longings for fulfilment'.[7] Furthermore, for Bloch, hope 'permeates everyday consciousness and its articulation in cultural forms, ranging from the fairy tale to the great philosophical and political utopias'.[8] What made Bloch's understanding of 'daydreams, fairy tales and myths, popular culture, literature, theater, and all forms of art, political and social utopias, philosophy, and religion' different from the other Marxist ideological critiques is his belief that all these forms 'contain emancipatory moments which project visions of a better life' and that they 'put in question the organization and structure of life under capitalism (or state socialism)'.[9]

According to Kellner's profoundly analytical reading of *The Principle of Hope*, in Bloch's map of humanity there are three dimensions of human temporality,

…'a dialectical analysis of the past which illuminates the present and can direct us to a better future. The past—what has been—contains both the sufferings, tragedies and failures of humanity—what to avoid and to redeem—and its unrealized hopes and potentials—which could have been and can yet be.'[10]

The *not-yet but realizable hopes* of the future and a vision of a free future are the most important part of Bloch's projections and convictions about creativity. The *not-yet but awaited* manifests itself as future and futurity: as an event of a coming, or future *advent*, as it is understood in some more recent work of philosophy and literature.[11] That is where the adventure of creativity is projected since the hope's tense is always a future tense. In Kellner's opinion Bloch encourages us to 'look for the progressive and emancipatory content of cultural artifacts' that are 'frequently denounced and dismissed as mere ideology'.[12]

Following Kellner's analysis of Bloch's 'principle of hope' one could easily agree with his conclusion that Bloch provides us with a model of cultural theory and ideology critique that is unique since it differs from other more dominant critical models. While Lenin, Althusser, and to a certain extent the Frankfurt School, presented 'ideology critique as the demolition of bourgeois culture and ideology, thus, in effect, conflating bourgeois culture and ideology',[13] according to Kellner, Bloch is 'more sophisticated than those who simply denounce all ideology as false consciousness' and interpret 'dominant ideology primarily as instruments of mystification, errors, and domination' of the 'ruling class' interest within ideological artefacts' because he rather 'sees emancipatory-utopian elements in all living ideologies, and deceptive and illusory qualities as well.'[14]

Instead of a *denunciatory* approach to ideology critique that he called 'half-enlightenment', because of its rationalistic dismissal of all elements that do not measure up to its scientific criteria, Bloch suggested reading more attentively for any critical or emancipatory potential. Interestingly enough, at first sight paradoxically, Bloch deemed ideology not only responsible for having a negative impact on society but also he believed that ideology contained a certain

**1** I am using the negative concept *potential not to* in terms of reference to the philosophical notion of aporia between potentiality and actuality known already in antique and Middle-Age philosophy. See Giorgio Agamben, *Potentialities*, ed. and trans. by Werner Hamacher and David E. Wellbery, introduction by Daniel Heller-Roazen (Stanford: Stanford University Press, 1999), 243–271.
**2** Suzana Milevska, 'Phantasm of Belonging: Belonging without Having Something in Common', Volksgarten: Politics of Belonging, ed. Adam Budak, Peter Pakesch and Katia Schurl, exhibition catalogue (Cologne: Walther König, 2008), 110–119.
**3** I hereby refer to Jacques Derrida's concept of *dangerous supplement*; see Jacques Derrida, *Of Grammatology*, trans. Gayatri Chakravorty Spivak (Baltimore: The Johns Hopkins University Press, 1976), 141–165.
**4** Giorgio Agamben, *The Coming Community*, trans. Michael Hardt (Minneapolis: University of Minnesota Press, 1993): 'Whatever singularity, which wants to appropriate belonging itself, its own being-in-language, and thus rejects all identity and every condition of belonging, is the principal enemy of the State' (87).
**5** Kenneth Frampton, 'Towards a Critical Regionalism: Six Points for an Architecture of Resistance', *The Anti-Aesthetic: Essays on Postmodern Culture*, ed. Hal Foster (Port Townsend, Wash.: Bay Press, 1983) 16–30.
**6** Ernst Bloch, *The Principle of Hope*, 3 vols. (Cambridge, Mass.: The MIT Press, 1986).

emancipatory dimension. Discourses, images, and figures that produced utopian images of a better world according to him helped the reconciliation of subjects with the existing world. That is of course only if one believes and hopes that such reconciliation is possible.

Today Ernst Bloch's assumption that art's mission, even when it is overburdened by ideological patterns, is to assist the subject's fulfilment and reification somehow resonates with the Guattarian concept of art as a process of *becoming*. Even though he understands art as a kind of autonomous zone of production, it is still important for the 'innovative segments of the Socius', since according to him the future of contemporary subjectivity is no longer to 'live indefinitely under the regime of self-withdrawal'.[15] Artists' mission is to *re-create and reinvent the subject*:

'The artist and, more generally, aesthetic perception, detach and deterritorialize a segment of the real in such a way as to make it play the role of a partial enunciator. Art confers a function of sense and alterity to a subset of the perceived world. […] The work of art, for those who use it, is an activity of unframing, of rupturing sense, of baroque proliferation or extreme impoverishment, which leads to a recreation and a reinvention of the subject itself. A new existential support will oscillate on the work of art, based on a double register of reterritorialization (refrain function) and resingularization.'[16]

## REGIONALISM AS 'DANGEROUS SUPPLEMENT'

The hope and potentiality for such a reinvention of contemporary subjectivity is under new pressure, in particular the pressure of globalization and the tensions between the nation-state and national identitarian politics versus new overarching political and universalist concepts.

Following Richard Rorty's skepticism expressed in his 1996 essay *Globalization, the Politics of Identity and Social Hope* about the relevance of the way in which globalization affected identitarian politics, and having in mind his remark about the 'loss of faith in cosmopolitanism and universalist notions',[17] I want to argue that at present there are certain attempts to compensate for the lost social hopes of cosmopolitan values and these are mostly based on newly provoked beliefs in regional values of everyday life.

It is no accident, though, that today's main contradictions and tensions are not to be found along the line of global–local but in the pragmatic and calculative move between global–regional wherein regional is seen as the democratic *potentiality* of the future, a concept that could supplement the local.

The logic of the supplementation of national identity with the paradigm of *regional identity* reverberates with a kind of Derridean understanding of the notion of supplement: as two apparently contradictory ideas comprised in one concept. The more obvious definition

of the notion of *supplement*, as something that aims to enhance the presence of something that is self-sufficient and therefore already complete, is overshadowed by the idea that a thing that has a supplement cannot be truly 'complete in itself'. 'But always by a way of compensation for [sous l'espèce de la suppléance] what ought to lack nothing at all in itself'.[18] Consequently, if it were complete without the supplement it shouldn't need or lean on the potential supplement.

Let me then ask here, what would be the origin of this Derridean 'originary lack' within the national identity that needs to be filled with something, that needs to be expanded, supplemented or complemented (by the regional identity?) in order to make it a *whole*? Pragmatic and economic arguments are in favour of the needs of the global markets and can eventually explain only the market value of the establishment of regional markets as instruments for easier and easier regionally distributed advertisement and distribution of commercial goods and regional art. However, one can assume that an explanation of the rapid rise of the phenomenon of regional identity is not as simple as that. Needless to state, homogenous, stable and self-sufficient national identity once again shows its cracks, inconsistencies and fuzzy borderlines, which are accompanied exactly by the insistence and the hope of expansion in the realm of the regional.

In the context of the extrapolation of the intrinsic mechanisms of rapid globalization, regionalism might seem an obsolete concept, yet it has actually flourished in recent decades. The most important thing to state from the outset of this discussion on the regional paradigm is that the regions are social and cultural constructs and are established because of the belief in a common history and consideration of common interests.[19] For example, hardly any scholar still takes seriously the so frequently used regional geopolitical framework: *the Balkans*. It became clear that the region could not function as a relevant identity concept due to the danger of essentialization and the overburdening complexities and exclusions that prevent it being used as a common denominator.

However, regional distinctions and definitions are not only still in use, they are also valued much higher today, and not only as metaphors. Perhaps they are necessary in pragmatic terms, for example for smaller-scale cooperations in the context of vast globalization: they facilitate economic networks, boost markets and advertising, enable political negotiations etc. Also, regionalism is seen as announcing the turn from identity politics towards what Nira Yuval-Davis so successfully dubbed 'transversal politics'.[20]

As an alternative to universalistic assimilationist and exclusivist politics, as well as to identity politics, 'transversal politics' deal with, 'people who identify themselves as belonging to the same collectivity or social category [that] can actually be positioned very differently in relation to a whole range of social locations (eg class, gender, ability, sexuality, stage in the life cycle etc). At the same time, people with similar positionings and/or identities, can have very different social and political values.'[21]

## REGIONAL GOVERNANCE

For some theorists, the only adequate political response to globalization is the consolidation of democracy through the strengthening of national borders. For others exactly the opposite is required, and preferred, when the national and other values are questioned from abroad. Many theorists of democracy would agree that democratic government could be maintained only by extending its borders beyond the nation. The expansion and acceleration of cultural, political

and economic activities cutting across national and regional borders is not inherently incompatible with democracy.

Adam Lupel identified three different ways in which the politics of transnationalism could serve to broaden democratic legitimacy beyond the nation-state: '(i) cosmopolitan democracy, (ii) democratic regionalism, and (iii) democratic network governance'.[22] According to Lupel the politics of regionalism found a supporter in Habermas, who offered a theory of a democratized European Union in terms of postnational citizenship and regionalism:

'One way to imagine the middle course between a retreat to national isolationism and the rush to global integration is the pursuit of regional structures of governance. The accelerated integration of separate nation-states into new political and economic units on a regional scale may be read as a particular response to the exigencies of globalization. Habermas offers a theory of a democratized European Union in these terms. His version of the post-national constellation presents a form of regionalism as an attempt to demonstrate how democratic politics might be reconfigured to regain power lost to transnational economic and political actors.'[23]

The newly emerged regionalism is usually interpreted as a political project that would lead us more easily towards democratization and globalisation. Such a tendency is seen not only as a gradual reintegration of a previously divided territory but also as a project that 'seeks to transcend long-standing ethnic or linguistic divisions'.[24] Habermas' version of the postnational constellation presents a form of democratic practice beyond the nation-state based on regionalism that is, 'an attempt to demonstrate how democratic politics might be reconfigured to regain power lost to transnational economic and political actors. And in this sense regionalism can be generalized to represent a normative project for the articulation of a new global order.'[25]

Habermas suggests that the achievement of postnational citizenship, taking into account recent developments within democratic structures, cannot happen by a simple and rapid shift from national identity to democratic identity. Thus regional integration emerges as necessary, but it has to be taken into account that the, 'regional political integration depends not only on a shared commitment to the values of liberal democratic practice but on a shared historical experience which may provide a common backdrop for the interpretation of basic constitutional principles and to a specific shared way of life. Sharing the values of liberal democratic practice is not the same as sharing a "specific way of life"'.[26]

On the contrary, one could argue that precisely the intrinsically different experiences and common but troubled past put into question 'the viability of political integration on the regional scale'.[27] This is exemplified by the most recent EU expansion to include former com-

7   Douglas Kellner, *Ernst Bloch, Utopia and Ideology Critique*, http://www.uta.edu/huma/illuminations/kell1.htm (19 April 2008), 1.
8   Ibid.
9   Ibid., 2.
10  Ibid., 2.
11  Jean-Paul Martinon, *On Futurity: Malabou, Nancy and Derrida* (London: Palgrave Macmillan, 2007) 152–153.
12  Kellner, *Ernst Bloch*, 3.
13  Ibid., 3.
14  Ibid., 3.
15  Félix Guattari, *Chaosmosis: An Ethico-Aesthetic Paradigm*, trans. Paul Bains and Julian Pefanis (Indianapolis: Indiana University Press, 1990), 132.
16  Ibid., 130.
17  Richard Rorty, *Philosophy and Social Hope* (London: Penguin, 1999), 229–239.
18  Derrida, *Of Grammatology*, 145.
19  Lothar Hönnighausen, Marc Frey, James Peacock, and Niklaus Steiner, eds., *Regionalism in the Age of Globalism*, vol. 1: *Concepts of Regionalism* (Madison: University of Wisconsin Press, 2004).
20  Nira Yuval-Davis, 'What is Transversal Politics', *Soundings—A Journal of Politics and Culture* 12 (Summer 1999), 94.
21  Nira Yuval-Davis, 'Human/Women's Rights And Feminist Transversal Politics', in Myra Marx Ferree and Aili Tripp, eds., *Transnational Feminisms: Women's Global Activism and Human Rights* (New York: New York Press), http://www.bristol.ac.uk/sociology/ethnicitycitizenship/nyd2.pdf, 17.
22  Adam Lupel, 'Tasks of a Global Civil Society: Held, Habermas and Democratic Legitimacy beyond the Nation-State', *Globalizations* 2, no. 1 (May 2005): 117–133.
23  Ibid., 123.
24  Ibid.
25  Ibid.
26  Ibid., 124.
27  Ibid.

munist bloc countries and by the tensions among these countries and the countries that were not accessioned. It is difficult to see how a democratic consensus could be reached at a regional level between the conflicted parts, for example in troubled regions such as the Balkans, where the borders and identities continuously overlapped and changed in the past, and the fights for common historic events and people are still at work. In such context, Chantal Mouffe's agonistic model of democracy has very few chances to survive because of much deeper confrontations at work than the ones needed for the 'privileged terrain of agonistic confrontation among adversaries'.[28]

If one agrees that a perspective like 'agonistic pluralism' differs from a model of deliberative democracy since it 'reveals the impossibility of establishing a consensus without exclusion' and 'warns us against the illusion that a fully achieved democracy could ever be instantiated',[29] then it is obvious that regionalism has opened an even bigger space of dissent and democratic contestation, which is vital for agonistic pluralistic democracy.

To go back to globalization and its contradictions, Habermas, for example, thinks that 'the challenges of globalization call for the re-aggregation of political authority at a level that, goes beyond the national frame but pulls up short of the global'.[30] He argues that in the absence of a global government, a democratic regionalism represented by the continuing project of the European Union could provide the necessary infrastructure for the democratic coordination of economic and political processes of globalisation.[31]

According to Habermas, European political integration depends upon a territorially based political identity situated in a shared history. In the sense that this shared history occurs at a regional level and entails solidarity among a variety of ethnic groups, it is understood as post-national. On the other hand, one could equally discuss this in terms of an 'extended nationalism', or a regional civic nationalism. However, it should be clear from the outset that regional governance does not transcend the relationship between universal citizenship and political particularity. Furthermore, the tension between the two remains and often results in coercion.

## LIBERALISM AND REGIONALISM

Political theorists commonly describe liberalism as a normative political doctrine that treats the maintenance of individual liberty as an end in itself. Liberty is seen as limiting both the objectives of government and the manner in which those objectives might be pursued. Even Foucault accorded it a central place in his account of liberalism as a rationale of government. Although he did not perceive the issue of individual liberty in normative terms, he suggested that the significance that liberalism attaches to individual liberty is intimately related both to the aim (which it shares with political reason) to recruit the government to its own larger purposes, and to a prudential concern that the state might be governing too much. Thus, the state regulation of certain kinds of behaviour might in fact turn out to be counterproductive.

In practice, however, and Louis Althusser noticed this first, it is clear that authoritarian rule has always played an important part in the government of states that declare themselves to be committed to the maintenance and defence of individual liberty, contrary to the government of states that do not make that commitment and do not force the citizens to make similar commitments.

Unfortunately coercive and oppressive practices are clearly currently employed in many governments. Such governmental practices continue to play an important part, not only in the independent states that took over the old imperial domains, but also in Western states

themselves; in systems of criminal justice; the policing of Romany people; the neglect of AIDS patients, immigrant communities and the urban poor; the provision of social services; and the management of large public and private sector organisations. Authoritarian rule has also been invoked as a necessary instrument of economic liberalization in much of Latin America, parts of southeast Asia, and central and eastern Europe.

How do such authoritarian practices relate to the liberal government of freedom? Indeed if, as Foucault suggests, the market plays 'the role of a "test"', then it is a test that surely cuts both ways, indicating not only that some people and some fields of activity can best be governed through the promotion of suitable forms of free behaviour. In this respect the description of liberal political reason, considered as a rationale of the government of 'the state as a whole' as being concerned with governing through the promotion of certain kinds of liberty, must be regarded as incomplete.[32]

Most importantly, governing is closely concerned with determining which individuals and which areas of conduct within the state can best be governed in this way and which cannot, and with deciding what can be done about governing the latter. Liberalism can hardly avoid the question of what to do about individuals and areas of conduct that seem not to be amenable to government through the promotion of suitable forms of individual liberty. Thus, rather than describe liberalism as committed to governing through freedom, it would be more appropriate to present it as claiming only that there are important contexts in which free interactions might be the most appropriate means of regulation: that certain populations, or significant individuals and groups and activities within them, can and should be governed through the promotion of particular kinds of free activity and the cultivation of suitable habits of self-regulation, and that the rest just have to be governed in other ways.

If ones agrees that a nation-state is governed 'too much', and that liberalism and individual liberty are subjected to strict rules and state interests within its borders, then one can easily agree with Habermas that regionalism and regional governance could help postnational development to reach a higher level of democratic governance. However, one should be aware that common history and the common way of pursuing everyday life may also entail easier regional agreement on which peoples are socially amenable, and which are not, which habits and liberties are seen as welcome and which are not. In this respect, regionalism and regionalization for some can facilitate the hopes of future belonging to a global and universal society but to others can bring ever more and bigger restrictions and borders.

This inner contradiction between liberalism and regionalism could be exemplified in attitudes towards minority rights. On the one hand, if one is a liberal, supporting individual autonomy, then 'one will oppose minority rights as an unnecessary and dangerous departure from the proper emphasis on the individual'.[33] On the other hand, minorities and minority rights are seen by communitarians as valuable societal and communal assets worth protecting for their 'coherent collective way of life' that have yet to give up under the pressure of individual autonomy and liberalism.[34]

However, perhaps the most important question here is whether minorities want to be protected from liberalism and rapid modernisation at all or, as Will Kumlicka stated, they would rather be equal participants within mainstream liberal societies.[35]

# THE VERNACULAR LANGUAGE OF DEMOCRACY AND THE DELIBERATIVE POTENTIALITY OF REGIONAL BELONGING

Even though the potential of *not* belonging to a homogenous national identity inscribed within the broadened concept of regional identity cannot be either the ultimate answer to the problems of limited political, cultural and economic resources of the nation-state, or the answer to a homogenized and globalized cultural identity, it could enable the democratization of various societal patterns of behaviour and bring forward certain hopes for the future.

When Kymlicka stated that 'democratic politics is politics in the vernacular', he invested his hopes in the local and familiar, and not in the global and unknown.[36] He was concerned with the language of democracy that in his view is not universal since it needs to address many concrete and particular issues that are expressed specifically in different cultures. It is a general rule for him 'that the more the political debate takes place in the vernacular, the greater the participation'.[37]

Finally, it becomes clear that the questions of *belonging* and of participatory and deliberative democracy, particularly in the case of regional identity, are intertwined in a complex and reciprocal relation. Being dependent upon each other in this case means that this leaning on belonging to a certain community, and not to some other, provides the motivation for a demanding participatory democratic process.

**28** 'I agree with those who affirm that a pluralist democracy demands a certain amount of consensus and that it requires allegiance to the values which constitute its "ethico-political principles". But since those ethico-political principles can only exist through many different and conflicting interpretations, such a consensus is bound to be a "conflictual consensus". This is indeed the privileged terrain of agonistic confrontation among adversaries'. Chantal Mouffe, *The Democratic Paradox* (New York: Verso, 2000), 103.
**29** Ibid., 104.
**30** Adam Lupel, 'Regionalism and Globalization: Post-Nation or Extended Nation?' Polity 36, no. 2 (January 2004), 153.
**31** Jürgen Habermas, 'The Postnational Constellation and the Future of Democracy', *The Postnational Constellation* (New York: Polity Press, 2001), 58–113.
**32** Barry Hindess, 'Politics as Government: Michel Foucault's Analysis of Political Reason', *Alternatives: Global, Local, Political* 30, no. 4 (October–December 2005), 392.
**33** Will Kymlicka, *Politics in the Vernacular: Nationalism, Multiculturalism, and Citizenship* (New York: Oxford University Press, 2001), 19.
**34** 'Rather than viewing group practices as the products of individual choices, communitarians view individuals as the product of social practices'. Ibid.
**35** Ibid., 20.
**36** Ibid., 214.
**37** Ibid.

# SPACE RENDEZVOUS
## CHRISTIAN PHILIPP MÜLLER

Photo credit: MART,
Archivio del '900, Fondo
Depero, Dep.7.1.1

The first transfer

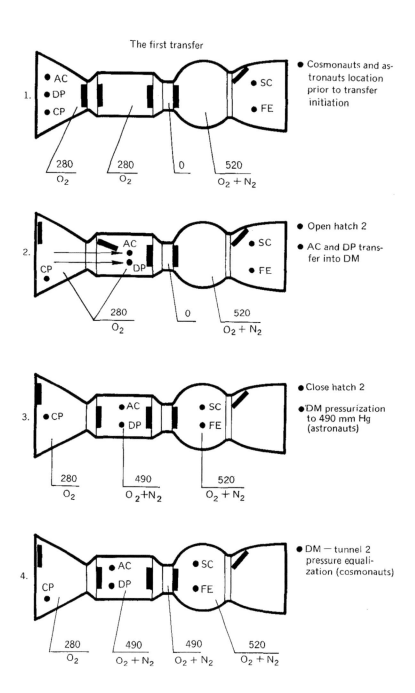

1.
- Cosmonauts and astronauts location prior to transfer initiation

2.
- Open hatch 2
- AC and DP transfer into DM

3.
- Close hatch 2
- DM pressurization to 490 mm Hg (astronauts)

4.
- DM — tunnel 2 pressure equalization (cosmonauts)

AC—Apollo Commander          SC  Soyuz Commander
DP—Docking Module Pilot      FE—Soyuz Flight Engineer
CP—Command Module Pilot

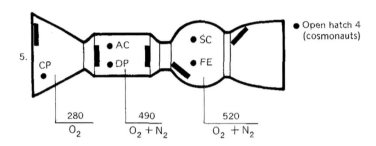

5.

280
$O_2$

490
$O_2 + N_2$

520
$O_2 + N_2$

- Open hatch 4
  (cosmonauts)

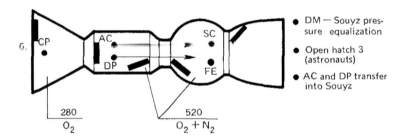

6.

280
$O_2$

520
$O_2 + N_2$

- DM — Souyz pres-
  sure equalization

- Open hatch 3
  (astronauts)

- AC and DP transfer
  into Souyz

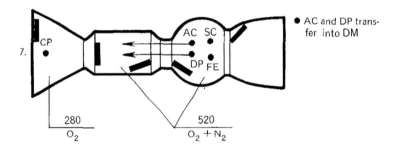

7.

280
$O_2$

520
$O_2 + N_2$

- AC and DP trans-
  fer into DM

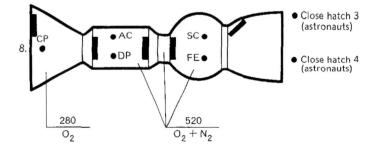

8.

280
$O_2$

520
$O_2 + N_2$

- Close hatch 3
  (astronauts)

- Close hatch 4
  (astronauts)

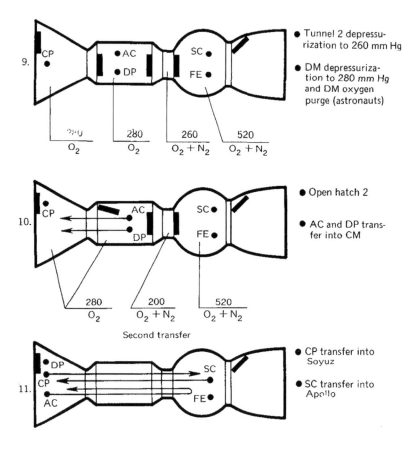

9.
- Tunnel 2 depressu-
  rization to 260 mm Hg
- DM depressuriza-
  tion to 280 mm Hg
  and DM oxygen
  purge (astronauts)

10.
- Open hatch 2
- AC and DP trans-
  fer into CM

Second transfer

11.
- CP transfer into
  Soyuz
- SC transfer into
  Apollo

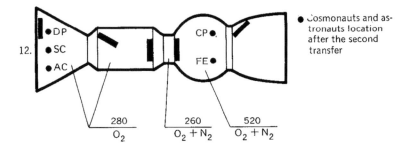

12.
- Cosmonauts and as-
  tronauts location
  after the second
  transfer

AC—Apollo Commander
DP—Docking Module Pilot
CP—Command Module Pilot

SC—Soyuz Commander
FE—Soyuz Flight Engineer

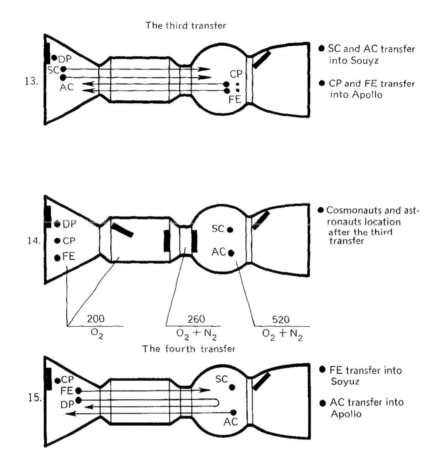

The third transfer

13.
- SC and AC transfer into Souyz
- CP and FE transfer into Apollo

14.
- Cosmonauts and astronauts location after the third transfer

200
$O_2$

260
$O_2 + N_2$

520
$O_2 + N_2$

The fourth transfer

15.
- FE transfer into Soyuz
- AC transfer into Apollo

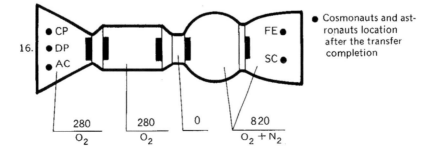

16.
- Cosmonauts and astronauts location after the transfer completion

280
$O_2$

280
$O_2$

0

820
$O_2 + N_2$

# REGIONALISM[1]
## ALAN COLQUHOUN

## REGIONALISM I[2]

Ever since the late eighteenth century one of the main directions of architectural criticism has been that of regionalism. According to this approach, architecture should be firmly based on specific regional practices based on climate, geography, local materials, and local cultural traditions. It has been tacitly assumed that such a foundation is necessary for the development of an authentic modern architecture. I want to subject this idea itself to criticism and to consider the notion of regionalism so defined in relation to the conditions of late capitalism.

I would like first to put the concept of regionalism into its historical context. Let me begin, therefore, by looking at the historical period nearest to us, the avant-garde of the early twentieth century. The twentieth century avant-garde can always be viewed from one of two perspectives: either as having inherited the principles of the Enlightenment, or as emerging from the tradition of the Enlightenment's great enemy, romanticism. One can hardly avoid noticing the presence of these contradictory strands: on the one hand the promotion of rationalism, universalism, and identity; on the other a recurrent enthusiasm for nominalism, empiricism, intuition, and difference. These contradictions came into the open during the famous debate between Hermann Muthesius and Henry Van de Velde at the Deutsche Werkbund Conference at Cologne in 1914, when Van de Velde maintained a Ruskinian belief in the virtues of the artist/craftsman and a betrayed medieval tradition.

At first glance it would appear that the former strand—universalism and rationalism—was triumphant in the Modern Movement of the 1920s. The elementariness of de Stijl, the *rappel à l'ordre* of Le Corbusier, and the *Neue Sachlichkeit* in Germany and Switzerland were all basically rationalistic. But, as has often been pointed out, the situation was in reality a good deal more complicated; rationalism was only one side of the Modern Movement. For example, when the paradigm of Schinkelesque classicism emerged in the first decade of the twentieth century, it not only laid claim to universal values but took over and transformed the regionalist philosophy of the Art Nouveau movement that it replaced. One example of this phenomenon is when classicism and 'Mediterraneanism' were adopted by the cultural nationalists of *Suisse romande*.[3] This fact was extremely influential in forming the mature ideology of Le Corbusier, in whose work reference to the Mediterranean vernacular (cubic form, white walls, etc.) was just as prominent as the idea of industrial standardisation. These tendencies became increasingly important in Le Corbusier's work in the 1930s when, under the influence of anarcho-syndicalism, he began to think in terms of separate vernacular regional traditions, and even proposed a Europe divided into 'natural' regions, including a Mediterranean region.[4] But Le Corbusier was only one case among many, though certainly the most articulate. Mediterraneanism was, I believe, deeply embedded in the whole Modem Movement from 1905 onwards. As for regionalism, one only has to look at the introductions to the successive editions of Sigfried Giedion's *Space, Time and Architecture*, first published in 1940 and revised in five editions until 1968, to realise the extent to which regionalist ideas

increasingly permeated modernist theory in the post–Second World War period. For example, Alvar Aalto's work was added in the second edition.

So there is a case for saying that the 1920s was not just the simple triumph of rationalism that it often seems. Instead, it should perhaps be seen as the stage on which a deep conflict of ideologies was still being enacted. What was the nature of this conflict? To answer this question it is necessary to go back to the eighteenth century and the beginnings of romanticism and historicism. It was then that Europeans started to notice the existence of ancient cultures that were neither antique nor Biblical. At the same time they began to be interested in their own pasts — in the vernaculars that had existed before the revival of antiquity in the Renaissance. One of the most significant results of this process was the creation of an alternative model for humanistic culture, one that made a sharp distinction between the study of nature and human history. Both Johann Gottfried Herder and Giambattista Vico independently claimed that the two studies demanded totally different methods, scientific in the one case and hermeneutic in the other.

This doctrine had a powerful effect in the German speaking countries because it coincided with the revolt against the hegemony of French culture. But it also affected France and England. Elaborate genealogies were invented to support the new sentiment of nationhood. The English traced their ancestry to the Anglo-Saxons, or, even more remotely, the Celts, who, in their Scottish Highland incarnation, arrived complete with a fictitious poet, Ossian. In Germany, the Goths were supposed to have invented Gothic architecture on German soil until it was proved (by an Englishman) that this event had taken place on the Isle de France. I will return to this 'invention of tradition', as it has been called by the historian Eric Hobsbawm, when I come to mention the national romanticism of the late nineteenth century.[5]

More important for an understanding of the origins of the doctrine of regionalism are the theories that were developed later in the nineteenth century, again mostly in Germany, concerning the problem of the rationalisation of social life under industrial capitalism. This process was perhaps given its most powerful formulation by Max Weber when he coined two expressions that are still by-words for our present situation: the 'disenchantment' of the world due to individualisation and secularisation, and the 'iron cage' of capitalism in which the modern world is imprisoned.

Among the concepts that German post-romantic theory used, two are of particular interest, if only because they reduce the problem to simple binary oppositions. The first is the distinction between *Zivilization* and *Kultur*. As Norbert Elias has shown, this distinction goes back to the early nineteenth century and was the direct result of the Ger-

**1** Collected together here are two essays originally published as 'The Concept of Regionalism' and 'Critique of Regionalism', respectively. In Black Dog Publishing's forthcoming title, Alan Colquhoun: Collected Essays in Architectural Criticism, they will be published as 'Regionalism I' and 'Regionalism II'. (Editorial note)

**2** Originally published as 'The Concept of Regionalism' in Gulsum Baydar Nalbantoglu and Wong Chong Thai, eds., *Postcolonial Space(s)* (New York: Princeton Architectural Press, 1997), 13–23. Reprinted courtesy of the author. (Editorial note)

**3** Guiliano Gresleri, 'Vers une Architecture Classique', in Jacques Lacan, ed., *Le Corbusier: Line Encyclopedic* (Paris: Centre Georges Pompidou, 1987).

**4** Mary McLeod, 'Le Corbusier in Algiers', *Oppositions* 19/20 (Winter–Spring 1980), 5.

**5** Eric Hobsbawm and Terence Ranger, *The Invention of Tradition* (Cambridge: Cambridge University Press, 1983).

**6** Norbert Elias, *History of Manners* (Oxford: Blackwell, 1994).

**7** Thorn, Martin, 'Tribes within Nations: The Ancient Germans and the History of Modern France', in Homi K. Bhabha, *Nation and Narration* (London: Routledge, 1991), 25–26.

**8** Though the Irish revolt started much earlier, its cultural manifestations belong to the 1890s.

**9** As had already happened in the Balkans earlier in the century.

**10** Maurice Barres, as cited in Thorn, 'Tribes within Nations', 38–39.

**11** Houston Stewart Chamberlain, *Die Grundlagen des neunzehnten Jahrhunderts* (Munich, 1900). Translated into English as *Foundations of the Nineteenth Century* (New York: John Lane The Boldly Head, 1910).

**12** Ferdinand Tönnies, *Gemeinschaft und Gesellschaft* (Leipzig, 1887).

man revolt against French cultural dominance. *Zivilization* meant aristocratic materialism and superficiality, as opposed to the less brilliant but more profound *Kultur*.[6] The idea of this distinction spread to other countries with the dissemination of romanticism. In England Samuel Taylor Coleridge adopted the word 'culture' with its German connotations. The concept was absorbed by John Ruskin and William Morris and, in the form of medievalism, became the cornerstone of the Arts and Crafts movement. In France itself, a school of historiography influenced by Chateaubriand held the view that the Frankish invasions of the fifth century were the true origins of modern French culture, rather than the institutions founded by the Gallo-Romans.[7] In the late nineteenth century the idea of *Zivilization* received the slightly different connotation of modern technological society, in opposition to pre-industrial human values. But, both in the earlier and later senses, *Zivilization* represented the rational and universal as against the instinctual, autochthonous, and particular. We find approximately the same set of ideas in Giedion's *Space, Time and Architecture* when be talks about the split in modern life between feeling and intellect—a conflict that he hoped to dissolve by arguing that science and modern art were in reality dealing with the same phenomena but from different perspectives.

The distinction between *Zivilization* and *Kultur* is a fruitful way of looking at the widespread nationalist movements of the 1890s, which in so many ways repeated the impulse of the earlier romantic movement. Just as the Germans had done around 1800, so a number of groups distanced themselves from the countries by which they had been politically or culturally dominated: the Irish from the English, the Catalonians from the Castillians, the Finns from the Russians and the Swedes.[8] In Finland, for example, the Finnish language was officially adopted, an ancestral aural literature was 'reconstructed', and an eclectic architecture representing 'Finnishness' was put together from various stylistic sources, some indigenous, some external (for example, one of its main sources was the English Arts and Crafts movement).[9] Such a representation of national 'essence' was largely fictional, but it had a clear ideological function: the legitimisation of a nation-state in terms of a regional culture, and in this it was successful.

The notion of *Kultur* was also taken up, in spirit if not in name, by chauvinistic movements in the late nineteenth and early twentieth centuries. Maurice Barres wrote in 1902, 'There is in France a static morality... Kantianism. This claims to regulate universal man, without taking individual differences into account. It tends to form young persons from Lorraine, Province, Brittany, and Paris in terms of an abstract, ideal man, who is everywhere the same, whereas the need will be for men rooted solidly in our soil, in our history'.[10]

In Germany the idea was adopted by the National Socialists in the 1920s, taking up the ideas of writers like Houston Stewart Chamberlain, who had used the distinction *Zivilization/Kultur* to promote the concept of racial purity.[11] In so doing they recruited several architects of the Heimatschutz persuasion, such as Paul Schulze-Naumburg, whose ideas were derived from the Arts and Crafts movement.

The second concept I want to discuss is the distinction between *Gesellschaft* and *Gemeinschaft*—a distinction made by Ferdinand Tönnies in his book of that title of 1887.[12] According to Tönnies these two words represent two types of human association. *Gesellschaft*-like associations are the result of rational deliberation, whereas *Gemeinschaft*-like associations are those that have developed organically. Again, we find the same opposition as in the case of *Zivilization* and *Kultur*, one term based on the idea of a natural law independent of historical or geographical contingency, the other implying rootedness in the soil. Examples of the former are bureaucracies, factories, and corporations, in which social relations are rational means to a de-

13 Alexander Tzonis and Liane Lefaivre, 'The Grid and the Pathway: An Introduction to the Work of Dimitris and Susana Antonakakis', *Architecture in Greece* 15 (1981).
14 Ernest Renan, cited in Homi Bhabha, 'Dissemination: Time, Narrative and the Margins of the Modern Nation', in Homi Bhabha, ed., *Nation and Narration* (Routledge, 1990), 310.
15 Ernest Gellner, *Nations and Nationalism* (Oxford: Basil Blackwell, 1983).
16 Michel de Certeau, *The Practice of Everyday Life* (Berkeley: University of California Press, 1984).

sired end. Examples of the latter are the family, friendship groups, clans, and religious sects—all groupings in which social relations are ends in themselves.

I do not need to demonstrate that the doctrine of regionalism belongs to the *Kultur* and *Gemeinschaft* side of these oppositions. The problem I would like to address is this: given the radically changed circumstances of the modern world, does this cluster of concepts still make sense, and, if so, in what way will its concept of culture—above all in its architectural manifestations—differ from those of its earlier incarnations: romanticism, Art Nouveau, and the early twentieth century avant-garde?

Obviously, the anxieties that were experienced in these periods have not simply evaporated. Many still feel disquiet at the increasingly abstract and homogenised world of modern post-industrial society. But it is questionable whether these doubts can any longer be expressed adequately in terms of the oppositions I have outlined. Clearly, the doctrine of regionalism is based on an ideal social model—one might call it the 'essentialist model'. According to this model, all societies contain a core, or essence, that must be discovered and preserved. One aspect of this essence lies in local geography, climate and customs, involving the use and transformation of local, 'natural' materials. This is the aspect that has most often been invoked in connection with architecture.

The first thing to note about this model is that it was formulated in the late eighteenth century precisely at the moment when the phenomena that it described seemed to be threatened and about to disappear. This is hardly surprising. The elements of society that operate without friction are invisible. It is only when imbalances and frictions begin to occur that it becomes possible to see them. So, from the start, the concept of a regional architecture was not exactly what it seemed. It was more an object of desire than one objective fact. The architecture of regionalism put forward by the romantics was not that 'authentic thing' of which it had formed a mental image, but only its representation. The question as to whether such an authentic thing ever existed is an idle one, so long as our only access to it is by means of its later conceptualisation. Nevertheless, the theory of regionalism adopted by the Modem Movement insisted on the need of such an architecture to be 'authentic'. Thus, what had to be eliminated were the very practices of the romantics themselves, by which *Gemeinschaft*-like societies had been invoked by mimicking their forms. It was not by such means that the essence of regional architectures could be recovered, but rather by discovering the causal relations that existed between forms and their environment. But if what I have said is correct this would be a hopeless task, even if we restricted ourselves to the regionalisms of romanticism. What would be discovered after the out-

er layer of mimetic forms had been removed would simply be a deeper level of mimesis. The use of local materials, sensitivity to context, scale, and so on would all be so many ways of representing 'the idea' of an authentic, regional architecture. The search for absolute authenticity that the doctrine of regionalism implies is likely to create an oversimplified picture of a complex cultural situation.

Fear of such an oversimplified approach seems to have lain behind one of the more sophisticated recent theories of regionalism. By qualifying the old term 'regionalism' with the new term 'critical', Alexander Tzonis and Liane Lefaivre have tried to pre-empt any imputation of regressive nostalgia. According to them, the word 'critical', in this context, means two things. First it means 'resistance against the appropriation of a way of life and a bond of human relations by alien economic and power interests'.[13] If we take away the mildly Marxian overtones of this statement what is left corresponds exactly to the notions of *Kultur* and *Gemeinschaft* that I have outlined above. It represents an attempt to preserve a regional essence that is seen to be in mortal danger and to uphold the qualities of *Kultur* against the incursions of a universalising and rationalising *Zivilization*. But any doctrine of regionalism has always implied such an intention, so that, taken in this sense, the word critical would seem to add nothing of substance to the concept. The second meaning Tzonis and Lefaivre give to the word critical is to create resistance against the merely nostalgic return of the past by removing regional elements from their natural contexts so as to defamiliarise them and create an effect of estrangement. This seems to be based on the Russian formalist theory of 'making strange'.

These two meanings do not seem to have anything to do with each other. What is being presented as a single idea, 'critical regionalism', is in fact two separate ideas. But the problem goes deeper, because the second interpretation of critical actually appears to contradict the first. It draws attention to the fact that the postulated organic world of regional artefacts no longer exists. Far from resisting the appropriations of rationalisation, it confirms them by suggesting that all that remains of an original, unitary body of regional architecture are shards, fragments, bits, and pieces that have been torn from their original context. Taking this view, any attempt to retrieve the original contents in all their original wholeness would result only in a sort of kitsch. The only possible attitude towards regionalism and the values of *Kultur* and *Gemeinschaft* would therefore be one of irony.

Behind the doctrine of a regionalism based on the old virtues of an organic (and therefore unconscious) social and artistic unity, lies the doctrine of a sophisticated manneristic art that consciously juxtaposes incongruous elements to produce unstable combinations. This being so, perhaps we should stop using the word regionalism and look for other ways of conceptualising the problems to which the word is supposed to respond. In saying this I am not saying that there are no longer any regions with their characteristic climates and customs. What I want to say is that regionality is only one among many concepts of architectural representation and that to give it special importance is to follow a well-trodden critical tradition that no longer has the relevance that it had in the past. It is true that many interesting contemporary designs refer to local materials, typologies, and morphologies. But in doing so their architects are not trying to express the essence of particular regions, but are using local features as motifs in a compositional process in order to produce original, unique, and context-relevant architectural ideas.

Take, for example, a recent building by the Swiss architects Jacques Herzog and Pierre de Meuron. In this small house in Italy there is play between local dry-stone walling (standing for

the rural) and a rational concrete frame such that wall and frame are related in unexpected ways. It is impossible to read this building as a synthesis. Rather it is a sort of endless text. What we find here cannot be called 'regionalism'. Instead it is a work that makes subtle comments on a number of architectural codes, including the *fenêtre en longeur*, the cube, the frame, and the 'organicity' of natural materials. One is not quite sure whether what is being suggested is tectonic solidity of theatricality, closure, or openness. In contemplating the building the mind tends to oscillate between a number of hypotheses, none of which are completely confirmed or denied.

Another example is the housing recently built in The Hague, The Netherlands, by Alvaro Siza. Here Siza imitates—but rather indirectly—certain features of Dutch vernacular classicism, such as its entry system, window proportions, and materials. Can this be called regionalism? If so, whose regionalism? But is not the question an absurdity? The one fact that could be called 'regional' is its ownership. If one wants to use the word regional in such a context one must see it as a second-order system, filtered through the eclectic sensibility of a particular architect. It is the result of a voluntaristic interpretation of urbanistic values, one that takes into account existing urban forms as an artistic context; it is certainly not a confirmation of a living local tradition. The architectural codes that were once tied to the customs of autonomous cultural regions have long ago been liberated from this dependence. It is a matter of free choice. Localism and traditionalism can therefore be seen as universal potentials always lurking on the reverse face of modernisation and rationalisation.

One of the intentions of a regionalist approach is the preservation of 'difference'. But difference, which used to be insured by the coexistence of watertight and autonomous regions of culture, now depends largely on two other phenomena: individualism and the nation-state. As regards individualism, the architect, as the agent through which the work of architecture is realised, is himself the product of modern rationalisation and division of labour. Designs that emphasise local architecture are no more privileged today than other ways of adapting architecture to the conditions of modernity. The combination of these various ways is the result of the choices of individual architects who are operating from within multiple codes.

With respect to the nation-state, in spite of the world-wide and almost instantaneous dissemination of technologies and codes, which results in an underlying similarity of the architecture in all Western and most Eastern countries at any one moment, it is usually possible to distinguish between the more typical products of individual countries. In this sense, the nation-state is the modern 'region'—a region in which culture is coextensive with political power. But this culture is of a different kind from that of the regions of the pre-industrial world. We may not quite agree with Ernest Renan when, in a lecture at the Sorbonne in 1882, he denied that national boundaries were dictated by language, race, religion, or any other 'natural' factor.[14] But at least we can admit the truth of his statement that what creates a nation is a will towards political unity rather than any pre-existent set of customs. These two functions may be coextensive but they do not have to be. The need for placing regions that often differ from each other under a single political umbrella comes from the needs of the modern industrial economy. As Ernest Gellner has pointed out, the reasons for the rise of the nation-state were the opposite of those underlying regional differentiation. Differences between regions were part of the structure of the agrarian world. The needs of industrial society, on the contrary, demand a high degree of uniformity and the flattening out of local differences.[15]

Perhaps it will be argued that this is not true universally. Recent events in the ex-Yugoslavia

and the ex-USSR have shown that old regional identities are still very much alive. But it is difficult to assess the status of regionalism in these cases, since it is obvious that ethnic emotions are being fanned for political reasons—that is, reasons connected with the formation of modern nation-states and the control of political power. The conflict in the ex-Yugoslavia cannot be attributed to profound differences in regional cultures but rather to residues of previous conflicts between the Habsburg, Ottoman, and Russian empires. As far as architecture and everyday artefacts are concerned, the cultures of the combatants are identical. The person who stands for the satanic 'other' is not marked by any specific cultural differences. Indeed one of the striking aspects of the television coverage of the war is that it is taking place in the familiar and banal context of badly built modern blocks of apartments and supermarkets—contexts common to the entire modern world.

A more plausible exception may be made of the so-called 'developing world'—especially that part of the third world consisting of ancient cultures, such as the Indian and the Islamic. In these countries, it will be argued, nationhood does sometimes coincide with living cultural traditions—traditions that are in conflict with modernisation. But however much we hope that crucial aspects of these traditions may turn out to be conformable with modernisation, we have to admit that the modern technologies and cultural paradigms that increasingly predominate in the urban centres of these countries also affect the rural areas. In these societies different historical times exist together, and under these circumstances it is already difficult to speak of 'authentic' local traditions in a cultural field such as architecture. It may be desirable to satisfy the demand for traditional forms with their socially embedded, allegorical meanings, even though the artistic and craftsman-like traditions that originally supported them have begun to atrophy, due to prolonged contact with the West. But these are matters of strategy rather than of essence.

With these questions we come to the core of the problem. What is the relation between cultural patterns and technologies? The problem is, to some extent, obscured in the West, because industrialisation evolved out of local cultural traditions, and adaptation to a post-industrialised culture is already quite far advanced. The problem is glaring, however, in the East and in Africa because of the friction between two worlds and two times: the agrarian and the industrial. Are cultural patterns absolutely dependent on an industrial base, or can they maintain a certain independence? Is an industrialised culture irrevocably Eurocentric?

But these questions take me too far from my theme, and I would like to end by looking again at the problem from the point of view of the technologically advanced countries, and at the same time to sum up my observations on the concept of regionalism, as it concerns these countries. Modern post-industrial culture is more uniform than traditional cultures because the means of production and dissemination are standardised and ubiquitous. But this uniformity seems to be compensated for by a flexibility that comes from the nature of modern techniques of communication, making it possible to move rapidly between codes and to vary messages to an unprecedented extent. This greater freedom, this ability of industrial society to tolerate difference within itself, however, does not follow the same laws that accounted for differences within traditional societies. In these societies, codes within a given cultural region were completely rigid. It was precisely this rigidity that accounted for the differences between different regions. In modern societies these regional differences are largely obliterated. Instead, there exist large, uniform, highly centralised cultural/political entities, within which differences of an unpredictable, unstable, and apparently random kind tend to develop.

The concept of regionality depends on it being possible to correlate cultural codes with geographical regions. It is based on traditional systems of communication in which climate, geography, craft traditions, and religions are absolutely determining. These determinants are rapidly disappearing and in large parts of the world no longer exist. That being the case, how is 'value' established? Whereas in earlier times value belonged to the world of necessity, it now belongs to the world of freedom that Immanuel Kant foretold at the end of the eighteenth century. Modern society is polyvalent—that is to say, its codes are generated randomly from within a universal system of rationalisation that, in itself, claims to be 'value free'.

Clearly this way of generating meaning and difference in modern technological society has serious consequences for architecture, whose codes have always been even less amenable to individual and random manipulation than the other 'arts' and more dependent on impersonal and imperative typologies and techniques. In the pre-industrialised world these technologies— summed up in the Greek word *techne*—were connected with myths relating to the earth and the cosmos. In modern society 'technique' is irreversibly disconnected from the phenomenal world of the visible, tangible experience upon which such myths were built. In the modern media the process of means-end abstraction has resulted in the rerouting of artistic codes from the stable to the apparently random. To speak more accurately, they have been rerouted from the public to the private realm. Such a process of 'privatisation' has been suggested by Michel de Certeau, for whom modern technocratic life has not so much destroyed the myths and narratives characteristic of agrarian societies, as it has confined them to the family and the individual, where they reappear as fragments of an older narration.[16]

This, then, is the problem of architecture in the postmodern world: It seems no longer possible to envisage an architecture that has the stable, public meanings that it had when it was connected with the soil and with the regions. How should we define the kinds of architecture that are taking its place?

# REGIONALISM II

## ■ REGIONALISM, ROMANTICISM, HISTORICISM

The discourse of regionalism belongs to the larger collection of ideas normally known as historicism, according to which cultural values, including those of architecture, are not *a priori*, unchanging, and universal but depend on particular, local, and inherited practices. This concept carries with it the apparently paradoxical assumption that one culture is able to 'understand' another, thus reintroducing, at another level, the universalism that it has just thrown out. Regionalism also implies the belief that regional cultures are autochthonous and spring from the folk rather than from standards imposed by social and intellectual elites. Generally speaking, supporters of regionalism have been concerned with anonymous, vernacular architecture (though there are exceptions, as when classic traditions are identified with particular nation- states, to be discussed later).

Regionalism has always been implicated in a metaphysics of difference, rejecting all attempts to generalise cultural values into systems based on the concept of natural law or other such universalising theories.

The idea that culture is particular and hereditary rather than universal and rational sprang

from anti-Enlightenment tendencies within eighteenth century thought, exemplified—though in different ways—by Herder and Vico. Later historicists were to see history as an evolving system, but for Herder and Vico history was a decline from a golden age, and this idealisation of the past was to be shared by the various regionalist movements of the nineteenth and twentieth centuries.

Historicism and romanticism led the attack on the classical system of the arts that had dominated Europe since the Renaissance. The Enlightenment had already disputed the mythical substructure of classical thought but it had left in place many of its concepts, including that of imitation. In Romantic theory, imitation ceases to be the representation of external forms and becomes the revelation of an inner, organic, and indivisible structure. In a corresponding movement, historicism forbids the artist the freedom to combine, mechanically, as it were, different historical forms as if they were lying ready-to-hand in the same historical space. But the nineteenth century, in its obsession with the past, never freed itself from the classical tradition of imitation. The problem of how to recover eternal architectural values without imitating the forms in which they were embodied was apparently insoluble. Thus, there were two traditions leading to regionalism, one stemming from classicism and the other from Romanticism; one figural and combinatory, the other functional and holistic.

## ▌▌ REGIONALISM AND ECLECTICISM

At first sight eclecticism would appear to be the antithesis of regionalism, with its doctrine of authenticity. Yet if we accept the proposition that regionalism was heir to two separate traditions and that its proponents have always had difficulty in relinquishing stylistic imitation, we must admit that the two concepts are dialectically related. Within eclecticism the criteria of choice are still the classical ones of propriety and character. Just as, in the classical tradition, the different orders were the appropriate metaphorical representation of certain ideas, so, in eighteenth century eclecticism, different styles produced certain associations. In both cases, architecture was seen as capable of creating specific moods in the observer. In the classical tradition it was accepted that this was achieved by artifice, in other words by deception, (the *vraisemblable*). Although this idea began to be challenged in the late eighteenth century, nineteenth century eclecticism still followed it implicitly. The romantic attack on the classical tradition was, on the contrary, based on the belief that the 'idea' could be symbolised without the mediation of secondary images. Translated into the terms of regionalism, this implied that the genius of the folk had a subtle body that persisted through changes in external form. This simultaneous appeal to the *Zeitgeist* and to the past depended on the possibility of the resurrection and transformation of an essence—an idea that could take hold only when history came to be seen as evolutionary and apocalyptic and the idea of a fixed golden age had lost its power.

## ▌▌▌ REGIONALISM AND NATIONALISM

Regionalism owed much of its influence to the growing power of the centralised nation-state. The relation between them was two-fold; on the one hand, peoples whose cultural identity had been suppressed used the concept of the *Volk* to legitimise claims to unification or independence: on the other, nation-states themselves sometimes idealised their own folk traditions. Germany in the early nineteenth century and France in the late nineteenth century are the main

examples. It is often hard to distinguish between these two types. German Romanticism, which was searching for a common cultural and political identity, was exported to France and England, both of which already had such an identity, and all three nations claimed a similarly reconstructed medieval world as their own.

The phenomenon of international cultural traditions being used to reinforce the self-image of individual nation-states occurred again in the early twentieth century, when both Germany and France appropriated aspects of the classical tradition.

The Romantic idea of the *Volk* and the positivist idea of material progress (and its corollary, liberal politics) were in contention with each other throughout the nineteenth century. In the 1890s there was a renewed burst of interest in folk myths, and this found expression in the movements of reform of the crafts as well as in the Art Nouveau movement. These tendencies were simultaneously progressive and regressive. Enthusiasm for primitive, naif, and popular art prompted the rejection of classicism and the search for new forms. But they also encouraged a return to tradition and the condemnation of industrialism. In Belgium and Catalonia the Art Nouveau movement emphasised modernity and novelty and became the emblem of a new industrial bourgeoisie. In Finland, on the other hand, it played a more mystical role, conjuring up remote folk origins, even if it represented these in the current idioms of the Arts and Crafts movement, just as in the music of Jean Sibelius we find late Romantic forms being used to convey the primitive essence of the Finnish landscape.

In Germany and France, too, conservatism existed alongside experimentalism. Julius Langbehn's best selling book *Rembrandt the Educator* (1890) claimed *völkisch* origins for a common Germanic *Kultur*. In France, Charles Maurras and Maurice Barrès promoted regional diversity and rejected a republicanism that had suppressed regional traditions in the name of an abstract, universal principle. This ideology was accompanied by a regionalist movement in architecture, equivalent to the *Heimatschutz* movement in Germany.

## IV
## REGIONALISM AND THE 1920S AVANT-GARDES

The pages of *L'Esprit Nouveau* testify to the antagonism of Le Corbusier to the eclectic regionalism that dominated popular architectural taste in post-war France. Le Corbusier was merely the most persuasive of those in Europe as a whole who opposed eclecticism with the ideal of universal modernism based on the abstract forms of modern painting and the industrialisation of the building industry.

Unlike Mies van der Rohe, who was still designing Biedermeier villas for wealthy clients as late as 1926, Le Corbusier had renounced his pre-war, Behrens-inspired neoclassicism. But he nevertheless claimed to be working within the French classical tradition—a claim that was in harmony with post-war French nationalist sentiment and critical opinion. It is not only in the context of postwar France that we find this *rappel à l'ordre*—this connection between modernism and classicism (a connection that had, in fact, already been made in *Werkbund* circles before the war). In Scandinavia the modernism of the 1930s grew directly out of the neoclassicism of the 1920s, as can be seen in the early work of Asplund and Aalto. In Germany, critics supporting the *Neue Sachlichkeit* movement in painting recognized its kinship with the French postwar neoclassicism of painters like Picasso. If we slightly extend the meaning of 'classical', we can add to this list the Dutch *de Stijl* movement, which promoted a rationalism that was opposed to the idea of an organic architecture springing from the soil. But in spite of the pre-

dominantly rationalist spirit of the postwar avant-garde, *völkisch* and anti-rationalist ideas lay just below the surface. The 'organic' or 'functionalist' school in Germany, and the post-1929 work of Aalto (so enthusiastically championed by Giedion in the later editions of *Space, Time and Architecture*), proposed a regional modernism based on concrete local conditions and specific programmes.

Even before the First World War, as I have already suggested, classicism had been seen as an essential ingredient of regionalist architecture in France. It is therefore not altogether surprising to find Le Corbusier, in 1928, writing a book *(Une Maison — Un Palais)* in which a fisherman's hut is seen as the humble forerunner of high classicism, thus separating classicism from its aristocratic and elitist connotations. We seem to be dealing here with an abstract notion of classicism which, with its emphasis on ethnography, is conformable to romantic theory. From the late 1920s Le Corbusier's interest in vernacular and regional building increased. Disillusioned, like many French intellectuals of the period, with parliamentary democracy, he became involved with the proto-Fascist neo-Syndicalist movement, with its combination of populist regionalism and authoritarian technocracy. Unlike the governments of Germany and the USSR, which outlawed modernism and returned to eclecticism, Le Corbusier and the neo-Syndicalists conflated regionalism with modernism, believing that art and technology were inseparable and that modern architecture would become popular.

The belief that popular customs and regional traditions could be reconciled with modem technology remained the mainspring of Le Corbusier's work for the rest of his life. Already in 1929 he had stated the problem with characteristic lucidity:

'L'Architecture est le resultat de l'état d'esprit d'une époque. Nous sommes en face d'un événement de la pensée contemporaine; événement international [...] les techniques, les problèmes posés, comme les moyens scientifiques de réalisation, sont universels.

Pourtant, les régions ne se confondront pas, car les conditions climatiques, géographiques, topographiques, les courants des races et mille choses aujourd'hui encore profondes, guideront toujours la solution vers formes conditonnées.'

Translation:

'Architecture is the result of the state of mind of its time. We are facing an event in contemporary thought; an international event, which we didn't realise ten years ago; the techniques, the problems raised, like the scientific means to solve them, are universal.

Nevertheless, there will be no confusion of regions; for climatic, geographic, topographic conditions, the currents of race and thousands of things still today unknown, will always guide solutions toward forms conditioned by them.'

This statement can be taken as more or less representative of a post-1930s architectural avant-garde that sought a modernism that would be determined simultaneously by modern technology and by the perennial architectural values inscribed in regional materials and customs.

## REGIONALISM AND LATE CAPITALISM

The statement by Le Corbusier quoted above makes several assumptions, the most important of which are:

1. Modern architecture is (should be?) conditioned by a universal technology.
2. Modern architecture is (should be?) conditioned by local customs, climates, etc.

Despite (or because of) the clarity of the statement, it presents two determinants as independent absolutes whose relation to each other remains a total mystery. What it ignores is the possibility that universal technology and local custom are intimately connected, so that a change in one necessarily produces a change in the other. The idea that they are somehow independent of each other seems to be derived from the Saint-Simonean notion that technical decisions made by specialists who 'know what they are doing' merely provide the optimum conditions for the peoples' enjoyment of unchanging needs and desires. But under the conditions of late capitalism desires and needs do not remain constant. They are affected by the changing technologies which make them possible. This is precisely the difference between the modern and the pre-industrial world. But in revenge, if, in this way, desires seem to become fluid, the gross economic conditions that create this fluidity become increasingly universal, abstract, and interdependent. Once the economy as a whole is commercialised the 'natural' (i.e., stable) relation between the individual and the social group ceases to exist, as sociologists like Georg Simmel and Max Weber pointed out many years ago. When subsistence farming gives way to cash-crop farming (as has happened in Europe and is even now happening in, for example, India), the old symbiotic relation between culture and nature disappears. In Western Europe, manual, rural economies co-existed for a long time with industrialisation and this gave some plausibility to the regionalist argument. But in late capitalism the arm of technology extends into the remotest regions, even in the so-called 'developing' countries which have no choice but to modernise.

The relationship between industrialisation and traditional cultures and techniques is not one in which they become organically fused with one another, as Le Corbusier implied, but one of hybridisation, where different cultural paradigms, detached from their original contexts, co-exist in an impure and unstable form. As an example of this in the area of urbanism, one can cite the co-existence of different economies in a city like Chandigarh, where an 'unofficial' economy of recycling has become necessary to facilitate the circulation of goods to the lowest social strata. (In Le Corbusier's plan such a theoretically impossible situation was not allowed for.) But this is the first stage of a process in which age-old habits become transformed and contaminated with international cultural paradigms spread by modern systems of communication. Local customs do not disappear completely; they become 're-territorialised'. Virtual cultures of choice take the place of cultures born of economic necessity. Dubrovnik becomes Disney World.

In conclusion, it is worth mentioning a third assumption in Le Corbusier's statement according to which society is conceptualised as an end-game situation. Culture is seen as having achieved a state of harmony and balance. An imagined and ideal state of organic unity is presented as a situation immediately attainable—an instant Utopia. In this situation of tautological illusion all 'solutions' become self-fulfilling prophecies. This is true both of the claim that there is a 'spirit of the époque' and of the belief in the persistence of regional cultures. But the real situation is not one of cultural stasis and fulfillment, but of indeterminacy and change, in which a complex, interlocking global economy creates new forms out of old cultures as it goes along—forms whose precise and determinate nature cannot be foretold with any accuracy. Architecture will certainly, when the economic conditions allow, continue to imagine ideal sociocultural forms, but its influence over social reality will be limited.

# BEYOND 'BEING' IN PLACE
## LUCY R. LIPPARD

In contrast to Kenneth Frampton's notion of 'critical regionalism'—which is more critical than regional—my own interests lie in the ways in which independence (and sometimes power) is generated even by temporary and/or serial senses of racination. Frampton's framework is world architecture, which is often irrelevant to my preoccupation with cultural landscapes. Nevertheless, I aspire to be a member of what he calls a 'critical arrière-garde' that 'distances itself equally from the Enlightenment myth of progress and from a reactionary, unrealistic impulse to return to the architectonic forms of the preindustrial past', avoiding 'nostalgic historicism or the glibly decorative', as well as conservative populism and 'sentimental Regionalism'.[1] My own project (and I am hardly alone) has been to untie 'the regional' from such dated associations, to set it free from the notion that 'the local' is by definition 'sentimental', 'reactionary', and 'nostalgic' and even 'fascist', and to describe its covert potential for resistance—for the most part unconscious and unrecognized.

The originators of the term 'critical regionalism' (Alexander Tsonis and Liliane Lefaivre) observed that 'regionalism bears the hallmark of ambiguity'.[2] In fact, *everything* interesting bears that hallmark, and the local is no exception. 'Critical regionalism' is a valuable concept in regard to public space, urban planning, and institutional architecture, but it is certainly ambiguous when applied to land-based lives and multicentred lives—as lived, untheorized. Too much academic writing on place today is written from a highly esoteric and 'objective' viewpoint that ignores the facts and the character of places themselves, forcing populism and communal (as opposed to jingoist) identity politics into the rightwing column. (If this smacks of the dreaded 'nostalgic anticapitalist escapism', so be it.)

Much has been written about the 'sense of place', which is symbiotically related to a sense of displacement. I am ambivalent about this phrase even as I am touched by it. 'A sense of place' has become not only a cliché, but a kind of intellectual property, a way for non-belongers to belong without doing anything other than declare their undying love for the place where they momentarily find themselves. The plural, *senses* of place, on the other hand, makes it clear that every place is different for every inhabitant and that most people are formed by their experiences of multiple places. What I call 'multicentredness' implies a serial sensitivity to place, which can be an invaluable social and cultural tool, providing much-needed connections to what we call 'nature' and, sometimes, to cultures not our own. Such motives—which usually (and fortunately) lie under the theoretical radar—should be neither discouraged nor disparaged.

All places exist somewhere between the inside and the outside views of them, the ways in which they compare to, and contrast with, other places. A sense of place is a virtual immersion that depends on lived experience and a topographical intensity that is rare today in the United States, both in ordinary life and in traditional educational fields. From the viewpoint of a writer or scholar, it demands extensive visual and historical research, a great deal of walking 'in the field', contact with oral tradition, and an intensive knowledge of both local diversity and the global contexts in which it endures. On the one hand, there is the quick read, rapid adaptation to a new place as a survival tool—a kind of scanning known to city dwellers as well as to

woodsmen, and a source of mapping in indigenous societies. On the other hand, memory is stratified. If we have seen a place through many years, each view, no matter how banal, is a palimpsest. Among the layers are stories told by others. Memory is part first-person, part collective. Some memories are positive, and they deserve to be remembered and utilized rather than being relegated to mere 'nostalgia'. In the virtually permanent energy crisis that faces the world today, a diminution of the need and motivation to move, travel, wander and tour is not nostalgic so much as it is necessary. 'Return' need not mean return to the past as a way of ignoring the present, but returning to reconsider a set of values that make possible a sustainable future.

Celebrations of nomadism and cosmopolitanism are of course woven into many celebrations of the local, including my own, thus the concept of multicentredness, which means thoughtfully touching down during one's lifelong trajectory. There is no point in travelling if we never know where we are, and if we never know how anyone else sees the place we are in. I too (as Miwon Kwon has put it) 'remain unconvinced of the ways a model of meaning and interpretation is called forth to validate, even romanticize, the material and socioeconomic realities of an itinerant lifestyle', and the ways in which 'uncertainty, instability, ambiguity, and impermanence are taken as desired attributes of a vanguard, politically progressive artistic practice'.[3] However, without resorting to the kind of 'either/or' thinking that has supposedly been supplanted by postmodernism, stasis and motion can be reconciled.

Senses of place, as the phrase suggests, do indeed emerge from the senses. Landscape, and even the *genius loci*, or 'spirit of place', can be experienced kinetically, or kinesthetically, as well as visually and conceptually. Walking was a major tool in Guy Debord's psychogeographical project of urban deconstruction. If one has been raised in a place, its textures and sensations, its smells and sounds, can be recalled as they felt to a child's, adolescent's, adult's body, especially the walking body, passing through and absorbing the landscape. And every landscape is a hermetic narrative. 'Finding a fitting place for oneself in the world is finding a place for oneself in a story', says Jo Carson, a professional storyteller from Johnson City, Tennessee. The story is composed of mythologies/histories/ideologies—the stuff of identity and representation. Carson is in a sense a narrative geographer. Her stories begin with 'basic central place functions—grocery store, gas station, auto mechanic, restaurant, movie house (read video rental, these days) and decent bookstore'. But when she talks about place, she means not only landforms and built environment, but 'the flavor of a society, the beliefs and activities of people who make up a given place'.[4] When these change, the place changes too, and not always for the worst. The local is a continuity, broken and reconstituted by events and individuals.

Place is most often examined from the subjective perspectives of an individual or a community, while 'region' has traditionally been more of an objective geographic term. In the 1950s, a region was academically defined by George Wilson Pierson as a geographic center surrounded by 'an area where nature acts in a roughly uniform manner'.[5] A region can also be understood not only as a politically or geographically delimited space, but as one determined by stories, loyalties, group identities, common experiences and histories (often unrecorded), rather than just a place on a map. I prefer this looser definition of region, like Michael Steiner's: 'the largest unit of territory about which a person can grasp "the concrete realities of the land", or which can be contained in a person's genuine sense of place'.[6] (The New Mexican phrase *patria chica* has a similar meaning.) Although it is beyond the scope of this

essay, bioregionalism seems the most sensible, most revolutionary, if least attainable, way of implementing a critical regionalism. Rejecting the artificial political boundaries that complicate lives and divide ecosystems, a bioregional structure could accommodate changing human populations as well as distinct physical territories determined by land, life forms, and especially watersheds. Ultimately, a region, like a community, is delineated by those who live there, as in Wendell Berry's description of regionalism as 'local life aware of itself',[7] emerging from a communal awareness that can and should have political ramifications.

As early as 1947, geographer John K. Wright stated the importance of including in his field the way people saw the world as well as its physical attributes, of mapping the desireability and undesireability of places and the reasons people feel the way they do about them. In the 1950s through the 1990s, geographic essayist John Brinkerhoff Jackson extended the notion of the cultural landscape to include contemporary views from both the 'local' and the 'stranger'. The concept of cultural landscape has infiltrated archaeology as well, finally removing the focus from material culture and drawing it out towards a vortex of land and lives. The relationship of peripheral places to central places provides a key to cultures across the centuries. But it will always be a changing relationship, just as the places themselves, even as we experience them, are morphing into places we have altered, consciously or unconsciously, responsibly or irresponsibly.

In the United States, 'regionalism' in the arts was named or practiced as either a generalized, idealized 'all-Americanism' or a progressive social realism (the two styles overlapped). It was most popular in the l930s when, thanks to hard times, Americans moved voluntarily around the country less than they had in the 1920s or would in the 1950s. During the Great Depression, the faces and voices of 'ordinary people' (i.e. the working or unable-to-find-work class) became visible and audible through art and writing, photographs and journalism that had a profound effect on New Deal government policy. John Dewey and other scholars recognized that local life became all the more intense as the nation's identity became more confusingly diverse and harder to grasp.

In the art world, the conservative 1950s saw regionalism denigrated and dismissed, in part because of its political associations with the radical 1930s, in part because its narrative optimism, didactic oversimplification and populist accessibility was incompatible with the Cold War.[8] Regionalism also fell out of fashion in the heyday of the sophisticated, individualist postwar Abstract Expressionist movement, just then being discovered as the tool with which to wrench modern art away from Parisian dominance. Today the term *regionalism* continues to be used pejoratively to mean corny backwater art flowing from trib-

**1** Kenneth Frampton, 'Towards a Critical Regionalism: Six Points for an Architecture of Resistance', in Hal Foster, ed., The Anti-Aesthetic: Essays on Postmodern Culture (Port Townsend, Wash.: Bay Press, 1983), 19–20.
**2** Alexander Tsonis and Liliane Lefaivre, 'The Grid and the Pathway', *Architecture in Greece* 15 (1981).
**3** Miwon Kwon, *One Place after Another: Site-Specific Art and Locational Identity* (Cambridge, Mass.: MIT Press, 2002), 160.
**4** Jo Carson, *High Performance* (Winter 1993).
**5** George Wilson Pearson, 'The Obstinate Concept of New England', *The New England Quarterly* (March 1955).
**6** Michael C. Steiner, 'Regionalism in the Great Depression', *Geography Review* (1983).
**7** Wendell Berry, 'The Regional Motive', in *A Continuous Harmony: Essays Cultural and Agricultural* (New York: Harcourt Brace Jovanovich, 1972).
**8** I'm obviously talking about left-wing populism, not the 'know-nothing' or Sagebrush Rebellion variety.
**9** Hüppauf/Bloch. I use the 'local' here rather than Bloch's *heimat*/hometown', which can be irrelevant to a multi-centred perspective.
**10** See Hüppauf on the *Kleinstadt*. He remarks that 'provincialism is not a function of the distance from the center; rather it is defined by a state of mind and a sense of inferiority'.
**11** Frampton, 21.
**12** Daniel Lazare, 'Mouseketopia', *In These Times* (March 17, 1997), 35.
**13** Henri Lefebvre, *The Production of Space* (Oxford: Blackwell, 1991), 52.

utaries that might eventually meet the mainstream, but are currently stagnating out there in the boondocks. New York City remains the art capital of the United States. It is rarely labelled 'regional' because it is the receiver and transmitter of global influences. The difference between New York (or Los Angeles or Chicago) and 'local' art scenes is that other places know what New York is up to, but New York is divinely oblivious to what is happening off the market and reviewing map.

It has been argued that there is no longer any such thing as aesthetic regionalism in our homogenized, peripatetic, electronic culture, where all citizens have theoretically equal access to the public library's copy of *Art in America*, if not to the Museum of Modern Art (which now costs twice as much as a movie). In fact, all art remains regional, even in the heyday of cyberspace, although its home bases are increasingly invisible in the actual 'globalized' product. Everybody comes from someplace; most of us come from a lot of places. The places we come from—cherished or despised—inevitably affect our psyches and therefore our work. If art is defined as 'universal', and form is routinely favoured over content, then artists are encouraged to 'transcend' their immediate locales by turning to 'placeless' international styles. But if content is considered the prime component of art, and lived experience is respected as a raw material, then regionalism is not a limitation, but an advantage, a welcome base that need not exclude outside influences but sifts them through a local filter. The most effective regional art has both roots and reach. It is often at its best when it is not a reaction to current marketplace trends, when the artist is simply acting on his or her own instincts; the word 'innocent' is often used rather condescendingly. But this can also be a matter of self-determination. Artists are stronger when they control their own destinies (and means of production). Some theorists of postcolonial and global art, deeply skeptical of both 'universalism' and 'authenticity', pride themselves on departing from the original voices (now dismissed as 'essentialist'). They paradoxically create a new, deracinated 'authenticity' in the process, with irony as a ubiquitous escape hatch. Yet the sources of land-based art and aesthetics remain opaque to those who only study them as opposed to living them.

All discussions of place involve questions of generalizations and specifics. To alter Hüppauf's paraphrase of Ernst Bloch, the local can be a site of resistance and 'a genuine counter-model within modernity […] [a] space where loss can be addressed and where modernity meets its own contradictions and offers compensation for its destructions'.[9] This is relevant to the 'region' where I live, New Mexico, an economically poor and culturally rich state in the Southwest United States, which remains unlike the rest of the nation. Its capital is Santa Fe—a relatively self-confident, 'open-minded small city'[10] and tourist destination that has been touted as the 'third largest art market in the U.S.'

On a recent trip to Vienna, I was amazed to see the gigantic, curiously shaped and mirrored Haas Haus rising abruptly on Saint Stephen's Square, across from the Cathedral. This would never be allowed in Santa Fe, where the Historical ('Hysterical') Design Review Board maintains an iron claw on new and old construction, disallowing innovation, no matter how compatible with the concocted past. Santa Fe (aka 'adobe Disneyland' and 'Fanta Se') has chosen to allow itself no option beyond the 'regional', in order to profit from tourism, second homes, and the film industry. This economic and sometimes highly emotional decision in favor of beloved 'traditions' (or, from another angle, 'hypothetical forms of a lost vernacular'[11]) virtually excludes the 'critical'. The result is the misrepresentation of a beautiful and poignant town whose history and failures are closer to the surface than in most U.S. cities. Despite its reac-

tionary architectural policies, however, Santa Fe is also known for its progressive politics, manifested in effective attempts to deal with water shortages, renewable energy, and a living wage. (Immigration, affordable housing, suburban sprawl, and destructive gas and oil development in Santa Fe County are still on the table.) Here the contradictions inherent in the specifically local are exposed, vulnerable, and hopeful.

Daniel Lazare writes that 'true re-urbanization requires re-politicization, a re-engagement with history and renewed class consciousness. And it requires democracy'.[12] This statement, which embodies what I would hope for from 'the local', is equally applicable to large and small cities, small towns, and rural life. 'New Urbanism' has been offered as a solution to urban unrest and suburban sprawl. Its fundamental principles are certainly desireable: building for people, not for cars; designing communities that emphasize walking and face-to-face contact, mixed use instead of segregation by zoning. But once built, the actual places often seem sterile, overmanaged, and, by implication, apolitical. The commodified communalism, the picture-perfect aspect of these monotone, mostly white and middle-class towns leaves me chilly.

At the moment, the centre of Santa Fe is being transformed by the construction of a new convention center, a new History Museum, a new County building, a new Railyard Park and adjacent commercial development. This is all part of an attempt to both 'make' and to maintain a place that is in danger of losing its character, and it has been undertaken with a vast amount (but perhaps not enough) of community input and participation. 'Placemaking' has become a popular term that needs scrutiny as a rather arrogant presumption on the part of planners dealing with the public domain. However, at the end of the day, only the community itself can make a place. It doesn't happen overnight, or on the drawing board. Urban dilemmas can not be reduced to design alone. No community is monolithic; the task is to make *places* rather than *a* place. From a necessarily defensive position, where too many regional neighborhoods find themselves, a strong sense of identity across race, ethnicity, and class is a powerful ingredient in creating community, providing a kind of armor against destructive change—*if* people can be organized and mobilized. The real task of urban planners is to offer a flexible structure in which things can happen unpredictably, to set up the context in which a place can be 'made' over time. It's easier to recognize than to make a place, but that means you have to learn to read it, see what it's used for, who goes there and why, where, and when; in other words you need to learn to think and see like a local. One definition of a local is a person who gives more than she takes. It's disconcerting to realize how many people feel they bear no responsibility for or have any control over their places, which means of course that they have abdicated critical capacity as well. It is this apathy or resignation that calls desperately for the 'principle of hope'. A real critical regionalism will finally come down to grassroots activism.

As Henri Lefebvre has declared, 'a new space' that confronts the abstract homogeneity of modernism and big capital 'cannot be born (produced) unless it accentuates differences'.[13] Is there, then, some possibility of a multicentred or decentred regionalism that is simultaneously a product of and a resistance to global hegemony? Hüppauf, noting that critical theory has 'demonstrated a lack of sensitivity to the local', the regional, and the vernacular, asks 'Could the regions be the crack in the tight architecture of economic and cultural globalization?' Could they 'open spaces of creativity and indigenous languages?' I hope o.

# WHO SINGS THE NATION-STATE?
## LANGUAGE, POLITICS, BELONGING[1]
## JUDITH BUTLER &
GAYATRI CHAKRAVORTY SPIVAK

## JUDITH BUTLER

What state are we in when we ask questions about global states? And which states do we mean? States are certain loci of power, but the state is not all that there is of power. The state is not always the nation-state. We have, for instance, non-national states, and we have security states that actively contest the national basis of the state. So, already, the term state can be dissociated from the term 'nation' and the two can be cobbled together through a hyphen, but what work does the hyphen do? Does the hyphen finesse the relation that needs to be explained? Does it mark certain soldering that has taken place historically? Does it suggest a fallibility at the heart of the relation?

The state we are in when we ask this question may or may not have to do with the state we are in. So: how do we understand those sets of conditions and dispositions that account for the 'state we are in' (which could, after all, be a state of mind) from the 'state' we are in when and if we hold rights of citizenship or when the state functions as the provisional domicile for our work? If we pause for a moment on the meaning of 'states' as the 'conditions in which we find ourselves', then it seems we reference the moment of writing itself or perhaps even a certain condition of being upset, out of sorts: what kind of state are we in when we start to think about the state?

The state signifies the legal and institutional structures that delimit a certain territory (although not all of those institutional structures belong to the apparatus of the state). Hence, the state is supposed to service the matrix for the obligations and prerogatives of citizenship. It is that which forms the conditions under which we are juridically bound. We might expect that the state presupposes modes of juridical belonging, at least minimally, but since the state can be precisely what expels and suspends modes of legal protection and obligation, the state can put us, some of us, in quite a state. It can signify the source of non-belonging, even produce that non-belonging as a quasi-permanent state. The state then makes us out of sorts, to be sure, if not destitute and enraged. Which is why it makes sense to see that at the core of this 'state'—that signifies both juridical and dispositional dimensions of life—is a certain tension produced between modes of being or mental states, temporary or provisional constellations of mind of one kind or another, and juridical and military complexes that govern how and where we may move, associate, work, and speak.

If the state is what 'binds', it is also clearly what can and does unbind. And if the state binds in the name of the nation, conjuring a certain version of the nation forcibly, if not powerfully, then it also unbinds, releases, expels, banishes. If it does the latter, it is not always through emancipatory means, i.e. through 'letting go' or 'setting free'; it expels precisely through an exercise of power that depends upon barriers and prisons and, so, in the mode of a certain containment. We are not outside of politics when we are dispossessed in such ways. Rather, we are deposited in a dense situation of military power in which juridical functions

become the prerogative of the military. This is not bare life, but a particular formation of power and coercion that is designed to produce and maintain the condition, the state, of the dispossessed.

[Hannah] Arendt refers to statelessness in this essay [*The Origins of Totalitarianism*][2], writing in 1951, as the expression of the 20th century, even as *the political phenomenon* of the 20th century. This is surely a strong claim. She cannot possibly know, she has only barely made it into the 51st year of that century, but, clearly, she is also saying that whatever else comes next, it will not deny her thesis. It is an extremely provocative claim that leaves us, in a way, to test it or read it and to see in what ways it remains at all readable for us. Arendt argues that the nation-state, as a form, that is, as a state formation, is bound up, as if structurally, with the recurrent expulsion of national minorities. In other words, the nation-state assumes that the nation expresses a certain national identity, is founded through the concerted consensus of a nation, and that a certain correspondence exists between the state and the nation. The nation, in this view, is singular and homogeneous, or, at least, it becomes so in order to comply with the requirements of the state. The state derives its legitimacy from the nation, which means that those national minorities who do not qualify for 'national belonging' are regarded as 'illegitimate' inhabitants. Given the complexity and heterogeneity of modes of national belonging, the nation-state can only reiterate its own basis for legitimation by literally producing the nation that serves as the basis for its legitimation. Here again, let us note that those modes of national belonging designated by 'the nation' are thoroughly stipulative and criterial: one is not simply dropped from the nation; rather, one is found to be wanting and, so, becomes a 'wanting one' through the designation and its implicit and active criteria. The subsequent status that confers statelessness on any number of people becomes the means by which they are at once discursively constituted within a field of power and juridically deprived.

If our attention is captured by the lure of the arbitrary decisionism of the sovereign, then we risk inscribing that logic as necessary and forgetting what prompted this inquiry to begin with: the massive problem of statelessness and the demand to find post-national forms of political opposition that might begin to address the problem with some efficacy.

The focus on the theoretical apparatus of sovereignty risks impoverishing our conceptual framework and vocabulary so that we become unable to take on the representational challenge of saying what life is like for the deported, what life is like for those who fear deportation, who are deported, what life is like for those who live as *gastarbeiters* in Germany, what life is like for Palestinians who are living under occupation. These are not undifferentiated instances of 'bare life' but highly juridified states of dispossession.

**1** This text is an excerpt from a conversation between Judith Butler and Gayatri Chakravorty Spivak published as *Who Sings the Nation-State?* (Calcutta and London: Seagull Books, 2007).
**2** Hannah Arendt, *The Origins of Totalitarianism* (London: Harcourt, 1994), 297.

In the last few years, the prospect of rights to legal residency and, ultimately, citizenship have been debated in the US Congress, and time and again we seem to be on the brink of a proposal that will pass. In the spring of 2006, street demonstrations on the part of illegal residents broke out in various California cities, but very dramatically in the Los Angeles area. The US national anthem was sung in Spanish as was the Mexican anthem. The emergence of *'nuestro hymno'* introduced the interesting problem of the plurality of the nation, of the 'we' and the 'our': to whom does this anthem belong? If we were to ask the question: what makes for a non-nationalist or counter-nationalist mode of belonging?—then we must talk about globalization, something I am counting on Gayatri to do. The assertion not only claims the anthem, and so lays claim to rights of possession, but also to modes of belonging, since who is included in the 'we?' For the 'we' to sing and to be asserted in Spanish surely does something to our notions of the nation and to our notions of equality. It's not just that many people sang together—which is true—but also that singing is a plural act, an articulation of plurality. If, as Bush claimed at the time, the national anthem can only be sung in English, then the nation is clearly restricted to a linguistic majority, and language becomes one way of asserting criterial control over who belongs and who does not. In Arendt's terms, this would be the moment when a national majority seeks to define the nation on its own terms and even sets up or polices norms of exclusion deciding who may exercise freedom, since that exercise depends upon certain acts of language. The problem is not just one of inclusion into an already existing idea of the nation, but one of equality, without which the 'we' is not speakable. So when we read on the posters on various public walls that favor legalization for illegal immigrants—'we are America'—and we hear illegal immigrants declaring in the streets, *'il pueblo unido jamas sera vencido',* we can trace the rhetorical terms through which the nation is being reiterated, but in ways that are not authorized—or not yet. The monolingual requirement of the nation surely surfaces in the refusal to hear the anthem sung in Spanish, but it does not make the anthem any less sing-able in that or any other language.

## GAYATRI CHAKRAVORTY SPIVAK

The national anthem of India was written in Bengali, which happens to be my mother tongue and one of the major languages of India. It has to be sung in Hindi without any change in grammar or vocabulary. It has to be sung in Hindi, because, as Bush insists, the national anthem must be sung in the national language. No translation there. When the Indian national anthem is sung, some Bengalis sing loudly with a Bengali pronunciation and accent which is distinctly different from the Hindi pronunciation and accent, but the anthem remains Hindi, although it is Bengali. The nation-state requires the national language. The anthem mentions many places with different nationalities, different language, and, sometimes, different alphabets. Two different language families, some of them Indo-European, some Dravidian in structure like the Finno-Ugric agglutinative languages. The anthem also mentions seven religions. Remember, this is not the situation of post-Enlightenment immigration as in the United States. These are older formations. Yet, the language of the anthem cannot be negotiated. Arendt theorized statelessness but could not theorize the desire for citizenship.

When Arendt talks about these Eastern European and Central European places, the activities of the Russian and the Habsburg Empires, she tries again and again to say that the minorities were treated as if colonized. This is a good strong point in the context of global states today. If you reterritorialize Hannah Arendt out of the situation in 1951 and the rights of man,

you notice arguments that the experiment of the nation-state—suggesting that it is the nation that organizes the modern state—is only slightly more than a century old and has not really succeeded. She says that its disintegration, curiously enough, started at precisely the moment when the right to national self-determination was recognized for all of Europe, and the supremacy of the will of the nation over all legal and abstract institutions—which is the state— was universally accepted. The nation won out over the state, as it were.

Today, it is the decline of the nation-state that we are witnessing in globalization. But the point to be made is that its genealogical force is still strong. In general, the decline is a result of the economic and political restructuring of the state in the interest of global capital. But Arendt allows us to realize that this may also be because the nation-state as a form was faulty from the start. As varieties of nation-state-style unification programs collapse all around us, what is emerging is the old multi-ethnic mix. On the one hand, there are the East and Central states, the Balkans and the Caucasus. Emergent also are India and China. Huge states with many 'nationalities' that cannot be thought of as nation-states in the Arendtian sense. Yet, in spite of the postnational character of global capital, the abstract political structure is still located in the state. The United States has generated a somewhat postnational combative structure which complicates the issue.

The reinvention of the state goes beyond the nation-state into critical regionalisms. These polyglot areas and these large states are of a different model. Hannah Arendt, speaking of them in the wake of the Second World War, could only think of it as a problem. We, in a different conjuncture, can at least think of solutions. It may be possible to redo the fairly recent national boundaries and think about transnational jurisdictions. Conflict resolution without international peacekeeping asks for this precisely in order to fight what has happened under globalization. We think of the decline of the national state as a displacement into the abstract structures of welfare moving toward critical regionalism combating global capitalism.

Let us for a moment consider what globalizing capital does do. Let us also remember that capital's move toward becoming global, which is an inherent characteristic of capital, and which can now happen for technological reasons, is not all related to nation-states or bad politics. Because of this drive, barriers between fragile state economies and international capital are removed. And, therefore, the state loses its redistributive power. The priorities become global rather than related to the state. We now have the managerial state on the free-market model. Galbraith had the sense, a long time ago, to point out to people that the so-called free market was deeply regulated by the interest of capital. When these managerial states with these globally regulated priorities work, some kinds of demands do not come up. The market is never going to throw up demands for clean drinking water for the poor.

Critical regionalism is a difficult thing because of the potency of nationalism, even ethnic sub-nationalism and, on the other side, because the transnational agencies go nation-state by nation-state. But a word first and foremost about Habermas and the European constitution. The European constitution is an economic document. To implement this, a certain cultural memory is invoked—perhaps to take the place of mere nationalism. The treaty toward the European constitution did not pass because France and the Netherlands voted 'no'. The document begins as if there was always a Europe, even as people came into it. We know that constitutions must always perform a contradiction [...] Yet, there is an asymmetry between different performative contradictions. Thus Europe bringing itself into being by invoking its originary presence for consolidating economic unity in the new global market—and thus

giving itself access to cosmopolitheia—cannot be seen as the same as the undocumented workers in California calling for a right beyond the nation and thus bringing it into being, simply because they inhabit varieties of performative contradiction. When Habermas talks about the advocates of a 'cosmopolitan democracy' based in Europe and the creation of a new political status of 'world citizens', place it within this argument.

When Habermas and other European thinkers talk about cosmopolitheia, they are talking about Kant. For lack of time, I will merely refer to Derrida's *Rogues* where he attends to the entire Kantian architectonics and shows that Kant's 'as if' for thinking the world and freedom and the connection between cosmopolitheia and war make him unsuitable for thinking and committing oneself to a global democracy to come. And, as I have been insisting, it is not unimportant to look again at Hannah Arendt because, in the context of statelessness, she's thinking the nation and the state separately. Derrida will later call this undoing of the connection between birth and citizenship the deconstruction of genealogy in *Politics of Friendship.* And that is where critical regionalism begins.

Our global social movements have been taken away from us. We are 'helped' at every turn. The lines are not clear. But you do see why the 'critical' comes into this thinking of regionalism. In the newspapers, India and Pakistan are still enemies although the prime ministers speak well. China and India are supposedly competing for the favor of the United States. And so on. Do the old lines, pre-dating Bandung, between pan-Africanism and anti-colonialism, survive? Heroes of the humanities like Anyidoho, Ndebele, Ngugi, and Soyinka would make us hope so. Can the New Latin America check the Euro-US craze for universalism? Evo Morales would make us hope so. Hence, why 'critical' and why 'regionalism'. It goes under and over nationalisms but keeps the abstract structures of something like a state. This allows for constitutional redress against the mere vigilance and data-basing of human rights, or public interest litigation in the interest of a public that cannot act for itself.

# THEIR MAPS VS. OUR MAPS
## A CONVERSATION BETWEEN AYREEN ANASTAS,
RENE GABRI, AND NINA MÖNTMANN

**Nina Möntmann** We first met as participants in *Liminal Spaces*, a long-term international art project consisting of workshops, conferences, excursions and an exhibition developing modes of expression towards the Israeli-Palestinian situation.[1] Many of our discussions referred to the spatial dimensions of the occupation, like the colonial situation in the West Bank including the ever expanding settlements; the absurd experience of distance induced by checkpoints; limited access to roads for Palestinians; the wall; the ethnic-religious segregation of Jerusalem; the spatial politics of Arab neighbourhoods in Israel; legal issues around space, like land confiscations etc. The experience of space and place in the region appears as a constant confrontation with limits, and people being exposed to a power which formulates itself through the execution of arbitrariness.

In your recent works you were exploring how people see and experience 'sites of the suspension of law', for example Palestine, where the public sphere is militarized and space is organized by mechanisms of warfare. I am thinking of your film *What Everybody Knows* (2006–2008), which was initiated within the framework of *Liminal Spaces* and includes interviews with people living under occupation in Palestine as well as Palestinians living inside Israel. But also of your project *Camp Campaign*, for which you drove a van through the USA and opened different situations to consider the internment camps in Guantanamo Bay. By doing this you also brought information and awareness to the people you encountered, whose lives are not directly affected by militant spatial politics, but who are living in a country that is setting up camps that are defying any lawful jurisdiction.

Both projects were based on an extensive trip you made through Palestine or respectively the United States, so your own experience of spatial dimensions, your mapping of the territory served as the background for your encounters and interviews with people living in these places. Could you elaborate a bit on your interest in the spatial politics these projects are unfolding as well as analyzing?

**Rene Gabri** Well in both cases, we begin with political problems which mark extreme conditions and call upon us to think. They are not only thought-provoking, but ask of us more than thought: they require acts, simply, and this is interesting for us. How to be present to our own time and to try to mark it, to give ourselves over to it?

On the one hand, it opens a question about where the work of art may be. In these cases, we say here, here is where things matter to us, politically. Where we see an important point of struggle or fissure in the ordinary discourses of development, democracy, equality or so-called freedom. On the other, it is necessary to also have a position, to take a position or try and formulate one through one's research, otherwise, the research has no force.

The questions in relation to the law or to spatial politics emerge from research and inquiry into specific problems (e.g., Guantanamo, Palestine). They also happen to be key nodes of struggle and resistance for many political activists today, because it is at this level that the largest and most violent forms of dispossession are taking place.

In the cases of Guantanamo Bay and Palestine, by saying they are extreme cases, we can also say they are exceptional instances. They are spaces of exception, within which the law applies by dis-applying, or remains suspended, in limbo, spaces within which individuals are deprived of basic human *and* political rights.

Yet, as exceptional as these sites are, the perimeters of these spaces are also marked by historical precedents, by structural, legal precedents, which open up to the world and connect them to other sites and times.

In this way, they are also examples, belonging to a set. We are against the set to which they belong.

So, as much as we needed to be as precise as possible in understanding specific situations, whether in Palestine and Israel or East Baltimore (just as we did in Palestine, we spent significant time, taking daily trips, meeting individuals, documenting what we saw); with *Camp Campaign*, we also attempted to use our case studies, to broaden the terrain, historically and spatially. To ask ourselves, where are the confines to this camp in Guantanamo Bay? What does such a space mark? What is the relation of that space to our own contemporary cities? What kind of subject constitutes a threat today? And which legal and spatial strategies are used by the state to dispossess these individuals of agency or simply their ability to exist?

**Ayreen Anastas** The spatial politics are not separate from the demographic engineering Israel is attempting and from the overall political situation. They are interconnected. What you mention above in relation to the occupation are a few examples of that interconnectedness. Our interest, as Rene mentions, came from thinking about the overall context and trying to understand and reformulate the questions. In our trips through occupied Palestine and then the few trips in Israel, we found from our meetings that Israel uses the law and planning to obfuscate its actions against Palestinians. House demolitions or creating 'open green spaces', for instance, in East Jerusalem are done in the name of good planning. But in both of these cases, these specific actions are taken to limit the opportunity for Palestinians to build viable communities.

The overall context I speak of also involves our work. We would like to defeat specialization, both in relation to us as artists (open to become something else) and in observing the situation on the ground. For instance, we consulted not only specialists (like geographers and architects) but also everyday people, passers-by, thus exploring different layers of those realities. Spatial analysis is necessary, but it is not enough, one has to constantly be using more means and tools of analysis. On our trip across the United States for example, we organized a few events to discuss the camps in Guantanamo, but we did so through two videos which acted more as agents to open up the con-

Ayreen Anastas & Rene Gabri
*Prisoner of War on Motorcycle*
(2006)
Courtesy the artists

Ayreen Anastas & Rene Gabri
*Afternoon in Camp Perry*
(2006)
Courtesy the artists

versation. One was shot in Al-Lydd and Al-Ramleh, in which a Palestinian architect-activist, Buthayna Dabit, explains how Palestinians within Israel, who are citizens of Israel, are deprived of a livelihood, through different measures of planning and regulations. We then showed a video of a drive through East Baltimore with the activist-organizer Glenn Ross. Again, in that video he discusses how the city of Baltimore and John Hopkins University have used planning and regulations to displace the African American community for 'development' purposes. In this case, to provoke thought, we wanted to confront people with three different situations and try to find points of relation and difference.

**Möntmann** The strategic concern of the spatial reorganization of Palestine seems to represent a military avant-garde. The complexity of the A, B, and C-zones that are under Palestinian administrative and military authority, or under Palestinian administrative and Israeli military authority or under Israeli administrative and military control, respectively, is very different from the way territory is conquered in 'traditional warfare' or land seizure. I find it interesting to look into the psychological dimensions of these strategies, and also try to see if and in what way we find similar processes elsewhere. Although very different from the outset, you mention the similarity of the camp situation in Guantanamo and Palestine; this is also where the psychological dimension comes into play, the 'spaces of exception' as you said, 'spaces within which individuals are deprived of basic human and political rights'. It is obvious to think of Agamben in that context. Since Agamben is so widely accepted these days in art-related discourses, I find it interesting to consider a critique that was recently reformulated in a conversation between Judith Butler and Gayatri Spivak, who are also referring to the situation of the Palestinians, and which says that 'these are not undifferentiated instances of "bare life" but highly juridified states of dispossession'.[2] Since the exposure of a potential of resistance is also crucial for your approach, I wonder how you see Agamben or Butler's critique respectively in relation to your own practice.

**Anastas** Before we answer the question directly, I would like to comment on a few words, as they may shed some light on the question of resistance. For example: the word *avant-garde* originates from the military and yet I would prefer not to use such a word in describing the Israeli military. In fact, there have been some efforts to emphasize the experimental aspect of Israeli military strategies or occupation strategies, but this kind of discourse risks fetishizing the very machine it purports to critique.

We have to arrive at an appraisal of the situations that does not ignore the intricacies at which violence is taking place: the measures we have alluded to, the scales at which Israelis are given agency and Palestinians denied, etc. But if we step back, it is also important not to lose ourselves in those intricacies, distracting us from a bigger picture, which is much clearer. Here what appears as complexity masks and obfuscates a brutal military and civilian occupation. So the law, the planners, the settlers, the military, the police, the nongovernmental organizations, corporations are given various degrees and forms of agency, creating what looks like a very complex picture, when in fact, the effect on the lives of Palestinians is quite uniform and consistent. It denies their rights as political subjects to determine the fate of their own territory.

Neither *traditional warfare* nor *warfare* are suitable words for the Israeli context because for me, the words already bring a misrepresentation of what is taking place.

What if instead we began to speak about the West Bank and Gaza as a large-scale prison or camp, which is being offered self-rule? Within that ever-confined space of 'self-rule', there are some who have elected to refuse, some even resist with very crude arms. But within

that perspective, it is much clearer that for Palestinians it is an uprising and revolt which refuses the policies of a state and the undignified life which it allots for them. Unfortunately Israel's warfare is largely against civilians.

**Gabri** I think for us as artists, it is even clearer that we cannot change the situation without also contesting the language which is being used. Language can open, but it can also confine and restrict our ability to understand a context or to see solutions. People who are actively involved in resisting Israeli policies are very aware of language as one site of struggle.

I want to go back to this idea of an avant-garde, however, and say more generally that I find that today, whether we are talking about military development or neoliberal development, there is clearly an experimental aspect to it. And clearly even this side of it, its employment of the latest technologies for instance or materials, is at times used to garner a strange fascination and to sanitize very violent processes. We can think about large-scale developments in city centers or the latest war on Iraq. For example, I am thinking of how the U.S. media spent a great deal of effort to showcase new weaponry being used by the military in their initial assault. Clearly, these efforts at emphasizing the newness often masked what David Harvey has characterized as a new imperialism.

I suppose upon my first entry within Israel and the Occupied Territories, I did have this sense that I was entering an experimental site unfolding on various levels and scales including but not limited to weapons, surveillance equipment, strategies of warfare, spatial planning/ zoning, legal measures, and psychological operations. A laboratory for various forms of dispossession, control, and collective punishment. To understand this, to have a clearer idea of the scales at which violence is present, the strategies being employed; one does need to go to particularities.

However, as we were saying earlier, the problem is not isolated. It has precedents historically and it is connected to a practice and discourse of security globally today. Clearly, it is a bankrupt discourse/practice which trades on fear and acts through unilateralism, disregarding its own laws or international ones, to purportedly protect itself and its people. Today Israeli policies allow it to dominate the lives of Palestinians, but they have not won it any security. On the contrary, they have brought it ever closer to an impending collective catastrophe.

Either Israel will succeed in expelling Palestinians from these territories or it will hasten its own collapse. If it is the latter, the question is whether this collapse will happen peacefully through international cooperation and advocacy, as was the case in South Africa in the struggle against apartheid, or it will happen through a protracted war which will destroy millions of lives and involve many different states. Unfortunately, we are seeing an immense investment materially, discursively and psychologically on the part of many governments around the world, most obviously the United States and to a lesser extent Great Britain, towards the idea of a protracted war. The more they can create 'theatres of war,' the more they can sell the idea that we are at war. 'We are not looting and robbing a country of its resources, we are not taking strategic control of a region, we are not creating managed chaos, we are at war!'
Of course, it emboldens and appeals to the most conservative elements within each and every society, and it is an immense challenge for every human to resist, at the level of our life and work.

Recently, I read an article, in the *Financial Times* of all places, about the election of Rome's first fascist mayor since the Mussolini era.[3] Incredibly, the headline of the article said that Jews in the city and local fascists were united in celebrating the victory. In the article, the main

reason cited for the Jewish support of the fascist politician was his and his party's support of Israel. I find this sad and sadly telling of where we stand today.

**Anastas** When we did *Camp Campaign*, in thinking about Guantanamo, we were also thinking about the relation between the United States and Israel. And it seemed to us that there was an arrow connecting the 'manifest destiny' practiced by early American zealots who strove to conquer greater land at the expense of the territories used by Native Americans, and Zionism. For Zionists, the land of Israel, including 'Judea and Samaria', which is how they continue to refer to the West Bank, is their manifest destiny and they would like nothing more than to create small Bantustans or reservations for the natives to live in. And what Rene is referring to is how that arrow now comes back toward the United States.

The specific means Israel is using may be new and unique to it, but we can see in these eight years of Bush that they are finding traction on a much larger scale. Reducing nearly all forms of resistance to its appointment with the future as the work of 'evil-doing terrorists' who are against 'our freedom'. It is scary to think that nearly every Palestinian male we encountered on our trip in 2006 spent some portion of their life inside an Israeli detention center for extended periods in increments, mostly without any charges, arguing that they pose a security threat.

**Gabri** This is the space of exception that Agamben talks about, which is where the law tries to appropriate what is outside of it by suspending itself, in matters of 'state security' for instance. His reading is a very rich and textured inquiry that unfortunately gets reduced to a few key words and notions, like 'bare life', which never retain the ambivalence and nuances that one finds in his writing. Agamben's approach is poetic in that he makes various movements towards a problem, without ever reducing it to a simplified account. So the majority of the problems emerging with Agamben for me, particularly as he is used within academia or art, emerge from mangled regurgitation or oversimplification. I think in our case, in our work in Palestine for instance, we were inspired by Agamben's refusal to acquiesce to a reading of the Nazis as a singular and aberrant exception in the history of the world. To also find that there is something which took place in those camps that is repeating itself. It attempts to look at various discourses and procedures, precisely at the level of the juridical, to find the specific manner in which those camps were born. He makes a specific attempt not to just decry the horrors of the camps but to try to present an account of how they worked. We wanted to do something similar with our trips in Palestine and the United States. Moreover, just as he is attempting to extend the research of particular thinkers and be in dialogue with them, we could be said to try something similar in our work. And in this sense, his ideas are confronted with various other cases and realities. Our process is not illustrative but interrogative and associative, a process of *thinking with* other thinkers and activists. For us, it was important in *What Everybody Knows* (2006–2008) to give time and space to a few individuals who are working within that local context, not to present a viewer only with effects of suffering but rather with the psychological impact of Israeli policies and the specific modes the state and various other actors (corporations, settlers, military) produce the harsh facts of the occupation. Having said this, we both have a great deal of respect for Gayatri Spivak and Judith Butler, as extremely close readers, as important thinkers, and especially Butler being a very adamant and public critic of Israeli policies. So to engage with their critique of Agamben would require greater familiarity with their discussion. But I do think that Agamben is also writing about the dispossession that takes place within the framework of the law, whether it is in applying it,

as the Nazis did in fully stripping Jews of citizenship (denationalizing) before sending them to the camps, or in suspending it in the name of preserving it.

**Möntmann** In *Camp Campaign* you have been traveling through the United States exploring the different iterations of states of exception or camps within its history. In connecting that inquiry to the camps in Guantanamo Bay, you were also provoking a certain awareness of present circumstances and their possible relation to historical precedents. How do you see the relation to the asylum camps in Europe and the awareness of people in Europe?

**Gabri** When we were doing our preliminary research for *Camp Campaign*, our friends in Rotterdam, Liesbeth Bik and Jos Van Der Pol, took us to a detention center for migrants who have no legal status in the country. It was located in a very nondescript harbor area, not far from the center of the city of Rotterdam. It looked like a small medium-security prison. These kinds of holding or detention centers are proliferating across the globe, particularly in the over-developed world, i.e. the economically dominant countries. Just as the private prison industry in the United States is proliferating, so too is the demand for surveillance equipment and temporary imprisonment and humiliating architecture for refugees, asylum seekers and migrants. In Europe and in the United States, there is a double language spoken with a forked tongue. On the one hand, open borders, the free flow of capital and goods. On the other, the movement of bodies, the policing of borders, new walls, new surveillance and security apparatuses.

Both movements have the potential to undermine the order of the modern nation-state, but only the movement of bodies threatens the economic order particularly when it is unscripted. I make the latter point because we know that many industries (from agriculture to construction) need precarious, low-wage workers who have less recourse to labor protections, and so there is often a structural need for nonlegalized workers. But today we see governments attempting to create 'guest worker' programs which derive the benefits of migrant workers without offering the legal and social protections afforded to citizens.

Our friend Alessandro Petti likens the emergent world order to a series of enclaves (where movement is restricted, delimited) and a network of interconnected archipelagos (which give a semblance of a smooth and borderless space). The economic or political refugee, the not-legalized migrant, undermines this order and reminds us that these archipelagos are nothing but a field of gated communities separating the world of privilege from what Frantz Fanon called the *wretched of the earth*. So for us, one of the great scandals of our time is not that these camps exist. After all, governments have historically protected the interests of the rich. The scandal is that we the people being governed do not revolt. We are inculcated not only to accept them, but even to ask for more of them for 'our security' or 'our jobs'. There are amazing groups of activists in Europe and a strong no-border network, more organized than any U.S. network I know of, but the struggle is large and demands a complete rethinking of current economic and legal frameworks. A discourse of no borders calls for a radical critique of the state, of citizenship, and of capitalism.

**Anastas** Nina, in relation to our activities as artists and curators, maybe more specifically for you as a curator, how do you see your role working in a context such as Palestine and Israel? And where do you place the question of resistance within your own practice as a curator? What are for you the means and ideas that enable you to think and act in such situations, Palestine or another?

**Möntmann** The basis for any political work in the art field — also eventually implying moments

of resistance—that is commenting on or intervening in any region of crisis and conflict, is the awareness of the relation of specificity and relativity in this very situation. This means analyzing the specificity of a situation without lapsing into claiming a sense of authenticity and uniqueness, and at the same time discussing similarities of situations without denying the individual dimensions of the effects this very crisis has on the lives of those people affected by this situation. Therefore, if you only look at the particular aspects of a crisis you imply that this could never happen again and in no other place; but it is equally fatal, to only point out the relativity of situations and seek similarities to other conflicts, times and regions.

I am interested in the emancipatory potential of these alternative spaces that you can create within the framework of an art- or research-based project, and also in fathoming the participatory potential of these spaces. I am also interested in participating in and contributing ideas to a collective process of thinking that for some might lead into activism, for others it becomes part of wider research. Also, for me it is always from the position of a 'participant-observer' that I am speaking, be it at a symposium on art and nationalism in Israel or when teaching students in Ramallah about the notion of 'New Communities', a subject that for Palestinians is bringing up questions about communities that are imposed on you rather than self-chosen, on ideas of a nation without a nation, united by a common struggle.

If we stay for a while with this image of the alternative or emancipatory space an art project can produce, how would you relate this rather abstract space in your work to the actual territories you are mapping? And what role do the people you are interviewing or including in other ways play?

**Gabri** There are many ways to answer this question, but I see in it two clear lines: one is relating to the physical sites of our inquiries and the second is opening up to the individuals we may involve or work with on these aforementioned projects. I cannot think of a text more suitable to cite in attempting to answer this question than Gilles Deleuze and Félix Guattari's *Nomadology: The War Machine*.[4] The text may be familiar to some, but I will try to explain what interests me in it and how it may refer back to your question. Directly at the beginning of this text, which is a section of *A Thousand Plateaus*, they distinguish between the state apparatus and the war machine. To illustrate the difference, they refer to the games of chess and Go. Chess stands in for the state, in its treatment of the game pieces, in the possible relation the pieces can have with one another and the spaces they occupy. The pieces, they argue, are coded (they have an internal nature or assigned properties) and their range of movement is determined by this coding: 'A knight remains a knight, a pawn a pawn, a bishop a bishop'. If chess (standing in for the state) speaks on behalf of interiority and fixed essences, identifying the role and potential for each actor to move, Go, then, stands in for exteriority and no fixed essence or possibly one that is morphological, that is able to change. The pieces are 'pellets, discs, simple arithmetic units, and have only an anonymous, collective or third person function—'"It" makes a move. "It" can be a man, a woman, a louse, an elephant'. Moreover, if in chess it is 'a question of arranging a closed space for oneself' and of coding and decoding space, Go for the two is a question of 'arraying oneself in open space', holding space, territorializing and deterritorializing it, not moving from one point to another, but in a perpetual movement, 'without departure or arrival'. For me, their ideas are very rich in recircuiting our habitual modes of reading space or understanding our own agency within a particular field. There is also a great deal of potential for this thought to encourage further thinking. We have both been inspired by Brian Holmes's recent inquiries investigating Guattari's research and propos-

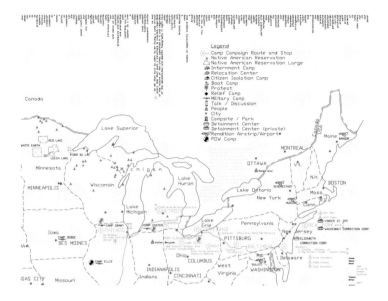

Legend
- Camp Campaign Route and Stop
- Native American Reservation
- Native American Reservation Large
- Internment Camp
- Relocation Camp
- Citizen Isolation Camp
- Boot Camp
- Protest
- Relief Camp
- Military Camp
- Talk / Discussion
- People
- City
- Campsite / Park
- Detainment Center
- Detainment Center (private)
- Rendition Airstrip/Airport*
- POW Camp

Ayreen Anastas & Rene Gabri
*Fear is Somehow Our For
Whom? For What? and
Proximity to Everything
Far Away* (Detail, 2006)
Courtesy the artists

**1** Organised by Galit Eilat,
Reem Fadda, Eyal Danon and
Philipp Misselwitz, www.limi-
nalspaces.org.
**2** Judith Butler and Gayatri
Chakravorty Spivak, *Who
Sings the Nation-State?* (Cal-
cutta and London: Seagull
Books, 2007), 42.
**3** 'Fascists and Jews United
for Rome Mayor', *The Finan-
cial Times* (4 May 2008).
**4** Gilles Deleuze and Félix
Guattari, *Nomadology: The
War Machine*
(Semiotext(e),1986).

ing possible modes of 'escaping the overcode'. Within the context of
your question, I can simply say that our struggle when we work with
any space or any context, is to open it up, see how it has been coded
and try, if possible, to destabilize or open up a different relation to it.
This can sometimes be done alone and sometimes it requires the help
of others. One hopes that in working with others, one is able to utilize
a similar ethics, which does not functionalize or ascribe a fixed com-
petence to the other, but leaves room for the individual to invent new
moves, to join with you into an assemblage, a war machine, able to
equally occupy and hold a territory or to unhinge, deterritorialize it.
 Although the discourses are quite different, I would liken Rancière's
notion of the 'redistribution of the sensible' to this act of deterritoriali-
zation. If art, politics or any field of struggle for that matter is to
retain a potential for emancipation, it must have the capacity to resist
this ascription of fixed competences, identities, or essences.
**Möntmann** Essentialist conceptions of identity are constituting the
central idea of any nationalism, which offers the narrative for the his-
torical nation-state. I say historical, because the nation-state is appar-
ently changing rapidly mainly in regards to its political power, but also
in its territorial responsibilities. In what way do you see your work as a
comment on different geographical, territorial and political entities,
like the changing parameters of the nation-state, regional and local
contexts, borders etc? Maybe you could mention a few examples.
**Anastas** We could probably give a number of projects which can in
some way address your question. Maybe the most interesting here is
a collective one. Continental Drift is a modular and experimental semi-
nar that 16 Beaver initiated together with Brian Holmes and various

other individuals. We started three years ago, with the desire to investigate some questions involving the geopolitical and economic shifts which took place between 1989 and 2001. More precisely, we were thinking about Continental Integration, which refers to the constitution of enormous blocks like NAFTA and the EU. These blocks that are functioning units one scale up from the nation-state, created to manage the unleashed energies after the technological developments of the last forty years: this means not only the reorganization of spaces and flows, but also creating and channeling new forms of subjectivities. It is important to remember that those changing parameters by capitalist power are extensive across social, economic and cultural life, as well as intensive, infiltrating the most unconscious subjective strata. Thus one can no longer claim to resist solely from an outside, through traditionally ascribed spaces of politics. It's equally important to resist on an everyday level, and being aware that both levels are crucial. Often the question of art and politics is reduced to the extensive level; it is our task to connect to other artists and activists taking into consideration that we are working on both levels.

The idea of Continental Drift was to create and think about projects through a geopolitical and geocultural lens. Moreover, to begin a process of dialogue which could inform one another's practices. We also wanted to create a space where the individual research implicit in many cultural practices could have a chance to enter a more collective process of thinking, uttering and resisting. And if this kind of work is to become effective, it needs to happen outside of scripted spaces, which limit the potential for individuals from different fields or backgrounds to affect one another. If the work calls for the reconstruction of human relations at many levels, then we believe that it is necessary for the forms we employ to also take into consideration our desires.

**Möntmann** And what about your own history, Rene, you shot/did the video *Movements (2001)* in Armenia, and Ayreen, you did *m* for Bethlehem* (2003) in your hometown. Could you elaborate a bit on the personal dimension of these works, the relation you created between your personal history and a more common narrative?

**Gabri** What connects me to Armenia is mainly through culture and language. Armenians have had a historic land they called home, but that map has shifted, at times through bottom-up processes like trade, cultural and religious ties, and at other times through top-down processes, often associated with sovereign state violence.

So there are multiple Armenias to belong to. One may be said to cling to the origin, particularly in contesting the forced displacements and genocide under Ottoman rule of a land and a people. Another is the Armenia that exists today, which has a rich connection to Soviet history and communism. And then there is the Armenia which has had connections to exile, diaspora cultures, migration, and movement. The Armenia that William Saroyan quipped was constituted wherever two Armenians met. I think today, we need to reinvent this idea, not in opposition to a notion of a homeland, but in addition. A new Palestine wherever two Palestinians meet. I do not have to move back to Iran to feel Iranian, nor Armenia to be considered Armenian. It is a notion that can propose a different space for retaining a cultural identity away from one's own country or region of origin and at the same time contest the model more dominant in the West, which constructs cultural identity solely through the lens of the nation-state, and thus views any perceived nonassimilation as a threat.

So for me, this question of home is also a hurdle, a mountain I have been looking to climb or blast through. What constitutes the personal and is proper to one's own can be in some sense a part of this re- and deterritorialization.

Today, being born in Iran, Palestine, Armenia, or any place facing extreme political or economic unrest presents immediate challenges that someone living in another country may not have to confront, but they are connected intrinsically to global dynamics and forces. Thus, exploring these particular challenges and experiences can provide certain insights and allow one to possibly understand our shared world a little better. I think for both Ayreen and I, any attempt to connect to these sites is in keeping with the latter idea. We cannot fully escape or forget where we come from (even if we always start in the middle) and what we have been given, and thus we also must be selective and make use of what we inherit. Nevertheless, I feel it is an important struggle to resist the kind of essentialism that is presented today as the only recourse or response to counter capitalist globalization.

We reject the Disneyfication of the world. We reject the homogenization of the global mall that enterprise-minded individuals would like to construct. We reject the exploitation of lands and energy of poor peoples. We reject the neoliberal values being employed by or forced down the throat of nearly every government today. All of these forces present a very restricted global community which locates equality and freedom strictly on the plane of consumption. We need to project upon a different plane, *a different justice, a different movement, another space-time* and we cannot comfort ourselves by believing that this vision can be found exclusively in some origin.

**Anastas** *m* * *of Bethlehem* was a spontaneous experiment of overlapping and shifting several layers on one another. What were these layers? First, my visit to Bethlehem, my mother during a period after the siege of 2002, a calm but very disturbing time in which curfew was regularly imposed. Second, a map of Bethlehem from 1972. Third, the meaning of Bethlehem. What is the meaning of Bethlehem? It is the home, and home weakens. We can never rest in it, we have to constantly challenge it. Similar to language, to words, to meaning. We cannot rest assured of meaning, and constantly have to invent new words. How overdefined Bethlehem are you? For me you are always new: an impression, a connection, a flash of an idea, a day in the future and a task in the present. Simply a present. How are you different than all others? I am one of many: Arab, Capitalist, Define, Enemy, Fundamentalism, Good, Homeland, Israel, Jew, Know-Nothing, Left, Marx, Nation, Orientalism, Palestine, Quote, Representation, Security, Terrorist, Use, Vampire, Woman, Xenophobia, Yes, Zionism.

What is the map of Bethlehem? It is the diagrammatic representation of an idea or ideas showing connections between personal and common narratives aiming at creating new modes of resistance in language. True, there is no thought outside language, and no resistance without thought. Interconnectedness is crucial. I am not where I come from, and yet I come from there. I drew the map anew to place myself in it. The map is not finished, it is changing me as I am drawing it. It is expanding and connecting to you. Do you have enough space and what about them? The state has an official map, its scale is enormous, I do not see you there anymore. The state is erasing our maps! We will redraw them once more, again, anew, another time if needed.

# EUROPE
# AND ITS
# RAMIFICATIONS

# WAYS THROUGH WAR
# THE AFRICAN LIBERATION OF EUROPE[1]
## JOCHEN BECKER

*During the war we saw those who had been our colonizers the day before naked. We fought at their side, suffered the same hunger and thirst, wept over the same sorrows. It was clear: there was no material difference between us. But the French made friends more readily with German enemy soldiers than with us, their black comrades. That embittered us. These experiences changed many things.*
Senegalese film director and war veteran Ousmane Sembène in a lecture held
in Tübingen, 19 September 1995

The eighth of May 1945 is regarded as the day Europe was liberated from National Socialism, as manifested in the victory of the Allies—the USA, the Soviet Union, Great Britain and France—over the Axis powers Germany, Italy, Austria and Japan in World War II. The war's battlefields had spread over almost the entire globe, forcing millions of people to places that were not of their own choosing. I do not mean only those deported to and murdered in camps, or prisoners of war, the displaced and the hunted.

In Algeria, for instance, 8 May 1945 is remembered as a day of massacre perpetrated by French colonial troops in Sétif and de Guelma. The end of the war, with French troops reinforced by tens of thousands of Algerian soldiers, was to be celebrated in the country as elsewhere. But when demands for Algerian independence were voiced in celebratory processions, French security forces stepped in. In the event, up to fifteen thousand Algerians were murdered. In retrospect, this was the start of the Algerian War of Independence that was to end in liberation a full eighteen years later.

Viewed thus, World War II not only changed Europe (creation of the EU and the Warsaw Pact) and the USA (leading world power) as established historiography claims, but also reshaped the continents of Africa and Asia, while at the same time fundamentally altering relations between the Global South and the North. The so-called Third World was a not inconsiderable mainstay of World War II, as battlefield, component of the wartime economy and recruiting ground. Colonial exploitation of natural and human resources, the plundering of raw materials (the uranium for the atom bombs came from the Belgian Congo) and agricultural products, the devastation wrought by acts of war (the destruction of subsistence economies) and the wartime economy are generally omitted from historical accounts. After the war, the reconstruction of France and Great Britain were effected with raw materials from the colonies, and colonial goods were used to pay off dollar debts to the USA. It was thus truly a *guerre mondial*, which did not have any real 'year zero'.

At the outbreak of World War II, Great Britain, the largest colonial power, presided over an empire that embraced a quarter of the world's population. France's colonial empire was twenty times the size of the 'fatherland' with over one hundred million inhabitants. Mobilization in the French colonies also began in 1939. The threat emanating from National Socialist racism was real enough in the African countries and was systematically exacerbated. By May 1940, in

North, West and Central Africa half a million soldiers had been recruited, generally by force, and transported across North Africa to Europe.[2] 'As we crossed the Libyan border on 18 November 1941', as the South African ambulance driver Frank David Kyzer put it, 'I experienced German stuka bomber attacks for the first time. It was hell, absolute hell, and I asked a comrade, "Just what are we doing here in this war?"' Around a fifth of the over five hundred thousand compulsorily recruited *Tirailleurs Sénégalais*[3] fell in the first months of the war and the Germans swiftly captured another ninety thousand.

## (NOUS SOMMES LES) INDIGÈNES (DE LA RÉPUBLIQUE)

The 'Third World' war victims were and are never counted. Not until independence in the 1960s do historical accounts of the formerly colonized peoples begin. In the 1990s, French West African veterans associations succeeded at least in ensuring they were no longer passed over in memory. Survivors are still fighting today for the same pensions as their fellow combatants born in France.

The feature film *Indigènes* (Days of Glory, literally 'Natives', 2006) by the Algerian director Rachid Bouchareb deals with North African soldiers as they make their way for Germany across France in winter.[4] The soldiers contributed considerably to the struggle for Europe's liberation. Yet their equipment was outdated, they wore sandals not boots, and their greatcoats were World War I stock. They were denied furlough and promotion. They were also vilified and subjected to chicanery.

*Indigènes* helped pass the debate on to the next generation. Rachid Bouchareb sees his 14.5 million–euro project not only as a historical redress, but as an aid to the immigrants' descendants in their search for identity. Touring the suburbs of French metropolises with film and actors, the director has stated: 'Adolescents need coordinates, role models and reasons to feel proud and hopeful. My heroes are their forefathers, men with courage who were ready to make sacrifices, children of France and the Republic one and all'. The offspring of immigrants and soldiers had already staked a claim to their rights under the motto 'Nous sommes les indigènes de la République' (We are indigenous members of the Republic).

'Jacques, you really must do something', Bernadette Chirac is reputed to have said after a private viewing at the Centre Pompidou in Paris. Punctually for the film's première, the Élysée Palace announced that pensions of the over eighty thousand surviving colonial soldiers would be brought up to those of the French 'ancien combattants' as of January 2008. The film received broad attention in France and triggered further discussion in the *banlieues*, whose populations continue to be discriminated by the French majority.

**1** The research that led to this essay was conducted during a residency at the Künstlerhaus Büchsenhausen in 2007, and was followed by the exhibition Liberation/Libération at the Kunstpavillon Innsbruck in 2008.
**2** Protests and subversive behaviour (speaking in indigenous languages, copying officers, forging paybooks, purloining and selling army materials, drinking methyl alcohol, strikes, absenteeism, feigned sickness) were rife among British colonial troops. In East Africa alone, some twelve thousand men deserted in 1944, and another fourteen thousand the following year. British officers were also occasionally shot or sent letter bombs.
**3** The 'Senegalese riflemen', as the colonial soldiers of French West Africa were called, had been conquering new territory for their colonial masters since the mid–nineteenth century. Napoleon III had formed the corps in 1857. By the start of World War I over a million men had been recruited. They were deployed for the first time in Europe in the Franco-Prussian war 1870–71. Military service for the fatherland became compulsory for the indigènes of French West Africa in 1919. These compulsory recruits were intended to fill the gaps in the French army left by the mass killing of World War I. After World War II, the tirailleurs sénégalais were deployed in colonial wars (1951–53 Indochina War in Cambodia, 1959–61 Algeria, and in putting down revolts in Lebanon, Syria, Madagascar, Tunisia, Morocco, Mauretania, Niger and Cameroon). At the end of the colonial era the corps was disbanded, the soldiers returning to civil life or transferring to new national armies.

## RED WAS IN THE AIR

More than thirty-five years ago the late Senegalese director Ousmane Sembène had addressed the subject of soldiers, mostly compulsory recruits, from the French African colonies in two feature films, *Emitai* (God of Thunder, 1971) and *Camp de Thiaroye* (Camp at Thiaroye, 1988).

Based on a real event in 1942, *Emitai* tells of awakening resistance in a Senegalese village when the French colonial power requisitions recruits and later the rice harvest. The recruits are shipped to Europe 'in defence of the fatherland', i.e. France, and to combat fascism. A poster of the new 'chief', de Gaulle, goes up in the village.[5] The women organize resistance.

In *Emitai* Ousmane Sembène addresses the period before wartime deployment, while *Camp de Thiaroye* begins with demobilization on African ground. West African soldiers from the various French colonies return to the transit 'Camp de Thiaroye' near Dakar, proud of having fought 'for France'. To communicate with each other, they speak the colonial language of French with their different dialects. Their journeys through numerous African and European countries are at an end.[6]

Thirteen hundred *tirailleurs* returning from Europe were transported from the port to the military camp. From here they were to return to their respective countries after receiving outstanding pay, dismissal allowances and other bonuses. Bad food, ill treatment and unpaid allowances became their daily bread. The francs they had brought with them from France were converted into the colonial CFA (Communauté Financière Africaine) currency and lost half their value.

When Vichy sympathizers tried to force the African soldiers back into old colonial patterns, Europe's black liberators rebelled. On 31 November 1944, French tanks surrounded the camp and opened fire at 5 a.m. The corpses of the former liberators were buried without coffins. The exact number who died is unknown. The documents on the subject are still 'top secret'. Entire French West Africa was shocked by the massacre and the news spread through the villages like wildfire.

In *Emitai*, but especially in *Camp de Thiaroye*, Ousmane Sembène addressed virtually forgotten history on the road to decolonialization. The director and writer, who died only recently, joined the French colonial forces in 1942, fought in the artillery and assisted in the liberation of Alsace. In 1947–48 he took part in the big railworkers' strike along the Dakar–Niger line, a key event in the politics of African self-determination. He worked as a docker in Marseilles, became a trade unionist and joined the Communist Party.

## OPERATION TORCH

On 8 November 1942 the landing of British and U.S. troops in North Africa with the support of mainly Jewish-Algerian resistance organizations — 'one of the rare Jewish victories in World War II' as Lucien Steinberg puts it in *La Révolte des Justes. Les Juifs contre Hitler* — broke Vichy's supremacy in Africa. De Gaulle set up the Central African colonial administration in Brazzaville and persisted in compulsory recruitment. The African soldiers constituted the bulk of the 'Free French Forces'. In 1944, the Allies drove the German troops out of North Africa, and the colonies under Vichy authority had to cede control to the Free French Forces. The Allies' advance from the Mediterranean began with the landing in Provence in August 1943. In November 1944, African soldiers reached Alsace and Lorraine.

Roberto Rosselini's episodic film *Paisà* (1946, script with Federico Fellini) tells six short stories of Italian, German and U.S. soldiers who meet in Italy in the course of the war's progres-

4  Indigènes has found no distributor or DVD outlet in the German-speaking world. The film received an award at the Cannes Film Festival 2006 and was nominated for an Oscar but lost to Florian Henckel von Donnersmarck's entry Das Leben der Anderen (The Lives of Others).

5  For a while African colonial soldiers of the Vichy regime under Marshal Philippe Pétain fought against troops recruited for the Free French Forces (Forces Françaises Libres) by de Gaulle. The governors of individual colonies had to decide for Vichy or the Free French Forces. Pétain always considered the colonies as under his control, and in the ceasefire negotiations with the Nazis declared himself ready to allow them a share in plundering the colonies.

6  My title derives from Brigitte Reinwald's study Reisen durch den Krieg (Journeys Through War) where she writes of the 'experiences and life strategies of West African war veterans'.

7  A wooden footbridge over the Inn is named after him.

8  Before de Gaulle's troops ceremoniously entered the liberated French capital, orders were given for the 'blanchissement' of the armed forces. While the Free French Forces marched under the Arc de Triomphe in Paris and were celebrated as liberators, the tirailleurs were waiting in transit camps in Central France to be repatriated. Or they were dispatched to the next theatre of colonial war.

sive ending there, from Sicily in 1943 to the Po Valley in 1945. In Naples a puppet-theatre 'moor' is contemptuously treated. Enraged, a black GI intervenes and finds himself on stage. The episode is part of the history of black soldiers who fought in Europe, Asia and Africa for liberation from fascism, and who were also colonized, or, as in the USA, discriminated and segregated.

The Rosselini scene recalls an incident in Ousmane Sembène's *Camp de Thiaroye*. When returning West African soldiers go out in American uniforms, they are welcome enough; but the moment people realize that they are not black GIs but African soldiers, they are thrown out of the bars and brothels of Dakar.

## TWO WOMEN

Vittorio de Sica's *La Ciociara* (Two Women, 1960, script: Alberto Moravia; with Sophia Loren, Raff Vallone and Jean-Paul Belmondo) is one of the few feature films to show not only soldiers of the Western Allies but also Africans. His Moroccan soldiers, however, who appear as grimaces and shadows, or in hordes, are heavily stereotyped and lack individuating features. Worse, at the end of the film they rape the two heroines in a church. The film—presenting a profusion of material on the chaos of war, Italian opportunism in the face of fascism, and diverse other nationalities, occupiers, liberators and forced labourers— went down in cinema history in particular because of the rape scene. Paths of flight, migration, retreat and attack cross and re-cross between Rome and Naples.

## MOROCCANS IN TYROL

Austria, like Germany, was partitioned among the four victorious Allied powers. The respective capitals of Vienna and Berlin were likewise divided for years into four sectors. That the French army would one day march into the former administrative district of Tyrol-Vorarlberg as well as Vienna and oversee the country's transition into peace could not be foreseen until shortly before the end of the war. Not until the end of 1944, thanks to de Gaulle's intervention 'from the depths of the French colonial empire' (Klaus Eisterer, Institut für Zeitgeschichte, University of Innsbruck), did France receive a seat on the 'European Advisory Commission' and join the military administration alongside the USA, Great Britain and the USSR. The French troops arrived tardily in Tyrol, taking over the sector from the swifter U.S. troops on 4 July 1945. General Marie-Émile Béthouart, a former soldier in Morocco, was the first military governor based in Innsbruck.[7]

Two rooms on the ground floor of the present Tyrolean Galerie in the Taxispalais served the French occupiers as documentation centre and library as early as 1945. In 1951, an Indochina exhibition was on show here, Indochina being colonially allied with France in the

Vietnam War. In July 1945, the French propaganda office, the so-called 'Direction de l'Information', took up its work in Innsbruck, but was transferred to Vienna in November. The 'Direction de l'Éducation et des Beaux Arts' responsible for education, intellectual exchange and denazification, which had been set up in August 1945, remained in Innsbruck. The French Cultural Institute Innsbruck, opened in July 1946, still testifies today to the French presence in postwar Tyrol.

Postwar Austria was to be detached from the German Reich and the German-Italian Axis smashed. Already at an early stage the French were profiling the country as a victim of National Socialism. Troops moving in were greeted with 'Ici l'Autriche Pays Ami' (Here Austria, friendly country) to make the point that Austria, unlike Germany, had been liberated and not conquered. General de Gaulle even described Austria as the 'key to Europe', meaning eastern Europe, which in the event came under the Soviet Union's sphere of influence in the Cold War.

More than half of the 550,000 men fighting in the French army in 1944 had crossed the Mediterranean to defend the 'fatherland'. They came from the Maghreb and Subsaharan francophone West Africa to liberate Europe from fascism. A little-known fact is that contingents of Moroccan soldiers recruited by the colonial power formed a large part of the thirty thousand–strong French army presence in Austria. The occupying forces were made up to begin with by the 4th Moroccan Mountaineers Division, which crossed the border to the Tyrol-Vorarlberg district on 29 April 1945, followed by the 2nd Moroccan Infantry Division, which proceeded to Landeck in Tyrol.

As early as September 1945 the Moroccan units were relieved by the 27th Mountaineers Division from Grenoble consisting of (white) French resistance troops. This was known as 'le blanchissement' (the whitening/whitewashing).[8] With the increase in military operations on the Indochinese front the remaining troops were withdrawn from the French occupied zone almost completely in 1953.

## RAPOLDI PARK

Headlines such as 'Tougher Crackdown on Moroccan Scene', 'Deportation Custody for Moroccans without Papers' and 'North African Criminal Scene in Innsbruck' set the current tone of local political debate in the regional capital Innsbruck. 'Moroccans' as 'criminal elements in the Rapoldi Park scene' here are synonymous with 'drug dealers'. The local city newspaper quotes the Austrian Interior Minister Günther Platter with the words: 'Innsbruck must be made as unattractive a location as possible for these people'. The provincial governor of Tyrol, Herwig van Staa, has even called for detention camps for 'criminal asylum seekers'.

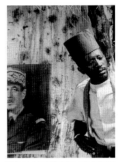

The recruits from a Senegalese village are shipped to Europe to defend the 'fatherland.' A poster of the new 'chief,' General de Gaulle, goes up and replaces the one of fascist friendly, Marshal Pétain.
Ousmane Sembène, *Emitai* (1971)

The murdered corpses of the former liberators of Europe were buried without coffins near Dakar, Senegal.
Ousmane Sembène
*Camp at Thiaroye* (1988)

Eric Deroo / Antoine Champeaux,
*La force noire. Gloire et infortunes d'une légende coloniale* (2006)

Every Monday at midday, the city's Youth Welfare Office offers cous-cous and mint tea at the Z6 youth centre. Streetworker Mor Dieye is there to help the young North African men, among other things in their dealings with the authorities. Himself from Senegal and a prac-tising Muslim, Dieye learned Arabic while studying in Cairo, is married to a Tyrolean woman, and enjoys the trust of these youths. For four years now there has been an increase in youths from the Maghreb living in Innsbruck and pushing light drugs obtained via connections to Italy. They are regulars at homeless centres, and some of them still know each other from when they were street children on the mar-gins of Casablanca.

Some of the youths have Austrian girlfriends and are already fathers. As with the 'occupation children' of binational relationships after 1945, this has caused a considerable stir in the media. There are still many postwar offspring of liaisons between Moroccan fathers and Austrian women who are not prepared to talk publicly. Born in 1962, the author and psychologist Hamid Lechhab, who moved to Vorarlberg for love, began recently to organize trips with a few 'occupation children' to the land of their fathers.

## FROM/TO EUROPE

European troops—the British army against the German Africa Corps, for instance—fought on the battlefields of North Africa, while African soldiers marched through France, Italy, Germany and Austria. D-Day in particular, the invasion of the Normandy coast by Allied troops in 1944, is generally picked out for special attention by the media. What this overlooks is that the struggle for an antifascist Europe was also waged from the south via the Mediterranean and sweeping across France, Italy and the Alps. Paths, attacks and rearguard actions may have touched each other. From the North's perspective, 8 May 1945 is the day of Europe's liberation from fascism, fought for by soldiers from throughout the world and, in no small part, by soldiers from the African continent. This is something their children can be proud of.

Moroccan soldier approaches the young refugee.
Vittorio de Sica
*Two Women*
(1960) Film Still

On the cover of the Tyrolian Newspaper Neue ‚no more compassion for criminal asy-lum seekers'
*Internierungslager*
Photograph: Jochen Becker
(Translated from the German by Christopher Jenkin-Jones)

Further Reading
Klaus Eisterer, ed., *Tirol zwischen Diktatur und Demokratie (1930–1950)* (Innsbruck: StudienVerlag, 2002)
Hamid Lechhab, *Mein Vater ist Marokkaner. Die vergess-enen Kinder des Zweiten Weltkriegs in Vorarlberg* (self published)
Brigitte Reinwald, *Reisen du-rch den Krieg: Erfahrungen und Lebensstrategien westafri-kanischer Weltkriegsveteranen* (Berlin: Klaus Schwarz Verlag, Zentrum Moderner Orient, 2005)
Rheinisches JournalistInnen-büro, *Unser Opfer zählen nicht: Die Dritte Welt im Zweiten Weltkrieg* (Berlin: Ver-lag Assoziation A, 2005)

# EUROPE OF CAMPS
## T.J. DEMOS

In *Foreigners' Camps in Europe and in Mediterranean Countries*, a 2007 map by the migrants' rights collective Migreurop, the region is shown riddled with detention centers.[1] There are camps for those awaiting examination of their admission requests, camps for the soon-to-be-deported, and informal camps, mostly in North Africa, built by clandestine travelers. It is in view of such proliferating spaces of enclosure that Xavier Arenós created his likeminded map. *Schengen, the Castle* (2008) similarly portrays Europe as an environment of segregation, a walled continent, combining blocks of text that describe the effects of the Schengen agreement, which has transformed Europe's interior into a borderless area, with documentary images of migrants stationed around its periphery who attempt to gain access to that well-guarded land. The point of these projects is to chart—and equally to contest—Europe's transformation into a stratified cartography, one constituted by increasingly controlled social, political, and economic hierarchies.

What does it mean to exist in the midst of this conflicted region, divided between the space of legal citizenship and the camps for criminalized immigrants? Living and traveling in Europe, one comes across few signs that these spaces of containment and segregation pockmark the continent. The enjoyment of relatively easy and affordable transportation within Europe, in other words, disguises the rarified privilege of such mobility, at least when considered in relation to the larger global context in which travel is now strictly regulated. The invisibility of these immigration camps is all the more striking, moreover, as Europe has become so thoroughly cosmopolitan, with multiple languages on the street continually within earshot and the appearance of denizens always heterogeneous and foreign. And it is this Europe that is commonly vaunted by historians, policy makers, and politicians, who praise it as 'a paragon of international virtues'. As American economist Jeremy Rifkin writes, 'the European Dream' in contrast to the largely discredited American one, now mired in unilateral militarism and obsessed with free-market liberalism, 'is a beacon of light in a troubled world. It beckons us to a new age of inclusivity, diversity, quality of life, deep play, sustainability, universal human rights, the rights of nature, and peace on Earth'.[2]

Such a utopian view as Rifkin's is surprising, for it indicates no awareness of the fact that the new age he describes—defined by inclusivity, diversity, and universal human rights—conceals a nearly invisible level of strict control, criminalization, and incarceration, which awaits multitudes wishing to gain access to that 'European dream'. Europe consequently turns into the site of a deep contradiction: on the one hand, we speak of its cosmopolitanism, freedom of self-determination, and open society; on the other, its paranoid sense of security and xenophobia, which has given rise to what Migreurop calls the 'great confinement', recalling a term used famously by Foucault to characterize the mode of generalized imprisonment originating in the seventeenth century.[3] The 'European dream,' it appears, masks a nightmare of historical regression. The contradiction could not be greater. Celebrating freedom of mobility within its walls, the EU refuses that freedom to outsiders. And it is precisely this regime of separation—between zones of legality, rightful belonging and political representation

and those of illegality, exclusion and political negation—that defines a particular aspect of what Étienne Balibar recently diagnosed as a 'virtual European apartheid', a phrase used 'to signal the critical nature of the contradiction between the opposite movements of inclusion and exclusion, reduplication of external borders in the form of 'internal borders', stigmatization and repression of populations whose presence within European societies is nonetheless increasingly massive and legitimate'.[4] Voiced as merely one of several possible futures, Balibar's worst-case scenario seems to be moving toward realization today.

In fact, rather than inaugurating a new era of freedom, the Schengen Agreement, upon which Arenós bases his map, established the same 'contradiction of opposite movements' of which Balibar speaks. Realized between 1985 and 1990, Schengen both abolished physical borders among participating European countries and instituted the standardization and cooperative enforcement of external border controls.[5] In attempting to erase the divisions *between* European countries, in other words, it has expanded and exteriorized those divisions to the international register of economic, social and political relations. In this regard, the accord coincided with Europe's move toward globalization—particularly in the post-wall years following the beginning of the dissolution of Soviet Bloc countries in 1989—as well as mirrored its own contradictions. Globalization may refer to worldwide economic and political integration, designating open borders, free trade zones, and transnational structures in the form of administrative, corporate, and representative bodies, which for Balibar suggest so many 'postnational cosmopolitan anticipations'.[6] However, even as globalization creates smooth spaces of (primarily) economic mobility—as has the Schengen agreement—it transposes local and national mechanisms of inequality to the supranational level, creating regions of economic and political privilege well protected from the undeveloped, impoverished, and unfree areas outside its terrain. Whereas in years past commentators articulated the hope that the formation of the European Union would uphold democracy and popular sovereignty in the face of the economic and political pressures of globalization, recent analyses have argued conversely that 'the EU is overwhelmingly about the promotion of free markets [...] regnant in this Union is not democracy, and not welfare, but capital'.[7]

Not surprisingly, one finds the same extremes and contradictions in recent developments of artistic practice. The period since the institution of Schengen has coincided with the emergence of the now well-established and often celebratory cultural discourse of 'nomadism', according to which artistic identities—from practitioners to critics, from curators to dealers and collectors—are said to be given over to itinerancy. As artworks have become dispersed across media, whether dematerialized as digital transmission or easily transportable DVDs, and ungrounded from specific geographical location, biennial exhibitions and art fairs have provided the new playing field for the global art world, figuring as so many sites of diasporic experience and endless exchange.[8] One sees the same 'transnational cosmopolitan anticipations' in these developments, even if at times they inspire romantic idealizations.[9] While the origins of this recent trend can be found in the 'nomadology' of Gilles Deleuze and Félix Guattari, first mentioned in their book *A Thousand Plateaus*, published in 1980, the complexity of their account is often lost on those who celebrate the nomadic. While Deleuze and Guattari hoped that the forces of dispersion and mobility would variously contest the 'despotic state apparatus', rigid economic structures, the reification of identity, and the hierarchical stratifications of space, they also warned that deterritorialization could play into the very hands of flexible capital, fueling adaptive 'military-industrial, and multinational complexes'.[10] This contradiction retains

1  Conceived out of a workshop devoted to 'The Europe of Camps' at the European Social Forum in Florence, November 2002, Migreurop represents 'a network of activists and scholars' aimed at spreading knowledge about the complex reality of migration and camps, and organizing exchanges between different action groups to facilitate action against illegalizing migration. For further information and further online versions of their maps, see http://www.migreurop.org.

2  Jeremy Rifkin, *The European Dream: How Europe's Vision of the Future is Quietly Eclipsing the American Dream* (New York: Penguin, 2004); cited in Perry Anderson, 'Depicting Europe', *London Review of Books* (20 September 2007).

3  See: http://www.migreurop.org/article643.html?lang=en; on the 'great confinement', which for Foucault represented 'an institutional creation peculiar to the seventeenth century' insofar as it designated 'an economic measure and a social precaution', see Michel Foucault, *Madness and Civilization: A History of Insanity in the Age of Reason* (1961), trans. Richard Howard (New York: Vintage, 1988), 63–64.

4  Étienne Balibar, *We, the people of Europe? Reflections on Transnational Citizenship*, trans. James Swenson (Princeton: Princeton University Press, 2004), x.

5  The Schengen Agreement was signed on 14 June 1985 by France, West Germany, Belgium, Luxembourg, and the Netherlands. The 1990 Convention Implementing the Schengen Agreement put the agreement into practice. Today, a total of twenty nine states—including twenty-five European Union states and four non–EU members (Iceland, Norway, Liechtenstein and Switzerland)–are signatories to the full set of rules in the Schengen Agreement, with most having implemented its provisions.

its relevance today, the danger being to proclaim the virtues of nomadism without awareness of the cost and limits of its freedoms, as if its 'post-national cosmopolitan anticipations' didn't cast the dark shadow of 'virtual European apartheid'. The solution, however, is not merely to critique the terms of nomadism as privileged and elitist; rather, this freedom of mobility should be universalized as a fundamental right of all.

To date, Schengen's cruel effect has been the creation of a vast terrain of excluded people, economic deprivation, and political repression outside Europe. One could have expected so much given the recent handling of European security, which the EU has effectively subcontracted to countries in North Africa and the Middle East, offering them economic incentives of development aid for the control of their population flows.[11] Because the EU habitually overlooks human rights abuses and selectively funds governments on the basis of the effectiveness of their border controls, the enforcement of security has led, not surprisingly, to the criminalization of emigration, as governments such as Morocco's and Libya's have made it illegal for inhabitants to exit their countries without the consent of the increasingly restrictive authorities.[12] The consequence is the virtual imprisonment of whole populations, giving rise to a system that all too conveniently feeds into the markets of deregulated labor and cheap manufacturing in those areas, which, as exploited by the EU, supports its own goals of profit and prosperity, even while cheap travel and free mobility are celebrated within Europe irrespective of the costs.[13]

When migrants do make it out of their countries of origin—normally at great economic cost and physical hardship—the camps that greet them are not simply spaces of containment; more fundamentally, they operate to keep foreigners at a distance, both spatially and legally, from the communities of host countries.[14] While this mechanism of separation is meant to fend off the perceived loss of Europe's distinctive cultural character to the invading hordes, the installation of camps corrodes that character by other means, for it negates European claims for safeguarding human rights, including the freedom of mobility, and ends up withdrawing those rights from the migrants it imprisons. For inside the camps, 'there is no freedom of movement; basic rights to asylum, to family life and private life, as well as minors rights are not guaranteed, while inhumane and degrading treatments are often perpetuated'.[15] One might argue that the presence and function of camps is merely an anomaly in a Europe whose true colors are democratic and humane. Yet given the growth and permanence of these installations, this conclusion seems inaccurate. Indeed, for Giorgio Agamben, the camp represents a state of exception that has become the rule, proposing nothing less than the 'new biopolitical *nomos* of the planet'.[16] In Agamben's reading, now well established over several

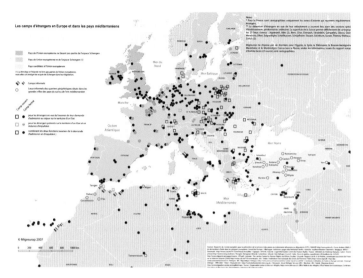

Les camps d'étrangers en Europe et dans les pays méditerranéens

© Migreurop 2007

Migreurop
*Foreigners' Camps in Europe and in Mediterranean Countries*
(2007)

**6** Balibar, *We, the People*, viii.
**7** Anderson, 'Depicting Europe'; On the democratic deficit of the EU, see Jürgen Habermas, 'Opening Up Fortress Europe' (2006), http://www.signandsight.com/features/1048.html (consulted June 2008).
**8** On the ungrounding of site-specificity, see Miwon Kwon, 'One Thing After Another: Notes on Site Specificity', *October* 80 (Spring 1997). On the biennial as proposing a 'diasporic public sphere', see Okwui Enwezor, 'Mega-Exhibitions and the Antinomies of a Transnational Global Form', *Manifesta Journal* 2 (Winter–Spring 2003–2004). Not least of these developments has been the formation of Manifesta, the 'nomadic' pan-European biennial. However, to its credit, Manifesta established itself in the mid-90s as a platform for *questioning* sites of geographical diversity and conflict within Europe and between the local and the global, rather than merely rejoicing in the region's newfound borderless space.
**9** Such idealizations are questioned and problematized in James Meyer, 'Nomads', *Parkett* 35 (May 1997), which distinguishes between lyrical nomads (Gabriel Orozco and Rirkrit Tiravanija) and critical nomads (Christian Philipp Müller, Andrea Fraser, Renée Green, Mark Dion); and also Carol Becker, 'The Romance of Nomadism: A Series of Reflections', *Art Journal* (Summer 1999).
**10** Gilles Deleuze and Félix Guattari, *A Thousand Plateaus: Capitalism and Schizophrenia*, trans. Brian Massumi (Minneapolis: University of Minnesota Press, 1987), 387.

books, current forms of sovereignty are directly proportionate to the authorization of spaces of legal exception (witness the growth of American presidential authority in George W. Bush's administration precisely via the capacity to maintain spaces of exception outside U.S. territory, such as the detention center at Guantánamo Bay). But the very logic of the camp turns its solution into a crisis: by including others on the basis of exclusion, nation-states incorporate increasing numbers of people without political rights, giving rise to a two-tiered political situation divided between citizens and residents that is clearly untenable (are 'human rights' contingent upon nationality, or are they truly universal?). It is precisely this growing 'zone of indistinction between the outside and the inside' that defines the Europe of camps today.

Ironically, externalizing security to repressive non-European countries ends up exacerbating poor living conditions abroad and provides further motivation for escape, driving, in turn, fears of invasion within Europe. And this logic has only intensified since September 11, 2001 and the subsequent and ongoing wars in Iraq and Afghanistan, as well as the continuing crisis in Lebanon. In response to these geopolitical upheavals, illegal migration, once associated largely with drug trafficking, has consequently become infused with terrorist threat. 'More and more, the migrant is depicted as the enemy, and "war" vocabulary is often used to describe the situation and to act against it: military equipment for controls at sea, high technology, walls and barriers, camps and collective expulsions'.[17] In European media and politics, one now confronts a paranoia of foreigners, particularly from North Africa and the Middle East, tied to the menace of terrorism as much as to a feared Islamicization, which, even more than the main-

stream's annoyance at non-assimilative cultural divergence, appears to threaten Europe's secu-
lar, democratic, and socially liberated makeup. Under such conditions, popular support for
Balibar's notion of 'transnational citizenship', advocated only a few years ago, seems remote
at best. Rather the opposite: governments continue their movement rightward with ever more
politicians elected on the basis of anti-immigration policies and xenophobic fear mongering.[18]
It seems 'European apartheid' is winning out.

How can we reverse this trend, challenging the movement toward social and political sepa-
ration with a more inclusive model of citizenship—a 'political identity that is open to continu-
ous admission of new peoples and cultures in the construction of Europe', as Balibar propos-
es[19]—or even with a modeling of some innovative form of life beyond citizenship that could
guarantee rights for all? Agamben proposes the construction of a new political philosophy
starting with the figure of the 'refugee', which brings the 'originary fiction of sovereignty to
crisis', for it ruptures the naturalized connection between nativity and nationality—as if rights
must be founded upon birth, and being human necessarily entails being a citizen—which de-
fines modernity's political-juridical categories.[20] If that originary fiction is rejected, then citizen-
ship would cease to function as the basis for either collective identification or social exclusion.
In that case, a 'Europe of the nations' would no longer protect the '*ius* (right) of the citizen',
but rather would secure 'the *refugium* (refuge) of the singular', and would thus define 'an ater-
ritoriality or extraterritorial space' in which 'the status of European would then mean the be-
ing-in-exodus of the citizen'.[21] The advantage of such a dislocation is that it entails both the
identification with those who are displaced—via 'a series of reciprocal extraterritorialities [...]'
where exterior and interior in-determine each other', as Agamben notes—and the recognition
of oneself as ultimately nonidentical to one's ethnic, racial or national community.

Given that matrix of identification and estrangement, what would it mean to reconstruct
Europe as a refuge of the singular? Agamben provides no specific answers—elsewhere he
claims it represents the politics of a coming community—and it is at this point that we might
turn to artistic practice for imaginative and experimental proposals for a critical rethinking of
geographical space and political being. There are numerous ways that such a 'topological in-
determination' of citizen and migrant has been advanced by recent artistic and exhibition
projects, of which I will only cite a few examples.[22] Among the foremost artistic ones, in my
view, involve creative documentary approaches—both in photography and video—that pro-
pose unconventional relations to figures that flee nationality (as in Yto Barrada's *A Life Full of
Holes—The Strait Project* [1998–2004], a suite of photographs that capture Moroccans in tran-
sit), or that place the spectator in the role of being-in-exodus (as in Steve McQueen's *Pursuit*
[2006], offering a luminous installation of sensory defamiliarization). Other compelling projects
may analyze the individual stories of exile (as does the work of Emily Jacir, particularly her re-
cent installation *Material for a Film* [2007], detailing the tragic life of Palestinian Wael Zuaiter);
or they may situate the desires for migration historically and politically (as in the various video
essays of Ursula Biemann); each of these cases shatter prevailing stereotypes that distance
refugees and migrants in the same way that camps enclose them within their walls. These ex-
perimental aesthetic forms have the advantage of establishing modes of proximity, even inti-
macy, with migrants that foster compassionate identifications; alternately, they may also evoke
antagonisms that provide pause to automatic behavior, provoking critical self-scrutiny in rela-
tion to the European treatment of migrants.[23]

Another route that collapses the distance between citizen and migrant has been the crea-

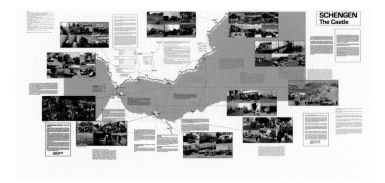

Xavier Arenós
*Schengen, the Castle*
(2008)
Courtesy the artist

**11** See Ali Bensaâd, 'The Militarization of Migration Frontiers in the Mediterranean', in *The Maghreb Connection: Movements of Life Across North Africa*, ed. Ursula Biemann and Brian Holmes (Barcelona: Actar, 2006).
**12** As the president of Migreurop Claire Rodier points out, the criminalization of emigration is in contravention of article 13, point 2 of the Universal Declaration of Human Rights, signed by all UN member states, which states that 'Everyone has the right to leave any country, including his own, and to return to his country': '"Emigration illégale": une notion à bannir', *Libération* (13 June, 2006).
**13** On these different overlapping and interconnected economies, see the analysis presented in *Schengen, the Castle.*
**14** 'By camp, Migreurop means as much as a process as a physical space: isolating and rallying foreigners does not only occur with the creation of closed centres. "The Europe of camps" is the whole set of devices that forces the disruption of migration paths. Preventing people to cross borders, to enter territory, assigning them to "residence"—legally or by police harassment—locking them up to ensure the possibility to escort them back, jailing them to punish the crossing of borders, those are some forms of this "Europe of camps". At the present time, police camps may appear covered under humanitarian necessity: despite an official rhetoric of compassion and euphemism, it is nothing more than the exact opposite policy that is carried out in the EU to isolate foreigners'. http://www.migreurop.org/article643.html?lang=en
**15** Migreurop, 'Definition of Camps'.
**16** Giorgio Agamben, 'What is a Camp?' (1993), in *Means without End: Notes on Politics*

tion of interventions in public space, which facilitate the expression and interrogation of relations to the socially and politically excluded. For instance, consider Ayreen Anastas and Rene Gabri's *Camp Campaign* (2006–07), which investigated the present and historical circumstances of the camp in the United States via a process-based project comprising extensive research and discussions with different publics, travel across the United States, video documentation, and interviews with activists and artists made available online.[24] The result critically placed the detention center at Guantánamo Bay in relation to other historical camps, bringing out a longstanding paradigm of legal exception that has been constitutive of America's political formation. Also exemplary is Christoph Schlingensief's *Foreigners Out!* (2002), for which the artist housed twelve refugees in a container placed near the steps of Vienna's Opera House, and ran a website where the Viennese could vote, Big Brother–style, for one deportation per day. Schlingensief's political theater performed sardonic interpretations of the extreme rightwing policies of Jörg Haider's recently elected Freedom Party government, eliciting their fascist roots and present dangers. Consider as well Pawel Althamer's *Fairy Tale* (2006), for which the artist used his invitation to the Berlin Biennial as a platform for social change. Althamer wrote to Berlin's interior minister to save an eighteen-year-old Kurdish man, Besir Oclay, from imminent deportation, spending the artist's cultural capital to direct media attention toward the cruel fate of one individual caught up within Germany's harsh treatment of noncitizens. Each of these projects brought about the opportunity for a dis-identification from current regimes of separation, whether by intimating the historical catastrophes that have resulted from such policies, or by creating platforms for political opposition that splinter the homogeneous image of the public and perforate the divisions between interior and exterior, citizen and migrant.

Might these projects, lastly, contribute to a redefinition of the EU as the site of a critical regionalism? If so, then they must develop further what Kenneth Frampton theorized as its 'dialectical expression'—that is, a force that would both contest the 'rapacity' of

economic globalization's homogenizing tendencies by cultivating local values and differences, and oppose the reactionary return to 'autochthonous elements' by learning from 'paradigms drawn from alien sources'.[25] If the interventions of current art reanimate these strategies, then critical regionalism cannot merely lead to a philosophy of cosmopolitanism celebrated solely within Europe's frontiers; rather, its 'dialectical expression' must take into account the global position of the EU vis-à-vis its outside, as well as consider the regional correspondence between its internal borderless space and its detention centers for migrants. Frampton suggests that the 'enclave' offers a way to conceive of a 'bounded fragment [posed] against [...] the ceaseless inundation of a place-less, alienating consumerism'.[26] Yet while his argument is careful to reject any regressive return to the nostalgic or populist vernacular, the rearticulation of critical regionalism today must be careful as well to resist the transformation of the 'enclave' of cultural distinctiveness into a community guarded against the residency of alien *people*. The enclave, in other words, must be 'topologically perforated'—to return to Agamben's strategy—in relation to the camp, where inclusion and exclusion are mutually cancelled, opening up the path toward a more flexible modeling of political being based around transnational existence. Given today's pervasive atmosphere of fear and aggression toward foreigners, the expectation of such a change in popular attitudes appears unlikely. Yet the answer is not to dismiss these creative proposals as naive or idealist, for this would only represent a surrender to the defeatism that drives political disengagement and serves the interests of those in power. Rather, let us animate these proposals with renewed urgency.

(Minneapolis: University of Minnesota Press, 2000), 45. Also see Giorgio Agamben, *State of Exception*, trans. Kevin Attell (Chicago: University of Chicago Press, 2005).
**17** Migreurop, 'From European Migration and Asylum Policies to Camps for Foreigners'.
18 Witness the return to power of Italian Prime Minister Silvio Berlusconi, as well as the recent election of Rome's neofascist mayor, Gianni Alemanno, running on a notorious anti-immigration platform.
**19** Balibar, *We, the People*, viii.
**20** Agamben, 'Beyond Human Rights', in *Means without End*, 21.
**21** Ibid., 24–25.
**22** A sampling of recent exhibitions that have investigated the present conditions of migration today include *No Place—Like Home: Perspectives on Migration in Europe* at Brussels' Argos, 2008; *Port City: On Mobility and Exchange* at Bristol's Arnolfini, 2007; the Vanabbemuseum's *Be(com)ing Dutch*, 2008; or Berlin's Kunstwerke's *B-ZONE: Becoming Europe and Beyond*, 2005–06.
**23** I have analyzed much of this work over the course of several essays, including 'Life Full of Holes', *Grey Room* 24 (Fall 2006), 72–88; 'Sahara Chronicle': Video's Migrant Geography', *Geobodies: The Video Essays of Ursula Biemann* (Umea, Sweden: Bildmuseet, forthcoming, 2008); and 'Emily Jacir: Poetry's Beyond', *Hugo Boss Prize 2008* (New York: Guggenheim Museum, forthcoming, 2008).
**24** For more information, see *Ayreen Anastas & Rene Gabri: Camp Campaign* (New York: Art in General, 2008).
**25** Kenneth Frampton, 'Prospects for a Critical Regionalism', in Kate Nesbitt, ed., *Theorizing a New Agenda for Architecture* (New York: Princeton Architectural Press, 1996), 472.
**26** Frampton, 'Prospects for a Critical Regionalism', 482.

# DON'T EXPLAIN
## ERDEN KOSOVA

At some point during our early formation someone comes up and tells us that there is actually a social unit that is larger than our family and the group of people in our immediate vicinity. We are told that there are a certain number of units like this. They are said to be specified by cultural differentiations and shaped by untraceably lengthy chunks of time. My own experience with this teaching has been a problematic one. During childhood I failed to establish a full sense of identification with this large unit called the nation, due to some complexities in my background, and other reasons, like an obsession with a certain colour as a result of a strong affiliation with a particular football club. Later, when at university, on account of affiliations with organizations and publication projects whose radical politics were not only critical of the fictive character of national identity but also claimed to produce nonessentialist forms of belonging to one's own territory, my distance from an imposed sense of national belonging reached its limit. Finally, my recent geographical mobility occasioned by links to academic and art institutions brought me to a point where I could finally assure myself that I was now standing 'outside'. This position of exteriority has recently become unstable.

During an exhibition project I co-curated in Cyprus three years ago, I came up against some criticisms (aside from the constructive ones) that occasionally became resentful in tone. This resulted in the curatorial team becoming branded with certain names. I was called 'yet another colonizer from Istanbul', and more pejoratively 'the Turk'. There is perhaps nothing peculiar about this. Many people suffer from this kind of abuse, but it was, genuinely, my first experience of having my worldly existence reduced to a single dismissive word specifying a national and ethnic identity. In the last couple of months I have been faced with the opposite extreme of this 'this is what you are' attitude. Some groups, motivated by nationalism, within the field of art in Istanbul have branded me, and also a number of my colleagues from the local contemporary art scene, as a traitor to national interests, and more blatantly, as a promoter of ethnic conflict within the country. But when did this fierce nationalist rhetoric enter into the field of art (or has it been always there) and when exactly did I enter into this minefield?

## STRATEGIES

The work that inspired me to concentrate more closely on the ways in which issues of national identity were being employed by contemporary artists was a video installation by Erzen Shkololli, exhibited at Manifesta 4. *Hey You* (2002) consisted of a film of Skurte Fejza performing in traditional Albanian dress. Fejza's song, contrasting with her historical costume and folkloric musicality, had lyrics that made direct reference to the immediate political agenda by addressing Europe in a tone of complaint and commenting on the suffering of the divided people of Albania. Her hypnotic voice—bare and touching—her unconstrained forward looking pose, and the film's dreamlike atmosphere, effortlessly grabbed the attention of the audience. I was informed about Fejza's troubled background. Her music was constantly criticized for its patriotic content, but Shkololli was a resident of the Kosovar city of Peja, so I was puzzled about how to relate these two details. How did the artist situate himself in relation to his sub-

ject? In comparison with other works by the artist, *Hey You* was ambiguous with respect to the position of the artist within the work. In a later photographic work, the hilariously funny *Albanian Flag on the Moon* (2003), Shkololli detourned an iconic image from recent history by making the national flag of Albania (and problematically also of Kosovo) appear to have been placed on the moon. He managed to establish a cunning and ironic matrix of the absurdities of a disproportionately enthusiastic nationalism and the peculiar status of Kosovar territory, in terms of international law. The fact that the Albanian flag *was* actually carried to the moon by the U.S. astronaut Alan Shepard (who was of Albanian origin) in 1971 was also a playful comment on contemporary politics. But could a similar sense of irony, and political commentary, be found in *Hey You*? Did the work's blankness run the risk of endorsing the content of the sung lyrics? Are we entitled to expect from contemporary artists an awareness of all the possible implications of their work and that they maintain a distance between themselves and their subjects?

For an exhibition entitled *Speculations* (Plaform Garanti, Istanbul, 2003), a curatorial collaboration with Vasif Kortun, we paired Shkololli's work with two other videos. One of those, Vahit Tuna's *Europe, Europe Hear Us* (2000), was composed of shots of an empty football pitch and the aggressive gestures and chanting of a hooligan supporting the Turkish national team. The hooligan, played by the artist himself, recited the then widely popular song chanted at the stands whenever Turkish clubs played against European teams. The lyrics were of an excessively sexist, fascist and 'anti-imperialist' nature. Reminiscent of Anselm Kiefer's early photographic work (*Besetzungen*), in which he is pictured giving the Hitler salute in the public squares of various European cities. In Kiefer's work the size of the public squares dwarfs and ironizes his isolated presence. Tuna's enactment of the hooligan took a humorous twist because the neglected and underdeveloped state of the pitch, and its surroundings, made the nationalist rhetoric sound ridiculous.

The experience with *Speculations* led me to focus on critical tools used for interrupting the absolutist call for full identification with the nation. I came across plenty of works that contained strategic identifications, as in Shkololli's *Albanian Flag* and Tuna's *Europe, Europe*, which set to displace the quoted ideology in the content through irony. The Ljubljana-based music group Laibach and the artist group IRWIN pushed irony to the extreme and formed a mode of 'overidentification' that created an ambiguous zone, in which the critical stance of the work is rendered unreadable or suspiciously complicit. Still, the grotesque and exaggerated eclecticism of Laibach's concerts, set between the iconography of conflicting authoritarian ideologies or the juxtaposition of a number of tropes of nationalisms with an equal distance consequently stripped them from their monopolistic claims for identity and superiority. The thirteen plus one national anthems that are brought together on their album *Volk* (2006) positions the audience in relation to a critical investment in a strategy of overidentification. Similarly blurring the distinction between overidentification and nonidentification, IRWIN's performances with NSK embassies challenge the limits of the sovereignty of existing nation-states, whilst contemplating the possibility of alternative governance. One that is not bounded by ethnicity and that discloses the absurdity of reproducing state rituals, like official paperwork, when cut off from a sense of national belonging.

Periods of political crisis and territorial conflict may reinforce an upfront and engaged critique rather than ironic distance. *Gott Liebt die Serben*, a series of installations by Rasa Todosijevic produced throughout the nineties, were courageous warnings against the ongoing

militarization of Yugoslavian society, the adoption of national socialism, and the ethnically mo-
tivated violence that was traumatizing the region. Along with her other works, Milica Tomic's
video installation, *XY Ungelöst* (1997) operated as a reminder of a veiled act of violence com-
mitted against the Kosovar Albanians by the Serbian armed forces back in 1989 (and as a
warning of things to come in the following years). In Turkey, Hale Tenger's works from the
early nineties onwards took the form of atmospheric installations whose elements built up na-
tional allegories based upon themes of self-imposed detention, introversion, militarization
and violence. The works of these and similarly motivated artists certified that the authors had
openly resisted the hasty calls for union around nationalist causes in times of crises. They
disassociated themselves from official politics and tried to deconstruct ongoing discursive
manipulations, and lamented crimes inflicted that led to civil wars, massacres and ethnic con-
flict, whilst pleading for political lucidity and common sense unbiased by fanaticism.

Other artists pursued a slightly different path, in which they retained a critical tone against
nationalism and other essentialist ideologies, but they also made it clear that their criticality
was implicated by the discursive field in question. It relied upon a perspective from within. Avi
Mograbi's flim works that combined methodologies of fiction and documentary are examples
of this prudent criticality. In *How I Learned to Overcome My Fear and Love Ariel Sharon* (1997),
Mograbi gave an account of how his outright hatred of Sharon gave way to complex emotions
and thoughts (fictional or not) after establishing intimate contact with him whilst filming his
political campaign. By acknowledging the fact that one has to inhabit the same territory as
people whose political and cultural orientations are unbearably different, and that besides the
apparent drastic divergences one might share similarities with a political enemy, a self-reflexive
view on political criticism was opened up.

In *Happy Birthday Mr. Mograbi*, the artist deconstructed, as he had with other works, the
myths that had been employed in building up the Israeli state. Yet, by focusing on the coinci-
dence that his birthday and that of the state of Israel coincide on the Hebrew calendar, Mograbi
set up a filmic game in which his personal fate ironically tied to him to the life of the state.

## CONTEXT

All the examples cited above hint at the conviction that any artistic practice has to be critical
of, or at least distant from, nationalist thinking. This conviction is apparently informed by
the cultural context I am residing in. Putting the personal stories aside, I would argue that the
discursive field of contemporary art in Turkey has emerged and expanded in conjunction with
the maturation of a certain politico-theoretical view of *the local* fed by theoretical positions
such as post-Althusserian socialism, poststructuralism, anarchism and gender-based politics
led by feminism. Consequently, a politically charged aesthetics, fed by critiques of statism,
nationalism, militarism and paternalism, and based upon narrative structures, became the
prominent character of the emerging contemporary art scene. Due to the strict conservatism
dominating painting and sculpture departments at the academies, this new language attracted
people coming from peripheral departments within the academies and other disciplines such
as philosophy and literature, which reinforced this tendency towards politicization. In the
absence, or weakness, of local support and interest, the synergic interaction among certain
circles managed to establish links with Western European art scenes (with the help of the
maturing Istanbul Biennial). There was a political message but the audience for this message

was not the one that the message was addressing. The critical edge in the works could not penetrate the processes of public negotiation.

In the last couple of years a lot of things have changed. There has been a sudden interest in contemporary art among the prominent bourgeois families and some corporate institutions—partly motivated by the cultural consequences of Turkey's membership negotiations with the EU, and partly by the need to reinforce the public image of the rootedness of those families and firms in Istanbul. New institutions of impressive scale have emerged. These new, sterilized, socially filtered spaces needed to exhibit some internationally acclaimed works from the local scene. This produced strange occasions where some artworks with quite an edgy character were co-opted by these projects.

The political climate also changed considerably. Until recently one could trace the logic of traditional distinctions between left and right. The heated paranoia on the 'Kurdish Question' following the upheaval of the invasion of Iraq and the shift of power, which brought the ex-Islamic movement into power, triggered nationalistic reflexes. The fear about the prospects of territorial unity and the cultural advances of the Republican Project caused a substantial split within the left, a massive part of traditionally left voters and intelligentsia sidelined with an ideological amalgamation between secularism and nationalism. Old enemies became new friends. New fronts have been shaped.

Against this background, what is called the contemporary art scene found hostile opposition. Linked with European organisations, the support coming from certain funds became highly suspicious. The political criticism of the previous years is taken as evidence of a betrayal. The recuperation of parts of this criticism by the new institutions is seen as a sign of decadence. The field of contemporary art is being portrayed as a prime example of moral and intellectual corruption. Moments of conflict and trauma ensued. An independent art space exhibiting photographs of the pogrom organized against non-Muslim minorities fifty years ago was raided by (left- and right-wing) nationalists in 2005. A series of trials were opened against public intellectuals by a group of nationalist lawyers in 2006. The 'enlightened' president of the Republic refused to congratulate the Nobel Prize winner Orhan Pamuk in 2006. Hrant Dink, a journalist of Armenian origin and one the country's most precious intellectuals, was assassinated in 2007. An ultrareligious newspaper accused an independent art space of blasphemy, and the police who came to protect the audience at the opening launched a prosecution against the exhibition, again in 2007. In 2008 Italian artist Pippa Bacca, who was travelling in a bridal gown from her country to Lebanon as a performance, was raped and killed.

Perhaps not representing the whole of the scene, but a number of artists have gathered around groups that work on specific issues, to try to maintain the political legacy of recent years, to collaborate with antimilitarist and queer groups, to open up art practice to larger social groups, and to elaborate a double-sided critique of nationalism and commercialization. A series of e-mails that circulated on the internet warned the authorities about the group WHW, the curators of the upcoming 11th Istanbul Biennial, alleging that the Zagreb-based group would incite ethnic conflict in Turkey.

# NOTES ON CONTRIBUTORS

**Ayreen Anastas** is a writer and filmmaker. Her work has been shown internationally in festivals, museums and cinemas. She is one of the organizers of 16 Beaver Group (16beavergroup.org) and she often collaborates with Rene Gabri. Recent commissions include *Camp Campaign* (www.campcampaign.info).

**Jochen Becker** is a critic, teacher and cultural producer based in Berlin. He contributes to *taz*, *springerin* and *Camera Austria*. Recent publications include, *Kabul / Teheran 1979ff* (2006), *Architektur auf Zeit* (2006) and *Self Service City: Istanbul* (2005). Recent projects include *Liberation/Libération*, Kunstpavillon, Innsbruck (2008) and *Doppelprojektionen*, Haus der Kulturen der Welt, Berlin (2008). (www.metroZones.info)

**Adam Budak** lives in Graz and Krakow and is currently curator for contemporary art at the Kunsthaus Graz am Landesmuseum Joanneum in Graz, Austria. He studied theatre studies in Krakow and history and philosophy of art and architecture in Prague. He worked with acclaimed artists such as John Baldessari, Pedro Cabrita Reis, -Cerith Wyn Evans and Monika Sosnowska, and has curated a large number of international exhibitions.

**Judith Butler** is Maxine Elliot Professor in the Department of Rhetoric and Comparative Literature at Berkeley and the author of numerous works including *Giving an Account of Oneself* (2005), *Antigone's Claim* (2000), *The Psychic Life of Power* (1997), *Excitable Speech* (1997), *Bodies That Matter* (1993), *Gender Trouble* (1990).

**Alan Colquhoun** is Professor Emeritus of Architecture at Princeton University. He has taught at the AA, Cornell University and University College Dublin, among many other schools of architecture. He is the author of several books including the seminal *Essays in Architectural Criticism* (1981), *Modernity and the Classical Tradition* (1991), and *The Oxford History of Modern Architecture* (2002).

**Simon Critchley** is Professor of Philosophy at the New School for Social Research, New York. He is the author of many books, most recently *Infinitely Demanding* (Verso, 2007) and *The Book of Dead Philosophers* (Granta, Vintage 2008). A book on Martin Heidegger's *Being and Time* is forthcoming.

**Marco de Michelis** is the dean of the faculty of arts and design at the IUAV University in Venice. He was the editor of *Ottagono* (1989–1991) and the chief curator at the Triennale Design Museum in Milan (1993–1996). He has written extensively on contemporary architecture. Recent publications include *Heinrich Tessenow* (Stuttgart/DVA and Milan/Electa 1991); 'Walter Gropius, Ludwig Hilberseimer' (special issues of *Rassegna*, 1983 and 1986); *Bauhaus* (Milan/Mazzotta 1996); *Luis Barragan* (Milan/Skira 2000); and *Enric Miralles* (Milan/Skira 2002).

**TJ Demos** is a critic and a lecturer in the Art History Department, University College London. He is a member of the editorial board of Art Journal and writes widely on modern and contemporary art. His articles have appeared in journals including *Artforum*, *Grey Room*, *October*, and *Texte zur Kunst*. He is the author of *The*

*Exiles of Marcel Duchamp* (MIT Press, 2007), and is currently at work on a new study provisionally titled *Migrations: Contemporary Art and Globalization*.

**Rene Gabri** organizes public discussions, readings and social activities, largely through his involvement with 16 Beaver, which he co-initiated in 1999. Together with Erin McGonigle and Heimo Lattner, he also works under the name e-Xplo (e-Xplo.org). Their collaboration has resulted in a variety of public art projects and commissions exploring cities and the social, economic, and political forces which shape the organization of space.

**Bernd Hüppauf** is Professor of German at New York University. He lives in New York and Berlin. He has published widely on a range of topics including the literature and culture of the Weimar Republic, representations of war in literature and photography, and image theory. Among his latest publications are *Vernacular Modernism* with Maiken Umbach (Stanford University Press, 2005), *Bild und Einbildungskraft* with Christoph Wulf (München, 2007), and *Science Images and Popular Images of the Sciences* with Peter Weingart (London, New York, 2008).

**Erden Kosova** is an art critic based in Istanbul. He is on the board of the art magazine *art-is* and is a PhD student in the Visual Culture Programme, Goldsmiths College London. He teaches at Kadir Has University in Istanbul.

**Lucy R. Lippard** is the author/editor of 20 books on contemporary art and cultural criticism, most recently: *The Lure of the Local: Senses of*

*Place in a Multicentered Society* (1997) and *On the Beaten Track: Tourism, Art and Place* (1999).

**Suzana Milevska**, Ph.D., is a curator and visual culture theorist based in Skopje, Macedonia. She has curated over 70 art projects and conferences internationally, and as an international correspondent writes for the *Feminist Review*, *Contemporary* and *springerin*. Her writing has also been included in many publications on art and theory.

**Nina Möntmann** is a curator and writer, and is Professor and Head of the Department of Art Theory and the History of Ideas at the Royal University College of Fine Arts in Stockholm. She is a correspondent for *Artforum*, and contributes to *Le Monde Diplomatique*, *Parachute*, *metropolis m*, *Frieze* among others. Recent publications, as editor, include *Art and its Institutions* (Black Dog Publishing, 2006) and, as co-editor with Yilmaz Dziewior, *Mapping a City* (Hatje Cantz, 2005).

**Gianni Pettena** is an artist, architect and designer. He was a key figure in the Radical Architecture movement in Italy. He has shown his work internationally since 1968 and created many seminal works, including *Clay House* (1972), *Tumbleweed Catcher* (1972), and *Ice House* (1971). (www.giannipettena.it)

**Christian Philipp Müller** is an artist and has exhibited internationally since 1986. His work has been shown in major exhibitions such as Documenta X in Kassel, Germany (1997) and at the Venice Biennial (1993). Recent solo exhibitions include a retrospective at the Museum für Gegen-

wartskunst, Basel (2007) and *Cookie-Cutter*, a project for Orchard, New York (2008). Permanent work by the artist can be found at, among other sites, the campuses of Bard College and Queens College and in the cloister garden in Melk (Austria). He has also published many artists books. (www.christianphilippmueller.net)

**Franco Rella** is Professor of Aesthetics at the Università IUAV di Venezia and head of the PhD programme in history and philosophy of the arts. He has worked in Italy and abroad on essays, readings and the organisation of exhibitions. His publications include *Figure del male* (2001), *Ai confini del corpo* (2000), *L'io nello specchio del mondo* (1998), *Miti e figure del moderno* (1993), *L'enigma della bellezza* (1991), and the novel *L'ultimo uomo* (1996).

**Gayatri Chakravorty Spivak** is University Professor in the Humanities and Director of the Institute for Comparative Literature and Society at Columbia University and author of numerous works including *Death of a Discipline* (2003), *A Critique of Postcolonial Reason* (1999), *Outside in the Teaching Machine* (1993), *The Post-Colonial Critic* (1990) and *In Other Worlds* (1987).

**Uqbar Foundation** is a project initiated by artists Irene Kopelman and Mariana Castillo Deball. Recent projects include *A for Alibi* at de Appel, Amsterdam (2007); *Philosophical Transactions* at the Historical Observatory, Cordoba, Argentina (2007); and *One eye, two eyes, three eyes*, a seminar on storytelling at the Piet Zwart Institute, Rotterdam (2007–2008).

**Mirko Zardini** is an architect and writer. He is Director of the Canadian Centre for Architecture, and was editor of *Casabella* magazine (1983–1988), *Lotus international* (1988–1999) and served on the editorial board of *Domus*. His publications include *Asphalt* (2003), *An almost perfect periphery* (2001), *Back from the Burbs* (2000), *Paesaggi ibridi: Highway, Multiplicity* (2000), *The Dense-City: After the Sprawl* (1999), *Paesaggi ibridi: Un viaggio nella città contemporanea* (1996), and *Frank O. Gehry: America as Context* (1994).

Managing Editor
**Dan Kidner**

Translators
**Christopher Jenkin-Jones**
(German-English)
**Jennifer Knaeble**
(Italian-English)

Adam Budak and Nina Möntmann would like to thank all the authors and artists for their thoughtful and inspiring contributions, the translators, and particularly Dan Kidner for his great work as managing editor.

July 2008

# COLOPHON

Manifesta 7 is an initiative of the International Foundation Manifesta, Amsterdam, The Netherlands and the Autonomous Province of Bozen/Bolzano and the Autonomous Province of Trento.
Manifesta 7 is organised by the Comitato MANIFESTA 7

**MANIFESTA 7 COMMITTEE**
PRESIDENT
Hedwig Fijen
VICEPRESIDENT
Allard Huizing
HONORARY TREASURER
Marilena Defrancesco
HONORARY SECRETARY
Birgit Oberkofler
MEMBERS
Gianluigi Bozza
Antonio Lampis

**MANAGEMENT TEAM**
DIRECTOR
Hedwig Fijen
COORDINATOR PROVINCE OF TRENTO
Fabio Cavallucci
COORDINATOR PROVINCE OF BOLZANO/BOZEN
Andreas Hapkemeyer
PROJECT MANAGER PROVINCE OF TRENTO
Cristina de Tisi

**M7 CURATORS**
Adam Budak
Anselm Franke/Hila Peleg
Raqs Media Collective:
Jeebesh Bagchi, Monica Narula, Shuddhabrata Sengupta

**ORGANISATION DEPARTMENT**

**BOLZANO/BOZEN**
ASSISTANT COORDINATOR
Lisa Mazza
ASSISTANTS
Marion Lafogler
Verena Malfertheiner

**TRENTO**
OFFICE MANAGERS
Orietta Berlanda
Cristina Maymone
TRAVEL & ACCOMODATION OFFICER
Betty Balduin
ORGANISATION ASSISTANT
Sara Dolfi Agostini
ASSISTANT
Laura Colucci

**GRANTS**
GENERAL COORDINATOR
Marieke Van Hal

**PRODUCTION**
DIRECTORS OF PRODUCTION
Peter Paul Kainrath
Sabrina Michielli
ASSISTANT TO THE DIRECTORS OF PRODUCTION
Chiara Prada
PRODUCTION ASSISTANTS
Francesca Batori
Marianna Liosi
Valentina Malossi

Chiara Veronesi
Katharina Kolakowski
TECHNICAL DIRECTORS
Weber+Winterle Architetti
TECHNICAL ASSISTANTS
RESPONSIBLE FOR VENUES
Andrea Polato – Bolzano/Bozen
Erwin Canderle – Fortezza/Franzensfeste
Thomas Pilati – Trento
Andrea Miserocchi – Rovereto
AV TECHNICAL DIRECTOR
Pascal Willekens
AV TECHNICAL TEAM
Kevin Bellemans
Charles Gohy
Hannes van Hoof
Thomas Nijs
Sam Raedts
Bart Reynartz
Imanol Sistiaga
Pieter Vervynck

**COMMUNICATION**
HEAD OF COMMUNICATION
Alessandra Santerini

**PRESS OFFICE**
INTERNATIONAL AND NATIONAL PRESS
Chiara Costa
LOCAL PRESS – TRENTINO
Danilo Fenner
LOCAL PRESS – SOUTH TYROL
Klaus Hartig
ASSISTANTS
Sofia Patat
Francesca Rossi

**INTERNATIONAL RELATIONS, SPECIAL PROGRAMS AND EVENTS**
Daniele Maruca
with Chiara Del Senno
ASSISTANTS
Silvia Scarpa
Tim van Lingen

**EDUCATION**
HEAD OF EDUCATION
Yoeri Meessen
COORDINATOR SOUTH TYROL
Thea Unteregger
COORDINATOR TRENTINO
Francesca Sossass
ASSISTANT COORDINATOR
Barbara Mahlknecht
ASSISTANT
Stefania Schir

**ART MEDIATORS**
Romina Abate
Antonia Alampi
Marco Anesi
Dorothea Arbesser
Martina Baroncelli
Oriana Bosco
Barbara Campaner
Silvia Conta
Valentina Curandi
Daria Ghiu
Nathaniel Katz
Riccardo Lami
Linda Jasmin Mayer
Melanine Mölgg
Marion Oberhofer
Martina Oberprantacher
Alexandra Ross
Karin Schmuck
Giovanna Tamassia
Chiara Villani

**PATRONS PROGRAM**
Mariapaola Spinelli

**ADMINISTRATION**
Mariano Brutto
Matteo Sartori
Rodolfo Tosi
Dea Martini

**RELATIONS IFM – M7**
Saskia van der Kroef
Suzanne Dijkema
Marieke Van Hal

**PUBLICATION INDEX**
Commissioned by Comitato Manifesta 7 and International Foundation Manifesta
MANAGING EDITOR
Maria Cristina Giusti
EDITORS
Rana Dasgupta
Stephen Haswell Todd
Dan Kidner
ENGLISH EDITOR
Jonathan Turner
ASSISTANT
Claudia Zini

**PUBLICATION COMPANION**
Commissioned by Comitato Manifesta 7 and International Foundation Manifesta
COPY EDITOR
Stephen Haswell Todd
EDITORS
Rana Dasgupta
Stephen Haswell Todd
Dan Kidner
Nina Möntmann
Avi Pitchon

**PUBLICATION SCENARIOS**
EDITOR
Julia Moritz

**GRAPHIC DESIGN/WEBSITE**
Surface, Frankfurt am Main:
Markus Weisbeck, Florian Feineis, Oliver Kuntsche, Pascal Kress, Max Weber

**EXHIBITION SCENARIOS (FORTEZZA/FRANZENSFESTE)**
CURATORS
Adam Budak
Anselm Franke, Hila Peleg
Raqs Media Collective:
Jeebesh Bagchi, Monica Narula
Shuddhabrata Sengupta
ASSISTANT CURATOR
Julia Moritz
ASSISTANTS
Silvia Ploner
Ausra Trakselyte

**EXHIBITION THE REST OF NOW (BOLZANO/BOZEN)**
CURATORS
Raqs Media Collective:
Jeebesh Bagchi, Monica Narula, Shuddhabrata Sengupta
ASSISTANT CURATOR
Denis Isaia
CURATORIAL ADVISORS
Anders Kreuger
Nikolaus Hirsch
Graham Harwood

VENUE ARCHITECTS
Nikolaus Hirsch/Michel Müller
ASSISTANTS
Marianna Sabena
Elisa Tosoni
Daniela Unterholzner

**EXHIBITION THE SOUL (TRENTO)**
CURATORS
Anselm Franke, Hila Peleg
ASSISTANT CURATORS
Katia Anguelova
RESEARCH ASSISTANT
Nana Bahlmann
VENUE ARCHITECTS
Kuehn Malvezzi
ASSISTANTS
Fabrizia Endrizzi
Irene Leveghi

**EXHIBITION PRINCIPLE HOPE (ROVERETO)**
CURATOR
Adam Budak
ASSISTANT CURATOR
Lorenzo Pezzani
CURATORIAL ADVISORS
Krist Gruijthuijsen
Tobi Maier
Nina Möntmann
Andreas Spiegl
Christian Teckert
ASSISTANTS
Veronica Bellei
Anna Babini
Luisa Filippi
Virginia Malucelli

**INTERNATIONAL FOUNDATION MANIFESTA**
DIRECTOR
Hedwig Fijen
PROJECT COORDINATOR
Saskia van der Kroef
EXTERNAL RELATIONS
Yoeri Meessen
OFFICE MANAGER
Suzanne Dijkema
GRANTS MANAGER
Marieke van Hal
BOOKKEEPER
George Konig

**BOARD**
CHAIR
Gilane Tawadros
VICE-CHAIR
Viktor Misiano
HONORARY TREASURER
Renze Hasper
MEMBERS
Daniel Birnbaum
Rector Städelschule Art Academy, Frankfurt am Main,
Director Portikus Gallery, Frankfurt am Main;
Iara Boubnova
Founding Director Institute of Contemporary Art, Sofia, Curator Manifesta 4;
Fabio Cavallucci
Director Galleria Civica di Arte Contemporanea, Trento, Coordinator Manifesta 7;
Charles Esche
Director Van Abbemuseum, Eindhoven;
Massimiliano Gioni
Curator, New Museum of Contemporary Art, New York,

Curator Manifesta 5;
Andreas Hapkemeyer
Former Director of Museion,
Bolzano/Bozen, Coordinator
Manifesta 7;

Sirje Helme
Director KUMU Museum, Tallinn;
Allard Huizing
Lawyer at Greenberg Traurig,
Amsterdam;
Sarat Maharaj
Professor of Visual Art and
Knowledge Systems, Lund
University, Malmö;
Marieke Sanders-ten Holte
Former Member of the European
Parliament, Amsterdam

**HONORARY COMMITTEE
OF MANIFESTA 7**
PRESIDENT
Sandro Bondi,
Minister of Cultural
Heritage and Activities, Italy
MEMBERS
Lorenzo Dellai
President of the Autonomous
Province of Trento;
Luis Durnwalder
President of the Autonomous
Province of Bolzano/Bozen;
Margherita Cogo
Vice President and Councillor
for Culture of the Autonomous
Province of Trento;
Sabina Kasslatter-Mur
Councillor for Family, Cultural
Heritage and German Culture of
the Autonomous Province
of Bolzano/Bozen;
Luigi Cigolla
Councillor for Cultural Heritage,
Italian Culture and Housing
Development of the Autonomous
Province of Bolzano/Bozen;
Florian Mussner
Councillor for Ladin Education
and Culture, Public Infrastructure
of the Autonomous Province of
Bolzano/Bozen;
Egbert Frederik Jacobs
Ambassador of the Royal Kingdom
of The Netherlands in Rome;
Alberto Pacher
Mayor of Trento;
Luigi Spagnolli
Mayor of Bolzano/Bozen;
Guglielmo Valduga
Mayor of Rovereto;
Johann Wild
Mayor of Fortezza/Franzensfeste;
Lucia Maestri
Councillor for Culture, Trento;
Sandro Repetto
Councillor for Assets and
Housing Politics Bolzano/Bozen;
Primo Schönsberg
Councillor for Culture, Research
and Strategic Development
Bolzano/Bozen;
Giovanni Cipolletta
Vice Mayor and Councillor for
Culture Fortezza/Franzensfeste;
Elmar Pichler-Rolle
Vice Mayor and Councillor
for Economic and Financial
Affairs Bolzano/Bozen;
Franco Bernabè
President MART – Museum of

Modern and Contemporary Art
Trento and Rovereto;
Alois Lageder
President MUSEION – Museum
of Modern and Contemporary Art
Bolzano/Bozen;

Gabriella Belli
Director MART – Museum of
Modern and Contemporary Art
Trento and Rovereto;
Corinne Diserens
Director MUSEION – Museum of
modern and contemporary art
Bolzano/Bozen;
Innocenzo Cipolletta
President University of Trento;
Hanns Egger
President Free University
of Bolzano/Bozen;
Davide Bassi
Head of the University of Trento
Rita Franceschini
Head of the Free University
of Bolzano/Bozen;

**MANIFESTA 7**
OFFICE BOLZANO/BOZEN
Via Crispi/Crispistraße 15
39100 Bolzano/Bozen
Tel. +39.0471.414980
fax. +39.0471.4141989
OFFICE TRENTO
Via Petrarca 32
38100 Trento
Tel. +39 0461.493670
fax. +39 0461.493671
info@manifesta7.it
www.manifesta7.it

**MANIFESTA AT HOME**
(Foundation offices & archives)
Prinsengracht 175 hs
1015 DS Amsterdam
The Netherlands
Tel. +31.20.6721435
fax. +31.20.4700073
secretariat@manifesta.org
www.manifesta.org

**COMPANION
MANIFESTA 7**
COMMISSIONED BY
Comitato Manifesta 7 and
International Foundation Manifesta
CURATORS
Adam Budak (Principle Hope)
Anselm Franke & Hila Peleg
(The Soul)
Raqs Media Collective
(The Rest of Now)
EDITORS
Rana Dasgupta (The Rest of Now)
Nina Möntmann (Principle Hope)
Avi Pitchon (The Soul)
EDITORIAL CO-ORDINATOR
Dan Kidner (Principle Hope)
Stephen Haswell Todd (The Soul)
COPY EDITOR
Stephen Haswell Todd
TRANSLATORS
Arianna Bove (Italian – English)
Rana Dasgupta (French – English)
Stephen Haswell Todd
(French-English)
Christopher Jenkin-Jones
(German-English)
Jennifer Knaeble (Italian-English)
Cathy Kerkoff-Saxon & Wilfried
Michael Meert (Dutch - English)
Prantner (German-English)
Shveta Sarda (Hindi-English)
PUBLICATION CO-ORDINATORS
Sara Dolfi Agostini
Maria Cristina Giusti

**PUBLISHER**
Silvana Editoriale, Milano
PRODUCED BY
Arti Grafiche Amilcare Pizzi Spa
DIRECTION
Dario Cimorelli
ART DIRECTOR
Giacomo Merli
ITALIAN/ENGLISH COPY EDITOR
Alessandra Galasso
GERMAN COPY EDITOR
Jan Heberlein
PRODUCTION COORDINATOR
Michela Bramati
EDITORIAL ASSISTANT
Sabrina Galasso
ICONOGRAPHIC OFFICE
Deborah D'Ippolito
PRESS OFFICE
Lidia Masolini,
press@silvanaeditoriale.it

EAN 97888-3661127-0

**GRAPHIC DESIGN**
Surface, Frankfurt am Main:
Markus Weisbeck,
Pascal Kress, Max Weber

**DISTRIBUTION**
Silvana Editoriale Spa

Silvana Editoriale Spa
via Margherita De Vizzi, 86
20092 Cinisello Balsamo, Milano
tel. +39 02 61 83 63 37
fax +39 02 61 72 464
www.silvanaeditoriale.it

Reproduction, print and binding by
Arti Grafiche Amilcare Pizzi Spa,
Cinisello Balsamo, Milano.
Printed in July 2008.

# MANIFESTA 7 HAS BEEN MADE POSSIBLE WITH THE SUPPORT AND COLLABORATION OF

INITIATORS

manifesta°
international foundation    AUTONOME PROVINZ BOZEN - SÜDTIROL    PROVINCIA AUTONOMA DI BOLZANO - ALTO ADIGE    PROVINCIA AUTONOMA DI TRENTO

SUPPORTED BY

Culture Programme    PARC MINISTERO PER I BENI E LE ATTIVITÀ CULTURALI    CITTÀ DI FORTEZZA / STADT FRANZENSFESTE    Città di Bolzano Stadt Bozen    COMUNE DI TRENTO    Comune di Rovereto

MAIN SPONSOR    PRODUCTION PARTNER    SPONSORs

Stiftung Südtiroler Sparkasse
Fondazione Cassa di Risparmio    ♦UniCredit Group    DR. SCHÄR    MINI

COMMUNICATION PARTNER    MEDIA PARTNER    SPECIAL PARTNER    TECHNICAL PARTNERS

SEAT PAGINE GIALLE    A    ZUMTOBEL    CENTOSTAZIONI GRUPPO FERROVIE DELLO STATO    VIDI SQUARE    A22

CONTRIBUTORS

DALLE NOGARE AG/SPA, LEITNER AG/SPA, KPMG ITALIA, OPERA UNIVERSITARIA DI TRENTO, NIEDERSTÄTTER, STADT BRIXEN/CITTA DI BRESSANONE, STADTWERKE ASM – BRIXEN/BRESSANONE, UTE & LORENZ MOSER, ARTE MUNDIT BY FTB REMMERS, GREENBERG TRAURIG, PAPIN SPORT, STAHLBAU PICHLER, MUSEION, MART, GALLERIA CIVICA DI ARTE CONTEMPORANEA DI TRENTO, PRESTABICI, MUSEUMPARTNER, MARTINA SCHULLIAN, SERVIZIO CONSERVAZIONE DELLA NATURA E VALORIZZAZIONE AMBIENTALE PROVINCIA AUTONOMA DI TRENTO, COOPERATIVA IL GABBIANO, TAGESZEITUNG

OFFICIAL ART HOTELS ALTO ADIGE/SÜDTIROL    OFFICIAL HOTELS

HOTEL LAURIN/HOTEL GREIF – BOLZANO/BOZEN    GRAND HOTEL – TRENTO, STADT HOTEL CITTÀ – BOLZANO/BOZEN

GRANTS ORGANISATIONS

AGENCY FOR CONTEMPORARY ART EXCHANGE (ACAX), ALLIANZ KULTURSTIFTUNG, ARTIS, ASSOCIATION FRANÇAISE D'ACTION ARTISTIQUE (AFAA), BRITISH COUNCIL, CENTRE CANADIEN D'ARCHITECTURE, CENTER FOR ICELANDIC ART (CIA.IS), CENTRE NATIONAL DES ARTS PLASTIQUES (CNAP), CENTRUM BEELDENDE KUNST ROTTERDAM (BMK), CULTURE IRELAND, CULTURESFRANCE, DANISH ARTS COUNCIL, DIRECÇÃO-GERAL DAS ARTES (DGARTES), FONDAZIONE DI VENEZIA, FONDAZIONE PER GLI ALTI STUDI SULL'ARTE (FASA), EMBASSY OF ISRAEL IN ROME, EMBASSY OF ISRAEL IN THE HAGUE, FORD FOUNDATION, FUNDAÇÃO CALOUSTE GULBENKIAN, FUNDAÇÃO LUSO AMERICANA, HELLENIC MINISTRY OF CULTURE, INSTITUT FÜR AUSLANDSBEZIEHUNGEN (IFA), INTERNATIONAL ARTISTS STUDIO PROGRAM IN SWEDEN (IASPIS), İSTANBUL KÜLTÜR SANAT VAKFI (IKSV), ISTITUT CULTURAL LADIN, ISTITUTO POLACCO DI ROMA, ISTITUTO ROMENO DI CULTURA E RICERCA UMANISTICA DI VENEZIA, LATVIJAS REPUBLIKAS KULTŪRAS MINISTRIJA, MINISTÉRE DE LA CULTURE ET DE LA COMMUNICATION DE LA FRANCE, MINISTÉRIO DA CULTURA DE PORTUGAL, MINISTRY OF CULTURE OF THE REPUBLIC OF CROATIA, MINISTRY OF EDUCATION SCIENCE AND CULTURE ICELAND, OFFICE FOR CONTEMPORARY ART NORWAY (OCA), ÖSTERREICHISCHES BUNDESMINISTERIUM FÜR UNTERRICHT, KUNST UND KULTUR (BMUKK), PRO HELVETIA, SCOTTISH ARTS COUNCIL, SOCIEDAD ESTATAL PARA LA ACCIÓN CULTURAL EXTERIOR (SEACEX), STATE CORPORATION FOR SPANISH CULTURAL ACTION ABROAD, THE NETHERLANDS FOUNDATION FOR VISUAL ARTS, DESIGN AND ARCHITECTURE (BKVB), UNIVERSITY IUAV OF VENICE, VLAAMS MINISTERIE VAN CULTUUR

OFFICE FOR CONTEMPORARY ART NORWAY    swiss arts council pro helvetia    Republic of Croatia Ministry of Culture    SEACEX